P9-CKW-855

The Harold Samuel Collection, comprising eighty-four seventeenth-century Dutch and Flemish paintings, has been described as the finest private collection of such works to be formed in Britain this century. It includes paintings by such masters as Frans Hals, Nicolaes Maes and Jacob van Ruisdael, acquired by Lord Samuel for his personal pleasure and to hang in his home, Wych Cross. The Collection was bequeathed to the Corporation of London in 1987 to be hung permanently in the Lord Mayor's residence, Mansion House.

The refurbishment of Mansion House has provided the unique opportunity for an exhibition tour, during which the Harold Samuel Collection will be seen by many for the very first time. Coinciding with the exhibition, a complete catalogue of the Collection has been compiled by an acknowledged expert, Peter C. Sutton. Dr Sutton is well known for his many publications in this field and through exhibitions such as *Masters of Seventeenth-Century Dutch Genre Painting*, shown in Philadelphia, Berlin and at the Royal Academy of Arts in 1984 and *Masters of Seventeenth-Century Dutch Landscape Painting*, shown in Amsterdam, Boston and Philadelphia in 1987–8.

This book is not simply the catalogue of an exhibition; it is the permanent record of a small but extremely important collection of paintings and one which will be of great interest to art lovers and scholars alike.

Dutch & Flemish
Seventeenth-century paintings

THE HAROLD SAMUEL COLLECTION

Dutch & Flemish
Seventeenth-century paintings

THE HAROLD SAMUEL COLLECTION

PETER C. SUTTON

CAMBRIDGE
UNIVERSITY PRESS

THE CORPORATION OF LONDON

ART SERVICES INTERNATIONAL

Published by the Press Syndicate of the University of Cambridge
The Pitt Building, Trumpington Street, Cambridge CB2 IRP
40 West 20th Street, New York, NY 10011-4211, USA
10 Stamford Road, Oakleigh, Victoria 3166, Australia

© The Corporation of London, 1992

First published 1992

Printed in Great Britain at the University Press, Cambridge

A catalogue record for this book is available from the British Library

Library of Congress cataloguing in publication data
Sutton, Peter C.
Dutch and Flemish seventeenth-century paintings: the Harold
Samuel collection / Peter C. Sutton
 p. cm.
Catalogue of a collection of works given to the Corporation of
London.
Includes bibliographical references.
ISBN 0 521 41795 3. – ISBN 0 521 42840 8 (pbk.)
1. Painting, Dutch. 2. Painting, Modern – 17th–18th
centuries – Netherlands – Exhibitions. 3. Painting, Flemish –
Exhibitions. 4. Painting, Modern – 17th–18th centuries – Flanders
– Exhibitions. 5. Samuel of Wych Cross, Harold Samuel, Baron,
1912–87 – Art collections – Exhibitions. 6. Painting – Private
collections – England – London – Exhibitions. 7. Corporation of
London – Exhibitions. I. Corporation of London. II. Title.
ND636.S87 1992
759.9492'09'032074–dc20 91–34350 CIP

ISBN 0 521 41795 3 hardback
ISBN 0 521 42840 8 paperback

Colour reproductions by courtesy
of Bridgeman Art Library

WD

Contents

Foreword

'This occasion is both a thanksgiving and a celebration', said Sir Robert Bellinger, who was Lord Mayor of London in 1966. Sir Robert was speaking at a luncheon in Mansion House on 30 November 1987, arranged to announce the most significant gift of art ever conveyed to the Corporation of the City of London. He described the event as a thanksgiving for the generosity of a remarkable man, Harold Samuel, and a celebration for the Corporation as a recipient of his benefaction.

Sir Robert Bellinger was absolutely correct, and spoke from personal knowledge of the magnanimity of Harold Samuel. He was also readily supported by the art world in his assessment of the importance of Lord Samuel's bequest to the Corporation, described as the greatest art bequest of the century. The Court of Common Council, meeting on 3 December 1987, furthermore expressed great indebtedness to Lady Samuel for her decision to convey the pictures to the Corporation immediately for hanging in Mansion House, rather than to retain them for her lifetime as Lord Samuel bequeathed.

Mansion House has been closed since August 1991 to enable large-scale renovation works to be carried out, and this is scheduled to take about two years. In the meantime, this unique and probably unrepeatable opportunity has been taken for the Harold Samuel Collection to be shown to the widest possible public. From 28 May to 19 July 1992, the Collection will form the centre-piece of 'The Celebrated City', a major exhibition of the Corporation's works of art at Barbican Art Gallery in London. Thereafter a selection from the Collection will be shown in several galleries in the United States of America, in a tour initiated by Marcia Brocklebank, UK representative of Art Services International.

The Barbican Art Gallery exhibition, followed by the American tour, will not only give great pleasure to many thousands of people. It will also enable them to assess for themselves the measure of generosity which Harold Samuel – not a man to court publicity – displayed when he decided that the Corporation of London should be the recipient of the magnificent works of art he painstakingly assembled for his own home.

This is not simply the catalogue of an exhibition, for such a definitive work has long been required and was 'in the pipeline' well before the tour proposals were finalized. The Corporation of London was anxious that the catalogue be compiled and published, and was delighted that it could be achieved under the prestigious imprint of Cambridge University Press. We were also extremely fortunate in securing the services of Peter C. Sutton, the Mrs Russell W. Baker Curator of European Paintings at the Museum of Fine Arts in Boston, Mass. He has carried out a most dedicated and scholarly task to bring this worthwhile project to fruition, a genuine expression of his feeling for the paintings themselves and a tribute to the memory of Lord Samuel of Wych Cross.

Melvyn Barnes *Director of Libraries and Art Galleries*
CORPORATION OF LONDON

Author's acknowledgements

Any book incurs debts, this more than most. I should like
first to thank Melvyn Barnes and Vivien Knight of the
Guildhall Art Gallery as representatives of the Corporation
of London for inviting me to undertake this fascinating
project. I am also deeply grateful to Lady Samuel for her
encouragement and to her daughter, Marion Naggar, and
grandson Albert for sharing their memories of Lord
Samuel. Edward and Anthony Speelman provided a wealth
of information about the paintings as well as fond remi-
niscences of Lord Samuel as a collector and friend. The
examination of the paintings and gathering of condition
notes was greatly facilitated by the Guildhall Art Gallery's
conservator Gillian Keay, and by Jeremy Johnson and the
other able members of the Gallery's staff. The research for
the catalogue was undertaken at several invaluable
institutions, the Witt Library at the Courtauld Institute,
London, the Frick Art Reference Library, New York, and
the Rijksbureau voor Kunsthistorische Documentatie in
The Hague. At the last mentioned I owe several expressions
of thanks to Gerbrand Kotting, Fred Meijer and P. A. de
Graaf. I also would like to thank Burton Fredericksen and
his staff at the Getty Foundation's Provenance Index.
Gillian Keay, Halbo Kool, Vivien Knight, Marjorie
Elizabeth Wieseman, Frits Duparc and Otto Naumann
read early drafts of the manuscript and made helpful
suggestions for revisions. The typescript was prepared with
care by Regina Rudser, while Marci Rockoff oversaw
correspondence. I would also like to thank Eleanor Alcorn,
Ronnie Baer, Christopher Brown, John Chvostal, Mary
Gillis, Walter Liedtke, Sam Nijstad, Sam Quigley, Sue
Reed, Joe Rishel, William Robinson, Stephanie Stepanek,
Karel Waterman and Sue Whithouse. For moral support,
as always, my love to Bug, Page and Spencer.

Acknowledgements by Art Services International

It is a great honour for Art Services International to present to American audiences the Harold Samuel Collection of Dutch and Flemish seventeenth-century paintings. The Corporation of London is the fortunate beneficiary of these superb works, bequeathed by British property developer Lord Samuel of Wych Cross, who died in 1987. Before they return permanently to the refurbished Mansion House, the residence of the Lord Mayor of London, it is our pleasure to make available these paintings by the foremost artists of the Golden Age for an exclusive tour of the United States.

This exhibition is a tribute to the discerning taste of Lord and Lady Samuel, and to their dedication and enthusiasm as collectors. We honour Lady Samuel for her generosity in donating these superb works and for endorsing the tour.

It is with the greatest pleasure that we express our thanks to The Rt. Hon. The Lord Mayor of London for sharing these paintings with the American public, and for serving as Honorary Patron for the tour. On this side of the Atlantic, we particularly wish to thank Sir Robin Renwick, Ambassador of Great Britain, and Hans Meesman, Ambassador of the Netherlands, for serving as Honorary Patrons for this exhibition, and to Gordon Tindale and Andreas te Boekhorst, Cultural Attachés to the respective embassies, for their valued assistance.

We are extremely grateful to Melvyn Barnes, Guildhall Librarian and Director of Libraries and Art Galleries of the Corporation of London, for his confidence and encouragement. It has been our great pleasure to work with him. We enthusiastically extend our thanks to Vivien Knight, Curator of the Corporation's Permanent Collection, for her invaluable support from the outset of this project. We are also grateful to Gillian Keay, Conservator of the Guildhall Art Gallery, for her technical assistance. Without their expertise, this exhibition would not have been possible.

It is a pleasure for us to thank our colleague, Dr Peter C. Sutton, Curator of European Paintings at the Museum of Fine Arts in Boston and Guest Curator of the exhibition. We congratulate him on his selection of paintings, and on the important contribution his text provides to the available scholarship on the Harold Samuel Collection and seventeenth-century Northern European art as a whole.

George Gordon and Arabella Chandos of Sotheby's provided us with their expert appraisals, and we send them our sincere thanks.

We are indebted to British Airways Cargo, and to Michael Aldwin in particular, for the support of this project, and are pleased to identify British Airways Cargo as the official carrier for the US tour.

We are delighted to recognize the institutions who have worked so closely with Art Services International in seeing this project to fruition. We extend our thanks to Alexander Lee Nyerges and Elise B. Smith of the Mississippi Museum of Art in Jackson; Katharine C. Lee and Richard B. Woodward of the Virginia Museum of Fine Arts in Richmond; DeCourcy E. McIntosh and Alan Fausel of the Frick Art Museum in Pittsburgh; Alan Shestack and our Guest Curator, Dr Peter Sutton of the Museum of Fine Arts in Boston; and Jay Gates and Dr Chiyo Ishikawa of the Seattle Art Museum. Their enthusiasm and support has been invaluable.

Contributing to the realization of this project was Mrs C. W. Brocklebank, our valued representative in the United Kingdom. Finally, we would like to add our personal thanks to the staff of Art Services International – notably Donna Elliott, Douglas R. Shawn, Susan W. Raines and Ana Maria Lim – for their expertise and the careful attention they have given to the myriad details of this project.

Lynn Kahler Berg *Director*
Joseph W. Saunders *Chief Executive Officer*

Tour itinerary

Mississippi Museum of Art, Jackson, Mississippi
Virginia Museum of Fine Arts, Richmond, Virginia
Frick Art Museum, Pittsburgh, Pennsylvania
Museum of Fine Arts, Boston, Massachusetts
Seattle Art Museum, Seattle, Washington

Introduction

The Harold Samuel Collection is the most distinguished private collection of Dutch and Flemish paintings to be assembled in England since the war. Its strengths in landscape, cityscape and genre paintings are peerless. Among collections of Northern paintings gathered in the modern era, only a handful – the Edward Carter and Norton Simon collections in Southern California, the Deder collection in Germany, a private collection in Montreal, and perhaps one or two others – attain such a high level of quality. Assembled over a period of more than thirty years beginning around 1950 and comprised mostly of intimately scaled cabinet-sized paintings, the Samuel collection was acquired with a domestic setting in mind, Lord Samuel's estate, Wych Cross Place in Sussex, but was bequeathed to the Corporation of London to remain together and be hung at Mansion House. When Lady Samuel generously declined her option to retain the collection during her own lifetime and presented it to the Corporation immediately following Lord Samuel's death in 1987, Sir Robert Bellinger, former Lord Mayor of London and a friend and associate of Harold Samuel, characterized it as 'the greatest gift of art ever conveyed to the Corporation of the City of London during the centuries of its existence'. With the exception of the Courtauld bequest, no other recent gift of art to a British institution has been so generous.

One of the most successful property developers of his day, Harold Samuel (fig. 1) was founder of Land Securities Investment Trust, and played a central role in the reconstruction and growth of central London as a world financial centre after the war. He also foresaw the impact of the automobile on British life, developing modern shopping centres throughout the United Kingdom. Among his major projects in London are the East Island site of John Lewis in Oxford Street, Bowater House at Knightsbridge, and the modernization of Victoria Street. A modest, self-effacing man who shunned publicity, Lord Samuel is also remembered for his quiet but exceptionally generous philanthropy. In addition to his gift of art, he made munificent donations to the British Heart Foundation, the Royal College of Surgeons, and to the Universities of

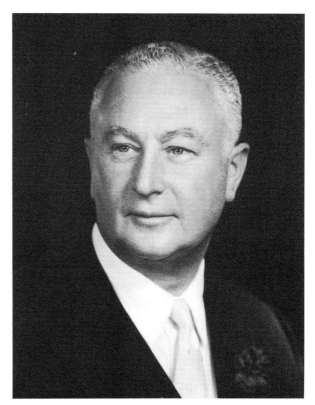

FIG. 1 Harold Samuel, photograph

Cambridge and London. He was a member of the court of several universities and an honorary fellow of Magdalene College, Cambridge, and University College, London. Lord Samuel was also a generous contributor to various Jewish causes, including the Joint Israel Appeal, the Hebrew University and the Anti-TB League of Israel.

Born in London and educated at the Mill Hill School and the College of Estate Management, Harold Samuel first worked for a firm of chartered surveyors before establishing his own firm in Baker Street in the 1930s. He founded Land Securities in 1944 with the modest assets of three houses in Kensington, but built the concern into a vast business and property empire with more than £3 billion of

assets at the time of his death. One of his greatest talents was capitalizing on the changing relationships between the property markets and financial houses, especially in the sixties and early seventies. He was knighted in 1963 and created a life peer in 1972 as Baron Samuel of Wych Cross Place in the County of Sussex.

Purchased by Samuel in 1954, Wych Cross Place (see figs. 2 and 3) was built in 1902 for Douglas Freshfield by the architect Edmund Fisher. The extensive gardens were designed by the well-known landscape architect, Thomas Mawson. The original owner had chosen the site to take advantage of its splendid prospects across the rolling Sussex Downs. Soon after it was completed, the house was featured in an article in *Country Life* (24 December 1910). Lord Samuel extensively remodelled the house, removing the west wing and refurbishing the interior. He took special delight in Wych Cross' meticulously maintained gardens. Samuel surrounded himself with English furniture and Dutch paintings, recognizing, as other collectors have, that the two art forms naturally complement each other (fig. 4).

Although there are several large canvases among the Samuel landscapes, the majority of his paintings are small, even tiny, works mostly on oak panel or copper. Of the eighty-four works here catalogued, fifty-three are on wood and fifteen on copper, supports which lend themselves more than canvas to a detailed and refined execution. Clearly it was not only the naturalism of Dutch art which appealed to the collector, but also its famously fastidious technique and emphasis on craft and a careful use of materials. Seventeenth-century art theorists reported that artists ran the risk of being ridiculed by their fellows if their paintings suffered from drying crackle or similar evidence of a careless use of materials. Like the original Dutch merchant/burgher collectors, Lord Samuel was obviously concerned about condition; for the most part his paintings are in excellent state.

In an age when most major collectors of Old Masters coursed freely not only back and forth among the galleries along New Bond and Duke Streets but also among dealers and art markets abroad, Lord Samuel was the exception in remaining loyal throughout his life to one dealer, Edward Speelman. By all accounts he also maintained unusual standards of loyalty in his professional business dealings, preferring selection to competition when making decisions in such matters as architecture, engineering and financing. His continuity of remuneration was a unique and legendary feature in the property market of his day and won the admiration even of his competitors. Happily, in Speelman Lord Samuel chose the best dealer of Dutch paintings of his

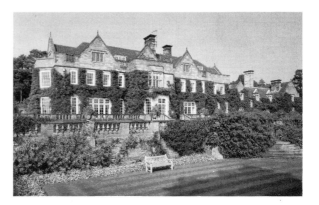

FIG. 2 Wych Cross Place, Sussex, south aspect, photograph

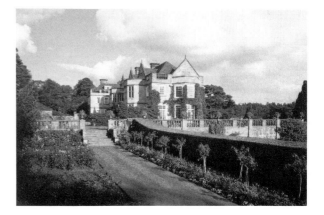

FIG. 3 Wych Cross Place, Rose Garden, photograph

generation and one of the finest connoisseurs in the field. Speelman not only sold him paintings directly but also acquired works for Samuel at auction. The most famous case of the latter was when Speelman purchased Frans Hals' *Merry Lute Player* (Cat. 24) at the 1963 New York sale of the collection of Oscar B. Cintas, a sugar and railway financier and former Cuban Ambassador to the United States; this painting is now the jewel in the Samuel crown and surely one of the finest Halses in existence. At the time of its purchase, the painting itself was of less interest to the press than its record price (£214,850) and the fact that Speelman had set a soon-to-become-common precedent of bidding transatlantically by telephone. It was typical of Samuel that he successfully remained anonymous through-out the sensation over the sale; indeed speculation ironically

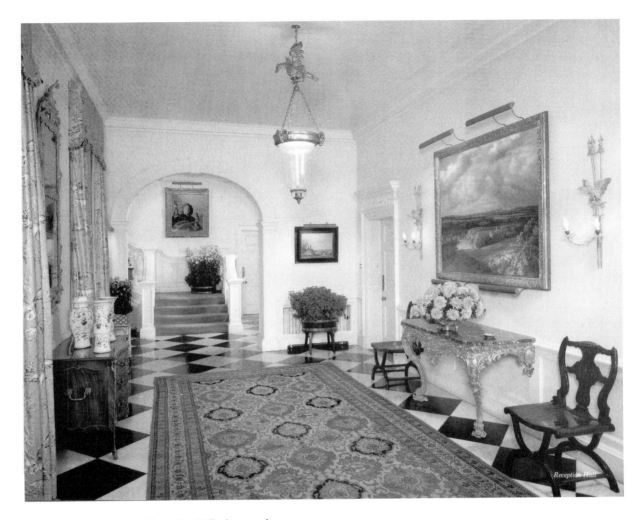

FIG. 4 Wych Cross Place, Reception Hall, photograph

cast another property magnate and collector, Sir Charles Clore, as the likely purchaser.

In point of fact the Hals is an anomaly in the collection, scarcely because of its exceptional quality but because it is a large-scale, life-size painting of a single half-length genre figure. Samuel never shunned the human form as have several recent Dutch collectors, notably Carter, who collected only landscapes and still lifes, or the late Senator John Heinz who specialized exclusively in still lifes. However Samuel preferred small-scale genre scenes, landscapes and portraits. It is typical of that intimate taste that the first paintings that Speelman sold him in the 1950s were a pair of slickly painted still lifes by the eighteenth-century Dordrecht painter Spandonck and a beautifully polished little domestic genre scene of a mother and her child in an elegant interior by the eighteenth-century French painter, Boilly (fig. 5). Samuel initially also collected eighteenth-century Italian *vedute*, owning important works by Canaletto, Marieschi and Guardi, but he disposed of these as his enthusiasm for Dutch paintings grew. Indeed virtually the only artistry which preempted that passion was that of nature itself: Samuel had at one point gathered together an excellent group of flower paintings by, among others, Bartholomeus van der Ast, Rachel Ruysch and Jan van Huysum, but sold them when he realized that he preferred living among the real blossoms from his own magnificent gardens. The still lifes that he kept for the most part depict tabletops set with a simple meal (Cats. 14, 15 and 63) or unpretentious arrangements of smoking supplies (Cats. 56 and 75).

For the collector, the crucial test of a picture was whether it enhanced his own life and he enjoyed living with it. Lady Samuel (the former Edna Nedas), to whom he was married in 1936, was always consulted before he acquired a new picture. Since Lord Samuel had assembled his collection not for display but for his own pleasure, he declined all requests for loans to exhibitions and was loath to share his paintings with other collectors, museum professionals or art historians. As a consequence, even specialists in the field were unaware of its rich contents until the collection was publicly displayed in 1988 at the Barbican Art Gallery after Lord Samuel's death. The exhibition's catalogue offered a brief introduction to the collection, while retaining the attributions that the paintings had held during Samuel's lifetime.

Besides excellent counsel, one advantage of establishing an exclusive relationship with a knowledgeable dealer is that he has a vested interest in sharing with you his contacts with other clients and collectors. Thus one has the possibility of acquiring works which might not otherwise come onto the public market. This worked to Samuel's advantage most spectacularly when in 1959 Speelman acquired no less than seven paintings from the famous Beit collection, which had been assembled around the turn of the century by the South African gold and diamond king, Alfred Beit (on the Beits, see Cat. 83; see also Cats. 27, 39, 44, 50, 52 and 62); part of this collection was recently presented to the National Gallery of Ireland, Dublin. The group acquired by Samuel included masterpieces by Jan van der Heyden, Nicolaes Maes, Adriaen van Ostade, Salomon van Ruysdael and Philips Wouwermans. Another important source for the formation of the collection was Speelman's contacts with the French wine merchant Etienne Nicolas who, through his Russian contacts, was able to acquire paintings directly from the Hermitage (see Cat. 17). A part of Nicolas' extensive collection, once housed in his Paris apartments, is now in the Louvre (including two paintings by Rembrandt, R.F. 1948–34 and 35). Eventually thirteen paintings from the Nicolas collection were acquired by Samuel (see Cats. 17, 20, 25, 28, 34, 40, 49, 58, 59, 61, 65, 78 and 82), including excellent works by, among others, Jan van der Heyden, Jacob van Ruisdael, Salomon van Ruysdael, Jan Steen and Emanuel de Witte. Speelman also secured major works by Philips Koninck (Cat. 36) and Jacob Ochtervelt (Cat. 47) from the famous collection of Sir William van Horne, the developer of the Canadian Pacific Railroad; from the well-known Dutch collection of H.E. ten Cate of Oldenzaal he secured an outstanding still life of a *Water Pump* by Adriaen van Ostade (Cat. 51) and a

still life of smoking requisites by Jan van de Velde (Cat. 75).

Although he amassed an extensive art history library and was well informed about his art, it was never Harold Samuel's intention to assemble an historically comprehensive survey of Dutch painting; whole categories, for example history painting, were omitted, although he admitted allegories in the guise of genre painting (Cats. 67–71). The majority of his paintings date from the third quarter of the century and the single largest and historically most representative group is the landscapes. The earliest of these are the tiny highly finished works by Jan Brueghel the Elder (Cats. 8, 9 and 10) which well illustrate the important contributions this influential Flemish artist made to the popular tradition of the river and open-road landscapes as well as favoured landscapes themes such as the halt before the inn. Eleven winter landscapes comprise the largest sub-genre in the collection and include such masterpieces as Hendrick Avercamp's large copper panel depicting a broad frozen river covered with the colourful panoply of the season's recreations and daily chores (Cat. 4). Though a mute, Avercamp was a keen observer of his fellow man and of the delicate hues and atmosphere of winter, celebrating the season as no other painter had before him. His art was soon imitated by followers, including the enigmatic painter known as 'Cabel' (Cats. 1 and 2). The broad and elaborately additive compositions favoured by Avercamp were replaced by the more intimate winter landscapes of Esaias van de Velde (Cat. 74) and his pupil Jan van Goyen. Van Goyen's early landscapes (Cat. 19) are deceptively close in style to those of his teacher, while still retaining the colourful bustle of skaters before riverside castles inherited from earlier pictorial traditions. Prior to 1630 van Goyen developed a less elaborate but more naturalistic style which employed a restrained palette, simple diagonal designs with fewer motifs, and a unifying range of values. This 'tonal' manner persisted into the 1640s (Cat. 20) and imbued even his winter scenes with a pervasive atmosphere and earth-coloured hues. Later winter landscapes reintroduced stronger contrasts of tone and colour, alternately seeking a painterly richness in their atmospheric effects, as best witnessed in the work of Jan van de Cappelle (Cat. 12), or a velvety meteorological refinement, as in the art of Adriaen van de Velde (Cat. 73). In several regards, the winter landscape tradition culminates in the works of Aert van der Neer, not through any creative advancement of design (his compositions hark back to the 'double wing' panoramas favoured by Avercamp) but through his unrivalled sensitivity to

coloured light and atmospheric pyrotechnics (see Cats. 42 and 43).

Second only to winter subjects, the panorama is usually regarded as the most archetypically Dutch of all landscape themes, its broad sweep and soaring skies seemingly embodying the Dutchman's pride and confidence in his own newly liberated little country. The collection boasts a superb example of the later 'tonal' style in a painting of a *Panorama with Shepherds* (Cat. 16) executed with a confident and generous touch by the young Aelbert Cuyp. Van Goyen (see Cat. 21) also made significant contributions to the painting type, but its true masters were Philips Koninck (see Cat. 36) and Jacob van Ruisdael (see Cat. 59). The former gave the theme an unprecedented scale and painterly symphonic grandeur, while the latter's more intimately conceived *haerlempjes* evoke the limitless horizon and vaulted heavens just as powerfully, but more eloquently for their vivid compression and refinement.

Jacob van Ruisdael was the most versatile and accomplished of all Dutch landscapists, bringing an authoritative new emphasis to landscape's forms, structure and texture, even in works conceived on a very modest scale, such as his *Bentheim Castle* (Cat. 57). With its Westphalian site, this work reminds us that Dutch landscapists not only recorded their own immediate surroundings – the dunes and polders around Haarlem and other artistic centres, or views along the Amstel, Maas and Vecht rivers or the nation's countless canals (Cats. 61 and 62) – but travelled to sites and terrain further afield and abroad. Like his teacher, Ruisdael, Meindert Hobbema probably also took sketching trips to regions in the provinces of Gelderland, Overijssel and Drenthe, although his handsome *Wooded Landscape* (Cat. 32) cannot with certainty be identified, as was previously believed, as a 'Scene in Westphalia'. Lord Samuel favoured Dutch landscapists who depicted their own flat and watery countryside or the plains and woodlands near the Dutch and German border. He eschewed the many Dutch Italianate landscapists (Cornelis Poelenburgh, Bartolomeus Breenbergh, Jan Both, Jan Asselijn, etc.) who made the popular artistic pilgrimage across the Alps to the south and returned with sunny mediterranean tones in their paint boxes. The only exception in the Samuel collection is Philips Wouwermans's glorious *Rustic Wedding* (Cat. 83), which probably comes by its lightened, colourfully Italianate palette at second hand; Wouwermans is not known to have travelled to Italy, but like Cuyp, was probably influenced by those who had. Surely the most exotic travels undertaken by the far-flung Dutch landscapists were those of Frans

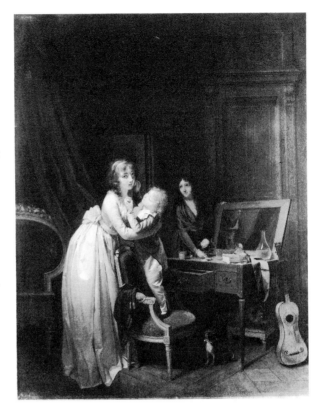

FIG. 5 Louis-Léopold Boilly, *Mother and Child in an Interior*, oil on canvas, 60 × 48.5 cm., Private Collection.

Post, who spent eight years in Brazil followed by thirty in his native Holland painting recollections of the New World. The Samuel collection claims a rare and early work by the master (Cat. 54), painted either at the very end of his trip or soon after his return, and a late painting executed from sketches and memory in 1666 (Cat. 55). Despite their subjects, both works attest to Post's artistic formation in the Netherlands, while their directness, simplicity and crisp execution convey the wonder of discovery.

A conspicuous strength of the Samuel collection, cityscape painting is often logically regarded as a subdivision of landscape. If distinguished from the earlier traditions of topographic portraits of cities and city profiles, the cityscape proper is a comparatively late development in Dutch painting, first flourishing in Delft in the 1650s. One of Samuel's six paintings by Jan van der Heyden belongs to this pioneering early stage in the development of the cityscape and depicts Delft's Boterbrug with the tower of the Stadhuis rising in the distance (Cat. 26). Like van der Heyden's *Wassertor, Kleves* (Cat. 29), the painting offers a fairly accurate depiction of an actual site, although the

former painting was probably based on a drawing by
Roelant Roghman. However, other works by van der
Heyden in the collection illustrate the complex and sub-
jective character of Dutch naturalism. The central structure
of one of his cityscapes (Cat. 28) is an imaginary hybrid
composed of architectural elements from Düsseldorf's St
Andreas church and Amsterdam's Town Hall; and yet
another painting dated 1663 of a town gate and triumphal
arch (Cat. 27) is a complete fiction. How the artist's patrons
received such *capricci* is unknown, but Dutch painters
clearly felt at liberty to rearrange nature to their own
aesthetic or conceptual advantage. Of course the truth of
this proposition is most readily demonstrated in cityscapes
where identifiable buildings are wilfully relocated, but it
applies equally to all landscapes, indeed to all Dutch art.
The formulaic aspect of so many river views by Salomon
van Ruysdael (see Cats. 60 and 61) attests to the painter's
manipulation of nature even in the absence of identifiable
landmarks. Indeed one scarcely needs the photographic
proof of Ruisdael's tumescent enlargement of Bentheim
Castle's promontory (Cat. 57, fig. 5) to realize that the
artist's dramatic goals were better met by a mountain than a
molehill.

There nevertheless is a poetic truth to the myth of the
literalism of Dutch naturalism. With their dramatic per-
spectives, shifting points of view, and strong contrasts of
light and shade, Gerrit Berckheyde's images of Haarlem's
Grote Markt and St Bavo's church (see Cat. 6) have a truth
to life that is scarcely matched before the advent of
photography. These cityscapes attest to the Dutchman's
pride of place, a natural celebration of the *polis* as the
embodiment of all of man's architectural, commercial,
social, even religious accomplishments. In Ruisdael's
haerlempjes (Cat. 59) this vision dilates from the city to its
rural surroundings and the larger context of nature's abun-
dance. Similarly, Berckheyde's *The Castle of Heemstede* (Cat.
5) and van Goyen's *Arnestein* (Cat. 22) record Holland's
little castles and country villas in the countryside. Although
the aristocracy played a far more limited role in the Dutch
republic than elsewhere in Europe, series of prints and
drawings prove that the *kasteeltjes* and homesteads of the
rich and privileged were a source of pride, indeed a factor
in the Dutch national identity not only because of their
beauty but also because of their associations with great
men, like Adriaen Pauw (see commentary to Cat. 5), who
shaped the country's history.

Lord Samuel sold his *Interior of the Church of Saint Bavo*
of 1628 by Pieter Saenredam (fig. 6), the pioneer of interior
architectural painting, but he did retain an excellent little

FIG. 6 Pieter Jansz Saenredam, *Interior of the Church of St Bavo,
Haarlem*, signed and dated 1628, oil on panel 38.5 × 47.5 cm., J.
Paul Getty Museum, Malibu, no. 85.PB.225.

painting of a church interior by Emanuel de Witte. Like
van der Heyden's architectural fantasies, this work is a
wholly imaginary scene of a gothic-style interior of a
Protestant church (Cat. 82). Like the gallows that appear so
frequently in the backgrounds of scenes of winter
recreations by Avercamp and his followers, (see Cats. 3 and
4, as well as 1 and 2), or the open timepiece that often
figures in Pieter Claesz's simple tabletop still lifes (Cat. 14),
the vignette of the nursing mother seated beside an open
grave with a skull in de Witte's church may be symbolic.
Warnings of the transitoriness of life trumpeted from
pulpits by Calvinist *predikants* became a pervasive admon-
ition heard throughout Dutch society and found expression
in various forms of *vanitas* allusions in Dutch art.

Again, Lord Samuel's genre paintings make no claim to
survey the painting type; the early small-scale depictions of
merry companies and guardrooms, as well as the
Caravaggesque tradition (save as reflected in the great Hals)
have been passed over, while high life and domestic subjects
have been weighted to the exclusion of the most unapolo-
getically gross aspects of Dutch low life. However, within
these genteel limits, Samuel gathered truly outstanding
examples, indeed several of the finest paintings in existence
by Nicolaes Maes, Jacob Ochtervelt, Adriaen van Ostade
and Jan Steen. Some of his genre paintings have an obvious
metaphorical dimension. For example, David Teniers' *Five
Senses* (Cats. 67–71) may be universally understood through
the individual activities depicted and the collective context.
However, the subject's traditional admonition against

undue reliance on the senses and excessive sensuality requires more specialized historical knowledge. The cautionary or exemplary aspects of other genre scenes are still more obscure. To modern viewers the traditional domestic virtue of good mothers who sew, knit, minister to children and supervise work in the kitchen, as depicted by Pieter de Hooch, Ochtervelt and Maes (Cats. 33, 47, 38) might seem self-evident if a bit old fashioned and hide-bound, but elsewhere in Maes' art the criticism of domestic havoc wrought by shrewish wives (Cat. 37) or idle unobservant serving girls (Cat. 39) will scarcely be obvious. Similarly, oysters might still carry the erotic connotations that they had when Ochtervelt served them up in the seventeenth century (Cat. 46) but an afternoon's siesta no longer risks charges of criminal lethargy (Cat. 65). The need to retrieve and consider a subject's seventeenth-century associations before interpreting a Dutch painting is obvious. It should also come as no surprise that attitudes towards some types of behaviour depicted in Dutch paintings, for example dancing (Cat. 50) or smoking (Cats. 56 and 75), could change over time or become profoundly ambivalent. What is certain is that the image of society portrayed in Dutch genre scenes is a highly selective portrait executed in broad strokes. Nowhere are these lines of artistic convention more clearly drawn than in the tiny juxtapositions of high life and low life in Wouwermans' masterfully resolved *Rustic Wedding* (Cat. 83).

The French nineteenth-century historian of Dutch art, Eugène Fromentin, was fond of the notion that all Dutch painting, regardless of subject matter, was a form of portraiture. Dutch paintings and portraits, to be sure, offered a faithful likeness of their subjects but, as in virtually all other cultures and times, they also edited and reformed their themes. Genre scenes omitted whole sections of society, not merely the disenfranchised but also central players such as sailors and merchant marines, although as much as 10 per cent of the male population of the Netherlands might be at sea at any given moment. Yet as Willem van de Velde's paintings in the Samuel collection attest (Cats. 76–80), the life of the sea was not neglected but recorded in countless marines featuring vessels on the open sea, plying the calm coastal waters or travelling over the vast network of inland waterways.

Portraiture also, of course, has long been a way of advancing and verifying social ambitions, of inventing and refining personae (see Cats. 7 and 18). Collectors have always recognized that art confers prestige as well as pleasure. Many of the paintings that Lord Samuel gathered had hung in some of the greatest collections assembled and dispersed over the course of the last three centuries. When early in this century the Philadelphian collector, John G. Johnson, scoffed that it took the strength of an athlete to consult the huge volumes in morocco leather that were then in fashion for catalogues of private collections, a picture's particularly distinguished pedigree was frequently pointed out in the introduction (eloquently written, as often as not, by a scholar like Wilhelm von Bode, Cornelis Hofstede de Groot, or W. R. Valentiner). The reference was, of course, designed to flatter the owner by his association with his predecessors. Today scholars again study provenance, but less as a way of verifying the nobility of a work than of revealing the history of taste. In this regard the Samuel collection offers fascinating glimpses into the past.

In the eighteenth century, when standards of the connoisseurship of Dutch paintings were often much higher than they are today, several Samuel paintings resided in some of the finest Dutch and Flemish collections of Old Masters. With his delicately conceived landscapes filled with elegant hunting parties, *fêtes-champêtres* and picturesque images of the peasantry, Philips Wouwermans was then one of the most sought-after masters. The *Rustic Wedding* (Cat. 83) graced the famous Amsterdam collections of both Gerard Braamcamp and John Hope before being imported by the latter's family into England. The prevailing taste for polished *fijnschilder* painting among eighteenth-century collectors favoured Gerard Dou, whose *Portrait of a Young Boy* (Cat. 18) is traceable to Willem Lormier's collection in The Hague as early as 1752; the painting by Dou's pupil, Pieter Cornelis van Slingelandt (Cat. 64), which by virtue of its detailed enamel-like surface was more recently ascribed to Dou, was correctly attributed to Slingelandt in the Antoni Bierens collection in Amsterdam as early as 1747. Similarly, ter Borch's elegantly refined *Portrait of a Man in his Study* (Cat. 7) was in the renowned collection of J. van der Linden van Slingelandt in Dordrecht in 1785 (a collection which has become legendary for its reserves of sunny Cuyps) before passing into French hands. Highly finished Dutch cityscapes also obviously appealed to eighteenth-century collectors: the Berckheyde (Cat. 5) appeared in two eighteenth-century Amsterdam sales in 1763 and 1798 before entering the famous Six collection, while Samuel's van der Heydens appeared in French collections in 1787, 1791 (see Cat. 29) and 1834 (Cat. 28). The relatively decorous genre scenes in the Samuel collection by Steen and Ostade also found their way into French collections before the Revolution (see Cats. 66 and 48).

The nineteenth century continued to admire Dou and the *fijnschilders*, but broadened its appreciation of Dutch naturalism to include not only the Dutch Italianate landscapists and Wouwermans but also the indigenous Dutch landscapists, such as Ruisdael, Hobbema and Aert van der Neer. For example, in a sale held in Paris in 1865, Baron Brienen van Grootelindt of The Hague disposed of both Ruisdael's *Bentheim Castle* (Cat. 57) and van der Neer's *Winter Landscape* (Cat. 42) for good prices. Much earlier in the century, William Wells of Redleaf had already been attracted not only to Samuel's Hobbema (Cat. 32) but also to his splendidly quotidian still life of a *Water Pump* by Ostade (Cat. 51). A more anecdotal type of genre painting came into fashion in these years; Nicolaes Maes' *Woman Selling Milk* (Cat. 39) was imported into England by the dealer Niewenhuys following the Brentano sale in Amsterdam in 1882, and found its way after mid-century into the collection of John Walter of Bear Wood, together with one of Samuel's van der Heydens and his Isack van Ostade (Cats. 27 and 52). All three pictures, as well as three other paintings now in the Samuel collection (Cats. 44, 50 and 83) were acquired late in the nineteenth century by Alfred Beit. Beit's associate and mentor, the French financier Jules Porgès, owned the *Merry Lute Player* (Cat. 24) by Hals, an artist whose star had then only recently risen so dramatically through the efforts of the critic Thoré-Bürger, the famous defender of the Impressionists. The late nineteenth century's taste for the loaded brush and a freer handling of paint also favoured painters like Jan van Goyen, but did not obviate collectors' traditional regard for tightly executed Dutch paintings; Jan van der Heyden's tiny almost microscopically painted *Fortified Moat* (Cat. 30) and its pendant (Cat. 30, fig. 1) were owned by a succession of important eighteenth, nineteenth and twentieth-century collectors including Porgès and Geoffrey and Dorothy Hart, who were the owners of Wych Cross before Lord Samuel. Other distinguished nineteenth-century collectors who owned Samuel paintings included Cardinal Fesch (whose ownership of Steen's *Sleeping Couple* has previously been overlooked, see Cat. 65) and Prince Demidoff of San Donato outside Florence, whose vast collections included Teniers' *Five Senses* (Cats. 67–71). It probably is not a matter of chance that Samuel's van Ostades had attracted more than one important figure in the world of nineteenth-century museums: Baron Vivant Denon, who owned the *Water Pump* (Cat. 51), had been director of the French Royal Museums, while Baron Steengracht, who owned the *Village Inn with Backgammon Players* (Cat. 49), was one of the first directors of the Dutch Royal Painting Collection in The Hague.

In this century paintings now in the Samuel collection have been owned by no less than three public museums: the Mauritshuis, The Hague (Cat. 15), the Wallraf-Richartz-Museum, Cologne (Cat. 2) and the Metropolitan Museum of Art, New York (Cat. 26). Two others have also belonged to a pair of the world's most famous private collections now open to the public, namely the Thyssen-Bornemisza Collection (Cat. 5) and the Princes of Liechtenstein Collection (Cat. 21). In turn paintings that Lord Samuel chose to let go (and here a cataloguer cannot help but feel a pang of regret) have subsequently found their way into other important public and private collections: Rembrandt's *Old Man in a Military Costume* (fig. 7), which like Samuel's Saenredam (fig. 6) is now in the J. Paul Getty Museum in Malibu, an important Isack van Ostade is now in the Thyssen Collection (acc. no. 1962.7), and the *Woman at her Toilet* by Gabriel Metsu (fig. 8) is in the Norton Simon Museum, Pasadena. Of course there has always been some circulation of great works of art among wealthy collectors, but the previous owners in this century of Lord Samuel's paintings create a strikingly varied group portrait; these include, among many others, European nobility (the Duke of Arenberg and the Duke of Buccleuch; see respectively Cats. 10 and 11 and Cat. 33), a Canadian railway magnate (see Cats. 36 and 47) as well as a streetcar king who became famous as a philanderer and cheat (see Cat. 46); a well-heeled Egyptologist (see Cat. 27); the United States Ambassador to the Netherlands (see Cat. 46) as well as, as we have seen, the Cuban Ambassador to the United States (Cat. 24); and a renowned family of brewers (see Cat. 48). Thus, while Fromentin might characterize the 'democratic' naturalism of Dutch art as befitting the tolerant, materialistic and proudly bourgeois little country that was the Netherlands – 'a nation of burghers, practical, imaginative, busy, not in the least mystical, of anti-latin mind, and with traditions destroyed, with a worship without images, and parsimonious habits' – happily, the heterogeneous audience for Dutch art continues to defy such stereotypes.

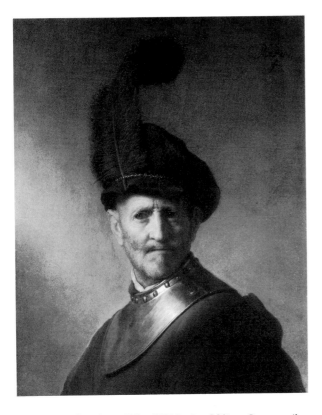

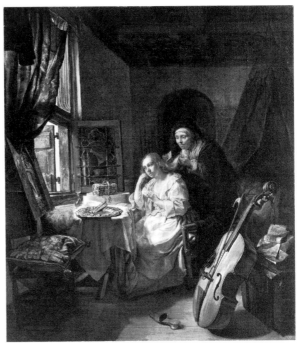

FIG. 8 Gabriel Metsu, *Woman at her Toilet*, oil on panel, 61 × 54.6 cm., Norton Simon Museum, Pasadena.

FIG. 7 Rembrandt van Rijn, *Old Man in a Military Costume*, oil on panel, 66 × 50.8 cm., J. Paul Getty Museum, Malibu, no. 78.PB.246.

Catalogue

ARENT ARENTSZ, CALLED 'CABEL'

(AMSTERDAM 1585/86–1631 AMSTERDAM)

A group of landscapes with fishermen, hunters and skaters which are signed 'A.A.' have been assumed to be by the painter Arent Arentsz, who was born in 1585 or 1586 to Arent Jansz, a sailmaker, and Giert Joosten. He married Joosje Jans, the daughter of another sailmaker, at Sloten near Amsterdam on 19 May 1619. In 1622 he was living on the Prinsengracht in Amsterdam in a house known as 'de Cable' (The Cable – the same name as his paternal home in Zeedijk), from which he received his sobriquet. His works appear in inventories in 1635, 1637 and 1641. He was buried on 18 August 1631 in the Oude Kerk in Amsterdam.

Arentsz specialized in small landscapes with an oblong format often depicting coastal views with water, rivers or polders in the distance and relatively large foreground figures. His art attests to the strong influence of Hendrick Avercamp.

LITERATURE: N. de Roever, in *Oud-Holland*, vol. 7 (1889), pp. 29–30; Wurzbach vol. 1 (1906), p. 27; E. W. Moes, in Thieme and Becker, vol. 5 (1911), p. 325; Georg Poensgen, 'Arent Arentsz (genannt Cabel) und sein Verhältnis zu Hendrik Avercamp', *Oud-Holland*, vol. 41 (1923–4), pp. 116–35; Neil MacLaren, *National Gallery Catalogues. The Dutch School* (London, 1960), p. 2; I. H. van Eeghen, 'Meerhuizen of de Pauwentuin en Arent Arentsz, genaamd Cabel', *Maandblad Amstelodamum*, vol. 54 (1967), pp. 219–21; L. J. Bol, *Holländische Maler des 17. Jahrhunderts nahe den Grossen Meistern. Landschaften und Stilleben* (Braunschweig, 1969), pp. 106, 153.

CAT. I

Winter Landscape with Figures on a Bridge, a Hunter and Skaters

Monogrammed on the bridge at the right: AA (ligated)
Oil on panel 14 × 24⅞ in. (35.6 × 63.1 cm.)

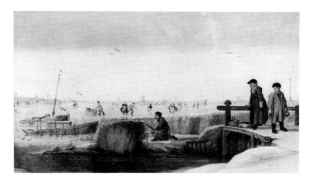

PROVENANCE: Prince von Sachsen-Coburg; acquired from Edward Speelman in 1967.

EXHIBITION: London 1988, no. 1.

LITERATURE: Russell 1988, p. 789.

CONDITION NOTES: The panel support has an old batten 12¼ in. (32 cm.) long, attached to the back which runs horizontally with the grain of the wood, 7⅛ in. (18.3 cm.) from the top edge, and which serves to secure an old break in the panel. The wood panel also reveals some old insect damage. The paint film is in relatively good condition, showing little abrasion but revealing retouching to disguise thinness where the grain of the wood shows through. There is also retouching in the boat frozen in the ice on the left, in the back of the head of the boy on the right and scattered along the edges. The varnish layer is thick and moderately discoloured. An old sticker with the artist's name and the inventory number D1520589 is attached to the back.

In a horizontally composed winter landscape on a coast, a woman and a boy look down from a low bridge spanning a narrow canal on the right to where a hunter kneels behind a blind of reeds. The hunter wears a greenish-brown coat and fur cap. The woman wears brown and green, red cuffs, and a black beret. The boy has a tan coat and holds a jug and an axe. Before them are dead ducks and a basket. In the left middle distance live ducks swim beside two vessels lodged in the ice. Farther back many figures skate over the wide expanse of ice. These include, from left to right, two 'colf' (on colf, see Cat. 3) players skating in tandem, a man pushing a sledge, a young couple holding hands as they skate, and three horse-drawn sleighs moving off in a line towards a large vessel lodged in the ice. On the far shore on the left are gallows with hanged people and a gibbet with a wagon wheel on top. In the right distance are the profiles of other buildings.

The subject of the duck hunter is probably derived from Hendrick Avercamp (see Cat. 2, fig. 1), and individual figures among the skaters also seem to be quoted directly from him; for example, the young couple who are seen in the central distance are also encountered on the right of Lord Samuel's Avercamp (Cat. 4) as well as in many other works by Avercamp and Cabel (see fig. 3),[1] and the woman and boy on the right also are encountered in a painting by Hendrick Avercamp that was with Speelman in 1966 (fig. 1).[2] There is a drawing by Avercamp for these figures in the Rijksprentenkabinet, Amsterdam (fig. 2);[3] whether Cabel consulted the painting or the drawing is unclear. However, it seems likely that it was the latter because there are details in the drawing such as the dead ducks on the bridge which do not appear in the painting.

1 See Cat. 4, note 5.
2 Clara J. Welcker, *Hendrick Avercamp (1585–1634), bijgenaamd, 'De stomme van Campen' en Barent Avercamp (1612–1679), 'Schilders tot Campen'*, revised edition by D. J. Henbroek-van der Poel (Doornspijk, 1979 1st edition Zwolle, 1933), cat. s57.7; see also California Palace of the Legion of Honor, San Francisco, Toledo Museum of Art, and Museum of Fine Arts, Boston, *The Age of Rembrandt* 1966–7, no. 43, ill.
3 Welcker 1979, cat. T19.

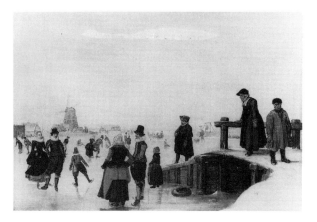

FIG. 1 Hendrick Avercamp, *Winter Landscape with Figures on a Bridge*, monogrammed, oil on panel 30 × 44 cm., with Edward Speelman, London, 1966.

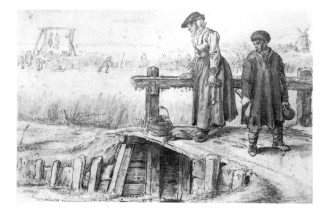

FIG. 2 Hendrick Avercamp, *A Woman and a Boy on a Bridge*, pen and ink with water-colour 151 × 237 mm. Rijksprentenkabinet, Amsterdam.

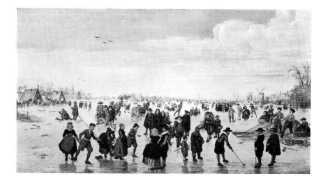

FIG. 3 Arent Arentsz (called Cabel), *Skaters on the Amstel*, oil on panel 63 × 97.5 cm., Art Gallery of Ontario, Toronto, no. 56/21.

CAT. 2

Winter Landscape with Duck Hunter

Monogrammed on barrel lower centre: 'AA' surmounting a
crown and trefoil
Oil on panel 12⅝ × 22¼ in. (32 × 58 cm.)

PROVENANCE: Wallraf-Richartz-Museum, Cologne, cat. 1957, no.
2835; Bryan Jenks, Astbury Hall; acquired from Edward Speelman
in 1968.

EXHIBITIONS: Breda, Cultureel Centrum 'de Beyerd', and Ghent,
Museum, *Landschap in de Nederlanden*, 1960–1, cat. no. 3 (lent by
E. Speelman); London 1988, no. 2.

LITERATURE: Wallraf-Richartz-Museum, Cologne, cat. 1957, no.
2835; Clara J. Welcker, *Hendrick Avercamp (1585–1634),
bijgenaamd 'De Stomme van Campen' en Barent Avercamp (1612–
1679), 'Schilders tot Campen'*, revised edition by D. J. Henbroek-van
der Poel (Doornspijk, 1979; 1st edition Zwolle, 1933), p. 205,
under cat. s14.2.

CONDITION NOTES: The panel support is not cradled. There is a
crack ¾ in. (1.9 cm.) from the bottom lower left edge. The paint
film is generally abraded. The sky and the ice in the lower left are
extensively overpainted. The paint film around the edges has also
been liberally retouched. A thick discoloured varnish obscures the
surface.

In the foreground of a winter landscape with a frozen river,
a hunter in a brown coat, black boots and green hat kneels
in profile to the viewer's left as he takes aim at some ducks
on the ice. Behind him stands a second man clad in a green
coat, fur-lined green cap and boots, holding a pike and an
axe. A tall pole rises from the bank left of centre. Beneath it
is a wooden barrel and at the hunter's feet a brown dog.
Several water birds and a game bag lie in the right fore-
ground. Skaters cavort on the ice in the background, while
on the far shore on the right two men are hanged from a
gibbet. Before them are 'colf' players (on colf, see Cat. 3)
and two skating couples, a pair of whom hold hands. At the
far right a man relieves himself on the ice.

Like many other works by Cabel, this painting appears to
be based on a composition by Hendrick Avercamp, in this
case a painting that was with P. de Boer Gallery in
Amsterdam in 1966 (fig. 1). The resemblance was first
noted in the revised edition of Welcker (1976).[1] The Cabel
is virtually a copy of the Avercamp but differs in details,
such as replacing the hunter's red cap with a fur-lined green
one and changing the position of many of the skaters. In a
winter landscape in Toronto (Cat. 1, fig. 3), Cabel depicted
the same hunter and man with a pike in the background on
the left. He also painted an image of a hunter of waterfowl
kneeling in profile in a summer setting (fig. 2) which is
similar in design to the present work, but smaller and

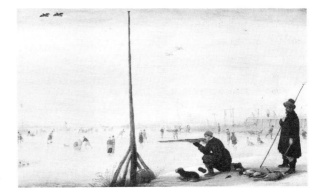

FIG. 1 Hendrick Avercamp, *Winter Landscape with a Duck Hunter*,
signed lower right, oil on panel 33 × 52 cm., with P. de Boer
Gallery, Amsterdam, 1966.

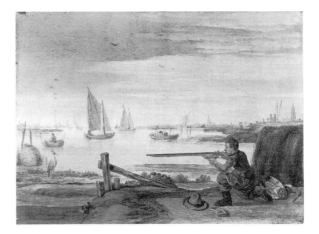

FIG. 2 Arent Arentsz (called 'Cabel'), *The Hunter*, oil on panel 24
× 33 cm., Rijksmuseum, Amsterdam, inv. no. A1969.

certainly not conceived as a pendant. The pole in the foreground is not tall enough to serve as a channel marker (compare Avercamp, Cat. 4) but may have been used to hoist heavy fishing nets; compare the pole in actual operation in Barent Avercamp's painting in Berlin (no. 760).[2]

Like Avercamp before him (see Commentaries to Cats. 3 and 4), Cabel often included images of figures hanging from gallows or gibbets in the distance of his landscapes. Although public executions were common enough in the Netherlands, the frequency of their appearance in these paintings and other early seventeenth-century landscapes by Jan Brueghel (Cat. 9, fig. 3 and Prado, Madrid, no. 1427), Joos de Momper (Statens Museum, Copenhagen, no. Sp. 213), Esaias van de Velde (see Cat. 4, fig. 4, and Cat. 74, fig. 3), Jan van Goyen, and others, implies that they carried a morally symbolic charge. Obviously they could provide a reminder of the brevity of life and a warning of the swift punishment of transgressors. Here and in Avercamp's original, some figures stop to look at the hanged men, perhaps reflecting on their sins or simply indulging human-kind's naturally morbid curiosity, while other figures, such as the lovers holding hands and the man defecating on the ice (again taken from Avercamp, see the background of Cat. 3) seem to suggest that life in all its sublime and earthy aspects forever ignores death. Logic suggests that these lessons could also relate to the painting's more obvious theme of the hunter and the hunted.

1 Sale London (Sotheby's) 24 March 1965, no. 77; exhibited by de Boer in his winter exhibition 1965–6, no. 2, ill.; Welcker 1933/79, p. 205, no. s14.2.
2 See Welcker 1933/79, p. 331, no. bas11, pl. 38, fig. 63.

HENDRICK AVERCAMP

(AMSTERDAM 1585–1635 KAMPEN)

Baptized in the Oude Kerk in Amsterdam on 27 January 1585, Hendrick Avercamp was born in a house on the west side of the Nieuwe Dijk next to the Nieuwe Kerk. His father, Barent Hendricksz Avercamp (c. 1557–1603), was the Friesian schoolmaster of the Latin school on the Nieuwezijds Burgwal. Barent Hendricksz was married in the Nieuwe Kerk in Amsterdam in 1583 to Beatrix Pietersdr Vekemans (1560/2–1634), the daughter of the Latin school's headmaster. The following year Avercamp's father was recorded as an 'Apothecary from Friesland', with citizenship in Amsterdam. In 1586 the family moved to Kampen where the elder Avercamp set up his apothecary business in the Oude Straat. Hendrick Avercamp's brother Lambert eventually succeeded his father as town apothecary. Another brother studied medicine. Hendrick's family was well educated and well travelled; their members continued to be prominent Kampen citizens throughout the seventeenth century.

The young Hendrick Avercamp was sent to Amsterdam to live and study with the history and portrait painter Pieter Isaacksz (1569–1625), who in 1607 was recalled to his native Denmark by Christiaan IV. The Antwerp painters Adriaen (1587–1658) and Willem van Nieulandt (1584–1635) were fellow pupils under Isaacksz. In the auction that preceded his teacher's departure, Avercamp was identified among the buyers as 'de stom tot Pieter Isacqs' (Pieter Isaacksz's mute); in another document of 1622 he was also called 'Hendrick Avercamp de Stomme.' When Hendrick's mother drew up her will in 1633 she expressed concern for her eldest son, who not only was unmarried but also being 'mute and miserable', might be unable to live off his portion of the inheritance; thus she stipulated that

Hendrick receive an annual sum of 100 guilders from the family capital for the rest of his life. There is no indication, however, that Hendrick was deaf as well as dumb.

Avercamp's earliest dated works are of 1601. During his formative years in Amsterdam he was influenced by the landscape tradition as practised in that city by the expatriate Flemish painters, Gillis van Coninxloo and David Vinckboons; the latter has been proposed, on stylistic grounds, as another of Avercamp's teachers. There is also a strong connection between Avercamp's earliest Flemish-style landscape designs and works by his fellow Kampen artist Gerrit van der Horst (1581/2–1629). On 28 January 1614, Avercamp was again living in Kampen. Further travels are undocumented, although both Welcker and Plietzsch speculate (improbably) that he journeyed to the Mediterranean. On 15 May 1634, he was buried in the St Nicolaaskerk in Kampen.

A painter of richly populated winter landscapes, his early works show a strong interest in narrative and genre-like anecdote in the tradition of Pieter Bruegel. His mature paintings are more concerned with evoking a wintry atmosphere. As no other early Dutch realist, he made a speciality of the ice view. Avercamp's low viewpoints and flat expansive scenes across the ice are crucial for the development of Dutch landscape painting, and are closely paralleled by the winter landscapes of Adriaen van de Venne. Avercamp also made numerous figure and landscape drawings, many of which served as preparatory studies for his paintings. Hendrick's nephew, Barent Avercamp (c. 1612–79), was his pupil and follower. Other followers include Arent Arentsz (called Cabel) (q.v.) and Dirck Hardenstein II (1620–after 1674).

LITERATURE: van Eynden, van der Willigen, vol. 1 (1816), pp. 32–4; Immerzeel 1842–3, vol. 1, p. 17; Kramm 1857–64, vol. 1, p. 35; Obreen 1877–90, vol. 2, pp. 195–234; N. de Roever, 'Hendrik Avercamp, de Stomme van Kampen', *Oud-Holland*, vol. 3 (1885), p. 53; Johanna de Jongh, 'Een verbetering [over de handteekening van Hendrick Avercamp]', *Bulletin van den Nederlandsche Oudheidkundige Bond*, vol. 5 (1903–4) pp. 151–2; Wurzbach vol. 1 (1906), pp. 35–6; E. W. Moes, in Thieme and Becker, vol. 2 (1908), p. 276; R. Juynboll, review of C. Welcker, *Hendrick Avercamp en Barent Avercamp 'Schilders tot Campen'* (Zwolle, 1933), *Oudheidkundig Jaarboek*, vol. 2 (1933), pp. 119–50; J. G. van Gelder, review of Welcker, *Zeitschrift für Kunstgeschichte*, vol. 3 (1934), pp. 78–9; Martin 1935–6, vol. 1, pp. 244–6; M. F. Hennus, 'Hendrick Avercamp als teekenaar', *Maanblad voor beeldende Kunsten*, vol. 25 (1949), pp. 1–10; Clara J. Welcker, 'Hendrick Avercamp of Arentsz', *Oud-Holland*, vol. 65 (1950), p. 206; Stechow 1966, pp. 85–7; Evert van Straaten, *Koud tot op het bot: De verbeelding van de winter in de zestiende en zeventiende eeuw in de Nederlanden* (The Hague, 1977); Clara J. Welcker, *Hendrick Avercamp (1585-1634), bijgenaamd 'De Stomme van Campen' en Barent Avercamp (1612-1679), 'Schilders tot Campen'*, revised edition by D. J. Henbroek-van der Poel (Doornspijk, 1979; 1st edition, Zwolle, 1933); Amsterdam, Waterman Gallery, *Hendrick Avercamp 1584-1634; Barent Avercamp, 1612-1679; Frozen Silence*, 1982 (also shown at Zwolle, Provinciaal Overijssels Museum); Albert Blankert, 'Hendrick Avercamp als schilder van Winter', *Tableau*, vol. 4 (1982), pp. 604–15; Haak 1984, pp. 197–8; H. Wiersma, *Hendrik Averkamp 1585-1634, de Stomme van Kampen* (Kampen, 1985); Amsterdam/Boston/Philadelphia 1987–8, pp. 26–7, 254–61.

CAT. 3

Winter Landscape on the River Ijsel near Kampen, c. 1615

Monogrammed on the bench at the left: HA (ligated)
Oil on panel 20⅞ × 38 in. (53 × 96.6 cm.)

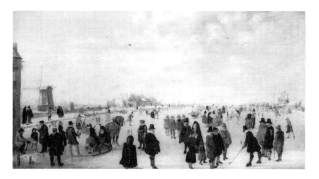

PROVENANCE: H. Houck, Deventer; sale C.F. Roos and Co., Amsterdam, 7 May 1895, no. 3, ill. (600 fl.); Dr. A.J. Kronenberg; sale Amsterdam (F. Muller), 14 May 1912, no. 103, ill, (600 fl.); the widow of Prof. A.C. Visser van Ijzendoorn-Mijnlieff, Scheveningen; R.P. van de Kasteele, Haarlem; dealer D. Katz, Dieren, 1961–2; dealer J. R. Bier, Haarlem, c. 1963; with J. de Gruyter, Amsterdam and Lausanne, 1966; acquired from Edward Speelman in 1966.

EXHIBITIONS: Zwolle 1882 (not in catalogue); Amsterdam, Goudstikker Gallery, *Tentoonstelling van hollandsche winterlandschappen uit de 17de eeuw*, 6–29 February 1932, no. 97; Eindhoven, Stedelijk Van Abbe Museum, *Nederlandse landschapkunst in de 17e eeuw*, 1948, no. 4 (lent anonymously); Kampen, Oude Raadhuis, *Avercamp Tentoonstelling te Kampen in de Schepenzaal van het Oude Raadhuis*, 9 July–13 August 1949, p. 7, cat. no. 1; Paris, Musée des Arts Décoratifs, *La Vie en Hollande au XVII siècle*, 1967, no. 80, ill.; London 1988, no. 4, ill. p. 4.

LITERATURE: *Altholländische Malerei*, no. II, 3 (1913); W. Martin, in *Mededelingen van het Departement van Onderwijs, Kunsten, en Wetenschappen*, no. 6 (1937), pp. 446–7, ill.; Clara J. Welcker, *Hendrick Avercamp 1585-1634, bijgenaamd 'De Stomme van Campen' en Barent Avercamp 1612-1679 'Schilders tot Campen'* (Zwolle, 1933), p. 206; revised edition (Doorspijk, 1979), p. 212, nos. s27 and s52.1, plate V A; Saskia Nihom-Nijstad, *Reflets du siècle d'or. Tableaux hollandais du dix-septième siècle*, Institut Néerlandais (Paris, 1983), p. 8, note 7.

CONDITION NOTES: The panel support has been thinned and cradled. The paint film is abraded in many passages and reveals extensive retouching in the sky and along the two vertical sides. The extent of the inpainting is obscured by the discoloured varnish layer. Underdrawing in a shorthand style is extensive and visible both with infra-red and, in isolated passages, with the unaided eye. Few changes appear save for details of individual figures, such as the man in brown watching the 'colf' on the right.

On the ice-covered river Ijsel near Kampen, scores of figures enjoy themselves skating, playing 'colf', riding in elaborately decorated horse-drawn sleighs, or merely promenading on the ice. In the foreground from left to right there is a man seated at a table with a brazier, apparently selling smoking supplies, a hunter with his back to the viewer, two ladies in tall caps in a sleigh, a man and woman in black with their backs to one another and two boys (one of whom blows on his hands) and six men watching a 'colf' player. In the middle distance on the left is a boy with a toy and a couple skating in tandem, while a second couple farther along to the right have taken a tumble. In the centre, four men in tall boots stand conversing. On the right is another decorated sleigh drawn by a horse with a harness decoration in the form of a serpent. A building just visible on the left creates a single wing design. On the bank beyond are a windmill and several low houses as well as a side canal. Behind the mill on the faint horizon appears the town of Kampen. On the right bank rising faintly in the haze of the middle distance is the silhouette of a gallows and gibbet with a wheel. Several figures stand around looking at the hanged person but others pass without heeding and one man squats with his trousers down to relieve himself. Overhead in the mottled grey sky birds migrate in a chevron formation.

The dating of Avercamp's paintings is famously difficult (see commentary to Cat. 4), but this painting probably predates Avercamp's painting of 1620 (Cat. 4, fig. 3), and undoubtedly postdates his less atmospheric paintings with high horizons of 1608–9; thus it may be tentatively assigned to c. 1615 – a date suggested privately by Albert Blankert, who has studied the artist's works closely and advanced the most plausible chronology for them. Here as elsewhere, Avercamp apparently employed preparatory drawings from his stock of studies for individuals and groups of figures like the man on the left smoking a pipe (see fig. 1).[1] The couple striding forward behind the young girl just to the right of centre appear in a sheet of studies by Avercamp preserved in Windsor Castle (no. 6472),[2] and the horse-drawn sleigh on the left is close to a drawing in the Kupferstichkabinett in Berlin (no. 11835).[3] Hendrick's nephew, Barent Avercamp, took over the figure of the seated smoker with his clients at the table and inserted the group into a painting that was formerly in Wilstach Collection in the Philadelphia Museum of Art.[4]

The game of 'colf', predecessor of the modern games of golf and hockey as well as the shorter game of 'kolf' that first became popular in the eighteenth century, had its origins in the Low Countries around 1300. It was played with wooden clubs which after c. 1430 often had forged-iron heads, and wooden (elm or beech) or, increasingly after the middle of the fifteenth century, leather-covered balls stuffed with cow's hair. The game was played on level ground in the warmer months and on ice in the winter. The object was to drive the ball with a club to a previously agreed upon target – a door, tree, hole in the ground (as early as 1500), a dinghy frozen in the ice, etc. Strokes were scored by notching a stick. The game soon became so popular that city magistrates in Holland, concerned about broken windows, injured passers-by, stampeded cattle and damaged crops, moved the inaccurate enthusiasts out of town to designated playing areas; Haarlem boasted a regularly mown colf field as early as 1390. Professional ball and club-makers appeared and soon leather balls were being exported from Bergen op Zoom to Scotland by the tens of thousands. After 1700 and continuing to this day in some parts of the Netherlands, a shorter game, 'kolf', was played out-of-doors in a rectangular court enclosed by boards with a post serving as the target at either end or on comparable indoor courts. Modern golf was finally developed in Scotland and at Blackheath, near London around 1750.[5]

The colourful spectacle of figures from all classes of society whizzing over the ice can obscure the origins of Avercamp's winter landscapes in an earlier moralizing pictorial tradition. Pieter Bruegel's famous print *Ice Skating before St George's Gate*, Antwerp carried an inscription in three languages, alluding to the wise and foolish ways in which people conduct their lives, some 'slipping and slithering their way through life, the basis of which is more ephemeral and fragile than ice'.[6] Other early prints also allude to the 'slibberachtigheyt van 's menschen leven' ('the slipperiness of human life').[7] Gallows or gibbets like those in the present work figured elsewhere in Avercamp's paintings (see Cat. 4) and drawings (fig. 3; and Cat. 1, fig. 2), where they recur at least seven times.[8] These were common enough structures in the Netherlands, where criminals were regularly hanged in public and their bodies left suspended on gibbets as grisly warnings to the citizenry.[9] Bosch and Bruegel had depicted gallows in the sixteenth century and in a roughly contemporary image, Esaias van de Velde underscored the association with punishment by juxtaposing a gibbet with highwaymen attacking travellers in a drawing of 1627 (Rijksprentenkabinet, Amsterdam).[10] Such images also naturally had the effect of *memento mori* and *vanitas* allusions, all of which could be related to winter's traditional identification with old age and death in the cycle and rotation of the seasons.

1　See Welcker 1979, p. 268, no. T268; from the Collection of Sir Bruce S. Ingram, see *Loan Exhibition. Collection Bruce S. Ingram*, Colnaghi's, London, 1952, no. 12.

2　See Welcker 1979, no. T86.

3　See Welcker 1979, no. T142, pl. 11.

4　Panel 54 × 91 cm., Wilstach Collection, cat. 1901, no. 10, sale Philadelphia (Freeman's), 25 October 1954, no. 159, later with P. de Boer and Heim Galleries; Welcker 1979, nos. S71.2, S72, S237.

5　See Bergen op Zoom, Gemeentemuseum het Markiezenhof, *Colf. Kolf. Golf. Van Middeleeuws volksspel tot moderne sport* 20 March – 2 May 1982, also shown in Ghent, Antwerp and Amersfoort.

6　On Bruegel's print, see A. Montballieu, 'Pieter Bruegel's Schaatenrijden bij de St Jorispoort te Antwerpen', *Jaarboek van het Koninklijk Museum voor schone Kunsten*, 1981, pp. 17–19. See also L. Baver and G. Baver, 'The Winter Landscape with Skaters and Bird Trap by Pieter Bruegel the Elder', *Art Bulletin*, vol. 66 (1984), pp. 145–50.

7　On the symbolism and associations of winter landscapes generally, see Evert van Straaten, *Koud tot op het bot: de verbeelding van de winter in de zestiende en zeventiende eeuw in de Nederlanden* (The Hague, 1977).

8　Saskia Nihom-Nijstad inventoried Avercamp's use of the motif in *Reflets du siècle d'or. Tableaux hollandais du dix-septième siècle*, Institut Néerlandais (Paris, 1983), p. 8. For the paintings see Welcker 1979, no. S14, fig. XXVI (Dreesmann Collection), no. S14.1 (= S15; with P. de Boer, Amsterdam, 1961); for the drawings, see Kupferstichkabinet, Berlin, inv. no. KDZ 2426; Musées Royaux des Beaux Arts, Brussels, inv. no. 94; and in the P. and N. de Boer Foundation, Amsterdam.

9　See H.G. Jelgersma, *Galgebergen en Galgevelden* (Zutphen, 1978). These public events were depicted by Esaias van de Velde in his drawing of the *Display on the Gallows of Gerrit van Leedenberg's Coffin* (1619, Teylers Stichting, Haarlem), and etching of the *Execution of Jan van Wely's Murderers*; see respectively G. Keyes, *Esaias van de Velde* (Doornspijk, 1984), nos. D5 and E2.

10　Keyes 1984, no. D22.

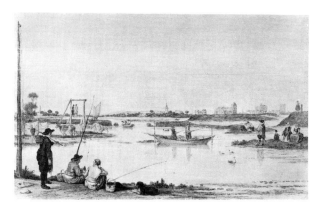

FIG. 2　Hendrick Avercamp, *Summer Landscape near Kampen with Fishermen and Gibbet*, oil on panel 24 × 39.5 cm., Institut Néerlandais, Frits Lugt Collection, inv. no. 2689.

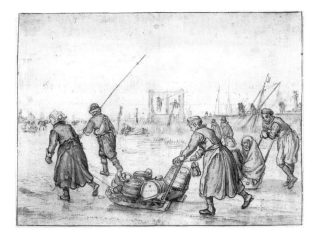

FIG. 3　Hendrick Avercamp, *Skaters before Gallows*, pencil, pen and watercolour, 128 × 176 mm., Rijksprentenkabinet, Rijksmuseum, Amsterdam, inv. A4198.

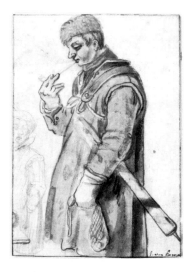

FIG. 1　Hendrick Avercamp, *Man with a Pipe*, pen and watercolour over black chalk, 100 × 72 mm, Fitzwilliam Museum, Cambridge, no. PD. 87-1963.

CAT. 4

Winter Landscape with a Frozen River and Figures, about 1620

Monogrammed on a barrel on the right: HA (ligated)
Oil on copper 16 × 25¼ in. (40.5 × 64.5 cm.)

PROVENANCE: Miss A.I. Nichols, Little Wayne Wells, Wroxall (near Bristol), Wiltshire; sale Hanning Philip *et al.* (Miss Nichols), London (Sotheby's), 6 March 1957, no. 78, ill.; dealer Leonard Koetser, London, 1957 (see exh.); acquired from Edward Speelman in 1957.

EXHIBITIONS: London, L. Koetser Gallery, 1 November – 31 December 1957, no. 19, ill.; London 1988, no. 3.

LITERATURE: *The Connoisseur*, vol. 140 (November, 1957), p. 116, ill. on cover; Welcker, 1933/1979, p. 212, no. s55.1.

CONDITION: The large copper support is in good condition and in plane. The paint film has some retouching on the upper and lower edges and minor retouching in the sky in the upper left but is in very good state overall with little abrasion. Infra-red examination reveals that the artist has followed his underdrawing faithfully, making only minor changes, for example to the hat of the man in the centre of the trio with their backs to the viewer in the left centre, and in the figure on the right of the trio walking towards the tents on the right. A discoloured varnish covers the surface.

On a frozen river numerous figures skate, socialize and conduct business. On the left a man in a red cap, mittens and leggings weighs out chestnuts from a wheelbarrow, placing some in the cap of a customer. Farther back a man has fallen down on the ice and two men and a woman skate in tandem. To their right are three men in conversation with their backs to the viewer. Rising high into the sky from the near shore in the centre foreground is the tall pole of a leading mark, with a basket probably for a beacon. Leading marks enabled vessels to manoeuvre their way into small or shallow harbours. Beneath and to the left of it a

man in brown and a woman in green hold hands beside a hunter standing with his back to the viewer and a woman with a baby in a sledge. To the right of the pole a boy blows on his hands as two couples, one elegantly dressed the other in local costume, skate by. On the right other elegantly dressed figures stand in couples and groups observing the scene. Farther back in the centre are many more skaters, 'colf' players, and horse-drawn sleighs. In the distance at right are a row of refreshment tents with gaily coloured flags, while on the left shore are gallows. In the far distance is a large vessel lodged in the ice and the profile of a city. The sky is overcast but the atmosphere and many colourful small motifs are treated with exceptional delicacy.

Welcker observed that there is a drawing for the figure of the chestnut seller and his two customers in the printroom in Berlin (fig. 1).[1] In the *Connoisseur* magazine in 1957, where the anonymous reviewer characterized the painting as 'one of the greatest and most important paintings of its kind to appear on the London art market in at least a quarter of a century', a second preparatory drawing in Windsor Castle (fig. 2) for the elegant couple to the right of the pole was also cited.[2] While there are some minor changes to the figures' costumes, their poses are virtually the same. Still another drawing in Windsor corresponds to the middle-aged couple on the far right in the middle distance;[3] and a study of a man tying on his skates in Dresden closely resembles the tiny figure in the right distance.[4] Since Avercamp employed a stock of figure drawings, many of his figures recur; the lively skating couple in provincial costume on the right, for example, not only reappears in several of Hendrick's works but also paintings by Barent Avercamp and Arent Arentsz (see Cat. 1).[5]

Avercamp was the first Dutch painter to specialize in winter scenes. He favoured broad horizontal compositions with high horizons, filling his wide frozen rivers and estuaries with a multitude of brightly coloured, nimble little figures. Typically in addition to winter recreations he also depicted the occupations of the working classes, with figures pushing sledges filled with firewood or groceries, or vendors plying their wares. As a consequence his paintings are as interesting to social historians as to art lovers. His earliest dated winter landscape is of 1608 (Billedgaleri, Bergen, Norway, no. 43)[6] and employs a traditional sixteenth-century design with a very high horizon and many additively composed little figures and motifs piled up on the paint surface to maximize the account of sundry details. This type of landscape descended from the art of Pieter Bruegel the Elder and was transmitted by sixteenth-century Flemish artists like Lucas van Valckenborch, Jacob

Grimmer and Hans Bol. Tracing Avercamp's stylistic development is hampered by the fact that he dated only two other paintings.[7] By 1609, his horizons had begun to descend and a suggestion of atmosphere had begun to appear in the hazy distance, trends that are assumed to continue into the second decade of the century. Avercamp's third dated winter scene of 1620 (fig. 3) employs larger figures and eliminates any conspicuous compositional 'wings' on either side of the design.[8] The panoramic Samuel painting is also unfettered by any lateral framing devices, employs a relatively low horizon line as well as atmospheric effects in the distance, and thus may date from approximately the same period of c. 1620.

Although painted in gentle pastel hues, the two banks of Avercamp's estuary provide a striking symbolical contrast. On the right crowds enjoy themselves around refreshment tents, the seventeenth-century equivalent of the modern 'Koek en zoopie', while in the left centre distance there is the spectre of a gallows – its three-columned form familiar to us from earlier brueghelian landscapes and Avercamp's own drawings (Cat. 3, fig. 3), and more recently encountered in the paintings and drawings of Esaias van de Velde (see fig. 4).[9] The tall leading mark surmounted with a basket for a beacon creates a strong vertical accent in Avercamp's composition. Whether it too functions symbolically is unclear. The image of a channel marker was used in Dutch emblematic literature to signify the importance of specialized knowledge that enables individuals to understand the symbols around them.[10] Although it would be excessively speculative to posit that Avercamp's marker bore this specific meaning, the gallows was a singularly emphatic symbol that all men could recognize and understand. The frequency with which Avercamp introduced the spectre of death and the hangman's punishment into his images of light-hearted winter recreations leaves little doubt that he intended a moral admonition.

1 Kupferstichkabinett, Berlin, cat. 1930, no. 115, ill.; Welcker 1979, p. 263, no. T63. A variant of the chestnut seller and his clients appears on the left of Avercamp's watercolour drawing of *Colf Players* (17.6 × 30.3 cm.) in the Teylers Museum, Haarlem, inv. no. OX 7; Welcker 1979, pp. 259–60, nos. T45 and T355. They also appear on the left-hand side of *Ice Skating Scene*, panel 35 × 58 cm., in the collection of Mevr. A. Gatacre-de Steurs, 1948 (Welcker 1979, p. 209, no. 534).

2 *Connoisseur*, vol. 140 (October 1957), p. 116; Windsor Castle, cat. 1944, no. 33, fig. 30; Welcker 1979, p. 279, no. T63.

3 See Welcker 1979, no. T150.

4 See Welcker 1979, no. T103.

5 See, as examples, Welcker 1979, cat. S33, fig. XXII, cat. S33.1, fig. XXIV, cat. S58.1, fig. XXV, and cat. S14, fig. XXVI. Barent Avercamp's painting in the Henle Collection, Duisburg (Welcker 1979, cat. S70) and Arent Arentsz's painting in Toronto (cat. 1, fig. 1), also include this skating couple.

6 Panel 33 × 55.4 cm., Bergen Museum, cat. 1961, inv. no. 3331; see Welcker 1979, p. 203, no. S3.

7 Albert Blankert has proposed a general chronology in Amsterdam, Waterman Gallery, 'Hendrick Avercamp', in *Hendrick Avercamp, 1584–1634; Barent Avercamp 1612–1679, Frozen Silence*, 1982, pp. 15–36.

8 Probably identical with Welcker 1979, cat. nos. 5, 6 and 7. See Stechow 1966, fig. 164; and Amsterdam/Boston/Philadelphia 1987/8, p. 261, fig. 3.

9 See G. Keyes, *Esaias van de Velde 1587–1630* (Doornspijk, 1984), cat. no. 115, fig. 114. See also Esaias' drawings in which it appears, Keyes 1984, cats. D95, fig. 101, and D162, fig. 244.

10 See Roemer Visscher, *Sinnepoppen* (Amsterdam, 1614), no. 119, an image of a beacon with the motto 'Intelligentibus' (for those who understand). The appended text explains 'In many corners of the Sea signs are set up, that there is a good harbour or anchor ground, so that the Helmsmen should know where to steer in order to salvage their ships; but that is only for those who have an understanding of navigation'. Lawrence Goedde (*Tempest and Shipwreck in Dutch and Flemish Art. Convention, Rhetoric, and Interpretation* (London, 1989), pp. 191–3, 241–2, note 58) has cited this emblem in interpreting Ruisdael's stormy seascapes with beacons as depictions of 'salvation in distress', however Ben Broos (*Great Dutch Paintings from America* exh. The Hague, and San Francisco, 1990–1, p. 397) has rightly expressed doubts about such interpretations.

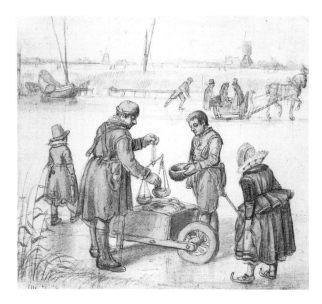

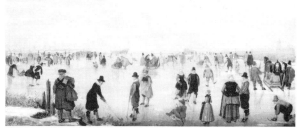

FIG. 3 Hendrick Avercamp, *Winter Landscape*, signed and dated 1620, oil on panel 33 × 53 cm., Private Collection.

FIG. 1 Hendrick Averkamp, *Chestnut Vendor with a Wheelbarrow*, pen and ink with colour and underdrawing 153 × 172 mm., Kupferstichkabinett, Staatliche Museen Preussischer Kulturbesitz, Berlin-Dahlem, no. 115.

FIG. 4 Esaias van de Velde, *Gallows on a Rise in a Panorama*, signed and dated 1619, oil on panel 13 × 26.5 cm., Kunstmuseet, Göteborg.

FIG. 2 Hendrick Avercamp, *Couple Skating*, (possibly Jacob Roelofsz Steenberch and Femmetje Avercamp), pen and ink with watercolour 145 × 130 mm., Windsor Castle, Royal Library, no. 6494.

GERRIT BERCKHEYDE

(HAARLEM 1638–1698 HAARLEM)

Baptized in Haarlem on 6 June, 1638, Gerrit Adriensz. Berckheyde (he sometimes signed his paintings 'Berck Heyde') was the younger brother of Job Berckheyde (1630–93) and the son of a butcher, Adriaen Joppen Berckheyde. In c. 1650 Gerrit and his older brother, who was probably also his teacher, journeyed up the Rhine to Cologne, Bonn, Mannheim and other German cities and worked for a period for the Elector Palatine in Heidelberg. They had probably both returned by 1653, when Job joined the Haarlem guild. The architectural studies that Gerrit made on his trip were later incorporated into fantasized scenes of Rhenish cities; his city views of Holland, on the other hand, were for the most part topographically accurate. Gerrit joined the Guild in Haarlem in 1660 and dated his first paintings in 1662 (see Cat. 5) or 1668. Although the chronology of his art has not been fully resolved and his style changed little over time, the costumes of his figures assist in dating. As a rule Gerrit painted his own staffage but occasionally collaborated with other painters; catalogues of eighteenth-century sales refer to cityscapes by Gerrit with figures by Job. While Job painted a wide variety of subjects including history, genre and church interiors, Gerrit specialized almost exclusively in town views. His works sometimes exist in multiple versions consisting of several autograph replicas (see Cat. 5), thus suggesting that there was a strong market for his highly specialized art. Gerrit's cityscapes employ more dramatic contrasts of light and shade than those of earlier artists like Jan Saenredam and even Jan van der Heyden, but he moderates any harshness in these effects with soft grey, brown and terra-cotta hues applied with a velvety brushwork that almost recalls the style (applied, of course, to very different subjects) of artists like Cornelis Poelenburgh. Very few of his drawings have survived and these are mostly preparatory studies for paintings. Houbraken wrote admiringly and at length about the two brothers, quoting poems in praise of their art by the poets F. Snellincx, P. Rixtels and Joost van den Vondel. He also reported that Gerrit died by drowning when he fell into a canal while returning home late at night.

LITERATURE: Houbraken, vol. 3 (1753), pp. 189–98; van der Willigen 1870, pp. 78–9; Wurzbach, vol. 1 (1906), p. 85; E. W. Moes, in Thieme and Becker, vol. 3 (1909), p. 376; Martin 1935–6, vol. 2, pp. 396–9; Amsterdam, Amsterdams Historisch Museum, and Toronto, Art Gallery of Ontario, *The Dutch Cityscape in the 17th Century and its Sources*, 1977, pp. 26–9, cats. 102–6; Walsh and Schneider, *A Mirror of Nature* exh. cat., Los Angeles, Boston, New York, 1981–2, pp. 8–11; I. Gaskell, *Seventeenth-century Dutch and Flemish Painting, The Thyssen-Bornemisza Collection*, (London, 1990), pp. 290–301.

CAT. 5

The Castle of Heemstede, 1662?

Signed and dated on the wall to the right: G. Berck-Heyde
166 (2 or 9)
Oil on panel 16⅞ × 21½ in. (42.8 × 54.7 cm.)

PROVENANCE: Sale J. Verkolje, Amsterdam (de Winter), 24 October 1763, no. 52 (to de Bruyn, 210 fl.); sale Jan Jacob de Bruyn, Amsterdam, 12 September 1798, no. 12 (to Yver, 312 fl.); Six Collection, Amsterdam; sale Six, Amsterdam (F. Muller), 16 October 1928, no. 3, ill. (17,000 fl. to J. and S. Goldschmidt); Baron Thyssen-Bornemisza, Lugano, by 1930 (see exh.); acquired from Edward Speelman in 1967.

EXHIBITIONS: Amsterdam, Arti et Amicitiae, *Tentoonstelling van voorwerpen van kunst en nijverheid uit vroegeren tijd*, 1 February–15 March 1854, no. 792 [as dated 1665, figures by Adriaen van de Velde; lent by Jhr. P. H. Six]; Amsterdam, *Catalogus der Verzameling Schilderijen en Familie-portretten van de heeren Jhr. P. A. Six van Vromade, Jhr. Dr. J. Six en Jhr. W. Six wegens verbouwing in het Stedelijk Museum van Amsterdam tentoongesteld*, 1900, no. 8 [1660]; Munich, Neue Pinakothek, Sammlung Schloss Rohoncz, 1930, no. 24, pl. 69 [as signed and dated 1660].

LITERATURE: W. Steenhoff, 'Collectie Six', *Bulletin van den Nederlandschen Oudheidkundigen Bond*, vol. 2 (1900–1), pp. 26–7; E. Moes, in Thieme and Becker, vol. 3 (1909), p. 376; Rudolf Heinemann, *Stiftung Sammlung Schloss Rohoncz*, 3 vols., Villa Favorita (Lugano-Castagnola, 1937), vol. 1, no. 32, vol. 2, pl. 171 [as signed and dated 1660]; J. C. Tjessing and J. G. Renaud, *Enkele gegevens omtrent Adriaen Pauw en het slot van Heemstede*, vol. 3 (Heemstede, 1952) p. 32; Russell 1988, p. 788; Woodhouse 1988, p. 125, fig. 4; H. W. M. van der Wyck and J. W. Niemeijer, *De Kasteel tekeningen van Roelant Roghman*, Rijksprentenkabinet, Amsterdam, 1989, vol. 1, p. xiii, ill.; Christopher Wright, *Images of a Golden Age, Dutch Seventeenth-Century Paintings*, exh. cat. Birmingham City Museums and Art Gallery, 7 October 1989 – 14 January 1990, p. 103.

CONDITION NOTES: The panel support is in good condition. It has ¼ in. (5 mm.) wood strips added on all sides. With the additions the overall dimensions are 17½ × 22⅛ in. (44.3 × 56.3 cm.). The paint film is in very good condition with minor retouchings scattered in the sky and along the right edge of the panel. A pentiment appears along the right side of the castle. Extensive underdrawing is visible with the aid of infra-red. The perspective has been carefully worked out in a series of vertical lines that run the full height of the panel and articulate vertical architectural features of the design. The horizontal lines are more difficult to decipher but appear to form a perspectival grid with their vertical counterparts. The varnish layer is uneven but relatively clear. Two old stickers appear on the back, one indecipherable, the other inscribed '1/26'.

With its striated brick façade, moat and bridge, Heemstede Castle is viewed at an angle with its façade on the left. The Castle's side recedes steeply to the right. On the walk before the wall in the left middle distance stand two men in dark clothing, an elegantly dressed woman, and a young man with three hunting dogs. In the distance before the bridge leading to the house a couple pause as they promenade. A peacock perches on the wall in the centre foreground. The bright sunshine casts long shadows from right to left.

When the painting was exhibited at the Arti et Amicitiae Society in Amsterdam in 1854 its date was read as 1665. Later, when it was exhibited with the entire Six Collection in 1900, when it was sold in 1928, and still later in the Thyssen-Bornemisza collection, the date was read as 1660. When exhibited in London in 1988, the date was recorded as 1667. The last digit of the date now appears to be either a '2' or a '9', with the former seeming most likely; thus it would seem to be the earliest dated painting by Berckheyde. At least two other versions of this painting exist, both of which are slightly larger and one (see fig. 1) is reported to be signed and dated 1667.[1] The Samuel version is probably primary not only because it is the freshest but also because it reveals extensive underdrawing beneath the paint film. It figured in the famous Jan Jacob de Bruyn and Six Collections in Amsterdam and the present author has traced the painting to the earliest confirmed owner, J. Verkolje, from whose sale in 1763 it was purchased by de Bruyn.[2]

Property of Adriaen Pauw, Grand Pensioner of Holland, from 1621, the original Heemstede Castle was constructed in the thirteenth century and repeatedly remodelled.[3] An engraving of 1607 after David Vinckboons (fig. 2) shows how the castle appeared before Pauw acquired it and began an ambitious expansion and alteration project, adding wings, towers, walkways and the elegant Pons Pacis (The Bridge of Peace). The foundation of the last mentioned is

all that exists of the structure today after the castle was destroyed in 1811.

Adriaen Pauw (1585–1653) was the son of Reynier Pauw (1564–1636), a powerful burgomaster of Amsterdam and exceptionally wealthy man who was one of the founders of the East India Company.[4] Already as a young man Adriaen displayed exceptional skills as a diplomat, undertaking missions to France, England, Denmark and the Hanseatic states. In April 1631 he was appointed Grand Pensioner of Holland, one of the most powerful positions in the country. He negotiated important agreements with Louis XIII in 1635 and remained at the French court for sometime thereafter. On 8 September 1644, Pauw received Queen Henrietta Maria, wife of King Charles I, when she met Prince Willem of the Netherlands at Heemstede Castle, a scene depicted in a print by Claesz Jansz. Visscher (fig. 3). In 1646 Pauw became plenipotentiary to the peace talks in Münster, and is most famous for having been the representative from the provinces of Holland and West Friesland who successfully engineered the Treaty of Münster that formally ended the war with Spain on 15 May 1648.[5] In 1649 he was sent to England in an unsuccessful attempt to save the life of Charles I. His last diplomatic mission was again to England in 1652, to secure a peace treaty. The unhappy results so enraged the populace that they threatened to plunder both his house in The Hague and Heemstede Castle. Pauw died on 21 February 1653 aged sixty-eight. As one of the leaders of the peace talks in Münster, Pauw dedicated Heemstede Castle to Peace in a stone plaque dated 1649.

One of the large series of drawings of Dutch castles that the twenty-year-old Roelant Roghman executed in 1646–7 shows Slot Heemstede from the opposite side and less foreshortened, thus stressing the expanse of the structure and its famous bridge (fig. 3).[6] The print by Visscher (fig. 4) illustrating the famous meeting between Pauw and Henrietta Maria on the *Pons Pacis* serves to remind us of the strong historical and nationalistic associations that such castles often had for Dutch viewers. While Heemstede had avoided the destruction that left Egmont and Brederode Castles in ruins after the sieges of 1572, it clearly was associated in the public's mind with a great man and great events.

When the painting was exhibited in Amsterdam in 1854 the figures were attributed to Adriaen van de Velde (q.v.). No later observers repeated this notion and there is no reason to assume that the painting was a collaborative effort. The underdrawing in this painting (see Condition Notes and fig. 5) is important for our understanding of

Berckheyde's working methods, which apparently involved an extensive geometric underpinning for his perspectives before he applied paint to his panel.

The J. J. de Bruyn Collection sold in 1798 was one of the finest of its day and the Six Collection, which also contained Rembrandt's famous *Portrait of Jan Six*, is still well known to lovers of Dutch art. In the nineteenth century the 'Galerie Six' on the Herengracht (now moved to 218 Amstel) was arranged as a museum by Jan Pieter Six van Hillegom (1824–99) and his brother Pieter Hendrik Six van Vromade (1827–1905) and was regarded as one of the greatest attractions of Amsterdam. The collection was inherited by Prof. Jan Pieter Six, who was an art historian and supporter of the Royal Archaeological Society. Following his death sixty-six paintings including this one were sold by the Six Foundation.[7] Soon thereafter it entered the Thyssen-Bornemisza Collection, which also is still extant in Lugano, but the painting was later sold.

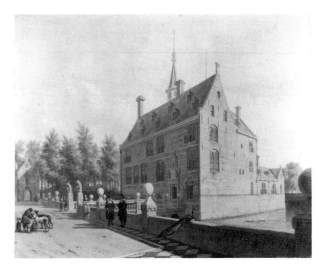

FIG. 1 Gerrit Berckheyde, *Heemstede Castle*, signed and dated 1667, oil on panel 48.3 × 61 cm., Private Collection.

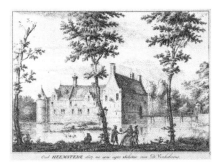

FIG. 2 Anonymous printmaker after David
Vinckboons, *Slot Heemstede*, 1607, engraving.

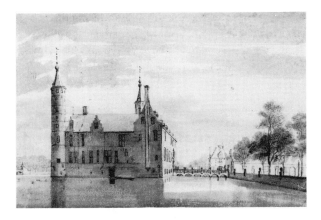

FIG. 3 Roelant Roghman, *Slot Heemstede*, 1646 or 1647, black
chalk drawing with grey wash, 322 × 493 mm., British Museum,
London, inv. 1879.5, 10.325.

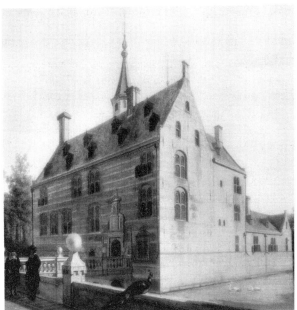

FIG. 5 Infra-red photograph showing the underdrawing of Cat. 5.

FIG. 4 Claes Jansz Visscher, *The Meeting of Queen Henrietta
Maria and Adrian Pauw at Slot Heemstede*, engraving.

1 Oil on panel 20½ × 28¾ in. (52 × 73 cm.). Sale Amsterdam (F.
Muller) 16 April 1901, no. 10, ill.; and oil on panel, 19 × 24 in.
(48.3 × 61 cm.), signed and dated 1667, sale Beatty *et al.* (Mrs
K. A. Sullivan), London (Christie's), 10 April 1970, no. 38, ill.
The latter is probably identical with the painting that appeared
in the Birmingham City Art Gallery's exhibition, *Images of a
Golden Age. Dutch Seventeenth-Century Paintings*, no. 77; how-
ever that work was said to be on canvas 63 × 49.7 cm. The
archival notes of C. Hofstede de Groot at the Rijksbureau voor
Kunsthistorische Documentatie, The Hague, mentions a
version without dimensions with the dealer Deemes, Brussels,
1902.

2 'Een Gezicht van het Huis te Heemstede buiten Haarlem, uit
de voorpoort te zien, de voorgrond zeer fraay gestoffeerd, alles
zeer natuurlyck en zonagtig. Op paneel geschildert, hoog 17
duim, breed 21 duim.'

3 On Heemstede Castle, see J. C. Tjessing and J. G. Renaud,
Enkele gegevens omtrent Adriaan Pauw en het slot van Heemstede, 3
vols. (Heemstede, 1948–52).

4 On Adriaen Pauw, see A. J. van der Aa, *Biographisch Woorden-
boek der Nederlanden*, vol. 6 (reprint Amsterdam, 1969), p. 41.

5 Pauw appears wearing a goatee and raising his right hand on
the left side of the signing table in ter Borch's *Signing of the
Treaty of Münster*, National Gallery, London, no. 896 (S. J.
Gudlaugsson, *Geraert ter Borch*, 2 vols. (The Hague, 1959–60);
vol. 2, no. 57). In c. 1646 ter Borch also painted *Adriaen Pauw's
Arrival by Carriage in Münster* (Landesmuseum, Münster) as
well as pendant portraits of Pauw and his wife (Elias-Pauw van
Wieldrecht Collection, Farnborough); see respectively
Gudlaugsson 1959–60, vol. 1, figs. 43, 41 and 42.

6 See Tjessing and Renaud, vol. 3 (1952), p. 32, fig. 3, where other images of the castle attributed to 'N. van Berghem' (1646?) and Jan Mijtens (1654) are mentioned; compare also the anonymous eighteenth-century ink drawing (154 × 241 mm.) of Heemstede Castle from a point of view and angle similar to Berckheyde's but less steeply foreshortened, in the Leiden University Library (Boedel Nijenhuis, portfolio 305, vol. 1, no. 33). On Roghman's three drawings of Heemstede Castle, see van der Wyck and Niemeijer, exh. cat. Rijksprenten-kabinet, Amsterdam, 1989, p. XIII, cat. nos. 65–7, ills. No doubt partly or wholly from his imagination, Roghman recreates in one of these drawings the appearance of Slot Heemstede before Pauw's renovations.

7 See Ben Broos, in The Hague, Mauritshuis, *Great Dutch Paintings from America* (28 September 1990–13 January 1991), p. 154. On the Six Collection before the sale in 1928, see W. Steenhoff, 'Collectie Six', *Bulletin van den Nederlandschen Oudheidkundigen Bond*, vol. 1 (1899–1900), pp. 205–11, vol. 2 (1900–1), pp. 22–31.

CAT. 6

The Smedestraat with a View of the Grote Markt and St Bavo's Church, Haarlem

Signed in white lower left: Gerrit Berck Heyde
Oil on panel 20⅛ × 15½ in. (52 × 39.5 cm.)

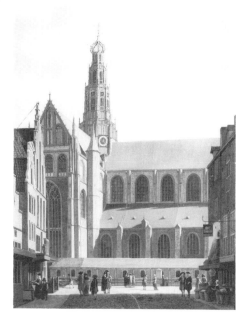

PROVENANCE: (Possibly) sale Haarlem, 3 December 1771, no. 1; Van Liphart Collection, Stachelberg; with dealer Julius Bohler, Munich, c. 1928; Major Parker, New Biggin Hall, Northumberland; acquired from Edward Speelman in 1968.

EXHIBITION: London 1988, no. 6.

CONDITION NOTES: The panel support is uncradled and in good condition. The paint film is in very good condition with minor losses in the grey roof of St Bavo's and scattered pinpoint losses in the sky. Some old tenting appears in the upper left corner. The varnish is slightly rubbed on the edges but otherwise clear.

The church of St. Bavo's (Grote Kerk) in Haarlem is viewed from the Smedestraat. A strong morning light (the clock in the tower reads 10:20) illuminates the scene and articulates the architecture with strong shadows. Elegantly dressed figures promenade in the street, conversing or doing their shopping. On the right is a greengrocer and poultry cages and a signboard with the image of a lamb. At the far left a man with a wheelbarrow disappears behind the buildings.

Berckheyde often depicted St Bavo's church in his native Haarlem, usually representing the church from the Grote

Markt (see fig. 1) or from various points around the Town Hall. Only rarely was it depicted from the small Smedestraat.[1] The present work may therefore be identical with a picture that was sold in Haarlem on 3 December 1771 with the description 'No. 1. The Groote Kerk in Haarlem seen from the Smeedstraat [sic], beautifully painted by G. Berckheyde'.[2] A comparably composed view is offered in the painting in Dresden (fig. 2) where the church's north side and spire are viewed from a point somewhat farther off in the recess of the neighbouring St Janstraat or Grote Houtstraat. Berckheyde apparently was the first to depict St Bavo's from a side street. A painting by Berckheyde in Raleigh (fig. 3) also depicts St Bavo's in an upright format but concentrates on the stalls of the Vismarkt clustered at its base.

Built between the end of the fourteenth and the end of the fifteenth century, St Bavo's acquired its distinctive tower spire in 1519–20 and today remains much as Berckheyde, Saenredam, Beerstraten and many other seventeenth-century artists painted it. However, while the Vleeshal (the former meat market, constructed by Lieven de Key in 1602–3) still stands on the south side of the church, the buildings of the Vismarkt, which are visible in the Samuel painting, have long since been removed. The Klokhuis (Bell Tower), built in 1479 (and visible in the distance of fig. 1) was also removed in 1804. The old fishmarket was built in 1603 and had its entrance on the east side near the north transept of St Bavo's. It contained

FIG. 2 Gerrit Berckheyde, *Grote Kerk from the St Janstraat (?), Haarlem*, c. 1680, oil on panel 43 × 39 cm., Gemäldegalerie, Alte Meister, Staatlich Museum, Dresden, no. 1523A.

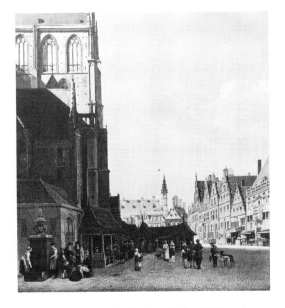

FIG. 3 Gerrit Berckheyde, *Grote Kerk with Vismarkt, Haarlem*, oil on panel 45.2 × 42.6 cm., North Carolina State Museum, Raleigh, no. 60.17.69.

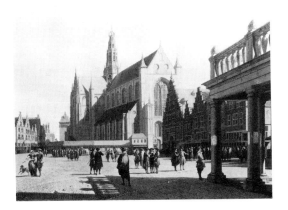

FIG. 1 Gerrit Berckheyde, *The Grote Markt with Grote Kerk, Haarlem* 1674, oil on canvas 52 × 67 cm., National Gallery, London, no. 1420.

fish stalls around a central paved court. In 1768 the old fish market was replaced by the present Vishal, which was entered on the west side and had two aisles with twelve fish stalls each.

Berckheyde signed and dated paintings from 1662 (or 1668) to 1696. A view of the Grote Kerk in Haarlem in the Jan Gildemeester Jansz Sale (Amsterdam, 11 June 1800) was reportedly dated 1666, the Uffizi, Florence owns one dated 1693 (inv. (1890) no. 1219),[3] the Detroit Institute of Art one of 1695, and the Frans Hals Museum, Haarlem, the latest dated example of 1696 (no. 464A). Although the Samuel painting is undated, the costumes of the figures suggest that it is a later work, perhaps painted around 1680.

1 A painting described as 'Een gezicht op de St Bavo vanuit de Smedestraat', panel 58.5 × 46 cm., signed lower left, Gerrit Berck Heyde, was lent to an exhibition in 1936 in Haarlem by M. J. Enschede, Heemstede. Pieter Biesboer, Curator of the Frans Halsmuseum has kindly informed me that this painting was with the dealer René Schreuder BV, Aerdenhout, in 1988, and that in Biesboer's opinion it was an autograph replica painted in the 1690s of a better version executed in the 1670s which was in a German private collection in 1926 and illustrated by Biesboer in the *Monumenten Bulletin* (a publication of the Monumentenzorg Openbare Werken Haarlem), February 1982, number 4, n.p. (incorrectly titled St Bavo's 'Exterior, Northside, from the Jansstraat').

2 'De Groote Kerk te Haarlem uyt de Smeedstraat te zien, fraay geschildert door G. Berkheyde' (without measurements).

3 See Marco Chiarini, *I Dipinti Olandesi del Seicento e del Settecento, Gallerie e Musei statali di Firenze* (Rome, 1989), pp. 44–6, cat. no. 6.22, ill.

GERARD TER BORCH

(ZWOLLE 1617–1681 DEVENTER)

Gerard ter Borch (often he signed Geraert ter Borch) was born in Zwolle, the son of Gerard ter Borch the Elder (1584–1662), an artist who worked in Italy in his youth. As Arnold Houbraken stated, ter Borch first studied with his father. In 1632 he evidently was in Amsterdam and in 1634 in Haarlem, where he was a pupil of Pieter de Molijn (1595–1661). He is said to have entered the Haarlem guild in 1635; in July of that year he was in England but may have returned to Zwolle by April 1636. According to Houbraken, ter Borch studied at Haarlem and travelled extensively in Germany, Italy, England, France, Spain and the Netherlands. He may have visited these countries after 1635, and in the 1640s certainly travelled to Münster, where he painted portraits of the representatives to the peace negotiations held there between 1646 and 1648 (see National Gallery, London, no. 896). Houbraken claimed that a Spanish envoy who had been attending the meetings took ter Borch with him to Madrid, but there is no trace of the artist in Spain. Further, he was recorded as being in Amsterdam in 1648 and in Kampen in 1650. On 22 April 1653, he signed a document in Delft together with the famous painter Johannes Vermeer (1632–75). In February 1654 he was married to Geertruyt Matthijs in Deventer, where he acquired citizenship in the following year. Ter Borch evidently resided continuously in Deventer until the troops of Cologne and Münster occupied the city in May and June of 1672. He sought refuge in Amsterdam and remained there until late in the summer of 1674 when he returned to Deventer, where he died in 1681.

In his early years ter Borch painted guardroom scenes in the manner of the Haarlem and Amsterdam painters Pieter Codde (1599–1678) and Willem Duyster (1598/9–1635). In the 1640s he executed miniature portraits, and he was active as a portraitist to the end of his career. During the 1650s he was instrumental in developing an elegant new type of genre painting characterized by great technical and psychological refinement. These works had a great impact on his contemporaries and served, more than the works of any other painter, to define the forms taken by late seventeenth-century Dutch genre painting. Ter Borch enjoyed the patronage of many prominent people of his day.

LITERATURE: Houbraken 1718–21, vol. 3, pp. 32, 34–40; Weyerman 1729–69, vol. 2, p. 376; Smith 1829–42, vol. 4, pp. 111–42; Immerzeel 1842–3, vol. 3, p. 132; Kramm 1857–64, vol. 6, p. 1612; van der Willigen 1870, p. 352; Carl Lemcke, 'Gerhard Terborch, ' in *Kunst und Künstler des Mittelalters und der Neuzeit*, edited by Robert Dohme (Leipzig, 1875); E. W. Moes, 'Gerard ter Borch en zijne familie', *Oud-Holland*, vol. 4 (1886), pp. 145–65; Emile Michel, 'Gérard Terbourg (Ter Borch) et sa famille', *Gazette des Beaux-Arts*, 2nd ser., vol. 34 (1886), pp. 388–404, vol. 35 (1887), pp. 40–53, 125–41; Abraham Bredius, 'Gerard ter Borch, 1648 te Amsterdam', *Oud- Holland*, vol. 17 (1899), pp. 189–90; Hofstede de Groot 1908–27, vol. 5 (1913), pp. 1–145; Abraham Bredius, 'Schilderijen uit de nalatenschap van den Delft'schen Vermeer', *Oud-Holland*, vol. 34 (1916), pp. 160–1; Wurzbach 1906–11, vol. 2, pp. 698–702; Walter Rothes, *Terborch und das holländsiche Gesellschaftsbild, Die Kunst dem Volke*, nos. 41–2 (Munich, 1921); F. Hannema, *Gerard Terborch* (Amsterdam, 1943); Eduard Plietzsch, *Gerard Ter Borch* (Vienna, 1944); S. J. Gudlaugsson, 'De datering van de schilderijen van Gerard ter Borch', *Nederlands Kunsthistorisch Jaarboek*, vol. 2 (1949), pp. 235–67; S. J. Gudlaugsson, *Gerard ter Borch*, 2 vols. (The Hague, 1959–60); The Hague, Mauritshuis, *Gerard Ter Borch, Zwolle 1617–Deventer 1681*, cat. by S. J. Gudlaugsson *et al.*, 1974; J. M. Montias, 'New Documents on Vermeer and His Family', *Oud-Holland*, vol. 91 (1977), pp. 285–7; S. A. C. Dudok van Heel, 'In presentie van de Heer Gerard ter Borch', in *Essays in Northern European Art Presented to Egbert Haverkamp Begemann on His Sixtieth Birthday* (Doornspijk, 1983), pp. 66–71; Alison McNeil Kettering, 'Ter Borch's Studio Estate', *Apollo*, vol. 117, no. 256 (June 1983), pp. 443–51; Philadelphia/Berlin/London 1984, pp. XLIV–XLVI, 142–54; Alison McNeil Kettering, *Drawings from the Terborch Studio Estate, Catalogue of the Dutch and Flemish Drawings in the Rijksprentenkabinet*, volume 5, part 2, Rijksmuseum, Amsterdam (The Hague, 1988).

CAT. 7

Portrait of a Man in his Study, c. 1668–9

Formerly monogrammed
Oil on canvas 28½ × 21⅞ in. (72.7 × 55.5 cm.)

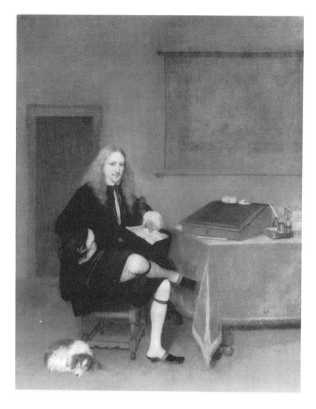

PROVENANCE: Sale J. van der Linden van Slingeland, Dordrecht,
22 August 1785, no. 433 (500 fl., to Fouquet); (possibly) sale
Verdun, Bouquet et al., Paris, 26 December 1797, no. 34 [the so-
called Portrait of Jan de Witt; the description corresponds but with
the dimensions 66 × 51 cm.]; sale Vicomte d'Harcourt, Paris, 31
January 1842, no. 154 (2300 frs.); sale Baron Gustave de
Rothschild, Paris; Marchioness Cholmondeley, London, by 1929;
acquired from Edward Speelman in 1961.

EXHIBITIONS: Paris 1892, no. 5; London R.A. 1929, no. 502c (not
in catalogue); London 1988, no. 68.

LITERATURE: Hofstede de Groot, vol. 5 (1913), nos. 328 and 335;
S. J. Gudlaugsson, Gerard ter Borch, 2 vols. (The Hague, 1959–60),
vol. 1, p. 147, ill. p. 358; vol. 2, cat. no. 224.

CONDITION NOTES: The canvas support has an old lining. The
darker passages of the paint film, especially in the background,
have suffered from abrasion. Many of the forms have been
strengthened with delicate inpainting that reinforces the outlines of
the figure (the forms and folds of his black costume, especially the
cravat, coat-tails and his right sleeve, as well as the shadows of his
face – the areas around the eyes, nose, etc.), the furnishings (the

lower rung of the chair, the outlines of the writing desk, and the
map on the back wall) and the setting in such details as the door-
way. A pentiment in the figure's knee shows that the hem of his
garment was raised to expose more of his elegant stockings. No
evidence of the monogram mentioned by Gudlaugsson could be
found, although one would expect to find it on the chair rung. The
varnish is moderately discoloured. Nearly a full inch of the original
image at the lower edge is obscured by the frame.

On the viewer's left a man holding a piece of paper sits with
his legs crossed beside a table with a writing desk, covered
in green felt, with an ink stand and books. His hair is long
and blond, his clothes black with red silk pantaloons and
light grey knee-length stockings. The table covering is dark
crimson velvet with gold trim. On the back wall is a map,
probably of Europe (the inscription above it is now
indecipherable), and at the left a door. On the floor at the
lower left lies a small brown and white spaniel.

Gerard ter Borch specialized in intimately scaled full-
length portraits of well-to-do sitters executed in a highly
refined, almost miniaturist technique. This type of small-
scale portrait of a gentleman scholar seated in his study had
been executed earlier by the Amsterdam portraitist,
Thomas de Keyser; see, for example, the latter's 1631
Portrait of a Scholar (fig. 1). Although ter Borch had painted
the Deventer scholar and historian Gosewyn Hogers
(1636–76) standing full length in his book-lined study as
early as c. 1665 (Marquis of Bute, Rothesay),[1] Sturla
Gudlaugsson regarded the Samuel portrait as ter Borch's
earliest painting of the seated scholar/gentleman type, and
related it to the artist's lost genre-like double portrait of
The Amsterdam Merchant Sybrand Schellinger and his wife
Jenneken (née ter Borch) with Two Children, painted shortly
after the couple's marriage in 1668, and now known
through a watercolour copy of 1669 by Gesina ter Borch
(fig. 2).[2] Ter Borch's new brother-in-law, Sybrand
Schellinger, probably introduced him to a wealthy circle of
potential patrons. These clients favoured highly refined
images of themselves posed with studied informality among
the appurtenances of scholarship. Although the present
sitter is unidentified, he presumably belonged to this circle
of acquaintances and the painting probably dates from the
same period as the double portrait of c. 1668–9. The
popularity of this portrait type can be gauged not only by
ter Borch's repeated return to its formulae,[3] but also by
their application by ter Borch's followers. Gudlaugsson
cites portraits by J. Grasdorp, Jan Verkolje and C. Picolet
which are all wholly or partly based on Lord Samuel's
painting.[4] He also noted that individual motifs in the
painting recur in other works by ter Borch (for example, the

tiny dog reappears in a musical genre scene from this period, fig. 3)⁵ and probably reflects the fact that ter Borch employed studio assistants in these and later years to paint subordinate details and accessories in his compositions.

1 See Gudlaugsson 1959–60, vol. 2, cat. no. 195, vol. 1, pp. 338, ill.
2 See Gudlaugsson 1959–60, vol. 2, cat. no. 225, vol. 1, pp. 147 and 359. See now, Alison McNeil Kettering, *Drawings from the Terborch Studio Estate. Catalogus van de Nederlandse Tekeningen in het Rijksprentenkabinet*, Rijksmuseum, Amsterdam, vol. 5, Parts I and II, 2 vols. (The Hague, 1988), vol. 2, p. 639, folio 74 recto, cat. no. G562, pl. XXI.
3 See, for example, ter Borch's *Portrait of Hermanus Quadacker* c. 1670–2, formerly Otto Henkell collection, Wiesbaden; *Portrait of a Man* c. 1675, formerly H.E. ten Cate Collection, Oldenzaal; and the *Portrait of the Preacher Jan van Duren*, 1681, Henry Janssen, Reading (Pa.), respectively Gudlaugsson 1959–60, vol. 2, cat. nos. 253, 269 and 292, vol. 1, ills.
4 For the J. Grasdorp see Gudlaugsson 1959–60, vol. 2, no. D42 (Hofstede de Groot, vol. 5 (1913), no. 356a); for the Jan Verkoljes, see sale Goldschmidt, Frankfurt, 4 May 1917, no. 605, and formerly von Nickl Collection, Budapest; and for the C. Picolet, see sale J. Lek, Amsterdam, 31 March 1925, no. 13 (as G. Coques).
5 Gudlaugsson 1959–60, vol. 2, cat. no. 221.

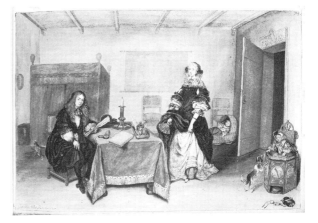

FIG. 2 Gesina ter Borch, copy after G. ter Borch's *Double Portrait of Sybrand Schellinger and his Wife, Jenneken ter Borch*, 1669, black chalk with watercolour, egg white, heightened with gold, 233 × 350 mm., Rijksprentenkabinet, Amsterdam, ter Borch Studio Estate, Folio 74 recto, cat. no. GS62.

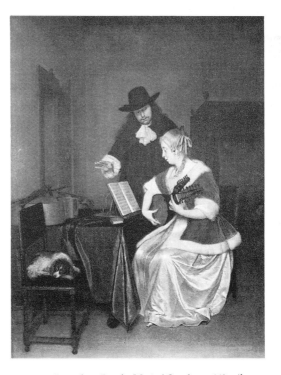

FIG. 3 Gerard ter Borch, *Musical Couple* c. 1668, oil on canvas 66 × 51 cm. formerly Fattorini Collection, Bradford, Yorkshire.

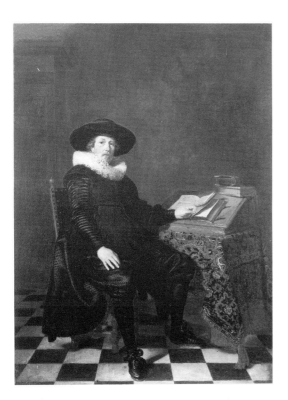

FIG. 1 Thomas de Keyser, so-called *Portrait of a Scholar*, monogrammed and dated 1631, panel 82.5 × 61 cm., Mauritshuis, The Hague, no. 77.

JAN BRUEGHEL THE ELDER

(BRUSSELS 1568–ANTWERP 1625)

The second son of the famous peasant painter, Pieter Bruegel the Elder (before 1525–69), Jan Brueghel was born in Brussels in 1568. According to Van Mander he was a pupil of Pieter Goetkindt (died 1583) in Antwerp, although this claim is not confirmed by documents. At about the age of twenty-one he made the traditional voyage to Italy, stopping along the way in Cologne where his sister lived. He arrived in Italy around 1589 and is documented as decorating a clock in Naples in 1590. His earliest works known to us were executed in 1592–4 in Rome, where he was patronized by Cardinal Ascanio Colonna, who also employed Peter Paul Rubens' brother Phillip. In Rome he undoubtedly met the landscapist Paulus Bril and the two had an important reciprocal influence on one another.

In 1595–6 he was in Milan where he won the favour of the great collector, Cardinal Federigo Borromeo, for whom he executed paintings throughout his career. The correspondence between the two (first published by Crivelli, 1868) offers important insights into Brueghel's art. By October of 1596 he had settled back in Antwerp. The following year he became a master in the guild of St Luke. In 1601 he became a citizen and the following year was named dean of the guild. On 23 January 1599 he married Elisabeth de Jode, who on 13 September 1601 bore his first son, Jan the Younger, who also became an artist. Elisabeth died in 1603, perhaps while giving birth to their daughter, Paschasia, who subsequently married the painter Jan van Kessel (q.v.). Jan remarried in 1605 to Catherine de Marienbourg, who bore him eight additional children.

The artist travelled to Prague in 1604 and to Nuremberg in 1606. The remainder of his career was determined by his appointment in 1606, like Rubens, as a (non-resident) painter to the court of Archduke Albert and the Infanta Isabella Clara Eugenia in Brussels. Residing in Antwerp during these years, Jan became close friends and collab-orated with not only Rubens (who served as his amanuensis in his letters to Cardinal Borromeo), but also with the Flemish painters Joos de Momper the Younger, Hendrick de Clerck, Hendrick van Balen and Sebastian Vrancx.

Around 1613 he was sent with Rubens and van Balen on an official mission to the United Provinces of the Northern Netherlands, a trip which resulted in fruitful artistic cross-fertilization but most benefited the Northern artists, who were strongly influenced by Brueghel's landscapes. Attesting to Brueghel's fame, Johann Wilhelm Neumyr's description of Ernest of Saxony's visit to Antwerp in February of 1614 notes the nobleman's eager pursuit of the works by the city's two 'eminent' painters, Rubens and Jan Brueghel. In 1615, the Antwerp authorities further honoured the painter by presenting four of his works to the regents of Brussels who were making an official visit to the city. Although Jan's only documented student was the Jesuit flower painter Daniel Segers, he had many imitators, including Jan Brueghel the Younger who can come very close to his style. The artist died in Antwerp 25 January 1625, the victim of an outbreak of cholera that also killed three of his children.

One of the most successful and celebrated Flemish artists of his day, Jan Brueghel was a specialist in landscape and still life, earning the sobriquet 'Velvet [de Velours] Brueghel' for his subtly detailed and delicate record of surfaces. Often he filled his compositions with a wealth of incident and decorative minutiae, but he was also strongly committed to naturalistic observation and made a lasting contribution to the rise of realistic landscape and still life painting. In addition to the latter subjects, Brueghel executed, often in his miniaturist style, history subjects, including mythological and religious scenes, and allegories (the Five Senses, Four Elements, etc.) as well as fanciful hell scenes.

LITERATURE: Van Mander 1603–4, fol. 234; G. Crivelli, *Giovanni Brueghel, Pittor Fiammingo o sue Lettere e Quadretti esistenti presso l'Ambrosiana* (Milan, 1868); F. J. van den Branden, *Geschiedenis der Antwerpsche Schilderschool* (Antwerp, 1883), pp. 312–13, 374, 444–5, 648, 651–2; Jean Denucé, *Brieven en Documenten betreffend Jan Brueghel I en II* (Bronnen voor de geschiedenis van de Vlaamsche kunst, iii) (Antwerp, 1934); Jacques Combe, *Brueghel de Velours* (Paris, 1942); Yvonne Thiéry, *Le Paysage flamand au XVIIe siècle* (Paris/Brussels, 1953); M. L. Hairs, *Les Peintres flamands de fleurs au XVIIe siècle* (Paris/Brussels, 1955; 2nd edition 1964); M. de Maeyer, *Albrecht en Isabella en de Schilderkunst* (Brussels, 1955), pp. 144–59; S. Speth-Holterhoff, *Les Peintres flamands de cabinets d'amateurs au XVIIe siècle* (Paris/Brussels, 1957); Matthias Winner, 'Zeichnungen des ältern Jan Brueghel', *Jahrbuch der Berliner Museen*, vol. 3 (1961), pp. 190–241; H. G. Franz, *Niederländische Landschaftsmalerei im Zeitalter des Manierismus*, 2 vols. (Graz, 1969); M. Winner, 'Neubestimmtes und Unbestimmtes im zeichnerischen Werk von Jan Brueghel d. Ä', *Jahrbuch der Berliner Museen*, vol. 14 (1972), pp. 122–60; London, Brod Gallery, *Jan Brueghel the Elder*, exh. 1979 (catalogue by Klaus Ertz); Klaus Ertz, *Jan Brueghel der Ältere (1568–1625): Die Gemälde* (Cologne, 1979); Brussels, Palais des Beaux-Arts, *Brueghel: une dynastie de peintres*, exh. 1980, pp. 165–78.

CAT. 8

River Landscape with a Village and a Landing, 1612

Signed and dated lower right: BRVEGHEL 1612
Oil on copper 8¼ × 12⅝ in. (20.9 × 32 cm.)

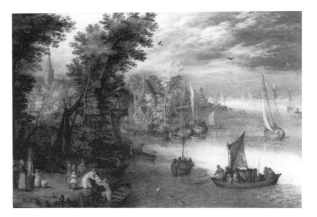

PROVENANCE: Major Hugh Rose.

EXHIBITION: London 1988, no. 7, ill. p. 28.

LITERATURE: Klaus Ertz, *Jan Brueghel der Ältere (1568–1625). Die Gemälde mit kritischem Oeuvrekatalog* (Cologne, 1979), p. 601, no. [259]; Russell 1988, p. 789.

CONDITION NOTES: The copper support is in good state and in plane. The paint film reveals little abrasion but old losses have been retouched in the upper left corner, in the lower left, and to a minor area of sky to the right of the central bird. The varnish layer is discoloured and an especially thick layer covers the signature.

In a broad river landscape receding diagonally into space, there is a landing in the left foreground with trees and a village. Beside a rowing boat moored to the landing a gentleman dressed in lavender with a green cape hands a child to a man waiting in the boat. Behind them a woman with two children and a man wait on shore, while to the left stand three elegantly dressed ladies in blue, yellow and red, accompanied by a child in yellow and a white dog. Beyond numerous men work on the boats that line the shore beside the village. On the right a ferry boat crowded with three horses and seven passengers is viewed from the port broadside, while a second ferryboat also loaded with cows and people is viewed from the starboard stern. Other sailingboats ply the river which stretches to a distant horizon bristling with sails. Through a clearing on the left, a church spire rises and houses appear beside a bridge. On the water in the foreground are ducks; other birds fly overhead.

Jan Brueghel the Elder was one of the pioneers of river landscape painting in Netherlandish art. While earlier sixteenth-century Flemish painters, like Joachim Patinir and Herri met de Bles, had included rivers in their encyclopaedic 'world landscapes', Jan Brueghel made river scenes a speciality, depicting not only perpendicularly receding canals and rivers with both banks visible,[1] but also landscapes with a single bank receding diagonally as in Lord Samuel's painting. The latter type had appeared in Brueghel's art at least as early as 1603 when he painted the well-known *River Landscape with a Landing and Ferry Boat* in the Koninklijk Museum voor Schone Kunsten, Antwerp (inv. 910).[2] Already anticipating the Samuel painting's composition, a river landscape in the Toledo Museum of Art dated 1604 includes a village with a landing on the left and a ferry boat functioning as a repoussoir on the right.[3] And a painting of 1606 in the Wellington Museum, Apsley House, London, is still closer in conception (fig. 1).[4]

At least three and probably more versions of Lord Samuel's painting exist, none of which appears from photographs to be superior in quality, and all of which may be copies of a lost prototype.[5] A version that was in the Wachtmeister Collection in Wanås, Sweden (fig. 2), was reported to be dated 1607, and thus could be assumed to be an earlier version with minor differences (e.g. the ducks in the foreground) of the Samuel composition; however, in reproductions it looks conspicuously weaker in execution.[6] Still another variant and/or copy in the Duke of Devonshire's Collection, Chatsworth, reported to be signed and dated 1610 (fig. 3), introduces more significant changes, chief among them a covered wagon on the shore at the left;[7] there are in turn several versions and/or copies of this particular variant of the composition.[8] In reproductions the Chatsworth pendants make no compelling claim to primacy or to Jan Brueghel the Elder's authorship. Moreover, despite its later date, the freshness and quality of the Samuel painting argues in favour of its being by the master, perhaps indicating that it is an autograph replica of an earlier lost original.

The Samuel painting came from the collection of Major Hugh Rose with another painting of virtually the same dimensions (see Cat. 9) but which differs in subject and design from the Chatsworth painting's companion. It is possible though not certain that the Samuel pair were designed as pendants by Brueghel, since they share similar elevated points of view, comparable height in the horizon line and complementary themes of travel.

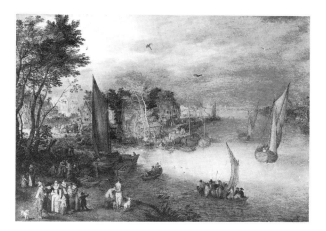

FIG. 1 Jan Brueghel the Elder, *River Landscape with a Landing and a Village*, signed and dated 1606, oil on copper 27.3 × 40.6 cm., Wellington Museum, Apsley House, London, no. 1574-1948.

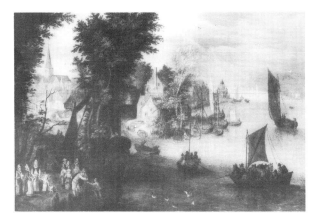

FIG. 2 Jan Brueghel the Elder?, *River Landscape with Landing and a Village*, signed and dated 1607, oil on copper 20.5 × 30.5 cm., Graf Wachtmeister, Wanås.

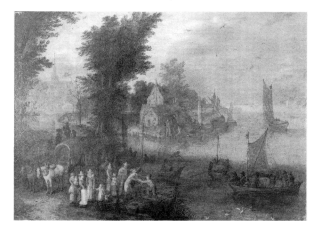

FIG. 3 Jan Brueghel the Elder?, *River Landscape with a Landing and a Village*, signed and dated 1610, oil on copper 21.5 × 26.7 cm., Duke of Devonshire, Chatsworth.

1 See the *Village Canal*, signed and dated 1602, oil on copper 18
 × 27 cm., sale Brussels (Palais des Beaux-Arts), 19 February
 1958, no. 104, ill.; Ertz 1979, no. 28, ill. fig. 28.
2 Oil on panel 39 × 63 cm.; Ertz 1979, cat. no. 94, ill. fig. 22.
3 Oil on panel 35.6 × 64.4 cm., acc. no. 58.44; Ertz 1979, cat. no.
 106, fig. 23. Compare also the painting of 1604, formerly in
 Dresden, no. 879 (not in Ertz).
4 Ertz 1979, cat. 135, fig. 24.
5 Versions and/or copies: *1*. Copper 21 × 22 cm., sale Paris
 (Galliera), 20 June 1961, ill; *2*. Panel 20 × 30.5 cm., sale Victor
 Decock, Paris (Charpentier), 12 May 1948, ill; *3*. Same as
 above?, panel 19.7 × 31.1 cm., sale London (Christie's) 14
 April 1978, no. 123, ill; *4*. Copper 17.5 × 22.5 cm., sale
 Brussels (Palais des Beaux-Arts), 7 May 1975, no. 4, ill. (from
 the Roman Jordan de Urries collection, Madrid).
6 Not in Ertz; Wachtmeister catalogue 1895, no. 3.
7 Not in Ertz. The painting has a pendant of the same dimen-
 sions, *Covered Wagons and Travellers on a Road Beside a River.*
8 Copies of this variant of the composition: *1*. Panel 27 × 37 cm.,
 sale Brussels (Galerie Giroux), 15 March 1926, no. 10, ill; *2*.
 Copper 12.6 × 19.4 cm., with dealer Slatter, London, c. April
 1953 (repr. in the *Illustrated London News*, 18 April 1953);
 3. Copper 24 × 32.5 cm., formerly Galerie R. Finck, Brussels
 (exh. *Maîtres flamands*, no. 29, with ill.); *4*. Copper 21.5 × 31.7
 cm., with Alexander Gallery, London, November and
 December 1978 (adv. in *Burlington Magazine*, November 1978,
 p. clxxiii; and *Connoisseur*, vol. 199 (December 1978), p. 65); *5*.
 Same as above?, sale London (Sotheby's) 24 March 1976, no.
 93, ill.

CAT. 9

Rest on the Way, c. 1612?

Signed lower right: BRVEGHEL
Oil on copper 8 ¼ × 12 ⅝ in. (21 × 32.2 cm.)

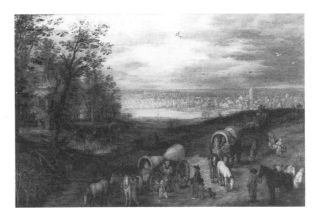

PROVENANCE: Major Hugh Rose.

EXHIBITION: London 1988, no. 10 [as Jan Brueghel the Younger].

LITERATURE: Ertz 1979, pp. 233, 601, cat. no. [260], fig. 304 [as 'J.
Brueghel d. Ä (?)']; Russell 1988, p. 789.

CONDITION NOTES: The copper support is in good condition and
in plane. The paint film is generally in very good condition, but has
been retouched along the edges and in some minor areas of drying
crackle in the sky. Other tiny retouches are scattered throughout.
Several pentimenti appear in the foreground; the position of the
small child by the foremost wagon wheel was changed and other
figures were shifted. The varnish is thick and unevenly applied.

Two covered wagons and a pair of riders have stopped by a
shallow stream in an open landscape with woods on the left
and a village near the horizon on the right. In the centre
foreground, a man in a red jersey unharnesses the horses as
another man helps one of the ladies down from the wagon.
A child with a basket stands by the front wheel; towards the
rear is a mother dressed in red and blue, holding the hand
of a child in yellow ochre and violet. To the right and in
front of the second wagon two horsemen have dismounted
and one bends to relieve himself. Peasants walk behind a
haywain that makes its way up the road that retreats
diagonally over the rise on the right. Beyond the lighted
plain in the distance are church spires, houses and a
windmill among trees.

Brueghel had first taken up the theme of the halt of
wagons and horsemen on the open road in a remarkably

understated little painting dated 1603 in the Prado, Madrid
(fig. 1), with a high horizon line and a darkling series of
superimposed hillocks.[1] He developed this composition
further in a painting dated 1605 in Dresden (fig. 2),[2] which
adds the woods on the left, the reedy stream and the broad
vista in the distance – indeed it incorporates virtually all of
the elements in, and fully anticipates the design of, the
Samuel painting. Ertz discussed the formal development of
this type of broad landscape with open road, and noted the
resemblance of a painting in the Minneapolis Institute of
Arts (fig. 3) as well as the Samuel painting to the earlier
Dresden picture.[3] He expressed some reservations about
the attribution of both former paintings to Jan the Elder,
but tentatively accepted the Minneapolis picture as a work
of about 1605,[4] while reserving judgement on the Samuel
picture. When the Samuel painting was exhibited in
London in 1988 it was improbably assigned to Jan the
Younger. Ertz noted that a copy of the Samuel painting is
dated 1612 (fig. 4),[5] but incorrectly reported that the
Samuel picture was also dated in that year, while in fact it is
undated. Nonetheless 1612 is a plausible date for the
Samuel picture, which is surely not a copy (several promi-
nent pentimenti appear in the foreground; see Condition
notes) and which could reasonably be regarded as an
autograph variant of the earlier treatments of the theme.

Ertz assumed, probably correctly, that the painting is the
pendant to the *River Landscape* also dated 1612 of similar
dimensions in the Samuel collection (Cat. 8), which
likewise descended from the collection of Major Hugh
Rose. However, it must be noted that we have no earlier
provenance for the paintings, let alone proof that the artist
himself regarded the paintings as pendants. Latter day
collectors often paired even disparate works by the artist
and his followers (see Cats. 10 and 11). Nonetheless, the
two paintings complement one another in viewpoint, style,
and thematic details – the contrasting realms of river and
overland travel –– and even such details as the man helping
a woman down from a wagon or handing the infant into the
boat.

1 See Ertz 1979, cat. 92, fig. 34; a copy of this painting is in the
 Kunsthistorisches Museum, Vienna, no. 915.
2 Ertz 1979, cat. 113, fig. 35.
3 Ertz 1979, p. 233.
4 Ertz 1979, cat. 117, fig. 303.
5 Ertz 1979, note 274, as in New York Private Collection. The
 copy is probably identical with the picture that was in the
 Leuchtenberg Collection, Munich, cat. 1852, no. 107 [as P.
 Bruegel the Elder], and later appeared in the Hermitage in St
 Petersburg, cat. 1885, no. 113 [as Jan Brueghel]. A copy (canvas
 75 × 128 cm.) that was a variant of only the right hand side of
 the Minneapolis and Samuel paintings was in a sale Berlin, 12
 March 1935, no. 155.

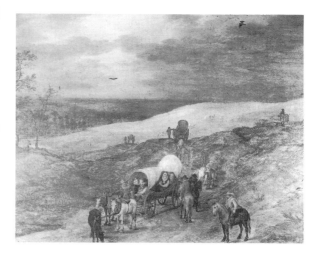

FIG. 1 Jan Brueghel the Elder, *Halt on the Way*, signed and dated
1603, oil on panel 33 × 43 cm., Prado, Madrid, inv. no. 1433.

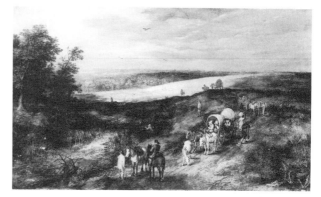

FIG. 2 Jan Brueghel the Elder, *Halt on the Way with Hunters*,
signed and dated 1605, oil on panel 42 × 71 cm., Gemäldegalerie,
Dresden, inv. no. 881.

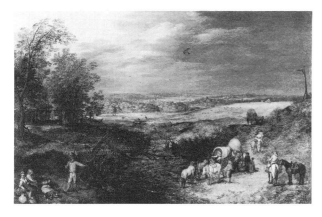

FIG. 3 Jan Brueghel the Elder, *Halt on the Way in a Broad Land-scape*, unsigned, oil on panel 36.5 × 56.2 cm., The Minneapolis Institute of Arts, Minneapolis, inv. no. 59.31.

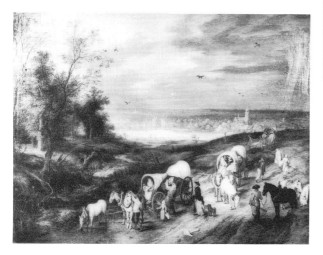

FIG. 4 Copy of Cat. 9, signed and dated 1612, panel 18 × 28 cm., Private Collection, New York, 1979.

CAT. 10

Village Landscape with Figures Preparing to Depart, 1613 or 1617

Signed and dated indistinctly in the lower left at the foot of the tree: BRVEGHEL [1]61(3 or 7)
Oil on copper 8⅞ × 11⅞ in. (22.4 × 30.1 cm.)

PROVENANCE: (Possibly though improbably) M. Coupry-Dupré and the two citations hereafter; J. B. P. Lebrun, Paris; Prince Auguste of Arenberg, Brussels; (certainly) the Duke of Arenberg; acquired from the Arenberg Collection by Edward Speelman and sold in 1956 to Samuel.

EXHIBITION: London 1988, no. 8.

LITERATURE: (Possibly) *Catalogue et description des tableaux qui forment la collection de S.A.S. le Prince Auguste d'Arenberg* (Brussels, 1833), p. 5, no. 12; E. Michel, *Les Brueghels* (Paris, 1892), ill. (reversed) in wood engraving p. 83 [as *Vue des Environs de Bruxelles*]; Ertz 1979, p. 216, no. 307, fig. 263; Speelman 1988, p. 14; Russell 1988, p. 789.

CONDITION NOTES: The copper support is in good condition and in plane. Minor paint losses along the edges have been retouched as well as a tiny scratch in the head of the small child. There is a minor repentir in the roof top of the building in the centre left. Although there is little general abrasion, the area around the signature and date has been rubbed. The edges also have been rubbed by the frame. The varnish is clear.

On the edge of a village with tall slender trees, figures gather on a road beside an inn. In the left foreground a covered wagon is being prepared for a group of four elegant ladies dressed in yellow, red, blue and green, one of whom ascends into the wagon, and a small child. A man in the lower left is busy with the team of horses. Farther back on the left, in front of the stable, two other women sit with a

child beneath a tree while talking to a standing man. On the right a drover herds seven cows along a road that curves back around a stand of trees in the centre right. In the middle distance on the left, a group of travellers quench their thirst at a tavern while two other women sit by the roadside. In the centre distance are other buildings and in the lighter prospect on the horizon the steeple of a village church.

The date on the painting has been abraded, but can be read as either 1613 or 1617. Thus it postdates a picture in Kassel of 1609 of a group of elegant figures on a village road, including a similar group of elegant ladies with a child and a covered coach in the foreground (fig. 2).[1] Jan Brueghel had begun painting village landscapes by 1597, the date on the *Entry to the Village* also in the Museum in Kassel (fig. 1).[2] By the time he painted the *Rest at the Inn (with the Flight into Egypt)* dated 1607 formerly in the Alte Pinakothek, Munich, and last recorded with Hallsborough Ltd, London (fig. 3), Brueghel had moved his point of view closer to the village and developed a more sophisticated treatment of space, although he still cleaved to the time-honoured Flemish landscape tradition (traceable to its earliest pioneers such as Joachim Patinir) of including in his villages a biblical reference to the Flight into Egypt, with Joseph and Mary searching for shelter in Bethlehem.[3] The tradition of the village landscape can be traced from Pieter Bruegel the Elder via the unpretentious little prints and drawings of the 'Master of the Small Landscapes' to Jan Brueghel the Elder, who in turn helped establish the theme of the halt by the inn that became so popular among seventeenth-century Dutch landscape painters such as Esaias van de Velde, Jan van Goyen and Salomon van Ruysdael (qq.v.).

Ertz noted that there is a drawing related to the Samuel painting in the printroom in Leipzig (fig. 4), which he correctly assumed was probably a preparatory study.[4]

The painting was highly regarded in the nineteenth century when E. Michel illustrated it, wrongly identifying the imaginary site as located in the vicinity of Brussels.[5] According to Speelman's records, this painting together with a putative pendant (see Cat. 11), came from the Arenberg collection in the 1950s, which by then was in the south of France. The 1833 catalogue of the collection of Prince Auguste d'Arenberg included two paintings by Jan Brueghel which were acquired from the dealer/expert, J. B. P. Lebrun (indicated in the 1833 catalogue by two asterisks) and which roughly correspond to the dimensions of this painting and its presumed pendant (see Cat. 11). However, the Samuel paintings do not conform in all

details to the catalogue description, which mentions boats on a canal in the distance of one of the pendants.[6] These two paintings apparently were no longer owned by Prince Prosper of Arenberg in 1859 when Thoré-Bürger catalogued the collection.[7] The two paintings owned by Lord Samuel are close but not identical in dimensions, nor are they obviously complementary in design. Most important, they are surely by two different hands; the putative companion can only be by a follower of Brueghel. In all likelihood the 'pendants' were united not by the artist but by a later collector.

1 Not in Ertz 1979; Kassel cat. 1929, no. 54; see Y. Thiery, *Le Paysage Flamand au XVIIe siècle* (Brussels, 1953), p. 176, fig. 44.
2 Not in Ertz 1979; Kassel cat. 1929, no. 49; colour repr. in M. Eemans, *Breughel de Velours* (Brussels, 1964), p. 7. A copy dated 1600 is in the Louvre, Paris, no. M.I. 909. Compare also the autograph painting of a *Village Landscape with Mill*, dated 160(3) in the Knecht Collection, Zurich; Ertz 1979, cat. no. 93, fig. 29.
3 Munich, inv. no. 1894; sale Lord Carew *et al.*, London (Sotheby's) 6 June 1957, no. 82; Ertz 1979, cat. no. 155, fig. 259. See also the similar treatment of this biblical subject in the painting dated 160(5?) in a Dutch private collection; Ertz 1979, cat. no. 116, fig. 258.
4 Ertz 1979, p. 216, note 247, fig. 264.
5 E. Michel, *Les Brueghels* (Paris, 1892), ill. p. 83.
6 *Catalogue et description des tableaux qui forment la collection de S.A.S. le Prince Auguste d'Arenberg* (Brussels, 1833), p. 5. no. 11: 'Point de vue dans la Flandre, des hommes à Cheval, des voitures chargées des femmes, des infans (sic), etc. remplissent le premier plan et se perdent au loin. On voit plusiers bateaux sur un canal borde (sic) de plantation', copper 8½ × 12 'pouces'; and no. 12: 'Autre point de vue Flamand, peint pour former le pendant en premier. Ces deux tableaux sortent du cabinet de M. Coupry-Dupré.'
7 W. Thoré-Bürger, *Galerie d'Arenberg à Bruxelles* (Paris/Brussels, 1859). The only work by Jan Brueghel mentioned was a *Forest Interior*, copper 19 × 27.5 cm., with no further description (p. 162, no. 79).

FIG. 1 Jan Brueghel the Elder, *Entry to the Village with a Mill*, signed and dated 1597, oil on copper 28.6 × 36.5 cm., Staatliche Kunstsammlungen, Gemäldegalerie Alte Meister, Kassel, no. 49.

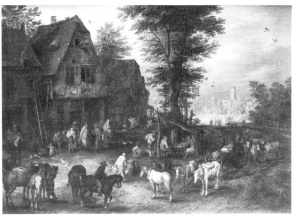

FIG. 3 Jan Brueghel the Elder, *Rest at the Inn (with the Flight into Egypt)*, signed and dated 1607, oil on copper 22 × 32 cm., with William Hallsborough Ltd, picture dealers, London, 1958.

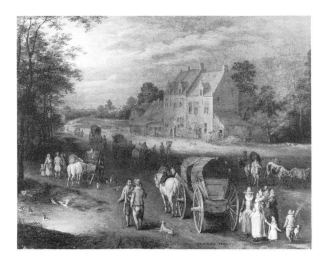

FIG. 2 Jan Brueghel the Elder, *Village Landscape*, signed and dated 1609, oil on canvas 16 × 22 cm., Staatliche Kunstsammlungen, Gemäldegalerie Alte Meister, Kassel, no. 54.

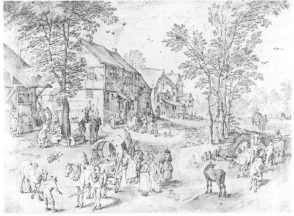

FIG. 4 Jan Brueghel the Elder, *Village Landscape*, pen and brown ink with grey wash on paper 226 × 327 mm., Museum der bildenden Künste, Leipzig, inv. no. NI.465a.

CAT. 11 Jan Brueghel the Elder (follower of)

The Road to the Market

Unsigned
Oil on copper 9½ × 12⅛ in. (24.1 × 31.4 cm.)

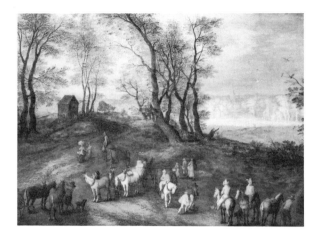

PROVENANCE: (Possibly though improbably) M. Coupry-Dupré and the two citations hereafter; J. B. P. Lebrun, Paris; Prince Auguste of Arenberg, Brussels; the Duke of Arenberg, Brussels; acquired from the Arenberg Collection by Edward Speelman in 1956 and sold to Lord Samuel.

EXHIBITION: London 1988, no. 9 [as Jan Brueghel, the Younger].

LITERATURE: (possibly) *Catalogue et description qui forment la collection de S.A.S. le Prince Auguste d'Arenberg* (Brussels, 1833), p. 5, no. 11; Russell 1988, p. 789 [as Jan Brueghel the Younger].

CONDITION NOTES: The copper support has been bent in the lower right corner and is out of plane along all the edges, probably as a result of careless framing in the past. There are resulting losses in the paint film and retouchings on all edges and extensively in the sky. The varnish layer is relatively clear but uneven and particularly pronounced along the edges, suggesting that the painting was once cleaned in its frame. Two inventory numbers appear on stickers on the reverse: 'No. 197', and 'Brueghel 1[9?]67'.

A track travelled by horsemen, carts and peasants on foot ascends a rise covered by tall slender trees. In the lower right, three riders on two dappled grey and one brown horse wait as one of the horsemen dismounts to relieve himself. To the left two pedestrians loaded with goods for the market step out of the way of a cart. Farther to the left another horse-drawn cart has stopped in the middle of the road while the horses of another appear in the lower left. A fourth wagon and other figures make their way up the hill. On the crest of the hill is a small wayside chapel with a figure kneeling in prayer. On the far side of the rise a covered wagon and other travellers are just beginning to descend toward the turn visible through a clearing in the lighted distance on the right.

Although Ertz did not mention this painting, he discussed the origins and development of its composition in Jan Brueghel the Elder's art.[1] A similarly conceived painting (fig. 1) with marketers on a road with slender silhouetted trees and a chapel was in the Wachtmeister Collection, Wanås, Sweden; it is signed and dated in an unusual fashion 'I. BRVEGHEL 1607'.[2] Ertz questioned the attribution of the Wachtmeister painting to Jan the Elder but allowed that the design was certainly conceived by the artist because it is documented in a drawing in Brussels from the de Grez Collection (fig. 2).[3] He believed that the idea for this particularly compositional variant of one of Jan's favoured designs probably originated about 1610, which is to say in the same period as the *Country Road with Travellers* dated that year (Alte Pinakothek, Munich, inv. 821) which also employs a wooded hillside rising from right to left and juxtaposed with a distant prospect of a village.[4] If the Wachtmeister painting is not autograph, then Ertz would posit a lost original.

Several other variations on the composition are known, including a poorly preserved painting in the Wellington Museum, Apsley House,[5] a tiny painting owned in 1979 by the dealer David Koetser, Zurich,[6] and a larger painting on copper that was said to be signed and dated 1606 when it appeared in Sotheby's sales in London in 1966 and 1979 but which is rejected by Ertz.[7] The attribution of the Samuel painting to Jan the Elder also seems unlikely. The treatment of the landscape forms, wispy trees and foliage does not have the master's resolve, the figures are not so well formed and the colours are more muted than in autograph paintings.

The possibility should be considered that the little chapel with the worshipper in this painting functions symbolically. Roadside chapels often appear in Brueghel's landscapes as well as in contemporary paintings by Joos de Momper and later works by Esaias van de Velde and Jan van Goyen. The chapel's appearance in landscapes with roads by the last mentioned have been discussed by Hans Joachim Raupp as a symbolic allusion to 'the pilgrimage of life',[8] a traditional landscape theme that can be traced back to origins in the work of Joachim Patinir.[9]

The painting comes from the Arenberg collection and may be identical with a picture that was in that collection in 1833 but its cursory description and that of its putative

pendant, Cat. 10 (see its commentary and footnote 6) do not conform in all details. Moreover the two works are clearly not by the same hand and differ minutely but significantly in dimensions.

1 Ertz 1979, pp. 146–8.
2 Ertz 1979, cat. 152, fig. 151.
3 Ertz 1979, p. 146, note 131, fig. 152.
4 See Ertz 1979, p. 146, cat. 216, fig. 18.
5 Oil on copper 20.3 × 31.7 cm., Apsley House, inv. no. N.M. 1640-1948; Ertz 1979, cat. 224, fig. 153.
6 Signed, copper 9.5 × 13 cm.; Ertz 1979, cat. 223, fig. 150.
7 Signed and dated 'BRVEGHEL 1607'; oil on copper 28 × 42 cm., provenance: Lady Beamach; Lord Swansea; sale London (Sotheby's), 6 July 1966, no. 22, ill.; sale London (Sotheby's), 11 July 1979, no. 15, ill.; Ertz 1979, pp. 146–8, note 131a. Still another version of the Samuel painting's design (panel 24 × 31.5 cm.) was in the sale, Paris (Drouot), 19 December 1941, no. 3, as 'attributed to Jan Brueghel I', and a weak variant (panel 30.5 × 41.5 cm.) is in the Musée Curtius-Musée d'Ansembourg, Liège, inv. no. MX/2468, as 'Jan Brueghel I'.
8 See Hans Joachim Raupp, 'Zur Bedeutung von Thema und Symbol für die holländische Landschaftsmalerei des 17. Jahrhunderts', *Jahrbuch der Staatlichen Kunstsammlungen in Baden-Wurtemburg*, vol. 17 (1980), pp. 102–4; for discussion see Peter C. Sutton, *Northern European Paintings in the Philadelphia Museum of Art* (Philadelphia, 1990), pp. 112–13; idem, Amsterdam/Boston/Philadelphia 1987–8, p. 13.
9 See R. L. Falkenburg, 'Joachim Patinir: Het Landschap als beeld van de Levenspelgrimage', dissertation, University of Amsterdam, 1985.

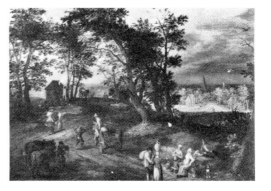

FIG. 1 Attributed to Jan Brueghel the Elder, *Road to the Market*, signed and dated 1607, oil on copper 21 × 32.5 cm., Wachtmeister Collection, Wanas, Sweden (RKD photo L43288).

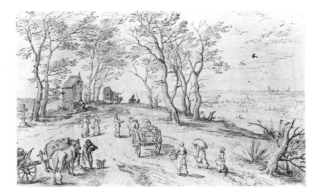

FIG. 2 Jan Brueghel the Elder, *Road to the Market*, drawing, Royal Museum of Fine Arts, Brussels (de Grez Collection).

JAN VAN DE CAPPELLE

(AMSTERDAM 1626–1679 AMSTERDAM)

Baptized in Amsterdam on 25 January 1626, Jan van de Cappelle was the son of Franchoys van de Cappelle (1592–1674), the owner of a successful dye-works called 'de gecroonde handt', and Anneken Mariens. Jan carried on the family business and is mentioned in documents as a carmosin-dyer, merchant and painter. On 2 February 1653, he married Anna Grootingh; he inherited two houses from his wife's family. Until 1663 he lived on the Keizersgracht among the richest citizens of Amsterdam. Thereafter he lived on the Koestraat in a house that he purchased for the large sum of 9,600 guilders. In June 1666 he was sick and made a will, but did not die until 22 December 1679. The inventory of his estate compiled the following year indicates that he had amassed not only a personal fortune (approximately fl. 92,000) but one of the largest art collections of the day, including 200 paintings and six thousand drawings. Among the many works by his contemporaries that he collected were large numbers of drawings by Hendrick Avercamp, Rembrandt, Jan van Goyen, Allart van Everdingen and Simon de Vlieger.

Van de Cappelle's teacher is not known and he may have been self-taught; a laudatory poem by the painter Gerbrand van den Eeckhout praises the art of van de Cappelle, 'who taught himself to paint out of his own desire'. The verses appear in the *Album Amicorum* of the Amsterdam poet and rector of the Gymnasium, Jacob Heyblocq (Koninklijk Bibliotheek, The Hague); other contributors to the album included leading scholars and literary figures, suggesting

that van de Cappelle moved in learned as well as wealthy circles. Although none of the works survive, Rembrandt, Frans Hals and Gerbrand van den Eeckhout all painted his portrait.

Van de Cappelle was a painter and draughtsman of seascapes, beach scenes and winter landscapes. He is best remembered for his calm views of ships at anchor in rivers or estuaries. Van de Cappelle owned sixteen paintings by Jan Porcellis, who like Simon de Vlieger probably influenced his marines. Van de Cappelle's winter and beach scenes are less numerous than his marines. Since few works are dated after 1653, his later development is difficult to trace. In addition to a small group of drawings, he made one etching.

LITERATURE: Abraham Bredius, 'De schilder Johannes van de Cappelle', *Oud-Holland*, vol. 10 (1892), pp. 26–40, 133–7; Wurzbach, vol. 1 (1906), pp. 242–3; E. W. Moes, in Thieme and Becker, vol. 5 (1911), p. 549; Hofstede de Groot, vol. 7 (1923), pp. 177–233; W. R. Valentiner, 'Jan van de Cappelle', *Art Quarterly*, vol. 4 (1941), pp. 272–96; Stechow 1966, pp. 95–8, 106–8, 116–21; Laurens J. Bol, *Die holländische Marinemalerei des 17. Jahrhunderts* (Braunschweig, 1973), pp. 218–28; Margarita A. Russell, *Jan van de Cappelle 1624/26–1679* (Leigh-on-Sea, 1975); Haak 1984, pp. 475–77; Amsterdam/Boston/Philadelphia 1987–88, pp. 285–7; Minneapolis, Minneapolis Institute of Arts, *Mirror of Empire, Dutch Marine Art in the Seventeenth Century* (cat. by George S. Keyes *et al.*) 23 September–31 December 1990, also shown at the Toledo Museum of Art, 27 January–21 April 1991, and the Los Angeles County Museum of Art, 23 May–11 August 1991.

CAT. 12

Winter Landscape

Signed lower left: I. V. Cappella
Oil on panel 14⅜× 19⅝ in. (36.5 × 49.7 cm.)

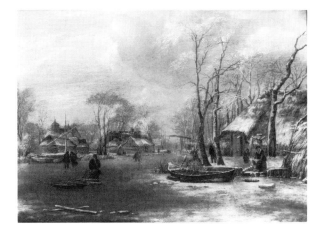

PROVENANCE: Captain P. Alexander, Co. Waterford; acquired from Edward Speelman in 1966.

EXHIBITION: London 1988, no. 13.

LITERATURE: Russell 1988, p. 789, fig. 69; Speelman 1988, p. 14.

CONDITION NOTES: The panel is in fragile condition with old insect damage spreading along an old horizontal crack 2¼ in. (5.7 cm.) down from the upper edge. Another crack 6⅛ in. (6.3 cm.) from the bottom edge has been mended with a button. The paint film is mildly abraded and has old flake losses in the lower right. Broad and prominent striations in the paint film, angling from lower left to upper right in the ice and reversed (from upper left to lower right) in the sky, seem to be an underpainting technique or perhaps an imprimatura in the ground layer. The varnish is moderately discoloured.

On a frozen river bordered by thatched cottages and bare trees, several figures move along the ice. In the left foreground an old man drags a sledge loaded with firewood. A woman with a basket and a child appear on the bank on the right where a boat is lodged in the ice before a cottage. Further back a man is seen between two trees. On the ice at the left two figures stop to converse. In the distance figures skate toward a drawbridge. While much of the scene is in the subdued hues of winter, a pink flush fills the sky in the upper left.

Probably totalling fewer than twenty and scarcely so numerous as his marines, van de Cappelle's winter scenes are admired for their painterly evocation of the moist atmosphere and subtle grey tones of the Dutch winter. As

Bredius first observed,[1] his interest in wintry atmosphere parallels that of his older colleague, Aert van der Neer, who curiously was not represented in van de Cappelle's extensive art collection. Yet while the figures are always conspicuous in van der Neer's paintings, they are subordinated to the winter landscape in van de Cappelle's art.

Only five of van de Cappelle's winter scenes are dated and all are from 1652 or 1653: the *Winter Landscape* formerly in the Beit Collection, now in a private collection, on loan to the Birmingham City Museums and Art Gallery, dated 1652 (fig. 1);[2] a *Winter Landscape*, signed and dated 1653, Mauritshuis, The Hague;[3] the *Winter Landscape*, signed and dated 1653, from the collection of Mrs Rudolf Heinemann, New York,[4] and the painting of 1653 in the Lugt Collection, Paris (fig. 2).[5] With the wide expanse of frozen river filling the foreground and the two tree-lined banks of the river weaving back to a central vanishing point, the design of the Samuel painting may be compared to both the Birmingham (ex-Beit) and Lugt Collection paintings (figs. 1 and 2).

Although it did not appear in her 1975 monograph on the artist, Russell first published and illustrated the painting in her review of the Samuel collection exhibition of 1988, characterizing it as 'an excellent example of the rare winter landscapes by Jan van de Cappelle, signed with the artist's characteristic signature. This hitherto unknown picture dates from c. 1652-54'.[6] She compared it not only to the ex-Beit painting but also to the winter scene in the Mauritshuis dated 1653.[7] Also similar in conception are the undated paintings in the Rijksmuseum, Amsterdam (no. A4043)[8] and the Assheton Bennett Collection in the Manchester City Art Gallery (no. 1979.453),[9] both of which include a bridge in the distance, and the painting in the Thyssen-Bornemisza Collection (fig. 3), which includes another old man with a sledge full of firewood as well as a drawbridge in the distance.[10] None of van de Cappelle's drawings of winter scenes, most of which also probably date from the early 1650s, seems to be directly related to this painting, but several share similar features of design.

1 See A. Bredius, *Oud-Holland*, vol. 10 (1892), p. 134.
2 Hofstede de Groot, vol. 7 (1923), nos. 176 and 151; Bode, *Beit Catalogue*, 1914, p.54; Russell 1975, p. 84, no. 151, pl. 22; see *Images of a Golden Age. Dutch Seventeenth-Century Paintings* (cat. by Christopher Wright), Birmingham City Museums and Art Gallery, 7 October 1989–14 January 1990, no. 117, colour pl. x.
3 Inv. no. 567; Russell 1975, p. 84, no. 148 (Russell's numbers correspond to those of Hofstede de Groot), pl. 24.
4 Russell 1975, p. 85, no. 157, pl. 25.

5 Russell 1975, no. 155, pl. 23; see Saskia Nihom-Nijstad, *Reflets du siècle d'or. Tableaux hollandais du dix-septième siècle* (Paris, 1983), cat. no. 19, pl. 28.

6 Russell 1988, p. 789, fig. 69.

7 Russell 1975, no. 24; see also Amsterdam/Boston/Philadelphia 1987–8, cat. no. 18.

8 Russell 1975, no. 160, pl. 26.

9 Russell 1975, no. 170, pl. 27; see F.G. Grossman, *Catalogue of the Paintings and Drawings from the Assheton Bennett Collection, Manchester City Art Gallery* (Manchester, 1965), no. 15, pl. xv.

10 Russell 1975, no. 158, fig. 29; Ivan Gaskell, *Seventeenth-Century Dutch and Flemish Painting, the Thyssen Bornemisza Collection,* (London 1990), no. 98, ill.

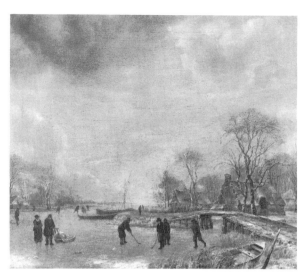

FIG. 2 Jan van de Cappelle, *Winter Landscape*, signed and dated 1653, oil on canvas 45.5 × 53.5 cm., Institut Neerlandais, Collection Frits Lugt, Fondation Custodia, Paris, cat. 19.

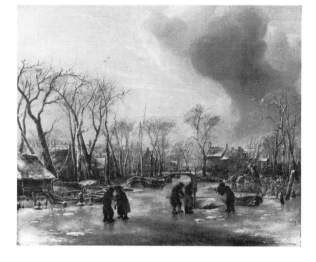

FIG. 1 Jan van de Cappelle, *Winter Landscape*, signed and dated 1652, oil on canvas 45 × 56 cm., Private Collection, on loan to the Birmingham City Museums and Art Gallery.

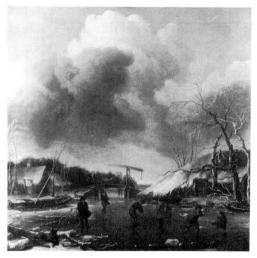

FIG. 3 Jan van de Cappelle, *Winter Landscape*, signed, oil on panel 41 × 42.2 cm. (cut down), Thyssen-Bornemisza Collection, Lugano, no. 1969.5.

CAT. 13 Jan van de Cappelle (follower of)

Ships at Anchor in a Calm

Oil on panel 29½ × 41⅞ in. (75.1 × 106.7 cm.)

PROVENANCE: Possibly sale D. de Jongh, Rotterdam, 26 March 1810, no. 17; Stuart Collection, Highcliffe (date?) (see sticker, Condition notes, below); Mrs. S. C. Weston, 1836 and 1864 (see exhs.); sale Mrs. F. Weston, London (Christie's) 21 October 1949, no. 20, to dealer C. Duits; with Duits, 1950 (see exh.); acquired from Edward Speelman in 1964.

EXHIBITIONS: London, British Institution, 1836, no. 42; 1864, no. 92; Rotterdam, Prins Hendrik Museum, *Van Vroom tot van de Velde*, 1950, no. 9 (lent by C. Duits); London 1988, no. 12.

LITERATURE: Hofstede de Groot, vol. 7 (1923), no. 140, and possibly no. 136f; Russell 1988, p. 789 ['seems to be a copy' and wrongly as on copper.].

CONDITION NOTES: The panel support is cradled and comprised of three pieces of wood with joins 10¼ in. (26 cm.) from the bottom and 9¼ in. (24.7 cm.) from the top. Channels have been cut in the back of the support and battens inserted to form the members of a cradle. The paint film is abraded, especially in the darks; the grey and brown passages in the water, for example, have become transparent. The sky reveals extensive retouching. The varnish is moderately discoloured. On the back is a sticker which reads 'Stuart Collection, Highcliffe', the number '825JM' in black stencil, and 'no. 11' in pencil.

Numerous small sailing vessels lie at anchor in a calm port. In the centre a barrel serving as a buoy appears before a long prospect between the boats. On the right is a galleon with passenger boat and on the left in the distance are the walls of the city. The horizon is low, less than one third the height of the design, and the sky is bright but overcast.

Van de Cappelle made a speciality of depicting vessels resting at anchor in the calm waters of a river or harbour.

In these horizontally disposed scenes he explored the limpid effects of the sea air and the pleasing order of the boats' masts and rigging silhouetted against the sky above a still horizon. A relatively large panel, this work employs a design with boats receding on either side of an open vista of water. The position and style at first seem consistent with autograph works in the master's œuvre; compare, for example, the composition of the monogrammed *Seaport in Calm Water* formerly in the collection of W. A. Hankey, Beaulieu, Hastings.[1] Moreover it was van de Cappelle's practice to re-use motifs in his marines which he presumably first recorded in preparatory drawings; the vessel with angled mast on the right of the Samuel marine reappears with alterations in a painting formerly in the W. P. Chrysler Collection.[2]

However, the painting's stiff and laboured execution is not that of van de Cappelle. The attribution to the artist was questioned on a photograph of the painting at the Rijksbureau voor Kunsthistorishe Documentatie[3] and in Russell's 1988 review of the Samuel Collection.[4] She believed it could be a copy but did not specify the original. Dated examples of van de Cappelle's calm harbours appear as early as 1649,[5] but it is not clear how much later this work, probably by a follower, might have been executed. It is conspicuously less subtle in execution than comparable large scale autograph works by van de Cappelle, such as the painting in the National Gallery, London (fig. 1).[6]

The Samuel painting may be identical with a painting of virtually identical dimensions but which was reported to be

FIG. 1 Jan van de Cappelle, *Ships in a Calm*, signed, oil on canvas, 112 × 154 cm., National Gallery, London, no. 4456.

on canvas that appeared in the De Jongh sale in Rotterdam in 1810.[7] A hitherto unrecorded addition to the painting's provenance is the 'Stuart Collection, Highcliffe' which appears on a sticker on the back.

1 Hofstede de Groot, vol. 7 (1923), no. 121.
2 Hofstede de Groot, vol. 7 (1923). no. 77a.
3 On the RKD's photograph the painting is only 'toegeschr'. (attributed)
4 Russell 1988, p. 789, 'seems to be a copy'.
5 See, for example, National Museum, Stockholm, no. 562; Hofstede de Groot vol. 7 (1923), no. 70.
6 Signed J. V. Cappelle, oil on canvas, 112 × 154 cm.; Russell 1975 p. 89, addenda no. 1, fig. 5a.
7 See Hofstede de Groot, vol. 7 (1923), no. 136f: *A River Scene with a Market-Vessel in Front*. Some men in a boat approach the vessel. There are other ships. An attractive distance, skillfully painted. Canvas 29½ × 41½ in.

PIETER CLAESZ

(STEINFURT 1597/98–1661 HAARLEM)

Little is known about the artist's life. According to a document dated 21 May 1617, which states that the artist was forty-three years old, Pieter Claesz was born in Steinfurt, Westphalia, in 1597 or 1598. He married Geertje Hendricksdr in Haarlem on 21 May 1617, when he was living on the Spaarne. Claesz was the father of the Dutch Italianate landscape painter Claes Pietersz Berchem (1620–83). He was buried in the Nieuwe Kerk in Haarlem on 1 January 1661.

Claesz was a still-life painter who specialized in the tabletop still lifes known as *ontbijtjes* or *banketjes* but also painted *vanitas* and fish still lifes. Houbraken claimed that Claesz first painted still lifes, and later small paintings of a table with various sweets, and often a silver bowl and porcelain dish. Dated paintings are known from 1621 (formerly E. C. Francis, England) to 1660. Indeed, Claesz dated so many works that his development can be readily traced. His early 'breakfast' still lifes follow in the local Haarlem tradition of Floris van Dyck, Nicolaes Gillis, and Floris van Schooten (q.v.). In the late 1620s, together with Willem Claesz Heda (1593/4–1680/2), he broke with the earlier tradition, that had featured additively composed designs with many objects observed from a high point of view, and reduced the number of motifs, lowered the point of view and adopted a more unified, 'monochrome' overall tonality. The works of Heda and Claesz have a superficial resemblance, but the latter's touch tends to be broader and his tonality warmer. Clara Peeters' art can also be confused with Claesz's, especially because she employed a similar monogram with the same initials. Johannes Cuvenes the Elder (c. 1620–c. 1656), Maerten Boelema, called 'de Stomme' (1611-after 1664), Roelof Koets, (c. 1592/9–1655), Franchoys Elout (died before 1641), and Adriaen Kraen (active c. 1645) were all close followers of Claesz.

LITERATURE: Houbraken 1718-21, vol. 2, pp. 110–11; Wilhelm Bode, *Studien zur Geschichte der holländischen Malerei* (Braunschweig, 1883), pp. 224–7; *Zeitschrift für bildenden kunst*, vol. 18 (1883), pp. 167–8; Wurzbach 1906–11, vol. 1 (1906), p. 285; E. W. Moes, in Thieme and Becker, vol. 7 (1912), p. 38; N. R. A. Vroom, *De Schilders van het monochrome banketje* (Amsterdam, 1945 (expanded and republished as, *A Modest Message as Intimated by the Painters of the 'Monochrome Banketje'*, 2 vols. (Schiedam, 1980)); Ingvar Bergström, *Dutch Still-Life Painting in the Seventeenth Century* (London, 1956, Reprint New York, 1983, pp. 114–23); M. Brunner-Bulst, *Pieter Claesz. Der Hauptmeister des Haarlemer Stillebens im 17. Jahrhundert* (Freren, forthcoming).

CAT. 14

Breakfast Still Life with Roemer, Meat Pie, Lemon and Bread, 1640

Monogrammed and dated
to the left of the roemer:

Oil on panel 21⅛ × 25⅛ in. (53.5 × 63.7 cm.); with additions 21⅝ × 25⅝ in. (55.2 × 65.2 cm.).

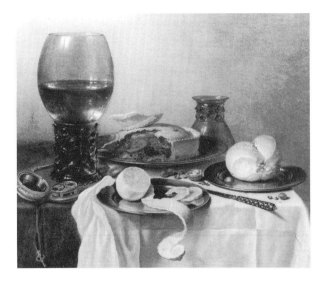

PROVENANCE: Dealer G. Stein, Paris, before 1937; sale London (Sotheby's), 1 December 1937, no. 171; Private Collection, Stockholm, 1937; with dealer Rob Noortman; acquired from Edward Speelman in 1966.

EXHIBITION: London 1988, no. 14, ill. p. 10.

LITERATURE: N. R. A. Vroom, *De Schilders van het monochrome banketje* (Amsterdam, 1945), no. 45; N. R. A. Vroom, *A Modest Message* (Schiedam, 1980), vol. 1, p. 153, fig. 204, vol. 2, cat. (Claesz) no. 95, cat. (F. Elout) no. 240; Russell 1988, p. 789.

CONDITION NOTES: The panel support has been thinned and cradled. Wood additions, approximately ¼ in. (5 mm.) wide, have been added to all sides, with the grain running against that of the original panel on the vertical edges. The support is comprised of two planks of wood joined horizontally 10 in. (25 cm.) from the top edge. Also there is a split in the panel 7½ in. (19.2 cm.) from the bottom edge. The paint film is extensively retouched in the background, especially around the glass and in the upper left. There is also retouching in the shadows of the pie, around the watch and its cover, along the horizontal join, and in the lower right corner. The '4' and 'o' of the date seem to have been strengthened, but the monogram, though abraded, is not repainted. The varnish is moderately discoloured and uneven, especially in the upper right.

On a table partially covered with creased white linen, a light meal is arranged parallel to the picture plane. A roemer of wine stands on the left beside an open watch. In the centre is a partially peeled lemon, its rind helixing down, and a meat pie, both on pewter plates. On the right is a bread roll on a plate and behind it a glass upturned on the table. Tawny browns and slate greys dominate the colour scheme.

Throughout its history and when Vroom discussed the work in 1945 the painting's attribution to Pieter Claesz has been upheld, but in 1980 Vroom opened the possibility that it could be by either Franchoys Elout or Pieter Claesz.[1] Franchoys Elout remains a shadowy figure, but he painted at least two tabletop still lifes with a wine glass and a lemon, both of which are monogrammed 'FE'.[2] Vroom extrapolated from these few certain works to posit an œuvre of more than twenty pictures, many of which appear only remotely connected to the core pictures. On the other hand, the Samuel painting very closely resembles another still life by Claesz with wine glass, meat pie and peeling lemon that was said to be monogrammed and dated 1637 when it was sold in Brussels in 1951 (fig. 1).[3] A still earlier work by Claesz which may be compared is a still life formerly in the Düsseldorf Museum (stolen in 1946) which featured a roemer of wine, a peeled lemon on a platter and a watch similar to the one in the present painting.[4] Confusing matters further, some paintings with similar compositions have been attributed by Vroom to the Claesz follower, Adriaen Kraen (active 1642–died Haarlem 1702),[5] but the latter's work is surely too laboured in technique to have created the Samuel painting.

Martina Brunner-Bulst, who is preparing a monograph with catalogue raisonné of Pieter Claesz's work, personally examined the Samuel painting in September 1990, and has generously shared her observations (private communication 19 March 1991) with the author. She too rejects the painting's attribution to Franchoys Elout and regards the monumentality of the work as typical of Claesz's work around the 1640s. She further notes that the complicated monogram (which ligates 'P', 'C' and 'H' vertically) appears on three other paintings of around 1640.[6] Since Claesz was regularly referred to in contemporary archival documents as 'Pieter Claesz van Haarlem' the ligated signature could readily be interpreted as such or, in Latin, 'Pieter Claesz Haarlemensis'. Brunner-Bulst also noted the evidence of past restoration to the Samuel painting and questioned

whether the signature might not have been altered, although there is no obvious evidence of tampering (see Condition notes). She also drew our attention to an additional comparison, a composition dated 1641, similar in colour and execution offering a horizontal view of a table-top with roemer (to the right of centre), meat pie, bread roll on a platter, and overturned glass (Private Collection).[7]

Whether the watch here functions as a symbol of temperantia and an admonition against excess is unclear.[8]

1 Vroom 1980, vol. 2 no. 95 (as Claesz), no. 240 (as Elout).
2 See the painting dated 1627 formerly with the dealer D. Koetser, Geneva (Vroom 1980, vol. 2, cat. 225, vol. 1, fig. 206) and the undated work in the Stedelijk Museum 'de Lakenhal', Leiden (Vroom 1980, cat. no. 228, fig. 196).
3 Not in Vroom 1980.
4 See Ingvar Bergström, 'Jan Olis as a Still Life Painter', *Oud-Holland*, vol. 66 (1951), p. 57, fig. 2.
5 See Vroom 1980, vol. 2, cat. 426, ill., monogrammed PC and dated 1637, present location unknown (ex-Stumpf Collection, Berlin); see also the tabletop still life attributed to Kraen by Vroom but illustrated as Claesz in Apollo, vol. 107 (May 1978), p. 127, adv. for C. Bednarczyk, Vienna.
6 *Still Life with Golden 'Pokal' and Glassware*, monogrammed and dated 1640, panel 56 × 41.2 cm., Private Collection (formerly G. Guterman, Bedford Hills, New York); *Still Life with Rummer, Tazza and 'Schinken'*, monogrammed and dated 1640, panel 73.5 × 99 cm., formerly de Stuers Collection, present location unknown; and *Still Life with Rummer and Crayfish*, monogrammed and dated 1642, panel 69 × 55 cm., Hofje van Aerden, Leerdam.
7 Panel 41.5 × 57 cm.
8 On the watch's potential temperantia symbolism, see Bergstrom 1956, pp. 189–90.

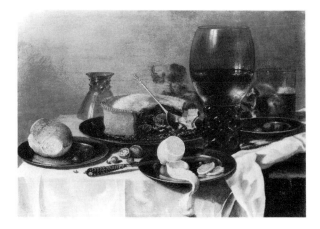

FIG. 1 Pieter Claesz, *Tabletop Still Life*, monogrammed and dated 1637, oil on panel 47.5 × 67.5 cm., sale Brussels (Palais des Beaux-Arts), 22/23 October 1951, no. 83, with ill.

CAT. 15

Still Life with Jug, Herring and Smoking Requisites, 1644

Indistinctly monogrammed and dated on the table edge, lower left: P 1644 Oil on panel 17¾ × 26¼ in. (45 × 65.5 cm.)

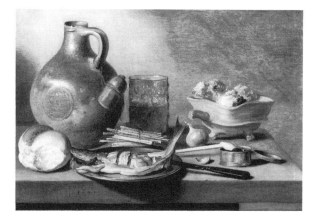

PROVENANCE: Van Hasselt, Arnhem; sale Neville D. Goldsmid, Paris, 4 May 1876, no. 45 [as Frans Hals the Younger, 155 frs.]; Royal Cabinet of Paintings, Mauritshuis, no. 403, sold in 1961 to Sam Nijstad; acquired from Edward Speelman in 1961.

EXHIBITION: London 1988, no. 15.

LITERATURE: Wilhelm Bode, *Studien zur Geschichte der holländische Malerei* (Braunschweig, 1883), p. 226; Wurzbach vol. 1 (1906), p. 285 [as dated 1641]; Mauritshuis, The Hague, *Catalogue Raisonné du Musée Royal de Tableaux*, 2nd ed. (The Hague, 1914), pp. 47–8, no. 403; 3rd ed. (The Hague, 1935), p. 50, no. 403; Hanna Blumenthal, 'Das holländische Stilleben', dissertation, Breslau, 1923, p. 28; Rolph Grosse, *Niederländische Malerei des 17. Jahrhunderts* (Berlin, 1936), pl. 59; Vroom 1945, p. 200, no. 54; Robert Genaille, *Dictionnaire des peintres flamands et hollandais* (Paris, 1967), p. 50; Paris, Musée du Petit Palais, *Le Siècle de Rembrandt*, 17 November 1970–15 February 1971, p. 38; Walter Bernt, *Die niederländische Maler des 17 Jahrhunderts*, vol. 1 (Munich, 1979), no. 249, ill.; Vroom 1980, vol. 1 p. 32, fig. 33, vol. 2, cat. no. 113; Russell 1988, p. 789; Speelman 1988, p. 14; Woodhouse 1988, p. 126, incorrectly as fig. 3.

CONDITION NOTES: The panel support is comprised of two planks with a join 8 in. (20.5 cm.) from the top. Battens have been attached to the back of the panel running along the seam. The support appears to be complete with all edges bevelled on the back. The paint film has been abraded and retouched, especially in the background, to obscure the grain of the wood that has become visible and to disguise the join. The shadows under the herring and beneath the brazier have also been strengthened. Old losses along the lower edge have been retouched. The varnish is clear.

Food, drink and smoking requisites are distributed on a simple stone tabletop. Arranged from left to right and alternating front and back are a bread roll, a stoneware jug, a pewter plate with a sliced herring, a glass of beer, an onion, a brazier with hot coals, a pipe resting on an open tobacco-box and a knife propped on the plate. The jug is decorated with a round seal and its stopper is attached to the handle by a string. A bundle of zwavelstokjes, the predecessors of matches, rests behind the plate. The overall palette is subdued and the background is loosely brushed in neutral tones of brown.

When this painting sold in Paris in the Goldsmid sale in 1879 it was attributed improbably to 'Frans Hals le Jeune' (Frans Hals the Younger), about whose art little is known with certainty, and the panel carried that artist's putative signature. The painting was acquired at the sale by the agents of the Dutch Royal Picture Gallery at the Mauritshuis, whose conservators removed the overpaint that obscured the monogram of Pieter Claesz. The monogram and date 1644 published in facsimile in the Mauritshuis' catalogues of 1914 and 1935 correspond to those now appearing on the painting. The painting was de-accessioned by the Mauritshuis in 1961 and found its way into the Samuel collection via the dealers Sam Nijstad and Edward Speelman.

Claesz frequently painted tabletops laden with simple meals and smoking supplies after about 1624.[1] During the later 1620s and 1630s he simplified these compositions, reducing the numbers and elegance of the objects and minimizing their intensity of hue and local colour with an overall 'monochrome' palette. In the early 1640s his palette took on a more amber cast, just as van Goyen's landscapes would in these years, and his touch became broader. The Samuel painting is typical of these stylistic developments and closely resembles other works from the mid-1640s in subject, design and execution.

A painting in the Museum in Nantes, also dated 1644 (fig. 1), depicts virtually all the same objects in a composition that freely reverses the Samuel picture's design on a tabletop now covered with a cloth and napkin.[2] The round earthenware jug is virtually the same, although the stopper differs slightly. A similar jug, brazier and smoking supplies also appear in a painting dated 1646 in Prague (fig. 2).[3] Martina Brunner-Bulst has drawn the author's attention to two other comparable paintings by Claesz, which include this type of 'Bartmann-krug', the painting dated 1644 in Aachen (fig. 3) and a painting (of unknown dimensions) in a Belgian private collection with an upright design which is signed and dated 1646.[4] Although the

Samuel painting is not in as good state as these comparable paintings, having been abraded and overpainted, it is nonetheless probably autograph. Brunner-Bulst speculated that it might have been painted by Claesz at the end of 1644, since the artist's paintings of 1645 are generally less carefully executed.[5]

1 See the paintings dated 1624 in the Rijksdienst Beeldende Kunst, The Hague, no. 2451, and formerly on loan to the Rijksmuseum, Amsterdam, (Vroom 1980, vol. 1, figs. 13 and 14, vol. 2, cats. 43 and 44).
2 See Nantes cat. 1953, no. 516; Paris, Petit Palais, *Le Siècle de Rembrandt. Tableaux hollandais des collections publiques françaises*, 1971, cat. no. 37, ill.
3 Vroom 1980, vol. 1, p. 31, fig. 28, vol. 2, cat. no. 127; see also Jaromir Šíp, *Les Peintres hollandais à la Galerie Nationale de Prague* (Prague, 1961), no. 37, ill.
4 Letter March 19, 1991. The former is Vroom 1980, vol. 2, no. 115, the latter is unpublished.
5 Ibid.

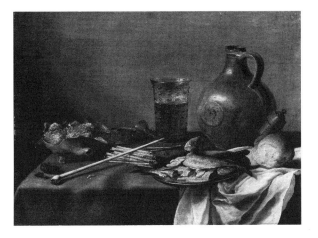

FIG. 1 Pieter Claesz, *Still Life with Jug, Herring and Smoking Supplies*, 1644, monogrammed and dated on the right, oil on panel 59 × 82 cm., Musée des Beaux-Arts, Nantes, inv. 516.

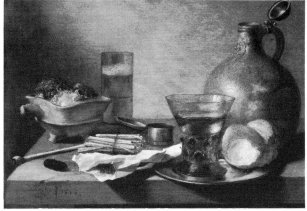

FIG. 2 Pieter Claesz, *Still Life with Jug, Wine Glass and Smoking Supplies*, 1646, monogrammed and dated, oil on panel 39.5 × 60.5 cm., Národní Galerie, Prague, no. 0.1409.

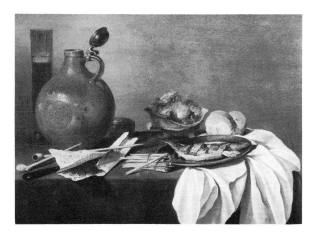

FIG. 3 Pieter Claesz, *Still Life with Jug, Herring and Smoking Supplies*, monogrammed and dated 1644, oil on panel 60 × 83 cm., Suermondt-Ludwig-Museum, Aachen, inv. no. 115.

AELBERT CUYP

(DORDRECHT 1620–1691 DORDRECHT)

Aelbert Cuyp was baptized in the Reformed Church in Dordrecht in October 1620. He was the son of Aertken van Cooten of Utrecht, and Jacob Gerritsz Cuyp (1594–1652), the history, portrait and genre painter; his uncle, Benjamin Cuyp (1612–50), was a history and genre painter in Rembrandt's circle. Aelbert first studied with his father, and the two collaborated on several paintings in 1641 and through the mid-1640s. His earliest dated paintings are of 1639, and by 1641 (see Cat. 16) he was working in a tonal landscape style derived from Jan van Goyen and Salomon van Ruysdael (qq.v.). Later Cuyp came under the influence of the Utrecht landscapists Herman Saftleven, Jan Both and Jan Asselijn. Around 1642 he made a sketching tour of Dutch cities, and in 1651 or 1652 journeyed up the Rhine, visiting Nijmegen, Emmerich, Elten and Kleves. Returning to his native Dordrecht, he enjoyed the patronage of the city's leading families, such as Pompe van Meerdervoort, van Beyeren, de Rouvere and Berck. In the 1650s he painted large-scale Italianate landscapes as well as equestrian portraits in landscapes. Cuyp's marriage in July 1658 to Cornelia Boschman, the widow of a wealthy regent, raised his social and financial standing. He became deacon and elder of the Reformed Church, a regent of a major charity, and a member of the Tribunal of South Holland. At his death in 1691 he was one of the wealthiest citizens of Dordrecht.

There is no evidence that Cuyp painted after about 1660. His work seems to have been little known outside Dordrecht until the eighteenth century, when he soon became one of the most sought-after Dutch landscapists among collectors. In addition to landscapes he painted portraits and a few interior scenes. His landscape drawings were sometimes completed with watercolour. The paintings of Cuyp's follower, Abraham van Calraet (1642–1722) can come close to his style, and those of the eighteenth-century imitator, Abraham van Strij have also been confused with Cuyp's autograph works.

LITERATURE: Mattys van Balen, *Beschryvinge der stad Dordrecht* (Dordrecht, 1677), pp. 186, 909; Houbraken, vol. 1 (1718), p. 248; van Eynden, van der Willigen 1816–40, vol. 1, pp. 382–9; Smith, vol. 5 (1834) and *Suppl.* (1842); G. H. Veth, 'Aelbert Cuyp, Jacob Gerritsz Cuyp en Benjamin Cuyp', *Oud-Holland*, vol. 2 (1884), pp. 30–282; Wilhelm von Bode, 'Das Geburtsjahr der Maler Albert Cuyp und Ferdinand Bol', *Repertorium für Kunstwissenschaft*, vol. 8 (1885), p. 136; G. H. Veth, 'Aanteekeningen omtrent eenige Dordrechtsche schilders', *Oud-Holland*, vol. 6 (1888) pp. 142–8; Emile Michel, 'Une famille d'artistes hollandais; Les Cuyps', *Gazette des Beaux-Arts*, vol. 34 (1892), pp. 5–23, 107–17, 225–38; Julius Hoffmann, 'Die Radierungen von Aelbert Cuyp', *Mitteilungen der Gesellschaft für vervielfältigende Kunst* (1906), pp. 14–16; Wurzbach vol. 1 (1906), pp. 364–9, vol. 3 (1911), pp. 70–1; Hofstede de Groot, vol. 2 (1909); Abraham Bredius, 'Wie wurde Cuyp während seines Lebens geschäzt', *Kunstchronik*, vol. 24 (1913), pp. 409–11; K. Lilenfeld, in Thieme and Becker, vol. 8 (1913), pp. 227–9; C. Hofstede de Groot, 'Aelbert Cuyp of Abraham van Kalraet', *Oude Kunst*, vol. 1 (1915-16), pp. 143–5, 241–3, 314, 346; Jerrold Holmes, 'The Cuyps in America', *Art in America*, vol. 18 (1930), pp. 165–85; Jerrold Holmes, 'Aelbert Cuyp als Landschaftsmaler', dissertation, Innsbruck, 1933; Martin, vol. 2 (1936), pp. 340–9; Hollstein, vol. 4, pp. 100–3; Stephen Reiss, 'Aelbert Cuyp', *Burlington Magazine*, vol. 95 (1953), pp. 42–7; A. Staring, 'De ruiterportretgroep van Aelbert Cuyp in het Metropolitan Museum te New York', *Oud-Holland*, vol. 48 (1953) p. 117; J. Nieuwstraten, 'Een ontlening van Cuyp aan Claude Lorrain', *Oud-Holland*, vol. 8 (1965), pp. 192–5; Utrecht Centraal Museum, *Nederlandse 17e eeuwse Italianiserende landschapschilders* (catalogue by Albert Blankert), 1965 (revised edition 1978); Stechow 1966, pp. 27, 61–4, 119, 161–2, 181–2; D. G. Burnett, 'Landscapes of Aelbert Cuyp', *Apollo*, vol. 89 (1969), pp. 372–80; J. G. van Gelder and Ingrid Jost, 'Vroeg contact van Aelbert Cuyp met Utrecht', in *Miscellanea I. Q. van Regteren Altena* (Amsterdam, 1969); J. G. van Gelder and Ingrid Jost, 'Doorzagen op Aelbert Cuyp', *Nederlands Kunsthistorisch Jaerboek*, vol. 23 (1972), pp. 223–9; London, National Gallery, *Aelbert Cuyp in British Collections*, 1973; Stephen Reiss, *Aelbert Cuyp* (London, 1975); Dordrecht, Dordrechts Museum, *Aelbert Cuyp en zijn familie, schilders te Dordrecht* (catalogue by J. M. de Groot, J. G. van Gelder and W. Veermann), 1977–8; Müllenmeister 1973–81, vol. 2, pp. 51–4; Amsterdam/Boston/Philadelphia 1987–8, pp. 290–304; Alan Chong, 'New dated works from Albert Cuyp's early career', *The Burlington Magazine*, vol. 133 (September 1991), pp. 606–12; Alan Chong, 'Social Meanings in the Paintings of Aelbert Cuyp', dissertation, New York University (forthcoming); J. G. van Gelder and Ingrid Jost, 'The Drawings of Aelbert Cuyp'.

CAT. 16

Panoramic Landscape with Shepherds, Sheep and a Town (Beverwijk?) in the Distance, c. 1641–4

Signed lower left: A cüyp fecit
Oil on panel 14⅞ × 21½ in. (38 × 54.7 cm.)

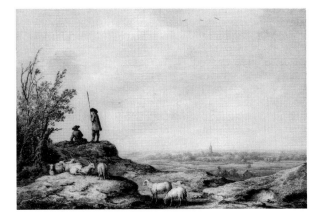

PROVENANCE: H. J. Pfungst, London, 1899; James J. van Alen, London, by 1903; acquired from Edward Speelman in 1970.

EXHIBITIONS: The Hague, Mauritshuis, 1899; London, Royal Academy, *Winter Exhibition*, 1903, no. 89; London, Whitechapel Art Gallery, *Dutch Exhibition*, 30 March–10 May 1904, no. 174; London 1988, no. 17.

LITERATURE: Hofstede de Groot, vol. 2 (1909), no. 691; Stephen Reiss, *Aelbert Cuyp* (London, 1975), p. 37, cat. no. 9, ill. (c. 1640); Russell 1988, p. 789; Speelman 1988, p. 15.

CONDITION NOTES: The wood panel has been thinned and cradled. Wood strip additions, ¼ in. (5 mm.) wide, have been secured to all sides with their grain running parallel to the horizontal grain of the original panel. The overall dimensions of the support with additions is 15⅜ × 22 in. (39 × 56 cm.). An old break in the panel runs horizontally at the level of the trees in the upper right; it is 4⅞ in. (12.5 cm.) from the upper left corner of the original panel and 4⅝ in. (11.5 cm.) from the upper right corner. The split has been repaired and inpainted. Scattered inpainting also appears along the panel's edges and throughout the sky, however the paint film is generally in very good condition and reveals little abrasion. A thick but only moderately discoloured varnish layer covers the surface. On the back of the cradle is stencilled '2555H'.

On a knoll on the left overlooking a broad panoramic landscape are two shepherds; one sits with his back to the viewer while the other stands in profile to the left holding a crook. In the left foreground are seven sheep and goats. A low tree and shrub appear at the left. On the right is a plain with a cottage in the middle distance and the silhouette of a town with a tall square church tower. Overhead is a bright but overcast sky. The palette is muted and dominated by tawny colors with bright lemony highlights.

Hofstede de Groot rightly characterized this painting as 'an exceptionally good picture of the early period; it is straw-yellow in tone'.[1] Cuyp's earliest dated paintings are from 1639 (see fig. 1).[2] In 1641 he collaborated with his father, Jacob Gerritsz Cuyp, on two family portraits in landscapes, in which the landscapes were painted by the young Aelbert.[3] These landscapes adopt the 'tonal' style first perfected by Jan van Goyen and Salomon van Ruysdael (qq.v.) in the late 1620s, but are lighter and more lemony in tonality. Reiss dated the Samuel painting 'circa 1640' and described it as 'One of the sketchiest of Cuyp's van Goyenesque paintings', adding that 'in fact, there is hardly sufficient paint for comfort' – an opinion which has found no supporters and which, in the view of this author, misrepresents the painting and its facture. The Samuel painting and several other 'monochrome' landscapes from the early 1640s, such as the *Pastoral Landscape near Utrecht* in Salzburg (fig. 2),[5] in fact best illustrate Cuyp's own personal approach to this influential tonal manner. His technique involved a thicker application of paint than found in van Goyen's work, with a rich build-up in the daubed modelling of foliage and the forms of the terrain, as well as the light citrus yellow tonality mentioned above. Later in his career Cuyp (see Cat. 17) lightened the tone and palette of his paintings, probably in response to landscapes produced by Dutch painters who had recently returned from Italy, such as Jan Both.

Another early painting in the Van der Heydt Museum, Wuppertal, *Shepherds and Sheep near Amersfoort* (fig. 3), adopts a composition similar to the present design but reversed, with the shepherds silhouetted on a knoll on the right and gesturing toward the city on the horizon on the left.[6] The cities in the distance of Cuyp's landscape can often be identified (see figs. 2 and 3);[7] on the photograph of

the Samuel painting at the Rijksbureau voor Kunst-
historische Documentatie in The Hague, it is suggested
that the city in the background could be the village of
Beverwijk. While Beverwijk indeed has a square church
tower, the identification seems less than certain.[8]

A copy of the Samuel painting, the dimensions of which
are unknown but which truncates the original's design, was
with the dealer Fischmann, Munich, before 1928.[9]

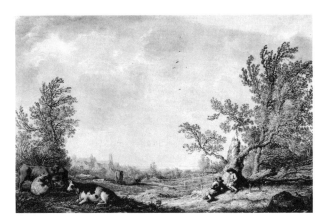

FIG. 2 Aelbert Cuyp, *Pastoral Landscape near Utrecht*, signed, oil
on panel 49 × 74 cm., Czernin Collection, Residenzgalerie,
Salzburg, cat. 1955, no. 30.

1 Hofstede de Groot, vol. 2 (1909), p. 207, no. 691.
2 See *Farm Scene*, signed and dated 1639, panel 37 × 47 cm.,
 Musée des Beaux-Arts, Besançon; and *Quayside, Dordrecht*,
 formerly Brunner Gallery, Paris, 1919 (Reiss 1975,
 cat. no. 4, ill.). On Cuyp's earliest career, see now Alan Chong,
 'New dated works from Albert Cuyp's early career', *The
 Burlington Magazine*, vol. 133 (September 1991), pp. 606–12;
 (which appeared shortly before this catalogue went to press).
3 Reiss 1975, cat. no. 16.
4 Reiss 1975, p. 37, no. 9.
5 Hofstede de Groot, vol. 2 (1909), no. 712; Reiss 1975, no. 11,
 ill.
6 See Eva Rowedder, *Niederländische Malerei des 17. Jahrhundert
 aus dem Von der Heydt-Museum Wuppertal* (Wuppertal, 1985),
 p. 34, no. 198. Compare also the *Panorama with View of
 Wageningen* in the Michaelis Collection, Cape Town, SA.
 (Reiss 1975, cat. no. 25); *Pastoral Landscape with Herdsmen*, Alte
 Pinakothek, Munich, cat. 1958, no. 1214; and *Landscape with
 Cattle and Figures*, Dulwich Picture Gallery, Dulwich, no. 348
 (Reiss 1975, no. 15, ill.). A later painting of *Herdsmen in a
 Landscape before Rhenen*, also in the Dulwich Picture Gallery, no.
 4 (Reiss 1975, no. 42, ill.), represents a transitional stage
 between the artist's early and mature manner.
7 Svetlana Alpers (*The Art of Describing* (Chicago, 1983), p. 146,
 ill. 89) related the staffage in the Wuppertal painting to
 similar figures that appear in the cartouches or border scenes
 of Dutch maps.
8 On Beverwijk, see Ruisdael cat. 58, note 1.
9 Photo Rijksbureau voor Kunsthistorische Documentatie.

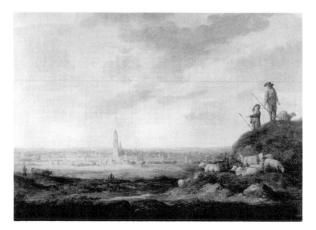

FIG. 3 Aelbert Cuyp, *Shepherds and Sheep near Amersfoort*, signed,
oil on canvas 97 × 136.5 cm., Van der Heydt Museum, Wuppertal,
no. 198.

FIG. 1 Aelbert Cuyp, *Landscape with Herdsmen*, 1639, signed and
dated 16[39], oil on panel 44 × 54 cm., sale London (Sotheby's) 6
April 1977, no. 52.

CAT. 17 Aelbert Cuyp (attributed to)

Cattle by a River, c. 1650

Unsigned
Oil on panel 15 × 21¼ (38.3 × 55.2 cm.)

PROVENANCE: Prince E. Sapiéga whose collection was confiscated in 1832; Emperor Nicolaes I of Russia; Hermitage, Leningrad, cat. 1901, no. 1104; de-accessioned in the 1930s; Etienne Nicolas, Paris; acquired c. 1959–60 from Edward Speelman.

EXHIBITION: London 1988, no. 16.

LITERATURE: Smith *Suppl.* (1842), no. 5; A. Somof, *Ermitage imperial catalogue de la galerie des tableaux. Deuxième partie: écoles néerlandaises et allemandes* (St. Petersburg, 1901), p. 60, no. 1104; Hofstede de Groot, vol. 2 (1909), no. 396; Wurzbach, vol. 1 (1906), p. 366, and p. 368, no. 3 (H. J. Antonissen's engraving); Stephen Reiss, *Aelbert Cuyp* (London, 1975), p. 124, no. 87, ill.; Walter Bernt, *Die Niederländischen Maler und Zeichner des 17. Jahrhunderts*, 3 vols. (Munich, 1979), vol. 1, no. 309, ill. [incorrectly as still in the Hermitage]; Alan Chong, in Amsterdam/Boston/Philadelphia 1987–8, pp. 293, 294, notes 2 and 5.

CONDITION NOTES: The original panel support has been thinned and cradled. A small cleat has been applied to the back of the panel. The paint film is in good condition with some minor abrasion. Retouches appear in the sky in the upper centre and upper right, around the boats in the distance, and in and around the heads and horns of the cows on the right. The varnish is moderately discoloured and uneven; a thick band of old varnish around the edges of the panel suggests that the painting was previously cleaned in its frame. In addition to old customs stamps, the Hermitage number (Kom. 1104) appears on the back, as well as the numbers 19.948 and 3812. The stickers of Etienne Nicolas' packers (Gerfaud and Pottier) also appear.

On the right five cows stand on the bank and in the shallows of a broad and placid river. In the centre one dark cow with white markings lowers its head to drink, while the others stand as a group to the right. In the distance boats set sail down the river, and on the left is a glimpse of the far bank. Overhead the sky is partly filled with billowing clouds and coloured by the light of a warm summer evening.

Hofstede de Groot noted that this painting was 'quite in the style of the Budapest painting [fig. 1], but not so strongly lighted'.[1] Reiss observed the close resemblance in design to a painting by Cuyp in the Robarts Collection (fig. 2), but questioned the Samuel painting's attribution, noting that 'if [it] is genuine, it seems clear it must be the earlier, being weaker both in design and chiaroscuro'.[2] Chong initially accepted the attribution of the Samuel painting and discussed at length its relationship not only to the Budapest and Robarts paintings but also to two other closely related works in the Marquis of Bute's collection (fig. 3) and the National Gallery, London (fig. 4).[3] Both the Robarts and Bute paintings, Chong noted, have pendants, while the Samuel and National Gallery paintings apparently were independently conceived or have since lost their companions. He argued that the National Gallery's painting is probably the earliest of the versions because it employs a more traditional arrangement through its inclusion of the boat with the fishermen and in displaying more of the river bank. The Samuel painting, he stressed, is closest to the Robarts painting and 'must date from about the same time',[4] although Reiss dated it earlier.[5] The entire group is painted in a style related to an equestrian portrait by Cuyp which on documentary evidence can be dated before 1652 (Mauritshuis, The Hague, inv. 25), thus Chong dated them all around 1650.[6] Other related paintings of cows belong to the British Rail Pension Fund (on loan to the J. Paul Getty Museum, Malibu) and the National Gallery of Art, Washington (no. 1986.70.1).

However in private and independent communications, several experts, including Frits Duparc and Albert Blankert, have followed Reiss' lead in doubting the attribution to Cuyp. While the painting's design is well considered and pleasing in its evocation of a still and placid scene, its paint application is more laboured, the modelling less assured, and the paint application opaque and less freely nuanced than in Cuyp's autograph works. Indeed in a private communication (March 1991) even Chong now doubts the attribution, and intends to reject it in his forthcoming dissertation. In recognition of these growing and, in this author's opinion, justifiable doubts, we demote the picture's authorship to a qualified attribution only.

In the seventeenth century, dairy cows like those depicted here were as central to the Dutch national identity as windmills, polders and the sea. Since the Dutch imported

much of the grain needed to feed their populations (see cat. 58, Ruisdael's *Cornfield*) they could devote the precious land that they had reclaimed from the sea to specialized horticultural and industrial crops, animal husbandry and dairy farming. Dutch cattle were renowned in seventeenth century Europe. In literature and the pictorial arts the milk cow was associated with earth (*terra*), the season of spring, fecundity, prosperity and numerous other virtues, indeed became the symbol of Holland in various political allegories.[7]

The painting was engraved by H. J. Antonissen in 1767 (fig. 5) and entered the Hermitage in 1832 when it was confiscated from Prince Sapiéga. Like many other works it was de-accessioned by the Russian State in the 1930s and subsequently found its way via the Nicolas Collection in Paris to Lord Samuel.

Copies of the painting were in the sale Earl of Derby, London (Christie's), 2 July 1954, no. 98 (canvas 17½ × 23½ in.) and in the Hugo Engleson Collection, Malmo, Sweden (38 × 55 cm.).

FIG. 1 Aelbert Cuyp, *Cattle in a River*, signed, oil on panel 59 × 74 cm., Szépmüvészeti Múzeum, Budapest, inv. 408.

1 Hofstede de Groot, vol. 2 (1909), p. 120, no. 396. The Budapest painting (inv. 408) is his no. 390.
2 Reiss 1975, p. 124, no. 87; the Robarts painting is Hofstede de Groot, vol. 2 (1909), no. 393; Reiss 1975, no. 86, ill.
3 Chong, in Amsterdam/Boston/Philadelphia 1987–8, pp. 293–4. See respectively Hofstede de Groot, vol. 2 (1909), no. 392 and collectively nos. 325, 328 and 391 (Reiss 1975, no. 88, ill.).
4 Chong, in Amsterdam/Boston/Philadelphia 1987–8, p. 294.
5 Reiss 1975, p. 124.
6 Chong, in Amsterdam/Boston/Philadelphia 1987–8, p. 294.
7 See H. van de Waal, *Drie eeuwen vaderlandsche geschieduitbeelding 1500–1800. Een iconologische studie*, 2 vols. (The Hague, 1952), pp. 21–2; Joaneath Spicer, '"De Koe voor d'aerde staet": The Origins of the Dutch Cattle Piece', in *Essays in Northern European Art Presented to Egbert Haverkamp Begemann on His Sixtieth Birthday* (Doornspijk, 1983), pp. 251–6; Egbert Haverkamp Begemann and Alan Chong, 'Dutch Landscape and its Associations', in *The Royal Picture Gallery: Mauritshuis* (New York, 1985), pp. 63–4; Peter C. Sutton, 'The Noblest of Livestock', *The J. Paul Getty Museum Journal*, vol. 15 (1987), pp. 97–100; Chong in Amsterdam/Boston/Philadelphia 1987–8, p. 295; and, above all, Dordrecht, Dordrechts Museum (25 September–20 November 1988) and Fries Museum, Leeuwarden (3 December 1988–29 January 1989), *Meesterlijk Vee. Nederlandse veeschilders 1600–1900*, with contributions by Sjraar van Heugten, Alan Chong, Joannes Hoes and Guido Jansen (Zwolle, 1988).

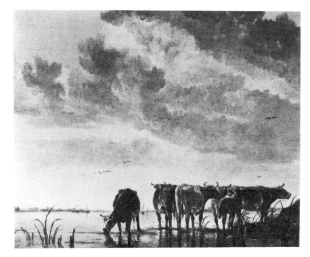

FIG. 2 Aelbert Cuyp, *Cattle in a River*, signed, oil on panel 59 × 72.5 cm., D. J. Robarts, London.

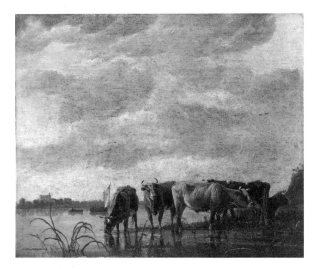

FIG. 3 Aelbert Cuyp, *Cattle in a River*, signed, oil on panel 59.7 × 71 cm., Marquess of Bute, Scotland.

FIG. 5 H. J. Antonissen (after Aelbert Cuyp), *Cattle by a River*, 1767, engraving.

FIG. 4 Aelbert Cuyp, *River Scene with Cattle and Anglers*, signed, oil on panel 45 × 74 cm., National Gallery, London, no. 823.

GERARD DOU

(LEIDEN 1613–1675 LEIDEN)

The son of the glass engraver, Douwe Jansz, and Marijtgen Jansdr van Rosenburg, Gerard Dou was born in Leiden on 7 April 1613. According to Orlers' *Beschrijvinge der Stadt Leyden* (1641), Dou first studied with his father, then with the printmaker (engraver) Bartolomeus Dolendo and the glass painter Pieter Couwenhorn. He was a member of the glazier's guild in Leiden from 1625 to 1627. In February 1628 he entered Rembrandt's studio, where he remained until the latter's departure for Amsterdam in c. 1631. In 1648 Dou became a founding member of the Leiden St Luke's Guild.

Charles II of England received several Dou paintings from the States General as a gift on the occasion of his restoration to the throne in 1660. Dou's other noble patrons included Queen Christina of Sweden and Archduke Leopold Wilhelm of Austria. Despite his international reputation, Dou scarcely left his native Leiden; invited by Charles to come to London, Dou declined. In the Netherlands he was one of the highest paid Dutch artists. In 1665 Johan de Bye, a local collector, mounted a private exhibition in Leiden which included twenty-seven of Dou's works. A bachelor all his life, Dou died in Leiden and was buried in the St Pieterskerk on 9 February 1675.

Executing small, highly finished genre scenes, portraits, still lifes and history paintings, Dou was the founder of the Leiden *fijnschilders*, a group of artists who all adopted a similar meticulous and polished style. His pupils included his nephew, Dominicus van Tol (c. 1635–76), Frans van Mieris (1635–81), whom he called the 'prince of my pupils', Godfried Schalcken (1634–1706), Matthijs Naiveu (1647–c. 1721), and Carel de Moor (1656–1738). Gabriel Metsu and Pieter van Slingelandt (qq.v.) were also strongly influenced by his work.

LITERATURE: J. J. Orlers, *Beschrijvinge der Stadt Leyden* (Leiden, 1641), pp. 377, 380; Philips Angel, *Lof der Schilderconst* (Leiden, 1642), pp. 23, 25, 57; de Bie 1661, pp. 106, 277; André Félibien, *Entretiens sur les vies et sur les ouvrages des plus excellents peintres anciens et modernes*, 5 vols. (Paris 1666′–88), vol. 4, p. 158; Balthasar de Monconys, *Journal des voyages. Vol. 2 Voyage de Pays-Bas* (Lyons, 1665–6), pp. 131, 132, 150, 153, 157; Sandrart 1675, pp. 11, 198, 320, 351; van Hoogstraten 1678, pp. 163, 257, 262, 268; Roger de Piles, *Abrégé de la vie des peintres* (Paris, 1699), pp. 428–30; Houbraken, vol. 2 (1719), pp. 1–3; Smith, vol. 1 (1829); E. Kolloff, 'Das Geburtsjahr Gerhard Dous', *Deutsche Kunstblatt*, vol. 1 (1850), pp. 138–9; Obreen 1877–90, vol. 5, pp. 26–30; W. Martin, *Gerard Dou* (London, 1902); Wurzbach, vol. 1 (1906) pp. 416–21; Hofstede de Groot, vol. 1 (1908); W. Martin, *Gérard Dou, sa vie et son œuvre: étude sur la peinture hollandaise et les marchands au dix-septième siècle* (Paris, 1911); W. Martin, *Gerard Dou*, Klassiker der Kunst (Stuttgart, 1913); W. Martin, in Thieme and Becker, vol. 9 (1913), pp. 503–5; Hollstein, vol. 5, pp. 267–72; E. Plietzsch, *Holländische und flämische Maler des 17. Jahrhunderts* (Leipzig, 1960), pp. 35–42; J. A. Emmens, 'Kunstenaar en publiek in een schilderij van Gerrit Dou in het Museum Boyman-van Beuningen', *Vereeniging van Nederlandse Kunsthistorici te Rotterdam* 21 December 1963; J. A. Emmens, 'Gerard Dou, "De Kwakzalver"', *Openbaar Kunstbezit*, vol. 15 (1971), pp. 4 a–b; Ella Snoep-Reitsma, 'De waterzuchtige vrouw van Gerard Dou en de betekenis van de lampetkan', in *Album Amicorum J. G. van Gelder*, ed. J. Bruyn (The Hague, 1973), pp. 147–243; Amsterdam 1976, pp. 82–93; Braunschweig, Herzog Anton Ulrich Museum, *Die Sprache der Bilder*, 6 September–5 November 1978, pp. 64–5; Arthur Wheelock, 'A Reappraisal of Gerard Dou's Reputation', in Washington DC, Corcoran Gallery of Art, *The William A. Clark Collection*, (26 Apr.–16 July 1978), pp. 61–7; London, David Carrit Ltd (Artemis Group), *Ten Paintings by Gerard Dou*, 1980; Ivan Gaskell, 'Gerrit Dou, His Patrons and the Art of Painting', *Oxford Art Journal*, vol. 5, no. 1 (1982), pp. 15–23; Philadelphia/Berlin/London 1984, pp. 181–8; Leiden, Stedelijk Museum 'de Lakenhal', *Leidse Fijnschilders, van Gerrit Dou tot Frans van Mieris de Jonge 1620–1760* (cat. by Eric Jan Sluijter, *et. al.*), 1988, pp. 97–115; Amsterdam, Rijksmuseum, *De Hollandse fijnschilders, van Gerard Dou tot Adriaen van der Werff* (cat. by Peter Hecht), 1989–90, pp. 24–64; Ronnie Baer, 'Gerard Dou', dissertation, New York University, 1990.

CAT. 18

Portrait of a Young Man

Oil on rectangular panel (with enlargements), 7¼ × 5⅞ in. (18.3 × 14.9 cm.); original oval 6½ × 5⅜ in. (16.5 × 13.7 cm.).

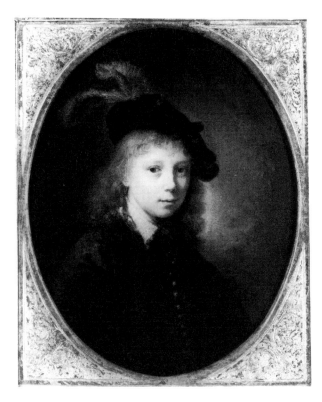

PROVENANCE: Willem Lormier, The Hague, 1752; sale W. Lormier, The Hague, 4 July 1763, no. 66 (400 fl.); sale Willem van Wouw, The Hague, 29 and 30 May 1764, at the first sale, no. 66 (400 fl.), at the second sale, no. 11 (312 fl., to Copello); sale Pieter van Copello, Amsterdam, 6 May 1767, no. 14 (255 fl.); sale P. Locquet, Amsterdam, 22 September 1783, no. 77 (100 fl., to Fouquet); Sale J. Goll van Frankenstein, Amsterdam, 1 July 1833, no. 16 (655 fl., to van den Berch of Leyden); Dowager J. L. van den Berch van Heemstede, 1881 (see exh.); sale R. della Faille de Waerloos *et al.* (Dowager van den Berch van Heemstede), Amsterdam (F. Muller), 7 July 1903, no. 57, ill. (6700 fl. to Van Buren); M. van Gelder, Uccle, near Brussels; sale Duc de Brissac *et al.* (W. van Gelder), London (Christie's), 14 May 1971, no. 35, ill.; acquired from Edward Speelman in 1971.

EXHIBITIONS: The Hague, *Catalogus der tentoonstelling van Schilderijen van Oude Meesters te 's Gravenhage ten behoeve de Watersnoodlijdenden onder de hooge bescherming van Hunne Majesteiten den Koning en de Koningin*, 1881, no. 116; London 1988, no. 19, ill. p. 12 [as *Portrait of a Boy (Self Portrait)*].

LITERATURE: Hoet, vol. 2 (1752), p. 421, Smith, vol. 1 (1829), nos. 12, 20, and *Suppl.* (1842) no. 7; E. W. Moes, *Iconographia*

Batavia (Amsterdam 1897–1905), vol. 1, no. 2096.10; W. Martin, *Het leven en de werken van Gerard Dou beschouwd in verband met schildersleven van zijn tijd* (dissertation, Leiden, 1901), p. 202, no. 125; W. Martin, *Gerard Dou* (London, 1902), p. 136, no. 165; Hofstede de Groot, vol. 1 (1908), no. 338; W. Martin, *Gerard Dou, des Meisters Gemälde in 247 Abbildungen*, Klassiker der Kunst (Stuttgart and Berlin, 1913) p. 181, ill. p. 34 (left); Fitzwilliam Museum, Cambridge, cat. 1960, under cat. no. 35; H. van Hall, *Portretten van Nederlandse beeldende Kunstenaars. Reportorium* (Amsterdam, 1963), p. 81 (under no. 8); London, David Carrit Ltd (Artemis Group), *Ten Paintings by Gerard Dou 1613–1675*, 13 November–12 December 1980, p. 22, under cat. no. 6; Werner Sumowski, *Gemälde der Rembrandt Schüler*, vol. 1 (Landau/Pfaltz, 1983), p. 528, no. 258, ill.; Russell 1988, p. 788.

CONDITION NOTES: The panel support was originally oval but has been converted by additions to a rectangle. The panel has a wood backing and has been cradled so that one cannot see the back of the original panel. There are tiny retouchings in the boy's collar, forehead, right cheek, chin and scattered throughout the background, but there is no evidence of the extensive damage suggested by Hofstede de Groot.

An adolescent boy is viewed half length and turned three quarters to the observer's right. His long blond hair falls to his shoulder. He wears a black velvet cap with reddish-orange and white feathers, a white collar, and a purplish doublet buttoned to the neck with gold buttons.

E.W. Moes and W. Martin (1901) initially believed that this painting was a self-portrait, but in 1908 Hofstede de Groot correctly rejected this idea and Martin in 1913 subsequently changed his mind.[1] Like his teacher Rembrandt, Dou painted self-portraits throughout his life, indeed an exceedingly large group of paintings have been identified as his self image.[2] Among the certain self-portraits are paintings in the Gemäldegalerie, Dresden (dated 1647, inv. 1704), the Herzog Anton Ulrich Museum, Braunschweig (no. 303), the Uffizi, Florence (dated 1658, no. 20.54), the Nelson-Atkins Museum, Kansas City (1663), the Metropolitan Museum of Art, New York (acc. no. 10.40.607) and the Louvre (inv. 1222), all of which depict a grown man with different features.[3] The same young sitter who is depicted in the Samuel painting appears in the tiny signed *Portrait of a Young Man in a Steel Gorget and a Beret* in the Fitzwilliam Museum, Cambridge (fig. 1).[4] Sumowski also believed that the same sitter appeared in a small portrait that sold at Christie's in London in 1973 (fig. 2); however that work may only be a copy with variations in costume of the Cambridge portrait.[5]

Hofstede de Groot speculated that a possible pendant to the Samuel painting was the *Woman in a Fur-Trimmed Cloak* (panel 7 × 6 in.) that also appeared in the W. Lormier sale in The Hague on 4 July 1763.[6] However, if

the putative pendant is, as Hofstede de Groot suggested, identical with the *Portrait of a Woman* in the National Gallery, London (no. 1415), once called Dou and now rightly catalogued as Frans van Mieris' *Portrait of his Wife, Cunera van der Cock*, the pairing is surely mistaken.[7] Hofstede de Groot also claimed that the Samuel painting had 'been damaged and afterwards restored, but it is still a good work. [The] panel [was] originally oval, but enlarged by the artist himself and now rectangular'.[8]

A copy that is slightly larger than the Samuel original was in the Dr C. J. K. van Aalst collection, Hoevelaken, cat. 1939, p. 112, ill.[9] Hofstede de Groot observed that a slightly smaller painting in the Marquis de Menars sale in Paris (February 1782, no. 40) may have been a replica of the Samuel painting.[10]

1 Moes (1897–1905), vol. 1, no. 2096.10; Martin 1901, p. 202, no. 125; Hofstede de Groot, vol. 1 (1908), no. 338; Martin 1913, p. 181.
2 See H. van Hall, *Portretten van Nederlandse beeldende Kunstenaars. Repertorium* (Amsterdam, 1963), pp. 80–5, nos. 1–62.
3 See respectively, Martin 1913, ills. pp. 17, 18 right, 19 left and 20 frontispiece and 21 right. Ronnie Baer kindly informs the author that she accepts all of these works as self-portraits by Dou as well as paintings in Cheltenham and in the collection of the Duke of Sutherland (though not the *Young Violinist* mentioned below). She rejects the Czernin painting in Salzburg (Margin 1913, p. 18 left). The identities of Dou's putative self portraits in the Rijksmuseum, Amsterdam (no. A86), and the National Gallery, London (no. 192), have rightly been questioned by others, but the works in the Louvre and the Uffizi have been wrongly doubted. The painter's very early *Young Violinist* dated 1637 (Duke of Sutherland's Collection, on loan to the National Gallery, Scotland; Hofstede de Groot, vol. 1 (1908), no. 82, Martin 1913, no. 85, ill.) has been regarded without foundation as a self-portrait; no adolescent self-portraits are known.
4 Hofstede de Groot, vol. 1 (1908), no. 336; Martin 1913, ill., p. 34 right; Fitzwilliam cat. 1960, no. 35, pl. 15.
5 Sumowski, vol. 1 (1983), p. 528, no. 260, ill.
6 See Hofstede de Groot, vol. 1 (1908), no. 85c.
7 See Maclaren 1960, pp. 251–3, no. 1415; Naumann 1981, vol. 2, cat. 30, pl. 30.
8 Hofstede de Groot, vol. 1 (1908), no. 338.
9 Oil on panel 22 × 19.7 cm. (8⅝ × 7½ in.), formerly (see adv. in *The Burlington Magazine*, December, 1920) with dealer Jean Herbrand, 31 rue Le Peletier, Paris. The painting did not appear in the 1960 sales of the van Aalst Collection.
10 Hofstede de Groot, vol. 1 (1908), no. 281: '*Portrait of the Painter as a Youth* – a three-quarter view. He wears a soft black cap with two feathers, and a coat with gold buttons and a lace collar. Possibly a replica of 338. Panel 6½ inches by 5½ inches'.

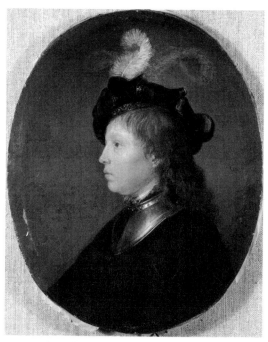

FIG. 1 Gerard Dou, Portrait of a Young Man in a Steel Gorget and a Beret, signed, oil on an oval panel, 6 × 4⅞ in. (15.2 × 12.4 cm.). Fitzwilliam Museum, Cambridge, no. 35.

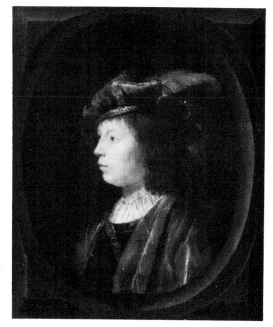

FIG. 2 Attributed to Gerard Dou, *Portrait of a Young Man in a Beret*, oil on panel 19.3 × 13.9 cm., present location unknown.

JAN VAN GOYEN

(LEIDEN 1596–1656 THE HAGUE)

Jan Josephsz van Goyen, the son of a shoemaker, was born in Leiden on 13 January 1596. According to J. J. Orlers (1641), he was a pupil from 1606 onward in Leiden, successively, of Coenraet van Schilperoort (c. 1577–1635/6), Isaack van Swanenburch (c. 1538–1614), Jan de Man (active early seventeenth century), and the glass painter Hendrick Clock, and later worked for two years under Willem Gerritsz at Hoorn. Orlers further claimed that van Goyen subsequently returned to Leiden, travelled in France for a year and finally returned to Haarlem, where he became a pupil of Esaias van de Velde. He married Annetje Willemsdr van Raelst at Leiden in 1618, was still living there the following year, and in 1625 bought a house on the St Pieterskerkstraat, which he sold in 1629 to the marine painter Jan Porcellis (before 1584–1632). He is mentioned regularly in Leiden documents of 1627–32. Van Goyen probably moved to The Hague in the summer of 1632, and he became a citizen two years later. Sometime in 1634 he was painting in Haarlem at the house of Isaack van Ruisdael (1599–1677), the brother of Salomon (q.v.). In 1635 he bought a house in The Hague on the Veerkade, and the following year built the house on the Dunne Bierkade in which the animal and landscape painter Paulus Potter lived from 1649 to 1652. Until his death van Goyen was regularly mentioned in The Hague as living in his house on the Wagenstraat. He was named *hoofdman* of The Hague guild in 1638 and 1640. In 1649 his two daughters were married: Maria to the still-life painter Jacques de Claeuw (died after 1676?), and Margarethe to Jan Steen (q.v.). In 1651 van Goyen painted a panoramic view of The Hague for the city's Town Hall. He died at The Hague on 27 April 1656, and was buried in the Grote Kerk. Throughout his life van Goyen had speculated with little success in various businesses, including real estate and tulips.

Jan van Goyen was one of the greatest and most prolific seventeenth-century Dutch landscapists. His early works (prior to 1626) closely resemble those of his teacher Esaias van de Velde (q.v.). Thereafter he developed a new 'tonal' manner with three other gifted Haarlem painters, Pieter de Molijn, Salomon van Ruysdael (q.v.) and Jan Porcellis. He made many drawings in the countryside around The Hague, Leiden, Haarlem and Amsterdam, and on trips to the Southern Netherlands, Gelderland and the area around Kleve. Nicolaes Berchem was his student, but his paintings reflect little or nothing of van Goyen's style.

LITERATURE: J. J. Orlers, *Beschrijvinge der stadt Leyden* (Leiden, 1641), pp. 373–4; Dirck van Bleyswijck, *Beschryvinge der stadt Delft*, 2 vols. (Delft, 1667), vol. 2, p. 847; Sandrart 1675, p. 310; Houbraken, vol. 1 (1718), pp. 171, 173, 275, 303; Descamps, vol. 1 (1758), p. 396; Carl Vosmaer, 'Johan Josefszoon van Goyen', *Zeitschrift für bildende Kunst*, vol. 9 (1874), pp. 12–20; Paul Mantz, 'Jan van Goyen', *Gazette des Beaux-Arts*, vol. 12 (1875), pp. 138–51, 298–311; Abraham Bredius, 'Jan Josephsz. van Goyen: Nieuwe bijdragen tot zijne biographie', *Oud-Holland*, vol. 14 (1896), pp. 113–25; Amsterdam, Stedelijk Museum, *Jan van Goyen* (cat. by Frits Lugt), 1903; Theodoor von Frimmel, 'Bemerkungen über den polychromen Frühstil des Jan van Goyen', *Blätter für Gemäldekunde*, vol. 2 (1906), pp. 71–6; Wurzbach, vol. 1 (1906), pp. 607–10; O. Hirschmann, in Thieme and Becker, vol. 14 (1921), pp. 460–3; Abraham Bredius, 'Het juiste sterf-datum van Jan van Goyen', *Oud-Holland*, vol. 34 (1916), pp. 158–9; Abraham Bredius, 'Heeft van Goyen te Haarlem gewoond', *Oud-Holland*, vol. 37 (1919), pp. 125–7; C. Hofstede de Groot, 'Jan van Goyen and his Followers', *Burlington Magazine*, vol. 42 (1923), pp. 4–27; Hofstede de Groot, vol. 8 (1927); Hans Volhard, *Die Grundtypen der Landschaftsbilder Jan van Goyens und ihre Entwicklung*, dissertation (Frankfurt, 1927), J. P. van der Kellen, *Teekeningen door Jan van Goyen uit het Rijksprentenkabinet te Amsterdam* (Amsterdam, 1928); Wolfgang Stechow, 'Die "Pellekussenpoort" bei Utrecht auf Bildern von Jan van Goyen und Salomon van Ruysdael', *Oud-Holland*, vol. 55 (1938), pp. 202–8; H.P. Bremmer, 'Jan van Goyen: Stadje aan de vaart', *Maandblad voor beeldende kunsten*, vol. 16 (1939), pp. 40–3; H. van de Waal, *Jan van Goyen* (Amsterdam, 1941); B. J. A. Renckens, 'Jan van Goyen en zijn Noordhollandse leermeester', *Oud-Holland*, vol. 66 (1951), pp.23–4; Ake Bengtsson, *Studies on the Rise of Realistic Landscape Painting in Holland 1610–1625*, (Figura, vol. 3) (Stockholm, 1952); Hans-Ulrich Beck, 'Jan van Goyens Handzeichnungen als Vorzeichnungen', *Oud-Holland*, vol. 72 (1957), pp. 241–50; Emil Filla, *Jan van Goyen* (Prague, 1959); Arnhem, Gemeentemuseum and Leiden, Stedelijk Museum, *Jan van Goyen*, 1960; J. C. Brown, 'Jan van Goyen: A Study of his Early Development', Master's Thesis, New York University, 1961; Hans-Ulrich Beck, 'Jan van Goyen om Deichbruch von Houtewael (1961)', *Oud-Holland*, vol. 81 (1966), pp. 20–31; Hans-Ulrich Beck, *Ein skizzenbuch von Jan van Goyen* (The Hague, 1966); Anna Dobrzycka, *Jan van Goyen 1596–1656* (Poznań, 1966); Hans-Ulrich Beck, *Jan van Goyen 1596–1656*,

3 vols. (Amsterdam, 1972–3, 1987); Egbert Haverkamp-Begemann, 'Jan van Goyen in the Corcoran: Exemplars of Dutch Naturalism', in Washington, DC, Corcoran Gallery of Art, *The William A. Clark Collection*, 1978, pp. 51–9; Amsterdam, Gallery Gebr. Douwes, *Esaias van de Velde, Schilder, 1590/91–1630; Jan van Goyen, tekenaar 1596–1656* (cat. by Evert Douwes), 1981; Amsterdam, Waterman Gallery, *Jan van Goyen 1596–1656 Conquest of Space* (cat. by H.-U. Beck, M.L. Wurfbain and W. J. van de Watering), 1981; Bob Haak, *The Golden Age: Dutch Painting of the Seventeenth Century* (New York, 1984) pp. 224, 243–5, 269, 336–7; Amsterdam/ Boston/Philadelphia 1987–8, pp. 31 ff.

CAT. 19

Winter Landscape with a Walled Castle, 1626

Signed and dated on the tree lower left: I V. GOIEN. 1626
Oil on panel 12⅝ × 23¼ in. (32.1 × 59.3 cm.)

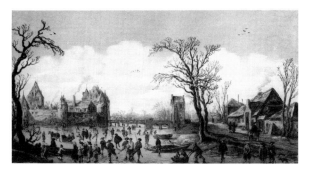

PROVENANCE: McDonnell Collection, Co. Wicklow; acquired from Edward Speelman in 1963.

EXHIBITION: London 1988, no. 20.

LITERATURE: Beck, vol. 2 (1973), no. 40, ill.

CONDITION NOTES: The support is a thin uncradled panel in very good condition that has been painted black on the back. Carved into the lower right-hand corner of the back of the panel are the initials FH, that may be the panel maker's mark. The paint film is in excellent state with some losses and repaint along the edges and scattered pinpoint losses in the sky and ice.

A frozen river filled with skaters recedes perpendicularly from the picture plane. On the right bank are cottages by a road beneath tall leafless trees, while on the left a darkened tree serves as a coulisse for a walled castle with turrets and gables in the middle distance. The castle is linked to the right bank by a bridge which leads to a tall gate tower. Among the many skaters are three 'colf' players (on colf, see Cat. 3) on the right with a dog, a man pushing a sledge in the middle foreground, and to the left two elegantly dressed couples with a beggar in red. Farther back is a horse-drawn sleigh with a boy skating after it. And on either bank boats are frozen in the ice.

With its broad horizontal composition, relatively thick paint application, and emphasis on the local colours of the numerous skaters and other motifs, this painting attests to van Goyen's continued admiration for the winter scenes and landscape art of his teacher, Esaias van de Velde (q.v.). Van Goyen had dated several closely related oblong-format skating scenes with castles (see figs. 1-3) in the two years prior to executing the Samuel painting; one of these is even

reported to be signed by Esaias van de Velde as well as by van Goyen (see fig. 2).[1] While it seems unlikely that that painting was actually a collaborative effort, the superficial resemblance between the two artists' styles through the mid-1620s was close enough to create confusion about authorship. In some of these paintings van Goyen's castles recall actual structures; Beck has identified the castle of Montfoort in the painting of 1625 (fig. 3), and one of the paintings of 1624 (fig. 2) combines elements of Batestein Castle with St Pol's near Vianen.[2] The castle in the Samuel

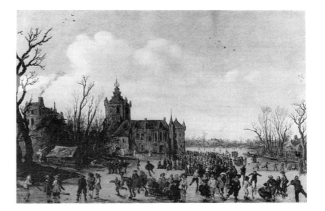

FIG. 3 Jan van Goyen, *Winter Landscape with Skaters before a Castle*, 1625, signed indistinctly and dated 1625, oil on panel 48 × 73 cm., sale Paris, 7 December 1954, no. 69, ill.

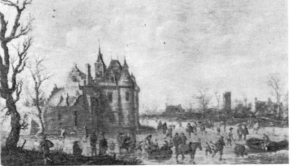

FIG. 1 Jan van Goyen, *Winter Landscape with Skaters before a Castle*, 1624, signed and dated 1624, oil on panel 29 × 51 cm., sale Amsterdam, 20 November 1951, no. 46.

FIG. 4 Simon Frisius, after David Vinckboons, *Winter (Hyems)*, etching.

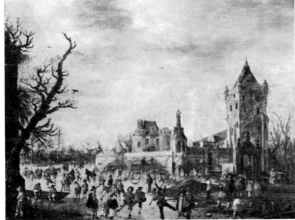

FIG. 2 Jan van Goyen, *Winter Landscape with Skaters before a Castle, 1624*, signed and dated 1624 (also signed by Esaias van de Velde), oil on panel 67 × 88 cm., Private Collection, Bremen, 1967.

painting cannot be identified, although its central section vaguely recalls Ijsselstein Castle.

The winter landscape tradition often included skating scenes with castles. Earlier examples are found in prints by Hans Bol and Jan van de Velde, and in paintings by Hendrick Avercamp, Adriaen van de Venne, and David Vinckboons.[3] David Vinckboons even designed a print series engraved by Hessel Gerritsz entitled 'The Seasons [with] Views of the Castles in the Vicinity of Amsterdam', which included views of Nijenroy (Nijenrode), Loenersloot, Maersen and Zuylen Castles.[4] A print of *Winter* (*Hyems*) after Vinckboons by Simon Frisius also includes horse-drawn sleighs, elegantly dressed skaters and 'colf' players before an unidentified castle (fig. 4). While the Samuel painting is not part of a landscape series, nor does it have a known pendant, its forms descend from this allegorical tradition of depicting the Seasons, specifically Winter, in an elegantly picturesque fashion.

1 For figs. 1–3, see respectively: Beck, vol. 2 (1973), pp. 17–18, cat. no. 34 (incorrectly as in Stichting Nederlands Kunstbezit, The Hague, no. NK1445), ill., p. 17; cat. no. 35, ill., p. 18; and cat. no. 38, ill. in vol. 3 (1987), p. 143.
2 Ibid. The painting of 1624 (fig. 1; Beck, vol. 2 (1973), cat. no. 34), repeats the same unidentified castle that appears in van Goyen's winter scene on a tondo format in the Rijksmuseum, Amsterdam, cat. no. A3946 (Beck, vol. 2 (1973), cat. no. 9).
3 For the Hans Bol, see Esaias van de Velde, Cat. 74, fig. 2; Hendrick Avercamp, *Winter Scene with Castle*, National Gallery, London, no. 1346; Adriaen van de Venne, *Winter Landscape with Castle*, dated 1615, Worcester Art Museum, Worcester, Mass, no. 1951.30; and David Vinckboons, *Winter Landscape with Castle*, c. 1610, with dealer Hoogsteder, The Hague (Amsterdam/Boston/Philadelphia 1987–8, no. 111, ill.).
4 See Hollstein, vol. 7 (n.d.), p. 107, nos. 17–20, ill.

CAT. 20

Winter Landscape with a Horse-Drawn Sleigh, 1645

Monogrammed and dated on the boat: J v G (the first two letters ligated) 1645 Oil on panel 5¾ × 7⅛ in. (14.6 × 17.9 cm.)

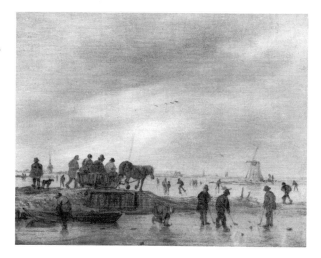

PROVENANCE: Sale Emile Monteaux, Paris, 20 December 1897, no. 237, ill. (440 frs.); sale J. Doucet, Paris, 5 June 1912, no. 155 (12,500 frs., to Kleinberger); G. B. W. ter Kuile, Enschede; Baron Leonino; Etienne Nicolas, Paris; acquired by Edward Speelman c. 1959/60, sold to Lord Samuel after 1964.

EXHIBITIONS: Enschede, *Catalogus van Nederlandsche 17e. eeuwsche schilderijen uit particuliere verzamelingen te Enschede, ter gelegenheid van het 1e. lustrum van het Rijksmuseum, Twenthe*, 1935, no. 16 (lent by G. B. ter Kuile); London, 1988, no. 22.

LITERATURE: Hofstede de Groot, vol. 8 (1927), no. 1198; Beck, vol. 2 (1973), p. 36, no. 70, ill.

CONDITION NOTES: The panel has ¼ in. (5 mm.) strip additions on all sides (running against the grain on the vertical sides) but is not cradled. The paint film is extensively repainted in the sky where horizontal striations of paint have been applied, presumably to disguise the grain of the wood showing through the paint. The varnish is moderately discoloured. On the back are the stickers of Gerfaud and Ch. Pottier, the French packers employed by the collector Nicolas, and the number '8'.

On a frozen river figures play colf, tie on their skates, or glide over the surface of the ice. A rowing-boat is lodged in the ice on the left before a low bank where figures and a horse-drawn sledge descend to the ice. Farther back are tiny skaters and on the right a windmill. A church spire rises on the horizon at the left.

Jan van Goyen painted winter scenes throughout his career. His early works employ a high horizon line and additive compositions in the tradition of sixteenth-century Flemish landscapists, Hendrick Avercamp (q.v.), and van Goyen's teacher, Esaias van de Velde (q.v.); however, around 1630 he lowered the horizon line and began to explore more atmospheric effects. His oblong compositions become progressively more spacious, and by c. 1638–40 he had perfected the broad winter panorama. Van Goyen's winter scenes from the first half of the 1640s are usually horizontally disposed with a very low horizon and the figures distributed at angles to the picture plane. In addition to large-scale panoramas (see Cat. 21), he continued to paint more intimately scaled scenes, like the Samuel picture of 1645.

The motif of the horse-drawn sledge descending to the ice had appeared in van Goyen's drawings as early as 1625 (see fig. 1),[1] and in his paintings by 1638.[2] The motif appeared silhouetted against the ice and sky in a large winter scene dated 164(o) formerly in the Norton Simon Collection (fig. 2),[3] and in another small painting in the National Gallery, London (fig. 3), which is dated the same year as the Samuel painting and includes a refreshment tent on the ice at right.[4] A later example of the use of the sledge appears in a painting dated 1646, which depicts a full panorama with skaters near Dordrecht (see Cat. 21, fig. 1).[5]

The three figures in the foreground play the game of 'colf', the predecessor of both modern golf and hockey that was played on ice in winter and on level ground in summer (see Cat.3).

1 Beck, vol. 3 (1987), p. 34, no. 50, ill.
2 Collection Willy Redelmeyer, Richmond Hill, Ontario; Hofstede de Groot, vol. 8 (1927), no. 1206; Beck, vol. 2 (1973), p. 25, no. 50.
3 Hofstede de Groot, vol. 8 (1927), no. 1169; Beck, vol. 2 (1973), no. 54.
4. Hofstede de Groot, vol. 8 (1927), no. 1166; Beck, vol. 2 (1973), no. 71, ill.
5 Hofstede de Groot, vol. 8 (1927), no. 38; Beck, vol. 2 (1973), no. 75, ill.; Saskia Nihom-Nijstad, *Reflets de la siècle d'or. Tableaux hollandais du dix-septième siècle* (Paris, 1983), no. 33, pl. 27. Later examples of winter scenes with the motif of the sledge include the paintings of 1647, formerly with Leonard Koetser (Beck, vol. 2 (1973), p. 41, no. 77, ill.), of 1649 in the Dienst Verspreide Rijkskollecties, The Hague, inv. no. NK2534, two drawings of 1651 in the Kupferstichkabinett, Dresden, no. C1189, and the Lugt Collection, Institut Néerlandais, Paris (Beck, vol. 1 (1972), nos. 197 and 198, ills.), and two drawings of 1653 in the Herzog-Anton-Ulrich-Museum, Braunschweig (Beck, vol. 1 (1972), no. 339, ill.) and Musée Turpin de Crisse, Angers, inv. no. 223 (Beck, vol. 3 (1987), p. 73, no. 338, ill.).

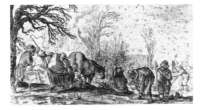

FIG. 1 Jan van Goyen, *Winter Scene with Horse-Drawn Sledge*, 1625, drawing (dimensions unknown), City Art Gallery, Plymouth, England.

FIG. 2 Jan van Goyen, *Winter Landscape with a Horse Sledge*, monogrammed and dated 164(o), panel 35 × 54.5 cm., Baron van Vadem.

FIG. 3 Jan van Goyen, *Winter Landscape*, signed and dated 1645, oil on panel 25.2 × 34 cm., National Gallery, London, no. 2579.

CAT. 21

Winter Landscape with Skaters before 's-Hertogenbosch, 1646

Signed lower left corner: J V GOYEN / 1646
Oil on panel; originally 17⅜ × 29⅝ in. (44.3 × 75.5 cm); with
additions 18 × 30½ in. (45.6 × 76.6 cm.)

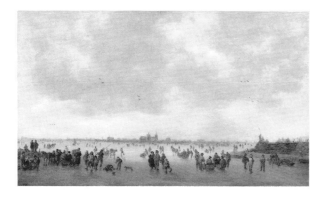

PROVENANCE: (According to Hofstede de Groot and Beck) Prince
P. Demidoff, San Donato near Florence (however the painting
does not appear in any of the Demidoff sales); Alphonse Allard,
Brussels, 1882 (see exh.); sale Prosper Grabbe from Brussels, Paris,
12 June 1890, no. 33, ill. (9000 frs.); with dealer Charles
Sedelmeyer, Paris, cat. 1898, no. 38, ill.; in 1890 sold to the Princes
of Liechtenstein, Vaduz, formerly in Vienna, cat. 1931, no. G904;
acquired from Edward Speelman in 1968.

EXHIBITIONS: Brussels, *Exposition Néerlandaise de Beaux-Arts
organisée au bénéfice de la Société Néerlandaise de Bienfaisance à
Bruxelles*, 1882, no. 80 (lent by Alphonse Allard); Lucerne,
Kunstmuseum, *Meisterwerke aus den Sammlungen des Fursten von
Liechtenstein*, 5 June–31 October 1948, no. 161; London 1988,
no. 23.

LITERATURE: Hofstede de Groot, vol. 8 (1927), nos. 135 and
1177h; Hans Volhard, *Die Grundtypen der Landschaftsbilder Jan van
Goyen und ihre Entwicklung*, dissertation (Halle, 1927), p. 186;
A. Kronfeld, *Führer durch die Fürstlich Liechtensteinsche Gemälde
Galerie in Wien*, (Vienna, 1931), no. G904; Beck, vol. 2 (1973), no.
76, ill.; Saskia Nihom-Nijstad, *Reflets du siècle d'or. Tableaux
hollandais du dix-septième siècle*. Collection Frits Lugt, Fondation
Custodia, Institut Néerlandais, Paris, 10 March–30 April 1983,
p. 56, note 4.

CONDITION NOTES: The panel has been thinned and cradled, and
approximately ¼ in. (5 mm.) wood strips have been added on all
sides. There is an old split in the panel 1⅝ in. (4 cm.) from the top
left and old insect damage on the upper edge. The paint film has
been extensively abraded and retouched, especially in the sky and
around the spires in the centre distance. There is also scattered
inpainting in the ice, and extensive retouching along the lower and
two side edges. The varnish is moderately discoloured. On the
back are the sticker of the Lucerne show of the Liechtenstein
collection in 1948, the red seal of Liechtenstein, and the inventory
numbers '141' and '269'.

The broad panorama of a frozen river is populated by
numerous skaters. On either side small points of land
extend a short distance into the scene. A couple stand and a
man sits on the spit at the left while before them the
occupants of two horse-drawn sleighs have stopped to
converse. Farther to the right are other skaters, a boy has
fallen and lost his hat and another boy has a dog. In the
centre a couple approaches the viewer as two youths skate
away. On the right are two sledges and three 'colf' players.
On the shore on the right are boats frozen in the ice. Many
small figures, sleighs and sledges appear in the distance. On
the horizon is the profile of the city of 's-Hertogenbosch
with the cathedral in the centre.

Panoramic landscapes on dry land had appeared earlier in
the paintings of Hans Bol and in the more naturalistic
drawings of Hendrick Goltzius, and were fully developed in
works by Hercules Segers. Panoramic winter scenes played
out across frozen canals and rivers, with elevated horizons
and an encyclopaedic account of Dutch society, were first
painted in the early seventeenth century by artists like
Hendrick Avercamp (q.v.). Van Goyen's first panoramic
winter views with low horizons were painted in 1638,[1] and
by 1641 he had eliminated the more traditional use of
coulisses, or 'wings', which had framed his earlier
compositions.[2] He subsequently executed unobstructed
winter panoramas in both vertical and horizontal formats;
however, as Saskia Nihom-Nijstad has observed, the only
other horizontal winter panorama dated 1646 is the
painting in the Lugt Collection (fig. 1).[3] Van Goyen
depicted other identifiable cities in his winter scenes, most
frequently Dordrecht, but this apparently is his only view of
's-Hertogenbosch. Especially effective in the Samuel
painting is the rapid recession and expanse of the
panorama, and the misty prospect of the city's profile on
the horizon.

According to Hofstede de Groot and Beck, the painting's
earliest known owner was the Russian Prince Paul
Demidoff (1839–85), who assembled a dazzling collection
of paintings and other works of art in his palace at San
Donato in Florence. However this painting did not figure
in any of the several sales of his collection (13 January 1863;
26 February 1863; 3 February 1868, or the sale with the
greatest of his Dutch and Flemish paintings, 18 April 1869).
Demidoff owned famous works by ter Borch (now in the
Metropolitan Museum in New York and National Gallery,
London), Steen (now in the Philadelphia Museum of Art),
Metsu (Metropolitan Museum), Rembrandt, Hobbema,
Cuyp, and many others, including Teniers' *Five Senses* (see
Cats. 67–71).[4] Alphonse Allard, who owned the painting in

1882 in Brussels, was 'Directeur de la Monnaie'. The painting later passed in 1891 into the collection of the Princes of Liechtenstein, hung in Vienna and was exhibited in Lucerne in 1948. The Liechtenstein Collection is now installed in Schloss Vaduz, but the van Goyen was de-accessioned sometime after 1948 (see exh.).[5]

1 See the paintings signed and dated 1638: Beck, vol. 2 (1973), no. 51 (Stedelijk Museum 'de Lakenhal', Leiden, and no. 968, Frits Markus Collection).

2 See Beck, vol. 2 (1973), no. 56 (Hermitage, St Petersburg, inv. no. 5614, signed and dated).

3 Nihom-Nijstad, *Reflets du siècle d'or*, Institut Néerlandais, Paris, 1983, cat. no. 33; see also Hofstede de Groot, vol. 8 (1923), no. 38; Beck, vol. 2 (1973), no. 75, ill. An upright winter scene (panel 36.5 × 34 cm.) with a signal tower is also dated 1646; see Beck, vol. 2 (1973), p. 16, no. 30, ill.

4 On Demidoff, in addition to the deluxe sale catalogues, see C. da Prato, *Firenze ai Demidoff, Pratolino e San Donato* (Florence, 1886); Charles Blanc, 'Une Visite à San Donato', *Gazette des Beaux-Arts*, vol. 16 (1877), pp. 5–19, 201–11 and 410–21; and Fabia Borroni Salvadori, 'I Demidoff Collezionisti a Firenze', *Annali della Scuola Normale Superiore di Pisa*, Serie 3, vol. 11, no. 3 (Pisa, 1981), pp. 937–1003.

5 On the Liechtenstein collections, See Reinhold Baumstark, *Masterpieces from the Collection of Princes of Liechtenstein* (New York, 1980); and New York, Metropolitan Museum of Art, *Liechtenstein: The Princely Collections*, 26 October 1985–1 May 1986.

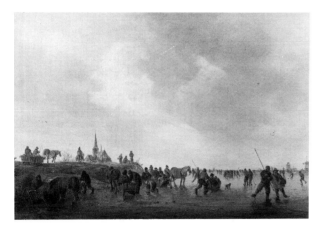

FIG. 1 Jan van Goyen, *Winter Landscape with Skaters*, signed and dated 1646, oil on panel 39 × 58 cm., F. Lugt, Fondation Custodia, Institut Néerlandais, Paris, inv. no. 394.

CAT. 22

Hofstede Arnestein, with Middleburg in the Distance, 1646

Signed and dated on the boat in the centre:
Jv (ligated) Goyen 1646
Oil on panel 25¼ × 35¼ in. (64 × 89.5 cm.)

PROVENANCE: (Possibly) sale Thomas Sivright, Edinburgh, 1 February 1836, no. 2911 (£11.0.6); Lilienfeld Galleries, New York, 1939 (see exh.); Adolf Mayer, The Hague and New York, 1948 (see exh.); with Edward Speelman, London, before 1959; J. Guedes de Souza, Lisbon; acquired from Edward Speelman in 1962.

EXHIBITIONS: The Hague, *Oude Kunst uit Haagsch Bezit*, 1936/7, no. 86; Detroit, The Detroit Institute of Arts, *Loan Exhibit of Dutch Landscape Paintings. The Twentieth Loan Exhibition of Old Masters* (cat. by E. P. Richardson), 3-26 February 1939, no. 14; Oberlin, Ohio, Oberlin College, *A Loan Exhibition of Dutch and Flemish Paintings. The Collection of Adolf Mayer* (cat. by Wolfgang Stechow) (*Bulletin of the Allen Memorial Art Museum*, vol. 5, no. 1 (January 1948)), pp. 5, 15, no. 4.; London 1988, no. 24.

LITERATURE: H. van de Waal, *Jan van Goyen* (Amsterdam, 1941), p. 43, ill.; Anna Dobrzycka, *Jan van Goyen* (Poznań, 1966), no. 167 [with the dimensions 67 × 94 cm.]; Beck, vol. 2 (1973), p. 346, no. 769, ill., vol. 3, (1987), p. 235; Speelman 1988, p. 14.

CONDITION NOTES: The panel support has been thinned and heavily cradled. It is made of three pieces of wood joined horizontally; one seam is 7⅞ in. (19.8 cm.) from the bottom, the other is 6⅝ in. (16.9 cm.) from the top. There is some old insect damage in the lower centre about 2½ in. (6.4 cm.) from the bottom. The paint film is in good state with some inpainting along the lower edge as well as the two horizontal seams. Additional inpainting is scattered throughout the sky. The varnish is mildly discoloured and rubbed along the lower edge. An especially thick but narrow strip of discoloured varnish around the edges suggests that the painting was once cleaned in its frame.

An old castle with tall square tower and gabled roof rises on a bulwark beside a canal on the left. In the centre, a small bridge spans a side canal. Before it sit two men in a boat and a fisherman drags a net in the foreground held by two others on the far shore. Several figures are on the bridge and road and in the middle distance. On the right a man and woman dance to the music of a fiddler and lovers appear beside haystacks. Beyond these broad fields the profile of the city of Middleburg rises on the horizon.

Most of the castles, villas and homesteads which appear in van Goyen's works are imaginary (see Cat. 19), but Beck has correctly observed that the large structure at the left in the Samuel painting is probably Gut Arnestein, situated on the outskirts of Middleburg.[1] The painting was identified as a 'View of Middleburg' in the early literature and in the catalogues of the exhibitions held in 1936/7, 1939 and 1988; only Stechow, writing in the exhibition catalogue of 1948, disagreed, stating that 'the identification of the town in the distance with Middleburg is incorrect', and titling the picture simply 'Fishermen near an Old Castle'.[2] However, the profile of the distant city includes a church spire that resembles the Dom in Middleburg and Beck's identification of the villa as Hofstede Arnestein is supported by comparison with a print of 1743 (fig. 1) depicting the structure, from *Het Verheerlijkt Nederland*, Part 5 (Amsterdam, 1754), no. 2.[3]

The subdued tonality, limited palette and thin paint application of the painting are characteristic of van Goyen's art of the mid-1640s; compare the *Winter Landscape* (Cat. 21), also dated 1646. Elements of this work's design – such as the tower at the left, the water-filled foreground, the central foot bridge and distant city profile – had already appeared in van Goyen's drawings as early as c. 1629/31.[4] No doubt responding to the lively activity in the foreground and the field at the right, E. P. Richardson commended this painting's 'cheerful bustle of human life. The hum of the activities of a busy, inhabited land is heard as a constant undertone beneath the greater harmony of earth and sky'.[5] Stechow discussed the painting's restricted tonality as typical of van Goyen's works from 1646, adding that 'It also shows the beginning of a somewhat greater emphasis on larger and darker masses which characterize the last years of van Goyen's activity as well as the entire output of the succeeding generation. The spirited crispness in the "shorthand" intimations of the foliage and the distant town belong with the properties which separate the master's own works from the weaker efforts of imitators which are so frequently mistaken for his.'[6]

1 Beck, vol. 2 (1973), p. 346, no. 769. He also tentatively identified Middleburg as the city represented in a river landscape in the M. B. Asscher Collection, London, c. 1952, (Beck, vol. 2 (1973), no. 404).
2 W. Stechow, in *A Loan Exhibition of Dutch and Flemish Paintings, The Collection of Adolf Mayer* (Oberlin, 1948), p. 15.
3 See also J. A. B. M. de Jong, *Zeeland in Prent* (Zaltbommel, 1967), n.p., ill.
4 Compare, for example, his drawing of the *Village Church at Lis*; Beck, vol. 3 (1987), no. 21, ill. (from 'Sketchbook B', c. 1629/31).
5 Detroit exh. 1939, n. p., under no. 14.
6 Oberlin exh. 1948, p. 5, no. 4.

FIG. I *Hofstede Arnestein near Middleburg*, engraved illustration from *Het Verheerlijkt Nederland; Kabinet van hededaagsche gezichten*, published by Isaak Tirion, Part 5 (Amsterdam, 1754), no. 2.

CAT. 23

An Estuary with Boats, after 1650

Monogrammed and indistinctly dated on the
rowing-boat on the left: VG. 165(?)
Oil on panel 12⅞ × 16⅝ in. (31.9 × 42.3 cm.)

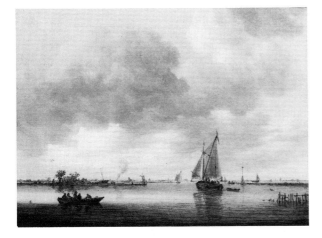

PROVENANCE: Sale Victor Alexander Baron Wrottesley, London
(Sotheby's) 10 July 1968, no. 3, ill. (£27,000 to E. Speelman);
acquired in 1968 from Edward Speelman.

EXHIBITION: London 1988, no. 21, ill. p. 16 [as dated 1636].

LITERATURE: Beck, vol. 2 (1973), no. 908, ill.

CONDITION NOTES: The panel support has additions on all sides;
the overall dimensions are 12⅞ × 17⅛ in. (33 × 43.5 cm.). The
paint film is generally in very good condition. There are minor
retouches in the upper right and lower left corner. An old scratch
has been repaired in the upper right. Additional small retouches are
scattered in the water and sky. The varnish is clear.

In a wide estuary a rowing-boat with five passengers
appears on the left. To the right is a sailing-boat towing a
dinghy. Further to the right, on a low point of land in the
middle distance, is a tall channel marker. Another narrow
strip of land extends into the water on the left, with shacks
and the rising smoke of a fire. In the background the sails of
other boats are visible, and the shapes of windmills and
churches dot the horizon.

 Although the painting was said to be dated 1636 when it
appeared in the 1968 sale, when acquired from Edward
Speelman and when exhibited in 1988, only the first three
digits are now decipherable: 165(?), which indicates that the
work was painted in the last six years of van Goyen's life.
Without having personally examined the work, Beck

plausibly suggested a date of 'around 1650'.[1] The com-
position, with the rowing-boat on the left counterbalancing
a sailing-boat heading out on the right toward an opening
between two narrow spits of land, was one that van Goyen
had favoured in the latter half of the 1640s and developed
further in the following decade.[2]

 Van Goyen began painting marines in the mid-1630s,
probably under the influence of Jan Porcellis, and dis-
tinguished himself as one of the most astute observers of
the ever-changing sea and moist sky of the Dutch water-
ways. His sketchbooks attest to the fact that he made
drawings from a small boat, travelling on Holland's rivers,
canals and estuaries. Many of his small-scale seascapes date
from the early 1650s. They belie their diminutive dimen-
sions in the suggestion of expansive horizons, towering
skies, and palpable atmosphere. In a later work such as this,
however, van Goyen did not hesitate to introduce a
startling accent of colour, such as the red spark of a fire that
appears in the middle distance.

1 Beck, vol. 2 (1973), p. 409, no. 908.
2 Compare the paintings dated 1646 (in the collection of Dr
 Frey, Zurich, 1962; Beck, vol. 2 (1973), no. 861, ill.) and 164(8)
 (Musée Royal des Beaux-Arts, Brussels, no. 1064; Beck, vol. 2
 (1973), no. 813, ill.) as well as the undated paintings in the
 collections of the Duke of Northumberland and the Marquis of
 Bath (respectively Beck, vol. 2 (1973), nos. 829 and 838, ills.).

FRANS HALS

(ANTWERP C. 1582/3–1666 HAARLEM)

Born in Antwerp, probably in 1582/3, Frans Hals was the son of Franchois Hals, a cloth-dresser from Mechelen, and Adriana van Geertenryck. After August 1585, when Franchois was registered as a Catholic member of Antwerp civic guard,the Hals family emigrated to the Northern Netherlands. They had settled in Haarlem by 19 March 1591, when Dirck Hals (1591–1656), Frans' younger brother and subsequently an accomplished genre painter, was baptized. A note in the posthumous second edition of Karel van Mander's *Het Schilder-Boeck* (1618), records that Hals studied with van Mander (1548–1606). This supposed apprenticeship would have taken place before 1603, when van Mander left Haarlem. Hals entered the St Luke's Guild in 1610 and the following year dated his earliest work, the *Portrait of Jacobus Zaffias*, Archdeacon of the church of the St Bavo (Frans Halsmuseum, Haarlem, no. 486). Frans Hals was a member of the St George Civic guard from 1612 until 1624. Throughout his career he was repeatedly commissioned to paint group portraits of officers of the St George and St Hadrian companies, all of which are now preserved in the Frans Halsmuseum. Hals' first wife, Annetje Harmansdr, died in June 1615, leaving the artist with two dependent children. From before 6 August 1616, and until 11–15 November 1616, the artist travelled to Antwerp, apparently the only time that he left Holland. On 12 February 1617, he married Lysbeth Reyniersdr in Spaarndam. The couple had eight more children, at least three of whom – Frans the younger (1618–69), Reynier (1627–71), and Nicolaes (1628–86) – became artists. However, Hals' son Pieter was an imbecile who required public support, and his daughter Sara was committed to the workhouse by her parents in 1642 following the birth of her second illegitimate child. In 1629, Hals was paid to restore paintings from the Commanderie of the Knights of St John, which had been transferred to the Prinsenhof in Delft. On 4 September of this year Judith Leyster complained to the guild authorities that Hals had lured away one of her pupils. The following year he refused a formal summons to travel to Amsterdam to complete the militia company portrait known as the *Meagre Company* (Rijksmuseum, Amsterdam),

which eventually was finished by Pieter Codde in 1637. In his *Beschrijvinge ende lof der Stad Haerlem* (1628), Samuel Ampzing praised Hals' ability to capture the life of his sitters; this opinion was reiterated in Theodor Schrevelius' *Harlemum sive urbis Harlemensis incunabula* (Dutch edition, 1648).

Several documents (dated 1629, 1634 and 1661) mention Hals buying paintings at auction; and before 6 November 1642, he and several fellow artists signed a recommendation to the Haarlem burgomasters to eliminate restrictions on art sales in the city. Hals also was asked to appraise paintings in 1662. On 17 January 1640, he was behind in his rent for a house in the alleyway off Lange Begijnenstraat, two years later was living in the Kleine Houtstraat, and in 1644 had an address on the Oude Gracht. In the same year he became a warden of the guild of St Luke. He was confirmed in the Reformed Church in 1655.

Hals' fortunes evidently declined in his later years. In 1654, he paid off a debt to a baker by surrendering household goods including several paintings by Karel van Mander, Maerten van Heemskerk and others. In view of his advanced age, Hals was exempted from paying his annual dues to the Guild of St Luke in 1661. In 1662–6, he requested a pension of 200 guilders; in 1664 he received three cartloads of peat and his rent was paid for him. Despite the evidence of financial hardship, Hals remained active until the end of his life, painting the portraits of the regents and regentesses of the Old Men's almshouse in Haarlem in 1664. Hals was buried in the choir of St Bavo's church in Haarlem on 1 September 1666.

LITERATURE: Karel van Mander, *Het Schilder-Boeck* (2nd edn, 1618), fol. 130; Samuel Ampzing, *Beschrijvinge ende lof der Stad Haerlem* (1628), p. 371; T. Schrevelius, *Harlemias: Of de eerste stichting der stad Haerlem* (Haarlem, 1648), p. 289; C. de Bie, *Het Gulden Cabinet* (1661), p. 281; Houbraken, vol. 1 (1718), pp. 90–5; Descamps 1753–64, vol. 1, pp. 360ff; Thoré-Bürger, 'Frans Hals', *Gazette des Beaux-Arts*, ser. 1, vol. 24 (1868), pp. 219–32, 431; Wilhelm von Bode, 'Frans Hals und seine Schule', *Jahrbuch für Kunstwissenschaft*, vol. 4 (1871), pp. 1–6; Wurzbach, vol. 1 (1906) pp. 636–41; J. G. Veldheer, C. J. Gonnet and F. Schmidt-Degener, *Frans Hals in Haarlem* (Amsterdam, 1908); Hofstede de Groot, vol. 3 (1910); E.W. Moes, *Frans Hals: sa vie et son œuvre* (Brussels, 1909); Wilhelm von Bode and M. J. Binder, *Frans Hals: Sein Leben und seine Werke*, 2 vols. (Berlin, 1914); Walter Rothes, *Franz Hals und die holländische Figurenmalerei*, Die Kunst dem Volke, nos. 41–2 (Munich, 1921); Hofstede de Groot, in Thieme and Becker, vol. 15 (1922), pp. 531–4; W. R. Valentiner, *Frans Hals*, Klassiker der Kunst, vol. 28 (Stuttgart, 1921); Abraham Bredius, 'Archief-sprokkels betreffende Frans Hals', *Oud-Holland*, vol. 34 (1923–4), pp. 19–20; F. Schmidt-Degener, *Frans Hals* (Amsterdam, 1924); F. Duhlberg, *Frans Hals: Sein Leben und seine Werk* (Stuttgart, 1930); W. R. Valentiner, *Frans Hals Paintings in America* (Westport, Conn., 1936); *Frans Hals* exh. Frans Halsmuseum, Haarlem, 1937; N. S. Trivas, *The Paintings of Frans Hals* (New York and London, 1941); Kurt Bauch, *Frans Hals* (Cologne, 1942); G. D. Gratama, *Frans Hals* (The Hague, 1943); Eduard Plietzsch, *Frans Hals* (Burg bei Magdeburg, 1944); C. H. van Heer, 'Archivalia betreffende Frans Hals en de zijnen', *Oud-Holland*, vol. 74 (1959), pp. 36–42; E. de Jongh and P. J. Vincken, 'Frans Hals als voorzetter van een emblematische traditie', *Oud-Holland*, vol. 76 (1961), pp. 117–52; Seymour Slive, 'Frans Hals Studies', *Oud-Holland*, vol. 76 (1961), pp. 173–200; H. P. Baard, *Frans Hals en het schutterstuk* (Amsterdam, 1962); *Frans Hals*, exh. (cat. by S. Slive) Frans Halsmuseum, Haarlem, 16 June–30 September 1962; Seymour Slive, *Frans Hals*, 3 vols. (London and New York, 1970–4); Claus Grimm, 'Frans Hals und seine Schule', *Münchner Jahrbuch der bildenden Kunst*, vol. 22 (1971), pp. 146–78; Claus Grimm, *Frans Hals: Entwicklung, Werkanalyse, Gesamtkatalog* (Berlin, 1972); Frances Suzman Jowell, 'Thoré-Bürger and the Revival of Frans Hals', *The Art Bulletin*, vol. 56, no. 1 (March 1974), pp. 101–17; Claus Grimm and E.C. Montagni, *L'Opera completa di Frans Hals* (Milan, 1974); Seymour Slive et al., *Frans Hals*, exh. cat. National Gallery of Art, Washington, Royal Academy of the Arts, London, Frans Halsmuseum, Haarlem, 1989–90; Claus Grimm, *Frans Hals. Das Gesamtwerk* (Stuttgart/Zürich, 1989).

CAT. 24

The Merry Lute Player, c. 1624–8

Signed with the monogram on lower right: F H (in ligature)
Oil on panel 35½ × 29½ in. (90.4 × 75 cm.)

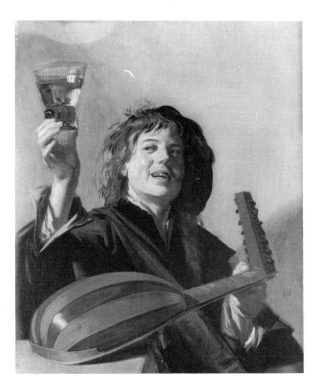

PROVENANCE: (Possibly) Sale P. van Capello, Amsterdam, 6 May 1767, no. 28 [as on canvas, 58 fl.]; bought in 1826 from Professor Fahlcrantz by the Counts Trolle-Bonde (see Granberg below); Count F. Bonde, Säfstaholm, 1885; dealer Martin H. Colnaghi, London; Jules Porgès, 1891 (see exh.); (probably) dealer Charles Sedelmeyer, cat. 1896, no. 19; Edmond Veil-Picard, Paris, by 1911 (see exh.); dealer Duveen, Paris and New York, c. 1933; John R. Thompson, Jr, Chicago, by 1925 (see exh.); sale J. R. Thompson, New York (Parke Bernet), 15 January 1944, no. 35; Oscar B. Cintas, Havana; sale Oscar B. Cintas, New York (Parke Bernet), 1 May 1963, no. 10 (to Speelman for Harold Samuel).

EXHIBITIONS: London, Royal Academy, 1891, no. 72 [as on canvas, lent by Porgès]; Paris, Musée Jeu de Paume, *Exposition rétrospective des grands et des petits maîtres hollandais*, 1911, no. 55 [lent by Viel-Picard]; Detroit, Detroit Institute of Arts, *Loan Exhibition of Dutch Paintings of the Seventeenth Century*, 9–25 January 1925, no. 4 [lent by Thompson]; London, Royal Academy, *Exhibition of Dutch Art, 1450–1900*, 4 January–9 March 1929, no. 372 [lent by Thompson]; Chicago, The Art Institute of Chicago, *A Century of Progress Exhibition of Paintings and Sculptures*, 1 June–1 November 1933, no. 62 [lent by Thompson]; Detroit, The Detroit Institute of Arts, *An Exhibition of Fifty Paintings by Frans*

Hals, 10 January–28 February 1935, no. 9 [lent by Thompson]; Haarlem, Frans Hals Museum, *Frans Hals Tentoonstelling ter gelegenheid van het 75-jarig bestaan van het Gemeentelijk Museum te Haarlem*, 1 July–30 September 1937, no. 30, fig. 31, [c. 1627, lent by Thompson]; New York, New York World's Fair, *Catalogue of European and American Paintings: 1500–1900, Masterpieces of Art*, May–October 1940, no. 82; Chicago, The Art Institute of Chicago, *Paintings by the Great Dutch Masters of the Seventeenth Century*, 10 November–16 December 1942, no. 11; London 1988, cat. 26, ill. p. 9.

LITERATURE: Olaf Granberg, *Sveriges privat tafelsamlingar* (Stockholm, 1885), p. 5, no. 4; Hofstede de Groot, vol. 3 (1910), no. 82; vol. 4 (1911), p. vi; Armand Dayot, *Des Grands et petits maîtres hollandais* (Paris, 1912), no. 57, ill.; Wilhelm von Bode and M. J. Binder, *Frans Hals, sein Leben und seine Werke*, 2 vols. (Berlin, 1914), vol. 1, cat. no. 58, ill.; W. R. Valentiner, *Frans Hals. Des Meisters Gemälde in 318 Abbildungen*, Klassiker der Kunst, vol. 28 (Stuttgart and Berlin, 1921), no. 55, ill. [c. 1627]; Arthur von Schneider, *Caravaggio und die Niederländer* (1933), p. 62, note 7; W. R. Valentiner, *Frans Hals Paintings in America* (Westport, Conn., 1936), p. 9, no. 20, ill. [dated to c. 1627; J. R. Thompson Coll.]; M. M. van Dantzig, *Frans Hals: echt of onecht* (Amsterdam/Paris, 1937), p. 12; N. S. Trivas, *The Paintings of Frans Hals* (London/New York, 1941), pp. 32–3, no. 27, pl. 40 [as on canvas, 'between 1625 and 1627'; J. R. Thompson Coll.]; J. Richard Judson, *Gerrit van Honthorst. A Discussion of his Position in Dutch Art* (The Hague, 1959), p. 66, note 3, fig. 77; Claus Grimm, *Frans Hals: Entwicklung, Werkanalyse, Gesamtkatalog* (Berlin, 1972), pp. 64, 70, 74, cat. 27, fig. 44; Seymour Slive, *Frans Hals*, 3 vols. (London, 1970–4), vol. 1, p. 88, vol. 2, pl. 48, vol. 3, p. 17, cat. no. 26 [about 1625]; Claus Grimm and E. C. Montagni, *L'Opera completa di Frans Hals* (Milan, 1974), p. 93, cat. 50, ill.; Woodhouse 1988, p. 126, fig. 7; Speelman 1988, p. 14; ill; Russell 1988, p. 788, ill.; Claus Grimm, *Frans Hals. Das Gesamtwerk* (Stuttgart/Zürich, 1989), pp. 214, 221, 273, fig. 86, and ill. on slip cover cat. 33 [c. 1626]; *Frans Hals*, cat. by Seymour Slive, Washington, National Gallery of Art, 1 October–31 December 1989, also shown at London, the Royal Academy of Arts, 13 January–8 April 1990 and Haarlem, Frans Halsmuseum, 11 May–22 July 1990, p. 172.

CONDITION NOTES: The panel support is cradled (9 vertical, 8 horizontal battens) and comprised of three pieces of wood with their grain running vertically. One seam is 7⅛ in. (18 cm.) from the left edge, the other is 9⅜ in. (23.8 cm.) from the right edge. An old split in the panel ascends part of the way up the panel from a point 6¼ in. (5.8 cm.) from the right lower edge; and a hairline fracture is 15½ in. (39.3 cm.) from the upper left edge. Retouches appear along all the edges but in general the paint film is in very good condition. A repentir appears at the top of the wine glass. In several passages of the figure (e.g. the hair and collar) the artist has left the pinkish ground as an intermediary tone and hue between his bravura blacks and highlights.

A young man with long blond tousled hair holds up a wine glass with his right hand and laughs. With his left hand he holds the neck of a lute which is striped in light and dark brown wood and has a red border. His loose-fitting dark blue costume has light blue cuffs. A beret rests jauntily on the back of his head. The corner of the table is pale green.

This painting is one of a group that Hals painted in the mid-1620s of life-size, half-length figures who drink or make music, wear fanciful theatrical costume, and are viewed in full daylight. As Valentiner noted, the motif of the raised glass appeared in Hals' painting of so-called *Jonker Ramp and his Sweetheart*, dated 1623 in the Metropolitan Museum of Art in New York (fig. 1).[1] It is generally agreed that Hals was probably first inspired to paint half-length genre figures by the Utrecht Caravaggisti, above all Hendrick Terbrugghen and Gerard van Honthorst.[2] Hals adopted motifs, designs and themes favoured by the Utrecht Caravaggisti but never embraced their more polished technique, retaining instead his own distinctly personal detached brush work. Moreover, he never experimented with the nocturnal lighting effects that they explored.

The single half-length genre figure was first introduced into the North by Caravaggio's Dutch followers from Utrecht; the earliest surviving dated examples are Hendrick Terbrugghen's pendants in the Museum in Kassel (GK 179 and 180), both dated 1621, Abraham Bloemaert's *Flute Player* of 1621 and Dirck van Baburen's *Lute Player* of 1622, both of which are in the Centraal Museum, Utrecht (respectively cat. (1952), no. 17, and inv. no. 11481). The subject and compositional type ultimately descend from Caravaggio, for example his single-figure *Lute Player* in St Petersburg (Hermitage, no. 217), but owes at least as great a debt to the intermediary images of Bartolommeo Manfredi (see, for example, his *Man Holding a Wineglass*, Galleria Estense, Modena). Slatkes demonstrated that the Caravaggesque innovations of the Utrecht painters had made their way to Haarlem as early as 1623.[3] Judson rightly stressed the resemblance between this painting and Honthorst's *Merry Fiddler* of 1623 in the Rijksmuseum (fig. 2), which depicts a similar laughing figure caught in a moment of exuberance as he throws back a curtain and bursts through a window into the viewer's space.[4] Grimm suggested that the closest formal connection with the Samuel *Lute Player* was Honthorst's *Merry Violinist* of c. 1624, in the Thyssen-Bornemisza Collection, Lugano (fig. 3), which also depicts the musician smiling and holding up his glass.[5] He also pointed to a possible source in a lost painting of a *Merry Violinist with a Glass* by Hendrick Terbrugghen only known through an engraving by T. Matham (fig. 4).[6]

In its half-length design, manner of paint application, and figure type, the Samuel painting closely resembles Hals' *Singing Boy with a Flute* in the Museum in Berlin (fig. 5) and his *Boy Holding a Skull* acquired in recent years by

the National Gallery, London (fig. 6).[7] Indeed the three paintings possibly represent the same model. Valentiner assumed without foundation that the young man was one of Hals' sons, and noted that Houbraken had reported in 1718 that according to J. Wieland, an aged amateur who claimed to have known Hals' children personally, all of them 'were vivacious spirits and lovers of song and music'.[8] However, Slive rightly stressed that the identification of the models remains tentative.[9] Other smiling half-length young men that Hals depicted may be compared to the Samuel *Lute Player*, including the so-called *Buffoon Playing a Lute* (Musée du Louvre, Paris, inv. R.F. 1984-32),[10] the *Two Boys Singing with a Lute* (Hessisches Landesmuseum, Kassel, cat. 1958, no. 215),[11] *Laughing Boy with Beer Jug* (Hofje van Aarden, Leerdam),[12] and the so-called *Finger-Nail Test* (Metropolitan Museum of Art, New York, no. 14.40.604).[13] The last mentioned depicts a laughing young man, who again may be the same model as in the Samuel painting, holding a lute and turning over a glass to demonstrate that he has drained it to the last drop. Valentiner suggested that the *Finger-Nail Test* 'forms a kind of companion piece' to the Samuel painting, inasmuch as the two are sequentially related by narrative;[14] however, the two differ in dimensions and support and surely were not designed as pendants.

The *Merry Lute Player* was dated c. 1627 by Valentiner, c. 1625–7 by Trivas, c. 1625 by Slive and 1626/7 by Grimm.[15] It undoubtedly postdates the *Jonker Ramp* of 1623 (fig. 1) which though expressively energized is less confident in handling; and possibly also follows the splendidly accomplished *Laughing Cavalier* dated 1624 (Wallace Collection, London, no. 84).[16] However, if one allows for the differences in support (the Samuel painting is exceptional among Hals' life-size genre scenes, and unusual even among the mature portraits, for being on panel), it shares aspects of execution and palette with the *Portrait of Isaac Massa* dated 1626 in the Art Gallery of Ontario, Toronto.[17] Thus the dated pictures suggest that Trivas' dating of c. 1625–27 is most acceptable, indeed it might even be expanded by a year on either end of its chronological brackets rather than posit, as some authors have, misleadingly narrow dates of origin.

The jaunty costume of the Samuel lute player is scarcely so outlandish as the striped outfit worn by the Louvre's lutenist or Hals' *Peeckelharing* in the Staatliche Kunstsammlungen, Kassel (inv. GK 216),[18] but, like his other musicians' costumes, it has seemed to some observers vaguely theatrical. Speculation has centred on the colourful attire of the Caravaggisti's musicians and drinkers, who are variously associated with street entertainers, Italian *bravi*, Dutch *rederijkers* (rhetoricians) and other theatrical types.[19] The costumes of seventeenth-century entertainers and thespians are still little understood, but it is certain that Hals was interested in the amateur world of drama since he was a member of the rhetoricians' chamber the 'Wijngaardranken' (The Vine Tendrils) in Haarlem from 1616 to 1624;[20] moreover, he depicted the well-known Leiden rhetorician Pieter van der Morsch in his painting in the Carnegie Museum of Art, Pittsburgh (inv. 61.42.2).[21]

The instrument depicted in the Samuel painting cannot be identified with certainty without seeing its front, however it appears to be a tenor seven-course lute, the most common type of lute. The nine staves of the lute's body alternate dark and light wood, reflecting common period practice. The solid pegboard, the sculpted border at the bottom (capping strip), and the size and pear-like shape of the body are all within reasonable tolerances of actual instruments of the period, if one allows for some distortions caused by the perspective.[22] Thus it seems probable that Hals painted an actual lute.

The provenance of the painting has been badly confused in the past with that of a copy or copies. The history of ownership first gathered in 1910 by Hofstede de Groot with assistants (vol. 3, no. 82) was mistaken, and was recanted in the following year (vol. 4, p. vi). However, Hofstede de Groot's revised provenance also incorporated mistakes corrected in part by Valentiner, Trivas, and more fully by Slive. A copy of the Samuel painting owned by Sir Edgar Vincent, Esher, Surrey, when Hofstede de Groot mistook its history for that of the original, was detected as 'a fake' by Valentiner.[23] Trivas reported that 'a modern copy (fake)' was with the Paris dealer Charles Sedelmeyer, cat. 1896, no. 19, and that this was the work that later entered the Vincent collection.[24] Slive correctly observed that nothing about the reproduction in the Sedelmeyer catalogue raised any doubts about that picture, adding that the provenance there provided (from Martin H. Colnaghi, who bought it in Stockholm; from the collection of Jules Porgès, who exhibited it at the Royal Academy, London, 1891) is consistent with that of the Samuel painting. However Slive was not able to confirm Hofstede de Groot's statement that the Samuel painting had been owned by the London dealer Wertheimer, the late Baron Ferdinand von Rothschild, Waddesdon Manor, and by the London dealer Gooden in 1896.[25]

1 W. R. Valentiner, *Frans Hals Paintings in America* (Westport, Conn., 1936), cat. no. 20.

2 See, as examples, Arthur van Schneider, *Caravaggio und die Niederlander* (1933), pp. 61–6; Seymour Slive, *Frans Hals* (London, 1970), pp. 84ff.; Claus Grimm, *Frans Hals* (Berlin, 1972), pp. 63–9.

3 L. J. Slatkes, review of Benedict Nicolson, *The International Caravaggesque Movement*, (Oxford, 1979), in *Simiolus*, vol. 12 (1981–2), pp. 173–5.

4 J. Richard Judson, *Gerrit van Honthorst. A Discussion of his Position in Dutch Art* (The Hague, 1959), p. 66, note 3, pp. 229–30, cat. 168, fig. 26.

5 Grimm 1972, p. 64; see Judson 1959, pp. 231–2, cat. 170, fig. 88; Ivan Gaskell, *Seventeenth-Century Dutch and Flemish Painting*. The Thyssen-Bornemisza Collection (London, 1990), no. 38, ill.

6 Ibid.; see Benedict Nicolson, *Hendrick Terbrugghen* (London 1958), cat. no. D88, plate 37c.

7 See respectively: Hofstede de Groot, vol. 3 (1910), no. 81; Valentiner, Klassiker der Kunst (1921), no. 55; Trivas 1941, no. 25; Slive 1974, cat. 25, pl. 45, 46; and Hofstede de Groot vol. 3 (1910), no. 102; Valentiner, Klassiker der Kunst (1921), no. 227; Trivas 1941, no. 26; Slive 1974, cat. 61, plates 97–9.

8 Valentiner, Klassiker der Kunst (1921), pp. 309–10, under cat. no. 52; see Houbraken, vol. 1 (1718), p. 93.

FIG. 2 Gerrit van Honthorst, *The Merry Fiddler*, signed and dated 1623, oil on canvas 108 × 89 cm., Rijksmuseum, Amsterdam, no. A180.

FIG. 1 Frans Hals, so-called *Jonker Ramp and his Sweetheart*, monogrammed and dated 1623, oil on canvas mounted on panel, 105.4 × 79.2 cm., Metropolitan Museum of Art, New York, no. 14.40.602.

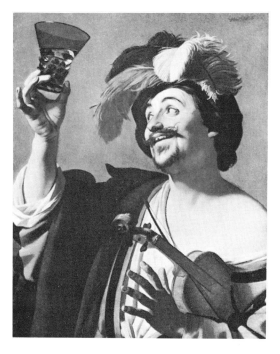

FIG. 3 Gerrit van Honthorst, *Merry Violinist*, c. 1624, signed, oil on canvas 82.5 × 87.5 cm., Thyssen-Bornemisza Collection, Lugano.

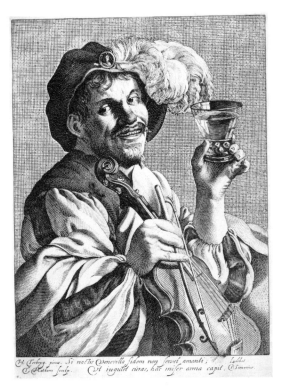

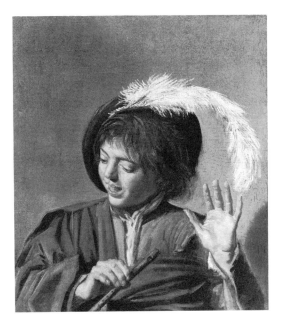

FIG. 5 Frans Hals, *Singing Boy with a Flute*, mono-grammed, canvas, 62 × 54.6 cm., Gemäldegalerie, Staatliche Museen Preussischer Kulturbesitz, Berlin, no. 801A.

FIG. 4 T. Matham, after Hendrick Terbrugghen, *Merry Violinist with a Glass*, engraving, 21.1 × 15.8 cm., Rijksprentenkabinet, Amsterdam.

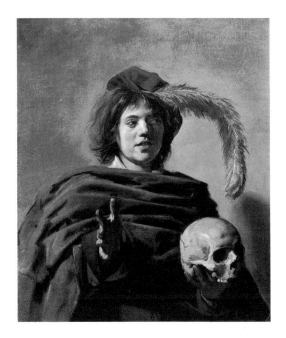

FIG. 6 Frans Hals, *Boy Holding A Skull*, oil on canvas 92.2 × 80.8 cm., National Gallery, London, inv. 6458.

9 Slive, vol. 3 (1974), p. 17; see also idem, in *Frans Hals*, exh. cat. Washington/London/Haarlem 1989–90, p. 172.

10 See Hofstede de Groot, vol. 3 (1910), no. 98; Valentiner, Klassiker der Kunst (1921), no. 29; Slive, vol. 3 (1974), no. 19, pl. 40.

11 See Hofstede de Groot, vol. 3 (1910), no. 134; Valentiner, Klassiker der Kunst (1921), no. 56; Trivas 1941, no. 14; Slive, vol. 3 (1974), no. 23, pl. 44.

12 See Hofstede de Groot, vol. 3 (1910), no. 125; Valentiner, Klassiker der Kunst (1921), no. 69; Trivas 1941, no. 15; Slive, vol. 3 (1974), no. 60, pl. 90.

13 See Hofstede de Groot, vol. 3 (1910), no. 86 and possibly 74; Valentiner, Klassiker der Kunst (1921), no. 59; Slive, vol. 3 (1974), no. 24, pl. 47.

14 W. R. Valentiner, *Frans Hals Paintings in America* (Westport, Conn., 1936) p. 9.

15 Valentiner, Klassiker der Kunst (1921), no. 55; Trivas 1941, no. 27; Slive vol. 3 (1974), no. 26; Grimm 1972, p. 64, cat. no. 27.

16 See Hofstede de Groot, vol. 3 (1910), no. 291; Valentiner, Klassiker der Kunst (1921), no. 38; Trivas 1941, no. 12; Slive, vol. 3 (1974), no. 30, pls. 52, 53, 55.

17 See Hofstede de Groot, vol. 3 (1910), no. 246; Valentiner, Klassiker der Kunst (1921), no. 45; Trivas 1941, no. 20; Slive, vol. 3 (1974), no. 42, pls. 64, 65.

18 See Hofstede de Groot, vol. 3 (1910), no. 95; Valentiner, Klassiker der Kunst (1921), no. 129; Trivas 1941, no. 35; Slive, vol. 3 (1974), no. 64, pls. 102, 104.

19 See, for example, Judson 1959, pp. 65–6; and C. Brown in exh. cat. Philadelphia/Berlin/London 1984, p. 212, who would place the iconography in the context of Northern Italian models related to the earthly delights of Bacchus and Venus.

20 See Irene van Thiel-Stroman, 'The Frans Hals Documents', in *Frans Hals* exh. cat. Washington/London/Haarlem 1989–90, p. 16, document no. 16.

21 Hofstede de Groot, vol. 3 (1910), no. 205; Valentiner, Klassiker der Kunst (1921), no. 11; Slive, vol. 3 (1974), no. 6, pls. 12, 13; see also P. J. J. van Thiel, 'Frans Hals' portret van de Leidse rederijker Pieter Cornelisz van der Morsch, alias Piero', in *Oud-Holland*, vol. 76 (1961), pp. 153–72.

22 I am grateful to Sam Quigley of the Musical Instruments Department, Museum of Fine Arts, Boston, for sharing these observations. He calls attention to a similar lute, illustrated by Joël Dugut, 'Some Lutes in Paris Museums, Part 2', *Journal of the Lute Society of America*, 1988, p. 94, ill.

23 See Valentiner, Klassiker der Kunst (1921), no. 58; see also E. W. Moes, *Frans Hals, sa vie et son œuvre* (Brussels, 1909), no. 214, where the Vincent Collection copy is cited as the original. Hofstede de Groot, vol. 3 (1910), no. 82, had noted that there was a 'modern copy in an English private collection' of the Samuel painting, then in the collection of A. V. Picard, Paris.

24 Trivas 1941, p. 33.

25 Slive, vol. 3 (1974), p. 17, cat. 26. Slive also cites several 'bad copies' of the head of the youth in the Samuel painting: sale C. Robertson of London, New York (Anderson Galleries) 20 February 1922, no. 129 (circular panel, diameter 16.2 cm.; Trivas (1941) cited the earlier provenance for this work as the collection of Sir Edward Hutchinson); Roberts Art Gallery, Toronto, 1923; sale R.S., Paris (Drouot), 11 March 1931, no. 49 (panel, 17 × 14 cm.).

CAT. 25 Follower of Frans Hals

The Lute Player

Signed with monogram upper right: FH (in ligature)
Oil on panel 7 × 7⅛ in. (17.8 × 18.1 cm.)

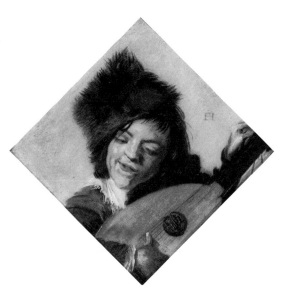

PROVENANCE: Baron von der Wense, Luneberg, dealer A. J. Drey, Munich, 1921; dealer Ch. A. de Burlet, Berlin, 1927; Etienne Nicolas, Paris, sold to Edward Speelman late in 1959; acquired from E. Speelman soon thereafter.

EXHIBITIONS: Paris, G. Neumans, 1925; London, Royal Academy, 1929, no. 56; London 1988, cat. 25.

LITERATURE: W. R. Valentiner, *Frans Hals*, Klassiker der Kunst (Stuttgart/Berlin, 1921), p. 285, ill.; Seymour Slive, *Frans Hals* (London, 1974), vol. 3, p. 136, no. D23, fig. 141; Claus Grimm and E. C. Montagni, *L'Opera completa di Frans Hals* (Milan, 1974), no. 314, ill.

CONDITION NOTES: The wood panel support has been thinned and cradled. An old split in the wood runs through the figure's forehead and his right cheek. Retouches appear along the edges, along the old break, and scattered throughout, especially in the uppermost corner. The thick varnish layer is discoloured.

A young boy viewed bust-length and wearing a fur cap and lace collar appears to tune a lute. The square panel has been turned on its end to create a diamond or lozenge-shaped format.

The traditional attribution to Frans Hals was accepted by Valentiner,[1] who drew attention to the close resemblance to Hals' diamond-shaped *Young Boy Playing a Violin* in a private collection in Montreal (fig. 1); the latter is the pendant to the *Girl Singing from a Music Book* (fig. 2).[2] However Slive and Grimm/Montagni correctly recognized that the Samuel painting is only the work of a follower.[3] The brushwork has the outward flourish of Hals' bravura stroke and even shows several spirited passages (such as the decorations scratched into the sound hole of the instrument), but little of the master's ability to define form.

The diamond or lozenge-shaped format was popular among Haarlem artists. It had been used by Goltzius for large history paintings with half and full-length and often dramatically foreshortened figures, and was later used for bust-length head studies by the Haarlem classicist, Pieter de Grebber.

1 Valentiner, Klassiker der Kunst (1921), p. 258.
2 See Hofstede de Groot, vol. 3 (1910), nos. 87 and 118; Valentiner, Klassiker der Kunst (1921), no. 68, upper and lower; Grimm 1972, p. 214 (both incorrectly as 'circle of Frans Hals'); Slive, vol. 3 (1974), nos. 53 and 54. Compare especially the large photographic detail of the *Boy Playing the Violin* illustrated by Slive in the exhibition catalogue *Frans Hals*, Washington/London/Haarlem 1989–90, under cat. no. 26, p. 204.
3 Slive, vol. 3 (1974), cat. no. 123; Grimm and Montagni 1974, no. 314.

FIG. 1 Frans Hals, *Young Boy Playing a Violin*, signed with the monogram, oil on panel 18.4 × 18.8 cm., Private Collection, Montreal.

FIG. 2 Frans Hals, *Girl Singing from a Music Book*, signed with the monogram, oil on panel, 18.2 × 18.4 cm., Private Collection, Montreal.

JAN VAN DER HEYDEN

(GORINCHEM 1637–1712 AMSTERDAM)

Originally from Flanders, the van der Heyden family settled in Bommal in the beginning of the seventeenth century. Jan van der Heyden's parents married in Utrecht in 1631 and soon thereafter moved to Gorinchem. The couple was Mennonite; Jan's father was by turns an oil mill owner, a grain merchant and a broker. The third of eight children, Jan was born on 5 March 1637, in Gorinchem. His oldest brother Goris made and sold mirrors. Jan first studied with a glass painter in Gorinchem before moving to Amsterdam, where he married Sarah ter Hiel of Utrecht on 25 June 1661. By this date he was already a practising artist, but no dated works are known before 1664. Between 1668 and 1671, Jan van der Heyden and his brother Nicolaes developed a pumping mechanism that greatly improved fire-fighting techniques; in 1673 he was appointed overseer of the city's fire departments. Further, in 1670 Jan was named overseer of Amsterdam street lighting. In 1679 he bought land on the Koestraat with the intention of building a house and fire engine factory. In 1690, Jan and his eldest son, Jan van der Heyden the Younger, published a large book on fire-fighting. The artist died in his house on the Koestraat at the age of seventy-five on 28 March 1712. His substantial estate was appraised at 84,000 guilders. In his possession at the time of his death were more than seventy of his paintings.

Jan van der Heyden was primarily a cityscape painter and draughtsman, and only rarely produced still lifes and landscapes. He occasionally collaborated with figure painters, such as Adriaen van de Velde (q.v.) and Jan Lingelbach (1622–74). The sites depicted in his works indicate that he travelled to the Rhineland and Southern Netherlands. The precision and specialized visual effects in his cityscapes suggest the use of lenses, mirrors and very possibly the camera obscura; however, these effects cannot be deduced in his landscapes. These number only about forty paintings but are varied in subject, including river valleys, hills, mountains and woods. His colleague Adriaen van de Velde apparently influenced him. Landscapes also figure among his few surviving paintings on glass (see Rijksmuseum, Amsterdam, inv. A 2511). Although no students are recorded, van der Heyden had numerous followers and imitators.

LITERATURE: Houbraken, vol. 3 (1721) p. 800; Weyerman, vol. 2 (1729–69) pp. 391–2; Descamps, vol. 3 (1753–64), pp. 48–52; Sir Joshua Reynolds, 'A Journey to Flanders and Holland in the Year MDCCLXXXI', in *The Literary Works of Sir Joshua Reynolds*, ed. H. W. Beechy, vol. 2 (London, 1851); Smith, vol. 5 (1835), pp. 369–411, vol. 9 (1842), pp. 668–79; G. K. Nagler, *Neues allgemeines Künstler-Lexicon* (Munich, 1835–52), vol. 6, pp. 168–9; Immerzeel 1842–3, vol. 2, pp. 37–8; Kramm 1857–64, vol. 3, pp. 687–8; G. K. Nagler, *Die Monogrammisten und die jenigen bekannten und unbekannten Künstler*, 5 vols. (Munich, 1858–79), vol. 3, no. 1647, vol. 4, nos. 570, 586; J. ter Gouw, 'Jan van der Heyden', in *Nederlands geschiedenis en volksleven*, vol. 4 (1872), no. 90; Obreen, 1877–90, vol. 4, p. 266; A. D. de Vries, 'Biografische aanteekeningen betreffende voornamelijk Amsterdamsche schilders, plaatsnijders, enz', *Oud-Holland*, vol. 3 (1885), p. 149; Wurzbach, vol. 1 (1906), vol. 3 (1911), p. 101; Hofstede de Groot, vol. 8 (1908–27) pp. 325–426; Bredius, 'De nalatenschap van Jan van der Heyden', *Oud-Holland*, vol. 30 (1912), pp. 129–51; John C. Breen, 'Jan van der Heijden', *Eigen Haard*, (1912), pp. 196–202, 215–20; C. G. 't Hooft, *Amsterdamsche stadsgezichten van Jan van der Heyden* (Amsterdam, 1912); A. Bredius, 'Twee schilderijen op glas van Jan van der

Heyden', *Oud-Holland*, vol. 31 (1913), pp. 25–6; J. C. Breen, 'Jan van der Heyden', *Jaarboek Amstelodamum*, vol. 11 (1913), pp. 29–92, 93–108, 109–18; Wilhelm von Bode, 'Jan van der Heyden', *Zeitschrift für bildende Kunst*, 26 (1915) pp. 181–7; Thieme and Becker, vol. 17 (1924), pp. 22–4; J. van Rijckevorsel, 'Jan van der Heyden in Nijmegen', *Oud-Holland*, vol. 50 (1933), p. 249; Martin, vol. 2 (1935–6) pp. 398–402; Amsterdams Historisch Museum, *Jan van der Heyden*, introduction by I. Q. van Regteren Altena (1937); A. C. van Eck, 'Jan van der Heyden', *Maandblad Amstelodamum*, vol. 24 (1937), pp. 33–6; J. G. van Gelder, 'Het werk van Jan van der Heyden in der Waag te Amsterdam', *Elsevier's geïllustreerd Maandschrift*, vol. 93 (1937), pp. 360–1; A. Heppner, 'Der maler und Erfinder Jan van der Heyden im Amsterdam Historischen Museum', *Internationale Kunstrevue* (1937), pp. 99–100; E. P. Richardson, 'A Painting by Jan van der Heyden and Adriaen van de Velde', *Bulletin of the Detroit Institute of Arts*, vol. 19 (1939–40), pp. 24–7; Heinreich Dattenberg, 'Wassertor zu Emmerich: Ein unveröffentliches Gemälde van Jan van der Heyden', *Die Heimat*, vol. 19 (1940), pp. 198–201; A. R. Kleyn, 'Jan van der Heyden', *Sibbe*, vol. 4 (1944), pp. 33–45; Neil Maclaren, *National Gallery Catalogue: The Dutch School* (London, 1960), pp. 156–63; Stechow 1966; H. Dattenberg, *Die Niederrheinansichten holländischer Künstler des 17. Jahrhunderts* (Düsseldorf, 1967), pp. 210–33; Helga Wagner, 'Jan van der Heyden als Zeichner', *Jahrbuch der berliner Museen*, vol. 12 (1970), pp. 111–50; H. Wagner, *Jan van der Heyden 1637–1712*, (Amsterdam and Haarlem, 1971); Bob Haak, review of H. Wagner (1971), in *Antiek*, vol. 7 (1972), pp. 53–4; I. H. van Eeghen, review of Wagner (1971), in *Maandblad Amstelodamum*, vol. 60 (1973), pp. 23–4; I. H. van Eeghen, 'Archivalia betreffenden Jan van der Heyden', *Maandblad Amstelodamum*, vol. 60 (1973), pp. 29–36, 54–61, 73–9, 99–106, 128–34; Egbert Haverkamp Begemann, review of Wagner (1971), in *Burlington Magazine*, vol. 115 (1973), pp. 401–2; Eric Jan Sluijter, review of Wagner (1971) in *Oud-Holland*, vol. 87 (1973), pp. 244–52; Lyckle de Vries, 'Post voor Jan van der Heyden', *Oud-Holland*, vol. 90 (1976), pp. 627–75; Gary Schwartz, 'Jan van der Heyden and the Huydecopers of Maarsseveen', *The J. Paul Getty Journal*, vol. 2 (1983), pp. 197–220; Haak 1984, pp. 483–5; L. de Vries, *Jan van der Heyden* (Amsterdam, 1984).

CAT. 26

View of the Boterbrug with the Tower of the Stadhuis, Delft, mid to later 1650s

Signed on the right: VHeÿde(n)
Oil on panel 21⅞ × 28 in. (55.5 × 71.2 cm.)

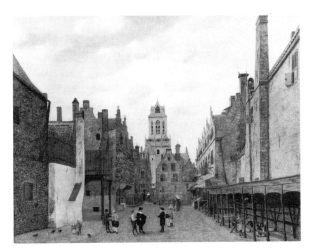

PROVENANCE: John Pemberton Heywood of Norris Green, Lancashire, and Cloverly Hall, Shropshire; sale J. Pemberton, London, 10 June 1893, no. 5 (£635 5s); Thomas M. Davis, Newport, Rhode Island, by 1909; presented by Davis in 1930 to the Metropolitan Museum of Art, New York, inv. no. 30.95.298; de-accessioned in 1972 (by partial exchange for a Carlo Saraceni) to the London dealer Julius Weitzner; acquired from Edward Speelman in 1972.

EXHIBITIONS: New York, Metropolitan Museum of Art, *The Hudson Fulton Celebration*, cat. by W. R. Valentiner, vol. 1, 1909, no. 44, ill. (lent by T.M. Davis); Dallas, Dallas Museum of Art, *30 Masterpieces. An Exhibition of Paintings from the Collection of the Metropolitan Museum of Art*, 4 October–23 November 1947, n.p., ill; Hartford, Wadsworth Atheneum, *Life in XVIIth Century Holland*, November 1950–January 1951, no. 4; University of California at Los Angeles, 15 March–30 April 1954 (no catalogue); Colorado Springs Fine Arts Center, 15 June–31 July 1955 (no catalogue); London 1988, cat. 32.

LITERATURE: W. Roberts, *Memorials of Christie's* (London, 1897), vol. 2, p. 217; C. G. 't Hooft, *Amsterdamsche stadsgezichten van Jan van der Heyden* (Amsterdam, 1912), p. 7; Hofstede de Groot, vol. 8 (1927), no. 54; Wagner 1971, p. 35, ill.; Speelman 1988, p. 15; Russell 1988, p. 788.

CONDITION NOTES: The panel support is comprised of two planks held together by butterfly keys; the join is 11½ in. (29.3 cm.) from the top. Uncradled, the panel is bevelled on all sides and appears to be complete. The paint film shows innumerable old losses and retouchings, surely the result of flaking in the past. There is extensive retouching in the sky, especially in the upper

right, in the herringbone brickwork of the square and along the lower edge. Photographs taken when the painting was treated at the Metropolitan Museum of Art in 1927 (negative nos. L1046/6302 A–C) show considerable active flaking, while the post-treatment photos (nos. 80246/6302g A–C) confirm that some old retouching was not removed. The back of the panel was waxed in 1937. The paint layer has also suffered abrasion from past cleanings. Nonetheless extensive underdrawing is visible with infra-red, and some changes in the final painted design are visible in details such as the spherical decorations on the gables at the left, and in the orthogonal lines of recession drawn between the gables on the right. Small adjustments appear in several places; for example the width of the chimney on the right was reduced. Underdrawn orthogonals are also visible in the foreground, e.g. along the base of the stays of the kiosks at the right. A thick discoloured varnish layer masks the surface.

In Delft a view stretches from the bridge known as the Boterbrug down the little plaza (also called the Boterbrug) which runs perpendicularly into the Wijnhaven (or Wijnstraat). Rising at the end of the street is the tower of the Stadhuis or Town Hall on the Groote Markt. On the right are empty market stalls, which would be filled on market day. They stand before a tall wall broken only by two windows and a chimney. Further on rises a large building with seven small stepped gables and the signboards of shops at street level. One shop has poultry cages and another features a signboard with a barrel between two vases. On the opposite side of the plaza are other houses with gabled facades; one half way up is dated (15)92. In the street stand two boys and two groups of men conversing, and on the left are children playing with a hoop and some chickens. Five other figures gather beneath the market stalls. At the end of the street a couple stands talking while a woman with a market basket walks toward the Groote Markt.

The Town Hall and Boterbrug in Delft still exist, but the appearance of the buildings on either side of the plaza and at the end of the street have changed. As Wagner noted, the street's eighteenth-century appearance is recorded in L. Schenk's engraving in *Gesigten van de Wydberoemde Stad Delft* (1736) (fig. 2).[1] An anonymous eighteenth-century drawing preserved in the Prinsenhof in Delft shows the Boterbrug with the Engelse Court or cloth market filled with busy shoppers and merchants (fig. 3). Its background is fantasized but the market stalls are probably accurately depicted. The square's appearance in the mid nineteenth century is recorded in a drawing from a viewpoint similar to that of the van der Heyden, signed 'CJH' and dated 3 June 1867, in the G. Langvelt Collection, The Hague.[2] In the Samuel painting van der Heyden has offered a faithful account of the site as it appeared in his day.

Van der Heyden repeatedly painted several Dutch cities (for example, Amsterdam, Leiden, Maarsen, Veere) as well as a few foreign cities including Brussels, Cologne and Düsseldorf, see Cat. 28. He depicted sites in Delft at least five times, representing besides the present scene, the Oude Delft with a view of the Oude Kerk (two variations, see fig. 1),[3] the Oude Delft with a view of the Gemeenlandshuis,[4] and the Oost Poort.[5] Wagner suggested that the first four Delft paintings constituted a series, analogous to series in topographic prints, and hypothesized that the Detroit painting (fig. 1) was a pendant to the Samuel picture.[6] While the two are close in style and dimensions, their pendantship is undocumented and less than fully persuasive when one compares viewpoint and details of execution. Nonetheless she may be correct in characterizing these works as the first true city views in van der Heyden's œuvre. To judge from the costumes of the figures in the Samuel painting, this work is probably an earlier work dating from the mid to late 1650s.[7] This was the decade when the so-called Delft school, including architectural painters such as Gerrit Houckgeest and Emanuel de Witte, as well as Carel Fabritius, Pieter de Hooch and Johannes Vermeer, was first developing the cityscape as a discrete sub-category of landscape and exploring expressive new uses of architectural space in church paintings and interior genre scenes. While the individual contributions of those various pioneers have yet to be fully specified, van der Heyden through his demonstrated early presence in the city may have played a significant role. The lightened tonality and rigorous perspective of this scene attest to his acquaintance with the most up-to-date artistic ideas then circulating in Delft.

The early provenance of the painting remains undiscovered, but after passing through the Pemberton sale in London in 1893, it was acquired by the wealthy Newport connoisseur and Egyptologist, Theodore M. Davis (died 1915), who bequeathed it with other Old Master paintings and antiquities to the Metropolitan Museum of Art in New York. The painting's attribution to van der Heyden was questioned (verbally) by J. G. van Gelder and David Röell in February 1954, the latter suggesting an alternative and unpersuasive attribution to Emanuel Murant (1622–c. 1700). Daan Cevat (verbally 1966) also challenged the attribution to van der Heyden, claiming that the painting was not even of the period and might be a copy. In the records of the Metropolitan Museum, Albert Blankert was alone in supporting (verbally 1969) the attribution to van der Heyden. The state of the picture was further impugned in conservator's records. In 1973, the Museum de-accessioned the work, offering it in partial exchange for a

Carlo Saraceni to the London dealer Julius Weizner. At the time, the museum's director, Thomas Hoving, described the painting to the press as 'a deteriorated work, not repairable'.[8] While the painting has certainly suffered from flaking and abrasion, its state is scarcely ruined and still permits an accurate appraisal of van der Heyden's pioneering early talents as one of the most accomplished draughtsmen and painters of cityscapes. Part of the criticism of the picture when it was exchanged was that the 'high degree of finish which is one of the characteristics of . . . this art [was] irretrievably lost', however to judge from the other early Delft period pictures this picture never had a high polish but favoured the matt finish of the Delft period pictures by Houckgeest and De Hooch.

An eighteenth-century watercolour copy of this painting was formerly in the Bredius Museum, The Hague.[9]

1 Wagner 1971, p. 74.
2 RKD Tographical Department, neg. no. L37563.
3 See fig. 1 (Wagner 1971, cat. no. 32) and Nasjonalgalleriet, Oslo, no. 106, signed and dated 1675 (Wagner 1971, no. 33, ill. p. 133).
4 Private Collection, England; see Wagner 1971, no. 34, ill. p. 34. She notes that the actual architecture has been imaginatively adjusted.
5 Wagner 1971, no. 36, ill. p. 34.
6 See Wagner 1971, p. 57. Wagner hypothesized, perhaps correctly, that the figures in the Detroit painting were added later, because she assumed that their costumes were too late to justify the early date suggested by the painting's style.
7 The authors of the Hartford exh. cat. 1950–1, no. 4, as well as other observers wrongly assumed that the painting itself, rather than the house it depicted, was dated [15]92.
8 Undated clipping from the *International Herald Tribune* (RKD).
9 Albert Blankert, *Catalogus van de schilderijen en tekeningen Museum Bredius, The Hague* (Zwolle, 1991) pp. 34 and 259, 'Prins naar van der Heyden'.

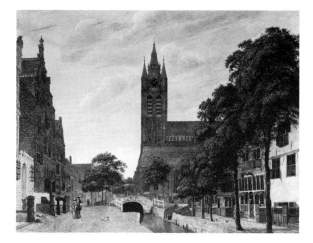

FIG. 1 Jan van der Heyden, *The Oude Delft with a View of the Oude Kerk*, c. 1655? oil on panel 55 × 71 cm., The Detroit Institute of Arts, Detroit, no. 48.218.

FIG. 2 L. Schenk, *The Boterbrug with View of the Town Hall, Delft*, engraving from *Gesigten van de Wydberoemde Stad Delft* (1736).

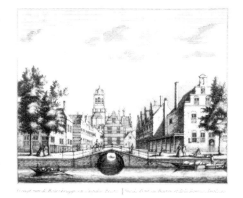

FIG. 3 Anonymous eighteenth-century artist, *The Boterbrug and Engelse Court*, pen and wash drawing, Museum het Prinsenhof, Delft.

CAT. 27

An Imaginary Town Gate with Triumphal Arch, 1663

Signed (indistinctly) but clearly dated 1663 on the coping of slanted wall of the steps lower left
Oil on panel, originally 11⅞ × 14¼ (30 × 36.4 cm.), with added strips: 12¼ × 14¾ in. (31 × 37.5 cm.)

PROVENANCE: John Walter, Bear Wood, Berkshire; George Field, 1893 (see exh. 1949); Alfred Beit, London, cat. 1904, p. 20; Otto Beit, London, cat. 1913, no. 27; Sir Alfred Beit, London and Blessington; acquired from Beit in late 1959 via Edward Speelman.

EXHIBITIONS: London, Grafton Galleries, *A Catalogue of an Exhibition of Old Masters in Aid of the National Art-Collections Fund* (ed. by Roger Fry and Maurice W. Brockwell), 1911, no. 97 (lent by Otto Beit); Cape Town, National Gallery of South Africa, *Old Master Paintings from the Beit Collection* (introduction by John Paris), 1949, no. 13 [as dateable before 1672]; London 1988, no. 27.

LITERATURE: Wilhelm Bode, *The Art Collection of Mr Alfred Beit at his Residence 26 Park Lane, London* (Berlin, 1904), pp. 20, 53; Wilhelm Bode, *Pictures and Bronzes in the Possession of Mr Otto Beit* (London, 1913), p. 24, no. 27; Hofstede de Groot, vol. 8 (1927), no. 124; Wilhelm von Bode, *Die Meister der holländischen und vlämischen Malerschulen* (Leipzig, 1917), p. 280; Wagner 1971, p. 93, no. 118, ill.; Speelman 1988, p. 14.

CONDITION NOTES: The panel support is in plane, uncradled and composed of a single piece of wood. The back of the panel is painted brown with a rough granular paint. The paint film is generally in very good condition, however there are retouchings along the edges, in the shadows of the beggar, and around a loss behind the dog at the fountain. The overall tonality of the scene may have darkened with age. The varnish is relatively clear. On the back is stencilled the number 3414, and 'no. 106' appears in white paint.

Before the ruins of a town wall on the right is a small Renaissance shrine. On the left an area bounded by low brick walls opens at the back onto a little bridge over the town moat. In the distance beyond the walls is a large triumphal arch at a right angle to the picture plane. The shadowed building on the far left is surmounted by a gargoyle. Within the walls, a man at the left draws water from a fountain with his hat while his dog laps at the surface. In the foreground a seated beggar accompanied by a boy (Bode regarded them as pilgrims) asks for alms from an elegant couple. The woman wears a blue wrap, the man a taupe-coloured costume with red ribbons. They are followed by a page. On the little bridge in the middle distance a man leans on the balustrade. The heads of two other men can be seen on the far side above the wall of the moat. In the lower right foreground is a dog.

This architectural fantasy joins disparate architectural structures and motifs with a whimsical freedom that recalls works like van der Heyden's paintings in London's National Gallery (fig. 1) and Philadelphia's Johnson Collection (fig. 2). Some of these elements may have been based on actual motifs. For example, the little shrine recalls a similar one in van der Heyden's *View of the Tiber Island, Rome* in the Akademie der bildenden Künste, Vienna (inv. no. 711),[1] in his so-called *View of Brussels Porte du Rivage* in the Ruzicka Stiftung, Zurich (fig. 3)[2] and in other works. However all of these paintings are characterized by a free flight of fancy. Architectural capricci had been painted in the North since at least the time of Hans Vredeman de Vries, the sixteenth-century pioneer of this painting type, but rarely with such naturalistic effect.

Writing in the Beit Collection catalogue of 1904, Wilhelm Bode was the first to attribute the staffage figures in this work to Adriaen van de Velde;[3] Wagner concurred with this view,[4] and there seems to be no reason to question it. Since Bode failed to see the date 1663 on the work, he could only assert that the painting had been executed before van de Velde's death in 1672, a dating followed by John Paris in the 1949 Capetown exhibition catalogue. In his unpublished notes taken during a visit to Otto Beit's home at 49 Belgrave Square on 8 August 1931, Ellis Waterhouse detected van der Heyden's signature and the date, and correctly noted that this 'very pretty piece of the finest quality [is] reminiscent of the N[ational] G[allery]'s architectural capriccio'.

According to both Bode and Hofstede de Groot, the painting was in the collection of John Walter of Bear Wood (or Bearwood) before it became part of the Beit collection. There were three men of this name: the grandfather (1739–

1819) who founded *The Times* in London in 1785, his son (1776–1847), who acquired most of the paintings, and grandson (1818–94); the latter were also proprietors of the newspaper. The last-mentioned built the present Bearwood in 1865–74, which was designed by Robert Kerr and now serves as Bearwood College.[5] A central feature of Kerr's Neo-Jacobean design was a skylit picture gallery to display the Walter paintings. Walter also owned Maes' *Woman Selling Milk* and Isaac van Ostade's *Ford* now in the Samuel Collection (see Cats. 39 and 52). The Samuel van der Heyden should not be confused with a pair of pendants by the artist that Gustav Waagen briefly mentioned in his review of the Walter collection published in his *Supplement* (1857) to the *Treasures of Art in Great Britain*, 3 vols. (1854).[6] However it may be identical with the single undescribed work by van der Heyden which appeared as no. 9 in an undated nineteenth-century inventory of the John Walter Collection, preserved in the Berkshire Record Office in Shire Hall, Reading, in which the painting was valued for insurance purposes at £350 (a sizeable sum).

FIG. 2 Jan van der Heyden, *Landscape with Romanesque Church*, oil on panel, 40.7 × 46.4 cm., John G. Johnson Collection, Philadelphia, no. 595.

FIG. 1 Jan van der Heyden, *Architectural Fantasy*, signed, oil on panel 51.8 × 64.5 cm., The National Gallery, London, no. 992.

FIG. 3 Jan van der Heyden, *View of Brussels Porte du Rivage*, Ruzicka Stiftung, Kunsthaus, Zürich, inv. no. R.13

1 Wagner 1971, no. 71; Renata Trnek, *Gemäldegalerie der Akademie der bildenden Künste in Wien. Illustriertes Bestandverzeichnis* (Vienna, 1989), p. 112, ill.
2 See Wagner 1971, no. 22, and for discussion Petra ten Doesschate Chu, in *Im Lichte Hollands. Holländische Malerie des 17. Jahrhunderts aus den Sammlungen Fürsten von Liechtenstein und aus Schweizer Besitz*, Kunstmuseum, Basle, exh. cat. 14 June–27 September 1987, no. 41, ill. Another version, panel 30.5 × 27.9 cm., was in the sale Christie's (London), 26 November 1974, no. 78.
3 W. Bode, in Beit 1904, p. 20; 1913, no. 27.
4 Wagner 1971, no. 118.
5 See M. Girouard, 'Bear Wood, Berkshire' *Country Life*, vol. 144, (October 1968), pp. 963–7. Kerr published the house in his own book, *The Gentleman's House; or How to Plan English Residences from the Parsonage to the Palace*, 3rd edn (London, 1871). For a plan of Bear Wood and a discussion of the tastes of Walter, the Victorian industrialist, see Ivan Gaskell, *Seventeenth Century Dutch and Flemish Paintings, The Thyssen-Bornemisza Collection* (London, 1990), pp. 25–7.
6 See G. Waagen, *Galleries and Cabinets of Art in Great Britain* (London 1857), p. 297.

CAT. 28

Cityscape with a Church and a Square, late 1660s

Oil on metal (?) 11⅝ × 15⅜ in. (29.5 × 39 cm.)

PROVENANCE: According to Smith, it was sold privately by a dealer in 1818 for 4000 frs.; Comte de Perregaux Lafitte, Paris, by 1834 (see Smith); sale Comte de Perregaux Lafitte, Paris, 8 December 1841, no. 12 (17,003 frs., to A. M. Laneville for Baron J. de Rothschild, Paris); possibly Thomas Baring, London, 1854 (see Waagen 1854, vol. 2, p. 188); Etienne Nicolas, Paris; sold to Edward Speelman in late 1959, who in turn sold it to Harold Samuel.

EXHIBITION: London 1988, no. 29 [*View of a Town (possibly Düsseldorf)*].

LITERATURE: Smith, vol. 5 (1834), no. 92; *Suppl.* (1842), no. 20; *Cabinet de l'amateur et de l'antiquaire*, vol. 1 (Paris, 1842), p. 90, no. 12; (possibly) Waagen 1854, vol. 2, p. 188; Hofstede de Groot, vol. 8 (1927), no. 183; Wagner 1971, p. 94, no. 121, ill, p. 154; Speelman 1988, p. 14.

CONDITION NOTES: It was not possible to analyse the silver-coloured or white metal support when the painting was examined in February 1991. It has been set into a cradled (!) wood backing with ¼ in. (5 mm.) wood strips added on all sides. The paint film is generally in very good condition. Minor retouchings appear along the edges, and in the paving stones in the lower left. Some lifting paint was visible in February 1991 in the building on the right and the tree on the left but it has since been consolidated. The varnish is relatively clear.

A church freely based on the Jesuit church of St Andreas in Düsseldorf is set in the cobblestone square of an imaginary town. Long shadows stretch across the square which is populated by a few scattered figures. On the extreme left is a pair of capuchin monks and in the foreground a woman with large bonnet covering her head. Several figures are seated beneath the trees. A group of figures exotically clad in 'oriental' costumes appear in the centre left, while further back are two other monks. On the right is a woman with a market stand and a man urinating against the wall. On the far right a woman converses with a man in a doorway. The square is closed at the right by a gothic house made of brick with a stone pinnacle and a sculpted figure in a niche.

Smith called the painting simply 'A View looking down a Street' and in the sale of the collection of the Comte de Perregaux Lafitte, it was titled 'Vue de Ville'. When Hofstede de Groot catalogued this cityscape in 1927, he speculated that it might depict the city of Luxemburg, while in the 1988 exhibition catalogue of the Samuel collection the site was tentatively identified as Düsseldorf. The latter identification acknowledges the fact that the large church on the right derives many of its features from the Jesuit church in that city but, as Wagner had already correctly observed in 1971, van der Heyden's painted church introduces imaginary gothic elements in the windows and towers, as well as baldachin figures which do not exist in the actual structure.[1] Van der Heyden made a faithful rendering of the church of St Andreas in 1666,[2] and one viewed from the east end in 1667 (fig. 1).[3] Two of his earliest dated works, these paintings attest to a youthful trip to Düsseldorf. To complete his fanciful structure in the Samuel painting, van der Heyden added to the west side of his church a cupola based on that atop the Amsterdam Town Hall, yet another of his favourite sites.

Smith, the compiler of the Perregaux Lafitte sale and Hofstede de Groot all believed that the staffage figures in the Samuel picture were painted by Adriaen van de Velde (q.v.), and there appears to be no reason to question the assumption. Smith's unqualified admiration for the work was well founded – an 'inimitable work of art . . . this chef d'œuvre of the combined masters is distinguished by the richness and variety of its composition and the exquisite beauty of its details'.[4] The reviewer of the Perregaux sale for the *Cabinet de l'amateur* in 1842 was also much impressed, adding that 'Perhaps never has a van der Heyden achieved such an elevated price' (17,000 frs.).[5]

1 Wagner 1971, p. 94.
2 Wagner 1971, no. 38.
3 Wagner 1971, no. 37; compare also van der Heyden's *Jesuit Church of St Andreas, Düsseldorf*, signed and dated 1666, panel 57 × 67 cm., formerly in the collection of Sir Alfred de Rothschild, Wagner 1971, cat. no. 38, ill.
4 Smith, vol. 5 (1834), no. 92.
5 *Cabinet de l'amateur et de l'antiquaire*, vol. 1 (1842), p. 90, no. 12.

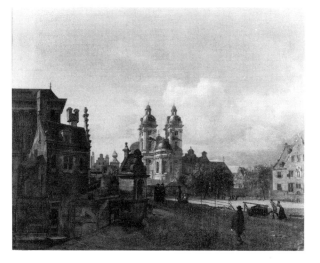

FIG. 1 Jan van der Heyden, *The Jesuit Church of St Andreas*, signed and dated 1666 (?), panel 51 × 63.5 cm., Mauritshuis, The Hague, no. 53.

CAT. 29

Wassertor, Kleves, 1660s

Oil on panel 9⅜ × 11⅜ in. (23.7 × 29 cm.)

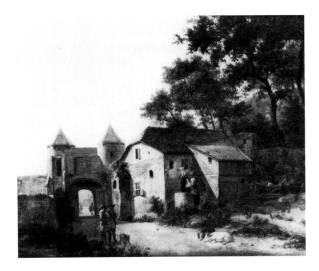

PROVENANCE: Sale Beaujon, Paris, 25 April 1787, no. 74 (1800 frs.); sale de Castlemore, Paris, 30 December 1791, no. 68 (2001 frs.); sale Jonkheer Johan Goll van Franckenstein, Amsterdam, 1 July 1833, no. 30 (1150 fl., to Roos); Baron Nagell van Ampsen, The Hague, 5 September 1851, no. 29 (5500 fl., to Le Roy); T. Patureau, Paris, 20 April 1857, no. 9 (14,500 frs., to Lagrange); acquired from Edward Speelman in 1966.

EXHIBITION: London 1988, no. 31.

LITERATURE: Smith, vol. 5 (1834), nos. 43 and 112; Hofstede de Groot, vol. 8 (1927), no. 137 and 186; Wagner 1971, p. 76, no. 44.

CONDITION NOTES: The original wood panel is 9⅜ × 11⅛ in. (23.7 × 29 cm.) but has ¼ in. (5 mm.) additions on all sides and the bevel has been cut away on both vertical sides by about 1¼ in. (3.2 cm.). The paint film is in good condition with minor retouchings in the upper left corner. The varnish layer is relatively clear. A stencilled inventory number 'T.P. No. 9', probably from the T. Patureau sale in 1857, appears on the back as well as a sticker with the number Y2674/2.

On the left is a gateway with turrets, connected on the right to a brick house beneath a grove of trees. Two men and a dog stand in the roadway at the left. Beneath the gateway stands a watchman armed with a long pike and shield; beyond him is a woman. Another woman draws water from a well in the sunlight on the right. On the step behind her are chickens and in the right foreground two pigs lie in the road. A hill with tall trees rises on the right.

Smith, Hofstede de Groot, and the 1988 exhibition catalogue titled the painting simply as a gateway in an anonymous town.[1] However Wagner identified the site as the Wassertor in Kleves, and plausibly surmised that Roelant Roghman's drawing of this subject (fig. 1) corresponds so closely to the painting that it probably was van der Heyden's source.[2] Van der Heyden employed Roghman's drawings on at least one other occasion; the *View of Loenersloot* now owned by the Städelsches Kunstinstitut, Frankfurt (cat. 1966, no. 590) is apparently based on a 1647 drawing by Roghman, also preserved in the Kunstinstitut.[3] Here, however, van der Heyden – or more likely Adriaen van de Velde – radically enlarged the staffage figures, who also differ in position and pose from those in the earlier drawing. These changes have the effect of rendering the Wassertor more intimate in scale. The compiler of the Beaujon Sale catalogue in 1782 first plausibly suggested that the figures were painted by Adriaen van de Velde, an opinion repeated in the de Castlemore and Goll van Franckenstein sales and by Smith, Hofstede de Groot and Wagner. Dating the painting is difficult but the figures' costumes suggest a date in the 1660s.

Many Dutch landscape artists travelled to Kleves and the lower Rhine, especially following the appointment in 1647 of Johan Maurits of Nassau as the Stadtholder of the Great Electorate, and the Treaty of Münster in 1648 which ensured greater freedom to travel in the region.[4] Laurensz van de Vinne's travel diaries record his responses to the local scenery,[5] and Joris van der Haagen, Pieter Post and Herman Saftleven were among the many landscapists who depicted Kleves and its surroundings.[6]

M. Beaujon, who sold the painting in 1787, was the Receiver General of Finance for the Generality of Rouen. According to the introduction to his sale catalogue, the greater part of his distinguished collection of Italian, Dutch and French paintings were acquired from the famous collections of the Duc de Choiseul, Blondel de Gagny, Randon de Boisset and the Prince de Conti. The catalogue commended the painting as 'très-soigné & d'un bon ton de couleur'. The de Castlemore collection (dispersed in 1791) reflected eighteenth-century tastes in its preference for

works by Wouwermans and Dutch Italianate painters (Berchem, Pynacker, Wijnants, W. Romeyn, F. de Moucheron, etc.). The sale catalogue of the Goll von Franckenstein collection of 1833 praised the van der Heyden's 'lightness of tone, excellent control of the brushwork, and the original and correct placement of the staffage which makes the little picture highly important'. A substantial nineteenth-century Dutch collector, Goll van Franckenstein owned a notable group of Dutch landscapes and genre scenes. Among his other posts, the Jonkheer was on the governing board of the Koninklijk Academie voor Beeldende Kunst.

1 Smith, vol. 5 (1834), no. 43; Hofstede de Groot, vol. 8 (1927), no. 137; London 1988, no. 31.
2 Wagner 1971, p. 76, no. 44. For the Roghman, see F. Gorissen, *Conspectus Cliviae* (Kleves, 1964), no. 144, and Heinrich Dattenberg, *Niederrheinansich holländischer Künstler des 17. Jahrhunderts* (Düsseldorf, 1967), p. 267, no. 305, ill.
3 See Wagner, no. 140.
4 See Bonn, Rheinisches Landesmuseum, *Rheinische Landschaften und Städtebilder, 1600–1850*, catalogue by F. Goldkuhle and H. P. Hilger, 1960–1; and Dattenberg 1967 (see note 2).
5 See Vincent Laurensz van de Vinne, *Dagelijckse aentekeninge van Vincent Laurensz van de Vinne*, ed. by B. Sliggers (Haarlem, 1979).
6 See Amsterdam/Boston/Philadelphia 1987–8, pp. 48-49, cat. no. 40.

FIG. 1 Roelant Roghman, *Wassertor, Kleves*, pen and wash drawing 18.6 × 31.5 cm., Paul Brandt Collection, Amsterdam, 1967.

CAT. 30

A Fortified Moat or Canal, about 1670?

Monogrammed indistinctly lower left: VH (ligated and canted)
Oil on copper 4½ × 6⅞ in. (11.4 × 17.5 cm.)

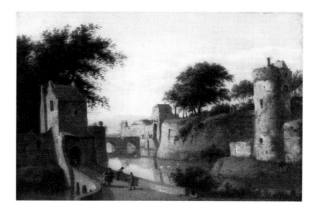

PROVENANCE: (Probably) sale A. Deutz, Amsterdam, 7 March 1731, no. 85 (105 fl., with pendant); (probably) sale W. van Wouw et al., The Hague, 29 May 1764, no. 24 (141 fl., with pendant); M. de la Boissière (Boexiere?) collection, Paris; sale Abbé Le Blanc, Paris (J. B. P. Lebrun), 14 February 1781, no. 21 (2808 frs., with pendant); sales Destouches, Paris (André Jean Lebrun, Ph. Fr. Julliot), 21 March 1794, no. 132 (2721 frs., to Lebrun with pendant); (probably) sale Montaleau, Paris, 19ff. July 1802, no. 58 (1220 frs., with pendant); Charles Brind, London, 10 May 1849, no. 57 (£33, with pendant (no. 56) to Smith); J. M. Oppenheim, London, 4 June 1864, no. 16 (£115. 10s, with pendant (no. 15), to Webb); Sir Charles Tennant, Bt., The Glen, Innerleithen, Peebles; Jules Porgès, Paris; Geoffrey and Dorothy Hart; acquired from Edward Speelman in 1956.

EXHIBITIONS: London, British Institution, 1841, no. 57; 1862, no. 65; Worthing, Worthing Art Gallery, *Dutch and Flemish Paintings from the Collection of Mrs Geoffrey Hart* (catalogue by L. M. Bickerton), 19 July–20 August 1952, no. 43, ill.; London 1988 no. 28.

LITERATURE: Hoet, vol. 1 (1752), p. 365; Terwesten (1770), p. 362, no. 81; Charles Blanc, *Le Trésor de la curiosité* (Paris, 1857), vol. 2, p. 46; Smith, vol. 5 (1834), no. 35; Hofstede de Groot, vol. 8 (1927), no. 144; Wagner 1971, p. 104, no. 163, ill.; Ivan Gaskell, *Seventeenth-Century Dutch and Flemish Painting*, The Thyssen-Bornemisza Collection (London, 1990), p. 402, note 3.

CONDITION NOTES: The copper support is in very good condition, but has been backed and inserted into a wood surround which enlarges the overall dimensions to 4⅞ × 7¼ in. (12.5 × 18.5 cm.). There is little abrasion to the paint film which is in very good condition. Minute losses have been inpainted, for example just below the tiny chapel or shrine on the far bank in the upper centre right and in other scattered areas. The edges of the image have an especially dirty build-up of varnish, which suggest that the picture may have once been cleaned in its frame. The varnish is only

moderately discoloured. A sticker on the back correctly identifies the painting as Smith no. 35 and as coming from the Destouches and Montaleau collections, adding the names 'Ch. Tenant' and 'J. Porgès', new provenance references.

A river or moat divides a fortified citadel with towers on the right bank from the stone gateway on the left bank. A bridge in the distance, traversed by minute figures, links the two. On the walkway in the foreground, an elegant couple are approached by a beggar. Further back a man leans on the wall and a man and a dog enter the gateway.

This small copper has been identified, probably correctly, as the pendant to van der Heyden's view of a fortified canal (fig. 1).[1] The two small paintings of identical dimensions complement one another in the curving architecture of their subjects, as well as in point of view and details of design. Although the pair remained together for at least two hundred years, they unfortunately were separated earlier in this century prior to entering the Samuel collection. Wagner suggested that the architecture (specifically the bridge and the walls) partly recalled the St Janspoort in Arnhem and the 'Plompe Toren' in Utrecht, but seventeenth-century prints by A. Rademaker and other topographical sources prove that these putative sources were, at very least, imaginatively revised and reformed by the artist.[2] With a gateway on the left side, the architecture of the present composition is also very similar in design to the corresponding elements in a larger painting that appeared in the E. Kums sale in Antwerp in 1898 (fig. 2).[3]

J. B. P. Lebrun (cataloguing the Le Blanc sale of 1781), and the authors of the catalogues of the Destouches sale in 1794, the Montaleau sale in 1802, Brind in 1849 and Oppenheim in 1864, as well as Smith and Hofstede de Groot, all attributed the figures in this painting to Adriaen van de Velde, although in such a microscopically executed work it is difficult to perceive the presence of two different hands. Their costumes would suggest a date for the painting around 1670. Lebrun praised the pendants in the Le Blanc sale, 'Ces deux précieux tableaux prouvent la merite de van der Heyden, dans les deux genres qui lui ont été les plus famileurs & qui sont, à juste titre, recherchés des Amateurs: l'œil le plus difficile ne peut rien reprocher à ces deux morceaux'. At 2808 frs. the pair brought a very good price. The pendants passed through the hands of some notable collectors. Abbe Le Blanc was the 'Historiograph des Batiments du Roi'. M. Destouche, chief steward of the household and treasury of Maria Teresa, Comtesse d'Artois, owned three van der Heydens in addition to this one, and kept his collection of Dutch and Flemish paintings

in his apartments in Saint-Marc, north of the Bourse in Paris, and later in the rue de Clichy. Although his fate remains unknown, he – like the rest of the House of Artois – was probably a victim of the upheavals of the French Revolution. His vast collection was sold in 1794 (Dutch paintings comprising the majority of the 280 lots) and reflected typical French eighteenth-century tastes. It was filled with Dutch Italianate landscapes, late classical Dutch history paintings (G. de Lairesse and G. Hoet), works by the *fijnschilders* (Dou and Schalcken) and, of course, Rembrandt. The van der Heyden pendants later passed together through the Brind and Oppenheim sales (1849 and 1864), where Samuel's *Woman Selling Milk* by Maes (Cat. 39) also appeared. The Parisian financier, Jules Porgès, who later owned the painting, was a business associate and mentor of Alfred Beit and like him had extensive interest in South African gold and diamonds (see Cat. 83).

1 See Smith, vol. 5 (1834), no. 34; Hofstede de Groot, vol. 8 (1927), no. 118; Wagner 1971, no. 167. When the two paintings were separated is unclear. The pendant was with Julius Böhler, Munich, in 1914; J. Goudstikker, The Hague, 1920, exhibited Copenhagen, 1922; then with Omnes van Nijenrode, Nijenrode; E. A. Veltman, Bussum, The Netherlands; and finally with Eugene Slatter, 1952 (exh. no. 2), before resurfacing at Agnew's in 1988.

2 In a painting in the Thyssen-Bornemisza Collection (fig. 3), a similar bridge and fortification appear but are freely inserted into a different imaginary cityscape; see Wagner 1971, p. 104, no. 164; and Ivan Gaskell (Thyssen-Bornemisza cat. 1990, no. 94) who suggested that the structure more closely resembled the Rijnspoort than the St Janspoort, but wisely cautioned 'any attempt to identify the scene . . . is vitiated by the near certainty that it is a composite view or invention'. The Rijnpoort in Arnhem appears on the left hand side of the *Panorama of Arnhem* by Joris van der Haagen in the Mauritshuis, The Hague (inv. no. 47).

3 See Hofstede de Groot, vol. 8 (1927), no. 241; Wagner 1971, no. 173.

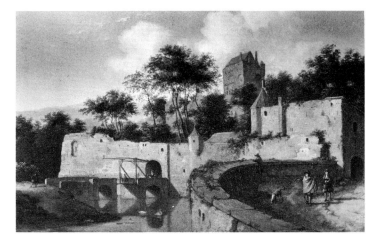

FIG. 1 Jan van der Heyden, *A Fortified Moat or Canal*, initialled, oil on copper 11.5 × 17 cm., monogrammed lower right, with Agnew's, London, 1988.

FIG. 2 Jan van der Heyden, *Fortified Castle along a Canal*, signed, oil on panel 31.5 × 44 cm., Sale Edward Kums, Antwerp, 17 May 1898, no. 104.

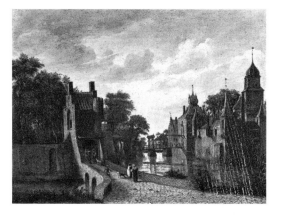

FIG. 3 Jan van der Heyden, *View outside a Town Wall*, signed, oil on canvas 29.5 × 34.6 cm., Thyssen-Bornemisza Collection, Lugano, acc. no. 1968.14.

CAT. 31

A Wooded Landscape with Figures, about 1668–72

Unsigned
Oil on panel 6⅜ × 8¼ in. (16.2 × 21 cm.)

PROVENANCE: Marquis de Biron, Paris; acquired from Edward Speelman.

EXHIBITION: London 1988, no. 30.

LITERATURE: (Not in Hofstede de Groot); Helga Wagner, *Jan van der Heyden 1637–1712* (Amsterdam/Haarlem, 1971) pp. 49, 111, no. 203, ill. p. 174.

CONDITION NOTES: The panel is shaved and cradled. Minor retouches appear along the upper edge and in the shadows of trees in the centre. Otherwise the paint film is in relatively good state and the varnish only moderately discoloured.

In a clearing in a wooded landscape a woman with a marketing basket has paused to speak to a man seated holding a staff beneath a partially denuded tree. On the left a boy kneels down, apparently hunting for mushrooms which he places in his hat. In the distance on the right an elegant couple promenade with a boy.

Although the cityscapist van der Heyden only painted about forty landscapes,[1] landscape elements are nonetheless important features in his views of cities, country houses and parks. With only two dated landscapes (see, for example, fig. 1),[2] this portion of the painter's œuvre reveals no clear chronology. An exceptional subgroup of his landscapes are painted in reverse on glass in the painstaking technique known as *verre eglomisé*. While the designs of these works on glass clearly reflect the influence of earlier Flemish

landscapists (Tobias Verhaecht, Abraham Goverts, Alexander Keirincx and others), it is not clear, despite Wagner's contentions, that they must be his earliest products since Flemish-styled landscapes and forest views were also revived by Dutch artists in the third quarter of the seventeenth century.[3]

However Wagner rightly relates a second group of van der Heyden's landscapes, to which the Samuel painting belongs, to the art of Adriaen van de Velde, who often collaborated with van der Heyden, painting the staffage figures into his landscapes. In the late 1650s and early 1660s,[4] van de Velde painted a group of horizontally disposed gentle park-like landscapes with trees arranged parallel to the picture plane and rising to about two-thirds the height of the scene (see, for example, fig. 2).[5] This type of cultivated woodland scene undoubtedly descends in turn from the paintings of Paulus Potter (see, for example, *The Departure for the Hunt,* signed and dated 1652, Staatliche Museen Preussischer Kulturbesitz, Berlin-Dahlem, inv. 872A) which eschewed the wilder forms of nature and impenetrable forests for a more cultivated scenery suggestive of seigneurial preserves and deer parks. Within his own œuvre van der Heyden's painting is closest in conception to a painting in the City Art Gallery in Bristol (fig. 3) which depicts a mother with children seated in a wooded clearing with figures promenading,[6] a bucolic scene in the collection of Graf Holstein (fig. 4),[7] and a painting in the University of Edinburgh.[8] Wagner speculated that the site of the Samuel painting, with its elegant couple promenading, might be the courtly Bosch on the outskirts of The Hague, but the location cannot be specified.[9]

1 See Wagner 1971, pp. 47-50, cat. nos. 177–208.
2 See *River Landscapes with Hills,* signed 1666, Godsfield Manor, Arlesford; respectively Wagner 1971, nos. 179 (Hofstede de Groot, vol. 8 (1926), no. 277) and 198 (Hofstede de Groot, vol. 8 (1926), no. 323).
3 Wagner 1971, pp. 47–8; and Amsterdam/Boston/Philadelphia 1987–8, pp. 344–5, note 3.
4 Wagner 1971, p. 49.
5 Wagner 1971, p. 49 also cited van de Velde's painting dated 1658 in the Städelsches Kunstinstitut, Frankfurt, inv. 1048. Compare also van de Velde's *Farm,* dated 1666, Staatliche Museen Preussischer Kulturbesitz, Berlin-Dahlem, inv. 922c.
6 Wagner 1971, no. 202 (Hofstede de Groot, vol. 8 (1926), no. 75a?).
7 Wagner 1971, no. 206 (Hofstede de Groot, vol. 8 (1926) no. 301).
8 *Park-Like Landscape with Deer,* panel 22 × 28.7 cm., The Department of Fine Art, University of Edinburgh, cat. 1924, no. 115; Wagner 1971, no. 204 (Hofstede de Groot, vol. 8 (1926), no. 297).
9 Wagner 1971, p. 111.

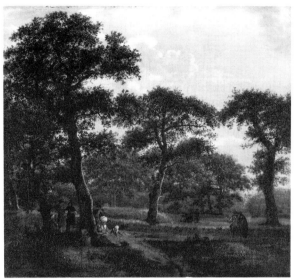

FIG. 1 Jan van der Heyden, *Landscape with Cottage*, signed and dated 1668, oil on panel 22 × 33 cm., Private Collection.

FIG. 3 Jan van der Heyden, *Wooded Landscape with Figures*, monogrammed, oil on canvas 28.9 × 33.6 cm., City Art Gallery, Bristol, Shiller Bequest, inv. K1640.

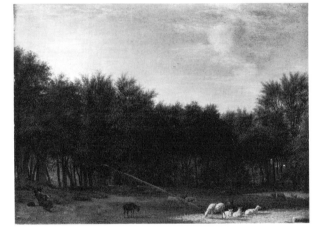

FIG. 2 Adriaen van de Velde, *Edge of Wood*, signed and dated 1658, panel 27 × 45 cm., National Gallery, London, no. 982.

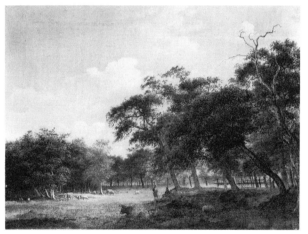

FIG. 4 Jan van der Heyden, *Wooded Landscape with Bucolic Figures and Animals*, oil on canvas 20 × 38 cm., Graf Holstein Holsteinborg, Holsteinborg Castle, Denmark.

MEINDERT HOBBEMA

(AMSTERDAM 1638–1709 AMSTERDAM)

The son of Lubbert Meyndertsz, Meindert (or Meijndert) was baptized in Amsterdam on 31 October 1638. At an early age he adopted the surname 'Hobbema', which his father evidently never used. In July 1660 Jacob van Ruisdael claimed that Hobbema, who was then living in Amsterdam, had been his apprentice for 'some years'. Hobbema's work, which is often based on Ruisdael's, seems to confirm this contact. In 1668 Hobbema became one of the wine gaugers for the Amsterdam octroi, a post he held until the end of his life. In the same year he was married to Eeltje Vinck, then thirty years old, with Ruisdael serving as a witness. It was previously believed that Hobbema gave up painting after getting married and assuming his new job, but a handful of later works, some of exceptionally high quality (see, for example, *The Avenue at Middelharnis* of 1689, National Gallery, London, no. 830), have been identified. It nevertheless seems clear that his activity as a painter was sharply curtailed after 1668. Hobbema lived on the Rozengracht in Amsterdam throughout his later years. He died in that city on 7 December 1709.

Hobbema was active as a painter and draughtsman of landscapes, above all wooded scenes, in the manner of Jacob van Ruisdael. Though sometimes wrongly thought of as a dilettante, he was a highly productive painter with a large œuvre. The earliest dated work is of 1658 (Institute of Arts, Detroit, no. 89.38). His early paintings recall the style of Salomon van Ruysdael and Cornelis Vroom. It was only around 1662 that the influence of Ruisdael's art became particularly pronounced in his work. Already by about 1663–4, however, he had asserted his independence from Ruisdael. His art became lighter, more colourful and expansive, his compositions gained a new spatial freedom, and his touch became more fluid. The majority of Hobbema's best works date from about 1662 to 1668, and are usually horizontal scenes of woods with houses, water-mills, and sandy roads. He is distinguished from Ruisdael by his livelier view of nature, yet in achieving this effect he sacrificed something of his teacher's power and intensity.

LITERATURE: Van Eynden and van der Willigen 1816–40, vol. 1, pp. 122–8, vol. 4, p. 101; Smith 1829–42, vol. 6, pp. 109–63, vol. 9, pp. 719–29; A. van der Willigen, 'Iets wegens de schilderijen, door M. Hobbema', *Algemeene Konst- en letter-bode*, 1831, pp. 302–4, 361–4, 409–10, 460, 474, 1832, pp. 24–5; H. J. Héris, 'Sur la vie et les ouvrages de Mindert Hobbema', *La Renaissance*, vol. 1 (1839–40), pp. 5–7; Immerzeel 1842–3, vol. 2, p. 41; H. J. Héris, *Notice raisonnée sur la vie et les ouvrages de Mindert Hobbema* (Paris, 1854); Kramm 1857–64, vol. 3, pp. 693–8; P. Scheltema, 'Meindert Hobbema', *Aemstel's oudheid*, vol. 5 (1863), pp. 45–64; P. Scheltema, 'De geboorteplaats van Meindert Hobbema', *Nederlandsche Kunstbode*, vol. 3 (1876), pp. 11–12; N. de Roever, 'Meindert Hobbema', *Oud-Holland*, vol. 1 (1883), pp. 81–5; A. D. de Vries, 'Biografische aanteekeningen', *Oud-Holland*, vol. 3 (1885), p. 151; E. Michel, *Hobbema et les paysagistes de son temps en Hollande* (Paris, 1890); F. Cundall, *The Landscape and Pastoral Painters of Holland* (London, 1891), pp. 39–62; Abraham Bredius, 'Uit Hobbema's laatste levensjaren', *Oud-Holland*, vol. 29 (1911), pp. 124–8, vol. 33 (1915), pp. 194ff.; Hofstede de Groot 1908–27, vol. 4 (1912), pp. 350–451; J. Rosenberg, 'Hobbema', *Jahrbuch der Preussischen Kunstsammlungen*, vol. 48 (1927), pp. 139–51; H. F. Wijnman, 'Het leven der Ruysdael', *Oud-Holland*, vol. 49 (1932), p. 176; Georges Broulhiet, *Meindert Hobbema* (Paris, 1938); Horst Gerson, 'Een Hobbema van 1665', *Kunsthistorische Mededelingen*, vol. 2, nos. 3-4 (1947), pp. 43–6; Wolfgang Stechow, 'The Early Years of Hobbema', *The Art Quarterly*, vol. 22 (Spring 1959), pp. 2–18; Wolfgang Stechow, *Dutch Landscape Painting of the Seventeenth Century* (London, 1966), pp. 76–80, 127–8; H. Hagens, 'Jacob van Ruisdael, Meindert Hobbema en de identificatiezucht', *'t inschrien*, vol. 14 (1982), pp. 7–12; Bob Haak, *The Golden Age: Dutch Painters of the Seventeenth Century* (New York, 1984), pp. 465–67; Sutton et al. 1987, pp. 345–55; Christopher Wright is preparing a monograph with *catalogue raisonné*.

CAT. 32

Wooded Landscape with the Ruins of a House, c. 1663–4

Signed lower right with remnants of a signature: h[o]bb[e]ma
Oil on panel 23⅝ × 33¼ in. (60 × 84.5 cm.)

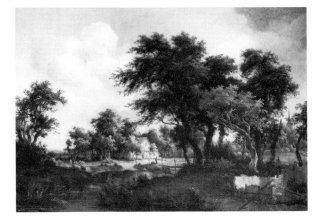

PROVENANCE: William Wells, Redleaf, Penhurst, Kent, inv. 2 November 1810 (acquired for £190 or £210; valued at £200 or £250 – the two paintings by Hobbema are not fully described; see note 11); William Wells II and III, Holme Wood, Peterborough; sale William Wells, London, 12 May 1848, no. 116 (£640. 12s., to Wells); sale William Wells, London, 12 May 1890, no. 91 (£2835); dealer Charles Sedelmeyer, Paris, 1898 (*Catalogue of 300 Paintings,* 1898, no. 65); with Duveen Gallery? (see label on the back); sale Charles T. Yerkes, New York, 5 April 1910, no. 124 (no. 43 of the *édition de luxe* catalogue) (according to Broulhiet 1938, sold to Scott and Fowles for Taft (Cincinnati collector), $48,000); C. J. Holmes; Mrs B. F. Jones, Pittsburgh, 1929 (see exh.); sale Mrs B. J. Jones, Jr, New York (Parke-Bernet) 4 December 1941, no. 28, ill.; Mrs T. J. Emery; Baron Cassel van Doorn; sale Baroness Cassel van Doorn, Paris (Charpentier), 20 May 1956, no. 37; acquired from Edward Speelman in 1956.

EXHIBITIONS: London, Royal Academy, Winter Exhibition, 1875, no. 84 (lent by Wells); London, Royal Academy, *Exhibition of Dutch Art 1450–1900,* 1929, p. 113, no. 229, ill. p. 38 (lent by Mrs B. F. Jones, Jr); London 1988, cat. no. 33, ill. p. 25.

LITERATURE: *The Diary of Joseph Farington (January 1811–June 1812),* ed. K. Cave, vol. 11 (New Haven and London 1983), p. 4005, no. 21; Smith, vol. 6 (1835), no. 18; William Roberts, *Memorials of Christie's; A Record of Art Sales from 1766 to 1896,* vol. 2 (London, 1897), p. 148; Hofstede de Groot, vol. 4 (1912), no. 236; *Apollo,* vol. 9 (February, 1929), p. 86, ill.; Georges Broulhiet, *Meindert Hobbema (1638–1709)* (Paris, 1928), pp. 399–400, no. 179, ill. p. 191; Albert Blankert and Rob Ruurs, *Amsterdams Historisch Museum. Schilderijen daterend van voor 1800. Voorlopige catalogus* (Amsterdam 1975/9), p. 142, under cat. no. 184; Speelman 1988, p. 14.

CONDITION NOTES: The panel support has been cradled and enlarged slightly on all sides by about ¼ in. (5 mm.). With the wood strip additions, the grain of which runs horizontally, parallel with that of the original support, the overall dimensions are 24 × 33¾ in. (61.1 × 85.8 cm.). The paint film on the upper and lower edges has been retouched. Other retouches are scattered throughout the sky, in the tree on the left, in the lower right corner, and around the church spire on the right. The figure of the fisherman in the centre is exceptionally abraded, perhaps indicating the area was at one time obscured by overpaint which has since been removed. Otherwise, the paint film is in relatively good state and the sky has not suffered as greatly as in many other works by the artist. On the reverse of the panel are two only partly preserved collectors' seals in red wax, one of which has three castles surmounted by a crown. There also are two French customs seals, a sticker from Duveen's gallery (no. 988L4H) and an unidentified sticker, no. 3255.

In a landscape wooded with tall trees, the ruined foundations of a house appear in the lower right foreground. Slightly to the right of centre, a bank with trees rises above a pool bordered by reeds. On the left bank of the pool other trees form a backdrop for a man with a walking stick. Another man walks across a rustic footbridge spanning a stream in the middle distance. Beyond a lighted clearing is a farmhouse nestled among trees; a woman with a broom stands in the doorway. To the left of the farmhouse is a vista where a walking couple is glimpsed through the screen of trees. A man is visible behind the ruins on the right. Behind him in the distance, a church steeple rises above the trees. An angler fishes from the bank of the pool in the foreground.

Hofstede de Groot claimed that the painting was signed in full on the left, while the Sedelmeyer catalogue of 1898 asserted that it was signed 'M. Hobbema' in the lower right, and the Baroness Cassel van Doorn sale catalogue (1956) reported that remnants of a signature were visible in the lower right. Only 'h[o]bb[e]ma' is now visible in the lower right. Hofstede de Groot believed that this painting was an enlarged replica of his catalogue no. 214, a smaller painting (panel 15 × 19½ in.; 38 × 49.5 cm.)[1] that sold in 1792 and 1833 with a pendant that is now preserved in the Amsterdams Historisch Museum (see fig. 1).[2] This smaller version is now lost, however. Broulhiet catalogued and illustrated what he believed was a study (esquisse) for the Samuel painting but that painting is only a copy.[3] The copy includes two additional figures of a standing fisherman and a woman in the centre of the composition, but omits the man on the bridge, the fisherman and the other staffage figures.

The Samuel painting is undated but can be dated fairly confidently to c. 1663–4 on the basis of its stylistic and

compositional resemblance to a similar woodland view in the Wallace Collection dated 1663, with a pool, trees and lighted cottage in the middle distance (fig. 2).[4] Other paintings by Hobbema dated 1663 are in the museums in Brussels, Dublin (formerly in the Beit collection) and Washington.[5] An undated painting formerly in the Six Collection employed a design similar to that of the Samuel painting but reversed;[6] and the composition of a painting in Museum Boymans-van Beuningen, Rotterdam, no. 1307, is also comparable.[7]

In 1835, Smith described this work as 'distinguished in its composition'. Hobbema's great gift was his ability to vary and re-combine designs and motifs to original effect. Exploring all permutations of a composition or variations of a theme – whether a woodland, watermill or ford – he ingeniously avoided repetition, creating agreeably diverse images which nevertheless betray a familial resemblance.

Although essentially generic scenes, the motifs in paintings such as the Samuel picture could have been inspired by sketching trips to regions in the provinces of Gelderland, Overijssel and Drenthe. Nonetheless, when this painting was catalogued by Smith in 1835, when sold in 1848 and 1890, when catalogued by Sedelmeyer Gallery in 1898 (no. 65), and even when exhibited in 1988, it was called 'A View of Westphalia', or 'View in Westphalia'; however the site, as is usually the case with Hobbema, cannot be specified. Ruisdael had travelled to Westphalia in c. 1650–1 (see Cat. 57) and it was in the years c. 1662–4 that his influence was strongest on Hobbema. We detect it here in the combination of monumental lush green trees, a still pond, and a ruin with crumbling brickwork. Hobbema's own personal artistic instincts are witnessed in the more open and airy design and lighter overall tonality. These qualities arise chiefly from the use of screens of trees before lighted passages in the middle distance. Rarely do Hobbema's trees extend to the upper edges of his paintings or coalesce into dense walls. There is little sense of closure in his domesticated woodlands, indeed they rarely qualify as forests.

The ruins in the right foreground could have a variety of associations. When the ruins of castles such as Brederode, Huis te Kleef or Spangen (which were all damaged by Spanish troops in the 1570s) were depicted by Dutch landscapists, they often had strong patriotic connotations.[8] But the crumbling foundations of Hobbema's nameless farmhouse are far less august remains with no specific associations. Of course ruins in general could prompt thoughts of the impermanence of man's efforts or, paradoxically, the durability of his works;[9] and ruins were implicitly commended in landscape print series and in contemporary literature as sites for the enjoyment of sylvan pleasures. However it would be out of artistic character for Hobbema to encode an elaborate allegorical programme in his landscapes. While Jacob van Ruisdael undoubtedly introduced the ruins of Egmond Castle in the background of his famous *Jewish Cemetery* for symbolic effect, Hobbema seems to have been less programatic or ideological in his iconography.[10]

The nineteenth-century owner of the painting, William Wells of Redleaf, had briefly been a captain of an 'East-Indiaman' in his youth and subsequently prospered in the oriental drug trade, owned London docks, notably Blackwall Dock, and later, breweries. Wells had been an active promoter of young contemporary artists like Edwin Landseer and was acquainted with leading English painters of the day, such as Constable, who however grew contemptuous of his prideful and opinionated patron. By 2 November 1810, when an inventory was drawn up, he had assembled a collection of ninety-two paintings, including many Dutch pictures by among others, Jacob van Ruisdael, Nicolaes Berchem, Aelbert Cuyp, Gerard Dou, Philips Wouwermans, F. Van Mieris, Nicolaes Maes, P. de Hooch, Isack van Ostade, ter Borch, Steen, W. van de Velde, and A. van Ostade (qq.v.) including the *Water Pump* (Cat. 51), and another painting by Hobbema now preserved in the Louvre (inv. 1342).[11] These he housed at his elaborately contrived country estate, Redleaf, near Penhurst, Kent, which featured many rustically picturesque details, including long vistas complete with newly constructed 'Woodman's Cottage'.[12] In the room where many of his Dutch paintings hung Wells kept a caged bullfinch that had been trained to sing 'God Save the King'. Many of Wells' best paintings were acquired from the dealer William Buchanan. The Hobbema was apparently acquired by Wells' own family at the sale following his death in 1848, and later was sold again in the Wells sale of 1890. However it was not, as mistakenly reported by Hofstede de Groot, in the Wells sale in 1852, which was a sale of English paintings.

The painting later was in the possession of Charles T. Yerkes (1837–1905) who began his roller-coaster career as a Philadelphia stockbroker, embezzled city funds, spent time in jail, and endured a sensational divorce following a sex scandal. He retreated to Chicago, where he built a fortune in trolley cars only to be pursued again for corruption. Yerkes ended his days in London, where he tried to electrify the Underground. Buying with the advice of Jan de Baers, Yerkes assembled a vast collection of Old Master paintings of very good quality that he hoped would one day

form the nucleus of an American National Gallery. The collection was dispersed in 1910 through a sale catalogued in two enormous de luxe volumes.[13]

1 Hofstede de Groot, vol. 4 (1912), no. 214; Smith, vol. 6 (1835) no. 112.

2 Smith, vol. 6 (1835), no. 111; Hofstede de Groot, vol. 4 (1912), no. 253; see Albert Blankert, *Amsterdams Historisch Museum. Schilderijen daterend van voor 1800. Voorlopige catalogus* (Amsterdam, 1975/9), p. 141, no. 184. The pendants sold together in both the sale J. Pekstok, Amsterdam, 17 December 1792, nos. 48 and 49; and sale Jhr. J. Goll van Franckenstein, Amsterdam, 1 July 1833, nos. 32 and 33.

3 Broulhiet 1938, p. 400, no. 180, ill. p. 192; sale Metropolitan Museum *et al.* (anonymous collection), New York (Sotheby Parke Bernet), 12 January 1979, no. 40, ill. [as manner of Meindert Hobbema, panel 15 × 19½ in. (38 × 49.5 cm.)].

4 *Wallace Collection Catalogues, Pictures and Drawings* (London, 1968), pp. 149–50 no. P75, ill. Hofstede de Groot, vol. 4 (1912), no. 167.

5 See respectively, Hofstede de Groot, vol. 4 (1912), nos. 127 and 136, and National Gallery, Washington, DC, no. 61.

6 Canvas 38 × 52 in., signed; Broulhiet 1938, no. 184.

7 Hofstede de Groot, vol. 4 (1912), no. 48.

8 See Amsterdam/Boston/Philadelphia 1987–8, p. 24.

9 See Egbert Haverkamp Begemann, *Hercules Seghers: The Complete Etchings* (The Hague, 1973), p. 38.

10 Amsterdam/Boston/Philadelphia 1987–8, cat. no. 86.

11 For the Louvre's painting, see Hofstede de Groot, vol. 4 (1912), no. 172, *An Oak Wood*. A partial transcription of the inventory of the William Wells' collection appears in Joseph Farington's diary in the entry for October 4, 1811; see *The Diary of Joseph Farington (January 1811–June 1812)*, ed. K. Cave, vol. 11 (London and New Haven, 1983), p. 4005, 'no. 21 Hobbima. A Forest Scene. ditto. Companion', prices paid respectively £190 and £200, value £200 and £250. Farington recorded that Wells estimated the collection was worth £14,715, or £3999.15s less than what Wells had paid for it, and reported that Wells had provided through his will that the collection should remain 'together at least for a generation or two'.

12 On Wells, see Gaskell, *Seventeenth-Century Dutch and Flemish Painting. The Thyssen-Bornemisza Collection* (London, 1990), pp. 22–5.

13 On Yerkes, see W. Liedtke, in The Hague/San Francisco 1990–1, pp. 37–8.

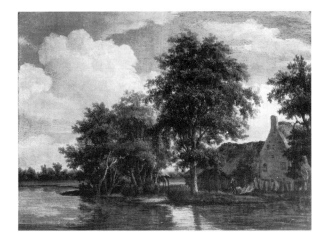

FIG. 1 Meindert Hobbema, *Peasant's Cottage beside a Stream*, signed, oil on panel 31.5 × 44 cm., Amsterdams Historisch Museum, Amsterdam, inv. no. A7513.

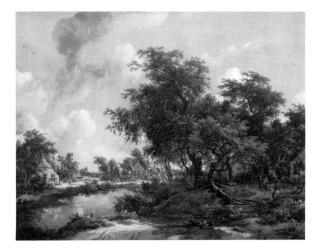

FIG. 2 Meindert Hobbema, *A Stormy Landscape*, signed and dated 1663, oil on canvas 99 × 131 cm., Wallace Collection, London, no. P75.

PIETER DE HOOCH

(ROTTERDAM 1629–1684 AMSTERDAM)

Pieter de Hooch (Hoogh) was baptized in Rotterdam on 20 December 1629, the son of a master bricklayer and a midwife. Arnold Houbraken informs us that he was a pupil of the Italianate landscapist Nicolaes Berchem (1620–83) at the same time as his fellow Rotterdamer, Jacob Ochtervelt (q.v.). De Hooch's first known appearance in Delft was in 1652, when he signed a document with the painter Hendrick van der Burch (1627–after 1666). In 1653 he was described as a painter and servant (*dienaar*) to a linen merchant, Justus de la Grange, and an inventory of the latter's collection drawn up in 1655 lists eleven paintings by De Hooch. In 1653 de Hooch attended a baptism in Leiden, but was recorded as a resident of Rotterdam in the following year, when he was betrothed to Jannetje van der Burch of Delft, no doubt the sister of Hendrick van der Burch. De Hooch joined the Guild of St Luke in Delft in 1655 and made two additional payments to the guild in 1656 and 1657. The artist's earliest dated works are from 1658 and include Delft motifs. By April 1661 de Hooch had settled in Amsterdam; he may have moved there up to eleven months earlier. Except for one appearance in Delft in 1663 (presumably as a visitor), de Hooch seems to have remained in Amsterdam for the rest of his life. At some point he entered the insane asylum (*Dolhuis*), but the date and precipitating circumstances of his commitment are unknown. On 24 March 1684, he was buried in the St Anthonius Kerkhof in Amsterdam.

De Hooch is remembered principally for his genre scenes of middle-class figures in orderly interiors and sunny courtyards. He first began to produce these works in Delft, while working with his famous colleague Johannes Vermeer (1632–75). Less well known are his early guardroom scenes and the numerous later works depicting elegant Amsterdam high life.

LITERATURE: Houbraken 1718–21, vol. 2, pp. 27, 34; Smith 1829–42, vol. 4, pp. 217–42, and *Suppl.*, pp. 563–74; P. Haverkorn van Rijsewijk, 'Pieter de Hooch', *Nederlandsche Kunstbode*, vol. 2 (1880), pp. 163–5; Abraham Bredius, 'Iets over de Hooch', *Nederlandsche Kunstbode*, vol. 3 (1881), p. 172; Abraham Bredius, 'Bijdragen tot de biographie van Pieter de Hoogh', *Oud-Holland*, vol. 7 (1889), pp. 161–8; C. Hofstede de Groot, 'Proeve eener kritische beschrijving van het werk van Pieter de Hooch', *Oud-Holland*, vol. 10 (1892), pp. 178–91; Hofstede de Groot 1908–27, vol. 1 (1908), pp. 471–570; Arthur de Rudder, *Pieter de Hooch et son œuvre* (Brussels and Paris, 1913); C. H. Collins Baker, *Pieter de Hooch* (London, 1925); Clotilde Brière-Misme, 'Tableaux inédits ou peu connus de Pieter de Hooch', Pts 1–3, *Gazette des Beaux-Arts*, 5th ser., vol. 15 (1927), pp. 361–80, vol. 16 (1927), pp. 51–79, 258–86; W. R. Valentiner, *Klassiker der Kunst in Gesamtausgaben*, vol. 35, *Pieter de Hooch* (Berlin and Leipzig, 1929); W. R. Valentiner, *Pieter de Hooch* (London and New York, 1930); F. W. S. van Thienen, *Pieter de Hoogh* (Amsterdam [c. 1945]); Peter C. Sutton, *Pieter de Hooch. Complete Edition* (Oxford, 1980); Philadelphia/Berlin/London 1984, pp. 214–22.

CAT. 33

Interior with a Woman Knitting, a Serving Woman and a Child

Oil on canvas 29 × 25 in. (74 × 63.8 cm.)

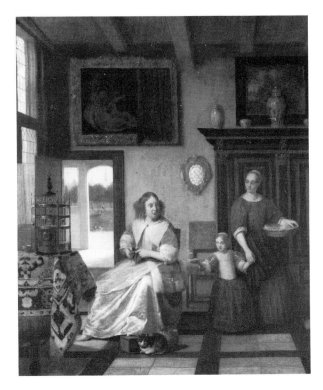

PROVENANCE: Acquired c. 1770, by the Duke of Montagu, Boughton House, Northamptonshire; in the inventory of c. 1780, as no. 98 (valued at £21); Duke of Buccleuch, Montagu House, unpublished cat. c. 1820; sold by the late Duke of Buccleuch and Queensberry, Drumlanrig Castle, Dumfrieshire, in 1965 to Marlborough Fine Art Ltd, London; acquired from Marlborough (via Speelman) in 1965.

EXHIBITIONS: London, British Institution, 1829, no. 134; London, National Gallery, 1917; London, Royal Academy, 1929, no. 334; London, 1988, no. 34, ill. p. 21.

LITERATURE: Montagu House, cat. c. 1820; Smith, vol. 4 (1833), no. 57; Henry Harvard, 'Pieter de Hooch', in L'Art et les artistes hollandais, vol. 3 (Paris, 1880), p. 111, no. 3; Hofstede de Groot, vol. 1 (1907), no. 112; A. de Rudder, Pieter de Hooch (Brussels, 1913), p. 100; C. H. Collins Baker, Masters of Painting. Pieter de Hooch (London, 1925), p. 6 [c. 1672]; Clotilde Brière-Misme, 'Tableaux inédits ou peu connus de Pieter de Hooch', Part III, Gazette des Beaux-Arts, 5th ser., vol. 16 (November 1927), p. 263, ill. p. 267; W. R. Valentiner, Pieter de Hooch. Des Meisters Gemälde in 180 Abbildungen mit einem Anhang über die Genremaler um Pieter de Hooch und die Kunst Hendrick van der Burchs, Klassiker der Kunst (Berlin and Leipzig, 1929), no. 109 [c. 1673]; C. H. Collins Baker,

'De Hooch or not De Hooch', The Burlington Magazine, vol. 57 (1930), p. 198; Peter C. Sutton, Pieter de Hooch. Complete Edition (Oxford, 1980), pp. 44, 106, cat. no. 103, pl. 106 [c. 1673]; Woodhouse 1988, pp. 126, 127; Speelman 1988, p. 14.

CONDITION NOTES: The canvas support has been relined. The paint film is abraded and retouched extensively: in the background, in the kast, the paintings on the wall, the garniture atop the kast, window, footwarmer, birdcage, tiled floor, the shadowed forms of the figures and scattered throughout. An old puncture has been repaired and filled beside the painting above the kast. The varnish is moderately discoloured. Two old inscriptions on the stretcher identify the painting as 'no. 35 Drumlanrig', references to the paintings in Drumlanrig Castle, owned by the Duke of Buccleuch and Queensberry.

In an interior a woman in a red fur-lined jacket and white silk dress sits knitting with her left foot resting on a footwarmer. She turns to look at the maidservant who holds a bread basket with her left hand and the hand of a young child in the other. The child shows a marzipan cake with a carnation in the centre to her mother. On the left a birdcage with a parrot rests on a table covered with a Turkey carpet. To the right is a large ebony and tortoiseshell kast surmounted by a garniture of ceramics decorated with a Chinese design. On the wall above the kast is a landscape in an ebony frame, and above the open door at the left a painting of Venus and Cupid in a gilt frame, partly covered by a curtain. The scene is illuminated by tall windows in the left wall. Viewed through the doorway at the left and across a foyer or voorhuis, a vista opens with a city skyline that includes a church spire loosely based on Amsterdam's Westerkerk, although the actual setting cannot be specified.

After moving from Delft to Amsterdam in c. 1660/1, de Hooch's favoured depictions of domestic interiors became increasingly elegant. Where once he had painted simple middle-class homes, now he focused on the townhouses and villas of well-to-do families, complete with costly furnishings and fashionably attired figures. Despite the social ascendence of his subjects, he continued to celebrate the life of women and children in the home. As before, de Hooch's domestic themes are complemented and enhanced by the geometric order of his interiors, with the view (or doorkijkje) through the doorway – virtually the artist's signature – offering both spatial and psychological relief. His images of women as the efficient managers of the household economy and the primary pedagogues in the home conform to seventeenth-century Protestant ideals of domestic virtue.[1]

The painting employs the darker palette and harder and dryer touch of de Hooch's art of the 1670s and can be dated about 1673 on the basis of its resemblance to a Woman and Child with a Parrot (formerly in the Schloss Collection) that

was signed and dated in that year (fig. 1).[2] That work depicts a similarly elegant interior with comparable figure types, and repeats details such as the small oval window decorated with putti and the image of Venus and Cupid, although the latter is here transformed into an overdoor with sculpted relief. The design of the Venus and Cupid also recurs as a source for paintings within de Hooch's late paintings of various musical and merry company themes.[3] It is unclear whether this detail, which the artist felt at liberty to use in such varied narrative contexts, was simply a convenient decoration or was designed to comment symbolically on the scene in the manner of so many paintings-within-paintings in seventeenth-century Dutch art. In this context, it is useful to recall that the art theorist Van Mander stressed that the subject of Venus and Cupid could be interpreted *in malo* and *in bono*, as the image of erotic temptation and seduction or, ironically, as the chaste champions of fidelity.[4]

The painting was acquired by George, Earl of Cardigan, the last Duke of Montagu, who lived at Boughton, around 1770, and was inventoried ('List C') in c. 1780 as 'no. 98 Pieter de Hoogh. A Woman Knitting & Other Figures, 2 feet 10 in. × 2 feet'. At Montagu's death in 1790 his paintings went to his daughter Elizabeth, who married the third Duke of Buccleuch. The paintings remained at Boughton until her death in 1824, when they were moved to Buccleuch. The painting hung for many years in Drumlanrig Castle, an ancient Douglas stronghold and the Dumfrieshire home of the Dukes of Buccleuch and Queensberry.

1 On themes of domestic virtue and their relationship to Dutch social ideals and the family, see Sutton 1980, pp. 45–9; Wayne Franits, 'The Family Saying Grace: A Theme in Dutch Art of the Seventeenth Century', *Simiolus*, vol. 16 (1986), no. 1, pp. 36–49; and E. de Jongh, in Frans Halsmuseum, Haarlem, *Portretten van echt en trouw. Huwelijk en gezin in de Nederlandse kunst van de zeventiende eeuw*, 15 February–13 April 1986. On the social history of the Dutch family, see D. Haks, *Huwelijk en gezin in Holland in de 17de en 18de eeuw* (2nd edn, Utrecht, 1985); Harry Peeters *et al.* (ed.), *Vijf eeuwen gezinsleven. Liefde, huwelijk en opvoeding in Nederland* (Nijmegen, 1988).
2 Sutton 1980, cat. 102, pl. 105.
3 See Sutton 1980, cat. nos. 105, 109 and 107, plates 108, 111 and 113.

4 See C. van Mander, *Wtlegginge op den Metamorphosis* (Haarlem, 1604), Bk 4, fol. 30. Venus and Cupid scenes also undoubtedly carried positive associations of love in Dutch family portraits. In de Hooch's *Portrait of the Jacott-Hoppesack Family* (Sutton 1980, cat. no. 92, fig. 95) the painting over the mantlepiece is based on a print by Jan Saenredam after Goltzius of *Venus and Cupid with their Suppliants* that was part of the series of prints depicting the devotees of Venus, Ceres and Bacchus (the traditional personifications of Love, Food and Wine); see Hollstein, vol. 18 (1980), pp. 53–5, nos. 69–71, ills. This fact, discovered by the present author since the publication of his monograph, argues against the sexually overheated iconographic interpretation of the Venus and Cupid theme in paintings within Dutch genre scenes and portraits offered by David Smith, 'Irony and Civility: Notes on the Convergence of Genre and Portraiture in Seventeenth-Century Dutch Painting', *The Art Bulletin*, vol. 69, no. 3 (September 1987), pp. 407–30.

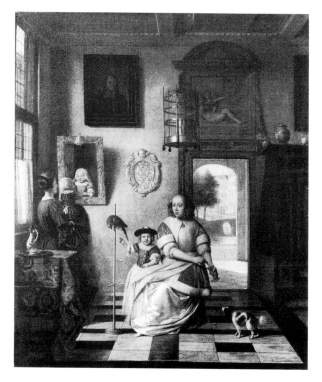

FIG. 1 Pieter de Hooch, *Woman and Child with a Parrot*, signed and dated 1673, oil on canvas 76 × 76 cm., formerly A. Schloss Collection, Paris.

WILLEM KALF

(ROTTERDAM 1619–1693 AMSTERDAM)

Willem Kalf was baptized in Rotterdam, probably in the St Laurenskerk, on 3 November 1619. His father, Jan Jansz Kalf, was a well-to-do cloth handler; his mother was Machtelt Gerrits. He had seven brothers and sisters, all but one of whom were older. The family lived in a house on the Hoogstraat across from the Town Hall. After the death of her husband in 1625, in 1631 Machtelt Gerrits (died 1638) moved with her children to a house named 'Het Comptoir' on the west side of the Leuvenhaven. Kalf was certainly in Paris by January 1642, and had probably been residing there earlier, from around 1640. His stay in Paris is corroborated by the manuscript biography (preserved in the library of the Ecole des Beaux-Arts, Paris) written by the Flemish artist, Nicolaes Vleugels, about his father, Philip Vleughels (b. 1619), who had lived with Kalf and several other Flemish painters in a house called 'La Chasse' in the St Germain-des-Près quarter. Kalf returned to Rotterdam by 26 October 1646 at the latest. On 22 October 1651, Kalf was married in Hoorn (northern Holland) to Cornelia Pluvier, a talented woman who was a calligrapher, poet and etcher of glass. The couple converted to Catholicism and had four children.

At the time of his marriage Kalf was living in Hoorn but probably moved to Amsterdam soon after, at any rate certainly by 17 June 1654. He remained in the city until his death in 1693. Kalf may also have lived in Amsterdam following his return from Paris but nothing is known of that period. Kalf was mentioned in a poem written by Jan Vos for the St Luke's guildfest of 1654 and in 1663 the great poet Joost van den Vondel praised the artistic talents of both Kalf and his wife, Cornelia Pluvier, in a poem entitled Raetsel ('Riddle'). On three occasions Kalf appeared before Amsterdam notaries to give his expert opinion about the authenticity of paintings: in 1661, together with Barent Cornelisz, Allart van Everdingen and Jacob van Ruisdael (q.v.), he examined a painting attributed to the marine painter Porcellis; in 1672 he and a large group of artists were asked their opinion about thirteen Italian paintings owned by the dealer Gerrit Uylenburgh and offered to Archduke Frederik Wilhelm of Brandenburg; and in 1686 he and the Berckheyde brothers authenticated a putative Titian. Like many other artists of the period, Kalf was also active as an art dealer, but it is unclear to what extent. In 1683 and 1690 Willem Kalf was mentioned in documents in Rotterdam concerning the Kalf family grave in the Grote Kerk, but when he died on 31 July 1693 he was buried in Amsterdam's Zuider Kerk. According to Houbraken, Kalf was a well-read man with good judgement who was friendly and entertaining. The painter Philip Vleugels also affirmed 'Calf's' generosity and friendliness.

Willem Kalf was primarily a painter of elegant *pronk* still lifes featuring precious metalware, porcelain, Turkish carpets and rare fruits. These works attest to the influence of Jan Davidsz de Heem and Simon Luttichuys, among others. Fewer then 20% of Kalf's works are dated. His earliest dated painting is of 1639 (see Cat. 34, fig. 1) and several date from 1643 and 1644 (see Commentary) but none then until 1653, while fully two-thirds of the dated works are from his prime period of 1658–63. In his early career he also painted stable interiors and kitchen still lifes with vegetables and crockery displayed in dilapidated surroundings. Several shell still lifes by the artist exist, and he apparently painted landscapes (although none is known today); two compositional sketches have also been attributed to him. He included fruit (especially peaches and citrus fruits), nuts, and on rare occasions flowers in his still lifes, but never insects, butterflies or animals. Several still life artists were influenced by him, including the Dutchmen Juriaen van Streek, Willem van Aelst, and Barent van der Meer. The German Georg Hinz and the Swedish Ottmar Elliger were also influenced by his Dutch period works, while Meiffren Conte and Hupin emulated his early Paris period paintings.

LITERATURE: Houbraken, vol. 2 (1721), p. 218; vol. 3, p. 189; Abraham Bredius, 'Italiaansche schilderijen in 1672 door Amsterdamsche en Haagsche schilders beoordeeld', *Oud-Holland*, vol. 4 (1886), p. 42; Abraham Bredius, 'Kunstkritiek der XVIIe eeuw', *Oud-Holland*, vol. 7 (1889), pp. 41–4; Wurzbach, vol. 1 (1906), p. 234; Abraham Bredius, 'Een en ander over Willem Kalf', *Oud-Holland*, vol. 42 (1925), pp. 208–9; H. Schneider in Thieme and Becker, vol. 19 (1926), pp. 465–6; H. E. van Gelder, *W. C. Heda, A. van Beyeren, W. Kalf*, Palet Serie (Amsterdam, 1941); H. E. van Gelder, 'Aanteekeningen over Willem Kalf en Corenelia Pluvier', *Oud-Holland*, vol. 59 (1942), pp. 27–46; R. van Luttervelt, 'Aanteekenigen over de ontwikkeling van Willem Kalf', *Oud-Holland*, vol. 60 (1943), pp. 60–8; Ingvar Bergström, *Dutch Still-Life Painting in the Seventeenth Century*, translated by Christina Hedström and Gerard Taylor (New York, 1956; Swedish edition 1947), pp. 260–90; Lucius Grisebach, *Willem Kalf 1619–1693* (Berlin, 1974); Sam Segal, *A Prosperous Past. The Sumptuous Still Life in the Netherlands 1600–1700* (The Hague, 1988), pp. 180–96.

CAT. 34

Still Life with a Pilgrim Flask, Candlestick, Porcelain Vase, Glasses and Fruit

Signed lower left on the edge of the table: W.KALF
Oil on canvas 28½ × 23⅛ in. (72.5 × 59 cm.).

PROVENANCE: Sale London (Sotheby's), 28 October 1936, no. 39; London art market, c. 1937–8 (with W. E. Duits, Matthiesen Gallery and Tooth and Sons); Goldsmidt, Paris; Etienne Nicolas, Paris; who sold it to Edward Speelman in late 1959, who in turn sold it to Harold Samuel.

EXHIBITIONS: London, Matthiesen Gallery, *Still Life and Flower Paintings*, 1938, no. 31, ill.; London, Tooth and Sons, 1938, no. 10; London 1988, no. 35.

LITERATURE: Ingvar Bergström, *Dutch Still Life Painting* (London, 1956), p. 268, ill. p. 264, fig. 219; A. I. Spriggs, 'Oriental Porcelain in Western Paintings 1450–1700', *Transactions of the Oriental Ceramic Society* (1966), p. 73, p. 83, ill. fig. 72c (of the copy, see below); Lucius Grisebach, *Willem Kalf 1619–1693* (Berlin, 1974), pp. 93–4, 239, cat. no. 67, fig. 77; Woodhouse 1988, p. 125, fig. 3; Speelman 1988, p. 14; Russell 1988, p. 789.

CONDITION NOTES: The canvas support has been relined and attached to a new stretcher. The paint film is extensively abraded and has suffered from lifting paint, especially in the centre of the composition. The retouching designed to knit together the crazed surface created by past and continuing lifting and to disguise old losses is extensive. There is also an extensive repaint in the darks, especially in the background, beneath the tabletop, and along the

edge of the canvas. Some forms have been strengthened through retouching: beneath the silver platter, the flask's chain, the fluting of the candlestick and parts of the porcelain vase. There is also some retouching around the signature and the 'K' has probably been reinforced. Abrasion has eliminated glazes, for example in the fruit, and whole forms, e.g. the foot and stem of the wineglass, have disappeared. The varnish is still relatively clear.

On the edge of a table a pilgrim flask rests on its side on a pewter plate. Behind it on the left is a silver candlestick and a Chinese porcelain vase. To the right is a half filled, footed wineglass, an orange and sliced lemon, knife, and behind, a glass jar with lid and decorated finial. Above a curtain is drawn up by a cord with a tassel in the upper left centre.

As Bergstrom noted,[1] this painting probably belongs to a group of about a dozen still lifes that Kalf painted during his youth in Paris in c. 1640–5/6. In addition to small scale, broadly painted stable and kitchen still lifes with everyday utensils, Kalf also painted rich pronk still lifes. The latter are mostly upright in format, diagonal in design and focus on exquisitely crafted metalware objects on a table edge; the scene is sometimes enlarged to include a chair and a shelf. Objects are arranged in front and behind one another and often, as in the Samuel painting, a vessel is overturned to enliven the design and enhance the sense of recession. Just as in Kalf's later pronk still lifes, the objects are selected for their ornament, luxury and splendour, and they glow amidst the rich darkness that surrounds them. But in these early works the objects still have a harder edge in the details, and the entire palette is keyed to the tints of the metalware. In the later works of the 1650s, the lustrous surfaces are burnished with halated highlights that seem to gleam from within, while the colour schemes employ more saturated, local hues. Earlier artists, like Pieter Claesz (q.v.) and Willem Claesz Heda, had painted precious metalware, but Kalf was the unrivalled master of sumptuous images of silver and gold.

As Segal observed, the earliest dated example of Kalf's early pronk still lifes seems to be the *Still Life with Temperantia Jug* (fig. 1) in the Carter Collection, Los Angeles; this bears the remnants of a date 163[?] which probably originally read 1639.[2] Segal hypothesized that this might have been one of the first still lifes that Kalf executed in Paris, the artist possibly arriving in that city as early as the year after his mother's death in 1638. Kalf often used the same objects in his still lifes; Grisebach noted that the same wineglass and covered glass cup that appear in the Carter painting appear also in the Samuel painting and several others.[3] Segal further observed that the overturned porcelain vessel in the Carter painting is the same Wan-li bottle that appears in the Samuel painting.[4] The Samuel

painting can probably be dated to about 1643–4. It closely resembles the *pronk* still life dated 1643 in the museum in Le Mans (fig. 2), which includes the same pilgrim flask with chain, wineglass and covered glass cup, as well as a nautilus shell, orange and other objects, all arranged on a similar stone tabletop.[5] The pilgrim flask also recurs in two other paintings dated or datable to 1643 (fig. 3),[6] in the painting dated 1644 formerly in Warwick Castle (fig. 4) which, like the Samuel painting, adds a curtain to the background of the scene,[7] and two other undated paintings.[8]

Grisebach rightly catalogued a painting in the Musée des Beaux-Arts, Rouen, as a copy of the Samuel painting, although it has repeatedly appeared in the literature as an original.[9] Unaware of the original, Arthur Spriggs reproduced and discussed the copy, pointing out that the porcelain bottle vase in the composition resembles similar bottles in the Victoria and Albert Museum and the British Museum.[10] In a private communication (letter 12 January 1991), Dr Spriggs also cited another similar bottle that was brought up by Captain Michael Hatcher from a wreck that sank in the South China Sea about 1640.[11] Ellenor Alcorn of the European Decorative Arts Department at the Museum of Fine Arts, Boston, has also drawn this author's attention to another very similar bottle in the 'Transitional period' style in the museum in Indianapolis (fig. 5).[12] These Wan-li style porcelain bottles with the globular body and tall waisted neck with swelling mouth were probably imported into Holland only shortly before Kalf painted the Samuel painting.

Although he occasionally included allusions to concepts such as temperance (the decorations on the jug in fig. 1) and watches suggestive of the residue of a vanitas tradition, Kalf's still lifes do not stress the symbolic dimension. In 1707 Gerard de Lairesse even singled out Kalf as an example of an artist who was not interested in 'private meanings;' Kalf 'could give us little Reason for what he did as others before or after him: He only depicted what occurred to him, a Porcelain Pot or Dish . . . without any thought of doing something of Importance which might bear some particular meaning or be applicable to something'.[13] For Goethe, however, Kalf's achievement was nothing less than an artistic apotheosis; writing about a copy (!) of fig. 3, he exclaimed, 'One must see this painting to understand in what respect art is superior to nature and what the spirit of man lends to these objects when he observes them with a creative eye. For me there is no question: if I would have to choose between the golden vases or the painting, I would choose the painting'.[14]

There has been a difference of opinion about the form of the signature on the Samuel painting: Bergström and

Grisebach record 'CALF', while the signature now clearly reads 'KALF', with a long tail on the 'F' and the 'K' strengthened through retouching (see Condition notes). The reflected self-portrait in the pilgrim bottle was also a traditional form of signature as well as a time-honoured illusionistic detail in still life painting; a reflected self portrait also appears in an early Kalf formerly with the dealer Edward Speelman, London (1979), and now in a private collection.[15]

1 Bergström 1956, pp. 268–70.

2 S. Segal, *A Prosperous Past* (The Hague, 1988), p. 184, ill.; see Grisebach 1974, cat. 65, fig. 69, without mention of a date.

3 Grisebach 1974, p. 238.

4 Segal 1988, p. 185, note 6.

5 Grisebach 1974, cat. 61, fig. 65.

6 Canvas 66 × 54 cm., Staatliche Museen Preussischer Kulturbesitz, Berlin, inv. no. 2137 (Grisebach 1974, cat. 63, fig. 68); canvas 144 × 101 cm., with Gallery Charles Roelofsz, Amsterdam (cat. 1988, no. 4, ill.; and Segal 1988, p. 185 and cat. 53, ill.). Although the latter painting is not dated, a copy long regarded as the original is in the Ludwig (Wallraf-Richartz) Museum, Cologne, inv. 2598, signed and dated 1643 (see Grisebach 1974, cat. 64, fig. 63, as the original).

7 Bergström 1956, p. 267, fig. 222; Grisebach 1974, cat. 70, fig. 71.

8 Bergström 1956, p. 269, fig. 223, and Grisebach 1974, cat. no. 68, fig. 70, canvas 98 × 77.5 cm., with H. Shickman, New York; Grisebach 1974, no. 69.

9 Grisebach 1974, p. 239, cat. no. 67a *copy*, signed and dated lower left: Kalf 1675 or 1645, canvas 68 × 60 cm., Musée des Beaux-Arts, Rouen, inv. no. 834-1, acquired in 1834 from M. Desclaux, Paris. Literature: Wurzbach, vol. 1 (1906), p. 234; Thieme and Becker, vol. 19 (1926), p. 465; Olga Popovitch, Rouen cat. (1967), p. 71.

10 A. I. Spriggs, 'Oriental Porcelain in Western Paintings 1450–1700', *Transactions of the Oriental Ceramic Society* (1966), pp. 73, 83, note 78, fig. 72c.

11 See the Hatcher Collection sale, Amsterdam (Christie's) 14 February 1985, no. 180; republished by Colin Sheaf and Richard Kilburn, *The Hatcher Porcelain Cargoes*, Phaidon/Christie's (London, 1988), pl. 73, in centre of top row.

12 See Chicago, The David and Alfred Smart Gallery, The University of Chicago *Blue and White Chinese Porcelain and its Impact on the Western World*, 3 October–1 December 1985, p. 122, no. 63, ill.

13 Cited from the English translation, *The Art of Painting, in all its Branches* (London, 1738), p. 555.

14 J. W. von Goethe, 'Zur Erinnerung des Städelschen Kabinets', in *Schriften zur Kunst. Gesamtausgabe*, vol. 33 (Munich, 1962), p. 62.

15 See Segal 1988, p. 184–5, fig. 10.2, note 9, canvas 153 × 166 cm. (not in Grisebach 1974); another version without the self portrait is in the Musée de Tessé, Le Mans, no. 384; Grisebach 1974, cat. 66, fig. 72. On the possible functions and meanings of this motif, see Celeste Brusati, 'Stilled Lives: Self-Portraiture and Self-Reflection in Seventeenth Century Still-Life Painting', *Simiolus*, vol. 20 (1990–1), nos. 2–3, pp. 168–82.

FIG. 1 Willem Kalf, *Still Life with Temperantia Jug*, 163[9], signed and dated 163[9], oil on canvas 56 × 45 cm., Mr and Mrs Edward Carter, Los Angeles.

FIG. 2 Willem Kalf, *Still Life with Pilgrim Flask, Nautilus Shell, Orange, Olives and Glasses*, signed and dated W. Kalf 1643, canvas 74 × 58 cm., Musée de Tessé, Le Mans, inv. nr. 10-89.

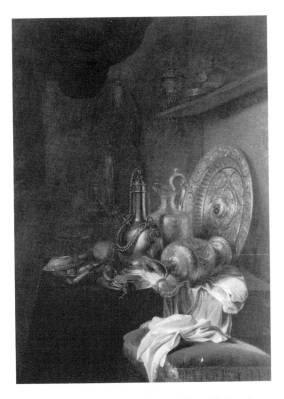

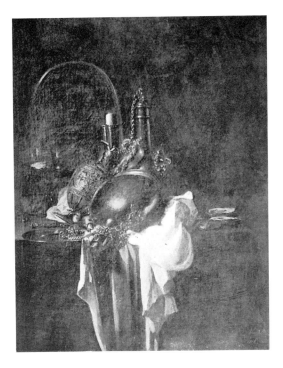

FIG. 3 Willem Kalf, *Still Life with Pilgrim Flask and Other Metalware*, 1643, signed, oil on canvas 144 × 101 cm., Charles Roelofsz Gallery, Amsterdam.

FIG. 4 Willem Kalf, *Still Life with two Silver Pilgrim Flasks, a Jug, Candle Stick and Platter*, signed and dated: W Kalf, 1644, oil on canvas 100 × 79 cm., owned by Lord Brooke of Warwick, Warwick Castle, until 1975.

FIG. 5 *A Transition Blue and White Bottle Vase*, porcelain 37 cm. high, Indianapolis Museum of Art, Gift of Mrs Eli Lilly, no. 60.127.

JAN VAN KESSEL

(ANTWERP 1626–1679 ANTWERP)

Jan van Kessel I was baptized in the St George Church in Antwerp on 5 April 1626, the son of Heironymus van Kessel and Paschaise Breughel. His maternal grandfather was Jan Brueghel the Elder (q.v.) and he was the nephew of Jan Brueghel the Younger and of David Teniers (q.v.). In 1634, at scarcely eight years of age, he was apprenticed to Simon de Vos. After eight years of study he became a master in the Guild of St Luke, qualifying in 1644 on his eighteenth birthday as 'painter of flowers'. He seems to have lived most of his life in Antwerp, where he was married to Maria van Apshoven in 1647. However he was also active for some undetermined time in Spain for Philip IV, perhaps around 1652. He died on 17 April 1679, leaving thirteen children, two of whom (Ferdinand and Jan II) also became painters. His work was appreciated by his contemporaries and figured in inventories of many amateur cabinets in Antwerp. Copies of his paintings were already in circulation in his lifetime. His portrait by Erasmus Quellinus was engraved by Alexander Voet. Van Kessel is not to be confused with the Dutch landscape painter of the same name (1641/2–80).

Van Kessel was a painter of animals, reptiles and batrachians, insects and butterflies, which he often introduced into representations of the Four Elements, the Four Parts of the World, and other allegories and fables. He also painted flowers, garlands and festoons and tabletop still lifes with fruits and vegetables.

LITERATURE: C. de Bie 1662, p. 409; Houbraken, vol. 2 (1719), pp. 139ff.; vol. 3 (1721), p. 238; F. J. van den Branden, 1883, pp. 1098–101; Wurzbach, vol. 1 (1906), p. 258; K. Zoege von Manteuffel, in Thieme and Becker, vol. 20 (1927), pp. 201–2; M. L. Hairs, *Les Peintres flamands de fleurs au XVIIe siècle* (Amsterdam/New York/Brussels, 1955) pp. 112–13, 225–8; S. Speth-Holterhoff, *Les Peintres flamands de cabinets d'amateurs au XVIIe siècle* (Paris/Brussels, n.d.), pp. 123–6; Edith Greindl, *Les Peintres flamands de nature morte au XVIIe siècle* (Sterrebeek, 1983), pp. 156–62, pp. 262–6, 365–8.

CAT. 35 Jan van Kessel (follower of)

A Still Life with Fruit and Flowers on a Table

The remnant of initials (?) in red on the handle of the knife at the right
Oil on copper 11⅞ × 20⅞ in. (30.3 × 53.3 cm.)

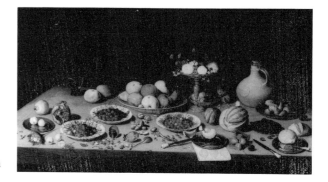

PROVENANCE: W.E. Duits, London and Amsterdam, c. 1928 [as Jan Breughel I]; dealer P. de Boer, Amsterdam, cat. 1934, no. 340, ill. [as 'Flemish School, c. 1600 (Joris Hoefnagel?)]; Mr and Mrs R. C. Graham, Stamford, Connecticut, 1957 (see exh.); E. and A. Silberman Galleries, New York [as Jan Brueghel I]; Madame Schoen-Chapan, Paris; acquired from Edward Speelman [as Jan Brueghel I] in 1964.

EXHIBITIONS: Amsterdam, P. de Boer, *De helsche en de fluweelen Brueghel en hun invloed op de kunst van de Nederlanden*, 10 February–26 March 1934, no. 340, ill. [as 'Flemish School, c. 1600 (Joris Hoefnagel?)']; Hartford, Wadsworth Athenaeum, *Connecticut Collects: An Exhibition of Privately Owned Works of Art in Connecticut*, 4 October–3 November 1957, no. 7, ill. fig. 3 [as Jan Brueghel I; lent by Mr and Mrs Robert C. Graham]; London 1988, no. 11, ill. p. 11 [as Jan Brueghel I].

LITERATURE: Ralph Warner, *Dutch and Flemish Flowers and Fruit Painters of the XVIIth and XVIIIth Centuries* (London, 1928; revised ed. Amsterdam, 1975), p. 44, pl. 17d [as J. Brueghel I]; Russell 1988, p. 189 [as J. Brueghel I].

CONDITION NOTES: The copper panel support has been attached to a wood backing which extends beyond the copper's edges on all sides by about ¼ in. (5 mm.). The paint film is in very good condition with minor retouches along the upper and lower edges.

A delectable assortment of fruits and flowers are arranged across a plain wooden tabletop. An unusually wide variety of fruit is displayed in ceramic dishes, pewter plates and strewn about the table; the scene includes peaches, pomegranates, cherries, apples, oranges, strawberries, melons, raspberries, plums, figs and blueberries. Green almonds, walnuts and other nuts are also scattered about. A golden tazza holds a simple arrangement of flowers. At the right is a large earthenware jug with a silver cap and a round seal; to the left are two glasses of red and white wine. Two guinea pigs nibble at the lower left and a red squirrel snacks at the right. Insects, flies and butterflies also figure among the objects.

The painting is neither signed nor dated, but there may be remnants of a monogram or initials in red paint on the knife at the right. When it was first published by Warner in the 1920s, while with the dealer Duits in Amsterdam, it was assigned to Jan Brueghel I (q.v.), but Brueghel never executed tabletop still lifes of this type.[1] Nonetheless, this attribution was upheld when the painting was exhibited in Hartford in 1957, when acquired from Speelman, when exhibited in London in 1988, and in Russell's review of this exhibition. However, another version of the painting with virtually the same dimensions but on panel was assigned to Jan van Kessel when it was with Waterman in Amsterdam in 1984 (see fig. 1).[2] Jan van Kessel's activity as a painter of flowers, allegorical still lifes and small scenes on copper with animals, birds, insects and butterflies is better understood than his activity as a painter of tabletop still lifes. He executed at least one relatively large-scale painting on canvas, signed and dated 1654, which depicts a *pronk* tabletop still life, but this appears to be a copy of Jan Davidsz de Heem (Gemäldegalerie, Dresden, no. 1221). Edith Greindl assigned several small tabletop still lifes on copper to the artist (see, for example, fig. 2).[3] These closely resemble the Samuel painting in design and style, with their additively arranged compositions of scarcely overlapping objects and careful, even fastidious, execution with strong local colouring. They are reminiscent in miniature of the larger still lifes painted in Antwerp earlier in the century by Osaias Beert (c. 1580–1623) and Jacob Foppens van Es (c. 1596–1666). The painting formerly in a private collection in Frankfurt (fig. 2) is smaller than the Samuel collection picture but very close in conception, and repeats individual motifs such as the flowers, melon and guinea pigs. A more elaborately decorative tabletop still life, again on copper, with fruit and flowers (fig. 3) is one of a pair in the Galleria Doria, Rome.[4] All three works and several other paintings in their style may be by the same hand.[5] But while they all

acknowledge van Kessel's precedents, especially in the painting of smaller-scale still lifes, there are no certain autograph works by van Kessel of this type.[6] His few signed still lifes on small coppers with comparable motifs (see the *Basket of Fruit with a Guinea Pig*, signed, oil on copper 18 × 22 cm., Enschede, Twenthe Museum, inv. no. 12) do not provide coercive comparisons. A still-life painting known as *Le Dejeuner*, formerly attributed to Floris van Schooten (see sale Brussels (Finck), 30 November 1963, no. 40, ill.) and most recently sold as 'anonymous Antwerp School', employed some of the same motifs as the Samuel painting, including the two apples and glasses in the upper left and the bread knife and bread buns in the lower right. The tazza of flowers that appears in both versions of the Samuel painting derives from a type introduced by Jan Brueghel around 1615–18. Three similar tazzas also figure prominently in a small still life of fruit and flowers that sold recently in London and which Fred Meijer correctly suggests may be by the same hand as the Samuel painting.[7] That work bore a (later?) inscription in Italian on the back identifying the painter as a Flemish immigrant, Raffo or Raffaello Morghen, who unfortunately has not been identified.[8] Meijer had previously expressed his belief that the author of the Samuel still life, whom he provisionally baptized 'pseudo-Van Kessel', was a Flemish artist who went to Italy.

An alternative though unconvincing attribution for the Samuel painting to the German painter Godert (Gotthardt) de Wedig (1583–1641) has been proposed by Anthony Speelman.

A potentially important clue to the author of the work and its possible patron is provided by the coat of arms on the napkin of the Austrian Habsburgs (a double-headed eagle with crown), probably not that of Rudolf II, who died as early as 1612, but perhaps Archduke Leopold II who was crowned king of Bohemia in 1655.

1 See Klaus Ertz, Jan Brueghel D.Ä., *Die Gemälde mit kritischem Oeuvrekatalog*, (Cologne, 1979). When exhibited by de Boer in Amsterdam in 1934 the painting was tentatively attributed to 'Joris Hoefnagel?' but he too never painted works like this.
2 See advertisement in *Tableau*, vol. 6 (Summer 1984), n.p., with ill.
3 Edith Greindl, *Les Peintres flamands de nature morte au XVIIe siècle* (Sterrebeek, 1983), pp. 159–60.
4 Galleria Doria-Pamphili, Rome, cat. (1970), nos. 314 and 313 [as Anonymous].
5 Fred Meijer at the Rijksbureau voor Kunsthistorische Documentatie in The Hague has kindly observed that in the circle of Jan van Kessel several small-scale still lifes on copper and panel in a style comparable to the Samuel painting have been wrongly attributed to Abraham Brueghel: see sale London

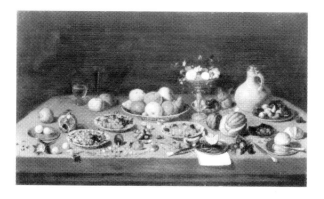

FIG. 1 Follower of Jan van Kessel, *Tabletop Still Life*, panel 31 × 54 cm., with dealers K. and V. Waterman, Amsterdam, 1984.

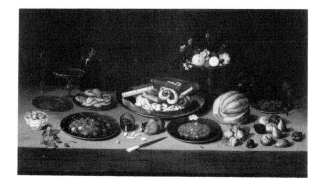

FIG. 2 Follower of Jan van Kessel, *Still Life with Flowers, Fruit, Sweets and Guinea Pigs*, oil on copper 20 × 34 cm., Stefan and Monika Schmink, Frankfurt a.M., c. 1983.

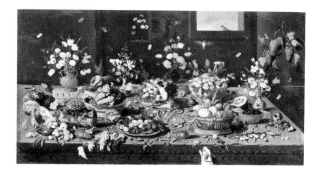

FIG. 3 Follower of Jan van Kessel, *Still Life with Fruit, Flowers, a Monkey and a Dog*, oil on copper 41 × 67 cm., Galleria Doria-Pamphili, Rome, no. 297.

(Sotheby's), 9 July 1975, no. 17 (companion pieces); and sale London, 10 July 1974, no. 79, ill.

6 Compare also the tabletop still lifes attributed to Jan van Kessel: pendant pieces (copper 16.5 × 21.5 cm.), London, Brian Koetser Gallery, *Exhibition of Old Master Paintings*, 16 April–12 June 1964, reprs. in *Apollo*, vol. 79 (1964), n.p.; Szépmüvészeti Museum, Budapest, nos. 58.6 and 58.7, *Still Lifes with Fruit and Animals* pendants (35.4 × 47 cm.), reprs. in Wausau, Wisconsin, *Delights for the Senses*, exh. cat. 1989/90, cat. nos. 26 and 27; and the two *Still Lifes with Fruit and Animals*, respectively panel 37 × 52.5 cm. and copper 31 × 42 cm., with Galerie Fillippo Franco, c. 1980, reprs. in Greindl 1983, p. 161, figs. 87 and 88, cats. 92 and 93.

7 Oil on canvas 23.5 × 58.5 cm., sale London (Bonhams), 4 July 1991, no. 170, as 'Italian School, late 18th century', however the painting is surely seventeenth-century.

8 Inscribed 'Raffo Morghen, originale flammengo, finissimo possedato Raffaello Morghen'. The artist is not to be confused with the eighteenth-century printmaker, Raphael Morghen (1758–1833).

PHILIPS KONINCK

(AMSTERDAM 1619–1688 AMSTERDAM)

The youngest of six brothers, Philips Koninck (Koning, Coningh, Coninck, and other spellings) was born in Amsterdam on 5 November 1619. His father, Aert de Koninck, was a goldsmith; his brother Jacob de Koninck (1614/15–after 1690) and cousin Salomon de Koninck (1609–56) were painters. Jacob served as Philips' first teacher in Rotterdam; on 2 January 1640 he received payment of thirty guilders for instructing Philips over a period of half a year. Philips had probably begun this instruction around 1637. By 1639, he had executed painted portraits and head studies as well as figure drawings, since works of these descriptions were mentioned in his father's inventory of that year. In 1640 he married Cornelia Furnerius (died 1642), daughter of a surgeon and organist and sister of the artist Abraham Furnerius (c. 1628–54), who was also a Rembrandt pupil and whose drawings closely resemble those of Philips. According to Houbraken, Koninck studied with Rembrandt. This probably took place following his move to Amsterdam in 1641; certainly Koninck's works from the latter half of the 1640s and early 1650s show the strong influence of both Rembrandt and Hercules Segers.

Koninck is not mentioned again in Amsterdam documents until 1653. His testimony in 1658/9 that he had received a pearl necklace about seven years earlier from Rembrandt proves that the two artists had met at the latest by around 1651. Koninck served as an expert in several disputes over the authenticity of paintings in Amsterdam. The fact that his portrait was sought by the Grand Duke of Tuscany for the latter's gallery of artists' self-portraits is proof of his international reputation. His art was praised by the poets Jan de Vos and Joost van den Vondel, whose portrait Koninck drew and painted (Museum Amstelkring, Amsterdam, dated 1665). Vondel, who also admired Jan Lievens and Juriaen Ovens, spoke only of Koninck's history paintings, not his landscapes. In 1657 Koninck was remarried, to Margaretha van Rijn; Vondel composed a poem on the artist's now lost portrait of his new wife. In 1658 Koninck was living on the Prinsengracht and in 1672 on the Leidsegracht, while at his death in 1688 he was a resident of the Reguliersgracht. Several documents indicate that later in life Koninck was the owner of the inland shipping line between Rotterdam and Amsterdam. His latest dated landscapes are of 1676 (see Amsterdam, Rijksmuseum, inv. A 206), and he seems to have given up painting entirely thereafter; Gerson could date no paintings to the 1680s.

A painter and draughtsman of portraits, history subjects, low-life genre themes and panoramic landscapes, Koninck excelled only at the last mentioned. Most of his panoramas are imaginary but evoke the landscape of Gelderland. He had developed his own distinctive style by the early 1650s. By the later 1660s his subjects became more idyllic, often populated by elegant or pastoral figures. Nearly three hundred drawings and eight landscape etchings are known by the artist.

LITERATURE: Houbraken, vol. 1 (1718), p. 269, vol. 2 (1719), pp. 53–4, 131, vol. 3 (1721), p. 79; Wurzbach, vol. 1 (1906), pp. 323–6; J. M. Turner, 'Philips and Jacob de Koninck', *The Burlington Magazine*, vol. 14 (1908–9), pp. 360–5; A. Bredius, *Künstler-Inventare*, vol. 1 (1915), pp. 149–69; C. Hofstede de Groot, in Thieme and Becker, vol. 21 (1927), pp. 271–4; Gustav Falck, 'Einige Bemerkungen über Philips de Koninck's Tätigkeit als Zeichner', *Festschrift für M. J. Friedländer* (Leipzig, 1927), pp. 168–80; M. B. H. Molkenboer, 'Philips Koninck en Vondel', *Vondelkronijk*, vol. 7 (1986), pp. 86–91; Horst Gerson, *Philips Koninck. Ein Beitrag zur Erforschung der holländischen Malerei des XVII. Jahrhundert* (Berlin, 1936); Horst Gerson, 'Bredius 447', *Festschrift Dr. Eduard Trautscholdt* (Hamburg, 1965); Werner Sumowski, *Drawings of the Rembrandt School*, vol. 4 (New York, 1979); S. A. C. Dudok van Heel, 'Het "Schilderhuis" van Govaert Flinck en de kunsthandel van Uylenburgh te Amsterdam', *Jaarboek Amstelodamum*, vol. 24 (1982), pp. 70–90; Werner Sumowski, *Gemälde der Rembrandt-Schüler* (London/Pfalz, 1983) vol. 3, pp. 1530–626; Amsterdam/Boston/London 1987–8, pp. 366–70.

CAT. 36

Panoramic Landscape

Signed in lower centre: 'PKn'
Oil on canvas 52 × 66¼ in. (132 × 168.5 cm.).

PROVENANCE: (Probably) sale H. J. A. Eyre, London, 8 December 1905, no. 15 (£2200 to Colnaghi's); dealer P. and D. Colnaghi, London; dealers Dowdeswell and Dowdeswell(?), London (see sticker); Sir William van Horne, Montreal, by 1906 (see exh.); acquired in January 1962 from van Horne's daughter-in-law by Edward Speelman for Harold Samuel.

EXHIBITIONS: (Possibly) London, British Institution, 1864, no. 70; Montreal, Art Association of Montreal, *Rembrandt*, 1906, no. 30; New York, Metropolitan Museum of Art, *The Hudson Fulton Celebration* (cat. by W. R. Valentiner), 1909, p. 60, no. 59, ill.; Montreal, Art Association of Montreal, *A Selection from the Collection of Paintings of the late Sir William van Horne, K.C.M.G. 1843–1915*, Montreal, 16 October–5 November 1933, no. 56; London 1988, no. 36.

LITERATURE: 'In the Sale Room', *Connoisseur*, vol. 14 (1906), p. 126; E. Waldman, 'Die Ausstellung holländischer Gemälde des 17. Jahrhunderts in New York', *Zeitschrift für bildenden Kunst*, N.F., vol. 21 (1910), p. 82; Kenyon Cox, 'Dutch Pictures in the Hudson Fulton Exhibition', *The Burlington Magazine*, vol. 16 (February, 1910), p. 306; Horst Gerson, *Philips Koninck. Ein Beitrag zur Erforschung der holländischen Malerei des XVII. Jahrhunderts* (Berlin, 1936), pp. 26, 108, no. 42; Speelman 1988, p. 14; Russell 1988, p. 789.

CONDITION NOTES: The canvas support has been relined. The paint film has been somewhat abraded, especially in the sky, where inpainting moderates the visual effects of losses and disguises areas of pronounced craquelure. Areas of liberal retouching appear in the center near the horizon, in the upper right, the lower right corner and to the right of the large building. However, the signature and the area around it are not obviously reworked. The varnish is moderately discoloured and rubbed along the lower edge. On the back is the sticker of the dealers Dowdeswell and Dowdeswell, London, and in red on the back of the canvas '71.De Koninck'.

In a large panoramic landscape a track curves into the scene from the lower left and retreats rapidly at a sharp angle to the right, passing a sunlit building on a bluff with classical façade and two towers, the larger of which has a square steeple with cupola. The road is travelled by small figures, including a man with a pannier and a woman with a basket on her head. On the left is a sunlit body of water with an angler on the near shore and buildings in the shadowed hollow on the far side. In the lower right, tall trees rise beside a fence bordering the road. The broad plain stretching back to the horizon is studded with trees and buildings and coursed by a meandering river with boats. On the horizon on the right are lighted dunes. Overhead, billowing clouds cast irregular shadows on the plain.

When the painting was exhibited in New York at the Hudson Fulton exhibition in 1909 it was entitled 'The Dunes: 'The Valley of the Rhine Near Arnheim'.

While Koninck executed drawings of known sites, such as Edam, Elten and the Rhine Valley near Emmerich viewed from the Spitzberg, the subjects of his landscape paintings are virtually all imaginary, even though many recall the broad plains of Gelderland. In his monograph on the artist, Gerson titled the painting simply 'Panoramic Landscape', and grouped it with the much blonder panorama, dated 1655, in the Thyssen-Bornemisza Collection, Lugano (fig. 1),[1] while comparing it also to the undated painting in the Hunterian Museum of the University of Glasgow (fig. 2).[2] Both of these works display panoramas that bisect the composition laterally and feature a strong diagonal thrust from the lower left to the right. Also comparable in design are the very large panoramas *The Waal River near Beck*, dated 1654, in the Statens Museum for Kunst, Copenhagen (fig. 3)[3] – one of the artist's few paintings with an identifiable site – and *Panorama with Cottages Lining a Road*, dated 1655, in the Rijksmuseum, Amsterdam (no. A4133).[4] Like these other works, the Samuel painting exhibits the broad painterly touch and brown, umber and lemony yellow palette, as well as the overall golden tonality, that Koninck favoured in his best period, c. 1654–65.

Koninck painted low-life genre scenes and portraits throughout his life but excelled only in landscape and specifically in the panorama. Although in his exploration of the painting type he followed in the footsteps of earlier landscapists, including Hans Bol, Hendrick Goltzius, Hercules Segers and Jan van Goyen, as well as his pur-

ported teacher, Rembrandt, Koninck elevated the panorama to unforeseen grandeur, not only in terms of scale and breadth of execution but also in his majestic treatment of light and symphonic handling of colour. His father's inventory of 1639 already mentions (unidentified) portraits and head studies by Philips, proving that he was then active as a painter, and he dated history paintings as early as 1642 and genre scenes two years later, but the first landscapes to be attributed on the basis of style to his early career are of c. 1645. The earliest certain date is 1646 on the panoramic *Landscape with Traveller* in the Victoria and Albert Museum, London (no. 3012).[5] By the mid-1650s Koninck had given the panorama an unprecedented sweep and freedom which, by its limitless horizon, seemed to embody the optimistic self-confidence and global reach of the tiny Dutch nation. Like Salomon van Ruysdael, Hobbema, and the skilled still-life painters of his era, Koninck was also exceptionally creative at exploring the artistic variations of a single theme and a favoured group of motifs. His masterful command of all the formalistic variations on the panorama had a special attraction for the first generation of twentieth-century art historians, like Gerson, who grew up with abstract painting.

The Samuel painting probably is identical with the work by Koninck that appeared in the Eyre sale ('P. DeKoning, *An extensive view over a landscape*, with church and figures in the foreground and river winding away in the distance, 51 in. by 66 in'.). That picture brought 2,100 guineas, the highest price in the sale, and prompted the anonymous reviewer for *Connoisseur* to remark that it was 'by far the highest price ever paid in this country for a work of this master at auction'.[6] The painting subsequently entered the

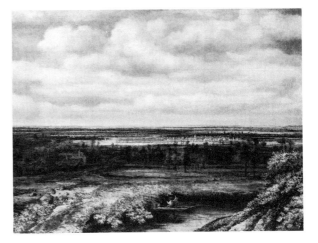

FIG. 2 Philips Koninck, *Panorama with Two Anglers*, oil on canvas 112 × 155 cm., Hunterian Museum, University of Glasgow, cat. (1973) no. 16.

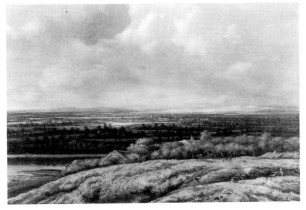

FIG. 3 Philips Koninck, *The Waal near Beck*, signed and dated 1654, oil on canvas 150 × 203 cm., Statens Museum for Kunst, Copenhagen, no. 3876.

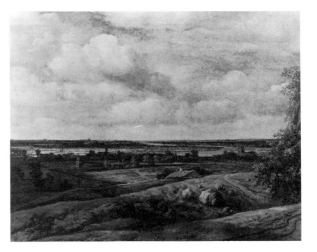

FIG. 1 Philips Koninck, *Panoramic Landscape*, signed and dated 1655, oil on canvas 83.5 × 127.5 cm., Thyssen-Bornemisza Collection, Lugano, acc. no. 1930.42.

collection of Sir William van Horne (1843–1915) of Montreal, a large and ebullient man who developed the Canadian Pacific Railroad, owned vast wheatfields in Manitoba, and gathered one of the finest Old Master collections ever assembled in Canada.[7] Van Horne lent the painting to the famous Hudson Fulton exhibition in New York in 1909, where reviewers like Kenyon Cox commended it for 'the immediate influence of Rembrandt in his brown tone and loaded handling, and a very modern acceptance of the forms of nature without obvious composition'.[8]

1 Gerson 1936, pp. 25–6, no. 51; for the Thyssen-Bornemisza painting, see Ivan Gaskell, *Seventeenth-Century Dutch and Flemish Painting, The Thyssen-Bornemisza Collection*, (London, 1990), p. 370–1, cat. no. 85, ill.

2 Gerson 1936, p. 26, no. 23 [or c. 1655–60]; however, Sumowski, vol. 3 (1983), no. 1062, ill. would date it later, c. 1665.

3 Gerson 1936, p. 27; Sumowski, vol. 3 (1983), no. 1054, ill.

4 Gerson 1936, no. 26, pl. 6; Sumowski, vol. 3 (1983), nos. 1055.

5 Gerson 1936, no. 34, pl. 2; Sumowski, vol. 3 (1983), no. 1043; ill.

6 *Connoisseur*, vol. 14 (1906), p. 126.

7 See Roger Fry's obituary, *The Burlington Magazine*, vol. 28 (1915–16), pp. 39–40. On the van Horne Collection, see Sir Martin Conway, 'Sir William van Horne's Collection at Montreal', *Connoisseur*, vol. 12 (July 1905), pp. 135–42; August L. Mayer, 'Die Sammlung Sir William van Horne in Montreal', *Der Cicerone*, vol. 8 (1916), pp. 1–9; Charles Wassermann, 'Canada's Finest Art Collection: Mrs William van Horne's Collection in Montreal', *Mayfair*, vol. 26 (October 1952), pp. 48ff.; and the exhibition held in Montreal in 1933 (see exh.).

8 Kenyon Cox, in *The Burlington Magazine*, vol. 16 (February 1910), p. 306.

NICOLAES MAES

(DORDRECHT 1634–1693 AMSTERDAM)

Born the son of a merchant in Dordrecht in January 1634, Maes was said by Arnold Houbraken to have learned drawing from a mediocre master ('een gemeen Meester'), and painting from Rembrandt. The latter period of tuition probably occurred in Amsterdam around 1650, and was certainly concluded by late 1653, when Maes returned to his native Dordrecht. He was betrothed to Adriana Brouwers, widow of the preacher Arnoldus de Gelder, in Dordrecht on 28 December 1653, and married there on 21 January 1654. In 1658 he bought a house on the Steechoversloot and in 1665 purchased a garden. Maes seems to have remained in his home town until 1673, when he settled permanently in Amsterdam. According to Houbraken he journeyed to Antwerp to see paintings by Peter Paul Rubens (1577–1640), Anthony van Dyck (1599–1641) and others, and visited several artists, including Jacob Jordaens (1593–1678). The date for this trip is usually placed in the early to mid-1660s. Maes was buried in Amsterdam on 24 December 1693.

Maes' earliest works have religious subjects and exhibit a strong Rembrandtesque style. Subsequently, he executed genre scenes, often of domestic themes, old women praying, and street pedlars, the last mentioned recalling the art of his fellow Rembrandt pupil, Jan Victors (1619/20–c. 1676). By 1654 he had begun painting the small-scale domestic interiors for which he is best remembered, and which anticipate works by the Delft painters such as Pieter de Hooch (q.v.) and Johannes Vermeer (1632–75). Maes continued to paint genre scenes only until about 1659; the remainder of his career was devoted exclusively to elegant portraiture. His portraits – both life sized and small-scale works – were influenced by Flemish art, especially that of van Dyck. According to Houbraken these works were in great demand, and several hundred have survived.

LITERATURE: Houbraken, vol. 1 (1718), pp. 131, 317, vol. 2 (1719), pp. 273–7; Smith, vol. 4 (1833), pp. 243–9; G. H. Veth, 'Aanteekeningen omtrent eenige Dordrechtsche schilders: 18. Nicolaes Maes', Oud-Holland, vol. 8 (1890), p. 127; Wurzbach, vol. 2 (1910), pp. 89–91; Hofstede de Groot, vol. 6 (1916), pp. 473–605; H. Wichmann, in Thieme and Becker, vol. 23 (1929), pp. 546–7; Abraham Bredius, 'Bijdragen tot een biografie van Nicolaes Maes', Oud-Holland, vol. 41 (1923–4), pp. 207–14; W. R. Valentiner, Nicolaes Maes (Berlin and Leipzig, 1924); The Art Institute of Chicago, Rembrandt after Three Hundred Years, 25 October–7 December 1969 (also shown at The Minneapolis Institute of Arts, 22 December 1969–1 February 1970), and The Detroit Institute of Arts, 24 February–5 April 1970, pp. 81–5; Werner Sumowski, Gemälde der Rembrandt-Schüler, vol. 3 (Landau and Pfalz, 1983), pp. 1951–2174; Philadelphia/Berlin/London 1984, pp. 239–43; William W. Robinson, 'The Eavesdroppers and Related Paintings by Nicolaes Maes', in Holländische Genremalerei im 17. Jahrhundert (Jahrbuch Preussischer Kulturbesitz, Sonderband 4 (Berlin, 1987)), pp. 283–313; Jeroen Giltaij, The Drawings by Rembrandt and his School in the Museum Boymans-van Beuningen (Rotterdam, 1988), pp. 220–41; William W. Robinson, 'The Early Works of Nicolaes Maes', dissertation, Harvard University, in preparation.

CAT. 37

An Eavesdropper with a Woman Scolding, 1655

Signed and dated on the bottom step of the spiral staircase:
N. MAES.1655 (the 'A' and 'E' ligated)
Oil on panel 18¼ × 28⅜ in. (45.7 × 72.2 cm.)

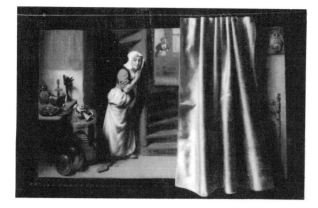

PROVENANCE: (Probably) sale Comte de Vence, Paris, 9 February
1761, no. 104 (160 frs.) with the measurements 16 × 25½ in. (but
see Descamps 1754); Lord Clinton, acquired c. 1800; (Lord
Clinton was the great-great-grandfather of the owner who sold the
painting anonymously in 1967); sale London (Christie's), 23 June
1967, no. 64, ill., to Speelman; acquired from Edward Speelman.

EXHIBITION: London 1988, no. 38, ill. p. 20.

LITERATURE: (Probably) Descamps 1754, p. 458; (probably)
Smith, vol. 4 (1833), no. 1; (probably) Hofstede de Groot, vol. 6
(1916), no. 127; adv. for Christie's sale, 23 June 1967, in *The
Burlington Magazine*, vol. 109 (June, 1967), p. lxxxix, ill.; *Christie's
Review of the Year 1966–67*, pp. 28–9; Battersby 1974, p. 34, ill. 27;
Philadelphia/Berlin/London 1984, p. LII, fig. 92; Werner
Sumowski, *Drawings of the Rembrandt School*, vol. 8 (New York,
1984), p. 3984, under cat. no. 1769; Werner Sumowski, *Gemälde
der Rembrandt-Schüler*, vol. 3 (Landau/Pfalz, 1983), p. 2018, cat. no.
1353, ill. p. 2079; William W. Robinson, 'The *Eavesdroppers* and
Related Paintings by Nicolaes Maes', in *Holländische Genremalerei
im 17. Jahrhundert. Symposium Berlin 1984 (Jahrbuch Preussischer
Kulturbesitz*, Sonderband 4 (Berlin, 1987)), p. 283ff., especially
p. 297, fig. 1, note. 2.

CONDITION NOTES: The panel support is in good condition with
a slight warp but uncradled. It appears to be complete, reveals the
panelmaker's chisel marks on the back and is bevelled on all sides.
The lower edge is slightly irregular showing minor chips and
losses. There are also a few old insect holes. The paint film is
abraded in the shadows of the curtain, in the darks of the eaves-
dropper's skirt, the cloth of the barrel on the left, and the figure
and area around the housewife in the room above. Old scratches
have been repaired in the lower centre. A pentiment on the wall at
the left reveals that the artist painted out a long-handled pan or
ladle. There are retouches in the curtain, beneath the jug on the
right, and to strengthen forms along the line of the frame above

the doorway and in the staircase. Additional minor retouches are
scattered to the left and along the upper edge. The varnish is clear.
A sticker with the number c/605 is attached to the back.

A young woman stands at the base of a spiral staircase
smiling and gesturing to the viewer to be quiet. She appears
to eavesdrop on a woman in the room to the upper right
who bends forward at the waist, cocks her head to one side
and places her arms akimbo in a scolding attitude, although
the object of her anger is unseen. On the left is a still life of
a ceramic vessel and pewter objects resting on a table and a
wooden barrel. On the right is a glimpse of a chair and a
ceramic jug hanging from the wall. The entire scene is
depicted as an illusionistic painting, with a black ebony
frame with ripple work decoration and an illusionistic blue
curtain suspended from a curtain rod attached to the upper
edge of the painted frame.

Although his activities in this particular field were
restricted to a few years in the 1650s, Nicolaes Maes was
one of the most innovative Dutch genre painters of the
seventeenth century. His contributions included a creative
approach to anecdotal genre subjects which is best illus-
trated by his six paintings of the 'Eavesdropper' theme,
ranging in date from 1655 to 1657.[1] Typical of this group is
the *Eavesdropper* in Apsley House (fig. 1). All of these works
depict women (or in the case of the painting in Boston, a
man) standing on a staircase gesturing with a raised index

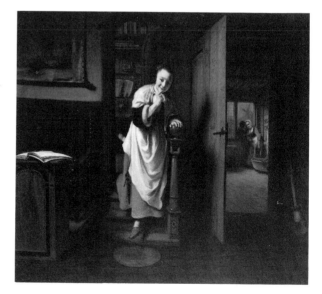

FIG. 1 Nicolaes Maes, *The Eavesdropper*, signed, oil on canvas 23
× 25 in., Wellington Museum, Apsley House, cat. 1901, no. 60.

FIG. 4 Nicolaes Maes, *Eavesdropper*, pen and brown ink, 69 × 102 mm., Fogg Art Museum, Cambridge, Mass., no. 1937.22.

FIG. 2 Jan Wierix, after Pieter Brueghel the Elder, *A Shrewish Woman Scolding her Husband*, engraving.

FIG. 5 Nicolaes Maes, *Eavesdropper*, pen and brown and grey ink, 102 × 72 mm., Present Location Unknown.

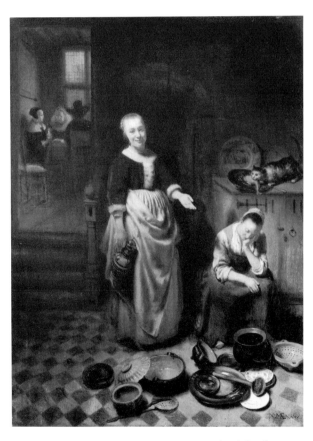

FIG. 3 Nicolaes Maes, *The Idle Servant*, signed and dated 1655, oil on panel 70 × 53.3 cm., National Gallery, London, no. 207.

finger to their lips for quiet, lest we alert the figures on which they are eavesdropping above or below stairs. In the other five examples the figures in these subsidiary scenes are lovers caught in a tryst (see, for example, fig. 1). However in the Samuel painting the scene upstairs reveals only a woman in a hectoring attitude.

In his lecture and article discussing the Eavesdropper paintings, Robinson has persuasively argued that this figure is related to the shrewish wife who was a perennial figure in Netherlandish art and literature. She is constantly scolding submissive or otherwise broken husbands in Dutch proverbs, emblems and prints.[2] A print after Bruegel well illustrates the tradition and the shrewish wife's posture (see fig. 2).[3] The husband that is the object of the wife's wrath must be interpolated from the scene, but the bemused serving woman clearly receives an earful of the shrew's domestic disruption. Maes' *Idle Servant* (fig. 3) depicts a woman pointing out a lazy scullery maid whose dozing permits a cat to steal the dinner's fish.[4] The notorious fecklessness and disrespectful qualities of female servants were constantly satirized and condemned in seventeenth-century literature.[5] Thus the wife's rage is made all the more indiscreet and unsettling for the presence of the eavesdropping maidservant.

As Sumowski observed, there is a preparatory drawing for this composition in the Fogg Art Museum (fig. 4) which depicts the eavesdropper with the curtain and barrel but omits the view with spiral staircase, the table with still life on the left and the eavesdropper's cap.[6] Russell made these connections as well and, like Robinson, drew attention to the sheet of figure studies of various eavesdroppers formerly in the Earl of Dalhousie's collection and now in the Boymans-van Beuningen Museum, Rotterdam (no. R.63 recto) which includes a woman raising her finger to her lips for quiet.[7] Sumowski also noted that a single half-length figure study of a woman eavesdropper (fig. 5) also is closely related in pose and situation to the Samuel painting.[8]

In addition to his creative contributions to the subject matter of genre, Maes also probably was an innovator in the expressive use of illusionistic perspectives in interiors. Besides spiral staircases he experimented with views to adjoining spaces in advance of the complex interiors of the Delft School painters, Pieter de Hooch (q.v.) and Johannes Vermeer.[9] His interest in the expressive manipulation of pictorial thresholds is seen in the illusionistic painted frame and curtain in the Samuel painting. Sumowski noted that Maes' teacher, Rembrandt, included a painted frame and curtain in the *Holy Family* of 1646 in Kassel, which he felt might have been a direct inspiration for this painting.[10]

Gerard Dou had also experimented earlier with illusionistic frames and curtains, and the Delft School, beginning with the architectural painters Emanuel de Witte and Gerard Houckgeest, made a speciality of such effects.[11]

The painting is probably the picture that was in the collection of the Comte de Vence, one of the most outstanding eighteenth century French collectors of Dutch art. Although the dimensions of that work were reported in the 1761 sale to be smaller,[12] Descamps described the Comte de Vence's painting in detail as the only cabinet picture by Maes known to him in France: 'Il represent une Femme qui fait des reproches à son mari; une joli servante est au bas de l'escalier ou elle écoute cette conversation vive, à laquelle elle paroit prendre quelque interet.'[13].

1 See Hofstede de Groot, vol. 6 (1916), nos. 121–5, which respectively are the paintings in the Dordrechts Museum (dated 1657), the Museum of Fine Arts, Boston, the Royal Collection, Buckingham Palace (1655), the Wallace Collection (1656), and the Wellington Museum, Apsley House, and Lord Samuel's painting (HDG no. 127).

2 See William W. Robinson, 'The *Eavesdroppers* and Related Paintings by Nicolaes Maes', in *Holländische Genremalerei im 17. Jahrhundert. Symposium Berlin 1984 (Jahrbuch Preussischer Kulturbesitz*, Sonderband 4 (Berlin, 1987)), pp. 283–311, esp. p. 297. On the theme of Maes' eavesdroppers generally, see E. de Jongh, 'De Luistervink, Nicolaes Maes', in *Openbaar Kunstbezit*, vol. 14 (1970), pp. 1a–1b; and in Amsterdam, Rijksmuseum, *Tot Lering en Vermaak*, 1976, cat. no. 34; and W. Robinson, in Philadelphia/Berlin/London 1984, pp. 242–3, no. 67.

3 Robinson (ibid.) noted that Breugel based his image on two Netherlandish proverbs. The rooster and hen in his image allude to the saying, 'It is a sad home where the hen crows and

the cock does not', while the other proverb is inscribed on the border of the print, 'A roof that leaks/and a smokey chimney, yes, where the monkey on the hearth sits and looks, a crowing hen/ a quarrelsome wife, is misfortune in the house/ yes, torment and grief'. Closer in date to Maes' painting, Jan Harmensz Krul's *Weg-wyser ter deughden* of 1639 also includes an illustration (Robinson, fig. 15) depicting an angry wife in a similar pose berating her melancholy husband and frightened children. Its title is 'Een booze vrouw, een quaed houwelijk' (An angry wife, a bad marriage); Krul advises that no woman should correct or quarrel with her husband within earshot of servants or children.

4 Hofstede de Groot, vol. 6 (1916), no. 100.

5 See Simon Schama, 'Wives and Wantons: Versions of Womanhood in Seventeenth Century Dutch Art', *The Oxford Art Journal* vol. 3, no. 1 (1980), pp. 9–12.

6 Werner Sumowski, *Drawings of the Rembrandt School*, vol. 8 (New York, 1984), no. 1769, ill.

7 Russell 1988, p. 788, note 2; Robinson 1987, p. 307, note. 40, fig. 22; see Valentiner 1924, fig. 6; Sumowski 1984, no. 1770, ill.

8 Sumowski, vol. 8 (1984), no. 1892, ill.

9 See Sutton 1980, pp. 20–1; Albert Blankert (with Rob Ruurs and Willem L. van de Watering), *Vermeer of Delft. Complete Edition of the Paintings* (Oxford, 1978), p. 31.

10 Sumowski, vol. 8 (1984), no. 1769.

11 On the illusionistic curtain, see P. Reuterswürd, 'Tavel förhanget. Kring ett motiv i holländst 1600-talsmaleri', *Konsthistorisk Tidskrift*, vol. 25 (1956), pp. 97–113.

12 That painting was described in the Comte de Vence sale in 1761, no. 104, as 'Une aimable Domestique au bas d'un Escalier, qui semble écouter avec attention ce que dit une Femme, que l'on voit dans une chambre & sur un plan éloigné'. Panel 16½ × 25½ 'pouces'. See Smith, vol. 4 (1833), no. 1, and Hofstede de Groot, vol. 6 (1916), no. 127.

13 Descamps 1754, p. 458.

CAT. 38

A Young Woman Sewing, 1655

Signed and dated in the centre right on the low dais: N.MAES (the 'A' and 'E' ligated) 1655
Oil on panel 21⅛ × 17½ in. (54.2 × 44.5 cm.), with later addition, 21⅞ × 18¼ in. (55.6 × 46.1 cm.)

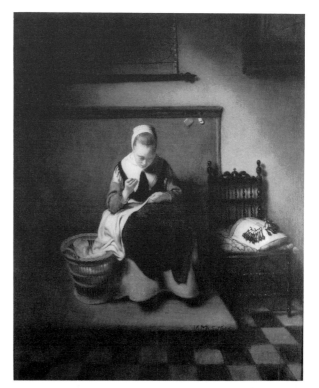

PROVENANCE: Lord Ashburton, The Grange (the collection sold *en bloc* to the London dealer Agnew's in 1907); Mrs Byers, Pittsburgh; Mrs Denniston Lyon, Locust Valley, New York, before 1935–after 1939 (see exhibitions); Knoedler and Co.; acquired from Edward Speelman in 1967.

EXHIBITIONS: London, Royal Academy, Winter Exhibition, 1871, no. 182; 1890, no. 104; Pittsburgh, Carnegie Institute (lent by Mrs Byers for an unspecified period before 1935); Chicago, Art Institute of Chicago, *Loan Exhibition of Paintings, Drawings and Etchings by Rembrandt and his Circle* (introduction by Daniel Catton Rich), 19 December 1935–19 January 1936, p. 29, no. 23; Providence, Rhode Island, Rhode Island School of Design, *Dutch Painting in the Seventeenth Century* (catalogue by Wolfgang Stechow) December 1938–January 1939, no. 23, pl. 28; London 1988, no. 37.

LITERATURE: Hofstede de Groot, vol. 6 (1916), no. 66; S. J. Gudlaugsson, 'Kanttekening bij de ontwikkeling van Metsu', *Oud-Holland*, vol. 83 (1968), p. 37, fig. 16; Peter C. Sutton, *Pieter de Hooch* (Oxford, 1980), p. 21, fig. 18; Saskia Nihom-Nijstad, *Reflets*

du siècle d'or, Institut Néerlandais, Paris, 1983, p. 79, under no. 475; P.C. Sutton, in exh. cat. Philadelphia/Berlin/London 1984, p. 211, fig. 91; Sumowski, vol. 3 (1987), pp. 1956, 2015, no. 1343, ill.; Woodhouse 1988, p. 124, fig. 1; Speelman 1988, p. 15.

CONDITION NOTES: The panel support has been thinned and cradled. It is comprised of two planks and has ¼ in. (5 mm.) strips added on all sides with the horizontal strips running against the grain of the panel. The join of the two pieces of the panel is 8¾ in. (22.2 cm.) from the left edge. The paint film is generally in good condition, but the join has been inpainted and several details strengthened: the dark moulding of the hanging on the back wall and the outline of the woman's apron. The painting has been selectively cleaned to accentuate the lighted passages of the scene: the figure, the lighted area on the back wall, and the lace-making pillow on the right. The rest of the scene has been left in the discoloured shadows.

A young woman facing the viewer sits sewing on a low dais or *soldertien*. To the left is her basket of linen; to the right a small chair with a pillow for making lace. The wall behind her is partially covered beneath the wainscoting to protect the work area. Above on the back wall is a map and to the right a painting. The floor is tiled.

 In addition to cautionary images of idle or lascivious servants and shrewish wives (see Cats. 37 and 39), Maes' domestic images include exemplars of virtue. These usually take the form of young women earnestly attending to household chores, preparing meals, attending to children or doing needlework. Spinning, sewing or making lace were traditional activities associated with domestic virtue; in portraits and history paintings virtuous women were often depicted spinning and sewing.[1] Maes depicted similar seamstresses facing the viewer and seated on their *soldertienen* in paintings in the Duke of Sutherland's collection, St Boswell's,[2] and in the Wallace Collection, London, (fig. 1), where the charming needlewoman looks up from her work to acknowledge smilingly a young boy who appears at the window beside her.[3] Maes' several paintings of young (see fig. 2) and old lacemakers are similar in conception.[4] He also seems to have re-used the same models; the young seamstress in Lord Samuel's painting may be the same as the young woman scraping carrots in the painting also dated 1655 in the National Gallery, London, no. 159,[5] and in the *Lacemaker* of the same year in Ottawa (fig. 2).[6] A sketch of a young woman seated doing needlework in the Lugt collection in Paris (fig. 3) may have been part of a group of studies which inspired this painting, but it cannot be said to be directly preparatory.[7]

 When this painting was reproduced by an anonymous nineteenth-century Dutch wood engraver, it was entitled 'In Gedachten [In Deep Thought] (Naar Nicolaes Maes. Uit de verzameling van Lord Ashburton)'.[8] Maes' still images of women silently concentrating on their needlework must have had a strong influence on the later domestic images of the Delft painters, De Hooch and Vermeer; compare, for example, the latter's famous *Lacemaker* in the Louvre, Paris (no. M.I. 1448) which, however, monumentalizes the needleworker by eliminating any details of the setting and focusing on her alone.

1 On sewing and spinning as traditional activities in domestic virtue scenes, see S. J. Gudlaugsson, *Gerard Terborch*, vol. 2 (1960), p. 107; Amsterdam, Rijksmuseum, *Tot Leering en Vermaak* (cat. by E. de Jongh) 1976, no. 3; M. G. A. Schipper-van Lottum, 'Een naijmantgen met een naijcussen', *Antiek*, vol. 10, no. 2 (August–September 1975), pp. 137–63; Sutton 1980, p. 49; Philadelphia/Berlin/London 1984, cat. nos. 50 and 15.

2 Hofstede de Groot, vol. 6 (1916), no. 61; Valentiner 1924, no. 22; signed, oil on panel 38 × 30.5 cm.

3 Hofstede de Groot, vol. 6 (1916), no. 60; Valentiner 1924, no. 21; signed, oil on panel 29 × 23¾ in.

4 See, for fig. 2: Hofstede de Groot, vol. 6 (1916), no. 60; Valentiner 1924, no. 15; Sumowski, vol. 3 (1987), no. 1342, ill. See also New York, Metropolitan Museum of Art, no. 1924.793 (Sumowski, no. 1340, ill.); and Hofstede de Groot, vol. 6 (1916), no. 71, *Old Woman Making Lace*, oil on panel 14 × 13½, which last appeared in sale London (Christie's), 18 April 1985, no. 114, ill., (Sumowski, vol. 3 (1987), no. 1337, ill., where the lacemaking, like spinning, is interpreted as an allegory of Domestic Diligence ['häuslichen Fleisses']). A painting of a young woman sewing formerly attributed to Maes in the Statens Museum, Oslo, may be by his Dordrecht follower, Cornelis de Bisschop.

5 Hofstede de Groot, vol. 6 (1916), no. 29, oil on panel 13½ × 11½ in.; Sumowski, vol. 3 (1987), no. 1333, ill.

6 See note 4.

7 W. Sumowski, *Drawings of the Rembrandt School*, vol. 8 (New York, 1984), no. 1807, ill.

8 Clipping from an unidentified periodical, RKD.

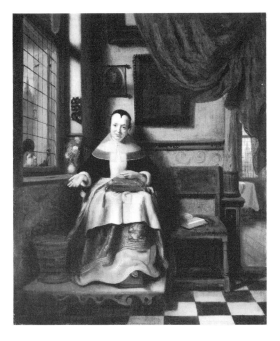

FIG. 1 Nicolaes Maes, *Young Woman Sewing with a Boy at a Window*, signed, oil on panel 29 × 23¾ in., Wallace Collection, London, no. 239.

FIG. 3 Nicolaes Maes, *Woman doing Needlework*, drawing, red chalk and brown wash 202 × 165 mm., Lugt Collection, Institut Néerlandais, Paris, no. 420.

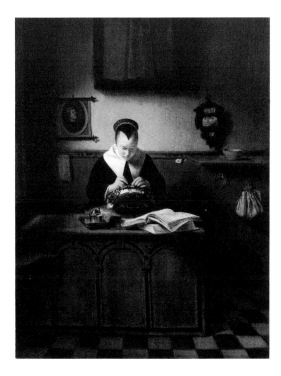

FIG. 2 Nicolaes Maes, *The Lacemaker*, signed and dated 9 March 1655 (on the calendar), oil on panel 57.1 × 43 cm., National Gallery of Canada, Ottawa, no. 6189.

CAT. 39

A Woman Selling Milk

Signed on the right below the balustrade: N.MAES
Oil on panel 22 × 16½ in. (55.9 × 41.9 cm.)

PROVENANCE: (Possibly) Elisabeth van Naerssen of Rotterdam and her husband Pieter van Regemorter, Dordrecht, 1667 (see commentary); sale J. A. Brentano, Amsterdam, 13 May 1822, no. 202 (700 fl., to De Vries); sold by De Vries to the dealer C. J. Nieuwenhuys; sale Charles Brind, London, 10 May 1849, no. 70 (£294, to B. S. Smith); sold by Smith to J. M. Oppenheim; sale Johann Moritz Oppenheim, London (Christie's), 4 June 1864, no. 31 (£430.10s, to Woodin, for J. Walter); J. Walter, Bear Wood, Wokingham, Berks.; Alfred Beit, London, cat. 1904, pp. 9–10; Otto Beit, London 1913, cat. no. 32; Alfred Beit, Blessington; acquired from Beit via Edward Speelman in 1959.

EXHIBITIONS: London, British Institution, 1837, no. 111; London, British Institution, 1845, no. 119; London, Royal Academy, 1882, no. 96; London, Burlington Fine Arts Club, 1907, no. 17; Cape Town, National Gallery of South Africa, *Old Master Paintings from the Beit Collection* (introduction by John Paris), 1949, no. 15; London 1988, no. 39.

LITERATURE: Smith, vol. 4 (1833), no. 25; W. Bode, *The Art Collection of Mr Alfred Beit at his Residence 26 Park Lane, London* (Berlin, 1904), pp. 9–10, 54; Bode, *Pictures and Bronzes from the Possession of Mr Otto Beit* (London, 1913), p. 7, no. 32, ill.; Hofstede de Groot, vol. 6 (1916), no. 30; W. R. Valentiner, *Nicolaes Maes* (Stuttgart, 1924), pl. 46; Franklin W. Robinson, *Gabriel Metsu (1629–1667)* (New York, 1974), p. 80, note 63, fig. 189; Werner Sumowski, *Drawings of the Rembrandt School* (New York, 1979ff.), vol. 5, p. 2694; Werner Sumowski, *Gemälde der Rembrandt Schüler*, vol. 3 (Landau/Pfalz, 1983), no. 1379, ill.

CONDITION NOTES: The uncradled support is a single plank of wood without joins. The paint film is in very good state. Some minor old retouches formerly appeared in her right forearm, in the folds of her skirt, in the vines at the left, and in the hinge of the shutter on the right. The painting has been selectively cleaned in the past, with the lighter areas revealed and a layer of old varnish left on the darks to exaggerate the tonal contrasts.

A young woman stands at the door of a brick house ringing the bell with a chain grasped in her left hand. Her right hand rests on a balustrade as she turns to smile at the viewer. She wears a broad brimmed straw hat, red dress with striped sleeves and a deep green skirt. Over her shoulder hangs a yoke. At lower left is a large brass vessel for carrying milk, while at the lower right a dog puts its muzzle in a wooden milk pail. At the upper left, beyond a finial and the vines at the side of the house is a vista of other houses.

Following his training with Rembrandt and before devoting himself exclusively to portraiture after c. 1660, Nicolaes Maes executed an important series of genre scenes in the early and mid-1650s. The majority of these are domestic subjects and several depict vendors or pedlars at the doors of wealthy homes. One of Maes' favourite subjects was the milkmaid; she appears selling her milk door-to-door in two other paintings, in the Rothschild Collection (fig. 1)[1] and the Duke of Wellington's Collection in Apsley House (fig. 2).[2] Drawings in Dresden and the Fitzwilliam Museum in Cambridge include figure studies of a milkmaid wearing her yoke with brass vessels, pouring milk and being paid by her customers.[3] The Samuel painting resembles figs. 1 and 2 in both conception and palette. The pedlar subject also proved very popular with Maes' imitators; for example, the *Vegetable Seller in Nijmegen* now preserved in the Offentliche Kunstsammlungen, Basle (bequest of Max Geldner), is probably by a follower of Maes,[4] and Renier Coveijn's *Milkmaid* in the Bredius Museum, The Hague (inv. no. 32-1946),[5] is based on this series of paintings.

In the 1904 Beit catalogue, W. von Bode observed that this painting's "'motif" was particularly adapted to the genius of the artist. It depicts a young milkmaid carrying

FIG. 1 Nicolaes Maes, *The Milk Girl*, signed, oil on canvas 69.8 × 82.5 cm., Lord Anthony de Rothschild, Ascott (National Trust).

FIG. 3 Nicolaes Maes, *Milkmaid and Swain*, oil on panel 26 × 32½ in., The John G. Johnson Collection at the Philadelphia Museum of Art, no. 485.

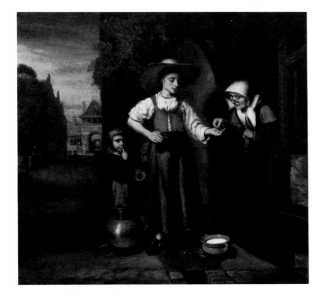

FIG. 2 Nicolaes Maes, *The Milk Girl*, signed, oil on canvas 23½ × 25⅛ in., Wellington Museum, Apsley House, London, cat. 1901, no. 63.

FIG. 4 Adriaen van de Venne, *Emblem* from Jacob Cats *Spiegel van den ouden en nieuwen tyt* (The Hague, 1632), no. XXXIV.

milk from house to house . . . as she smiles *roguishly* (emphasis the author's) at the on-lookers'. The 'come hither' aspect of the milkmaid's glance may no longer be obvious to modern viewers but it was surely clear to seventeenth-century observers and even to an early twentieth-century audience. Maes' approach to narration often reveals moralizing inclinations. His young serving women and milkmaids are frequently idle creatures given to temptation. In a painting in the Johnson Collection in Philadelphia (fig. 3), for example, Maes depicted a young milkmaid ignoring her chores and brass milk pail to dally amorously with a swain.[6] In Lord Samuel's painting she smiles long enough at the observer to enable a dog to greedily stick its muzzle in her bucket to lap up the milk. A similar detail appears in a drawing of a milkmaid attributed to Maes by Valentiner in the Fitzwilliam Museum (no. 3045B).[7] The dog or cat with its head in a pot or bucket was an image made familiar through numerous Dutch proverbs, emblems and prints. It served as an admonition that anything desirable left unattended will attract a predator. For Jacob Cats, who in 1632 published an emblem of a dog in the pot with the motto 'Een open pot, of open kuyl, Daer in steeckt licht een hont sijn muyl' (fig. 4), the image prompted warnings about lascivious and wayward serving girls.[8]

The painting may be identical with a picture described as 'No. 36 . . . een melkmeisie' by Maes in the inventory of the goods bought by Elisabeth van Naerssen of Rotterdam to her marriage in Dordrecht in November 1667 to Pieter van Regemorter.[9] Although wrongly recorded as on canvas in the Brentano sale and by Smith, the painting was correctly described as on panel by Hofstede de Groot, Bode and Sumowski. In both the Charles Brind (1847) and Johann Moritz Oppenheim (1864) sales, the painting appeared with the small painting by Jan van der Heyden (Cat. 30), also now in the Samuel collection. The author of the Oppenheim sale catalogue hailed the picture as 'A beautiful work of the master'.

On the newspaper magnate and industrialist, John Walter, who like Alfred Beit after him (on Beit, see Cat. 83), also owned Samuel's Isack van Ostade (Cat. 52) and the *Imaginary Town Gate* by van der Heyden (Cat. 27), see the entry for the latter. The present painting is one of no less than twenty six paintings, most of which were Dutch, that Walter lent to the Royal Academy's exhibition in 1882. A copy of the Samuel painting was in the collection of Lord Nieuwenhuys, Brussels, in 1964.

1 Hofstede de Groot, vol. 6 (1916), no. 31; Valentiner 1924, p. 10; Sumowski, vol. 3 (1983), no. 1376, ill.

2 Hofstede de Groot, vol. 6 (1916), no. 32; Valentiner 1924, p. 10, pl. 45; Sumowski, vol. 3 (1983), no. 1378, ill. Compare also the *Maidservant with Slaughtered Pig*, canvas 101.6 × 78.7 cm., formerly with Speelman, London (Sumowski, vol. 3 (1983), no. 1375, ill.). A drawing for the Apsley House painting is in the Fitzwilliam Museum, Cambridge, no. 3045B; W. Sumowski, *Drawings of the Rembrandt School*, vol. 8 (New York, 1984), no. 1788.

3 See Valentiner 1924, figs. 64 and 66; see also Sumowski, vol. 8 (1984), nos. 1868x and 1788. A drawing of a milkmaid formerly assigned to Maes in the British Museum (1895-9-5-1201) has been correctly re-attributed to Samuel van Hoogstraten by Sumowski, vol. 5 (1981), no. 1215x.

4 Hofstede de Groot, vol. 6 (1913), no. 34; Geldner cat. (Basle 1958), p. 14; Sumowski, vol. 3 (1983), no. 1380, ill. *The Vegetable Market*, ascribed to Maes in the Rijksmuseum, Amsterdam, no. A3254, also appears to be by a follower of the artist. However, the fish vendor painting listed as Hofstede de Groot no. 46 (now Rijksdienst Beeldende Kunst, no. NK3045; on loan to the Dordrecht Museum, no. DM/948/113) probably is by Maes (as Sumowski affirmed, vol. 3 (1983), no. 1377), even though it presently carries an attribution (first advanced by Plietzsch 1950, p. 75, fig. 9) to Coveijn. In the van Naerssen dowry drawn up on 12 November 1667, one of the two paintings by Maes was described as 'No. 37. Een meit met salm' (a maid with a salmon); see note 9 below.

5 Bredius Museum, The Hague, cat. 1978, no. 39, ill; repr. in Bernt, vol. 4, no. 60.

6 Hofstede de Groot, vol. 6 (1916), no. 126, called 'Lovers at the Lattice'. On Maes' genre scenes moralizing over the idle ways of serving girls, see Cat. 37, and Robinson 1987.

7 Valentiner 1924, fig. 66; Sumowski, vol. 3 (1983), p. 4022, under cat. no. 1788.

8 See Jacob Cats, *Spiegel van den ouden en nieuwen tyt* (The Hague, 1632), p. 104, no. XXXIV, as cited and discussed in Robinson 1987, p. 302.

9 Gemeentearchief, Dordrecht (GAD)ONA147, public notary Arent van Neten, the inventory compiled on 12 November 1667. I am grateful to William Robinson for sharing this information discovered by John Loughman.

GABRIEL METSU

CAT. 40 Gabriel Metsu (1629–67) (copy after)

Young Woman at her Toilet

Signed falsely lower left: Me[t]s[u]
Oil on panel: 11⅛ × 9 in. (28.1 × 22.8 cm.)

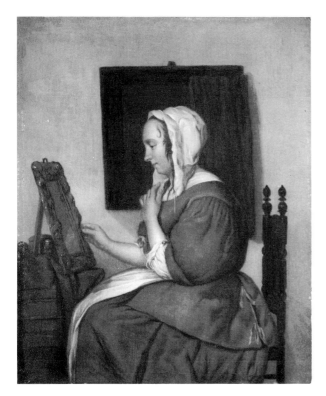

PROVENANCE: Lord Overstone 1857 (see exh.); dealer D. Katz of Dieren, 1935; H.E. ten Cate, Oldenzaal, by 1938 (see exh.); C. Ward; Destrem, Paris; Etienne Nicolas, Paris; acquired from Edward Speelman.

EXHIBITIONS: Manchester, *Art Treasures Exhibition*, 1857, no. 169 [lent by Lord Overstone] (label on the reverse); Brussels, 1935 (D. Katz); Rotterdam, Boymans Museum, *Meesterwerken uit vier eeuwen 1400–1800*, 25 June–15 October 1938, no. 18 [lent by H. E. ten Cate] (label on the reverse); New York, World's Fair, *Masterpieces of Art*, 1939, no. 269 [lent by H. E. ten Cate] (the exhibition later travelled to the museums in San Francisco, Toledo,

Minneapolis, Detroit, St Louis and Springfield – labels on the reverse); London 1988, no. 40.

LITERATURE: Russell 1988, p. 788.

CONDITION NOTES: The panel has been thinned and cradled with ¼ in. (5 mm.) strips of wood added to all sides; the overall dimensions with these additions are 11⅛ × 9½ in. (29.5 × 24.2 cm.). The paint film is moderately abraded. Extensive repaint appears along the upper edge and throughout the background. The forms of the woman's skirt and cap, the chairback, the mirror, and the painting on the back wall have been reinforced by retouching. The varnish is discoloured.

A young woman in a grey-green jacket, a mustard yellow skirt and white cap is viewed half-length as she sits in profile to the viewer's left before a mirror on a low table. With her right hand she holds the golden frame of a mirror with an auricular design. Her left hand is drawn to her bosom. The chair on which she sits is decorated with elaborate finials. A striped pattern decorates the table-cloth. Behind her is a painting in a black ebony frame covered with a green curtain.

 This painting is probably a copy of a painting that may have been the picture that was in the Marquess of Camden's sale in London on 12 June 1841, no. 45,[1] and later was in the Clowes Sale in London in 1950 and repeatedly exhibited when it formed part of the Sidney van den Bergh Collection (fig. 1).[2] Another slightly larger copy of the van den Bergh painting was with J. Goudstikker, Pulchri Studio, Amsterdam, 15 July 1915, no. 30, ill. (signed, panel 33 × 25.5 cm.), and later was in Lady Storr's collection (with Agnew's, London, 1921). This or still another version was in the Garret Sale, London (Sotheby's), 14 May 1935, no. 133. Metsu treated the subject of the woman at her toilet looking in a mirror repeatedly. In addition to the earlier half-length painting in the Wallace Collection (no. P206),[3] there is a similarly conceived painting in the Petit Palais, Paris (no. 593),[4] and a more elaborate treatment of the subject formerly owned by Lord Samuel and now in the Norton Simon Museum, Pasadena, in which an old woman combs the young woman's hair (see Introduction, fig. 7).[5] The same model

apparently was used for the similarly conceived half-length composition of the *Woman at the Virginal* (Petit Palais, Paris, no. 594),[6] and the full-length *Musical Company* (Boymans-van Beuningen Museum, Rotterdam, no. 49 (van der Vorm Collection)).[7] Metsu's decision to depict a young woman in an elegant costume looking into a mirror was probably inspired by ter Borch's several examples. Depictions of women before mirrors first appeared as representations of *Superbia* in series of the Seven Deadly Sins (see, for example, Hieronymus Bosch's famous table-top, Prado, Madrid, no. 2822) and later were commonly encountered in early seventeenth-century *vanitas* images. Whether and to what extent Metsu's much later images carried such associations is unclear.

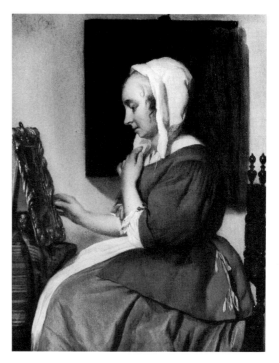

FIG. 1 Gabriel Metsu, *Young Woman at her Toilet*, signed indistinctly upper left: G. Metsu(e), oil on panel 10¾ × 8½ in. (27.3 × 21.5 cm.), formerly S. J. van de Bergh, Wassenaar.

1 The description in the Camden sale catalogue was very brief ('A lady at her toilet; a small but capital work of the master. [Sold to Neuwenhuysen for £87]), but a fuller description was provided by Smith *Suppl.* (1842): 'A young lady, attired in a morning dress, consisting of a dark drab jacket, a tawney yellow skirt, and a white kerchief over her head, seated at her toilet, with one hand placed on her bosom, and holding a looking glass on the table with the other. A closed window and a curtain compose the background. Painted in a fine broad style, like Terburg. 10½ × 8¼ (on panel)'. See also Hofstede de Groot, vol. 1 (1908), no. 93.
2 PROVENANCE: eighteenth-century private collection, England (engraved by James Watson, 1776, as 'The Dishabille'); Reverend Clowes, Manchester; Colonel H. A. Clowes Norbury, Ashborne; sale Clowes, London (Christie's), 17 February 1950, no. 41; dealer Ch. Duits, London, who lent it to the exh. *Some Dutch Cabinet Pictures of the Seventeenth Century Art Gallery*, Birmingham 1950, no. 41. Exhibitions: Zürich, Kunsthaus, *Holländer der 17. Jahrhunderts*, 1953, no. 84; Rome, *Mostra di Pittura Olandese del '600 Rome*, 1954, no. 86 (2nd edn, cat. no. 88, fig. 63); Rotterdam, Boymans Museum, *Kunstschatten uit Nederlandse verzamelingen*, 1955, no. 86, ill.; Laren, Singer Museum, *Kunstschatten. Twee Nederlandse Collecties Schilderijen*, 14 June–16 August 1959, no. 57; Leiden, Stedelijk Museum de Lakenhal, *Metsu*, 1966, no. 11, ill.; The Hague, Mauritshuis, *Terugzien in bewondering*, 1985, no. 54, ill. LITERATURE: S. J. Gudlaugsson, 'Kanttekeningen bij de ontwikkeling van Metsu', in *Oud-Holland*, vol. 83 (1968), p. 33; Franklin W. Robinson, *Gabriel Metsu 1629–1667* (New York, 1974), ill. no. 151.
3 Hofstede de Groot, vol. 1 (1908), no. 87; Robinson 1974, ill. no. 123.
4 Juliette Laffon, *Catalogue sommaire illustré: des peintures, Musée des Petit Palais*, 2 vols. (Paris, 1982), vol. 2, no. 594, ill.; Hofstede de Groot, vol. 1 (1908), no. 89, Robinson 1974, ill. no. 150.
5 Hofstede de Groot, vol. 1 (1908), no. 88; Robinson 1974, ill. no. 122.
6 Laffon 1982, vol. 2, no. 593, ill.; Hofstede de Groot, vol. 1 (1908), no. 161; Robinson 1974, ill. no. 152.
7 D. Hannema, *Beschrijvende catalogus van de schilderijen uit de kunstverzameling Stichting Willem van der Vorm* (Rotterdam, 1962), p. 37, no. 49, ill.; Hofstede de Groot, vol. 1 (1908), no. 160; Robinson 1974, ill. no. 148.

FRANS VAN MIERIS

CAT. 41 Frans van Mieris (1635–81) (copy after)

A Young Woman Stringing Pearls

Oil on canvas 9¼ × 7⅛ in. (23.5 × 18.1 cm.)

A young woman in silk sits stringing pearls at a table covered with a Turkish carpet. A ewer and basin rest on the table and a maidservant appears in the background.

As Naumann observed in his monograph on the artist, this painting is a copy of Frans van Mieris' painting of 1659 (fig. 1) in the Musée Fabre, Montpellier.[1]

1 Naumann 1981, vol. 2, p. 29, no. 25a.

FIG. 1 Frans van Mieris, *A Woman Stringing Pearls*, signed and dated 1659, oil on panel 23.4 × 18.3 cm., Musée Fabre, Montpellier, cat. (1926) no. 248.

PROVENANCE: Pierre Martel, Menton, France; acquired from Edward Speelman.

EXHIBITION: London 1988, no. 41 [as Frans van Mieris].

LITERATURE: Otto Naumann, *Frans van Mieris (1635–1681) the Elder*, 2 vols. (Doornspijk, 1981), vol. 2, p. 29, no. 25a; Russell 1988, p. 789.

CONDITION NOTES: The canvas support has been relined, the paint film is in good state, and the varnish is relatively clear.

AERT VAN DER NEER

(AMSTERDAM 1603/04–1677 AMSTERDAM)

Aert van der Neer was probably born in 1603 or 1604 in Amsterdam; on 12 May 1642, he was recorded as 'about 38'; on 22 July 1647, 'about 43 years old'; on 20 October 1651, 'about 48 years old'; and on 5 June 1653, 'about 50 years old'. According to Houbraken, van der Neer lived in his youth in Arkel near Gorinchem, and was subsequently a steward (*majoor*) in the service of a family at Gorinchem. Among the leading artists in Gorinchem at the time were Jochem (1601/2–59) and Raphael Govertsz Camphuysen (c. 1597/8–1657). Documents and stylistic connections suggest that the latter was van der Neer's teacher; on 28 December 1642, Raphael Camphuysen was a witness at the baptism of van der Neer's daughter Cornelia. Van der Neer married Lysbeth Goverts and around 1632 moved to Amsterdam. His son, the painter Eglon van der Neer (1634?–1703) was born there; Johannes was born in 1637/8 (d. 1665); Pieter was born on 4 March 1640; Cornelia, on 28 December 1642; Pieter, on 5 July 1648; and Alida, on 7 July 1650.

On 24 January 1659, and again on 14 June, Aert van der Neer was mentioned as a citizen of Amsterdam, working as an innkeeper at 'de Graeff van Hollant' on the Kalverstraat. Aert and his son Johannes were both *wyntappers* (taverners) in Amsterdam. On 25 January 1662, he again appeared in a list of innkeepers. On 12 December of the same year he went bankrupt, and an inventory of his belongings was drawn up. His paintings were appraised at relatively low values, mostly five guilders and less. At the end of his life he lived in impoverished conditions. His address was given as the Kerkstraat near the Leidsegracht when he died in Amsterdam on 9 November 1677.

The artist's earliest dated painting is a genre scene of 1632 (Národní Galerie, Prague); his earliest landscape is of 1633 (Bachmann 1982, fig. 2). A painter of winter scenes and moonlight and twilight landscapes, van der Neer developed into one of the most important landscapists of his age. His early landscapes are influenced by the Camphuysen brothers, and his winter landscapes show an interest in the works of Hendrick Avercamp and Esaias van de Velde (qq.v.).

LITERATURE: Houbraken, vol. 3 (1721), p. 172; van Eynden, van der Willigen, vol. 1 (1816), pp. 92–6; Immerzeel 1842–3, vol. 2, pp. 257–8; Kramm 1857–64, vol. 4, pp. 1191–2, Supplement, p. 113; Obreen 1877–90, vol. 2, pp. 25–6, vol. 4, p. 212; Wilhelm Bode, *Rembrandt und seine Zeitgenossen* (Leipzig, 1906); Wurzbach, vol. 2 (1910), pp. 221–3; Hofstede de Groot, vol. 7 (1923); Abraham Bredius, 'Waar is A. van der Neer begraven?', *Oud-Holland*, vol. 39 (1921), p. 114; Hans Kauffmann, 'Die Farbenkunst des Aert van der Neer', in *Festschrift für Adolph Goldschmidt zum 60. Geburtstag* (Leipzig, 1923); Ralph Grosse, *Die holländische Landschaftskunst 1600–1650* (Berlin and Leipzig, 1925), pp. 30–2; Martin 1935–6, vol. 2, pp. 283–8; Fredo Bachmann, *Die Landschaften des Aert van der Neer* (Neustadt, 1966); Stechow 1966, pp. 96–8, 176–82; Fredo Bachmann, 'Die Brüder Rafael und Jochem Camphuysen und ihr Verhältnis zu Aert van der Neer', *Oud-Holland*, vol. 85 (1970), pp. 243–50; Fredo Bachmann, *Aert van der Neer als Zeichner* (Neustadt, 1972); Fredo Bachmann, 'Die Herkunft der Frühwerke des Aert van der Neer', *Oud-Holland*, vol. 89 (1975), pp. 213–22; Fredo Bachmann, *Aert van der Neer, 1603/4–1677* (Bremen, 1982); Manja Zeldenrust, 'Aert van der Neers "Rivier landschap bij maanlicht opgehelderd"', *Bulletin van het Rijksmuseum* (Amsterdam), vol. 31 (1983), pp. 99–104; Amsterdam/Boston/Philadelphia 1987–8, pp. 381–7.

CAT. 42

Winter Landscape with Figures on a Frozen Canal, mid 1650s

Monogrammed in yellow, lower right: AV DN
(the first and last two letters ligated)
Oil on canvas 24⅛ × 29⅜ in. (61.5 × 74.5 cm.)

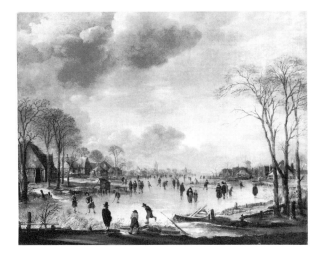

PROVENANCE: Sale Amsterdam, 17 August 1757, no. 16 (93 fl., to Stepfry for Ketelaer); sale Huybert Ketelaer, Amsterdam, 19 June 1776, no. 152 (70 fl., to Wubbels); sale G. T. A. M. Baron van Brienen van Grootelindt of The Hague, Paris, 8 May 1865, no. 20 (33,200 frs., to Hertford); Princess Murat, Paris, by 1911 (see exh.); (not in sale Princess Murat, Paris, 5 May 1961); acquired from Princess Murat by Edward Speelman, who in turn sold it to Harold Samuel.

EXHIBITIONS: Paris, Musée Jeu de Paume, *Exposition rétrospective des grands et des petits maîtres hollandais*, 1911, no. 101; London 1988, no. 44.

LITERATURE: Terwesten 1770, no. 11; Armand Dayot, *Les Grands et petits maîtres hollandais* (Paris, 1912), no. 110, ill. opp. p. 14.; Hofstede de Groot, vol. 7 (1923), no. 521.

CONDITION NOTES: The canvas support has been relined and its tacking margins cut. The paint film has been abraded in the sky in the upper right and retouched extensively around the edges, in scattered areas throughout the sky and especially in the upper left. Several pentimenti appear around the figures. The varnish is dull and discoloured. A red seal with lion, unicorn and crown appears on the back, as well as an old label in French, partly torn away, probably related to the exhibition in Paris in 1911.

A frozen canal filled with skaters recedes perpendicularly from the viewer with buildings on either bank. A strip of land extends across the immediate foreground and tall trees

rise on the right. A rowing-boat is lodged in the ice in the right foreground, and several figures play 'colf' on the left (on colf, see Cat. 3). One man with his back to the viewer watches the game while another in red further down the shore leans over to play a shot that has landed in the rough of the bank. Beside him a skater whizzes by and many more skaters fill the distance (Dayot in 1912 counted sixty-one). In the distance are church spires. The thick clouds overhead seem to threaten a snowstorm but the atmosphere is filled with subtle colours - pinks towards the horizon and blues becoming more intense as the sky ascends.

By 1641 van der Neer had begun painting winter scenes in a style descended from Hendrick Avercamp (q.v.). Two years later by 1643 he had adopted his own favoured 'two-bank' design, which offered a centralized view down a frozen river or canal with both banks visible and usually featuring buildings and trees, a tall sky overhead and tiny figures scattered across the ice.[1] The Corcoran painting of 1645 (see Cat. 43, fig. 1), illustrates the emerging design. The Samuel painting, however, probably dates somewhat later because it shows affinities with the subtly tinted atmospherics and luminosity of paintings from mid to late 1650s, such as the Rijksmuseum's ice-skating scene (fig. 1).[2] The painting may not date quite that late, however, because its design more closely resembles that of a painting owned by Jonkheer John Loudon, Wassenaar, which is dated 1647.[3]

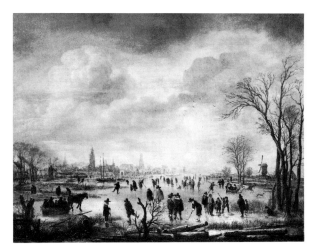

FIG. 1 Aert van der Neer, *Winter Landscape with Frozen River*, monogrammed, oil on canvas 64 × 79 cm., Rijksmuseum, Amsterdam, inv. C191.

1 See *Winter Landscape with Skaters*, dated 1643, formerly
 P. Saltmarshe Collection; Bachmann 1982, p. 43, fig. 26.
2 See Bachmann 1982, pp. 117–18, fig. 89; Amsterdam/Boston/
 Philadelphia 1987–8, cat. no. 60, ill. Compare also Bachmann
 1982, figs. 90, (Museum der bildenden Künste, Leipzig;
 Hofstede de Groot, vol. 7 (1923), no. 512), and 91 (with David
 Koetser, Zurich, 1982; Hofstede de Groot, vol. 7 (1923), no.
 538).
3 Hofstede de Groot, vol. 7 (1923), no. 488; the painting was in
 the Simon sale, Amsterdam (F. Muller), 25 October 1927, no.
 56.

CAT. 43

Winter Landscape with Skaters, c. 1655-60?

Monogrammed on the lower left: AVDN
(the first and last two letters ligated)
Oil on canvas 23⅜ × 29⅜ in. (59.4 × 74.6 cm.)

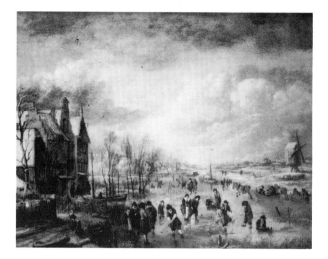

PROVENANCE: George Wilbraham, Delmere House, Northwick;
with dealer J. Goudstikker, Amsterdam, cat. 1930, no. 45; S.
Kramarsky, Amsterdam; acquired from Edward Speelman in 1967.

EXHIBITIONS: Amsterdam, J. Goudstikker Gallery, *Tentoonstelling
van Hollandsche winterlandschappen uit de 17e eeuw*, 6–29 February
1932, no. 51; Rotterdam, Museum Boymans, *Meesterwerken uit vier
eeuwen*, 1938, no. 107; London 1988, no. 43.

LITERATURE: Unpublished.

CONDITION NOTES: The canvas support has an old lining and the
original tacking margins have been clipped. The paint film is in
good condition but reveals retouches along the edges and especially
in the upper three to four inches of the sky. A scratch has been
repaired in the upper right. There also are retouches in the lower
centre, behind and to the right of the most prominent 'colf' player
and scattered along the bottom edge. The varnish is clear. In
stencil on the back appears the number 942FE.

In a winter landscape a wide frozen stream meanders into
the distance perpendicularly from the picture plane with
the left bank dominating, distinguished by several large
gabled buildings beside which are a dirt road, a fence, fish-
ing nets and, farther back, a boat frozen into the ice. On the
ice numerous figures play 'colf' (on colf, see Cat. 3), skate
or simply take a cautious stroll. Further back on the right
are horse-drawn sleighs and many additional skaters. The
ice fills most of the foreground; the right shore only

appears in the middle distance and features a tall windmill. The atmosphere is chilled but moist, and the heavy cloud-filled sky threatens to snow.

One of van der Neer's many atmospheric depictions of winter landscapes with frozen canals, rivers or streams, this painting adopts a design – with the ice receding centrally between two banks but with the left bank dominating – that had appeared in his work by 1645 (see fig. 1). However the atmospheric treatment of the scene and its colouristic subtlety suggest a date in the second decade of his activity. Although it is notoriously difficult to date van der Neer's mature works, this picture may be a product of the latter half of the 1650s. The figures, which are relatively large (compare those of Cat. 42), wear costumes that are not inconsistent with this dating.

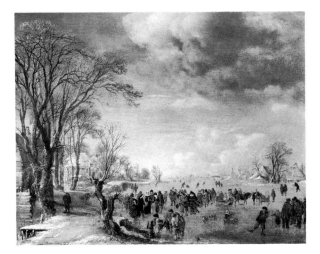

FIG. 1 Aert van der Neer, *Winter Landscape with Skaters*, monogrammed and dated 1645, oil on panel, 54.5 × 70 cm., Corcoran Gallery, William A. Clark Collection, Washington, DC, acc. no. 26.148.

CAT. 44

Evening Landscape, early 1660s

Monogrammed (in yellow paint) on the façade of the tavern at the left: AV DN (the first and last two letters ligated)
Oil on panel 33¼ × 48⅛ in. (84.5 × 122.5 cm.)

PROVENANCE: Alfred Beit, London, cat. 1904, p. 54; Sir Otto Beit, London, cat. 1913, no. 37; Sir Alfred Beit, Blessington, who sold it to Edward Speelman in 1959, who in turn sold it to Lord Samuel.

EXHIBITIONS: Cape Town, National Gallery of South Africa, *Old Master Paintings from the Beit Collection* (intro. by John Paris), 1949, no. 18; London 1988, no. 42, ill. p. 26.

LITERATURE: Wilhelm Bode, *The Art Collection of Mr Alfred Beit at his Residence, 26 Park Lane, London* (Berlin, 1904), pp. 18, 54; Wilhelm Bode, *Pictures and Bronzes in the Possession of Mr Otto Beit* (London, 1913), pp. 22, 79, no. 37; Hofstede de Groot, vol. 7 (1923), no. 50.

CONDITION NOTES: The panel support is comprised of two large planks joined 17 in. (43.2 cm.) from the bottom edge. The panel is also reinforced at the back with three battens that have been set into channels in the wood: 9 in. (22.9 cm.), 14½ in. (36.7 cm.) and 20⅞ in. (53 cm.) from the top edge. There is an old horizontal break in the panel 9¾ in. (24.7 cm.) from the upper right edge. The paint film is generally in good condition but is retouched on the two vertical sides, along the horizontal join, and in the upper right to disguise the old crack. The varnish is thick and moderately discoloured. Additional dirty varnish appears on the two vertical sides.

A village with a track winds back on the left bank of a broad stream that recedes on the right. Beneath the evening sky and under tall trees, figures have stopped at an inn in the left foreground. A horseman with a feathered hat and a man in a dark cape stand beside the open door of the inn where a serving girl in red holds a tall flute glass. The signboard of

the inn is decorated with a moon surmounted by a little jug. Four other travellers appear in an open wagon on the road. A pedlar is just coming over the rise of a low bridge and farther into the middle distance five figures gather outside a house on the left. In the right centre distance a large church rises and still farther back are a mill and various other spires. The far shore is lined with other low houses and cottages. The sky is ablaze with pink, red and yellow, while the landscape forms are mostly executed in darker muted shades of brown umber.

Bode (in both 1904 and 1913), Hofstede de Groot and the compilers of the Cape Town exhibition catalogue in 1949 all incorrectly reported that the painting was on canvas, while in fact it is on a large panel. Bode noted in the 1904 Beit catalogue that van der Neer 'is famous for his moonlight landscapes, for his fire effects at night, and for his winter scenes; yet his rare evening atmospheres and simple landscapes are in some cases superior, for they show the artist in a more naive mood and as a close observer of nature'. In the 1913 catalogue he further described the painting as an 'effective picture . . . the colouring [of which] is warm and brown in tone, the whole executed with breadth and sureness of hand, even to the figures of some-what large dimensions which, as is usually the case in England, were erroneously ascribed to A[elbert] Cuyp, though they are certainly by the hand of Aert van der Neer himself'.[1]

Van der Neer was the most important and influential Dutch painter of evening and twilight landscapes. His earliest dated evening landscape of 1643 is in Schloss Friedenstein, Gotha (fig. 1).[2] A moonlit landscape with castle dated 1646 is in the Israel Museum, Jerusalem (inv. 3561-8-55), and a picture of a similar subject in a private collection, Montreal, is dated the following year.[3] Works of any type by Aert van der Neer dated after 1647 are rare but it is generally assumed that he remained active until 1658, when his extra-artistic business ventures and subsequent financial debacle may have slackened his productivity. From about 1662 until his death in 1677, he continued to paint despite deteriorating skill and dwindling inspiration.

This painting may not date as early as the first twilight and nocturnal scenes of 1643–7, which are executed with a somewhat tighter more controlled stroke, but neither does it have the weaknesses of the artist's very late works. When Ellis Waterhouse saw the painting on a visit to the Beit Collection in 49 Belgrave Square in 1931, he jotted in his unpublished private notebooks, 'Hot colour: close to N.G. large one', probably referring to van der Neer's *View along a River near a Village at Evening* in the National Gallery,

London (fig. 2), which employs a similar composition with both sides of a stream visible and relatively large-scale figures gathered beside buildings and a tall tree in the lower left. Maclaren thought that the costumes of these figures, especially the man on the left bending forward, indicated a date after c. 1660.[4] However, Bachmann regarded the figures as later additions and dated the National Gallery painting about 1645.[5] In his forthcoming revision of Maclaren's catalogue, Christopher Brown rejects the notion that the staffage was added later and supports Maclaren's dating in the 1660s.[6] The Samuel painting surely does not date as early as 1645, and seems also to be a work of the mature career, or early 1660s. Bachmann compared the design of the National Gallery painting to that of a similar though much smaller, less well-preserved and undated painting of *Moonlight Landscape* in the Thyssen-Bornemisza Collection (acc. no. 231),[7] which also shares aspects of its design with the Samuel painting. Ivan Gaskell has recently proposed a date for the Lugano picture in the 'second half of the 1640s or early 1650s',[8] which once again seems too early for the much larger and more broadly painted Samuel painting. Still another undated work to which the latter may be compared was in the collection of the Earl of Wemyss, Gosford House, inv. 1948, no. 245.[9]

With the advent of colour photography, sunsets have become a pictorial cliché in our century. As a consequence it has become more difficult to appreciate the poetry and nuance, let alone the revolutionary achievement of van der Neer's twilight scenes. Even as recently as seventy years ago, Kauffmann wrote of van der Neer's command of coloured light with the excitement of revelation,[10] while Stechow was inspired to liken his subtle adjustments of hue and value to the complexity of differential calculus.[11] If we have become jaded to van der Neer's astute record of colour, we may still appreciate his twilight paintings' parallels with seventeenth-century Dutch poetry, such as Philibert van Borsselen's 'hofdicht', *Den Binckhorst* (1613), which celebrates the beauties of evening with special eloquence.[12]

1 See respectively, Bode 1904, p. 18 and Bode 1913, p. 22.
2 See Bachmann 1982, p. 44, fig. 27; Amsterdam/Boston/
Philadelphia 1987–8, p. 382, fig. 1.
3 See Bachmann 1982, pp. 62–5, fig. 60; Amsterdam/Boston/
Philadelphia 1987–8, no. 59, ill.
4 Neil Maclaren, *National Gallery Catalogues. The Dutch School*
(London, 1960), p. 262, no. 732.
5 Bachmann 1982, p. 49, figs. 35 and 36.
6 Christopher Brown, revised edition of Maclaren 1960, pp.
276–7, pl. 234. I wish to thank Christopher Brown for per-
mitting me to see the page proofs of the forthcoming catalogue.
7 Bachmann 1982, p. 49, fig. 36.
8 Ivan Gaskell, *Seventeenth-Century Dutch and Flemish Painting.
The Thyssen-Bornemisza Collection* (London, 1989), p. 349, cat.
no. 48, ill.
9 Hofstede de Groot, vol. 7 (1923), no. 192.
10 See Hans Kauffmann, 'Die Farbenkunst des Aert van der Neer',
in *Festschrift für Adolph Goldschmidt zum 60. Geburtstag* (Leipzig,
1923), pp. 106–10.
11 Stechow 1966, p. 94.
12 'In the evening what a joy to take in the cool air,/To hasten
with hurried step out of the anxious houses into the open
field,/To look at the heavens and lose earth's vain care to the
stars,/Permitting one's inner spirit to soar up'. See for trans-
lation and quotation, Amsterdam/Boston/Philadelphia 1987–8,
p. 12, note 82.

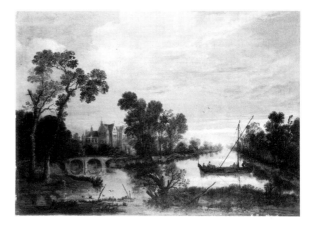

FIG. 1 Aert van der Neer, *Evening Landscape with Canal and Villa*,
signed and dated 1643, panel 72 × 101 cm., Schloss Friedenstein,
Gotha.

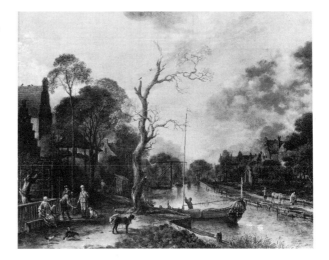

FIG. 2 Aert van der Neer, *View Along a River near a Village at
Evening*, signed, oil on canvas 133.5 × 167.5 cm., National Gallery,
London, no. 732.

CAT. 45 Aert van der Neer (imitator of)

A Canal in Winter

Monogrammed: AVN
Oil on panel, 10½ × 15½ (26.3 × 37.8 cm.)

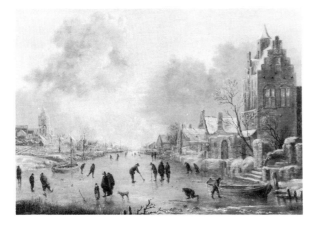

PROVENANCE: Presented by Lady Samuel.

LITERATURE: London 1988, no. 45.

CONDITION NOTES: The panel support is made of a single oak plank, the grain running horizontally. The paint film is in good condition although there is some age crackle and a 5 cm. wide loss on the bottom edge. The varnish is relatively clear.

In a twilight landscape a canal recedes perpendicularly from the picture plane. On the right is an unusually tall gabled building. In the centre, among the approximately two dozen figures on the ice are several men playing 'colf', and a couple and a child with a dog. Boats are lodged in the ice off both banks, and a church spire dominates the village in the middle distance on the left.

With its centrally receding canal, multitude of dark silhouetted skaters and russet palette, this painting imitates Aert van der Neer's twilight winter landscapes of c. 1645 and thereafter, but the master's richly variegated sunset hues (pink, salmon, coral and a spectrum of blue and violet (see Cat. 44) have been reduced here to a relatively unmodulated colour scheme of rust and brown. The forms of the objects have been drained of their substance by the omission of intermediary tones and values; white highlights accent form but hover disembodied on the surface of the image. Though apparently not a copy of any known composition, the painting appears to be only an imitation of van der Neer's art, possibly even dating as late as the eighteenth century.

JACOB OCHTERVELT

(ROTTERDAM 1634–1682 AMSTERDAM)

Baptized in February 1634 in the Reformed Church in Rotterdam, Jacob Ochtervelt was one of the six children of Lucas Hendricksz, a bridgeman on the Roode Brugge in Rotterdam, and Trintje Jans. The Ochtervelts were a seafaring family; two of Jacob's brothers were sailors and a sister married one. Houbraken reported that Ochtervelt and Pieter de Hooch (q.v.) were students of the Haarlem landscapist Nicolaes Berchem at the same time. The precise date of this apprenticeship has not been determined but it may have been in the early 1650s. Ochtervelt was back in Rotterdam on 28 November 1655 when he and Dirkje Meesters posted their marriage banns. The couple apparently had no children but, according to an agreement of 1666, Ochtervelt served as guardian to the orphaned children of his brother Jan. On 1 May 1667, Ochtervelt rented a house on the Hoogstraat (at a price of 190 fl. per year) for a four-year period. In October of the same year, Ochtervelt was nominated for the post of dean of the Rotterdam St Luke's Guild, but lost the election to the painter Cornelis Saftleven. The latest documented evidence of Ochtervelt's presence in Rotterdam dates from 10 July 1672, when he and his wife were witnesses at the baptism of his brother-in-law's infant daughter.

By 1674 they had moved to Amsterdam and acquired property, the taxation of which suggests that they lived comfortably but were not wealthy. In the same year, Ochtervelt painted a group portrait of the regents of Amsterdam's leper house. Five years later the couple had rented a house at Keizersgracht 608. When the house was sold by foreclosure in January 1681, they moved to the Schapenmarkt, near the Royal Mint. Although sometimes wrongly reported to have lived into the eighteenth century, Ochtervelt died in Amsterdam in 1682 and was buried in the Nieuwezijds Kapel on 1 May.

A painter of genre scenes, family portraits, and a few landscapes and history paintings, Ochtervelt was influenced in his early years by the local Rotterdam painter Ludolf de Jongh and in his maturity by Gerard ter Borch and Frans van Mieris. He is best known for his images of high-life merry companies, and particularly specialized in entrance hall scenes, where the mistress of the household meets vendors or street entertainers.

LITERATURE: Houbraken, vol. 2 (1719), p. 35; Johan van Gool, *De Nieuwe schouburg der Nederlantsche kunstschilders en schilderessen*, vol. 2 (1751), p. 488; Immerzeel 1842–3, vol. 3, p. 149; Kramm 1857–64, vol. 6, p. 1653; E. J. Thoré-Bürger, *Les Musées de la Hollande*, vol. 1: *Amsterdam et La Haye* (Paris, 1858), p. 251; Obreen 1877–90, vol. 1, p. 155, vol. 5, pp. 316–22; Wurzbach, vol. 2 (1910), p. 249; W. R. Valentiner, 'Jacob Ochtervelt', *Art in America*, vol. 12, no. 6 (October 1924), pp. 269–84; H. Gerson, in Thieme and Becker, vol. 25 (1931), pp. 556–7; Eduard Plietzsch, 'Jacob Ochtervelt', *Pantheon*, vol. 20 (July–December 1937), pp. 364–72; Eduard Plietzsch, *Holländische und flämische Maler des 17. Jahrhunderts* (Leipzig, 1960), pp. 64–8; Susan Donahue Kuretsky, 'The Ochtervelt Documents', *Oud-Holland*, vol. 87 (1973), pp. 124–41; Susan Donahue Kuretsky, 'The Ochtervelt Documents (aanvulling)', *Oud-Holland*, vol. 89 (1975), pp. 65–6; Amsterdam, Rijksmuseum, *Tot Lering en Vermaak* (cat. by E. de Jongh *et al.*), 16 September–5 December 1976, pp. 202–5; Susan Donahue Kuretsky, *The Paintings of Jacob Ochtervelt (1634–1682)*, (Montclair, NJ, 1979); Philadelphia/Berlin/London 1984, pp. 277–81.

CAT. 46

The Oyster Meal c. 1664–5

Oil on canvas 21 × 17½ in. (53.5 × 44.5 cm.)

PROVENANCE: Le Comte de Morny; sale Paris (Hotel Drouot), 27–8 April 1874, no. 73; Bischoffsheim Collection, London; sale Bischoffsheim, London (Christie's), 7 May 1926, no. 75 (to Wallis); sale A. Preyer, Amsterdam (F. Muller), 8 November 1927, no. 23, ill.; Teixeira de Mattos Collection; with dealer D. Katz, Dieren, 1936; Galerie Meissner, Zurich, 1965; J. William Middendorf II, Washington; acquired from Edward Speelman in 1971.

EXHIBITIONS: Dieren, D. Katz Gallery, *Oud Hollandsche en Vlaamsche Meesters*,16 November–15 December 1935, no. 49; on loan to the Metropolitan Museum of Art, New York, 1967–9 (loan no. 67.45); London 1988, no. 47.

LITERATURE: E. Plietzsch, 'Jacob Ochtervelt', *Pantheon*, vol. 20 (1937), p. 364; E. Pleitzsch, *Holländische und flämische Maler des XVII Jahrhunderts* (Leipzig, 1960), p. 67; Susan Donahue Kuretsky, *The Paintings of Jacob Ochtervelt (1634–1682)* (Oxford, 1979), pp. 17, 61, cat. 23, fig. 33; Otto Naumann, *Frans van Mieris (1635–1681) The Elder*, 2 vols. (Doornspijk, 1981), vol. 1, p. 62, note 64; Woodhouse 1988, p. 127, ill. on cover; Speelman 1988, p. 15; Ivan Gaskell, *Seventeenth-Century Dutch and Flemish Painting, The Thyssen-Bornemisza Collection* (London 1990), p. 258, note 10, ill.

CONDITION NOTES: The canvas has been recently relined. The surface of the paint film is somewhat flattened and slightly rubbed in the darks but generally in good condition. In February 1991, the varnish was thick, discoloured and matt. On the reverse are a seal with a crown and other indecipherable motifs, and a sticker with the no. 686.

A standing young man in a dark brown costume tinged with lavender and trimmed with silver embroidery on the sleeves bends at the waist to offer a plate of oysters to a seated young woman. Wearing a red velvet jacket with white fur trim, a light blue satin dress and blue and orange ribbons in her hair, she leans back casually in her chair, her right hand extended and holding a wine glass, her left arm hooked over the chairback. At the left is a table covered with a Turkish carpet, on which lies a closed tric-trac board with a pewter wine pitcher set on top. The chair has only one finial on the back and an embroidered cushion. A small brown and white dog jumps up towards the lady's glass. In the dark background in the upper right is a birdcage and some bedclothes hung over the railing of a sleeping loft. In the shadows at the left is a chest with a candlestick and vessels, and a painting on the back wall.

Though not so well known today as painters like Gerard ter Borch or Gabriel Metsu, Jacob Ochtervelt was one of the most accomplished painters of high-life genre scenes during the third quarter of the seventeenth century. One of his favourite premises for an elegantly piquant meeting of the sexes was the sharing of an oyster meal. As Susan Donahue Kuretsky has observed, the offering of oysters had been a subsidiary motif in the artist's early works, such as the *Merry Company with a Violinist*.[1] In the 1660s the theme became the focus of several major compositions including Lord Samuel's painting, in which the amorous relationship between the man and the woman is made clear. In a painting in the Thyssen-Bornemisza collection, a lutanist serenades his young female drinking companion, as a serving maid presents the couple with a large plate of oysters (fig. 1).[2] And in a painting dated 1667 (fig. 2) in Rotterdam a young gallant offers a seated woman a single oyster from a platter as she appears to reciprocate with a toast from her wineglass.[3] In the Samuel painting the cavalier offers his compliantly smiling companion the entire plate.

The popular idea that oysters were not only delicacies but also aphrodisiacs can be traced to antiquity, and may derive from the notion that Aphrodite was conceived in an oyster shell. Schotel, de Jongh, Naumann, Cheney and others have discussed the fact that Dutch seventeenth-century writers regarded oysters as provocative and

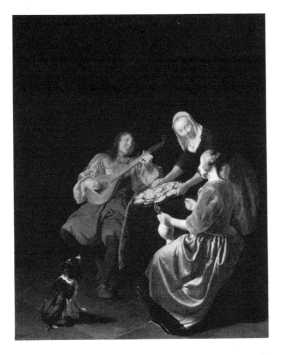

FIG. 1 Jacob Ochtervelt, *The Oyster Meal*, c. 1663–5, oil on panel 47 × 37.5 cm., Thyssen-Bornemisza Collection, Lugano/Castagnola.

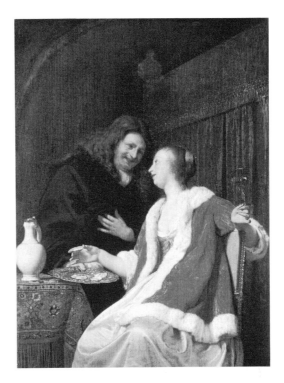

FIG. 3 Frans van Mieris the Elder, *The Oyster Meal*, 1661, oil on panel 27 × 21 cm. (originally arched at the top), Mauritshuis, The Hague, no. 819.

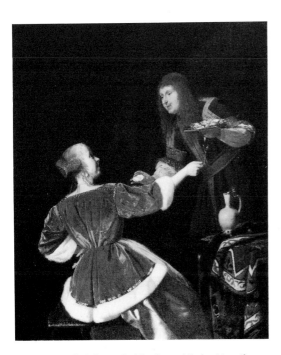

FIG. 2 Jacob Ochtervelt, *The Oyster Meal*, 1667, oil on panel 43 × 33.5 cm., Museum Boymans-van Beuningen, Rotterdam, no. 1618.

libidinous foods, which might be used as aids to fertility and sexual potency.[4] In his *Houwelick* (Marriage), the poet Jacob Cats called oysters 'minne-kruyden' (love herbs), while the medical advisor Johan van Beverwijk's *Schat der Gesontheydt* (Treasury of Health) claimed that oysters 'arouse the appetite and make one want to eat and then sleep, both of which please lively and delicate people' ('appetijt verwecken, en lust omte eten, en by te slapen, 't welck alle beyde de lustige en delicate luyden well aenstaet'). Kuretsky correctly observed that the tumbled bed sheets and bird-cage in the Samuel painting serve to underscore its erotic content.[5] Gaskell also noted the prominent crucifix around the woman's neck, which recalls a similar ornament worn by the serving girl in van Mieris' *Inn Scene* of 1658 in the Mauritshuis, The Hague (no. 860), where the setting is clearly a brothel. He noted the popular notion which held that prostitutes were often Roman Catholic because they supposedly could easily secure absolution for their sins.[6]

Kuretsky dates the painting about 1664–5, noting that in the artist's works of the early and mid-1660s, 'the figure types become more slender and elongated (like the shapes of the canvases themselves), diagonal figure groupings are accentuated, and there is an increasing emphasis upon the material opulence of shimmering satins embroidered with gold and silver'.[7] In part, these developments reflect the pervasive influence that ter Borch's art had on high genre scenes after the middle of the century, but an even stronger influence on Ochtervelt in these years was the Leiden *fijnschilder* Frans van Mieris the Elder (q.v.). Van Mieris' *Oyster Meal* dated 1661 formerly in the Alte Pinakothek, Munich, and now in the Mauritshuis (fig. 3), clearly inspired Ochtervelt's oyster meal paintings of several years later; indeed the pose of the seated woman in the Samuel painting directly paraphases its prototype.[8]

1 See Kuretsky 1979, p. 61 and cat. no. 7, fig. 16.
2 Kuretsky 1979, cat. no. 21, fig. 29; Gaskell 1990, cat. no. 56. Kuretsky dates the Lugano painting c. 1663–5 while Gaskell suggested that the date 'should be extended to included the later 1660s'.
3 Kuretsky 1979, cat. no. 36, fig. 40.
4 G. D. J. Schotel, *Het Oud-Hollandsch huisgezin in de zeventiende eeuw* (Amsterdam, 1903), pp. 302–3; E. de Jongh, 'Realisme en schijnrealisme', in *Rembrandt en zijn tijd*, Musées Royaux d'Art et d'Histoire, Brussels (1971), p. 169; E. de Jongh *et al.*, *Tot Lering en Vermaak*, Rijksmuseum, Amsterdam, 1976, under cat. nos. 51 (Ochtervelt) and 62 (Steen); Naumann 1981, p. 110; L. Cheney, 'The Oyster in Dutch Genre Paintings: Moral or Erotic Symbolism', *Artibus et Historiae*, vol. 15 (1987), pp. 135–158.
5 Kuretsky 1979, p. 17.
6 Gaskell 1989, p. 258.
7 Kuretsky 1979, p. 118.
8 Naumann 1981, vol. 2, no. 36, pl. 36; on the relationship of van Mieris and Ochtervelt, see Kuretsky 1979, pp. 17–18; and Naumann 1981, p. 55, note 31, 56, note 35, pp. 61, 64.

CAT. 47

A Lady and Maid Choosing Fish, c. 1671–3

Oil on canvas 27¼× 22¾ in. (69.3 × 57.7 cm.)

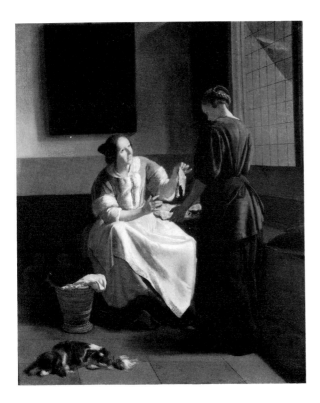

PROVENANCE: Sale Paris, December 1893 [as Pieter de Hooch] (for 680 frs., to dealer F. Kleinberger of Paris); Erich Gallery, New York, 1908; Sir Robert van Horne, Montreal; Sir William van Horne, Montreal, 1924; Mrs Margaret van Horne, Montreal; acquired from W. van Horne's daughter-in-law by Edward Speelman in 1967 for Harold Samuel.

EXHIBITIONS: Montreal, Montreal Art Association Galleries, *A Selection from the Collection of Paintings of the late Sir William van Horne*, 16 October–5 November 1933, no. 57; London 1988, no. 46.

LITERATURE: Hofstede de Groot, vol. 1 (1908), p. 487, no. 37 [as P. de Hooch]; W. R. Valentiner, 'Jacob Ochtervelt', *Art in America*, vol. 12 (1924), pp. 269–70, fig. 6; Horst Gerson, in Thieme and Becker, vol. 25 (1931), p. 556; E. Plietzsch, 'Jacob Ochtervelt', *Pantheon*, vol. 20 (1937), p. 364; E. Plietzsch, *Holländische und flämische Maler des XVII Jahrhunderts* (Leipzig, 1960), p. 57; Susan Donahue Kuretsky, *The Paintings of Jacob Ochtervelt (1634–1682)* (Oxford, 1979), p. 82, cat. no. 67, fig. 137.

CONDITION NOTES: The painting has been relined and the original tacking margins clipped. The paint surface has been moderately abraded, especially in the darks. The varnish is somewhat discoloured. On the reverse a sticker identifies the former owner as Mrs William van Horne, another sticker reads '109', and '75 Ochtervelt' appears in red paint.

In an interior a seated woman in a fur-trimmed red jacket and yellow skirt has set her sewing aside to select fish from a platter offered by the serving woman who stands before her. Her sewing basket rests beside her, and a small spaniel sleeps in the lower left. The scene is illuminated by a leaded window in the upper right. A still-life painting in the style of Otto Marseus van Schrieck or Matthias Withoos hangs in a black ebony frame on the back wall.

Ochtervelt painted several dozen scenes with women performing domestic tasks. These mistresses of the household perform the role of domestic manager prescribed to them by Jacob Cats (see *Houwelick, dat is de gantsche gelegenheyt des echten-staets* (Middelburg, 1625)[1]) and other moralists. According to these contemporary writers, the model wife not only oversaw the rearing of the children but also carefully supervised the kitchen, policing maidservants and monitoring the purchasing, selection and quality of foodstuffs and their preparation.[2] The subject of women selecting fish was taken up by Ochtervelt in several of his entrance hall scenes (see fig. 1).[3] A speciality of the artist, the latter paintings depicted the foyers of elegant homes where the lady of the household encounters vendors and merchants at the threshold of the front door. Other artists, including Ochtervelt's fellow Rotterdammer, Hendrik Sorgh,[4] and the Leiden painter, Quirijn van Brekelenkam, had earlier depicted scenes of housewives selecting fish.

Kuretsky even suggested that the inspiration for
Ochtervelt's painting may have been Brekelenkam's paint-
ing dated 1664 in Manchester (fig. 2); she plausibly dates
the Samuel painting about 1671–3 on the basis of the figure
types and the short-sleeved velvet jacket worn by the lady.[5]

In 1893 the Samuel painting was sold in Paris with a false
attribution to Pieter de Hooch.[6] Pieter de Hooch (q.v.) had
been a fellow pupil with Ochtervelt under Nicolaes
Berchem and made a speciality of depicting orderly
interiors with domestic subjects and subtle effects of light.
During the 1660s and 1670s he too repeatedly painted
images of women overseeing the purchasing and selection
of food, and treated the fish subject at least twice (see fig.
3).[7]

Like Lord Samuel's Koninck, the painting came from the
van Horne Collection, which is discussed in Cat. 36. Three
copies of the present painting are known: in the York City
Art Gallery, England (no. 40); the Dahl sale, Amsterdam,
17 October 1905, no. 107; and in the Hammer Collection,
1957.[8]

1 Reissued in *Alle de Wercken* (Amsterdam, 1712), pp. 235–727.
2 See 'Vrouw', in *Alle de Werken*, pp. 309–10, and especially pp.
 352–64, where Cats inventories the duties of the mistress of the
 household, including the judicious selection of fresh fish. For
 discussion, see Sutton 1980, pp. 46–9.
3 Kuretsky 1979, cat. no. 41, fig. 55; see also Kuretsky cat. nos.
 55 and 103, figs. 132 and 135.
4 See, for example, Hendrik Sorgh, *Kitchen with Woman Selecting
 Fish*, signed and dated 1643, oil on panel, Muzeum Narodwe,
 Warsaw, no. 136227; repr. Philadelphia/Berlin/London 1984,
 fig. 86.
5 Kuretsky 1979, p. 82.
6 Hofstede de Groot, vol. 1 (1908), p. 787, no. 37 [as P. de
 Hooch].
7 See, for example, *A Woman and Maid in a Courtyard*, c. 1660/1
 or 1663, canvas 73.7 × 62.6 cm., National Gallery, London, no.
 794 (Sutton 1980, cat. 44, pl. 48); and *Mother and Child with a
 Serving Girl*, c. 1674–6, canvas 85.8 × 79 cm., John G. Johnson
 Collection, Philadelphia Museum of Art, no. 501 (Sutton 1980,
 no. 112A, pl. 115).
8 Respectively Kuretsky 1979, no. 67-A, fig. 131, oil on canvas
 78.7 × 66 cm.; no. 67-B, fig. 139, oil on canvas 62 × 50 cm.;
 no. 67-C, oil on canvas 76 × 61 cm. The last-mentioned differs
 in details from the original: the painting on the back wall has
 been changed into a still life of flowers in a glass vase, figures
 have been added to the tiles, and foliage and architecture are
 visible through the window.

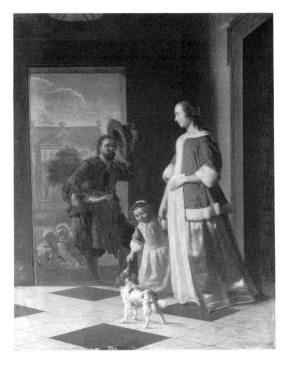

FIG. 1 Jacob Ochtervelt, *Entrance-Hall with a Woman, Child and Fish Seller*, signed, canvas 55.5 × 44 cm., Mauritshuis, The Hague, no. 195.

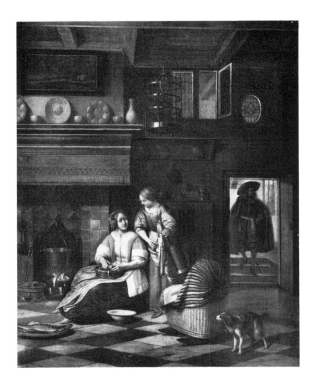

FIG. 3 Pieter de Hooch, *Woman Selecting Fish*, oil on canvas 83 × 72 cm., Museum Boymans-van Beuningen, Rotterdam, inv. no. 2500.

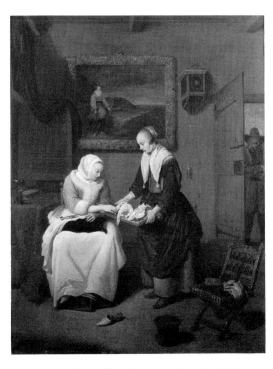

FIG. 2 Quirijn van Brekelenkam, *Lady and a Maid Selecting Fish*, signed and dated 1664, oil on canvas 49.8 × 39.4 cm., Assheton Bennett Collection, Manchester City Art Gallery, Manchester, England, cat. (1965), no. 11.

ADRIAEN VAN OSTADE

(HAARLEM 1610–1685 HAARLEM)

Baptized at Haarlem on 10 December 1610, Adriaen van Ostade was the son of Jan Hendriksz of Eindhoven and Janneke Hendriksdr. Adriaen and his younger brother Isack (q.v.), who was also a painter, probably adopted the surname Ostade from a village near Eindhoven. Adriaen is first mentioned by this name in documents of 1636. A document of 1632 indicates that he was active as a painter by this date, and was receiving commissions from outside his home town. He joined the Haarlem guild in 1634 and served as a *hoofdman*, or leader, in 1647 and 1661 and *deken*, or dean, in 1662. In 1636 he was a member of the militia company 'Oude Schuts'. He was married in Haarlem in 1638 to Machteltje Petersdr, who died four years later. He was remarried in 1657 to Anna Ingels (d. 1666), who came from a wealthy Catholic family. Ostade may have converted at the time of his marriage. Although his second marriage took place in Amsterdam, Ostade seems to have spent virtually his whole life in Haarlem, where he was buried in St Bavo's on 2 May 1685. At his death Ostade resided on the Ridderstraat in a well-to-do neighbourhood in Haarlem.

According to Arnold Houbraken, Ostade was a pupil of Frans Hals (1581/5–1666) at the same time (around 1627) as Adriaen Brouwer (1605/6–38). While Hals had little discernible influence on the artist, Brouwer made a clear impact on his contemporary's approach to low-life genre. After about 1640, Ostade seems to have been influenced by Rembrandt's lighting effects. Unlike his brother and student Isack, who died young, Adriaen had a long and productive career as a painter, draughtsman and etcher of peasant life. He also executed a few biblical paintings and several portraits. Ostade had many followers; the best known is Cornelis Dusart (1660–1704). His pupils also included the genre painters Cornelis Bega (1631/2–64) and Jan Steen (q.v.).

LITERATURE: De Bie, 1661, p. 258; Houbraken, vol. 1 (1718), pp. 320, 347–9; Theodor Gaedertz, *Adriaen van Ostade: Sein Leben und seine Kunst* (Lübeck, 1869); van der Willigen 1870, pp. 21–3, 29, 233–41; Arsène Houssaye, *Van Ostade: sa vie et son œuvre* (Paris, 1876); Wilhelm Bode, 'Adriaen van Ostade als Zeichner und Maler', *Die Graphischen Künste*, vol. 1 (1879), pp. 37–48; C. Vosmaer, 'Adriaen van Ostade', *L'Art*, vol. 22, no. 3 (1880), pp. 241–50, 265–8; Marguerite van de Wiele, *Les Frères van Ostade* (Paris, 1892); Adolf Rosenberg, *Adriaen und Isack van Ostade* (St Petersburg, 1912); Wilhelm von Bode, 'Die beiden Ostade', *Zeitschrift für bildende Kunst*, vol. 27 (1916), pp. 1–10; E. Trautscholdt, 'Notes on Adriaen van Ostade', *The Burlington Magazine*, vol. 54, no. 311 (February 1929), pp. 74–80; Louis Godefroy, *L'Œuvre gravé de Adriaen van Ostade* (Paris, 1930); Abraham Bredius, 'Een en ander over Adriaen van Ostade', *Oud-Holland*, vol. 56 (1939), pp. 241–6; J. G. van Gelder, *Adriaen van Ostade: 50 etsen* (Haarlem, 1941); I. Kouznetsov, *Adriaen van Ostade* (in Russian) (Leningrad, 1960); Bernhard Schnackenburg, 'Die Anfänge des Bauerinterieurs bei Adriaen van Ostade', *Oud-Holland*, vol. 85 (1970), pp. 158–9; Bernhard Schnackenburg, *Adriaen van Ostade, Isack van Ostade: Zeichnungen und Aquarelle*, 2 vols. (Hamburg, 1981); Philadelphia/London/Berlin 1984, pp. 281–9.

CAT. 48

Tavern with Tric-Trac or Backgammon Players, 1669 or 1674?

Signed and dated lower left: Av Ostade (The 'A' and 'v' ligated)
and remnants of a date
Oil on panel 11⅞ × 9⅞ in. (30.2 × 25.3 cm.)

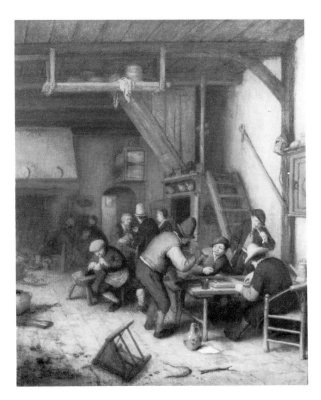

PROVENANCE: (Probably) sale Count van Wassenaer-Obdam, The Hague, 19 August 1750, no. 36 (320 fl., to Hoet); sale Prince de Conti, Paris, 8 April 1777, no. 311 (2000 livres); sale Chevalier Lambert et du Porail, Paris, 27 March 1787, no. 66 (2555 frs.); sale Prince de Talleyrand-Bénévent, Paris, 9–10 July 1817, no. 23 (see Condition notes) – (the Talleyrand sale never took place because William Buchanan bought the collection *en bloc* for 320,000 frs.); Edward Gray, Haringey House, Hornsey, 1829; sale Comte de Perregaux, Paris, 8 December 1841, no. 23 (7000 frs., to the dealer Nieuwenhuys; or according to Smith, to George; or according to Blanc and the *Cabinet de l'amateur* (1842), to A. M. de Morkowe); A. de Rothschild; Earl of Iveagh, 1889; Arthur Ernest Guinness, Holmbury House, St Mary, Surrey; The Hon. Mrs Ernest Guinness; sale A. E. Guinness, London (Christie's), 10 July 1953, no. 66, to Edward Speelman; acquired from Edward Speelman.

EXHIBITIONS: London, Royal Academy, 1952/3, no. 483; London 1988, no. 49.

LITERATURE: Hoet, vol. 2 (1752), p. 292; W. Buchanan, *Memoirs of Paintings*, vol. 2 (London, 1824), p. 331; Smith, vol. 1 (1829),

nos. 63, 204; *Supplement* (1842), no. 115; *Cabinet de l'amateur et de l'antiquaire*, vol. 1 (1842), p. 191, no. 23; Charles Blanc, *Le Trésor de la curiosité*, (Paris, 1858), vol. 2, p. 447; Hofstede de Groot, vol. 3 (1910), nos. 718 [with incorrect dimensions] and 826; *The Burlington Magazine*, vols. 94/5 (July 1952/3), p. ii, ill.

CONDITION NOTES: The panel support is in good condition, uncradled, bevelled on all sides, and complete. There are minor losses in the paint film, mostly along the edges, but considerable abrasion, especially in the subsidiary figures at the back of the room. A pentimento appears in the overturned three-legged stool in the foreground. The varnish is very thick and discoloured. An old inscription on the back in English states 'This picture comes from the Collection of Prince de Tallyrand, Paris, July 5, 1817. [signed] W.B. [probably William Buchanan].' Other stickers include the inventory numbers 'wo/2227/6' and 'b973', and '28kk' in stencil.

In a rustic tavern four men gather around a table in the right foreground to play tric-trac or backgammon. Two of them stand while smoking their pipes and commenting on the play of the two who sit at the game board; the standing man at the left has a maroon waistcoat, grey hat and greenish shirt. To the right, a narrow stairway ascends behind the group. Beyond and to the left a man in a blue jacket and red cap sits lighting his pipe from a brazier. Beside him, a man and woman settle their bill with the tavern hostess. In the back left two peasants warm themselves by the fire. On the tiled floor in the immediate foreground is an overturned three-legged stool. Overhead a rag hangs from the rafters. The floor is strewn with litter.

The provenance of this painting has been confused and may still contain inaccuracies. A hitherto overlooked early provenance reference for the painting's having been in the Prince de Talleyrand(-Bénévent) Collection in 1817 is provided by an old inscription on a sticker on the back, in all likelihood written by the well-known Scottish dealer, William Buchanan (see Condition notes). Buchanan acquired the entire Talleyrand collection before the public sale, imported it to England, and later published the Samuel painting with a full description in his *Memoirs of Paintings* (1824), noting that 'This little production was painted at the best time of Adriaen Ostade, but it has suffered at some period or another, and therefore has lost a great part of its value'.[1] The Talleyrand Collection was regarded as one of the most select collections of Dutch and Flemish cabinet-sized paintings in France, and had been acquired from Malmaison, the Duc de Choiseul, Randon de Boisset, de Tolozan, and other fine collections under the guidance of the Parisian dealer Le Brun. In the Talleyrand sale catalogue, the painting appeared (without mention of a pendant) as no. 23, with the measurements 11 × 9 'pouces',

and a description that corresponds in detail to the Samuel picture.[2] Smith added the work's distinguished earlier provenance – the collections of Count van Wassenaer-Obdam, the Prince de Conti, and the Chevalier Lambert et du Porail – noted that the picture was dated 1669, and stated that at the time of his writing it was in the possession of Edward Gray, Esq. The description in the Wassenaer-Obdam sale catalogue is too cursory to confirm the identification ('Des paysans jouant aux Tric Trac dans une Maison, avec 10 figures & accompagnements' 12 × 10 'pouces'), however an extensive description in the catalogue of the sale of the vast collection of the Chevalier Lambert et du Porail in 1787 leaves no doubt about the identification and refers specifically to the earlier Prince de Conti provenance.[3] Through error, or for some other inexplicable reason, under his no. 718 Hofstede de Groot incorrectly transcribed the measurements that Smith had provided as 11¼ × 9¾ in. (which are virtually the same as the Samuel picture's) as 13 × 11½ in., thus suggesting that this was a different, slightly larger painting.

The painting has been traditionally assumed to be identical with a picture that appeared with a pendant, a scene of tric-trac players in a somewhat more respectable middle class tavern, now also in the Samuel collection (see Cat. 49) that appeared in the sale of paintings from the collection of the Comte de Perregaux (Smith, no. 204 and *Supplement*, no. 115, and Hofstede de Groot no. 826) as dated 1674. (It is unclear why Smith regarded the Tallyrand and Perregaux paintings as two different works.) The date on the Samuel painting can no longer be deciphered, but the work's style would not be inconsistent with a date of either 1669 or 1674. The reviewer of the Perregaux sale for the *Cabinet de l'amateur* (1842) and Charles Blanc both characterized the two paintings as pendants. However, it is not at all clear that Ostade himself conceived the two as a pair (see commentary to Cat. 49). They differ slightly in size and apparently have different histories both prior to and after their appearance in the Perregaux sale. No mention was made of pendants in the sales in 1750, 1777, 1787 or 1953.

1 W. Buchanan, *Memoirs of Painting, with a Chronological History of the Importation of Pictures by the Great Masters into England since the French Revolution*, vol. 2 (1824), pp. 331–2, no. 23. On William Buchanan, see Hugh Brigstocke, *William Buchanan and the 19th Century Art Trade: 100 Letters to his Agents in London and Italy* (London, 1982).

2 'No. 23. H. 11 pouces. L. 9 pouces. Intérieur d'Estaminet. On y remarque sur la droite, près d'une table, deux hommes debout, fumant et regardant des joueurs de tric trac; vers le milieu de la salle un autre fumeur, accoudé sur un billot, tient un réchaud de terre, et met le feu à sa pipe; derrière lui un de ses camarades s'entretient avec la maîtresse de l'estaminet, en présence d'une seconde femme; deux autres personages sont dans le fond du tableau, à côté d'une cheminée. Ce petit ouvrage est généralement regardé comme devant être mis au rang des meilleurs d'A. van Ostade'. Translation in Buchanan 1824, p. 331. Also in the sale was Adriaen van Ostade's *Woman with a Child at a Half Door*; Hofstede de Groot, vol. 3 (1910), no. 56.

3 'L'intérieur d'une auberge, composition de 12 figures; à droit devant une cheminée trois hommes & une femme se chauffent; à gauche on voit une longue table, devant laquelle sont deux joueurs de tric trac, d'autres buveurs les regardent; dans le fond deux hommes jouant aux cartes, une femme assise près d'eux. Ce précieux tableau vient de la collection de Monseigneur le Prince de Conty, no. 311, vendu 2000 livres. Hauteur 11 pouces 6 lignes, largeur 10 pouces 9 lignes'.

CAT. 49

Village Inn with Backgammon (Tric-Trac) and Card Players, 1674 or 1675

Signed and dated lower right: Av (ligated) Ostade 167(4 or 5)
Oil on panel 12⅜ × 10½ in. (31.5 × 26.6 cm.)

PROVENANCE: Sale De Quarles, Amsterdam, 19 October 1818, no. 41 (1550 fl., to J. de Vries); sale Comte de Perregaux, Paris, 8 December 1841, no. 24 (7000 frs., to the dealer Nieuwenhuys or (according to *Cabinet de l'amateur* and C. Blanc) to A. M. de Morkowe); Jhr. Steengracht van Oostkapelle, The Hague; Jhr. Steengracht van Duivenvoorde, The Hague, 1899 (see 't Hooft); sale Steengracht van Duivenvoorde, Paris, 9 June 1913, no. 54, ill.; Madame C. van Pannwitz, Heemstede; Ch. A. de Burlet, 1929 (see exh.); Etienne Nicolas, Paris, who sold it to Speelman late in 1959; acquired from Edward Speelman.

EXHIBITIONS: London, Royal Academy, 1929, no. 201; London 1988, no. 48.

LITERATURE: Smith, vol. 1 (1829), no. 205; *Suppl.* (1842), no. 116; *Cabinet de l'amateur et de l'antiquaire*, vol. 1 (1842), p. 191, no. 24; Charles Blanc, *Le Trésor de la curiosité* (Paris, 1858), vol. 2, p. 447; C. G. 't Hooft, *Vereeniging tot bevordering van beeldende kunsten. Verzameling Jhr. Steengracht van Duivenvoorde* (n.p., 1899), n.p., ill.; H. J. Scholten, *Catalogue raisonné des dessins des écoles françaises et hollandaises*, Teylers Museum, Haarlem (1904), p. 151; Hofstede de Groot, vol. 3 (1910), no. 816; Bernhard Schnackenburg, *Adriaen van Ostade. Isack van Ostade. Zeichnungen und Aquarelle.*

Gesamtdarstellung mit Werkkatalogen, vol. 1 (Hamburg, 1981), p. 131, under cat. no. 256; Russell 1988, p. 788; Michiel Kersten, in New York, Pierpont Morgan Library, *From Michelangelo to Rembrandt. Master Drawings from the Teyler Museum*, 10 February– 30 April 1989, also shown at Chicago, Art Institute of Chicago, 13 May–30 July 1989, p. 147, under cat. no. 96.

CONDITION NOTES: The panel support is cradled. The paint is generally in very good condition with few losses and little abrasion. The varnish is somewhat discoloured and slightly crazed in several areas along the edges.

In the interior of a village inn figures gather to socialize, drink and game. Three men and a woman assemble beside a hearth on the right. To the left, four men gather around a long table with benches beneath two large leaded windows where they play tric-trac or backgammon. Before them is a boy with a dog, and in the lower left hand corner an empty, three-legged chair. At the far end of the table at the back of the inn, other figures drink and converse with a serving maid. On the back wall hang beer jugs and from the ceiling hangs a basket.

This painting apparently appeared in the Comte de Perregaux sale in Paris in 1841 together with the other painting of tric-trac players now in the Samuel Collection (Cat. 48); although the two pictures were characterized as pendants in the sale catalogue, by the reviewer of the sale in the *Cabinet de l'amateur*, and by Charles Blanc in *Le Trésor de la curiosité*, they have different provenances both prior to and following the 1841 sale. The putative pendant did not appear in the de Quarles sale in Amsterdam in 1818 and the two paintings parted ways only to be reunited in this century when they were sold separately by Speelman to Harold Samuel. While the paintings are very close in size, and similar in theme and design, their pendantship was probably the creation of the Comte de Perregaux rather than the artist. (Perregaux also owned one of Samuel's van der Heydens, see Cat. 28). Smith and Hofstede de Groot accepted the idea that the paintings were pendants but the latter neither addressed the issue of the different early provenances nor questioned the difference that he perceived in the two works' dates; the date on the present work was read by Smith as 1674 (the same as its putative pendant), while Hofstede de Groot read '167-', and dated it on stylistic grounds to 'about 1670'.[1] The last numeral of the date cannot now be accurately deciphered, but it appears to be either a '4' or '5'. A watercolour drawing by Ostade depicting the same scene as the present work and dated 1675 is preserved in the Teylers Museum in Haarlem (fig. 1).[2] The drawing is so finely resolved and finished to suggest that it was executed after the present work, rather

than as a preparatory study preceding the painting; thus it may provide a *terminus ante quem* for the dating of the present work. Schnackenburg, who assumed on the basis of Scholten's report that the Samuel painting was certainly dated 1674, also believed that the painting preceded the drawing.[3]

The theme of tric-trac players in an inn was very popular with Dutch painters of both high and low-life genre.[4] Like most other gaming themes, it could be merely a harmless diversion or, from a moralizing point of view, could carry admonitory associations with idleness. Ostade himself had treated the subject of tric-trac in several earlier paintings which probably date from the late 1630s or 40s, including pictures formerly in the Borden and Cook collections.[5]

Jonkheer Steengracht van Oostkapelle, who owned the painting in the nineteenth century, was the Director of the Royal Cabinet of Paintings in The Hague (Mauritshuis) and owned a superb collection of Dutch paintings, some of which entered the Mauritshuis, while others have been dispersed to the museums in Amsterdam, New York, Ottawa, Paris, Quimper and elsewhere.

An engraving by W. Steelink after the painting appeared in *Oude Kunst in Nederland* in c. 1890.

FIG. I Adriaen van Ostade, *Village Inn with Backgammon Players*, pen and black ink, watercolour and gouache (314 × 276 mm.), Teylers Museum, Haarlem, no. P80.

1 Smith, vol. 1 (1829), no. 205; Hofstede de Groot, vol. 3 (1910), no. 816. C. G. 't Hooft, writing on the Steengracht paintings in the *Vereeniging tot bevordering van Beeldende Kunsten* (1899), described the painting as 'een uitstekende staaltje van zijn tweede periode', which he implied predated 1671.

2 See Scholten, Teylers Museum cat. (1904), p. 150, no. 80; and Schnackenburg, vol. 1 (1981), pp. 45, 131, no. 256, ill. pl. 121.

3 Schnackenburg, vol. 1 (1981), p. 45. See also Michiel Kersten in New York, Pierpont Morgan Library, *From Michelangelo to Rembrandt. Master Drawings from the Teyler Museum*, 1989, also shown at the Art Institute of Chicago, p. 147, cat. 96, ill.

4 On the theme of tric-trac, see Philadelphia/Berlin/London 1984, p. 293.

5 See Hofstede de Groot, vol. 3 (1910), no. 828, sale M. C. D. Borden, New York, 14 February 1913, no. 11, ill.; Hofstede de Groot, no. 577, formerly Cook Collection, Doughty House, Richmond, sale London (Sotheby's) 5–6 July 1983, no. 104, ill. (in reverse).

CAT. 50

Peasants Dancing in a Tavern, 1675

Signed and dated to the lower right of centre:
Av. (ligated) Ostade. 1675
Oil on panel 21 × 28½ in. (53.4 × 72.4 cm.)

PROVENANCE: Sale Lambert Witsen, Amsterdam, 25 May 1746, no. 2 (1200 fl.); sale Dulong, Amsterdam, 18 April 1768, no. 3 (1550 fl., to van Diemen); sale N. Doekscheer, Amsterdam, 9 September 1789, no. 37 (1825 fl., to van der Vinne); Mlle Hoofman, Haarlem, 1829 (appraised by Smith at £525); sale Hoofman, Haarlem, 5 June 1846; A. Tomline, Orwell Park, near Ipswich, 1854; A. Seymour; with Charles Sedelmeyer, Paris, 1896; Alfred Beit, London, cat. 1904, p. 55; Otto Beit, London, cat. 1913, no. 42; Sir Alfred Beit, Blessington; acquired from Beit via Edward Speelman in 1959.

EXHIBITIONS: Cape Town, National Gallery of South Africa, *Old Master Paintings from the Beit Collection. Supplement* 1950, no. 59 [incorrectly as dated 1678]; London 1988, no. 50.

LITERATURE: Hoet, vol. 2 (1752), p. 186; Smith, vol. 1 (1829), no. 7; Gustav Waagen, *Treasures of Art in Great Britain*, vol. 3 (London, 1854), p. 440 [as dated 1675]; *Sedelmeyer's Catalogue of 100 Paintings* (Paris, 1896), no. 26; Hofstede de Groot, vol. 3 (1910), no. 543; Wilhelm Bode, *The Art Collection of Mr Alfred Beit at his Residence, 26 Park Lane, London* (Berlin, 1904), p. 15 [as dated 1678], p. 55 [as dated 1675] (?); Wilhelm Bode, *Pictures and Bronzes in the Possession of Mr Otto Beit* (London, 1913), p. 16, no. 42 [incorrectly as dated 1678], pl. xi; Wilhelm von Bode, *Die Meister der holländischen und vlämischen Malerschulen* (Leipzig, 1917), p. 131 [as dated 1675]; D. Bax, *Hollandse en Vlaamse schilderkunst in Zuid Afrika* (Cape Town, 1952), p. 45, note 12, fig. 13; Bernhard Schnackenburg, *Adriaen van Ostade. Isack van Ostade. Zeichnungen und Aquarelle. Gesamtdarstellung mit Werkkatalog*, vol. 1 (Hamburg, 1981), p. 128, under cat. no. 239; Russell 1988, p. 788; Michiel Kersten, in New York, Pierpont Morgan Library, *From Michelangelo to Rembrandt. Master Drawings from the Teyler Museum*,

10 February–30 April 1989, also shown in Chicago, Art Institute of Chicago, 13 May–30 July 1989, p. 47, note 5.

CONDITION NOTES: The panel support is uncradled but 2 in. (5 cm.) battens have been attached along all sides and a horizontal batten of the same width has been attached 3¾ in. (9.6 cm.) from the top edge probably to reinforce an old split in the panel 5¼ in. (13.4 cm.) from the top. Some minor abrasion appears in the background but generally the painting is in a very good state. Some minor retouching may have been applied to the green of the trees in the doorway, and other retouches are scattered in the shadows. A thick moderately discoloured varnish obscures the surface. The red seal of Sedelmeyer's Gallery appears on the back as well as several inventory numbers: 'B831'; 'W.O./4201/5'; 'No. 10569/A. Ostade'; and '11784'.

In the centre of a large unruly tavern, a rustic couple dance to the music of a fiddler who stands on his seat as he plays. All around figures eat, smoke and drink. At the table on the left men smoke, drink and turn to watch the dancers, while a woman looks after children playing with dolls. On the right a man asks a stout woman to dance while another man viewed in lost profile sits on an overturned wooden tub. In the back are other tables with revellers. On the left through an open door is a landscape and at the back right a stairway leads to a loft. In the foreground a dog stands beside an overturned three-legged stool and litter (branches, a stick and stones) covers the ground. At the open door a man in an apron, probably the tavern keeper, gives alms to a beggar.

The subject of bumptious dancing was traditional to peasant painting, originating in sixteenth-century images of the kermis and tavern scenes. From the art of Pieter Bruegel and his followers the theme descended by way of early seventeenth-century painters like David Vinckboons to Ostade, who made a speciality of the theme. This colourful and carefully finished late painting by the artist culminated more than forty years of depicting the subject; between c. 1633 and 1675 Ostade produced at least one dozen paintings of peasants dancing in taverns to the rude strains of a violin or the still more tortured sounds of a bagpipe or doodlesack.[1] His earliest images of dancers from the 1630s (see, for example, fig. 1) had a wild, almost crazed vitality that suited his unapologetically coarse first conception of the peasant – a notion that owed much to Adriaen Brouwer's revolutionary peasant paintings.[2]

By the time he painted this picture, however, Ostade's peasants had become more domesticated and prosperous. Even their dance steps, though no less spritely, are not so manic. These trends are confirmed by Ostade's other painting of dancing peasants from 1675, the so-called 'Golden Wedding' in the Art Institute of Chicago (fig. 2).[3] That

painting adopts an upright format but employs the same refined technique and assured touch that the nineteenth-century connoisseur Smith found so commendable in a painter who had reached his sixty-fifth year.[4] Smith correctly praised the Samuel painting as 'one of the most capital pictures of the master for size and subject', while Waagen observed that it was 'a rich composition, executed in the reddish flesh-tones of his later pictures', and Bode characterized it as a masterpiece whose large and elaborate composition distinguished it as one of the 'principal works of the artist'.[5] The painting's popularity is confirmed by the existence of copies, including a watercolour by S. Troost.[6]

Preserved in the Teylers Museum in Haarlem is a pen and wash drawing now regarded as a copy after a lost sketch by Ostade, that probably constituted the master's first conception of the Samuel painting's composition (fig. 3).[7] It already establishes the general design, with figures watching from a bench on the left, musicians at the back, and the dancing couple on the right; and even some of the specific poses, for example, the two seated men at the left. Still another drawing (fig. 4) in the Teylers Museum which is elaborately worked up in watercolour and gouache represents a more advanced stage in Ostade's conception of the theme, and indeed must have been regarded as a finished work of art.[8] Dated 1673, two years earlier than the Samuel picture, it is a very close variant of the final painting, which nonetheless changes many details; for example, substituting a seated man on the right for a bench, exchanging the child in the foreground for an overturned three-legged stool, adding children at the far left and eliminating the bagpiper who accompanied the violinist. The charitable vignette in the doorway had also not yet been added. Writing in the catalogue of the exhibition of the Teylers Museum's drawings held in New York and Chicago in 1989, Michiel Kersten mentioned yet another panel painting unknown to this author which was dated 1673 and was a close variant of the design; sale Paris, 9 March 1931, no. 33. He reported that 'the composition is virtually identical, differing only from the drawing in some details: the stools and casks on the right have been substituted by a bench, the pipe-player has been anulled and instead of the boy playing with a dog in the center foreground there is now a piece of crockery'.[9]

In the seventeenth century, attitudes toward dancing differed greatly in the Netherlands. Orthodox Calvinist preachers condemned it as a 'vain, rash, unchaste' activity.[10] In 1641 Wassenburgh even claimed that doctors believed that dancing was unhealthy, especially after meals when one had to avoid 'all violent movements and great shakings of the body'.[11] However the church and the medical establishment were at odds with popular culture, which embraced the pastime wholeheartedly. Dancing schools and public dance halls sprang up not only in Dutch cities but also in villages. The Spaniard Vásquez even claimed that Dutch women were dance-crazy.[12] Laws prohibiting dancing at weddings remained in effect in Dordrecht as late as 1681, but by this time it was a common pastime of all social classes.[13] If Ostade's bumptious dancers had become more decorous and civilized than their orgiastic ancestors in Vinckboons's *kermis* scenes, they nonetheless recollect the comic and moralizing pictorial heritage that was so closely allied to literary traditions expressed in works like G. A. Bredero's *Boertigh liedt-boeck*, the eighty-eight coarse and earthy peasant songs which comprise the first part of the author's famous *Groot liedt-boeck* (Amsterdam, 1622); see fig. 5.[14]

1 See the dated examples: Hofstede de Groot, vol. 3 (1910), no. 594 of 1633 (ex-Schloss Collection, Paris); Hofstede de Groot, no. 551 of 1635; Hofstede de Groot, no. 554, of 1636; Hofstede de Groot, no. 544 of 1641, Munich, Alte Pinakothek, no. 567; Hofstede de Groot, no. 605 of 1643; Hofstede de Groot, no. 553 of 1645; Hofstede de Groot, no. 545 of 1652, National Museum, Prague, inv. no. DO856; and Hofstede de Groot, no. 546 of 1652, Toledo Museum of Art, no. 69.339 (see note 3).

2 See also Rijksmuseum, Amsterdam, no. A2568.

3 Hofstede de Groot, vol. 3 (1910), no. 542; and compare Ostade's undated *Peasants Dancing in an Inn*, panel 17¾ × 23¾ in., St Louis Art Museum, no. 147:66. In the course of discussing the Samuel painting, Bode wrote in the Beit catalogue (p. 15), 'Whilst we see in the earlier pictures the loose joviality, wild dancing, drunken revels, and fighting, in which the wantonly attired people indulge, we find in the later works the contentment of those leading comfortable lives of homely happiness, whose simple pleasures are restrained and decorous'. See also William Robinson's discussion of van Ostade's *Dancers in an Inn* of 1652, in the Toledo Museum of Art, exh. cat. Philadelphia/Berlin/London 1984, pp. 284–5, which observes that the domestication of Ostade's peasant dancers had begun at least two decades earlier.

4 Smith, vol. 1 (1829), no. 138.

5 Smith, vol. 1 (1829), no. 7; Bode 1913, p.16. In the 1904 Beit catalogue (p. 15), Bode compared this picture in its 'picturesqueness of treatment' to an *Adoration of the Shepherds*, also from Ostade's later career.

6 Panel 45.5 × 55.5 cm., signed and dated 'A. van Ostade 1673' [sic], sale Paris, 9 March 1921, no. 33; watercolour by S. Troost, 25 × 41 cm., sale Utrecht (van Huffel), 31 March 1938, no. 326, ill.

7 See H. J. Scholten, *Catalogue raisonné des dessins des écoles françaises et hollandaises*, Teylers Museum, Haarlem (Haarlem, 1904), p. 148, no. 77 [as by A. van Ostade]; Schnackenburg 1981, vol. 1, pp. 128, 299, fig. 119 [as a copy by an unknown artist].

FIG. 1 Adriaen van Ostade, *Dancers in a Tavern with a Fiddler*, panel 39 × 56 cm., Gemäldegalerie, Staatliche Kunstsammlungen, Dresden, no. 1395.

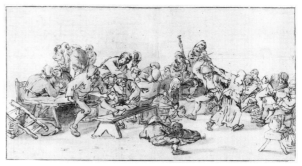

FIG. 3 Copy after Adriaen van Ostade, *Peasants Dancing*, pen and brown ink with watercolour over black chalk, 195 × 375 mm., Teylers Museum, Haarlem, no. P77.

FIG. 2 Adriaen van Ostade, *Rustic Couple Dancing in an Inn*, signed and dated 1675, 17 × 14½ in., Art Institute of Chicago, no. 1894.1028.

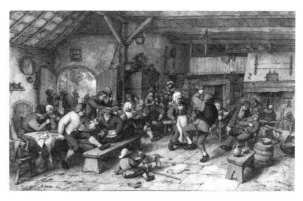

FIG. 4 Adriaen van Ostade, *Tavern with Peasants Dancing*, 1673, pen and brown ink, watercolour and gouache, 251 × 410 mm., Teylers Museum, Haarlem, P78.

FIG. 5 Jan van de Velde, *Peasants Dancing*, engraving from G. A. Bredero's *Groot liedt-boeck* (Amsterdam, 1622).

8 Scholten 1904, p. 149, no. 78; Schnackenburg 1981, vol. 1, pp. 45, 128, no. 239, vol. 2, pl. 113.

9 *From Michelangelo to Rembrandt. Master Drawings from the Teyler Museum*, 1989, p. 147, under cat. no. 95.

10 G. D. J. Schotel, *Het Oud-Hollandsch huisgezin der zeventiende eeuw* (Arnhem, 1903), p. 278; A. Th. van Deursen, *Volkskultuur, Het kopergeld van de Gouden Eeuw*, vol. 2 (Amsterdam, 1978), pp. 17–19.

11 Cited by van Deursen 1978, p. 17; see Wassenburgh, *Dans-feest der dochteren te Silo: wt den woorde Gods, de oudt-vaders ende heydensche autheuren met sijn behoorlijcke sauce op-gedischt* (Dordrecht, 1641), p. 128.

12 Cited by van Deursen 1978, p. 17; see J. Brouwer, *Kronieken van Spaansche Soldaten uit het begin van den tachtigjarigen oorlog* (Zutphen, 1933), p. 109.

13 Schotel 1903, p. 279.

14 See Sutton in exh. cat. Philadelphia/Berlin/London 1984, pp. LXXIX–LXXX, pp. 176–7.

The Water Pump, later 1660s or 70s

Oil on panel 17⅞ × 14½ in. (45.3 × 36.9 cm.)

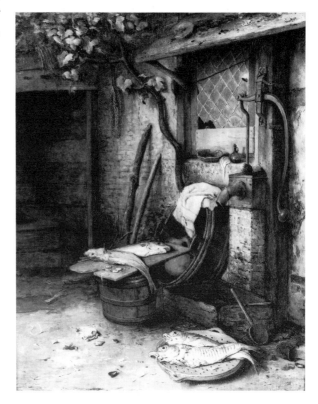

PROVENANCE: Sale Baron Vivant Denon, Paris (A. N. Pérignon), 1826, no. 100 (7410 frs.); dealer Emmerson, London, who sold it to William Wells; William Wells, Redleaf, 1829; sale W. Wells, London, 12 May 1848 (£435.15s, to Farrer for Lord Overstone); Lord Overstone, London, 1857 (see exh.); Lord and Lady Wantage, Carlton Gardens, London, cat. 1905, no. 169: Earl of Crawford and Balcarres; dealer D. Katz, Dieren, 1935; H.E. ten Cate, Oldenzaal, by 1938 (see exhs.); acquired from ten Cate's son by Edward Speelman, who in turn sold it to Harold Samuel in 1966.

EXHIBITIONS: Manchester, *Art Treasures Exhibition*, 1857, no. 740 (lent by Mr King or Lord Overstone (?), the sticker on the reverse lists them both); London, Royal Academy, Winter 1871; 1888, no. 112; The Hague, Kunstzaal Kleykamp, *Oud Hollandsche en Vlaamsche Meesters*, cat. 1927, no. 26, ill.; Brussels, Exposition Universelle et Internationale, *Cinq Siècles d'Art*, 24 May–13 October 1935, no. 753 (lent by D. Katz); Rotterdam, Museum Boymans, *Meesterwerken uit vier eeuwen*, cat. by D. Hannema, 1938, no. 118 (lent by A. E. ten Cate); New York, New York World's Fair, *Masterpieces of Art*, cat. by George Henry McCall and W. R. Valentiner, 1939, cat. no. 269 [lent by H.E. ten Cate] (the exhibition travelled to Detroit Institute of Art; California Palace of

the Legion of Honor, San Francisco; Cleveland Museum of Art; Minneapolis Art Institute; Toledo Museum of Art; and Museum of Fine Arts, Springfield, Mass.); Almelo, *Oude kunst uit Twents particulier bezit*, cat. by D. Hannema, 1953, no. 36, ill. no. 39; Dordrecht, Dordrechts Museum, *Nederlandse Stillevens uit vier eeuwen*, 1954, no. 76 [lent by H.E. ten Cate, Oldenzaal]; Rotterdam, Boymans Museum, *Kunstschatten uit Nederlandse verzamelingen*, cat. by E. Haverkamp Begemann and Bernardine R. M. de Neeve, 1955, no. 93, ill. no. 89 [lent by H. E. ten Cate]; London 1988, no. 51, ill. p. 22.

LITERATURE: Smith, vol. 1 (1829), no. 174; Gustav Waagen, *Supplement* (1857), p. 443; Ch. Blanc, *Le Trésor de la curiosité* (Paris, 1858), vol. 2, p. 362; W. Thoré-Bürger, *Trésors d'art en Angleterre* (Manchester, 1858), p. 314; A. G. Temple and Lady Wantage, *A Catalogue of Pictures forming the Collection of Lord and Lady Wantage at 2 Carlton Gardens, London, Lockinge House, Berks, and Overstone Park and Ardington House*, (London, 1905), pp. 116–17, no. 169, ill.; Hofstede de Groot, vol. 3 (1910), no. 916; H. P. Bremmer, in *Beeldende Kunst* (February 1928), no. 30, with ill.; D. Hannema, *Catalogue of the H. E. ten Cate Collection*, 2 vols. (Rotterdam, 1955), vol. 1, pp. VII, 12, vol. 2, pl. 1.

CONDITION NOTES: The panel support is in very good condition, uncradled, comprised of a single piece of wood, bevelled on all sides, and complete except for minor nicks on the edges. The paint film is also in very good state, with some minor abrasion in the darks and an old dent 5½ in. (14 cm.) up from the lower left corner. The greens of the vines have also suffered. The varnish layer is moderately discoloured and rubbed by the frame along the edges. On the reverse are numerous stickers from the various exhibitions, including Manchester 1857, Almelo 1935, Brussels 1935, Rotterdam 1938, and the travelling World's Fair exhibition of 1939–40 (with several temporary loan numbers from the museums in Cleveland, Toledo, Minneapolis, Springfield and San Francisco). Other unidentified inventory numbers: '170/14'; 'no. 5'; and 'no. 9'. In pencil the name [Earl of] 'Crawford' appears.

A still life is arranged around a water pump in a simple courtyard on the side of a brick house. Two haddocks lie in a colander in the foreground. Resting on a wooden basket behind is a chopping board with two other fish. Fish parts and mussel shells litter the ground. Beneath the broken pantry window rests a wooden tub with a ceramic pitcher and a blanket. Beside two wooden poles and a fish net, a vine rises along the side of the house. A wooden ladle rests beside the shallow trough of the pump. No figures appear in the scene.

In his mature and later years van Ostade executed at least three still lifes with an old pump as the central motif. In addition to the present work, there is a painting in the Offentliche Kunstsammlung, Basle, presented to the museum by Max Geldner (fig. 1),[1] which includes figures in the background, and another figureless painting that sold at Christie's in 1990 (fig. 2).[2] This type of *boerderij* still life was painted earlier by still-life artists like Willem Kalf and the Rotterdam and South Holland painters Cornelis Saftleven,

Frans Rijkhals, Hendrick Sorgh and Egbert van der Poel. Adriaen's brother Isack van Ostade (who died in 1649) also probably preceded him in the painting and drawing of figureless still lifes centred on a water pump (see fig. 3).[3]

The colourful palette (note the strong brick red of the colander and pitcher and the intense green of the vines) coupled with the refined treatment of the surfaces of simple objects in the Samuel painting suggest a date in the later 1660s or 70s. Lavishing such powers of observation on even the most quotidian and unpretentious of objects, Ostade earned the admiration not only of the author of the Denon sale catalogue, who wrote 'La perfection de l'exécution fait oublier le peu d'intéret de l'objêt representé', but also of Smith, who in 1829 cited the work as 'a model of perfection in objects of still life'.[4] Thoré-Bürger hailed the painting, 'Cette peinture d'objets *matériels* est une merveille et un chef-d'œuvre',[5] while Hannema, writing in the ten Cate catalogue, called it 'one of the most pure and intimate works of the master, of his mature period'.[6]

Baron Vivant Denon, who sold the painting in 1826, had been a Director of the Royal Museums of France, and owned an extensive collection of Dutch, French and Italian paintings and drawings. On the collector William Wells, see the Hobbema (Cat. 32), which he also owned. Lord Overstone (who was then Jones Lloyd) acquired the painting along with four others (including the de Hooch now in the Mauritshuis, The Hague) at the Redleaf sale in 1848. He had begun collecting about 1831, and in 1846 acquired no less than ten Dutch paintings from the famous Baron Verstolk van Soelen collection in The Hague. His collection of Dutch paintings was hung at Carlton Gardens. The tastes of Lord and Lady Wantage, who inherited his collection, ran more to nineteenth-century art (Burne-Jones, Corot, Turner, etc.). In addition to Dutch paintings, the ten Cate collection in Oldenzaal also included eighteenth- and nineteenth-century French paintings, for example Barbizon landscapes and Hague School paintings, as well as good seventeenth-century Dutch drawings.

1 See Hofstede de Groot, vol. 3 (1910), no. 917. Max Geldner bequest cat., 1958, p. 9.
2 Formerly in J. Tresfon Collection, Kaapprovince (South Africa); not listed in Hofstede de Groot, however see Von Moltke, in *Oud-Holland*, vol. 71 (1956), pp. 244–5, fig. 1.
3 In the Kupferstichkabinett in Berlin there is a drawing (no. KDZ3891, as A. van Ostade) of a *Water Pump* by Isack van Ostade which Adriaen apparently completed after his brother's death; see Bernhard Schnackenburg, *Adriaen van Ostade. Isack van Ostade. Zeichnungen und Aquarelle. Gesamtdarstellung mit Werkkatalogen* (Hamburg, 1981), vol. 1, pp. 22, 200, no. 631, vol. 2, pl. 261. Still another drawing in Berlin (KDZ5353) of the

same subject is entirely by Adriaen's hand; see Schnackenburg
1981, vol. 1, p. 105, no. 122, vol. 2, pl. 122.

4 Smith, vol. 1 (1829), no. 174.

5 Öffentliche Kunstsammlung, bequest of Max Geldner, cat.,
1958, p. 9.

6 D. Hannema, *Catalogue of the H. E. ten Cate Collection*
(Rotterdam, 1955), vol. 1, p. 12.

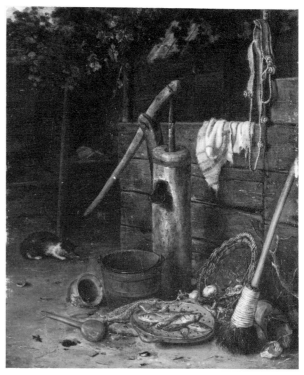

FIG. 2 Adriaen van Ostade, *Still Life with Pump*, oil on panel
27.4 × 21.6 cm., sale London (Christie's), 9 April 1990, no. 5, ill.

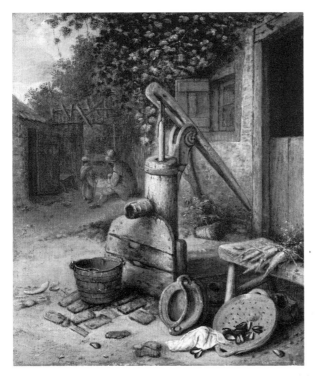

FIG. 1 Adriaen van Ostade, *Still Life with Pump*, oil on panel 27.5
× 23 cm., Öffentliche Kunstammlung, Basle, inv. no. G1958.34.

FIG. 3 Isack van Ostade, *Still Life with Pump*, dimensions
unknown, J. van Duyvendijk, Scheveningen, 1956.

ISACK VAN OSTADE

(HAARLEM 1621–1649 HAARLEM)

Baptized in Haarlem on 2 June 1621, Isack van Ostade was the youngest child of Jan Hendricksz of Eindhoven and Janneke Hendriksdr. Houbraken stated that Isack was a pupil of his older brother, Adriaen van Ostade (q.v.). His earliest dated painting is of 1639, but he did not enter the Haarlem guild until 1643. In the same year he was mentioned in the guild records when the council arbitrated his three-year dispute with the Rotterdam dealer Leendert Volmarijn concerning payment for and delivery of paintings. At least in these early years he seems to have been paid very little for his works; a contract of 1642 specified thirteen paintings for a price of twenty-seven guilders (hence just over two guilders per painting), while in the following year, when he joined the guild, he agreed to deliver nine paintings for fifty-six guilders, theoretically raising the price per painting to about six guilders. Isack lived in Haarlem until his death at the age of twenty-eight. He was buried on 16 October 1649, in St Bavo's Church.

A painter and draughtsman of landscapes and genre scenes, Isack van Ostade was active for only a decade. His early works are strongly dependent on the art of his brother and teacher, Adriaen; indeed, the two painters' hands have often been confused. However, Isack gave landscape greater prominence in his art, while Adriaen stressed figures. Chief among Isack's landscape subjects were winter scenes and the 'Halt before the Inn' theme. In addition to Adriaen van Ostade, the Haarlem artists Pieter de Molijn and Salomon van Ruysdael (q.v.) may also have influenced Isack.

LITERATURE: Houbraken, vol. 1 (1718), p. 347; Descamps, vol. 2 (1754), pp. 173–5; Smith, vol. 1 (1829), pp. 129–78, vol. 9 (1842), pp. 121–36; Marguerite van de Wiele, *Les Frères van Ostade. Les artistes célèbres* (Paris, 1893); A. Rosenberg, *Adriaen and Isack van Ostade* (Bielefeld and Leipzig, 1900); Wurzbach, vol. 2 (1910), pp. 287–9; Hofstede de Groot, vol. 3 (1910), pp. 437–556; W. von Bode, 'Die beiden Ostade', *Zeitschrift für bildende Kunst*, vol. 27 (1916), pp. 1–10; Wilhelm van Bode, *Die Meister der holländischen und flämischen Malerschulen* (Leipzig, 1921), pp. 167–86; Rolf Fritz, in Thieme and Becker, vol. 26 (1932), p. 75; Martin 1935–6, vol. 1, pp. 402–6; Ernst Scheyer, 'Portraits of the Brothers van Ostade', *Art Quarterly*, vol. 2 (1939), pp. 134–41; Rüdiger Klessmann, 'Die Anfänge des Bauerninteriurs bei den Brüdern Ostade', *Jahrbuch der Berliner Museen*, vol. 2 (1960), pp. 92–115; Stechow 1966, pp. 28, 39, 90, 92, 98, 99; Lea Eckerling, 'Isack van Ostade in the Literature: A Study of His Artistic Reputation', Thesis, University of California, Los Angeles, 1977; Paris, Institut Néerlandais, *Le Monde paysan d'Adriaen et Isack van Ostade* (catalogue by Bernard Schnackenburg), 1981; Bernard Schnackenberg, *Adriaen van Ostade, Isack van Ostade: Zeichnungen und Aquarelle*, 2 vols. (Hamburg, 1981); Haak 1984, pp. 238-239, 248; Amsterdam/Boston/Philadelphia 1987–8, pp. 390–3.

CAT. 52

A Ford c. 1648–9

Oil on panel 29¾ × 43¼ in. (79.6 × 109.5 cm.)

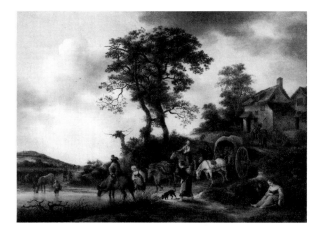

PROVENANCE: John Walter, Bear Wood; Alfred Beit, London, cat. 1904; Otto Beit, London, cat. 1913, no. 44; Sir Alfred Beit, Blessington; acquired from Edward Speelman in 1959.

EXHIBITIONS: Cape Town, National Gallery of South Africa, *Old Master Paintings from the Beit Collection* (intr. by John Paris), no. 22; London 1988, no. 52.

LITERATURE: G. Waagen, *Suppl.* (1857), no. 297; Wilhelm Bode, *The Art Collection of Mr Alfred Beit at his Residence, 26 Park Lane, London* (Berlin, 1904), pp. 15–16, 55; Wilhelm Bode, *Pictures and Bronzes in the Possession of Mr Otto Beit* (London, 1913), p. 18, no. 44, pl. XII; Hofstede de Groot, vol. 3 (1910), no. 123; Russell 1988, p. 789.

CONDITION NOTES: The support is cradled and composed of three planks of wood. One join runs horizontally 9¾ in. (24.5 cm.) from the top, the other is 10½ in. (27 cm.) from the bottom. The paint film reveals some abrasion and retouching along the joins, the edges and scattered throughout the sky. A scratch in the upper right corner has been repaired and inpainted. Some of the forms of the figures and animals have been reinforced with retouching: details of the horseman in the left foreground, the folds of the skirts of the woman fording the stream, the harness of the wagon, the horseman on the far side, and the head of the woman seated at the right. The varnish is mildly discoloured.

In the centre foreground of a landscape dominated by two tall trees a group of travellers ford a stream. Three men appear on horseback and one in a wicker covered wagon drawn by an old white horse, while other men and women travel on foot. The rider in the left foreground rides a chestnut-coloured horse and wears long tan boots, a purple coat and a tall brown hat. Behind him a woman in blue raises her violet skirts to wade through the water. Beyond the wagon a horseman leads a heavily laden donkey. At the upper right the road rises to an inn where several figures have halted; at the far left the travellers emerge from the shallow stream. One man pauses to water his horse while others move on. In the lower right a woman in a red skirt and yellow and black top sits beside a standing child.

The painting is not signed, but its traditional attribution to Isack van Ostade was supported by Waagen, Bode and Hofstede de Groot before Margarita Russell questioned it in her review of the Samuel Collection exhibition in 1988.[1] The painting closely resembles paintings by Isack in theme and design but its execution is less controlled and its drawing less certain than in most autograph works by the master. The painting combines two traditional landscape themes, the fording of a stream and stopping at the inn, both of which were not only treated by Isack but also by earlier landscapists, such as Jan Brueghel and Esaias van de Velde (qq.v.). Isack had painted the scene of travellers halting before an inn repeatedly in the 1640s.[2] The treatment of the theme and the compositional design of the Samuel painting are encountered in an analogous painting of 1646 (fig. 1), formerly in the collections of Talleyrand and Lord Ashburton and last recorded in the Henle Collection, Duisberg.[3] That work also depicts an inn on the right with a cart and travellers, a tree in the centre, and a small boy wading through the inundated roadway on the left, although the treatment of space and characterization of the figures appear more assured. However, one must bear in mind that the quality of Isack's production was uneven. Conceivably Lord Samuel's painting is an autograph but late work of about 1648 or 1649; it is, for example, comparable in handling to the painting dated 164[8] from the Duke of Bedford's collection, last recorded in the Nicolas Argenti collection (fig. 2).[4] The painting has had its admirers in the past. Wilhelm Bode, for example, commended it for its 'simplicity of subject . . . development of the shadows . . . deep warm colouring, [and] skillful drawing of the figures', indeed, he regarded it as 'one of the best of the master's works', concurring that 'It must have been painted in the very last years of his life'.[5]

On John Walter of Bearwood, who also owned paintings by Maes and van der Heyden (Cats. 39 and 27), see the latter. On the Beits, see cat. 83.

1 Russell 1988, p. 789: 'the attribution of *The Fort* [sic] by Isaak van Ostade is questionable.'

2 See, for example, Rijksmuseum, Amsterdam, no. A303 (dated 1643), and compare especially the paintings of 1646 in the Duke of Sutherland's Collection, St Boswell's, Roxburghshire (Hofstede de Groot, vol. 3 (1910), no. 18) and of 164[8] formerly in the Duke of Bedford's collection (Sale London (Christie's), 19 January 1951, no. 43, ill.; later in the Nicolas Argenti collection); see also the undated depictions of the theme in Her Majesty the Queen's Collection, Buckingham Palace (Hofstede de Groot, vol. 3 (1910), no. 19); The Frick Collection, New York (Hofstede de Groot, vol. 3 (1910), no. 25); the Southhampton Art Gallery (Hofstede de Groot, vol. 3 (1910), no. 59); the Museum Boymans-van Beuningen, Rotterdam, no. 1638 (dated 1640 or 1646?), and the painting with Hirschl and Adler Galleries, New York, in 1960 (see *Burlington Magazine*, vol. 102 (Dec. 1960), pl. VIII).

3 Hofstede de Groot, vol. 3 (1910), no. 79; Cologne, Wallraf-Richartz-Museum, *Die Sammlung Henle. Aus dem grossen Jahrhundert der niederländischen Malerei*, 22 February–5 April 1964, no. 27, ill.

4 See note 2. A painting with a comparable design and also attributed to Isack's late career is in the Kunsthistorisches Museum, Vienna (inv. no. 6235); however that painting is not by Isack.

5 Bode 1904, p. 16.

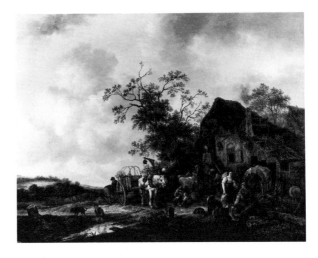

FIG. 1 Isack van Ostade, *Halt at the Inn*, signed and dated 1646. Oil on panel 82.5 × 107.5 cm., Dr G. Henle, Duisberg, 1963.

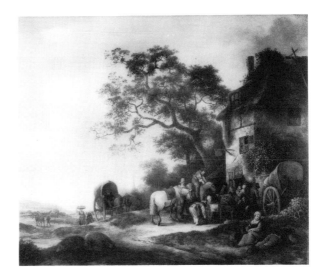

FIG. 2 Isack van Ostade, *Halt at an Inn*, signed and dated 164[8], oil on canvas, formerly Duke of Bedford.

PALAMEDES PALAMEDESZ

(LONDON? 1607–1638 DELFT)

The brother and student of the Delft genre and portrait painter, Anthonie Palamedesz (1601–73), Palamedes Palamedesz was born in 1607, probably in London where his father was in the service of James I. In 1627 he was a member of the Delft guild. Although he was described as small, hunchbacked, ill-favoured and sickly, he was married in 1630 to Maria Euwouts van 'sGravensande, who came from a well-to-do Delft family. Palamedesz made a will before travelling to Antwerp in 1631. Anthony van Dyck painted his portrait there in the same year; it was engraved by P. Pontius. Palamedesz was also called Stevers, Stevens and Stevaerts, but is not be be confused with Anthonie's son, Palamedes Palamedesz II (1633–1705). Palamedesz was buried in Delft on 28 March 1638.

Palamedesz was a painter of cavalry engagements, field battles and bivouacking troops in the manner of Esaias van de Velde (q.v.). Dirck van Bleyswijk, the chronicler of Delft, claimed in a standard topos that Palamedesz taught himself to paint by studying and copying van de Velde's works so well that he 'soon surpassed his model'.

LITERATURE: De Bie, pp. 9, 102; Dirck van Bleyswijck, *Beschryvinge van Delft* (Delft, 1667), vol. 2, p. 847; Houbraken, vol. 1, p. 303, vol. 2, p. 131; Wurzbach, vol. 2 (1910), p. 299; Thieme and Becker, vol. 26 (1932), pp. 155–6; Laurens J. Bol, *Holländische Maler des 17. Jahrhunderts nahe den Grossen Meistern. Landschaften und Stilleben* (Braunschweig, 1969), pp. 247–8; George Keyes, *Esaias van de Velde 1587–1630* (Doornspijk, 1984), pp. 14–15, 113.

CAT. 53

Cavalry Battle on a Bridge, c. 1630

Unsigned
Oil on panel 13½ × 21½ in. (34.5 × 54.5 cm.)

PROVENANCE: Sale W.A. von Manner *et al.*, Vienna, 12 May 1924, no. 118 [as Palamedes Palamedesz]; acquired from Edward Speelman in 1968 [as Anthonie Palamedesz].

EXHIBITION: London 1988, no. 53 [as Anthonie Palamedesz].

LITERATURE: Russell 1988, p. 789 [as Palamedes Palamedesz]; Speelman 1988, p. 14, ill.; Woodhouse 1988, p. 127, fig. 6.

CONDITION NOTES: The wood support has two vertical battens on either side and one horizontal batten reinforcing an old break in the panel 5⅝ in. (14.2 cm.) from the bottom left edge. Another horizontal crack is 2¼ in (6 cm.) from the bottom right. The paint film is in poor condition, extensively abraded and repainted throughout the sky, in the lower left, along the edges and the cracks. The arch of the bridge has been reinforced with overpaint and the definition of several of the combatants strengthened. An old inventory 'no. 1000 P.P'. is stencilled on the back.

Mounted cavalry charge and engage in battle on an arched bridge in the left foreground. Smoke rises from the combatants' guns and several draw their swords. One casualty slumps over the edge of a bridge beneath a crude wooden cross. Another man is seen falling off the bridge on the far

side of the arch while a riderless horse flails about in the water. All about is confusion. On the left rises the coulisse of the leafless blasted trunk of a tree. In the distance at the upper right is a classical temple.

When this painting sold in 1924, it was correctly attributed to the battle painter Palamedes Palamedesz, but when Speelman sold it to Lord Samuel and when it was exhibited in London in 1988, it was wrongly assigned to the painter's brother, Anthonie, who today claims a somewhat greater reputation. Despite the misattribution, Speelman was the first to advance correctly the notion that this is the painting being copied by the young boy in Wallerant Vaillant's *Young Copyist* (formerly attributed to Sweerts), also in the Samuel collection (see Cat. 72). Martin had tried to attribute the painting within the painting, thoughtfully suggesting Jan Jacobsz van der Stoffe (c. 1611–82) or Hendrick de Meyer (active 1641–83), whose paintings resemble the art of Jan Maertsen de Jonge (1609-1639), but Martin had never seen the actual painting by Vaillant.[1]

The attribution of this picture to Palamedesz, apparently first advanced in the sale in 1924 (and perhaps based on a lost signature?), is supported by comparison with paintings like Palamedesz's *Cavalry Battle* (fig. 1) which includes similarly conceived figures and another leafless, blasted tree to one side. Palamedesz also executed several other battle paintings with bridges,[2] and favoured the motif of the undoubtedly symbolic cross amidst the combatants; see the *Cavalry Battle with a Cross* (fig. 3).[3] The cross appears earlier and quite prominently not only in Esaias van de Velde's battle paintings but also in prints, such as a *Hold-Up in a Landscape* by Hans Bol.[4]

As early as 1667 Dirck van Bleyswijck already correctly observed Palamedesz's indebtedness to Esaias van de

FIG. 2 Esaias van de Velde, *Battle on a Bridge*, 1621, oil on panel 34 × 50 cm., signed and dated, formerly A. Schloss Collection, Paris, 1940, present location unknown.

FIG. 3 Palamedes Palamedesz, *Cavalry Battle with a Cross*, oil on panel 42 × 60 cm., Galerie bei Theresianum, Vienna.

FIG. 4 Jan Maertsen de Jonge, *Cavalry Battle on a Bridge with a Cross*, oil on panel 50.5 × 83 cm., Earl of Mar and Kelley, sale Vienna (Dorotheum), 21 March 1972, no. 62.

FIG. 1 Palamedes Palamedesz, *Cavalry Battle*, oil on panel 44.3 × 75 cm., Rijksmuseum Twenthe, Enschede, cat. no. 103 (147).

Velde's art. In works of about 1620, van de Velde was the first Dutch artist to paint battle scenes, cavalry skirmishes, and highway hold-ups, probably under the influence of the Flemish battle painter, Sebastian Vrancx.[5] Esaias painted a battle on a bridge (possibly the Battle of the Milvian Bridge) with a temple in the background in 1621 (fig. 2).[6] Keyes considered this the source for Jan Maertsen de Jonge's *Cavalry Battle on a Bridge with a Cross* (fig. 4);[7] but it seems more likely that the Samuel Palamedesz was the intermediary source.

1 W. Martin, 'The Life of a Dutch Artist in the Seventeenth Century', *The Burlington Magazine*, vol. 7 (1905), p. 424.
2 See the painting incorrectly attributed to Ph. Wouvermans in the collection of S.P. Newmann, New York and Montreal (panel 46 × 48.5 cm.; photo RKD).
3 Repr. in *Weltkunst*, 1 November 1978, p. 2456.
4 See George Keyes, *Esaias van de Velde* (Doornspijk, 1984), fig. 69.
5 Keyes 1984, pp. 105–6.
6 See Keyes 1984, cat. no. 42, fig. 279, panel 34 × 50 cm., present location unknown. Keyes correctly deduces that this work was probably inspired by Pieter Lastman's *Battle of the Milvian Bridge* of 1613, in the Kunsthalle, Bremen.
7 Keyes, 1984, p. 130, under cat. no. 42, fig. 83 (formerly in the collection of the Earl of Mar and Kelley).

FRANS POST

(HAARLEM C. 1612–1680 HAARLEM)

The son of the Haarlem glass painter Jan Jansz Post (d. 1614), and the brother of the painter and architect Pieter Post (1608–69), Frans Post was born about 1612 in Haarlem. Together with the animal and figure painter, Albert Eckhout (c. 1610–65), he joined the expedition of Prince Jan Maurits of Nassau-Siegen to Brazil. They embarked on their journey on 25 October 1636, and arrived at Recife in January 1637. A sketchbook that Post made with nineteen views of the voyage and of Brazil is preserved in the Scheepvaart Museum, Amsterdam. Of the many paintings of Brazil's terrain, flora and fauna that Post executed for the Prince, only six paintings dated to the years of his stay in the New World (1637–40) survive. The artist returned to Haarlem in 1644 and spent the rest of his life painting increasingly decorative views of Brazil. In 1644 and 1650 the *stadtholder* Frederik Hendrik paid large sums for Post's West Indian landscapes. Post also designed the illustrations for Caspar van Baerle's description of Brazil, *Rerum per octennium in Brasilia*, published in Amsterdam in 1647. He joined the Haarlem guild in 1646 and served as *vinder* in 1656/7 and *penningmeester* in 1658. On 27 March 1650 he married Jannetje Bogaert, the daughter of a schoolmaster, in Zandvoort. The couple had five children. Post joined the Reformed Church on 9 October 1654. He was buried in Haarlem's Grote Kerk in 17 February 1680.

Post was a painter, draughtsman and etcher of Brazilian landscapes filled with exotic buildings, natives, plants and animals. His œuvre included dated works from virtually every year between and including 1647 and 1670.

LITERATURE: Caspar van Baerle, *Rerum per octennium in Brasilia* (Amsterdam, 1647); Houbraken, vol. 2 (1721), p. 344; Descamps, vol. 3 (1764), pp. 8–9; Immerzeel 1842–3 vol. 2, p. 322; van der Willigen 1870, pp. 245–9; Wurzbach, vol. 2 (1910), pp. 346–7; A. Bredius, *Künstler-Inventare*, vol. 5, pp. 1691–718; Jacques Combe, 'Un douanier Rousseau au XVIIe siècle: Franz Post (1612–1680)', *Amour de l'Art*, vol. 12 (1913), pp. 481–9; J. Held, in Thieme and Becker, vol. 27 (1933), pp. 296–7; A. van Schendel, 'Frans Post, le brésilien', dissertation, Paris, 1937; Joaquim de Sousa-Leão, *Frans Post* (Rio de Janeiro, 1948); R. C. Smith Jr, 'The Brazilian Landscapes of Frans Post', *Art Quarterly*, vol. 1 (1938), pp. 239–67; T. Thompsen, *Albert Eckhout* (Copenhagen, 1938); J. G. van Gelder, 'Post en van Eckhout, schilders in Brazilie 1637–1644', *Beeldende Kunst*, vol. 26 (1940), pp. 65–72; Rio de Janeiro, Museu Nacional de Belas Artes, *Esposicão Frans Post*, 1942; Joachim de Sousa-Leão, 'Frans Post in Brazil', *The Burlington Magazine*, vol. 8 (1942), pp. 59–61; vol. 83 (1943), pp. 216–17; The Hague, Mauritshuis, *Maurits de Braziliaan* (catalogue by A. B. de Vries), 1953; Argeu Guimaraes de Segadas Muchado, 'Na Holanda com Frans Post', *Revista do Instituto Histórico e Geográfico Brasileiro*, vol. 235 (1957), pp. 85–295; Erik Larsen, *Frans Post, interprète du Brésil* (Amsterdam, 1962); J. G. van Gelder, review of Larsen 1962, in *Oud-Holland*, vol. 78 (1963), pp. 77–9; Stechow 1966, pp. 168–9; Rio de Janeiro, Museu de Arte Moderna, *Os Pintores de Mauricio de Nassau*, 21 May–7 July 1968; Laura Reviglio, 'Frans Post, o primeiro paisagista do Brasil', *Revista do Instituto de Estudos Brasileiros*, vol. 13 (1972), pp. 7–33; Joachim de Sousa Leão, *Frans Post* (Rio de Janeiro, 1948 (2nd revised edition 1973)); R. Joppien, 'The Dutch Vision of Brazil: Johan Maurits and his Artists', *in Johan Maurits van Nassau-Siegen 1604–1679: Humanist Prince in Europe and Brazil: Essays on the Occasion of the Tercentenary of his Death*, ed. E. van den Boogaert (The Hague, 1979); The Hague, Mauritshuis, *Zo wijd de wereld strekt: Tentoonstelling naar aanleiding van de 300ste sterfdag van Johan Maurits van Nassau-Siegen*, 1979–80; Frits Duparc, 'Frans Post and Brazil', *The Burlington Magazine*, vol. 124 (1982), pp. 761–72; Erik Larsen, 'Supplements to the Catalogue of Frans Post', *The Burlington Magazine*, vol. 124 (1982), pp. 229–43; Amsterdam/Boston/Philadelphia 1987–8, pp. 410–16.

CAT. 54

Brazilian Village with Buildings and Native Figures, 164(3 or 5?)

Signed and dated in stone in the centre foreground: F POST. 164(3 or 5?)
Oil on panel 19½ × 27¼ in. (49.9 × 69 cm.)

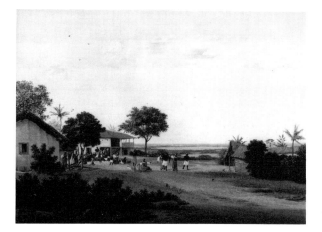

PROVENANCE: The Reverend Cecil Bosanquet, England; Bernard Bevam, London, who according to Speelman's files inherited the work from his grandfather, who had acquired it in Bruges c. 1890–5; sale Lord Belper et al. (anonymous collection), London (Christie's), 2 July 1976, no. 67, ill. [as dated 1643 or 1653]; acquired from Edward Speelman in 1976.

EXHIBITIONS: London 1988, no. 54.

LITERATURE: Joachim de Sousa Leão, Frans Post, 2nd revised edn (Rio de Janeiro, 1973), p. 63, no. 10, ill.

CONDITION NOTES: The panel support is comprised of two horizontal planks held together by cleats. The horizontal join is 9⅞ in. (25 cm.) from the bottom. A split in the panel appears 2⅛ in (5.8 cm.) from the bottom left. The join has been inpainted and additional repaint appears along the top and bottom edges. Some lifting paint previously appeared around an irregularity in the surface of the panel to the right of centre near the join, but has since been set down. Overall there is relatively little abrasion to the paint film. The varnish is moderately discoloured, while a thicker band of old varnish around the edges suggests that the painting was once cleaned in the frame. An inscription on the reverse identifies the painting as the property of Bernard Bevam.

On the left of this Brazilian landscape are two adobe houses, one of which has a balcony overlooking the cane fields and broad plain beyond. Before the houses are twenty-three native figures, some of whom have market baskets of fruit and poultry, while others eat, drink and dance in the spacious clearing in the middle ground. To the right are other low huts. In the shadowed left foreground a thicket of darkened plants, logs and rocks serves as a coulisse.

When Sousa-Leão first published this painting in 1973 he deciphered the date as 1648.[1] However, when the picture was sold at auction three years later, it was reported to be dated either 1643 or 1653. Speelman's records subsequently stated that it was dated 1643 and painted during the artist's stay in Brazil. Examination of the work in February 1991 suggested that the final digit was either a '3' or a '5', indicating that the picture is a very early work painted either at the very end of Post's stay in Brazil or soon after his return to Haarlem in 1644.

Although artists like Jan Mostaert (1475–1555/6) and Jan van der Straet had created fanciful views of the New World earlier,[2] Frans Post was the first trained European landscapist to paint the Americas. No paintings are known by him before he departed for Brazil and only a handful are certainly dated from the years of his trip. The earliest of these bears the date 1637 and depicts the island of Itamarca in Brazil (Mauritshuis, The Hague, inv. 915) while four of a group preserved in the Louvre, Paris (see Inv. 1726, 1727, 1728, 1729) are dated 1638 or 1639. The latter were part of a gift of forty-two Brazilian paintings by Post and Albert Eckhout that Johan Maurits presented to Louis XIV in 1679. The straightforward unpretentious naturalism of the paintings that Post executed in Brazil is only partly the result of direct observation. He brought to his task the legacy of Haarlem landscape painting, less the atmospheric tonalism of van Goyen, Ruysdael and Molyn than the crisper more opaque style of his brother, Pieter Post, and of Cornelis Vroom (c. 1591-1661). As Stechow first noted, Pieter Post painted broad Dutch landscapes under muted skies as early as 1631, which anticipate Frans's more exotic Brazilian paintings; compare, for example, Pieter Post's Landscape with a Hay Enclosure, dated 1633, Mauritshuis, The Hague, inv. 970.[3]

There are no other dated works by Post from either 1643 or 1645, however he dated a painting of Fort Frederik Hendrik in 1640 (J. de Sousa-Leão collection, Rio de

Janeiro, 1973) and both a *Brazilian Village* (Biblioteca Municipal, São Paulo) and *Paulo Afonso Waterfall* (Museu de Arte, São Paulo) in 1648.[4] With its depiction of native figures before dwellings surrounded by trees and the watery vistas of canefields, the Samuel painting initiates one of Post's favourite landscape themes.

1 Sousa-Leão 1973, p. 63, no. 10.
2 See Hugh Honour, *The New Golden Land: European Images of America from the Discovery to the Present Time* (London, 1976).
3 Wolfgang Stechow, *Dutch Landscape Painting of the Seventeenth Century* (London, 1966), p. 169; see also Sousa-Leão 1973, pp. 23–4, and Alan Chong in Amsterdam/Boston/Philadelphia 1987–8, p. 411–12.
4 See respectively, Sousa-Leão 1973, cat. nos. 6, 8 and 7, ills.

CAT. 55

Brazilian Landscape with Native Figures, 1666

Signed and dated lower right: F. POST 1666
Oil on panel 19 × 24⅛ in. (48.3 × 61.5 cm.)

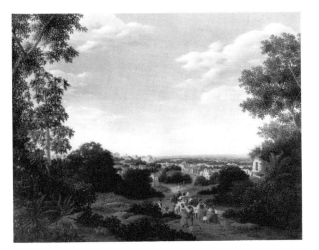

PROVENANCE: Comte de Jouvencel, France; acquired from Edward Speelman in 1964.

EXHIBITION: London 1988, no. 55.

CONDITION NOTES: The panel support has ¼ in. (5 mm.) strips added on both vertical sides. It is not cradled and is comprised of a single unbroken plank of wood. The paint film is in very good condition with minor retouches in the sky and in the palm tree on the right.

A panoramic landscape in Brazil is bracketed by tall trees on either side. In the right foreground are native figures with market baskets and drums and a single European, perhaps a Portuguese soldier. At the left, among the leafy foliage accented with red flowers, are an armadillo and an anteater. In the middle distance are low adobe buildings and on the horizon the indication of a church and a cloister. Although the site cannot be identified, the latter structures are vaguely reminiscent of buildings at Ingaraçú.

This exceptionally fine example of Post's later landscapes was unpublished before it was exhibited in 1988. After Post returned to the Netherlands in 1644, his landscapes became progressively more decorative, favouring darkened repoussoirs and coulisses in the foreground, and reverting to a rather *retardataire* tripartite colour scheme dividing the foreground, middleground and distance. The animals, reptiles and lushly exotic foliage that fill his foregrounds

have inspired comparisons which are essentially unhistorical and inappropriate with the nineteenth century artist, Le Douanier Rousseau.[1] In fact there is nothing naive about Post's landscapes, indeed his command of the panorama and aerial perspective was highly sophisticated.

Post had begun employing 'double wing' compositions with a delicate filigree of foliage silhouetted against the sky by 1659.[2] Moreover he had employed a pair of bushy repoussoirs as framing devices in a painting of *Engenho* (fig. 1) dated just one year before the Samuel painting.[3] Elsewhere, in undated works from the 1660s, Post employed slender palm trees in a 'double wing' panorama (see fig. 2, which is especially close in design).[4] The technique of dramatically silhouetting the crisp forms of the leaves of the trees against the sky undoubtedly descended from works by the Haarlem landscapist Cornelis Vroom, but Frans' brother Pieter may have provided a more direct conduit for these motifs.[5] Although Post dated at least nine paintings in 1665,[6] the Samuel picture appears to be his only dated work of 1666. Post last dated a painting in 1669,[7] and he seems not to have worked at all during the final decade of his life, when he was described as 'having fallen to drinking and become shaky'.[8]

Post's images of Brazil were expensive in his day and undoubtedly appealed to the Dutchman's patriotic sense of his nation as a world power with a global reach; the Dutch had wrested Brazil from the Portuguese in 1630. These paintings not only served a documentary and topographic function, but also stressed the beauty and productivity of land, with its rich forests and lucrative sugar industries.

1 See Jacques Combe, 'Un Douanier Rousseau au XVIIe siècle: Franz Post (1612–1680)', *Amour de l'Art*, vol. 12 (1931), pp. 481–9.

2 See *Rural Landscape*, signed and dated 1659, oil on panel 48 × 61 cm., Hermitage, Leningrad, cat. 1960, vol. 2, p. 240, no. 3433; Sousa-Leão 1973, no. 29. ill. See also *A Franciscan Cloister*, signed and dated 1663, oil on panel 55 × 68 cm., Gemäldegalerie, Staatliche Museen Preussischer Kulturbesitz, Berlin-Dahlem; Sousa-Leão 1973, no. 38, ill.

3 Sousa-Leão 1973, no. 45, incorrectly as dated 1656. Compare also the bushy framing repoussoirs of the *Waterfall with Indians Hunting* also signed and dated 1665, oil on panel 57 × 72 cm., Museu de Belas Artes, Rio de Janeiro; Sousa-Leão 1973, no. 49, ill.

4 Compare also *Rural Landscape*, signed, oil on panel 56 × 79 cm., Museu de Arte, São Paulo; Sousa-Leão 1973, no. 88, ill.; and the Hermitage painting (see note 2).

5 The motif of the silhouetted trees are especially pronounced in the late 'single wing' paintings in the National Gallery of Ireland, Dublin; see cat. 1986 (by Homan Potterton), no. 847, fig. 125 (Sousa-Leão 1973, no. 72) and Muzeum Narodwe, Warsaw (Sousa-Leão 1973, no. 140).

6 Sousa-Leão 1973, cats. 41–9.

7 See *Varzea Landscape*, signed and dated 1669, oil on panel 45.6 × 63.5 cm., Kunstmuseum, Düsseldorf; Sousa-Leão 1973, no. 59.

8 Reported by Jacob Cohen on 9 January 1679; quoted in Sousa-Leão 1973, p. 32.

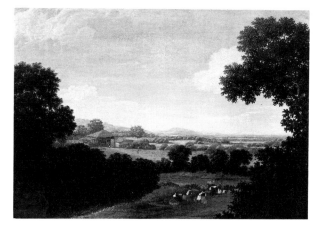

FIG. 1 Frans Post, *Engenho*, signed and dated 1665, oil on panel 41 × 54 cm., Frans Halsmuseum, Haarlem, no.735.

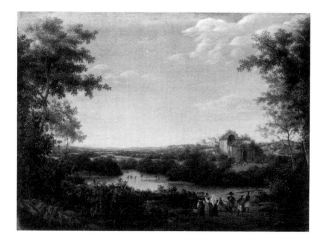

FIG. 2 Frans Post, *Ingaraçú, The Cloister and Church*, signed, oil on panel 43 × 58.5 cm., sale London (Sotheby's), 10 December 1975, no. 27, ill.

HUBERT VAN RAVESTEYN

(DORDRECHT 1638–BEFORE 1691 DORDRECHT)

Little is known of the artist's life. Baptized in Dordrecht in 1638, Hubert van Ravesteyn married Catharina van Meurs in 1669 in Papendrecht. The couple lived on the Hofstraat in Dordrecht. Their children were buried in Dordrecht in 1681, 1683 and in 1691, when a bier was also ordered by the widow of van Ravesteyn. The painter probably was related to Gryphonius van Ravesteyn, the vicar of Dordrecht, and to other members of that distinguished Dordrecht family.

As Houbraken observed, Ravesteyn painted a few stable interiors and genre scenes, while Hofstede de Groot logically reasoned that the anonymous monogrammist 'HR', who painted kitchen and smoking still lifes, was identical with Hubert van Ravensteyn. The majority of paintings in his small œuvre are still lifes with beer or wine and smoking supplies, late examples of a sub-category of still lifes invented by the Dutch.

LITERATURE: Houbraken, vol. 3 (1721), p. 215; G.H. Veth, 'Aanteekeningen omtrent eenige Dordrechtse schilders XXIX', *Oud-Holland*, vol. 9 (1891), pp. 37–38; C. Hofstede de Groot, in *Oud-Holland*, vol. 19 (1901), p. 121; G. H. Veth, in *Oud-Holland*, vol. 21 (1903), p. 33; Wurzbach, vol. 2 (1910), p. 379; H. Gerson, in Thieme and Becker, vol. 28 (1934), p. 53; N. R. A. Vroom, *A Modest Message*, 2 vols. (Schiedam, 1980), vol. 1, p. 200, vol. 2, pp. 108–9; Laurens J. Bol, *Holländische Maler des 17. Jahrhunderts nahe den grossen Meistern* (Braunschweig, 1969), pp. 276–80.

CAT. 56

Still Life with a Stoneware Jug, Glass and Smoking Requisites

Monogrammed on the table edge: HR (in ligature)
Oil on panel 17 × 13¾ in. (43.1 × 35 cm.)

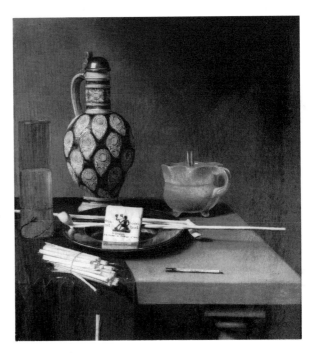

PROVENANCE: J. P. R. M. de Nerée van Babberich, 1899, whose heirs lent it to the Rijksmuseum, Amsterdam, from 1899 to 1968; Leonard Koetser Gallery, London, 1969; sold by Edward Speelman to Lord Samuel.

LITERATURE: *Catalogue of the Pictures in the Rijksmuseum at Amsterdam* (Amsterdam, 1905), p. 274, cat. no. 1974; *Beeldende Kunst*, vol. 2 (1915), no. 44, ill.; *Oude Kunst*, vol. 5 (1919/20), p. 33; Rijksmuseum, Amsterdam, cat. 1927, p. 159, no. 1974; A. P. A. Vorenkamp, *Bijdrage tot de Geschiedenis van het hollandsche stilleven in de zeventiende eeuw*, dissertation, Leiden, 1933, p. 47; Rijksmuseum, Amsterdam, cat. 1934, p. 233, no. 1974; W. Martin, *De hollandsche schilderkunst in de zeventiende eeuw*, vol. 2: *Rembrandt en zijn tijd*

(Amsterdam, 1936), p. 418, fig. 218; N. R. A. Vroom, *De schilders van het monochrome banketje* (Amsterdam, 1945), pp. 176, 216, 161; Rijksmuseum, Amsterdam, cat. 1951, p. 145, no. 1974; R. van Luttervelt, *Schilders van het stilleven*, Kunst van Nederland (Naarden, 1947), p. 30, ill. opp. p. 30; Rijksmuseum, Amsterdam, cat. 1957, p. 145; 1960, p. 252, no. 1974; Laurens J. Bol, *Holländische Maler des 17. Jahrhunderts nahe den grossen meistern: Landschaften und Stilleben* (Braunschweig, 1969), pp. 276–7, fig. 261, note 382; N. R. A. Vroom, *A Modest Message as Intimated by the Painters of the 'Monochrome Banketje'*, 2 vols. (Schiedam, 1980), vol. 1, p. 200, fig. 272, vol. 2, cat. no. 543; Ingvar Bergström, in Washington, National Gallery of Art, *Still Lifes of the Golden Age: Northern European Paintings from the Heinz Family Collection*, 14 May–4 September 1989 (also shown at Boston, Museum of Fine Arts, 4 October–31 December 1989), p. 121, fig. 2; H. E. Henkes, '"Kometen" bekers', *Antiek* (January, 1989), pp. 332–3, ill.

CONDITION NOTES: The wood panel support has been enlarged with ¼ in. (5 mm.) strips of wood on all edges running with the grain of the wood. The original panel measures 16½ × 13¼ ins. (42 × 33.7 cm.). The paint film is in good condition but there is some retouching in the background to moderate the appearance of the grain showing through the paint. There are also retouches in the area behind the jug and glass, in the shadow beneath and in the area to the right of the brazier. The varnish is discoloured and dull. A sticker in Dutch on the back reports that the painting was treated in December 1918 ('gepoesderd en vernist'). Another identifies the ceramic jug as 'Raeren Pottery'.

A pewter platter with two clay pipes and a packet of tobacco rests on the edge of a table partly covered with a cloth. Also on the table are a tall glass partly filled with wine, a ceramic brazier, an earthenware jug, and a bundle of stalks known as *zwavelstokjes*, the predecessors of matches which were used to light pipes. A burnt stalk lies on the bare table above the spiralling table leg and still another is suspended on the table cover. Printed on the packet of tobacco is the silhouette of an exotic smoker viewed in profile, with the inscription: 'Orien/tal Verginis/Toback. Tot Dordrecht inde Nieustraat in Bliënburgh – Ao 1664' (Oriental Virgin Tobacco. in the Nieustraat in Bliënburgh, Dordrecht).

As Bergström noted, this type of tobacco still life was an invention and speciality of the Dutch 'tonal' still-life painters and probably can be traced to Pieter Claesz's works of the 1630s.[1] Intermediary precedents mentioned by both Vroom and Bol were the designs of the Amsterdam still-life painters Jan Jansz van de Velde (q.v.) and Jan Fris (c. 1627–72).[2] Working after 1660 in Dordrecht away from major artistic centres, van Ravesteyn perpetuated the monochrome style of still life that elsewhere in the Netherlands had largely run its course. However, he gave new life to his rare tobacco still lifes with a crisper execution and stronger local colours. Bergström correctly noted the Samuel painting's resemblance in subject, design and individual motifs to Ravesteyn's undated *Tobacco Still*

Life (fig. 1) in the Heinz Collection.[3] That work also includes a packet of 'Oriental Tobacco' imprinted with a somewhat different design, as well as a very similar earthenware jug with slightly altered decorations (the circular motifs within the decorative reprise are coloured red). Still another painting of a tobacco still life (fig. 2) with a pitcher, wineglass and walnuts in a Chinese bowl is dated 1670.[4] It includes a pipe and a tobacco packet decorated with a similar figure silhouetted in profile with his foot resting on a square object and two stylized puffs of smoke rising from his mouth and the bowl of the pipe. The inscription on the packet reads, 'Tot Dordrecht by Marschael – Ao 1670'.

The presence here of the commercially distributed packets of tobacco serves to remind us that by the time that van Ravesteyn became active as a still-life painter in the 1660s smoking had become a more respectable recreation than it had been early in the century (see Cat. 75). Whereas its use, other than for medicinal purposes, had once been scorned and ridiculed – the pastime of sailors, mercenary soldiers and other forms of low life – after mid-century it was increasingly embraced by the middle class and haute bourgeoisie. The expensive crops from America (imported by around 1580) were now mixed with a domestically harvested leaf, grown in quantity in the region around Amersfoort, while simultaneously a tobacco processing industry grew up that still thrives today to cure, spin and cut the weed. The social stigma attached to smoking gradually fell away, although the condemnation would survive as a convention of art and literature.[5] During the same period an allied industry grew up to manufacture clay pipes, which were first introduced by English soldiers into the Netherlands and remained dependent upon clay from England but were produced locally, particularly in the town of Gouda.[6] The long slender pipes depicted here in van Ravesteyn's still life served to cool the smoke and moderate the acrid taste which gave early forms of tobacco their legendary power to stupefy and nauseate the smoker. However they were fragile and, relative to short-stemmed pipes, costly, and thus associated with the new class of well-to-do smoker.

The ceramic jug is probably of rhenish origin and is called a 'Westerwald krug'; many comparable examples have survived.[7] The glass with decorated base on the left of the Samuel painting is a special form of Venetian-style glassware known as a 'comet' glass (*komeet beker*).[8] Cylindrical and colourless, these glasses were decorated around their bases with schematized images of three, or sometimes four, comets rising from left to right (see fig. 3). Contemporary illustrations of comets adopt a similar stylized way of

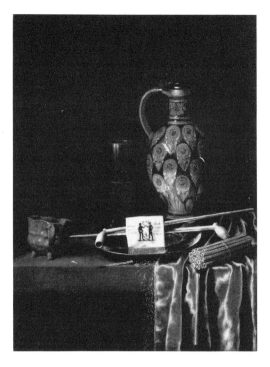

FIG. 1 Hubert van Ravesteyn, *Tobacco Still Life*, oil on panel 38 × 29 cm., Senator and Theresa Heinz Collection.

FIG. 3 *'Komeet beker'*, signed and dated by M. van Gelder, 1656, Museum Boymans-van Beuningen, Rotterdam, inv. no. 570.

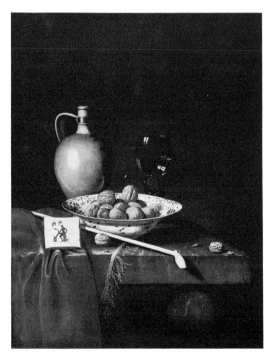

FIG. 2 Hubert van Ravesteyn, *Tobacco Still Life*, 1670, oil on canvas 70 × 53.5 cm., J.H. Gispen, Nimwegen.

FIG. 4 'Vase with comet prunts', H. J. Powell, Whitefriars Glass Works, London, 1911.

depicting these astronomical phenomena.[9] Especially following the appearance of Halley's comet in 1658, there was a great deal of curiosity about comets, which was manifested in various forms in the decorative arts.[10] Henkes noted that comet glasses also appear in paintings by Gabriel Metsu, Jan Jansz van de Velde, C. Mahu, Cornelius Stangerus and Osaias Beert;[11] it is also encountered in *Still Life with Smoking Requisites* by Hendrick Andriessen (Heinz Collection).[12] Fancier than the common beer glass, the comet glass here and in the Andriessen and J. J. van de Velde's still life of 1663 in the Frans Halsmuseum (no. 682) is filled with red wine, suggesting, like the long-stemmed pipes, a relatively high class of consumer.

Incidentally, as Henkes noted, versions of the comet glass were designed early in this century by Henry James Powell, owner of the Whitefriars glassworks in London, following a visit to the Rijksmuseum on 28 September 1910; there he not only saw actual comet glasses but also could have seen the Samuel collection Ravesteyn which hung in the Museum as a loan from 1899 until after 1960.[13] Thus the painting may have helped inspire the design of Powell's 'comet' vases produced from 1911 (fig. 4) and the later series of 'serpent vases' that were mass produced in the 1930s.

1 Heinz Collection exh. cat. 1989, p. 121.

2 Vroom 1980, p. 200; Bol 1969, p. 276.

3 See note 1.

4 See Bol 1969, fig. 262; Vroom 1980, no. 547, ill. *A Tobacco Still Life* dated 1671 (canvas 65 × 49 cm.), now in the Toronto Art Gallery, is a reversed variant of the Gispen Collection painting (see Vroom 1980, no. 545, as 'Location Unknown'). Compare also the *Tobacco Still Life with Walnuts in a Kang-shi Bowl* of 1670 (canvas 59.5 × 49.5 cm.), sale Metropolitan Museum of Art, New York (Sotheby Parke Bernet) 8 January 1981, no. 32; and sale London (Christie's), 8 July 1988, no. 45, ill.

5 See Ivan Gaskell, 'Tobacco, Social Deviance and Dutch Art in the Seventeenth Century', in *Holländische Genremalerei im 17. Jahrhunderts. Symposium Berlin 1984, in Jahrbuch Preussischer Kulturbesitz*, vol. 4, pp. 117–37; and Simon Schama, *The Embarrassment of Riches* (New York, 1987), pp. 197–214.

6 See D. H. Duco, *Goudse pijpen: de geschiedenis van de pijpmakerij te Gouda* (Amsterdam, 1978).

7 See, for example, Gisela Reineking-von Bock, *Steinzeug*, Kunstgewerbemuseum, Cologne (1971), no. 511

8 See H.E. Henkes, '"Kometen" bekers. Zestiende- en zeventiende-eeuwse façon de Venise glazen', *Antiek*, vol. 23, no. 6 (January 1989), pp. 329–34.

9 See the illustration of comets' tails in Henkes 1989, fig. 3, from U. Müller's *Cometa caudatus vel bartatus. Salve Academicum* (Schweinfurt, 1687), p. 43.

10 See Klaas Akkerman, 'De komeet komt', *Antiek*, vol. 20 (1986), pp. 396–403.

11 For Metsu, see Franklin W. Robinson, *Gabriel Metsu* (New York, 1974), figs. 36 and 72; J. J. van de Velde, *Still Life with Oysters*, 1663, Frans Halsmuseum, Haarlem, inv. no. 682; Mahu, see Brussels, Palais des Beaux-Arts, *La Nature morte hollandaise* (cat. by E. Zarnowska), 1929, no. 69; for Stangerus, see Guido Jansen, 'Cornelis Stangerus, an "artful painter"', *Hoogsteder-Naumann Mercury*, vol. 1 (1985), p. 49; and for O. Beert, see Brussels exh. 1929, fig. 19.

12 Repr. in Walther Bernt, *Die Niederländischen Maler und Zeichner des 17. Jahrhunderts*, 3 vols. (Munich, 1979), vol. 1, fig. 10.

13 Henkes 1989, p. 334. Wendy Evans, Curator, Later Department, Museum of London, has kindly informed us of the existence of the two variants of the design.

JACOB ISAACKSZ VAN RUISDAEL

(HAARLEM? 1628/9–1682 HAARLEM)

Jacob van Ruisdael was probably born in Haarlem in 1628 or 1629. The exact date is unknown; although a notarial act of 9 June 1661, states that he was then thirty-two, the ages of several other artists are incorrectly recorded in this document. The painter's father, Isaack Jacobsz van Ruysdael (1599–1677), originally called 'de Goyer', was a framemaker, art dealer, and painter from Naarden. Isaack and his brother Salomon van Ruysdael (q.v.) later adopted the name Ruisdael or Ruysdael, presumably because their father was from Blaricum, near the Castle Ruisdael (or Ruisschendael). On 12 November 1628, Isaack, then described as a widower, married Maycken Cornelisdr. While Jacob was probably a child of this marriage, the possibility that Isaack's first wife was Jacob's mother cannot be ruled out. In 1634 Isaack, who was not a guild member, was fined because Jan van Goyen (q.v.) had worked in his house. Landscapes only recently identified as by Isaack support the presumption that he was Jacob's first teacher. Jacob may also have studied with his uncle Salomon van Ruysdael.

Although Jacob did not become a member of the Haarlem guild until 1648, there are numerous signed and dated works of 1646. On a visit to Bentheim in Germany around 1650 Ruisdael was accompanied by the Italianate landscapist Claes Berchem (1620–83), who, according to Arnold Houbraken, was a 'great friend'. The two artists probably continued to Steinfurt, the birthplace of Berchem's father. Both Steinfurt and Bentheim castles appear in Ruisdael's landscapes (see Cat. 57). Occasionally Berchem painted staffage in Jacob's landscapes.

By June 1657 Jacob had settled in Amsterdam, where he evidently lived for the rest of his life. Although his family was Mennonite, in 1657 Ruisdael was baptized in the Reformed Church in Ankeveen near Amsterdam. In 1659 Ruisdael became an Amsterdam citizen. The following year he testified that Meindert Hobbema (q.v.) had lived and worked with him for several years. He was later a witness at Hobbema's marriage. Jacob made two wills in 1667 at a time when he appears to have been very ill. He was then living on the Kalverstraat near the Dam. By 1670 he was living on the south side of the Dam. The artist remained a bachelor all his life and seems to have supported his father. Jacob probably died in Amsterdam and his body was sent to Haarlem, where he was buried in St Bavo's Church on 14 March 1682. One curious feature of his biography is the possibility of a second career. Houbraken stated that Ruisdael studied medicine and performed successful surgical operations in Amsterdam. On the register of Amsterdam doctors appears the crossed-out name 'Jacobus Ruijsdael' who received his medical degree in Caen on 15 October 1676. In addition, a landscape with waterfall was sold in 1720 as by a 'Doctor Jacob Ruisdael'.

Ruisdael is regarded today as the greatest of all Dutch landscapists, and is certainly one of the most versatile. Many of his paintings bear dates between 1646 and 1653, but only very few thereafter. The influence of Cornelis Vroom (c. 1591–1661) is particularly evident in works of 1648 and 1649. While his uncle Salomon may also have had an early impact on his landscapes, clearer is his dependence on Jan Porcellis (c. 1584–1632) and Simon de Vlieger (c. 1601–53) in his marines. Ruisdael's mountain waterfalls and torrents were inspired by Scandinavian scenes by Allart van Everdingen (1621–75). In addition to paintings of landscapes, winter scenes, cityscapes and marines, he also executed thirteen etchings, all of which date from his early career, and numerous drawings. Philips Wouwermans (q.v.), Claes Berchem, Adriaen van de Velde (q.v., 1636–72), and Johannes Lingelbach (c. 1624–74) all painted staffage in Ruisdael's paintings. Ruisdael collaborated with Thomas de Keyser (1596/7–1667) on a large-scale landscape portrait of the family of Cornelis de Graeff, burgomaster of Amsterdam (oil on canvas 46 × 67⁵⁄₁₆ in. (117 × 171 cm.), National Gallery of Ireland, Dublin, inv. no. 287). Although Meindert Hobbema was the artist's most important pupil, he had many other followers and imitators, including his cousin Jacob Salomonsz van Ruysdael (1629/30–81), Cornelis Decker (d. 1678), Jan van Kessel (q.v., 1641/2–80), Adriaen Verboom (c. 1628–c. 1670), and Roelof van Vries (c. 1631–after 1681).

LITERATURE: Houbraken 1718–21, vol. 2, p. 65; Descamps 1753–64, vol. 3, pp. 9–12; Johan Wolfgang van Goethe, 'Ruysdael als Dichter (1816)' in *Goethes Werke*, 7th edn, vol. 12, ed. E. Trunz (Munich, 1973); Smith 1829–42, vol. 6, pp. 1–107, vol. 9, pp. 680–718; Emile Michel, *Jacob van Ruisdael et les paysagistes de l'école de Haarlem* (Paris, 1890); Wurzbach 1906–11, vol. 2, pp. 517–22; Hofstede de Groot 1908–27, vol. 4 (1912), pp. 1–349; Georges Riat, *Jacob van Ruisdael* (Paris, 1928); Jakob Rosenberg, *Jacob van Ruisdael* (Berlin, 1928); Kurt Erich Simon, *Jacob van Ruisdael: Eine Darstellung seiner Entwicklung* (Berlin, 1930); H. G. Wijnman, 'Het leven der Ruysdaels', *Oud-Holland*, vol. 49 (1932), pp. 49–60, 173–81, 258–75; Horst Gerson, 'The Development of Ruisdael', *The Burlington Magazine*, vol. 65, no. 377 (August 1943), pp. 76–80; Kurt Erich Simon, in Thieme and Becker 1907–50, vol. 29 (1935), pp. 190–3; Wolfgang Stechow, *Dutch Landscape Painting of the Seventeenth Century* (London, 1966), pp. 3, 4, 6–8, 10, 11, 21, 28–30, 32, 38, 39, 42–3, 45–8, 56, 59, 60, 62–4, 66, 69, 70, 72–82, 96–9, 104–9, 111, 115, 118, 121, 122, 125, 127, 128, 130, 138–41, 144–147, 182, 184–6, 189; Herman Hagels, 'Die Gemälde der niederländischen Maler Jacob van Ruisdael und Nicolaas Berchem von Schloss Bentheim im Verhältnis zur Natur des Bentheimer Landes', *Jahrbuch des Heimatvereins der Grafschaft Bentheim*, 1968, pp. 41ff.; Wilfred Wiegand, 'Ruisdael-Studien: Ein Versuch zur Ikonologie der Landschaftsmalerei', dissertation, Hamburg, 1971; R. H. Fuchs, '"Over het landschap" een verslag naar aanleiding van Jacob van Ruisdael, "Het Koreveld"', *Tijdschrift voor Geschiedenis*, vol. 86 (1973), pp. 281–92; Iouryi Kouznetsov, 'Sur le symbolisme dans les paysages de Jacob van Ruisdael', *Bulletin du Musée National de Varsovie*, vol. 14 (1973), pp. 31ff.; James D. Burke, 'Ruisdael and His Haarlempjes', *M: A Quarterly Review of the Montreal Museum of Fine Arts*, vol. 6, no. 1 (Summer 1974), pp. 3–11; George S. Keyes, 'Les Eaux-Fortes de Ruisdael', *Nouvelles de l'Estampe*, no. 36 (November–December 1977), pp. 7–20; Hans Kauffmann, 'Jacob van Ruisdael: "Die Mühle von Wijk bei Duurstede"', in *Festschrift für Otto von Simpson zum 65. Geburtstag* (Frankfurt, 1977); U. D. Korn, 'Ruisdael in Steinfurt', *Westfalen: Hefte für Geschichte, Kunst und Volkskunde*, vol. 56 (1978), pp. 111–14; D. Maschmayer, 'Jacob Isaackszoon van Ruisdael und Meindert Hobbema malen Motive aus der Grafschaft Bentheim und ihrer Umgebung', *Jahrbuch des Heimatvereins der Grafschaft Bentheim, Das Bentheimer Land*, vol. 92 (1978), pp. 61–71; Jeroen Giltay, 'De tekeningen van Jacob van Ruisdael', *Oud-Holland*, vol. 94 (1980), pp. 141–86; Frits J. Duparc, Jr, *Ruisdael* (The Hague, 1981); Winfried Schmidt, 'Studien zur Landschaftskunst Jacob van Ruisdaels: Frühwerke und Wanderjahre', dissertation, Hildesheim, 1981; The Hague, Mauritshuis *Jacob van Ruisdael* (catalogue by Seymour Slive and H. R. Hoetink) 1 October 1981 – 3 January, 1982 (also shown at the Fogg Art Museum, Harvard University, Cambridge, 18 January 1982 – 11 April 1982); E. J. Walford, 'Jacob van Ruisdael and the Perception of Landscape', dissertation, Cambridge, 1981; Amsterdam/Boston/Philadelphia 1987–8, pp. 437–65; Seymour Slive, 'Additions to Jacob van Ruisdael', *The Burlington Magazine*, vol. 133, no. 1062 (September 1991), pp. 598–606.

CAT. 57

The Castle of Bentheim, mid 1650s

Signed on the road at the lower left with the monogram:
JvR (in ligature)
Oil on canvas 15¼ × 18¼ in. (38.8 × 46.5 cm.)

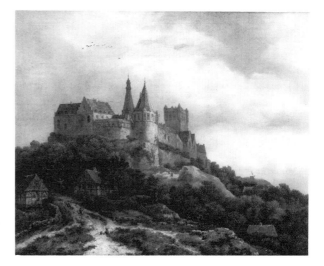

PROVENANCE: Sale van Roothaan, Amsterdam, 29 March 1826, no. 93 (1700 fl., to van Brienen van de Grootelindt); sale G. Th. A. M. Baron van Brienen van de Grootelindt, Paris, 8 May 1865, no. 33 (26,000 frs.); sale M. A. Hulot, Paris, 9 May 1892, no. 44, ill. [as '*Le Chateau de Brederode*']; sale Féral, Paris, 22 April 1901, no. 94; Private collection, Paris; acquired from Edward Speelman in 1965.

EXHIBITION: London 1988, no. 59.

LITERATURE: Smith, vol. 6 (1835), no. 233; Hofstede de Groot, vol. 4 (1912), nos. 31 and 33; Jakob Rosenberg, *Jacob van Ruisdael* (Berlin, 1928), cat. 19, fig. 45, pl. XXVIII; Kurt Erich Simon, *Jacob van Ruisdael. Eine Darstellung seiner Entwicklung* (Berlin, 1930), pp. 29, 73; Dietrich Maschmeyer, 'Jacob Isaackszoon van Ruisdael und Meindert Hobbema malen Motive aus der Grafschaft Bentheim und ihrer Umgebung', *Jahrbuch des Heimatvereins der Grafschaft Bentheim, Das Bentheimer Land*, vol. 92 (1978), p. 69; Speelman 1988, p. 14; Russell 1988, p. 789.

CONDITION NOTES: The canvas support has been relined. There are minor retouches in the sky but the paint film is generally in very good state. A thick discoloured varnish that previously masked the surface has been removed. A red seal with a rampant unicorn and lion appears on the back as well as a sticker with the number 4087.

The Castle of Bentheim is set on the rocky crest of a hill. The slopes below are wooded and punctuated with boulders and cottages. Three sandy roads converge on the left to form a single track bordered by a stone wall, which leads up

the hill between two half-timbered houses, one with a slate roof, the other tiled. A man and woman descend the road while a lone traveller has sat down with his pack at the junction of the paths. Two other tiny figures are visible standing by a boulder at the base of the castle's walls. A windmill stands out above the profile of the hill on the right.

Many Dutch landscapists travelled widely; for example, Frans Post visited Brazil, Allart van Everdingen journeyed to Scandinavia, and countless artists travelled to the Rhineland or even further to Italy. Ironically, however, there is no evidence to suggest that the most versatile landscapist of them all, Jacob van Ruisdael, ever travelled far from his native Holland. The only extended trip he seems to have taken probably occurred around 1650, and certainly by 1651 (see fig. 1), when he travelled the 175 kilometres from Haarlem to the area of the Dutch and German border, where he visited the Castle of Bentheim in Westphalia, as well as the watermills of Singraven in the province of Overijssel. Ruisdael may have travelled in the company of Claes Berchem, who according to Houbraken was a 'groot vrint' ('great friend'),[1] and who depicted Bentheim Castle in several works, including a drawing dated 1650 (Städelsches Kunstinstitut, Frankfurt a.M., no. 3842). Korn and Maschmeyer identified the 'Buddenturm' of Steinfurt Castle in the vicinity of Bentheim in two of Ruisdael's paintings from the early 1650s (Wallace Collection, London, no. P156; and Herzog Anton Ulrich-Museum, Braunschweig, inv. 376); Korn further speculated that the fact that Berchem's father, the still-life painter Pieter Claesz (q.v.), was born in Steinfurt might have inspired the travelling companions to venture to the region.[2]

Whatever the motivation to journey to Bentheim, Jacob van Ruisdael was so impressed with the castle that he later incorporated it into at least fourteen paintings.[3] Although inexplicably described as a view of the Castle of Brederode in the Hulot Sale in Paris in 1892, the Samuel painting is unmistakably one of these images of Bentheim. The Bentheim paintings were executed throughout his career but, as we have noted, the earliest dated example is of 1651 (fig. 1).[4] Ruisdael depicted the castle from many different angles, elevations and points of view, but the grandest and most ambitious treatment is the version signed and dated 1653 (fig. 2), and recently presented by the Beit Collection Foundation to the National Gallery of Ireland.[5] Simon believed that the small Samuel painting was a study for the larger Beit Collection painting.[6] Two undated paintings of Bentheim, in Sir Nicholas Bacon's collection and sold in

New York in 1988 (respectively figs. 3 and 4), offer close comparisons with the Samuel version, especially in their low points of view which dramatize the height of the edifice.[7] As Jacob Rosenberg already noted in 1928, Ruisdael's various depictions of Bentheim, most of which situate the castle high on a promontory, bear no relationship to the castle's actual site, a low rise in the relatively flat Westphalian countryside (fig. 5).[8] Clearly Ruisdael took artistic liberties with the site to enhance the imposing majesty and authority of the castle. Berchem also freely inserted the castle into the backgrounds of his landscapes (see fig. 6). But whereas in Berchem's art the motif is little more than a picturesque accessory, in Ruisdael's paintings the elevated castle on the hill assumes a grandeur that has been considered symbolic, inspiring various iconographic interpretations. Wilfred Wiegand first interpreted Bentheim Castle in Ruisdael's work as an allegory of the sin of Pride (*Superbia*), relating it to emblems and literature of the period.[9] H. J. Raupp concurred,[10] but Joshua Bruyn rejected the idea, claiming that the castle on the mountain represented 'the eternal city on Mount Zion'.[11] In his forthcoming book on Ruisdael, John Walford disputes the notion that the painter was concerned with the 'illustration of a literary topos', and instead sees the monument primarily as a landmark. He points to the long pictorial tradition of representing hilltop castles (from Joachim Patinir to the seventeenth-century landscapists like Hendrick Vroom, Allart van Everdingen and Herman Saftleven) both for their aesthetic appeal and association with impregnability; Karel van Mander advised painters to 'set castles on rocky hilltops, difficult to destroy' ('Kastelen op rotspunten, moeilijk kapot te krijgen').[12] Whatever his symbolic intentions, Ruisdael showed a particular fascination with castles and watchtowers on mountain tops, often with waterfalls below.[13] Indeed these themes, their precedents and legacy, have recently been the subject of an entire dossier exhibition devoted to Ruisdael's *Waterfall with Watch Tower* in Braunschweig.[14]

The Samuel painting appeared in the distinguished nineteenth-century Dutch collection of G. Th. A. M. Baron van Brienen van de Grootelindt, who owned four Ruisdaels as well as works by, among other Dutch artists, Hobbema, Potter, Steen, Dou, A. van de Velde and de Hooch (qq.v.). It was characterized by John Smith as an 'excellent example of this master'.

1 Houbraken, vol. 3 (1721), p. 65.

2 D. Maschmeyer, 'Jacob Isaackszoon van Ruisdael und Meindert Hobbema malen Motive aus der Grafschaft Bentheim und ihrer Umgebung', *Jahrbuch des Heimatvereins der Grafschaft Bentheim, Das Bentheimer Land*, vol. 92 (1978), pp. 61–71; U. D. Korn, 'Ruisdael in Steinfurt', Westfalen: *Hefte für Geschichte, Kunst und Volkskunde*, vol. 56 (1978), pp. 111–14. The history of Bentheim Castle is presented by A. Nöldeke, *Die Kunstdenkmäler der Provinz Hannover*, vol. 4, no. 4, *Die Kreise Lingen und Grafschaft Bentheim*, (Hannover, 1919); see also H. Krul, 'Das Schloss zu Bentheim und die Ereignisse im Jahr 1795', *Jahrbuch des Heimatvereins der Grafschaft Bentheim*, 1956, pp. 73–81; and H. Götker, 'Beitrag zur Baugeschichte der Burg Bentheim', *Jahrbuch des Heimatvereins der Grafschaft Bentheim*, 1964, pp. 96–100.

3 For images of Bentheim, see the list of his paintings compiled by Maschmeyer 1978, pp. 69–70; see also Hofstede de Groot, vol. 4 (1912), nos. 21–35a; Rosenberg 1928, nos. 10–18, 20–2; and Slive in The Hague/Cambridge, 1981–2, pp. 50–5.

4 Hofstede de Groot, vol. 4 (1912), no. 24; Rosenberg 1928, no. 15, fig. 37; Slive in The Hague/Cambridge 1981–2, no. 12.

5 Hofstede de Groot, vol. 4 (1912), nos. 25; Rosenberg 1928, no. 18.

6 Simon 1930, p. 29.

7 See respectively Hofstede de Groot, vol. 4 (1912), nos. 23 and (possibly) no. 27; Rosenberg 1928, nos. 14 and 21. The latter was sold in 1988 as the property of Albert N. Norweb.

8 Rosenberg 1928, p. 26, fig. 46; see also The Hague/Cambridge 1981–2, nos. 12–14.

9 Wilfred Wiegand, 'Ruisdael-Studien: Ein Versuch zur Ikonologie der Landschaftsmalerei', dissertation, Hamburg, 1971, pp. 93–8.

10 H.J. Raupp, 'Zur Bedeutung von Thema und Symbol für die holländische Landschaftsmalerei des 17. Jahrhunderts', *Jahrbuch der Staatlichen Kunstsammlungen in Baden-Württemberg*, vol. 17 (1980), pp. 85–110.

11 Joshua Bruyn, 'Toward a Scriptural Reading of Seventeenth Century Dutch Landscape Painting', in Sutton *et al.*, Amsterdam/Boston/Philadelphia, 1987–8, p. 99, note 52, where he refers to the castle on the hill as the 'Celestial Fortress', a commonplace of the pulpit, especially in England. The fallen and dead trees in the foreground of the Beit painting (fig. 2) 'emphasize the *vanitas* symbolism of the forested area, through which the tiny travellers must move in order to reach their goal'.

12 E. John Walford, 'Jacob van Ruisdael and the Reception of Landscape', Yale University Press (forthcoming), Mss. Chap. 4, p. 6, note 6; Carel van Mander, *Grondt der edel vrij schilderkonst* (1603), book 8, verse 29.

13 See, as examples, the *River Landscape with Castle on a High Cliff*, Cincinnati Art Museum, no. 1946.98 and *Waterfall with Watchtower*, Herzog Anton Ulrich-Museum, Braunschweig, no. 378, respectively, Hofstede de Groot, vol. 4 (1912), nos. 772 and 207; Rosenberg 1928, nos. 439a and 143.

14 Braunschweig, Herzog Anton Ulrich-Museum, *Jacob Isaacksz van Ruisdael. Wasserfall und Wachtturm - eine Werkmonographische Ausstellung* (cat. by Jochen Luckhardt) 21 February–17 March 1991.

FIG. 1 Jacob van Ruisdael, *Landscape with Bentheim Castle and Riders*, signed and dated 1651, canvas 97.7 × 81.3 cm., Sir Nicholas Bacon, Bt., Gainsborough.

FIG. 2 Jacob van Ruisdael, *The Castle of Bentheim*, 1653, signed and dated 1653 oil on canvas, 110.5 × 144 cm., National Gallery of Ireland, Dublin, no. 4531 (ex. Beit Collection.)

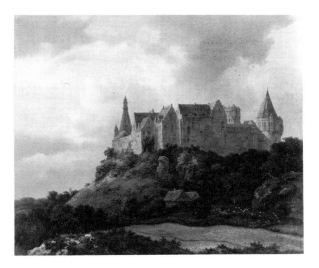

FIG. 3 Jacob van Ruisdael, *Landscape with Bentheim Castle*, oil on canvas, 38 × 47 cm., Sir Nicholas Bacon, Bt., Gainsborough.

FIG. 5 Photograph of Bentheim castle.

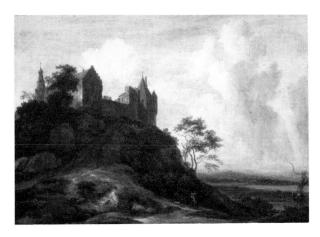

FIG. 4 Jacob van Ruisdael, *Landscape with Bentheim Castle*, oil on canvas, 42 × 56 cm., sale New York (Christie's), 2 June 1988, no. 140, ill.

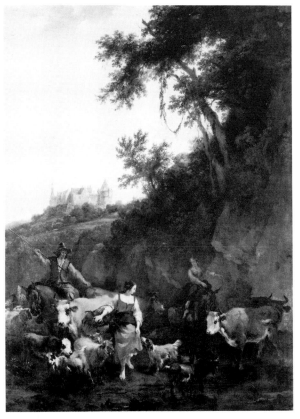

FIG. 6 Claes Berchem, *Herders in a Landscape with Bentheim Castle*, 1656, oil on canvas, 138 × 103 cm., Gemäldegalerie, Dresden, no. 1481.

CAT. 58

Landscape with Cornfield, 1660s

Signed lower left corner: J v Ruisdael (the 'J' and 'v' ligated)
Oil on canvas, original dimensions 13⅝ × 13¼ in. (35.6 × 33.4 cm.)

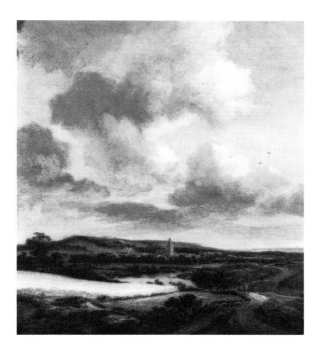

PROVENANCE: August Lürmann, Bremen, by 1904 (see exh.); Dr Thuerling; Etienne Nicolas, Paris; acquired from Edward Speelman.

EXHIBITIONS: Bremen, Kunsthalle, *Ausstellung historischer Gemälde aus bremischem Privatbesitz in der Kunsthalle, Oktober 1904* (cat. by Carl Schüneman), 1904, no. 304; London 1988, no. 58, ill. p. 24.

LITERATURE: Gustav Pauli, *Gemälde alter Meister im bremischem Privatbesitz, Eine Erinnerung an die Ausstellung in der Kunsthalle zu Bremen in der Monaten Oktober und November 1904* (Bremen, 1905), p. 45, fig. 8; Hofstede de Groot, vol. 4 (1912), no. 108; Jakob Rosenberg, *Jacob van Ruisdael* (Berlin, 1928), p. 76, no. 75; Kurt Erich Simon, *Jacob van Ruisdael. Eine Darstellung seiner Entwicklung* (Berlin, 1930), p. 54, note 56.

CONDITION NOTES: The canvas support has been relined and the tacking margins let out. The enlarged relined dimensions are 14¼ × 14⅜ in. (37.5 × 36.5 cm.). The paint film was pressed in relining with the result that the weave of the canvas has become more prominent. The edges have been repainted, a loss in the upper centre right has been repaired and inpainted, and some of the forms of the landscape have been strengthened. The narrow shadows before the cornfield and behind the pond have been strengthened. There is also considerable general abrasion, which was already noted by Pauli in 1905 and by Hofstede de Groot, who wrote in his own copy of the 1904 Bremen exhibition catalogue 'heel erg verpoetst'. The varnish is moderately discoloured. On the

back are the stickers of Nicolas' French packing firms, Ch. Pottier and H. Gerfaud.

In the middle of a rolling plain is a village with a square church tower and a windmill. In the left foreground is a sunlit cornfield, beyond it a pond. On the right a fork in the road joins and meanders into the distance; the sandy path is travelled by a few tiny figures. In the right distance is a glimpse of an inland sea. With more than two-thirds of the upright composition devoted to the dramatic, cloud-filled sky, the view has a monumentality that belies its size.

Ruisdael repeatedly depicted panoramic views of cornfields with villages nestled in rolling plains. These views were not identifiable sites, but generally recall the plains and coastal villages along the southern and eastern coasts of the Zuider Zee in the Netherlands. In a note (formerly attached to the reverse of the canvas) written in French and dated (19)32, the Dutch art historian W. Martin is said to have observed that this scene recalled the area around villages like Eemnes (near Laren). A similar panoramic composition with a village with square tower and mill and a harvested cornfield on the left, but horizontal in format, was in the Simon sale in 1927 (fig. 1).[1] A square tower similar to the one in this painting appears in still another painting by Ruisdael.[2] The cornfield became a central theme in Ruisdael's art during the 1660s. Two closely related paintings in Rotterdam and Basle (figs. 2 and 3 respectively) depict rolling sunlit cornfields with a view of an inland sea in the distance.[3] He also depicted harvested cornfields with the grain arranged in bundles (see, for example, the painting in the Carter Collection).[4] The Metropolitan Museum of Art in New York owns the most grandly conceived of Ruisdael's cornfields, a very large canvas from the Benjamin Altman Bequest,[5] depicting broad fields on either side of a central road; as well as a smaller cornfield (from the Friedsam Collection) which employs the same design as the Basle painting but replaces the sea with a windmill and a town.[6]

Ruisdael's strong interest in cornfields has been related to the medieval tradition of depicting in landscape series the summer season or the months of July and August with ripe cornfields. However, as Seymour Slive has pointed out, the earlier images usually included peasants at work, haying or reaping, or at rest, while the figures in Ruisdael's cornfields are rarely emphasized; this led Slive to conclude that in Ruisdael's cornfields the 'intent . . . was secular, not allegorical'.[7] Alan Chong traced the ancestry of Ruisdael's cornfields to some of the earliest Flemish landscapes, including not only images of the Seasons but also Joachim

Patinir's depictions of the Rest on the Flight into Egypt, with its inclusion of the tale of the Miraculous Wheatfield.[8] He argued that the cornfield first emerged as an independent theme in landscapes executed early in the seventeenth century by Jan Brueghel the Elder, and subsequently took different forms in Flemish and Dutch art, in part because of the two areas' different agricultural histories. Whereas the Fleming David Teniers the Younger continued to depict vast cornfields on aristocratic estates with field labourers and seigneurial supervisors, cornfields were rarely depicted by seventeenth-century Dutch artists before Ruisdael.[9] While the Southern Netherlands continued to grow large quantities of grain, until the mid 1600s Holland imported most of its grain from Poland and the German Hanseatic states around the Baltic, concentrating instead on dairy farming, animal husbandry and industrial and specialized horticultural crops.[10] After mid-century, however, when Ruisdael again made the cornfield a central theme in Dutch landscape, the Baltic grain trade declined as Holland began to grow grain in regions to the south and east of the Zuider Zee and in western Friesland, areas that proved unsuitable for grazing cattle.[11] Thus, Chong concluded that Ruisdael's cornfields not only revived a theme in Dutch painting but also presented 'a new feature of the Dutch countryside with enormous economic and social importance'.[12] R. Fuchs offered still another interpretation of Ruisdael's cornfield in Rotterdam (fig. 3), based on a semiotic analysis, which explains the work as a series of contrasting and complementary indicators which reflect a 'code' that implies an allegorical view of the world.[13]

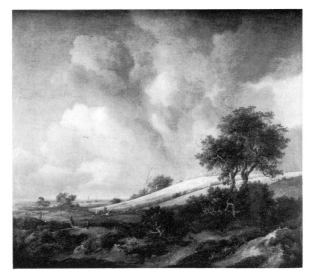

FIG. 2 Jacob van Ruisdael, *Landscape with Sunlit Cornfield*, oil on canvas, 61 × 71 cm., Museum Boymans-van Beuningen, Rotterdam, no. 1742.

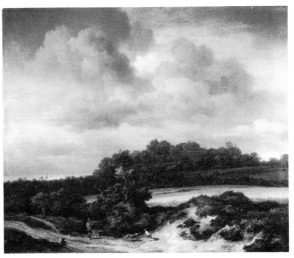

FIG. 3 Jacob van Ruisdael, *Landscape with Sunlit Cornfield*, oil on canvas, 46 × 56.6 cm., Öffentliche Kunstsammlungen, Basle, inv. 924.

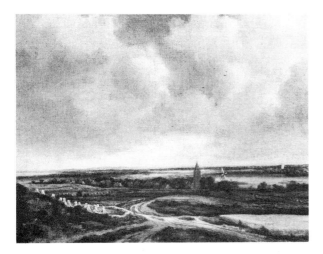

FIG. 1 Jacob van Ruisdael, *Landscape with Cornfield and Village*, oil on canvas, 31.5 × 41 cm., sale Dr James Simon, Amsterdam (F. Muller), 25 October 1927, no. 41, ill.

1 Probably identical with Hofstede de Groot, vol. 4 (1912), no. 35b, which was described as 'A *Panoramic View with the Church of Beverwijk* – On the right [left] is a slope with a cornfield; the corn is in sheaves. A small picture in the collection of James Simon, Berlin'. Although Beverwijk's church tower is square with a peaked roof (see for example, S. van Ruysdael's *View of Beverwijk*, Museum of Fine Arts, Boston, 1982.396), the site here seems to be imaginary.

2 Hofstede de Groot, vol. 4 (1912), no. 977; Rosenberg 1928, no. 521.

3 See, respectively, Hofstede de Groot, vol. 4 (1912), nos. 144 and 124, and Rosenberg 1928, nos. 72 and 92. See also the painting in the Thyssen-Bornemisza Collection; Gaskell 1989, cat. no. 87; Rosenberg 1928, no. 73a.

4 J. Walsh and C. Schneider, *A Mirror of Nature. Dutch Paintings from the Collection of Mr and Mrs Edward Carter* (Los Angeles, 1981), cat. no. 21, ill.

5 Hofstede de Groot, vol. 4 (1912), no. 119; Rosenberg 1928, no. 86a.

6 Hofstede de Groot, vol. 4 (1912), no. 141; Rosenberg 1928, no. 87.

7 Seymour Slive, in *Jacob van Ruisdael*, exh. The Hague/ Cambridge 1981–2, p. 94.

8 Chong, in exh. cat. Amsterdam/Boston/Philadelphia 1987–8, pp. 446–7. On the theme, see also H. Wenzel, 'Die "Kornfieldlegende"', in *Festschrift Kurt Bauch* (Munich, 1957), pp. 177–92.

9 Chong, in exh. cat. Amsterdam/Boston/Philadelphia 1987–8, pp. 446–7. On Teniers' images of agricultural estates, see F. P. Dreher, 'The Artist as Seigneur: Chateaux and their Proprietors in the Work of David Teniers II', *Art Bulletin*, vol. 60 (1978), pp. 682–703.

10 See Jan de Vries, *The Dutch Rural Economy of the Golden Age* (New Haven, 1974), pp. 137–53, 169–73.

11 J. A. Faker, 'The Decline of the Baltic Grain Trade in the Second Half of the 17th Century', *Acta Historia Neerlandica*, vol. 1 (1966).

12 Chong, in exh. cat. Amsterdam/Boston/Philadelphia 1987–8, p. 447.

13 R. H. Fuchs, 'Over het landschap: Een verslag naar aanleiding van Jacob van Ruisdael, 'Het Korenveld", *Tijdschrift voor Geschiedenis*, vol. 86 (1973), pp. 281–92. Both Slive (The Hague/Cambridge 1981–2, p. 94) and Chong (Amsterdam/ Boston/Philadelphia 1987–8, p. 447) question this view.

CAT. 59

Panoramic View of Haarlem, c. 1670?

Signed lower right centre: J v Ruisdael (the first three letters ligated)
Oil on canvas 17 × 16½ in. (43.2 × 41.9 cm.)

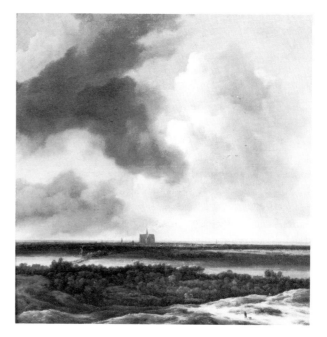

PROVENANCE: Acquired from Thomas Agnew's Gallery before 1906 by Oscar Huldschinsky, Berlin (hung in 'Der Festsaal'), cat. by W. Bode (1909), no. 25; sale Huldschinsky, Berlin, 10 May 1928, no. 28, pl. XXIV (sold to P. Bottenwieser, Berlin); August Berg, Portland, Oregon, 1929; with dealer Knoedler, New York, 1938 (see exh.); Etienne Nicolas, Paris; acquired from Edward Speelman.

EXHIBITIONS: Berlin, Kaiser Friedrich Museum Verein, Graflich Redern'schen Palais, *Ausstellung von Werken Alter Kunst*, 27 January–4 March 1906, no. 118; Rhode Island, Rhode Island School of Design, Providence, *Dutch Painting in the Seventeenth Century* (catalogue by Wolfgang Stechow), December 1938– January 1939, no. 45; London 1988, no. 57.

LITERATURE: Wilhelm Bode, *Die Sammlung Oscar Huldschinsky* December 1938–January 1939 (Frankfurt a.M., 1909), p. 21, no. 25, pl. 27; Hofstede de Groot, vol. 4 (1912), no. 58; Wilhelm von Bode, *Die Meister der holländischen und vlamischer malerschulen* (Leipzig, 1917), p. 172, ill.; Jakob Rosenberg, *Jacob van Ruisdael* (Berlin, 1928), p. 57, cat. 41, fig. 118, pl. LXXXI; Kurt Erich Simon, *Jacob van Ruisdael. Eine Darstellung seiner Entwicklung* (Berlin, 1930), p. 51; *The Studio* (December 1929), ill.; *Art News*, vol. 4, no. 1 (1929), p. 20, ill.; James D. Burke, 'Ruisdael and his Haarlempjes', *M: A Quarterly Review of the Montreal Museum of Fine Arts*, vol. 6, no. 1 (1974), p. 11, note 20; The Hague, Mauritshuis,

Jacob van Ruisdael (catalogue by Seymour Slive) 1 October 1981–
3 January 1982, also shown at Cambridge, Fogg Art Museum, 18
January 1982–11 April 1982, p. 223, ill.; Amsterdam/Boston/
Philadelphia 1987–8, pp. 463–4; Russell 1988, p. 789; Ivan Gaskell,
*Seventeenth Century Dutch and Flemish Painting, The Thyssen-
Bornemisza Collection*, (London, 1990), p. 388, note 5.

CONDITION NOTES: The canvas support has been relined and its
tacking margins cut; the dimensions of the original canvas are 16¼
× 16¼ in. (42.5 × 41.2 cm.). The paint film is in very good state
with little abrasion although it has been slightly pressed in relining.
There is a small loss of paint in the lower left corner and another
three quarters of the way up the left edge. Minor retouches appear
along the lower edge. On the back is a label from the 1906
exhibition at the Kaiser Friedrich Museum Verein and two inven-
tory numbers in pencil: A1979 and CA1084.

In a panoramic landscape on an upright format, the profile
of the city of Haarlem with its large cathedral of St Bavo
appears on the horizon. Dunes fill the foreground and
beyond woods alternate with open fields. Buildings,
cottages and windmills stud the landscape and in the lower
right a man walks with two dogs. Overhead the soaring,
cloud-filled sky fills most of the composition.

Jacob van Ruisdael's chief contribution to the time-
honoured tradition of the panorama was to convert the
horizontal format developed by his fellow Haarlemmers,
Hendrick Goltzius and Cornelis Vroom, as well as Jan van
Goyen, Philips Koninck (qq.v.) and others, to an upright
format. At the same time he enhanced the sweep of the land
and the huge vault of the skies by creating complementary
passages of alternating light and shade between the cast
shadows and sunbeams on the land and the mottled sky
overhead.[1] This splendidly well-preserved panorama has a
grandeur that belies its diminutive scale and inspired Jakob
Rosenberg to cite it in his monograph on Ruisdael as an
exemplar of its type. Rosenberg stressed the high point of
view, the distant skyline and the relatively flat topography
as features that hasten the recession, and discussed the
important functions of its 'Hochformat', in which nearly
three-quarters of the design is given over to the interplay of
the light and clouds in the sky.[2]

When the painting was in the Oscar Huldschinsky
collection in Berlin early in this century Bode titled it
'Haarlem von den Dünen bei Overveen gesehen' (Haarlem
seen from the Dunes of Overveen), while Hofstede de
Groot observed that the 'bleaching grounds and cottages of
Overveen are not shown'; in the Huldschinsky sale
catalogue of 1928, the claim was reasserted that it was a
view of Haarlem from the dunes of Overveen and that the
blue passage on the horizon was the Zuider Zee. Rosenberg
contented himself with calling it only 'Blick auf Haarlem'.[3]

In an Amsterdam estate inventory of 1669 a painting by
Ruisdael was called 'een Haarlempje';[4] as a consequence
virtually all of Ruisdael's panoramas have come to be called
'haarlempjes' or 'little views of Haarlem'. James Burke
made a systematic study of Ruisdael's series of panoramas in
relation to the topography in and around Haarlem
(Bloemendaal, Overveen and other sites); he concluded that
despite their apparent realism they are never an exact rep-
resentation of a specific prospect and that the viewing point
is rarely an identifiable spot.[5] Discussing the Samuel
painting in a note, Burke observed that it appeared to
represent Haarlem from the west,[6] and might be compared
to a painting from a similar vantage point in the collection
of the Earl of Wemyss and March, Gosford House,
Scotland (fig. 1).[7] In his hypothetical chronology for the
entire group of paintings he dated the Samuel painting very
precisely (indeed probably too exactly): 'perhaps 1669
instead of 1670', and complemented the work's 'high
quality [which] admits it to the magnificent "classic" group
of Haarlempjes'.[8] Both Rosenberg (1928) and Stechow
(exh. 1938–9) suggested a date of 'about 1670' which seems
most acceptable for this entire group. Slive first observed
that a black chalk drawing in the Rijksmuseum (fig. 2) is
probably a preliminary study for the Samuel painting.[9] Slive
further observed that 'significant alterations were intro-
duced in the final work, where the silhouette of the upper
edge of the dense woods has been made more regular, more
of the plain beyond it is portrayed, and a rhythm of light
and shadow has been set up which suppresses the lively
detail that animates the drawing. The changes in the
painting result in a gain in coherence and an increased
effect of the vastness of the plain.'

While most of Ruisdael's so-called 'Haarlempjes'
logically depict Haarlem with the ample form of St Bavo's
church and other city monuments on the horizon, the sites
of some of these works have been questioned. In an opinion
unpublished until 1987–8, H. Gerson and E. H. ter Kuile
suggested in 1940 that the Samuel painting and a very
closely related but somewhat larger canvas in the Bearsted
Collection (fig. 3),[10] as well as another view of the same
scene but from a different point of view in the Museum of
Fine Arts, Boston (fig. 4), were all depictions of Alkmaar,
rather than Haarlem, with the Grote Kerk of Alkmaar on
the horizon and the ruins of Egmont castle in the left
middle distance.[11] In 1987, not having at that time seen the
Samuel painting and working only from photographs, I
supported this theory.[12] Ivan Gaskell in cataloguing a
painting of a related view in the Thyssen-Bornemisza
Collection (the authenticity of which Horst Gerson at first

doubted and which is now only attributed to Ruisdael) also upheld the identification of the Boston, Bearsted and Samuel paintings as depictions of Alkmaar, but noted changes in the Lugano painting to the structure of the ruins which effectively elide them into a single building, concluding that that work was probably derived by a follower of Ruisdael from the Bearsted painting and no longer bore any direct relationship to observed reality.[13] Examining the Samuel painting at last in detail and in the flesh, I have changed my mind and now feel certain that while the Boston and Upton House paintings are indeed depictions of Alkmaar, the skyline in the Samuel painting is undoubtedly that of Haarlem.

Some difference of opinion has been expressed about the spelling and form of the signature on the Samuel painting; in the 1906 Berlin exhibition catalogue it was read as 'J Ruisdael'; in the Huldschinsky catalogue of 1909 Bode read 'V. Ruisdael', and Stechow in the 1938–9 Providence exhibition catalogue (surely incorrectly) deciphered 'V. Ruysdael;' it now appears to be signed in the lower right centre: 'J v Ruisdael' with the first three letters ligated.

It may be noted that the former owner of this painting, Oscar Huldschinsky, also owned Jacob van Ruisdael's *Egmont Castle* now in the Art Institute of Chicago (no. 47.475), as well as such noted Dutch paintings as Jan Steen's *Sampson and Delilah* (Los Angeles County Museum) and Gerard Dou's *Kitchen* (Gemäldegalerie, Berlin-Dahlem).[14]

1 On the history of the panorama, see Stechow 1968, pp. 45–9; Slive, The Hague/Cambridge, *Ruisdael* exh. cat. 1981–2, pp. 127–31; and Sutton, in Amsterdam/Boston/Philadelphia 1987–8, p. 463.
2 Rosenberg 1928, p. 57.
3 For all of these references, see exhibitions and general literature cited above.
4 See A. Bredius, *Künstler-Inventare: Urkunden zur Geschichte der holländischen Kunst des XVI., XVII., und XVIII. Jahrhunderts*, 8 vols. (1915–22), vol. 3, p. 425.
5 James D. Burke, 'Ruisdael and his Haarlempjes', *M: A Quarterly Review of the Montreal Museum of Fine Arts*, vol. 6, no. 1 (1974), pp. 3–11.
6 Burke 1974, p. 11, note 20.
7 Rosenberg 1928, no. 47; Hofstede de Groot, vol. 4 (1912), no. 65.
8 Burke 1974, p. 11, note 20.
9 Seymour Slive, The Hague/Cambridge, *Jacob van Ruisdael*, exh. cat. 1981–2, p. 223, cat. no. 91. The drawing is closely related to three haarlempje studies in the Museum Bredius, which perhaps once belonged to the same sketchbook and were also exhibited in the 1981–2 Ruisdael exhibition, cats. 88–90, ills.
10 First reported in Amsterdam/Boston/Philadelphia 1987–8, pp. 463–5, cat. 89.
11 See Hofstede de Groot, vol. 4 (1912), no. 70; Rosenberg 1928,

no. 55. Apparently unaware of the theory of Gerson and ter Kuile, R. van Luttervelt wrongly asserted that the Boston painting depicted Haarlem with the Huis te Kleef at the lower left, see 'Een gezicht op Haarlem van Jacob van Ruysdael', *Historia: Maandschrift voor geschiedenis en kunstgeschiedenis*, vol. 14 (1949), pp. 223–5.
12 See Amsterdam/Boston/Philadelphia 1987–8, p. 465.
13 Ivan Gaskell, *Seventeenth-Century Dutch and Flemish Painting, The Thyssen-Bornemisza Collection*, (London, 1990), cat. no. 89. ill. Attributed to Jacob van Ruisdael, *View Inland from the Coastal Dunes*, canvas 52.7 × 66.7 cm., acc. no. 1930.101.
14 See Bode 1909, and 'Die Sammlung Huldschinsky', *Pantheon*, vols. 1–2 (1928) pp. 128–31.

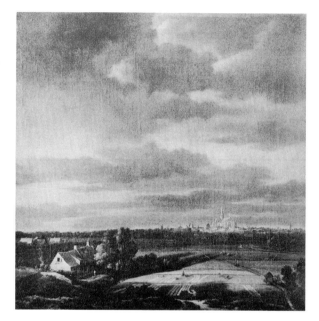

FIG. 1 Jacob van Ruisdael, *View of Haarlem*, canvas 45 × 48 cm., Earl of Wemyss and March, Gosford House, Scotland.

FIG. 2 Jacob van Ruisdael, *View of Haarlem*, black chalk and grey wash drawing, 8.9 × 14.8 cm., Rijksprentenkabinet, Rijksmuseum, Amsterdam, no. 1961.43.

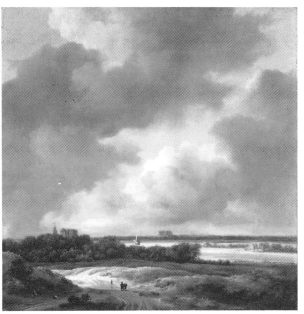

FIG. 4 Jacob van Ruisdael, *View of Alkmaar*, signed, oil on canvas 44.4 × 43.5 cm., Museum of Fine Arts, Boston, Ernest Wadsworth Longfellow Fund, acc. no. 39.794.

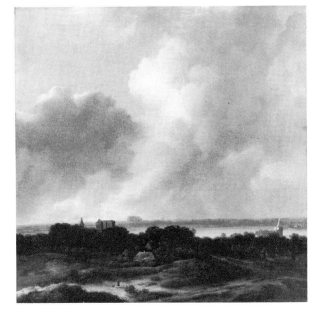

FIG. 3 Jacob van Ruisdael, *View of Alkmaar* ('Coup de Soleil'), signed, oil on canvas 40 × 41 cm., Bearsted Collection, Upton House (National Trust), near Banbury, Oxfordshire.

SALOMON VAN RUYSDAEL

(NAARDEN 1600/3–1670 HAARLEM)

Salomon Jacobsz van Ruysdael was born in Naarden in Gooiland. He was originally called Salomon de Gooyer (Goyer), but he and his brother Isaack (1599-1677), also an artist, adopted the name 'Ruysdael' from Castle Ruisdael (or Ruisschendael), near their father's home town. Salomon spelled his name Ruysdael (or occasionally Ruyesdael), as distinguished from his nephew Jacob, who used the name Ruisdael (q.v.). Salomon entered the painters' guild in Haarlem in 1623 (as Salomon de Gooyer), was named a *vinder* of the guild in 1647, a dean the following year, and a *vinder* again in 1669. His earliest known dated painting is of 1626, and as early as 1628 he was praised as a landscapist by the chronicler of Haarlem, Samuel van Ampzing. In a document of 1651 he was called a merchant, and dealt in blue dye for Haarlem's bleacheries. His wife, Maycken Buysse, was buried in St Bavo's Church in Haarlem on 15 December 1660.

Like his father, Salomon was a Mennonite and in 1669 was listed among the members of the 'Vereenigde Vlaamsche, Hoogduitsche en Friesche Gemeente' when he was living on the Kleyne Houtstraat. As a Mennonite, he could not bear arms but contributed to Haarlem's civic guard. Although Salomon seems to have lived and worked in Haarlem his entire life, he probably made several trips through the Netherlands, making views of, among other places, Leiden, Utrecht, Amersfoort, Arnhem, Alkmaar, Rhenen and Dordrecht. The artist was buried in St Bavo's Church on 3 November 1679.

Although Salomon's teacher is unknown, his earliest works of about 1626–9 recall the art of Esaias van de Velde (q.v.), who worked in Haarlem from 1609 to 1618. In addition to van de Velde's influence, these early works reveal many parallels with Jan van Goyen's work. Together with Pieter de Molijn, Salomon van Ruysdael and Jan van Goyen were the leading 'tonal' landscapists of their generation and seem to have influenced each other. They laid the foundation for the great 'classical' period of Dutch landscape painting that followed. In addition to landscapes and numerous river and seascapes of a calm, never stormy, type, he painted a few still lifes in his later years. Salomon was the father of Jacob Salomonsz. van Ruysdael (c. 1629/30–1681), also a painter.

LITERATURE: Samuel Ampzing, *Beschrijvinge ende lof der stad Haerlem in Holland* (Haarlem, 1628); Houbraken, vol. 2 (1719), p. 124, vol. 3 (1721), p. 66; Descamps 1753–64, vol. 3, p. 11; Wurzbach, vol. 2 (1910), pp. 524–5; K. E. Simon, in Thieme and Becker, vol. 29 (1935), pp. 189–90; Franz Dulberg, *Die drei Ruysdael* (Leipzig, 1922); Rolph Grosse, *Die holländische Landschaftskunst, 1600–1650* (Berlin/Leipzig, 1925), pp. 79–87; H. F. Wijnman, 'Het leven der Ruysdaels', *Oud-Holland*, vol. 49 (1932), pp. 46–60, 173–81, 258–75; Amsterdam, dealer J. Goudstikker, *Salomon van Ruysdael*, exh. 1936; J.G. van Gelder, review of Goudstikker exh., *Elsevier's geillustreed maandschrift*, vol. 91 (1936), pp. 201–3; A. Heppner, 'Salomon van Ruysdael', *Die internationale Kunstwelt*, vol. 3 (1936), pp. 31–2; Wolfgang Stechow, *Salomon van Ruysdael. Eine Einführung in seine Kunst* (Berlin, 1938; reprint Berlin, 1975); Wolfgang Stechow, 'Die "Pellekussenpoort" bei Utrecht auf Bildern von Jan van Goyen und Salomon van Ruysdael', *Oud-Holland*, vol. 55 (1938) pp. 202–8; Wolfgang Stechow, 'Salomon van Ruysdael's Paintings in America', *Art Quarterly*, vol. 2 (1939), pp. 251–63; J.W. Niemeyer, 'Het topografisch element in enkele riviergezichten van Salomon van Ruysdael nader beschouwd', *Oud-Holland*, vol. 74 (1959), pp. 51–6; H. J. J. Scholtens, 'Salomon van Ruysdael in de contreien of Holland's landengte', *Oud-Holland*, vol. 77 (1962), pp. 1–10; Stechow 1966, pp. 23–28, 38, 43, 54, 62, 90–1, 103, 113–16; Bol 1973, pp. 148–56; Amsterdam/Boston/Philadelphia 1987–8, pp. 466–75.

CAT. 60

View of the River Lek with Boats and Liesvelt Castle, 1641

Signed and dated on the boat: S. v Ruysdael. 1641
(the 'v' and 'R' ligated)
Oil on panel 26½ × 40⅜ in. (67.5 × 102.5 cm.)

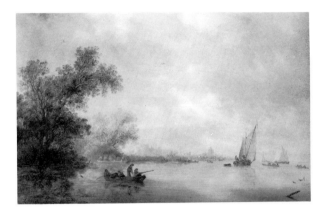

PROVENANCE: Dealer D. Katz, Dieren, by 1933 (see exh.); Jhr.
den Tex, Rheden; J.L. ten Bos, by 1953 (see exh.); Mevr. E. M. E.
ten Bos-Verheyden, Almelo, by 1955 (see exh.); J.R. Bier, Haarlem,
1963; Igor Bier, Bloemendael, 1966; acquired from Edward
Speelman.

EXHIBITIONS: Zutphen, Gemeentelijk Museum, *Kunsthandel D.
Katz*, 1933, no. 16; The Hague, dealer D. Katz, 1934, no. 95;
Almelo, *Oude Kunst uit Twents particulier bezit*, 1953, no. 41, fig. 30;
Rotterdam, Museum Boymans, *Kunstschatten uit Nederlandse
Verzamelingen*, 19 June–25 September 1955, no. 108, pl. 76;
Dieren, dealer D. Katz, *Jubileum tentoonstelling*, 1957, no. 27.
London 1988, no. 60.

LITERATURE: Wolfgang Stechow, *Salomon van Ruysdael. Eine
Einführung in seine Kunst mit kritischem Katalog der Gemälde* (Berlin,
1938; revised edn Berlin, 1975), p. 119, cat. no. 333; J. W.
N.[iemeyer], 'Het topografisch element in enkele riviergezichten
van Salomon van Ruysdael nader beschouwd', *Mededelingen van het
Rijksbureau voor Kunsthistorische Documentatie*, in *Oud-Holland*, vol.
74 (1959), pp. 51–6.

CONDITION NOTES: The wood support is thinned and cradled
and comprised of three horizontal planks of wood. The joins are
5¾ in. (14.8 cm.) from the top and 10½ in. (26.5 cm.) from the
bottom edge. The paint film is in good condition with inpainting
along the seams and scattered throughout the sky. An old scratch
has been repaired in the upper left above the tree. A good deal of
underdrawing is visible through the paint film, for example among
the figures in the boat. The varnish layer was deeply discoloured in
February 1991 and has been removed and a fresh coat of varnish
applied. On the back of the cradle is the sticker from the 1953
Almelo exhibition.

A broad river recedes diagonally from left to right. The
bank at the left is covered with trees and in the distance are
grandly proportioned buildings. In the left foreground five
bird hunters with a gun wait in a small rowing-boat for
their prey. In the distance and slightly to their left a ferry-
boat heavily laden with six people and three cows is just
poling off from the shore. Farther down the river are
numerous rowing-boats and sailing-boats. And in the
farthest prospect the spectres of castles and church spires
rise from the shore.

As Stechow observed, Ruysdael first addressed the
subject of river landscapes in 1631. The *River Landscape*
dated that year in the National Gallery, London (fig. 1),
achieves its rapid spatial recession largely by virtue of a
dramatic orthogonal retreat, while a painting dated only
one year later (Hamburg, Kunsthalle, inv. 627) enhances
the recession through a subtle use of atmospheric per-
spective.[1] The Petworth House *River Landscape with a Ferry
and Sailing-Boats* (fig. 2), also dated 1632, already includes
virtually all the elements of the Samuel painting's design –
the wedge-shaped, tree-lined bank receding from left to
right, the mottled, cloud-filled sky and watery reflections,
as well as the use of boats and even sunken logs, floats and
birds to punctuate the space.[2] The Samuel painting is one
of at least thirteen paintings by Ruysdael that date to 1641.[3]
Another river landscape dated that year, with the left bank
dominant and covered with trees and the turrets of a castle,
is in the Sinebrychoff Art Museum, Helsinki (fig. 3).[4]
Ruysdael executed various combinations of these simple
compositional elements scores of times over the course of
three decades, exploring all possible permutations of the
subject. His genius was in avoiding mechanical repetition,
constantly discovering fresh features in his favoured
themes.

J. W. Niemeyer first observed that the castle with large
round crenellated tower that is faintly visible in the distance
of the Samuel painting is Liesvelt Castle on the Lek near
Groot-Ammers.[5] Liesvelt Castle also appears in three of
Salomon's other river views: on the right of the painting
also dated 1641 formerly in the Smith Collection,
Washington (fig. 4),[6] in the distance of a painting of 1642
in the Bayerische Staatsgemäldesammlungen, Alte
Pinakothek, Munich,[7] and in an undated painting that
Stechow has dated around 1660.[8] In each case the castle's
setting is partly or entirely imaginary. Although Liesvelt
Castle was rebuilt several times, its appearance in the
seventeenth century is known from the drawings of Roelant
Roghman of 1646–7, and the prints of Anthonie Waterloo

and A. Rademaker (fig. 5).[9] The last mentioned print was published in Rademaker's 1725 *Kabinet van Nederlandse Outheden en Gezichten* but shows the castle as it appeared in 1631, ten years before Salomon first painted it. Castles often appeared in seventeenth-century Dutch landscapes (see, for example, Samuel's van Goyen of 1626, cat. 19), and had figured prominently in early series of landscape prints by Hessel Gerrits after David Vinckboons, and by Jan van de Velde. Like the many seventeenth-century chronicles of Dutch cities and local histories, these castles seem to reflect a form of local pride of place – the Dutchman celebrating his indigenous achievements and the beauty of his newly independent country.

Since no drawings by Salomon have survived, it has sometimes been assumed that he did not traverse the countryside on sketching trips, as did contemporaries like Jan van Goyen, whose sketchbooks attest to extensive travels around the United Provinces. However, despite his penchant for varying an established repertoire of designs and motifs, his paintings attest to fairly wide travels. In addition to Liesvelt Castle and other sites in South Holland, he painted Alkmaar, Amersfoort, Amsterdam, Deventer, Dordrecht, Egmond (and Egmond Castle), The Hague, Haarlem, Naarden, Nijenrode, Rhenen, Scheveningen, Spaarndam, Utrecht, Valkenburgh, Weesp, Zandvoort, and even on one occasion Brussels.

1 Stechow 1938/1975, cat. nos. 435 and 498, figs. 8 and 9.
2 Stechow 1938/1975, cat. no. 322; see also St John Gore, 'Old Masters at Petworth', in *The Fashioning and Functioning of the British Country House*, vol. 25 of *Studies in the History of Art*, National Gallery of Art, Washington, DC (1989), p. 127, ill.
3 See Stechow 1938/1975, nos. 87, 184–6, 330A, 331–4, 502–4, 574.
4 Stechow 1938/1975, no. 334.
5 J. W. N.[iemeyer], 'Het Topografisch element in enkele riviergezichten van Salomon van Ruysdael nader beschouwd', *Oud-Holland*, vol. 74, (1959), p. 52.
6 Stechow 1938/1975, no. 331; Niemeyer 1959, p. 52, fig. 6.
7 Bayerische Staatsgemäldesammlungen, Alte Pinakothek, inv. no. 2718, panel 73.5 × 107 cm., Stechow 1938/1975, no. 447; Niemeyer 1959, fig. 4.
8 Stechow 1938/1975, no. 395 (panel 40.5 × 67.5 cm.); Niemeyer 1959, fig. 2.
9 For the Roghmans, see Jhr. H. W. M. van der Wyck and J. W. Niemeyer, *De Kasteelteekeningen van Roelant Roghman* (1989); and for the Waterloo etching, see Dutuit, no. 26 (Niemeyer 1959, fig. 5). On the history of Liesvelt Castle, see van der Aa, *Aardrijkskundige Woordenboek*, vol. 7 (1846).

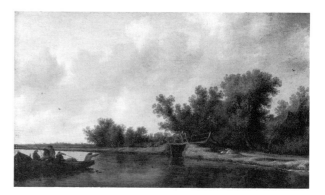

FIG. 1 Salomon van Ruysdael, *River Landscape*, monogrammed and dated 1631, panel 36.6 × 65.5 cm., National Gallery, London, no. 1439.

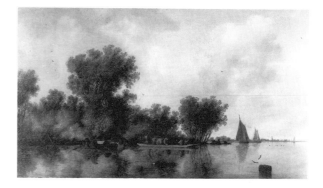

FIG. 2 Salomon van Ruysdael, *River Landscape with a Ferry and Sailing-Boats*, monogrammed and dated 1632, oil on panel 37 × 63.5 cm., Petworth House, West Sussex, cat. (1920) no. 441.

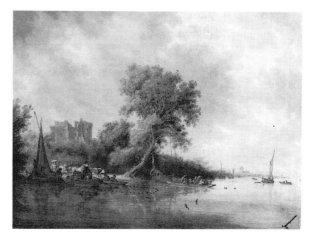

FIG. 3 Salomon van Ruysdael, *River Landscape with Egmond Castle*, signed and dated 1641, oil on canvas 80 × 109 cm., Sinebrychoff Art Museum, Helsinki, no. S117.

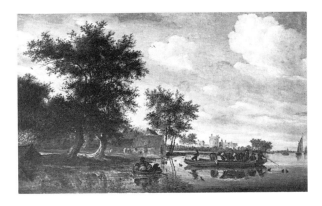

FIG. 4 Salomon van Ruysdael, *River Landscape with Liesvelt Castle*, 1641, signed and dated 1641, panel 55.5 × 78 cm., formerly Robert Smith, Washington, DC.

FIG. 5 A. Rademaker, *Liesvelt Castle* (as it appeared in 1631) from *Kabinet van Nederlandse Outheden en Gezichten* (1725).

CAT. 61

Sailing-Boats on a River, 1640s

Oil on panel 5⅛ × 8¼ in. (13 × 21 cm.)

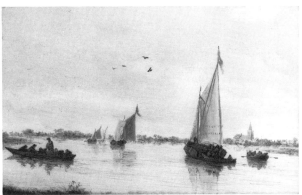

PROVENANCE: Goldschmidt, Paris; Baron Leonino, Paris; Etienne Nicolas, Paris, from whom it was acquired by Edward Speelman in 1959.

EXHIBITION: London 1988, no. 62.

LITERATURE: Wolfgang Stechow, *Salomon van Ruysdael. Eine Einführung in seine Kunst* (Berlin, 1938; 2nd revised edition Berlin, 1975), p. 113, no. 295A.

CONDITION NOTES: The panel support is in good condition and has not been cut. The paint film is in excellent condition with minor retouches along the upper edge, in the lower centre edge and in several minute horizontal striations to the right of the large sailing-boat. The varnish is slightly discoloured. On the back is the number '31' and the stickers of two French packers of the collector Nicolas, Ch. Pottier and Gerfaud.

On a river that fills virtually all of the foreground are several vessels silhouetted against the water. To the right of centre a large sailing-boat with sails raised and towing a smaller rowing-boat moves off into the distance. To its right is another rowing-boat filled with figures, two of whom man the oars. On the left, beyond a narrow strip of bank in the immediate foreground, another rowing-boat filled with figures (one of whom stands) and viewed broadside moves away to the left. In the centre distance are three other sailing-boats under full sail. About one-third of the way up the scene a narrow tree-lined bank stretches across the full width of the composition. In the distance at the right is a church with square tower and pointed spire and a cluster of houses. Smoke rises from a tiny house in the far left distance and overhead four birds fly in an overcast grey sky.

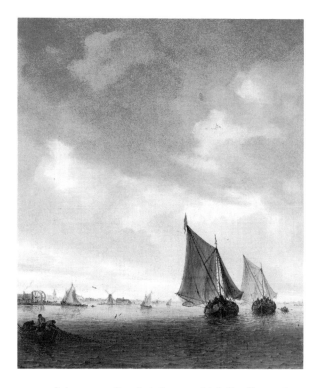

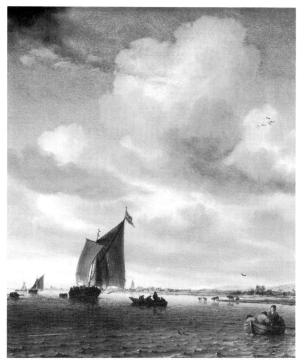

FIG. 1 Salomon van Ruysdael, *Seascape with Sailing-Boat on the Right*, monogrammed, oil on panel 36.5 × 32.5 cm., Residenz-galerie, Salzburg, inv. no. 552.

FIG. 2 Salomon van Ruysdael, *Seascape with Sailing-Boat on the Left*, monogrammed, panel 36 × 33 cm., Residenzgalerie, Salzburg, inv. no. 553.

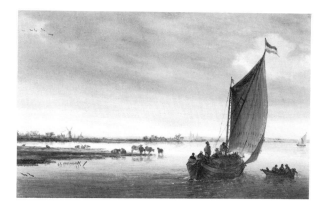

FIG. 3 Salomon van Ruysdael, *Seascape with Sailing-Boat*, monogrammed, oil on panel 20.5 × 32.5 cm., sale London (Sotheby's), 14 December 1977, no. 58, ill.

To judge from Stechow's *catalogue raisonné* of Salomon van Ruysdael's œuvre of more than 600 paintings, this fresh little painting is the tiniest picture that the artist executed. Salomon painted several other intimately scaled marines depicting broad rivers or estuaries with boats moving away down stream, which employ both upright (see for example the pendants from the Czernin Collection[1] (figs. 1 and 2)) and horizontal designs (see fig. 3);[2] however none adopts such diminutive proportions as the Samuel painting.[3] Virtually all of Salomon's mature river scenes and seascapes are diagonally disposed. Here the movement from right to left is very subtle and the absence of a dominant bank is unusual, though not unprecedented.[4] Although the painting is not signed, its execution – with the wet loaded brush sweeping across the panel to indicate the ripples of the water and the windswept sky –- is highly characteristic of Salomon's technique. Especially effective is his manner of recording the trembling reflections of the vessels and their passengers on the water. While it is difficult to establish a firm date for the painting, it is comparable in style to the *Seascape with Sailing-Boat and Rowing-Boat* dated 1642 in the collection of Sir Edmund Bacon, Bt. (died 1982), Raveningham Hall, Norwich,[5] and may therefore also date from the 1640s.

1 See Stechow 1938/1975, nos. 51 and 52; *Residenzgalerie mit Sammlung Czernin und Sammlung Schönborn-Buchheim* (Salzburg, 1980), p. 98, pl. 23.
2 Stechow 1938/1975, no. 301A.
3 Other tiny marines by Salomon include Stechow 1938/1975, nos. 542 (16 × 21 cm.) and 38 (22 × 18 cm.), and 299 (16 × 23 cm.; see following note).
4 Compare Stechow 1938/1975, no. 305 (Kempner Collection, Berlin, 1938) and 299 (Baron Janssen sale, Amsterdam, 26 April 1927, no. 109).
5 Panel 21.5 × 33 cm.; Stechow 1938/1975, no. 280, fig. 52.

CAT. 62

River Landscape with Ferry Boat, 1650

Signed and dated on the ferry boat: S. v.Ruysdael
(the 'v' and 'R' ligated) 1650
Oil on canvas 43⅞ × 59½ in. (111.5 × 151 cm.)

PROVENANCE: Earl of Shrewsbury, Alton Towers; dealer Charles Sedelmeyer, Paris, cat. 1896, no. 41; acquired from Sedelmeyer in 1897 (for about 28,420 frs.) for Alfred Beit, London cat. (1904), p. 56; Otto Beit, London, cat. (1913), no. 54; on loan to National Gallery of South Africa, Cape Town, c. 1952; Sir Alfred Beit, London and Blessington, sold to Edward Speelman in 1959 who in turn sold it to Harold Samuel.

EXHIBITIONS: London, Royal Academy, *Exhibition of Dutch Art 1450–1900*, 1929, no. 185 (lent by Otto Beit), illustrated in the Burlington House Souvenir, 1929, p. 67, no. 79; London 1988, no. 61.

LITERATURE: Paris, Sedelmeyer Gallery, *Sedelmeyer's 3rd 100 Paintings*, 1896, no. 41; Paris, Sedelmeyer Gallery, *One Hundred Masterpieces*, 1914, no. 54; Wilhelm Bode, *The Art Collection of Mr Alfred Beit at his Residence, 26 Park Lane, London* (Berlin, 1904), pp. 16–17, 56 [with the incorrect measurements, 106 × 123 cm.]; Wilhelm Bode, *Pictures and Bronzes in the Possession of Mr Otto Beit* (London, 1913), p. 18, no. 54 [with the measurements 41½ × 59 in.], pl. XIII; Wolfgang Stechow, *Salomon van Ruysdael, Eine Einführung in seine Kunst* (Berlin, 1938; reprint Berlin, 1975) p. 23, 126, no. 368 [with the measurements 105.5 × 150 cm.]; D. Bax, *Hollandse en Vlaamse Schilderkunst in Zuid-Afrika* (Cape Town, 1952), pp. 68–9, fig. 29; Speelman 1988, p. 14.

CONDITION NOTES: The canvas support has been relined and its tacking margins clipped. A 1½ in. (4 cm.) addition at the bottom edge has been overpainted and is hidden by the frame. It is unclear when the canvas was enlarged but in the Beit Collection catalogue of 1913 Bode recorded the dimensions as 41½ × 59 in., implying that the vertical dimension has been subsequently altered. The bottom edge of the original canvas is liberally retouched. Other retouches are scattered throughout the sky and around the boats

with canvas covers in the middle distance. There are also several small losses in the lower left. The end of the signature has been abraded. On the reverse are stickers with the numbers 17560 and 12791.

The river landscape with tree-lined bank receding from right to left includes a ferry boat on the left. Six people and five cows have crowded into the low-riding vessel. Farther back on the right, two fishing boats equipped with canvas awnings to shield them from the weather float in the shallows. On the right bank tall trees appear in the centre, arching skyward up and back from the water. To the right a couple on horseback travel a road leading to a house where three wagons have stopped. In the distance on the left, but still on the diagonally receding right bank, is a castle and a stout round tower with conical roof. Still further on are boats, a church and a tall 'overtoom' – a waterwheel-like device which was used to transfer small craft between two waterways of different levels, where the building of a complex of locks would be uneconomical.

Salomon van Ruysdael is perhaps best remembered for his many river landscapes, especially those of the 1640s and 1650s. These begin by 1631 (see commentary to Cat. 60) and were well established by the time Salomon painted the Samuel painting in 1650. The basic features of the specific design employed here had already appeared in a painting in Munich dated 1642 (fig. 1).[1] There, the river bank recedes from right to left, the boat serves as a repoussoir on the left, tall trees rise in the centre, and a road recedes on the right bank with towers in the distance. Other examples of related river landscapes by Salomon which are dated 1650 include paintings in the Walker Art Gallery, Liverpool,[2] formerly in the A. Schwarz Collection, Amstelveen,[3] the Edward and Hanna Carter Collection, Los Angeles,[4] the Staatsgalerie, Aschaffenburg (no. 6497),[5] the Art Gallery of Toronto, Ontario,[6] and a private German collection.[7] The last three paintings reverse the design, which is to say that the river bank recedes from left to right. The paintings which are closest to the Samuel painting in design and individual motifs are, in addition to the Carter picture, the paintings of 1652 in the Statens Museum, Copenhagen (fig. 2),[8] and the painting of 1649 formerly in the Charles Cunningham Collection, now on loan to the National Gallery, London (fig. 3).[9]

During the later 1640s and 1650s, Ruysdael brought sharper value contrasts and stronger colour accents to his art. The trees and foliage, the surface of the water, even the details of the boats and architecture are observed with a new precision. The upswept clouds reiterate the forms of the trees on the banks below. As we have observed above (see commentary to Cat. 60), Ruysdael repeatedly varied the designs of his river scenes, but it is a testament to his creativity that the variations are always naturalistically plausible, never formulaic.

The subject of the ferry boat had a long tradition in Netherlandish landscapes. It can be traced to the paintings of Jan Brueghel (see his *River Landscape*, dated 1603, Koninklijk Museum voor Schone Kunsten, Antwerp, inv. 910), the prints of Jan van de Velde,[10] and the more recent precedents of the landscapes of Esaias van de Velde and Jan van Goyen (see, respectively, *The Ferryboat*, 1622, Rijksmuseum, Amsterdam, inv. A 1293; and *River Landscape with Ferryboat and Windmill*, 1625, Foundation E. G. Bührle Collection, Zurich, no. 152).[11] The bustling river traffic in Salomon's paintings also serves to remind us how important the vast network of inland waterways was for commerce, trade, communication, indeed even culture in the Netherlands. The canals and rivers not only provided a cheap and ready source of transportation, but also insolubly wed the Dutch civilization to the water in the same way that inhabitants of other, drier lands have relied on roads and footpaths.[12]

While this painting was in the collection of Alfred Beit on Park Lane in London it was hung in the Billiard Room with three other truly outstanding Dutch landscapes: Jacob van Ruisdael's *Castle of Bentheim* of 1653 (Cat. 57, [Ruisdael], fig. 2), Meindert Hobbema's *Wooded Landscape with Castle* of 1663, both of which have now been given to the National Gallery of Ireland in Dublin, and Jacob van Ruisdael's *Rough Sea*, now in the Museum of Fine Arts, Boston (no. 57.4). As Wilhelm Bode explained in the 1904 catalogue of the Beit Collection, these four works were hung together because they represented three generations of landscape painters with examples that were all painted about the same time. The Salomon, according to Bode, was an 'exceptionally fine and ably executed picture', representative of a 'national movement [which first] discovered the beauty of its own country and . . . understood how to reproduce its atmosphere on canvas by simple means . . . A composition on broad free lines was no more his intention than was it his endeavour to strive after poetic feeling. The prevailing note in this picture is its whole tone, the actual colouring being only a secondary consideration. The details are worked out in a typical and even somewhat affected manner'.[13]

1 Stechow 1938/1975, no. 447.

2 Steechow 1938/1975, no. 368A.

3 Stechow 1938/1975, no. 363 (panel 54 × 84 cm.); see The Hague, Mauritshuis, *Terugzien in bewondering*, 19 February–9 March 1982, cat. 74, ill.

4 Stechow 1938/1975, no. 363A, pl. 36; see also John Walsh Jr and Cynthia Schneider, in Los Angeles, Los Angeles County Museum of Art, *A Mirror of Nature: Dutch Paintings from the Collection of Mr and Mrs Edward William Carter*, 13 October 1981–3 January 1982 (also shown at Museum of Fine Arts, Boston, 20 January–14 March 1982, and The Metropolitan Museum of Art, New York, 7 April–20 June 1982), cat. no. 22 (52 × 83.3 cm.).

5 With Nijenrode Castle, Stechow 1938/1975, no. 365 (77.5 × 114 cm.).

6 Stechow 1938/1975, no. 366 (77.5 × 114 cm.).

7 Stechow 1938/1975, no. 367 (98 × 143 cm.).

8 Copenhagen cat. (1951), p. 281, no. 629; Stechow 1938/1975, no. 320 (panel 68 × 101 cm.).

9 Stechow 1938/1975, no. 357 (panel 91 × 126 cm.); see Amsterdam/Boston/Philadelphia 1987–8, no. 94.

10 See D. Franken and J. P. van der Kellen, *L'Œuvre de Jan van de Velde* (Amsterdam, 1883; reprint Amsterdam, 1968), no. 406.

11 For the Brueghel, van de Velde and van Goyen, see Amsterdam/Boston/Philadelphia 1987–8, cat. 94, fig. 1, cats. 106 and 33.

12 On the importance of Dutch waterways, see the various publications of J. de Vries, including *The Dutch Rural Economy of the Golden Age* (New Haven, 1974); *Barges and Capitalism: Passenger Transportation in the Dutch Economy 1632–1839* (Utrecht, 1981); and 'The Dutch Rural Economy and the Landscape: 1590–1650', in London, National Gallery, *Dutch Landscape: The Early Years, Haarlem and Amsterdam*, 1986, pp. 79–83. On the history and administration (*heemraadschap*) of Dutch hydraulic systems, see H. van der Linden, 'Iets over wording, ontwikkeling en landschappelijk spoor van de Hollandse waterschappen', in *Land en Water* (Amsterdam, 1978), pp. 101–13; and S. J. Fockema Andrae, *Overzicht van de Nederlandse waterschapsgeschiedenis* (Leiden, 1952).

13 Bode 1904, pp. 16–17.

FIG. 2 Salomon van Ruysdael, *River Landscape with a Road*, 1652, signed and dated 1652, oil on panel 68.5 × 101 cm., Statens Museum for Kunst, Copenhagen, no. 629.

FIG. 3 Salomon van Ruysdael, *River Landscape with Ferry*, 1649, signed and dated 1649, oil on panel 91 × 126 cm., formerly Charles Cunningham Collection, now on loan to the National Gallery, London.

FIG. 1 Salomon van Ruysdael, *River Landscape with Liesvelt Castle*, signed and dated 1642, oil on panel 73 × 106 cm., Bayerische Staatsgemäldesammlungen, Alte Pinakothek, Munich, no. 2718.

FLORIS VAN SCHOOTEN

(ACTIVE IN HAARLEM 1612–1655)

Floris van Schooten was the son of Gerrit Jacobsz van Schooten, and apparently lived in Haarlem his entire life. In 1612 he married Ryckloet Willems, daughter of Willem Gerritsz Bol. The couple began their life together with substantial financial support; her father gave her 1200 fl. and his father gave him 1000 fl. Van Schooten became a dean of the Haarlem St Luke's guild in 1639, and in 1640 was nominated to be treasurer. He was active in Haarlem until at least 1655.

Van Schooten was primarily a painter of market and kitchen still lifes, kitchen utensils and fruit still lifes. Gammelbo (1966) catalogued more than one hundred works by the artist with dates ranging from 1617 to 1644. From 1617 he painted horizontal breakfast pieces with additive compositions and strong local colouring, which closely resemble those painted by his fellow Haarlemmers, Nicolaes Gillis (c. 1580–after 1632) and Floris van Dyck (1575–1651). In his early years and through the 1620s he also executed market and kitchen scenes with figures in the tradition of the sixteenth-century Flemish artists Pieter Aertsen and Joachim Beuckelaer and their later Dutch followers, such as Cornelis Jacobsz Delff and Cornelis Engelsz Verspronck; however, van Schooten's figures are consistently more rigid and wooden than any by these predecessors. Van Schooten's 'monochrome' breakfast pieces begin in the mid 1620s. His tabletop still lifes with fruit, cheese and bread from the 1640s are perhaps his best known-works.

LITERATURE: A.P.A. Vorenkamp, *Bijdragen tot de geschiedenis van het Hollandsch stilleven in de zeventiende eeuw* (dissertation, Leiden, 1933), p. 258; N .R. A. Vroom, *De Schilders van het monochrome banketje* (Amsterdam, 1945); Ingvar Bergström, *Dutch Still Life Painting in the Seventeenth Century* (New York, 1956), pp. 103–4, 134–7; Paul Gammelbo, 'Floris Gerritsz. van Schooten', *Nederlands Kunsthistorisch Jaarboek*, vol. 17 (1966), pp. 105–42; N. R. A. Vroom, *A Modest Message as intimated by the painters of the 'Monochrome Banketje'* (Schiedam, 1980), vol. 1, pp. 79–87, vol. 2, cats. 562–627.

CAT. 63

Still Life with Beaker, Cheese, Butter and Biscuits

Initialled lower left on table edge: F V S
Oil on panel 15½ × 22⅝ in. (39.5 × 57.5 cm.)

PROVENANCE: Sale Erich Ehlermann, Dresden, 1928, no. 28, ill.; Leonard Koetser, London, 1961; acquired from Edward Speelman in 1968.

EXHIBITION: London, Leonard Koetser Gallery, Autumn Exhibition, 1961, cat. p. 27, ill.; London 1988, no. 63.

LITERATURE: N. R. A. Vroom, *De Schilders van het monochrome banketje* (Amsterdam, 1945), no. 260; *The Burlington Magazine*, vol. 103 (October 1961), p. xxv, ill. (November 1961), p. xxv, ill. (advs. for L. Koetser); *Weltkunst*, 15 October 1961, p. 25, ill. (adv. for L. Koetser); *Connoisseur*, October 1961, p. lxxix, ill. (adv. for L. Koetser); *Illustrated London News*, 21 October 1961, p. 650, ill.; Paul Gammelbo, 'Floris Gerritsz van Schooten', *Nederlands Kunsthistorisch Jaarboek*, vol. 17 (1966), p. 136, no. 87; N. R. A. Vroom, A Modest Message as *Intimated by the Painters of the 'Monochrome Banketje'* (Schiedam, 1980), vol. 1, p. 80, fig. 98, vol. 2, p. 116, no. 591; Onno ter Kuile, *Seventeenth-Century North Netherlandish Still Lifes*, Rijksdienst Beeldende Kunst, vol. 6 (The Hague, 1985), p. 164, note 2; Russell 1988, p. 788.

CONDITION NOTES: The wood panel support is comprised of two horizontal planks with a seam 6¾ in. (17 cm.) from the top edge. There is evidence in the wood of old insect damage. The paint film

is generally in good condition, but there has been some lifting paint at the left where the panels are joined, and some old repaint in this area and along the panel's edges. The shadow on the cheese has been strengthened. The varnish is only mildly discoloured. An old inventory sticker on the back reads '13' or J3' and a partially effaced inscription reads 'Pet . . . Stosskop[?]'

In the centre of a table partly covered with a white cloth is a metal beaker on a pewter dish. To the right is a large yellow cheese surmounted by a smaller dark cheese, presumably a mature Edam, on a pewter dish, with two biscuits before it. To the left is a ceramic dish with butter, a walnut, two hazelnut shells and a knife.

Van Schooten's varied still lifes offer a fairly representative sampling of the stylistic development of the painting type from its sixteenth-century Flemish roots in market and kitchen scenes, to its fruition in mid seventeenth-century Dutch breakfast (*ontbijtje*) and fruit still lifes (see the general comments about the artist's œuvre in the biography above). Though undated, the type of simplified and restrained still life depicted in the Samuel painting surely postdates van Schooten's more elaborate early additive still lifes of c. 1617.[1]

Assigning a more exact date to the work is complicated by the paucity of dated paintings in van Schooten's œuvre. The painting has more points of comparison, both in design and shared motifs, with the artist's small *Still Life with Beaker, Butter Dish and Grapes* of 1642 (fig. 1)[2] than with the large *Fruit and Kitchen Utensils Still Life* dated 1630 (Private Collection, The Netherlands).[3] The same metal beaker with engraved decoration and moulded border on the foot appears in many of van Schooten's undated still lifes, including the paintings in Poznań (fig. 2),[4] formerly with Richard Green, London (fig. 3),[5] formerly with S. Nystad, The Hague,[6] the Musée des Beaux-Arts, Brussels, (No. 1149),[7] Kunsthalle, Hamburg (no. 508),[8] Landesmuseum, Düsseldorf (inv. 339),[9] and the Rijksdienst Beeldende Kunst, The Hague (inv. no. NK 2457),[10] suggesting that like many other Dutch still life painters of the period, he worked from a limited stock of objects. The simplicity of the design and the restrained palette of the Samuel painting calls to mind the 'tonal' still lifes that van Schooten's fellow Haarlemmers, Willem Claesz Heda (1593/4–1680/2) and especially Pieter Claesz (q.v.), developed in the late 1620s and 1630s. However, van Schooten's touch remains conspicuously drier and his colouring tends more to steely greys than to the blond and brown tonalities of these other masters.

There have been some unconvincing efforts to endow similarly unpretentious images of meals with cheeses with

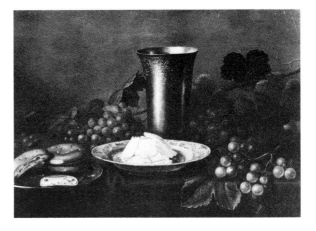

FIG. 1 Floris van Schooten, *Still Life with Beaker, Butter Dish and Grapes*, signed and dated 1642, panel 38 × 54 cm., Private Collection.

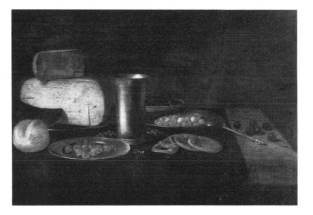

FIG. 2 Floris van Schooten, *Still Life with Beaker, Cheese, Bread, Fruit and Biscuits*, panel 52.5 × 84 cm., Muzeum Narodwe, Poznań, inv. no. 828.

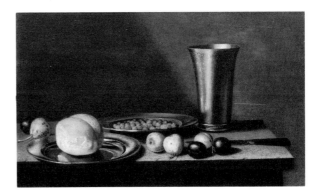

FIG. 3 Floris van Schooten, *Still Life with Beaker, Bread and Fruit*, panel 32.4 × 54.6 cm., formerly with Richard Green, London.

symbolic dimensions. One far-fetched interpretation even suggested that the cheese in such scenes symbolizes the Transubstantiated Body of Christ.[11] However, the subject probably had less pretentious or portentous associations. A staple of the Dutchman's diet, the simple meal of cheese, like the herring, was the most quotidian of fare. Indeed in Jacob Westerbaen's poetry, a cheese-munching character named Kees (*Kaas* is cheese in Dutch) epitomizes all the Dutchman's simple, hard-working and unaffected virtues, while being juxtaposed with an effete and idle patrician named Tijs, who dines on partridges.[12] On the other hand the combination of cheese and butter was generally considered in the seventeenth century to be a wasteful luxury. In a legend, Prince Maurits fell into a quarrel with the skipper of a ship, because he, the prince, placed a piece of cheese on a slice of bread that was already buttered; and in Simon de Vries' comedy published in 1682, *De zeven duivelen regerende en vervoerende de hedendaagsche dienstmaagden* (The seven devils governing and tempting present-day maidservants), one of the most serious transgressions is butter with cheese ('zuivel op zuivel, is 't werk van den duivel').[13]

1 See the *Breakfast Piece with Meat and Cheese*, signed and dated 1617, canvas 80 × 113 cm., Private Collection, Switzerland; Gammelbo 1966, no. 56, fig. 20; Vroom 1980, cat. no. 562, figs. 2, 154.

2 Gammelbo 1966, no. 88, fig. 33; Vroom 1980, no. 606, ill.

3 Panel 83 × 128 cm., Vroom 1980, no. 564, ill. (exh. Auckland, Auckland City Art Gallery, *Still-Life in the Age of Rembrandt*, (catalogue by E. de Jongh *et al.*), 1982, no. 5).

4 Gammelbo 1966, no. 79, fig. 29; Vroom 1980, no. 598, fig. 106.

5 Vroom 1980, no. 589, fig. 103.

6 Vroom 1980, no. 614, fig. 105.

7. Gammelbo 1966, no. 71; Vroom 1980, no. 588, ill.

8 Gammelbo 1966, no. 73; Vroom 1980, no. 594, ill.

9 Gammelbo 1966, no. 74; Vroom 1980, no. 595, ill.

10 Cat. (ter Kuile) 1985, no. VI-51, ill; Gammelbo 1966, no. 69, fig. 25; Vroom 1980, no. 586, ill.

11 J. Lammers, 'Fasten und Genuss', in exh. cat. Münster/Baden-Baden, *Stilleben in Europa*, 1979, pp. 406–7. See Eddy de Jongh's criticism of such overreading in Auckland, New Zealand, 'The Interpretation of Still Life Paintings: Possibilities and Limits', in *Dutch Still Life Painting*, 1983, p. 67, where he notes 'Cheese . . . was rarely consumed on an allegorical level in the seventeenth century.' For additional symbolic associations of cheese, see Sam Segal, *A Prosperous Past. The Sumptuous Still Life in The Netherlands 1600–1700* (The Hague, 1988), p. 73.

12 For discussion and a translation, see Simon Schama, *The Embarrassment of Riches, An Interpretation of Dutch Culture in the Golden Age* (New York, 1987), p. 164.

13 Cited by de Jongh, in Auckland exh. 1983, p. 68.

PIETER CORNELIS VAN SLINGELANDT

(LEIDEN 1640–1691 LEIDEN)

According to Houbraken, Pieter van Slingelandt was born on the Oude Vest in Leiden on 10 October 1640, the son of the bricklayer Cornelis Pietersz van Slingelandt and Trijntje van Polanen. Pieter was baptized in the Hooglandse Kerk on 4 November 1640. In all likelihood he was a student of Gerard Dou (q.v.), because as early as 1672 he was mentioned by Simon van Leeuwen (*Korte beschrijving van het Lugdunum Batavorum nu Leyden* (Leiden, 1672), pp. 191–2), together with Frans van Mieris, as 'one who was reared by' ('een opkwekeling van') or a protégé of Dou, and who one day might even surpass his master. In 1661 he enrolled in the St Luke's Guild, to which he paid dues from 1662 to 1668 and from 1673 to 1680 (during the period 1669–72 dues were not regularly collected by the guild). In 1690 Slingelandt was named *hoofdman* and in 1691 *deken* in the guild. Like Dou and van Mieris he was apparently very well paid. Balthasar Monconys complained in his journal in 1663 about the price of 400 livres demanded by the young Slingelandt for a single small painting. However, according to Houbraken, Slingelandt earned more fame than money for his time-consuming working methods. The writer claimed that he would work for four to six weeks on a single 'bef met kant' (band of lace). Documents further suggest that Slingelandt worked more than two years on a portrait of the Meerman family for which he received the substantial sum of 1500 fl.; a law suit protracted the time for the work's delivery to fourteen years from the original date of commission. Jacob van der Sluis (c. 1660–1732) and Jan Fielius are mentioned as Slingelandt's pupils. Although there are several purported portraits of the artist and his family, there is no record that he was ever married. Slingelandt died on 7 November 1691 and was buried in the Pieterskerk in Leiden.

A painter, draughtsman and printmaker, Slingelandt specialized in domestic and high-life genre scenes and elegant portraits in the style of the Leiden *fijnschilders* Gerard Dou and Frans van Mieris (qq.v.). He closely imitated Dou's themes and figure types and paraphrased or recast narratives invented by van Mieris and Gabriel Metsu, but his touch was harder and colours more insistent and enamel-like; Houbraken already recognized these features of Slingelandt's style in 1721 when he noted that his extreme elaboration and polishing of details ('uitvoerigheit en gepolystheit') created a more laboured or stiffer ('styver') effect than in Dou's art. And John Smith observed in 1829 that Slingelandt's 'excessive attention to minutiae . . . fails in its intended object; namely a faithful representation of nature'; nevertheless, the very fact that Smith included him in his famous *catalogue raisonné* implied that he regarded him as one of 'the most eminent painters' of the Dutch School.

LITERATURE: B. de Monconys, *Journal des voyages de monsieur de Monconys*, 2 vols. (Lyons 1665–6), vol. 1, p. 157; Simon van Leeuwen, *Korte beschrijving van het Lugdunum Batavorum nu Leyden* (Leiden, 1672); Houbraken, vol. 3 (1721), p. 161; Descamps, vol. 3 (1760), p. 98; Smith, vol. 1 (1829); Immerzeel, vol. 3 (1843), p. 92; Kramm 1857–64, vol. 5, p. 1527; Obreen, vol. 5 (1882–5), p. 254; Wurzbach, vol. 2 (1910), p. 625; Hofstede de Groot, vol. 5 (1913); E. Trautscholdt, in Thieme and Becker vol. 31 (1937), pp. 136–7; Eduard Plietzsch, *Hollandische und Fläamische Maler des XVII. Jahrhunderts* (Leipzig, 1960), pp. 80ff.; R. E. O. Ekkart, 'Het portret van de familie Meerman door Pieter van Slingelandt', *De arte et libris; Festschrift Erasmus* (Amsterdam, 1984), pp. 69–74; Leiden, Stedelijk Museum de Lakenhal, *Leidse Fijnschilders. Van Gerrit Dou tot Frans van Mieris de Jonge 1630–1760* (cat. by E. J. Sluijter *et al.*), 1988, pp. 205–13; Amsterdam, Rijksmuseum, *De Hollandse fijnschilders van Gerard Dou tot Adriaen van der Werff* (cat. by Pieter Hecht), 1989, pp. 46–8.

CAT. 64

Woman Making Lace with Two Children, late 1660s or c. 1670

Formerly signed in full by Slingelandt
Oil on panel 18⅝ × 15½ in. (47.5 × 39.4 cm.)

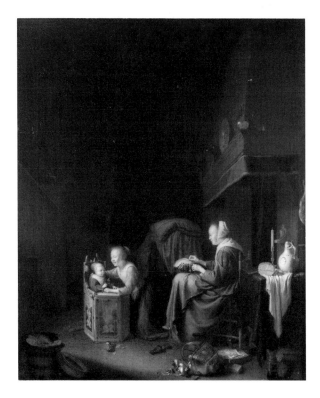

PROVENANCE: Sale Antoni Bierens, Amsterdam, 20 July 1747, no. 2 (1250 fl., to Jacob Bierens – see Hoet); in the collection of Jacob Bierens, 1752 (see Hoet); Madame Backer (De Haan)-Bierens, Amsterdam, 1842 (see Smith *Suppl.*); sale D. Bierens, Amsterdam, 15 November 1881, no. 17; sale E. Secretan, Paris, 1 July 1889, no. 162; dealer Charles Sedelmeyer, Paris; dealer D. Katz, Dieren (see exh.) [as Dou and hereafter]; Private Collection, Twenthe 1938 (see exh.); Mevr. E.M.E. ten Bos-Verheyden, Almelo, 1953 and 1955 (see exhs.); acquired from Edward Speelman in 1958.

EXHIBITIONS: Amsterdam, *Tentoonstelling van Schilderijen door Oude Meesters te Amsterdam*, 1845, no. 23 [as Pieter van Slingerland (sic.), lent anonymously]; Rotterdam, Boymans Museum, *Meesterwerken uit vier eeuwen 1440–1800*, 25 June–15 October 1938, no. 69, fig. 167 [as G. Dou]; Almelo, De Waag, *Oude Kunst uit Twents bezit*, 31 October–30 November 1953, no. 13, fig. 137 [as G. Dou]; Rotterdam, Museum Boymans, *Kunstschatten uit Nederlandse verzamelingen*, 19 June–25 August 1955, no. 59, fig. 139 [as G. Dou]; London 1988, no. 18 [as G. Dou].

LITERATURE: Hoet, vol. 2 (1752), p. 198; Smith, vol. 1 (1829), no. 6; *Suppl.* (1842), no. 4; (not in Martin 1901 or 1913); Hofstede de

Groot, vol. 5 (1913), pp. 434–5, no. 41; Werner Sumowski, *Gemälde der Rembrandt Schüler* (Landau/Pfaltz, 1983), vol. 1, no. 285, ill. [as G. Dou, c.1655–60]; Russell 1988, p. 788 [as G. Dou].

CONDITION NOTES: The panel support is uncradled and in good condition. The back has been painted with grainy brown paint. The paint film is also in very good condition, with several minor areas of old abrasion such as in the shadow of the hearth; scattered tiny repaints appear in the darks in the background. Some incipient cleavage formerly appeared in the flask of red wine on the mantel (repainted?). The varnish is only mildly discoloured.

A young woman making lace is seated in profile to the viewer's left. She wears a purple jacket, brown skirt and blue apron, and holds in her lap a lace-maker's pillow and bobbins. To the left a young girl holding a rattle leans forward and smiles at a baby in an infant's seat decorated with a painting of a red bird sitting in a tree. The baby holds a flower (lily of the valley?) in its hand. To the right is a tall fireplace, with two pewter plates, three glasses and a decanter of red wine on the mantel shelf. In the foreground is a table with a green cover, white napkin, ceramic jug decorated with a seal with double eagles, bread, nuts and shells, a knife, can and candlestick. On the floor on the lower right are an overturned copper shopping pail with turnips, books and pamphlets and a thimble. To the left are a bucket and a plate with a fish. The woman has removed her shoe to place her red-stockinged foot on a footwarmer. A bed with the bedclothes turned over to air appears in the background. At the back left is a staircase with cellar and barrel below.

This painting was sold repeatedly in the eighteenth and nineteenth centuries as the work of Pieter Cornelisz van Slingelandt, and was catalogued by Smith and Hofstede de Groot as a fully signed work by the master. Exactly when Slingelandt's signature disappeared (presumably it was effaced or overpainted) is unknown, but in 1938 the dealer Katz exhibited the painting in Rotterdam as the work of Slinglandt's more famous teacher, Gerard Dou (q.v.), and the misattribution has been retained until now. Slingelandt was a close follower of Dou but developed his own distinctive palette and touch. Together with Frans van Mieris, who was five years older, he is regarded as Dou's most accomplished pupil. His personal *fijnschilder* style was much admired in the eighteenth and early nineteenth century, with the result that he was included in John Smith's *Catalogue Raisonné of the Works of the Most Eminent Dutch Painters of the Seventeenth Century* (London, 1829). Like other Leiden fijnschilders, Slingelandt was largely neglected in the first half of the twentieth century. Interest in his art has only recently been revived.[1]

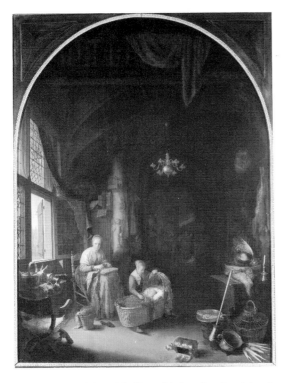

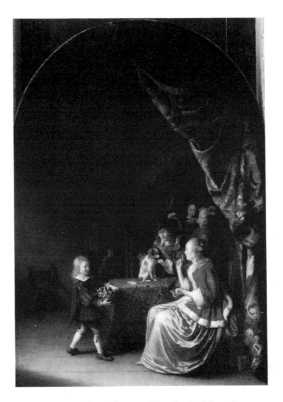

FIG. 1 Gerard Dou, *The Young Mother*, signed and dated 1658, oil on panel 29 × 22 in., Mauritshuis, The Hague, no. 32.

FIG. 3 Pieter Cornelisz van Slingelandt, *Merry Company*, signed and dated 1663, oil on panel 43.5 × 30 cm., Statens Museum for Kunst, Copenhagen, no. 665.

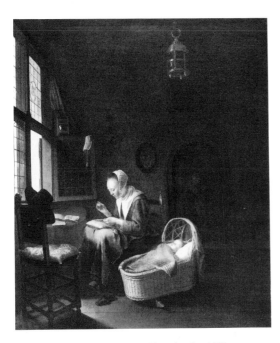

FIG. 2 Pieter Cornelisz van Slingelandt, *A Woman Sewing*, signed, oil on panel 19½ × 15½ in., Alte Pinakothek, Munich, no. 553.

It is scarcely surprising, therefore, that Lord Samuel's painting should have been mistaken for Dou's work, since it is clearly inspired by paintings like the latter's so-called *Young Mother* of 1658 (fig. 1).[2] However when the style of the Samuel painting is compared to Slingelandt's *Woman Sewing* (fig. 2) in Munich the two hands are identical.[3] The figure type also may be compared in details to other works by Slingelandt; for example, the young girl closely resembles the *Girl Feeding a Parrot* in the Eckstein sale, London (Sotheby's) 8 December 1948, no. 24, ill.[4] The painting cannot be dated precisely, but may have been executed in the late 1660s or c. 1670; this dating is deduced from the fact that it probably did not predate Slingelandt's early *Merry Company* of 1663 in the Statens Museum, Copenhagen (fig. 3) or postdate the well-known and somewhat more slickly executed *Poultry Dealer at the Window* and *Unmusical Dog*, both of 1672, in the Gemäldegalerie, Dresden (respectively nos. 1762 and 1761).[5]

1 See Otto Naumann, *Frans van Mieris the Elder*, 2 vols. (Doornspijk, 1981); Leiden, Stedelijk Museum 'de Lakenhal', *Leidse Fijnschilders. Van Gerrit Dou tot Frans van Mieris de Jonge 1630–1670*, ed. Eric Jan Sluijter *et al.*, 1988; Amsterdam, Rijksmuseum, *De Hollandse fijnschilders. Van Gerard Dou tot Adriaen van der Werff*, (catalogue by Peter Hecht), 1989.

2 Hofstede de Groot, vol. 1 (1908), no. 110; compare also Dou's *Lacemaker* (W. Martin, *Gerard Dou*, Klassiker der Kunst (Stuttgart, 1913), no. 105) and *Young Woman with Infant and a Cradle* in Buckingham Palace (Martin 1913, no. 92).

3 Hofstede de Groot, vol. 5 (1913), no. 35. Compare also the domestic scene, *Nursing Mother* by Slingelandt (with remnants of a signature), in the Staatliche Kunsthalle, Karlsruhe, no. 269 (panel 52 × 41.5 cm.); Sumowski vol. 1 (1983), p. 508, ill.

4 Hofstede de Groot, vol. 5 (1913), no. 111; see *The Burlington Magazine*, vol. 90 (June 1948), p. 174.

5 Hofstede de Groot, vol. 5 (1913), nos. 12 and 93.

JAN STEEN

(LEIDEN 1625/6–1679 LEIDEN)

Steen was born in Leiden, the son of a brewer. His date of birth has not been pinpointed, but in 1646, when he matriculated at Leiden University, he was recorded as being twenty years old; hence, he must have been born in 1625 or 1626. His training as an artist probably did not begin until after his stay at the university. Arnold Houbraken claimed that he was a pupil of the landscapist Jan van Goyen (q.v.), whose daughter he married. J. C. Weyerman further claimed that he studied successively with Nicolaes Knüpfer (c. 1603–55) at Utrecht, Adriaen van Ostade (q.v.) at Haarlem and, last, Jan van Goyen at The Hague. Steen is recorded in Leiden between 1644 and 1646. In March 1648 he became a member of the newly founded St Luke's Guild in Leiden, indicating that in the relatively brief period of two years he had become an independent master. By September 1649 he was living in The Hague and was married there to Margarethe van Goyen. Although he was still living in The Hague in July 1654, in April 1653 he had paid dues to the Leiden guild. His father leased a brewery for him at Delft from 1654 to 1657, and he painted a Delft scene in 1655; but there is no proof that he ever resided or remained long in that city. From 1656 to 1660 he was living in a small house in Warmond several miles from Leiden. By 1661 he had settled in Haarlem, where he entered the guild in the same year and is recorded until 1670, when he inherited a house in Leiden. Until the end of his life he evidently remained in Leiden, where he obtained permission to open an inn in 1672 and served as *hoofdman*, or leader, of the guild in 1671, 1672 and 1673 and dean in 1674. He was buried in Leiden on 3 February 1679.

Steen is best known for his humorous genre scenes, but he also painted religious, mythological and historical subjects. His works reveal a knowledge of contemporary literature and the theatre. Although recent efforts have reduced the size of his accepted œuvre, he must have been an exceptionally prolific artist.

LITERATURE: Houbraken 1718–21, vol. 1, p. 374, vol. 2, p. 245, vol. 3, pp. 7, 12–30; J.C. Weyerman, *De levens beschryvingen der nederlandsche konstschilders*, vol. 2 (The Hague, 1729), p. 348; Tobias van Westrheene, *Jan Steen: étude sur l'art en Hollande* (Haarlem, 1856); van der Willigen 1870, pp. 38, 267–70; Obreen 1877–90, vol. 5, pp. 182–3, 207, 250; Hofstede de Groot 1908–27, vol. 1 (1908), pp. 1–252; Wurzbach 1906–11, vol. 2, pp. 655–8; J. B. F. van Gils, 'Jan Steen en de rederijkers', *Oud-Holland*, vol. 52 (1935), pp. 130–3; Willem Martin, 'Jan Steen as a Landscape Painter', *The Burlington Magazine*, vol. 67, no. 392 (November 1935), pp. 211–12; London, Dowdeswell and Dowdeswell, *Jan Steen*, 1909; C. J. H[olmes], 'Notes on the Chronology of Jan Steen', *The Burlington Magazine*, vol. 15, no. 76 (July 1909), pp. 243–4; Abraham Bredius, *Jan Steen* (Amsterdam, 1927); E. Trautscholdt, in Thieme and Becker 1907–50, vol. 31 (1937), pp. 509–15; Albert Heppner, 'The Popular Theatre of the Rederijkers in the Work of Jan Steen and His Contemporaries', *Journal of the Warburg and Courtauld Institutes*, vol. 3 (1939–40), pp. 22–48; S. J. Gudlaugsson, *The Comedians in the Work of Jan Steen and His Contemporaries*, translated by James Brockway and Patricia Wadle (Soest, 1975); Horst Gerson, 'Landschappen van Jan Steen', *Kunsthistorische mededelingen van het Rijksbureau voor Kunsthistorische Documentatie*, vol. 3, no. 4 (1948), pp. 50–6; Willem Martin, *Jan Steen* (Amsterdam, 1954); C. H. de Jonge, *Jan Steen* (Amsterdam, 1939); Cornelis Wilhemus de Groot, *Jan Steen: Beeld en woord* (Utrecht, 1952); P. N. H. Domela Niewenhuis, *Jan Steen: Catalogus van de tentoonstelling* (The Hague, 1958–9); Lyckle de Vries, *Jan Steen: De schilderende Uilenspiegel* (Weert, 1976); Baruch D. Kirschenbaum, *The Religious and Historical Paintings of Jan Steen* (New York, 1977); Lyckle de Vries, 'Jan Steen "de kluchtschilder"', dissertation, Groningen, 1977; Karel Braun, *Alle tot nu toe bekende schilderijen van Jan Steen* (Rotterdam, 1980); Peter C. Sutton and Marigene H. Butler, 'Jan Steen: Comedy and Admonition', *Bulletin of the Philadelphia Museum of Art*, vol. 78, nos. 337–8 (Winter 1982–Spring 1983); Sutton *et al.* 1984, pp. 307–25; Lyckle de Vries, 'Jan Steen zwischen Genre- und Historienmalerei', *Niederdeutsche Beiträge zur Kunstgeschichte*, vol. 22 (1984), pp. 118–28; John Walsh, 'Jan Steen's *Drawing Lesson* and the Training of Artists', *Source*, vols. 8–9 (Summer–Fall, 1989), pp. 80–86; Leo Steinberg, 'Steen's Female Gaze and Other Ironies', *Artibus et Historiae*, vol. 22 (1990), pp. 107–28.

CAT. 65

The Sleeping Couple, c. 1658–60

Signed with initials on the stone plinth lower left: IS
Oil on copper 7⅜ × 9⅝ in. (18.7 × 24.5 cm.)

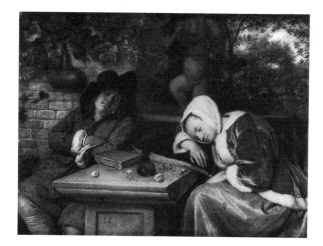

PROVENANCE: (Possibly) sale G. van Oostrum of Heusden, The Hague, 23 September 1765, no. 64 (16 fl.); Cardinal Joseph Fesch (1763–1839), Palazzo Falconieri, Rome; sale Cardinal Fesch, Rome, 17 March 1845, no. 227 (5500 fl. to Baron J. de Rothschild); (possibly but doubtfully) Cavens Collection, Brussels, 1907; Robert de Rothschild, Paris; Etienne Nicolas, Paris, by 1954, who sold it to Speelman late in 1959; acquired from Edward Speelman.

EXHIBITION: London 1988, no. 64, ill. p. 23.

LITERATURE: (Possibly) Terwesten, vol. 3 (1770), [reference to G. van Oostrum Sale]; Smith, vol. 4 (1833), no. 93; (probably) *Catalogue des tableaux composant la galerie de feu son éminence le Cardinal Fesch* (Rome, 1841), no. 331; 'Vente de la Galerie Fesch à Rome', *Le Cabinet de l'amateur et de l'antiquaire*, vol. 4 (1845 and 1846), p. 283 [as sold to Baron J. de Rothschild]; Tobias van Westrheene, *Jan Steen: étude sur l'art en Hollande* (The Hague, 1856), no. 472 and (possibly) no. 369; Hofstede de Groot, vol. 1 (1908), no. 373, and (possibly) 759 and/or 756; Karel Braun, *Alle tot nu toe bekende schilderijen van Jan Steen* (Rotterdam, 1980), no. 93, ill; Russell 1988, p. 788; Woodhouse 1988, pp. 124, 127, fig. 2; Speelman 1988, p. 14.

CONDITION NOTES: The copper support for the painting is the back of an engraving plate (see Commentary). It is in plane and in good condition. The paint film is in very good condition with minor retouches along the edges and scattered throughout. Several minor pentimenti are visible, for example in the seam that divides the two halves of the pillow. A change in hue (common to later Dutch paintings) in the greens of the foliage in the right distance has turned the leaves a chalky blue. The varnish is relatively clear. On the reverse of the panel, in addition to the incised lines of the engraving mentioned above, are the seal of Cardinal Fesch's Collection and the number 'B.27' in white paint.

On either side of a stone plinth that serves as a table, a man and a woman have fallen asleep. Before them are shards of walnuts, a small wine carafe and a closed book. The woman rests her head and arm on a blue and salmon-pink pillow. She wears a red jacket with white fur trim, a blue satin skirt and a white head-dress. The man sleeps with crossed arms and leans back against a brick wall. His black slouch hat is cocked to one side and he wears red knee socks beneath his brown costume. Above him on the wall are vines with bunches of grapes and a wine sack. Behind the woman is a fountain with a urinating putto holding a wild boar on his shoulders. In the background on the right is a balustrade with a flower pot and a view of trees.

Jan Steen frequently painted figures asleep or dozing off. Usually their slumber is brought on by strong drink and excessive eating and smoking. Sleeping drunks of both genders are satirized in his tavern scenes (see fig. 1);[1] drunken clients who fall asleep in bordellos are fleeced by prostitutes (see fig. 2);[2] and the sleeping parents in his several 'Dissolute Household' paintings snooze through the domestic havoc wreaked by their servants, children and pets.[3] Sleep, especially a drunken stupor, was associated with sloth, idleness and indolence and had traditionally been a subject to be admonished in depictions of the sin of Acedia, which was personified by a sleeping woman.[4] In a culture inculcated with the work ethic, Dutch moralists repeatedly condemned over-indulgent sleepers for bringing misfortune, above all poverty, upon themselves; the influential Dirck Volkersz Coornhert quoted the biblical proverb: 'For the drunkard and the glutton shall come to poverty, drowsiness shall clothe a man with rags, and slothfulness casteth into a deep sleep and an idle soul shall suffer hunger.'[5]

Lord Samuel's painting is most closely related to a larger painting, last seen in the de Ridder sale in 1924, that also depicts a midday nap (fig. 3).[6] That painting clearly depicts the arbour of a country house where a young woman, again clothed in a fur-trimmed jacket and white kerchief, has fallen asleep, her head resting on the table covered with the remnants of a meal. At the back sits the master of the house still reading his book, while beside him stands a maid-servant. Neither of these midday rest paintings convey for the modern viewer outward criticism of the siesta, but in the industrious climate of seventeenth-century Dutch society the admonishment to rich idlers could be implicit. Still another painting by Steen (fig. 4), or more likely a follower, depicts a family after a meal on an elegant terrace and again shows the mother asleep while the satin-clad father smokes extravagantly. Here, however, a more explicit

warning is introduced by the two children on the left who imitate their father's luxurious actions with the pipe as they cheerfully blow bubbles – a clear recollection of putti in *vanitas* representations of *Homo Bulla* (Man['s life] is like a bubble).[7] Steen took a mischievous delight in casting himself as the model for his most debauched characters, and his features are clearly recognizable in the male slumberer in the Samuel painting. Braun may also be correct in assuming that his wife, Grietje van Goyen, posed for the sleeping woman,[8] but there is no reason to suppose that Steen was recording his own life here or elsewhere in his art. This autobiographical fallacy has long obscured a deeper cultural understanding of Steen's art.

In the only published attempt to date the Samuel painting, Braun suggested that it might have been painted in 1656–60, thus predating the de Ridder sale painting, which he dated 1666–8. It is not clear that a full decade separates these two paintings, but the execution and small scale of the Samuel painting support the date in the late 1650s, or c. 1658–60.

The provenance of the Samuel painting has been confused and, owing to incomplete descriptions in early sales, can be only partially reconstructed. According to Braun (1980) and the files of the Rijksbureau voor Kunsthistorische Documentatie in The Hague, the painting is identical with Hofstede de Groot's no. 756, then in the Cavens Collection, Brussels, but that work was described only as 'Two Persons at Table Asleep [without support or dimensions]. It may be genuine but is in a bad state of preservation, and has no great artistic value'. There is no reason to question the Samuel painting's attribution, however, nor is the work in problematic condition. In the dealer Edward Speelman's records, it was assumed to be identical with Hofstede de Groot no. 759 (Smith 1833, no. 93; Westrheene 1856, no. 369), which was said to have passed through the van Oostrum (1765), Smeth van Alphen (1810) and Le Brun (1811) sales; but while the (composite) dimensions recorded by Hofstede de Groot accord, the support was said to be canvas and the cursory description differs in several minor details.[9] In Hoet and Terwesten's transcription (vol. 3) of the Burgomaster Gerard van Oostrum's 1765 sale, under entry no. 64 no measurements are provided and the description is inconclusive ('Een dito stuk verbeeldende Jan Steen en zyn vrouw die op haar arm aan een tafel te slapen zit, zeer natuurlyk en uitvoerig door hemzelf geschildert. 10-6 fl.'). Moreover the dimensions (22 × 30 in.) noted in the Pieter de Smeth van Alphen sale catalogue (1 August 1810, no. 97) accord better with the de Ridder collection picture (fig. 3).

The only certain nineteenth-century provenance for the picture, the collection of Cardinal Joseph Fesch (whose seal appears on the back) has previously been overlooked, but the respectable price that the picture received in the Fesch sale in 1845 (5500 fl.) suggests that the work was then regarded as of significant quality and in good state.[10] The painting is probably identical with the unattributed picture that was described in the 1841 catalogue of the Fesch collection as '*Deux petites demi-figures qui dorment*, La vérité la plus frappante s'y trouve réunie au fini le plus parfait' (7 × 9 'pouces').[11] Cardinal Fesch was the uncle of Napoleon I, and, as the young military commander of Imperial forces in Italy, assembled an extensive collection of paintings, 3326 of which appeared in the 1841 catalogue. His collection was estimated ultimately to have numbered as many as 14,000 objects.[12] According to a review of the Fesch sale in *Le Cabinet de l'amateur* (1845 and 1846), the Steen was purchased for Baron J. de Rothschild. The later Paris provenance (Robert de Rothschild and Etienne Nicolas) was provided by Speelman; a reference cited by Braun to the work's having been sold in 1965 in Majorca to an E. Ligtelijn from Hilversum is surely wrong.

The metal support for this painting is the back of a recycled plate for an engraving of the Virgin and Child, with the Madonna holding a flower (recalling Our Lady of Antigua or the Madonna of Seville) and a border of flowers encircling the image (see fig. 5). The plate is inscribed: 'SALVE PARVE PVER, SALVE VIRGVNCVLA MATER/TER FOELIX MATER, TER VENERANDE PVER' ('Hail little son, hail young Virgin, threefold blessed mother, threefold venerable son') and signed (by the publisher?) and numbered in the lower right 'Lanthiel CX'. Although no print from this plate has yet been identified, the plate itself appears to be a copy of a print of 1579 by the Wierixes (see fig. 6),[13] although the border of flowers is different. In both the plate and the print, the central image of the Virgin and Child is oriented towards the right, suggesting that the engraver copied directly from the print without, as one would expect, reversing the image. Dutch paintings executed on engraving plates are rare but not unprecedented,[14] and probably reflect economic constraints; copper was a relatively costly support.

A copy of the left-hand side of the Samuel composition depicting the sleeping man only is attributed to Frans van Mieris in the Musée des Beaux-Arts, Besançon.[15]

1 See as examples, Steen's *Tavern Scene with a Sleeping Woman and a Laughing Man Smoking*, in the Hermitage, St Petersburg (Hofstede de Groot, vol. 1 (1908), no. 758; Braun 1980, no. 104) and *The Effects of Intemperance (De Gevolgen van Onmatigheid)* in the National Gallery, London (Hofstede de Groot, vol. 1 (1908), no. 111; Braun 1980, no. 250) and his depiction of the drunkest imaginable couple in the painting in Rijksmuseum, Amsterdam, our fig. 1 (Hofstede de Groot, vol. 1 (1908) no. 100; Braun 1980, no. 327, ill.) that illustrates the popular saying depicted in the print on the wall 'Wat Baet er Kaers en Bril, als den Uyl niet Sien en Wil' (What need has the owl for candle or spectacles if he cannot or will not see) – an explicit condemnation of their besotted slumber.

2 Hofstede de Groot, vol. 1 (1908) no. 835; Braun 1980, no. 262.

3 Both parents sleep in Steen's *Dissolute Household* formerly in the Percy B. Meyer Collection (Hofstede de Groot, vol. 1 (1908), no. 110; Braun 1980, no. 190) in which a partially legible inscription on the letter on the floor reads 'Syt des slapend sot, vergeeten ge van godt', (To be a sleeping sot is to be forgotten by God). In Steen's famous version of this theme in the Wellington Museum, Apsley House, London (Hofstede de Groot, vol. 1 (1908), no. 109; Braun 1980, nos. 110, 197), the mistress of the household has fallen asleep before an enormous roemer of wine as the husband cavorts with a prostitute and the servant and children loot and ransack the house. On the Dissolute Household theme, see Simon Schama, 'The Unruly Realm: Appetite and Restraint in Seventeenth Century Holland', *Daedalus*, vol. 108, no. 3 (Summer 1979), pp. 103–23; P. C. Sutton in Philadelphia/Berlin/London 1984, cat. no. 109; and Nanette Salomon, 'Jan Steen's Formulations of the Dissolute Household, Sources and Meanings', in *Holländische Genremalerei im 17. Jahrhundert Symposium Berlin, 1984*, in *Jahrbuch Preussischer Kulturbesitz*, Sonderband vol. 4 (1987), pp. 315–43.

4 The sin of sloth (*Acedia, luiheid, traagheid*) was one of the seven deadly sins and was depicted by Philips Galle and others as a sleeping woman resting her head in her hand; see E. de Jongh *et al. Tot Lering en Vermaak* exh. cat. Rijksmuseum, Amsterdam, 16 September–5 December 1976, p. 145.

5 Salomon 1987, p. 45; Dirck van Coornheert, *Recht gebruyck ende misbruyek van tydelycke have* (Leiden, 1585), no. v.

6 Hofstede de Groot, vol. 1 (1908), no. 373; Braun 1980, no. 274.

7 Hofstede de Groot, vol. 1 (1908), no. 869; Braun 1980, no. B-263. Another version is in the Brera Gallery, Milan.

8 Braun 1980, p. 98, no. 93.

9 'A Couple Asleep. An interior with a man and woman asleep. The woman, wearing an orange jacket trimmed with white fur, leans on her right arm on a blue cushion. The man sits on the left, with his head on the table. "Painted in the manner of Metsu" (Smith) canvas, 7 in. by 9 in.'

10 Hofstede de Groot, vol. 1 (1908), no. 373. In the review of the sale in the *Cabinet de l'amateur*, vol. 4 (1845 & 1846), p. 283, is the description '*La Sieste*. Un bourgeois hollandais et sa femme endormie devant une table de pierre sur laquelle se trouvent quelques noix, une bouteille et un livre fermé. Adjugé à M. Claret.'

11 *Catalogue des tableaux composant la galerie de feu son éminence le Cardinal Fesch* (Rome, 1841), p. 17, no. 331.

12 On Cardinal Fesch and his collections, see Dorothy Carrington, 'Cardinal Fesch, a Grand Collector', *Apollo* (November 1967), pp. 346ff.; *New Catholic Encyclopedia* vol. 5

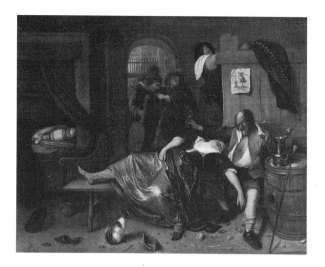

FIG. 1 Jan Steen, *Drunken Couple ('Wat Baet er Kaers en Brill, als den Uyl niet Sien en Wil')*, oil on panel 52.5 × 64 cm., Rijksmuseum, Amsterdam, no. C232.

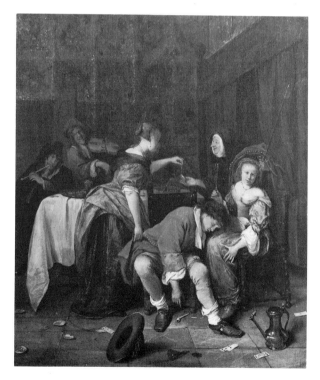

FIG. 2 Jan Steen, *Bad Company*, oil on panel 41.5 × 31.5 cm., Louvre, Paris, no. R.F. 301.

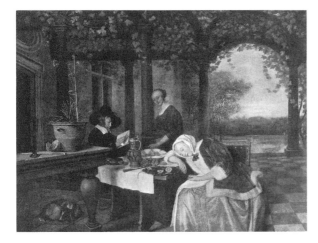

FIG. 3 Jan Steen, *The Midday Rest*, oil on canvas 58 × 75 cm., sale A. de Ridder, Paris, 2 June 1924.

FIG. 5 The back of the copper support.

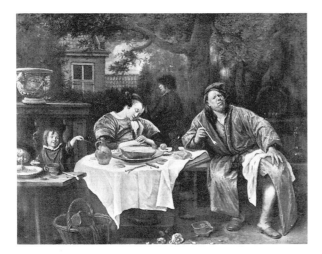

FIG. 4 Follower of Jan Steen (?), *Family on a Terrace after a Meal*, oil on panel 66 × 86 cm., formerly with Wildenstein's.

FIG. 6 Wierixes, *The Virgin and Child*, engraving, 1579.

(Washington, DC, 1967), p. 899; Michael Wynn, 'Seven Paintings from the Fesch Collection', *J. Paul Getty Museum Journal*, vol. 5 (1977), pp. 101–5; Michael Wynn, 'Fesch Paintings in the National Gallery of Ireland', in *Gazette des Beaux-Arts*, vol. 89 (January 1977), pp. 1–8; 'La Musée Fesch d'Ajaccio', *Connaissance des Arts* (October, 1988) pp. 63–72. Some of the Fesch paintings were sold in Paris as early as 17 June 1810, but the major sale was held in 17 March 1845, following the Cardinal's death in 1839 and the catalogue of the collection that was published in 1841.

13 See Marie Mauquoy-Hendrickx, *Les Estampes des Wierix conservées au cabinet des estampes de la Bibliothèque Royale Albert 1er*, vol. 1 (Brussels, 1978), p. 133, no. 741, pl. 99. I am grateful to John Chvostal and Stephanie Stepanek of the Prints and Drawings Department of the Museum of Fine Arts, Boston, for assisting in this identification.

14 A landscape by a van Goyen follower in the John G. Johnson Collection, Philadelphia (no. 505), is painted on the back of Gerard ter Borch the Elder's plate for a Lot and his Daughters of 1632.

15 Oil on copper 18.8 × 15.8 cm.; exhibited at the Musée des Arts Decoratifs, Paris, 1957

Musical Company (known as '*The Young Suitor*'), 1661 or 1664?

Signed above the keyboard: Jan Steen
Oil on canvas 25½ × 20¾ in. (64.7 × 51.6 cm.)

PROVENANCE: Sale Gaillard de Gagny, Paris, 29 March 1762, no. 22; sale David Fiers Kappeyne, Amsterdam, 25 April 1775, no. 91; R. Bishoffscheim, Paris; Michel Ephrussi, Paris; dealer Charles Sedelmeyer, Paris, cat. 1911, no. 42; J. Heugel, Paris, 1959 (see exh.); acquired from Edward Speelman in 1980.

EXHIBITIONS: Paris, Galerie Charpentier, *Danses et Divertissements*, 1948–9, no. 199; The Hague, Mauritshuis, *Jan Steen*, (cat. by P. N. H. Domela Niewenhuis), 20 December 1958–15 February 1959, no. 26, ill.; London 1988, no. 65.

LITERATURE: Tobias van Westrheene, *Jan Steen: études sur l'art en Hollande* (The Hague, 1856), no. 463; Hofstede de Groot, vol. 1 (1908), no. 427; A. Bredius, *Steen* (1927), no. 76; Karel Braun, *Alle tot nu toe bekende schilderijen van Jan Steen* (Rotterdam, 1980), no. 247; Peter C. Sutton and Marigene H. Butler, 'Jan Steen: Comedy and Admonition', *Bulletin of the Philadelphia Museum of Art*, vol. 78, nos. 337–8 (Winter 1982–Spring 1983), p. 43, under cat. no. 13; Russell 1988, p. 788.

CONDITION NOTES: The canvas support has been relined and its edges clipped. The paint film is in good condition although it has been retouched around the edges. The forms of many details have also been strengthened: the shadows of the woman's dress, head-dress, the outlines of the leg of the harpsichord, details of the suitor's cheek and forehead, the outline of the lute, and the window seen through the doorway. The varnish is moderately discoloured. On the back are labels from the exhibition at Sedelmeyer's Gallery in 1911 and Galerie Charpentier in 1948–9, as well as the French shipping agent Chenue's 'no. 54'

A young man, holding in his hand a wineglass, and seated on a chest, gazes up in rapture at an elegantly dressed young woman who stands playing music at a harpsichord. On the far side of the instrument a serving woman peels a lemon to place in the glass resting on the window sill, and a wide-eyed boy in a broad-brimmed hat gazes directly at the viewer. Still farther back, another boy reaches up for a lute hanging on the wall, and a parrot sits eating on its perch. On the right a birdcage hangs from the ceiling and a small rose window pierces the wall above a doorway that offers a view to a courtyard with an arbour, from which emerges a man wearing a black costume with tall hat. In the right foreground is a large pewter tankard. A dog lies at the young man's foot and on the floor behind the trunk is a wine vessel. The scene is illuminated by tall leaded windows in the left wall.

The foremost comedian among Dutch genre painters, Steen often depicted young ladies receiving or entertaining their beaux. Sometimes the courtship is all broad satire and gross buffoonery, as in the painting in Brussels (fig. 1) where the suitor dances into the room holding a phallic herring and two onion bulbs.[1] Here the young man's moonstruck attention to the keyboardist conveys a subtler comedy. Although the painting was described in neutral terms in early sales catalogues, when it was exhibited at the Mauritshuis in 1959, Domela Niewenhuis entitled it the *Young Suitor* ('De Jonge Aanbidder') and the catalogue entry suggested that the motif of the young boy reaching on the back wall for the lute that is hung so high as to be out of reach was a subtle commentary on the longing of the young man in the foreground. The catalogue goes on to suggest that the man in 'puritan' costume ('een puriteins geklede heer') approaching the door plays the role of the preacher or moralist ('zedemeester'). Although Steen's moralizing is not so clear here as in, for example, his 'Dissolute Household' themes, or paintings with epithets actually inscribed in the composition, the conspicuousness of the tankard and wine vessel suggest that the music and drink could readily become a prelude to merrier activities,

notwithstanding the musician's upright restraint. In the beautifully understated painting dated 16(5)9 in the National Gallery, London (fig. 3),[2] a woman sits playing the harpsichord as a man leans on the instrument listening, while in the back a boy carries a lute through a doorway for the man to play; the composition seems almost to depict a sequel, albeit without the comedy, to the Samuel painting's narrative.

The light tonality and orderly interior space, with its foreshortened windows in the left wall and view through the doorway at the right, recall developments in interior design achieved by the Delft School artists around 1658, above all de Hooch and Vermeer. Although dated works are scarce, Steen's painting in the Chicago Art Institute dated 1666 displays a similar interest in dramatic fore-shortening.[3] In the 1958–9 Steen exhibition, the Samuel painting was dated 'c. 1663', and Braun in 1980 proposed a date of 'around 1665'.[4] A partially abraded date of 16[6]1 or 16[6]4 on a copy of the Samuel painting in the Philadelphia Museum of Art (fig. 2) is not inconsistent with the style and execution of Steen's original, and may reflect a lost date.[5] However the copy differs from the original in several details: the rose window and pewter pitcher have been eliminated; the floor is wood instead of tile, and the stand-ing young woman wears a dark rather than light-coloured jacket.

The instrument played in the Samuel painting is not a virginal or spinet but a harpsichord. Sam Quigley, of the Musical Instruments Department of the Museum of Fine Arts, Boston, has observed that as painted it is unusually short for a wing-shaped instrument, but he calls attention to a similarly designed model in the Gemeentemuseum, The Hague, that was built by Andries Ruckers of Antwerp in 1627.[6] Quigley also notes that the lute on the wall seems quite plausible, including the oblique angle of the peg box.

M. Gaillard de Gagny, who sold the painting in Paris in 1762 (sale catalogue written by Pierre Rémy) had been the Receiver General of Finances for Grenoble and owned an extensive collection of Dutch paintings that included works by ter Borch, Potter, Rembrandt, and the *fijnschilders* van Slingelandt, Godfried Schalcken and Adriaen van der Werff.

1 Westrheene 1856, nos. 30 and 412; Hofstede de Groot, vol. 1 (1908), no. 385; Braun 1980, no. 224.

2 Westrheene 1856, no. 102; Hofstede de Groot, vol. 1 (1908), no. 409; Braun 1980, no. 106.

3 Oil on canvas 86.6 × 101 cm.; Westrheene 1856, no. 124; Hofstede de Groot, vol. 1 (1908), no. 442 and 424e; Braun 1980, no. 265.

4 The Hague, exh. 1958–9, no. 26, fig. 26; Braun 1980, no. 246.
5 P. C. Sutton, *Northern European Paintings* (Philadelphia, 1990), no. 111, ill. acc. no. E24-3-37.
6 See Raymond Russell, *The Harpsichord and Clavichord. An Introductory Study* (London, n.d.), no. 37, ill. See also Lucas van Dijck and Ton Koopman, *Het Klavecimbel in de Nederlandse Kunst tot 1800* (Amsterdam, 1987).

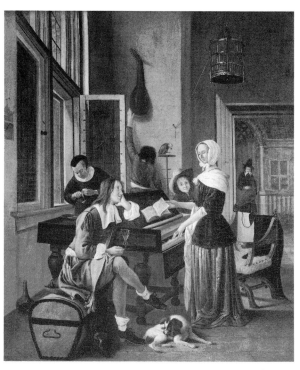

FIG. 2 Copy after Jan Steen, *Musical Company*, signed and dated 1661 or 1664, oil on canvas 64.1 × 55.2 cm., Philadelphia Museum of Art, Philadelphia, E'24-3-37.

FIG. 1 Jan Steen, *The Suitor's Offer*, signed, oil on canvas 79 × 64 cm., Musées Royaux des Beaux-Arts, Brussels, inv. 1717.

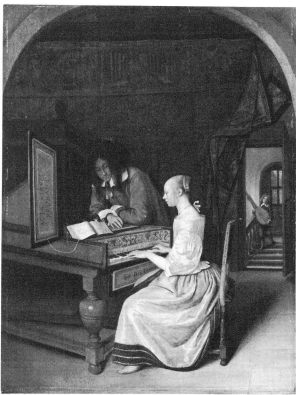

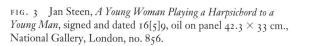

FIG. 3 Jan Steen, *A Young Woman Playing a Harpsichord to a Young Man*, signed and dated 16[5]9, oil on panel 42.3 × 33 cm., National Gallery, London, no. 856.

DAVID TENIERS THE YOUNGER

(ANTWERP 1610–1690 BRUSSELS)

Baptized in Antwerp on 15 December 1610, David Teniers was the son as well as father of painters of the same name. David Teniers the Elder (1582–1649), an art dealer and painter of small-scale history paintings, was his son's first teacher. Even as a youth, Teniers the Younger was attracted to very different subjects than his father, above all rustic genre and some 'high life' scenes. He became a master in the Antwerp guild in 1632–3, and his first paintings date from these years. On 22 July 1637, he married Anna Brueghel, the daughter of Jan Brueghel (q.v.) and moved into his father-in-law's house 'De Meerminne' (The Siren) on the Lange Nieuwstraat. In the 1640s Teniers prospered and was able to rent (and would later, in 1662, buy) a manor-farmhouse called 'Dry Toren' (Three Towers) near Perck, between Mechelen and Vilvorde. In 1645 he became a dean of the Antwerp guild. In these years he also enjoyed the patronage of Antoine de Triest, Archbishop of Ghent, and in 1647 received his first commission from the newly appointed governor of the southern Netherlands, Archduke Leopold Wilhelm. In 1651 Leopold Wilhelm named Teniers *Ayuda da camara* (chamberlain); he assumed the duties of court painter in Brussels upon the death of his predecessor, Jan van den Hoecke (1611–51). Teniers was also made director of Leopold Wilhelm's painting collection, a post which sent him to London in 1651 to buy Italian paintings from the collection of Charles I at Whitehall. During the same year, 1651, Teniers painted interior views of the Archduke's gallery (Brussels, Musée des Beaux-Arts, no. 2569; and Madrid, Prado, no. 1813). He later made small copies of Leopold Wilhelm's Italian paintings to serve as models for engravers; finished in October of 1656, four months after Leopold Wilhelm's departure from the Netherlands, the 244 engravings appeared as the celebrated *Theatrum Pictorium Davidis Teniers antverpiensis*, published in 1658 under the supervision of David's brother Abraham.

Teniers remained court painter to the new governor, Don Juan of Austria, until 1659, fulfilling commissions and also, according to Descamps, teaching Don Juan to draw and paint. He also worked for Philip IV of Spain and per-haps more unexpectedly, for Willem II, stadholder of the Northern Netherlands. An application in 1649 for elevation to the rank of nobility apparently went unrequited, but Teniers was later granted a family coat of arms. After the death of his first wife, he was remarried in 1656 to Isabelle di Fren, daughter of the secretary of the Council of Brabant. With the consent of the local St Luke's Guild, Teniers opened an art academy in Antwerp in 1665. An unusually prolific artist, he continued to paint at least as late as 1680. He died in Brussels on 25 April 1690.

Together with his mentor Adriaen Brouwer (1605/6–38), David Teniers the Younger was the most important seventeenth-century Flemish painter of low-life genre scenes. In addition, he painted history and mythological subjects and allegories (Five Senses, Four Elements, etc.). Besides his speciality in peasant subjects, he painted a few high-life scenes and various lower-class professions, including barber-surgeons, alchemists, quacks and charlatans. In the tradition of Hieronymous Bosch he painted witches and demons and images of the temptation of St Anthony. Teniers also popularized a curious form of humorous genre painting that substitutes monkeys for human figures. His landscapes are descended from those of Paulus Bril and Joos de Momper. Especially in his mature career, he collaborated with other artists, including Jan van Kessel (q.v.) and Jan Davidsz de Heem (1606–83/4). An enormously prolific and long-lived artist, Teniers had many followers whose weak imitations of his art have obscured the high quality of the autograph œuvre. In addition to the numerous prints which disseminated his compositions, tapestries were woven from his designs.

LITERATURE: De Bie 1661, p. 355; Houbraken, vol. 1 (1718), pp. 345–7; Descamps, vol. 2 (1760), pp. 152–69; Smith, vol. 3 (1831), pp. 247–502; *Suppl.*, vol. 9 (1842), pp. 405ff., 813, 848ff.; E. Dutuit, *Manuel de l'amateur d'estampes* (Paris/London, 1881–8), vol. 6 (1888), pp. 418ff.; F. J. van den Branden, *Geschiedenis der Antwerpsche Schilderschool* (Antwerp, 1883), pp. 981–1003; A. Rosenberg, *Teniers der Jüngere* (Bielefeld/Leipzig, 1895); N. de Pauw, 'Les trois peintres David Teniers et leurs homonymes', *Annales de l'Académie Royale d'Archéologie de Bélgique*, ser. 4, vol. 10 (1897), pp. 301–59; Wilhelm von Bode, 'David Teniers', *Zeitschrift*

für Bildende Kunst, vol. 53 (1918), pp. 191–200; K. Zoege von Manteuffel, in Thieme and Becker, vol. 32 (1938), pp. 527–9; S. Speth-Holterhoff, *Les Peintres flamands des cabinets d'amateurs au XVIIe siècle* (Paris/Brussels, 1957), pp. 127–60; Hans Vlieghe, *David Teniers II in het Licht der geschreven bronnen* (Ghent, 1959–60); Hans Vlieghe, 'David II Teniers (1610–1690) en het Hof van Aartshertog Leopold-Wilhelm en Don Juan van Oostenrijk 1647–1659', *Gentse Bijdragen tot de Kunstgeschiedenis*, vol. 19 (1961–6), pp. 123–50; Margret Klinge-Gross, 'Zu einigen datierten Frühwerken von David Teniers d. J. aus dem Jahre 1633', *Jaarboek van het Koninklijk Museum voor Schone Kunsten, Antwerpen*, 1969, pp. 181–200; London, Kenwood House, *Cabinet Pictures by David Teniers*, exh. 1972; Faith P. Dreher, 'The Vision of Country Life in the Paintings of David Teniers II', dissertation, New York (Columbia University), 1975; F. P. Dreher, 'The Artist as Seigneur: Châteaux and their Proprietors in the Work of David Teniers II', *Art Bulletin*, vol. 60 (1978), pp. 682–703; Richard D. Leppert, 'David Teniers the Younger and the Image of Music', *Jaarboek van het Koninklijk Museum voor Schone Kunsten, Antwerpen*, 1978; Jane P. Davidson, *David Teniers the Younger* (Boulder, 1979); New York/Maastricht, Noortman and Brod, *Adriaen Brouwer, David Teniers the Younger*, exh. 1982 (catalogue by Margret Klinge); Antwerp, Koninklijk Museum voor Schone Kunsten, *David Teniers de Jonge: Schilderijen, Tekeningen*, exh. 1991 (catalogue by Margret Klinge).

CATS 67–71

The Five Senses Series, c. 1640

Each, oil on copper 8⅝ × 6½ in. (21.8 × 16.5 cm.)

PROVENANCE: Lord Sudeley, Richmond, Surrey; sale Prince Demidoff, Florence (San Donato), 15 March 1880, nos. 1141–5, with etched reproductions; sale E. Secretan, Paris, 1 July 1889, nos. 164–8; Henry Goldman, New York, 1922; Redford, Montreal; acquired from Edward Speelman in 1968.

EXHIBITION: London 1988, nos. 67 a–e.

LITERATURE: Smith, vol. 3 (1831), nos. 272–4; W. R. Valentiner, *Catalogue of the Henry Goldman Collection* (New York, 1922), all five catalogued under lot no. 15, ills; Woodhouse 1988, p. 127; Speelman 1988, p. 15.

David Teniers' *Five Senses Series*, catalogued individually below, ultimately descends from antique concepts which posited that the senses (sight, hearing, touch, taste and smell) were not only man's way of experiencing his surroundings but also a link between the micro- and macrocosms. The faculties of perception were the point of departure in classical thought for the theory of the Elements, for Plato's theory of the four regularly shaped bodies and for Aristotle's paired sensory concepts. The Senses even functioned morally, for example in Hercules' dilemma of the crossroads, the choice between *Virtus* (spiritual virtue) and *Voluptas* (physical vice); to fall victim to the temptations of the senses was considered reprehensible. The contempt for and preoccupation with sensuality remained strong throughout the Middle Ages, but moderated with the rise of empiricism in the Renaissance and seventeenth century when the senses were at least regarded as more than a route to sin and even possibly the fulcrum for insight and information.

In art the senses were initially depicted as abstract personifications with emblematic attributes but gradually became more specific and naturalistic, even mundane.[1] The Haarlem mannerists apparently were the first artists to bring the theme of the Five Senses to the Netherlands. In five prints uncertainly attributed to Jacob Backer the Five Senses are depicted as a series of classical nudes reclining in a landscape surrounded by their attributes.[2] In a series of designs engraved by Jan Saenredam, Hendrick Goltzius conceived of the personifications of the Senses as half-length genre figures with objects apposite to their sensory faculties (Cats. 67–71, figs. 1–6).[3] Jan Miense Molenaer (see his *Five Senses*, dated 1637, Mauritshuis, The Hague, nos. 572–6), Dirck Hals (1636, Mauritshuis, The Hague,

nos. 771–5) and Gonzales Coques (Koninklijk Museum voor Schone Kunsten, Antwerp, nos. 759–63) depicted these themes in both low and high-life genre scenes but consistently in the context of everyday situations. Indeed Molenaer's peasant scenes are deliberately audacious, gross with the earthy essence of the senses.

Teniers, too, often depicted allegories in the guise of genre, such as the *Seasons* (National Gallery, London, nos. 857–60; and Rijkdienst Beeldende Kunst, The Hague, nos. NK2413–16), the *Four Elements* (see the *Palace Kitchen*, Hermitage, St Petersburg, no. 586), the *Virtues* (Poesia, Abundantia, Nobilitas, Concordia and Fortitudo, based on Cesare Ripa's *Iconologia* (Amsterdam, 1644); see sale Viscount Hampton, London (Christie's), 25 November 1938, no. 67) as well as other metaphorical concepts. A *Five Senses Series* by Teniers also represented by half-length genre figures is in the Akademie der bildenden Künste, Vienna, where it has wrongly been regarded in the past as the work only of Teniers' workshop (Cats. 67–71, figs. 7–11).[4] Another *Five Senses* series assigned to Teniers, with small full-length figures, was sold in Paris in 1972.[5] A painting in Brussels by Teniers depicting a genre scene of revellers in a tavern unites all Five Senses in a single merry company scene (Cats. 67–71, fig. 12).[6] The shackled ape in the foreground of this painting probably refers symbolically to mankind's ruinous addiction to sensuality, while the grotto landscape with prominent cross in the painting within the painting may offer a Christian admonition, suggesting that Teniers inherited something of his predecessors' moralizing scepticism about the Senses. Other individual works by Teniers are also probably part of several incomplete series of the Senses.[7] A set of copies of the Samuel paintings was in a Belgian private collection in 1968.[8] The Samuel paintings have wrongly been assumed to be identical with a set of *Five Senses* by Teniers that appeared in the Comte de Dubarry sale on 21 November 1774, no. 16; this lost series was on wood panels (7 × 5 in.) and apparently depicted full-length figures peddling various wares.[9]

Dating the series is difficult. The Brussels *Merry Company as Five Senses* is a relatively early work that can be dated about 1633 or 1634, based on similar dated genre scenes.[10] The Akademie's series is probably later; the bagpipe player, as personification of hearing, also appears in the 1637 *Peasant Wedding* in the Prado, Madrid (inv. 1788). The Samuel series perhaps dates a few years later, or c. 1640.

1 On the Five Senses, see above all Hans Kauffmann, 'Die Funfsinne in der niederländischen Malerei des 17. Jahrhunderts', in *Kunstgeschichtliche Studien. Dagobert Frey zum 23. April 1943* (Breslau, 1943), pp. 133–57; Chu Tsing Li, *The Five Senses in Art. An Analysis of its Development in Northern Europe*, dissertation, State University of Iowa, 1955; Seymour Slive, *Frans Hals*, vol. 1 (London, 1970), pp. 78–9; E. de Jongh, in Amsterdam, Rijksmuseum, *Tot Lering en Vermaak*, 1976, pp. 112–15; Braunschweig, Herzog Anton Ulrich-Museum, *Die Sprache der Bilder. Realität und Bedeutung in der niederländischen Malerei des 17. Jahrhunderts*, 6 September–5 November 1978, pp. 67–73, cat. 10; Bob Haak, *The Golden Age. Dutch Painters of the Seventeenth Century* (New York, 1984) p. 72–3; and DIAL 31A 31–35.

2 Hollstein, vol. 1 (1949), nos. 1–5; Slive 1970, fig. 54; DIAL 31A3.

3 Hollstein, vol. 8, nos. 380–4 and vol. 23, nos. 101–5; Slive 1969, fig. 55; DIAL 31A3.

4 See Robert Eigenberger, *Die Gemäldegalerie der Akademie der bildenden Künste in Wien* (Leipzig, 1927) vol. 1, pp. 395–9, inv. nos. 820–5; however, see now Renata Trnek, *Gemäldegalerie ... Illustriertes Bestand verzeichnis* (Vienna, 1989), pp. 242–3, nos. 820–5 [as Teniers].

5 Oval and on copper, each 8.5 × 6.2 cm.; sale Paris (Galleria), 28 November 1972, nos. 26–30, ill.

6 See Antwerp, Koninklijk Museum voor Schone Kunsten, *David Teniers de Jonge (cat. by Margret Klinge)*, 11 May–1 September 1991, cat. no. 7.

7 See *Pedlar with Glass Vials (Taste)*, National Museum, Warsaw, inv. no. 185965; *Pedlar with a Glass (Taste)* and *Hurdy Gurdy Player (Hearing)*, Lord Sackville's Collection, Knole, Sevenoaks, Kent.

8 Oil on copper 22 × 16.5 cm. ACL negative nos. 203945B–203949B.

9 '*La vue* est representée par un marchand de lunettes, qui a près de lui un chien; dans la lointain deux bergers et quelques moutons. *L'ouie* s'annonce par un marchand de chansons; le fond est orné de paysages. *Le gout*, c'est un marchand d'eau-de-vie, dans la lointain une petite figure. *L'odorat* est indiqué par un jardinier qui tient un pot d'œillet, derrière lui sa femme qui flaire deux œillets; *le toucher* par un homme qui lève l'emplâtre, pendant qu'un jeune homme lui fait chauffer une compresse; dans le lointain on remarque un pecheur.' Compare the paintings listed in note 7.

10 See Antwerp 1991, cat. no. 7.

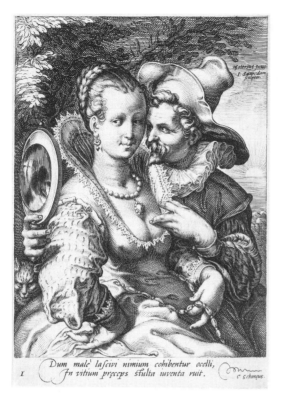

Dum male' lascivi nimium cohibentur ocelli,
In vitium preceps stulta iuventa ruit.

1

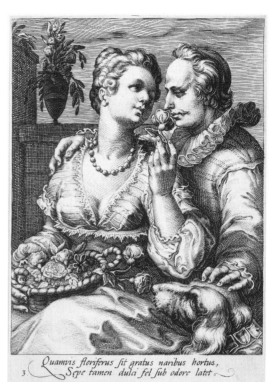

Quamvis floriferus sit gratus naribus hortus,
Sepe tamen dulci fel sub odore latet.

3

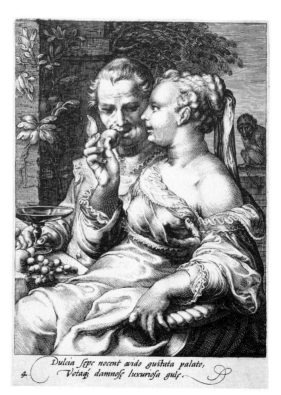

Ne patulas blandis prebe Syrenibus aures,
Que dulci cantus sepe lepore nocent.

2

Dulcia sepe nocent avido gustata palato,
Votaq; damnose luxuriosa gule.

4

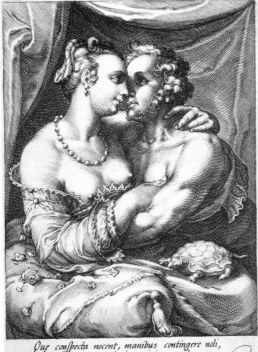

Quę conspecta nocent, manibus contingere noli,
Ne mox peiori corripiare malo.

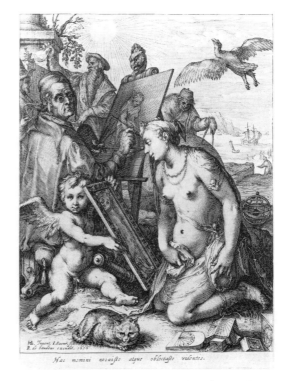

FIG. 6 Jan Saenredam, after Hendrick Goltzius, *Allegory of Visual Perception*, 1616, engraving.

FIGS. 1–5 Jan Saenredam, after Hendrick Goltzius, *The Five Senses*, c. 1595, engravings.

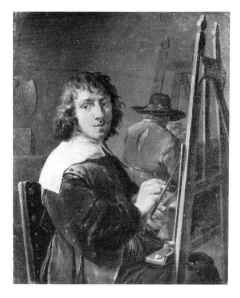

FIG. 7 David Teniers the Younger, *Sight*, monogrammed, oil on panel 27 × 22.5 cm., Akademie der bildenden Künste, Vienna, no. 821.

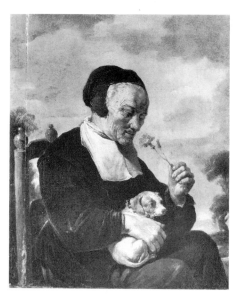

FIG. 9 David Teniers the Younger, *Smell*, monogrammed, oil on panel 27 × 22.5 cm., Akademie der bildenden Künste, Vienna, no. 822.

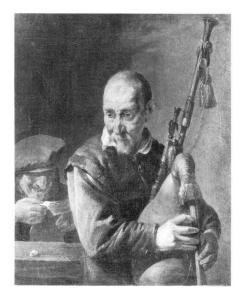

FIG. 8 David Teniers the Younger, *Hearing*, monogrammed, oil on panel 27 × 22.5 cm., Akademie der bildenden Künste, Vienna, no. 825.

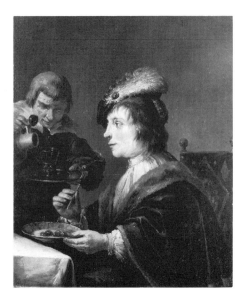

FIG. 10 David Teniers, the Younger, *Taste*, monogrammed, oil on panel 27 × 22.5 cm., Akademie der bildenden Künste, Vienna, no. 820.

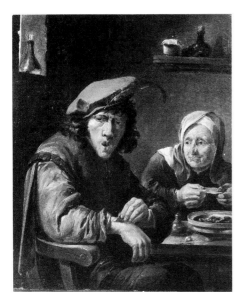

FIG. 11 David Teniers the Younger, *Feeling*,
monogrammed, oil on panel 27 × 22.5 cm.,
Akademie der bildenden Künste, Vienna, no. 824.

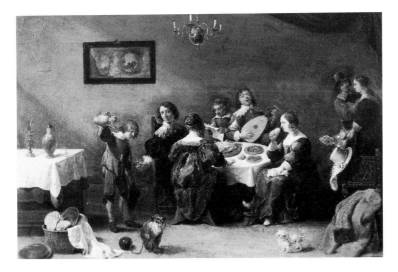

FIG. 12 David Teniers the Younger, *Merry Company as an Allegory of the Five
Senses*, oil on copper 37.5 × 56 cm., Musée Royal des Beaux-Arts, Brussels, no. 544.

CAT. 67

Sight

Signed upper right: D TENIERS

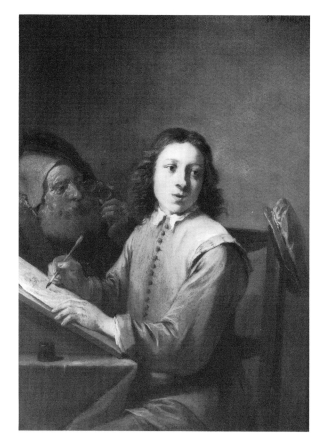

CONDITION NOTES: The copper support has some planar irregularities along the lower and left edges, presumably from framing. The paint film is generally in very good condition with some pinpoint losses in the background and the central figure's upper lip. Several of the shadows have been strengthened: beneath the beret hanging on the chair, along the draughtsman's sleeve, and in the crease of the tablecloth. Some rubbing from the frame is detectable. The varnish is clear.

A man viewed two-thirds length and turned to the viewer's left is seated at a table making a drawing with a quill pen. His inkwell rests on the table which also supports his drawing board. On the back of his high-backed chair hangs a red beret with silver cord at the brim. The draughtsman wears a grey jacket over mustard yellow sleeves and sea-green trousers. Behind him and to the left is an old bearded man wearing a cap with ear flaps, beret and fur collar, who removes his spectacles to peer at the young draughtsman.

When this painting was catalogued by Smith in 1831, it was titled '*Seeing*, by a dealer in Spectacles'.[1] While it is undoubtedly the personification of the sense of sight (*visus*), one of the attributes of which was spectacles (see note 8 to general commentary), the central figure is surely an artist. Other symbolical objects associated with sight included the mirror, an eagle, the rays of the sun, as well as artists and their art works. In an elaborate allegory of visual perceptions, Hendrick Goltzius's design for Jan Saenredam's print of 1616 (Cats. 67–71, fig. 6 in General Commentary above) includes an artist wearing spectacles painting Venus looking in a mirror held by Cupid.[2] And in the depiction by Jan Brueghel and Peter Paul Rubens of *Seeing* dated 1617 in the *Five Senses* series in the Prado, Madrid (inv. no. 1394),[3] the allegory of sight is symbolized by an image of Venus and Cupid in a lofty 'kunstkamer' filled to bursting with paintings, sculpture and medals as well as scientific instruments (such as the telescope, sextant and astrolabe) which exercise and enhance the sense of sight. In Teniers' own *Five Senses* series in the Vienna Akademie (inv. no. 821; see Cats. 67–71, fig. 7 in General Commentary above), *Sight* is again depicted as an artist but as a painter rather than a draughtsman, who like the sitter in the Samuel painting may represent Teniers himself.[4]

An etching by L. Carred of the Samuel painting of *Sight* appeared as an illustration in the Demidoff Sale at San Donato in 1880.

1 Smith, vol. 3 (1831), p. 273, no 47.
2 Hollstein, vol. 23, p. 79, no. 106, ill.; on *Sight* in *Five Senses* series, see Kauffmann 1943, pp. 13–14.
3 See Ertz 1979, cat. 327.
4 Renata Trneck, *Gemäldegalerie der Akademie der bildenden Künste in Wien* (Vienna, 1989), p. 242, ill.

CAT. 68

Hearing

Signed upper right: D. TENIERS

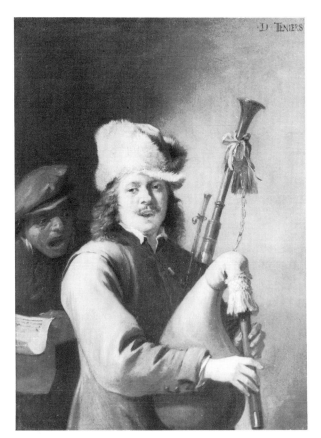

A bagpipe or doodlesack player is viewed at slightly more than half-length and turned to the viewer's right. He wears a blue coat, a white collar and a brown fur cap with a blue peak. His instrument is decorated with pink and blue ribbons, and he seems to sing as he plays. He is accompanied in the back on the left by a coarse looking songster who holds a sheet of paper, probably a song sheet.

Musical instruments, musicians and singers were among the most common symbolical attributes of *Hearing* (see, for example, Jan Brueghel and Peter Paul Rubens, *Allegory of Hearing*, oil on panel 65 × 107 cm., Madrid, Prado, no. 1395).[1] In the Samuel picture and in the painting of this subject from the *Senses Series* in the Vienna Akademie (no. 825; see Cats. 67–71, fig. 8 above) the musicians play the bagpipe, an instrument favoured by common street musicians and also symbolic of idle fools and buffoons; Cornelis Dankerts' engraving after Abraham Bloemaert of a *Bagpipe Player* bears an inscription in Latin which reads, 'Hot Sweat will never smell good to these nostrils / As long as he pleases farmers by playing a tune on the bagpipes' and in Dutch, 'I have no use for either plough or spade, / As long as I can earn a few farthings in this way.'[2]

Abel Lurat's etched illustration of the painting appeared in the Demidoff sale catalogue, San Donato, 1880.

1 See Ertz 1979, p. 351, cat. 329, ill. In Teniers' *Five Senses* series in the Dubarry sale of 1774 (see General Commentary, note 8), Hearing was personified by a pedlar of songs.
2 See Philadelphia/Berlin/London 1984, p. xxxi, fig. 32. On the associations of bagpipes, see E. Winternitz, *Musical Instruments and Their Symbolism in Western Art* (London, 1967), pp. 66–85.

CONDITION NOTES: The copper support is slightly bent along the upper edge. The paint film is in very good condition with minor losses retouched along the edges. There also are retouches in the bagpipe player's lower lip, hair and the shadow of the brim of his hat. The varnish is clear.

CAT. 69

Smell

Signed upper left: D. TENIERS F.

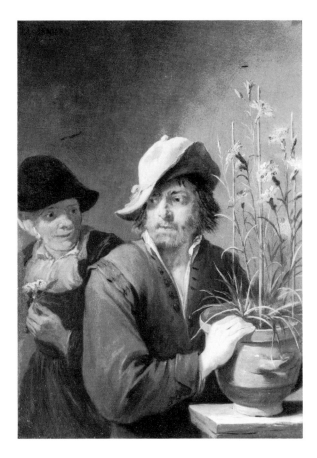

A bearded man is viewed half-length holding a clay pot with ten pink carnations attached to thin canes, which rests on a stone plinth or pedestal. He wears a lavender coloured jacket over a white shirt and a tan hat with one side of the brim turned down and a pink ribbon as a band. A woman standing behind him and to the left is dressed in black and white and holds a pink carnation as she smiles at the man.

Flowers and the smelling of their scent were naturally the most common symbolic attributes of the sense of smell. They were used in the prints attributed to Jacob Backer and to Jan Saenredam mentioned above (see General Commentary), as well as in prints by Abraham Bosse, Hans Vredeman de Vries and Frans Floris, which featured classical figures as well as secular genre.[1] Carnations in pots supported by canes were also one of the most popular ways of depicting flowers in these images; see, for example, Nicolaes Maes' later painting of a *Couple on a Terrace Smelling a Pot of Carnations*, Ashmolean Museum, Oxford, and Teniers' own depiction of smell in the Dubarry sale series (General Commentary, note 8). Their ubiquity perhaps also reflects the carnation's traditional association with marital fidelity. An old woman holding a dog (also a symbol of fidelity) with a man in the distance smells a carnation or 'pink' in Teniers' painting in Vienna (fig. 9 in General Commentary above).

An etched reproduction of the Samuel painting by Henri Vien appeared in the Demidoff sale catalogue, San Donato, 1880.

1 See Kauffmann 1943, pp. 134–5, figs. 2–4.

CONDITION NOTES: The copper support is in plane. Retouches appear along all the edges and the grey area of background beneath the woman's right arm has been entirely overpainted. The details of several shadows have been delicately strengthened: beneath the brim of the man's hat, under the woman's cap, and along the edge of the plinth or pedestal in the lower right. The varnish is clear.

CAT. 70

Taste

Signed upper left: TENIERS F

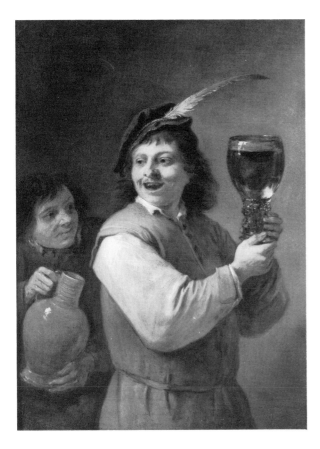

A laughing young man with a moustache and long hair holds up a very large *roemer* of wine. He wears a tan jacket with light brown sleeves, white cuffs and collar, and a grey belt. His cap is blue and decorated with a stiff white feather. Behind him and to the left a serving man stands cradling a large earthenware jug.

Taste was usually depicted in early allegorical prints by figures eating fruit,[1] but Teniers depicted the sense with wine or *eau-de-vie* sellers, tavern owners (see Lord Sackville's painting) or simply merry drinkers.[2] Such figures naturally suited his interest in boisterous peasant genre scenes.

An etched reproduction of the painting by Edmund Ramus appeared in the Demidoff sale catalogue, San Donato, 1980.

1 See Kauffmann 1943, pp. 141–2.
2 A half-length image of *Taste* by Teniers depicted a man holding up a wineglass and jug, with a second man eating soup; sale Zurich, 30 April 1932, no. 254 (signed, panel 22 × 16.5 cm.). See also the Dubarry sale (1774) series, where *Taste* is depicted by a merchant of *eau-de-vie* (General Commentary, note 8).

CONDITION NOTES: The copper support is bent in the upper left corner. Retouches appear along all the edges. The shadows have been strengthened: on the folds of the central figure's jacket, around his beret, above the feather, along the contour of his right sleeve and around the jug at the left.

CAT. 71

Feeling

Signed upper right: D. TENIERS

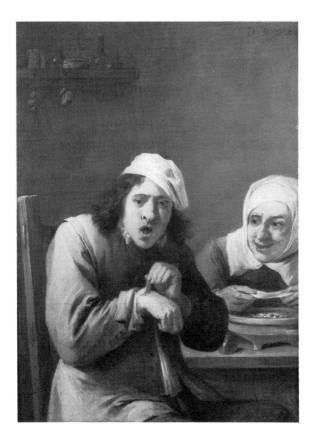

CONDITION NOTES: The edges of the copper support are slightly out of plane in several areas. Losses have been retouched along the edges and in the man's lap. Repaint is also apparent beneath the table edge. The forms have been strengthened beneath the brazier, around the woman's fingers, mouth, head-dress, and in both figures' left eyes.

A seated man howls as he removes what may be a heated poultice from his hand. The patient wears a lavender jacket, with sea-green sleeves and a white cloth cap. Behind him is a smiling old woman with a white head-dress and blue dress holding a piece of dressing over a brazier with hot coals. The tiny brass vessel resting on the table to the right of the man's left elbow identifies the woman as one of those well-known medical quacks called *kopsters*, who were infamous for applying hot metal cups to a patient's skin, ostensibly to draw an illness to the surface. At the upper left, bags of medicine hang down from a shelf that supports vials of liquid and ointment jars.

Feeling (*Tactus*) had more commonly been depicted in earlier art as a classical nude whose hand is pecked by a bird,[1] or by couples in an intimate embrace (see Saenredam after Goltzius, fig. 5). However after Adriaen Brouwer popularized images of barber-surgeons treating their ignorant patients brutally (see, for example, his depictions of foot operations in the Städelsches Museum, Frankfurt, and Alte Pinakothek, Munich) Teniers adopted the theme of the quack to illustrate the tactile sensation in his *Five Senses* series; compare the description of Teniers' *Feeling* in the lost series mentioned in the Dubarry sale of 1774 (General Commentary, note 8). Since at least the time of Bosch, when the latter included in his famous table in the Prado illustrations of the Seven Deadly Sins with a surgeon performing a head operation (probably one of the charlatans known as *keisnijders*, literally 'stone cutters', who claimed to be able to cut the 'stone of ignorance' from a client's head!), amateur surgeons were one of the stock figures of low-life genre and carried a comically admonitory message.[2]

1 See Kauffmann 1943, pp. 135–6. See the print by Jacob Backer (?) and the prints by Frans Floris in Kauffman.
2 See Philadelphia/Berlin/London 1984, pp. 229–30.

WALLERANT VAILLANT

(LILLE 1623–1677 AMSTERDAM)

Baptized in Lille on 30 May 1623, Wallerant (Wallerand) Vaillant was the eldest son of a cloth merchant from the Artois who moved to Amsterdam around 1642. His brothers Jacob (Jacques) and Jan (Jean), and his step-brothers Bernard and André, were also artists. He is reported to have studied with Erasmus Quellinus in Antwerp, probably around 1637, when he was fourteen. In 1647 he entered the guild at Middelburg. In 1649, he painted a portrait of Jan Six in Amsterdam (Six Collection, Amsterdam) and he was recorded in the city again in 1652. By 1658 he was in Frankfurt working for King Leopold I, whose portrait he etched. In the late 1650s, Vaillant was one of the first artists to practise mezzotint engraving. He also seems to have been Prince Ruprecht von der Pfaltz's instructor in this medium. Writing in the early eighteenth century, George Vertue claimed that Vaillant visited England but there is no proof of such a visit. From 1659 to 1665 he was in Paris, then appeared in Amsterdam again in 1668 and 1672. In 1672 he also paid dues to the Middleburg guild. Vaillant died in Amsterdam in 1677.

A painter, draughtsman and printmaker, Vaillant was primarily active as a portraitist, depicting heads of state and other important people, working mostly in chalk and mezzotint. He executed seven etched and engraved portraits from his own designs and over two hundred and thirty mezzotints from his own designs and those of others. Sandrart remarked on the high degree of perfection he had brought to the art of mezzotint and noted that his prints were highly sought after among collectors. His genre scenes are not numerous and his still lifes rare. His brother Jacques and step-brother Bernard, executed portraits in a similar style.

LITERATURE: J. von Sandrart, *Teutsche Academie* (1675), vol. 2, p. 375; Houbraken, vol. 2 (1719), pp. 102–4; C. Kramm, *De Levens der Hollandsche Kunstschilders*, vol. 6 (1863), p. 1667; J. E. Wessely, *Wallerant Vaillant: Verzeichniss seiner Kupferstiche* (2nd edn, 1881); Obreen, vol. 6 (1884–7), pp. 175, 213; *Oud-Holland*, vol. 4 (1886), pp. 143, 269; vol. 11 (1893), p. 156; vol. 12 (1894), p. 166; Wurzbach, vol. 2 (1910), pp. 733–6; *Walpole Society*, vol. 18 (1930), p. 33; M. Vandalle, 'Les Freres Vaillant', *Revue Belge d'Archéologie et d'Histoire de l'Art*, vol. 7 (1937), pp. 341–60; K. G. Boon, in Thieme and Becker, vol. 34 (1940), pp. 41–42; Neil MacLaren, *The Dutch School National Gallery Catalogue* (London 1960), pp. 410–13; Clifford S. Ackley, in Museum of Fine Arts, Boston, *Printmaking in the Age of Rembrandt*, 28 October–4 January 1981 (also shown at St Louis Art Museum, 19 February–12 April 1981) pp. 272–3.

CAT. 72

A Young Boy Copying a Painting

Oil on (original) panel 12⅝ × 15½ in. (32.1 × 39.5 cm.)

PROVENANCE: Acquired in 1872 from Sir J. C. Robinson by Sir Francis Cook (1817–1901); by descent to Sir Frederick Cook (died 1920), Doughty House, Richmond; Sir Herbert Cook, cats. 1914 and 1932, no. 361, on loan for a period from the Cook Collection to the Fitzwilliam Museum, Cambridge, and to Manchester (?) (see sticker in Condition Notes); sale London (Christie's) 25 November 1966, no. 65, ill. [as Michael Sweerts] (to Speelman); acquired from Edward Speelman in 1966.

EXHIBITIONS: London, Burlington Fine Art Club, *Catalogue of a Collection of Pictures Including Examples of the Work of the Brothers Le Nain and Other Works of Art*, 1910, cat. no. 5 [as Michael Sweerts]; London, Royal Academy, Dutch Art exhibition, 1952–3, no. 533 [as Michael Sweerts]; Rotterdam, Boymans Museum, *Michael Sweerts en zijn tijdgenoten*, 4 October–23 November 1958, no. 39, ill. fig. 39b. [as Michael Sweerts]; London 1988, no. 66, fig. 167 [as Michael Sweerts].

LITERATURE: W. Martin, 'The Life of a Dutch Artist in the Seventeenth Century, Part II', *The Burlington Magazine*, vol. 7 (1905), p. 424, ill. opp. pl. 3 [as M. Sweerts]; W. Martin, 'Michiel Sweerts als schilder. Proeve van een biografie en een catalogue van zijn schilderijen', *Oud-Holland*, vol. 25 (1907), p. 156 [no longer certain as Sweerts]; Herbert Cook (ed.), *A Catalogue of the Paintings at Doughty House, Richmond and Elsewhere in the Collection of Sir Frederik Cook BT, Visconde de Montserrate*, vol. 3 *Dutch and Flemish Schools*, by J. O. Kronig (London, 1914), cat. no. 361, pl. XXII [as Michiel Sweerts, *'The Little Copyist'*; Long Gallery, no. 136]; [Maurice W. Brockwell], *Abridged Catalogue of the Pictures at Doughty House, Richmond, Surrey, in the Collection of Sir Herbert Cook, Bart.* (London, 1932), p. 45, no. 361 [as M. Sweerts, and hanging on the back wall of the 'Long Gallery']; Rolf Kultzen, *Michael Sweerts*, dissertation, Hamburg 1954, no. 56; Malcolm R. Waddingham, 'The Sweerts Exhibition in Rotterdam', *Paragone*,

vol. 107 (November 1958), p. 72 [as Wallerant Vaillant]; Vitale Bloch, 'Michael Sweerts und Italien', *Jahrbuch der Staatlichen Kunstsammlungen in Baden-Württemberg*, vol. 2 (1965), p. 172, note 22; Malcolm R. Waddingham, 'Michael Sweerts, *Boy Copying the Head of a Roman Emperor*', *Minneapolis Institute of Arts Bulletin*, vol. 63 (1976–7), p. 62, note 22; Woodhouse 1988, p. 127, fig. 8; Speelman 1988, p. 15, ill. p. 14; Russell 1988, p. 788.

CONDITION NOTES: The panel support has been enlarged with ¼ in. (5 mm.) strips on all sides. There are minor retouches to the paint film in the upper right corner, in the blue drapery behind the manikin, in the frame around the painting within the painting, in the shadows around the manikin, and in the boy's hair. The varnish is slightly discoloured. On the back is a loan sticker from the 'City of Manchester Art Gallery/M/7611', and two old Doughty House inventory numbers, 'no. 361' and 'no. 361 (136) Long Gallery'.

A young boy is viewed half-length and seated with his back to the viewer in a panelled room. On a drawing board resting on his knees, he works on a sheet of paper on which he is making a copy of the ebony-framed painting of a battle scene which hangs on the wall before him. To the right is a large lay figure or manikin, with dark yellow drapery wrapped around it and greyish drapery on its head. A stretched canvas leans against the wall behind the manikin.

According to the exhibition catalogue of the Burlington Fine Arts Club exhibition in London of 1910, this painting had been variously attributed while in the Cook collection to 'Peter de Hoogh, Terburg, Metsu, Vermeer of Delft and, with greater probability, Michael Sweerts'. W. Martin was the first to assign the painting to Sweerts in his famous article of 1905 on the life and instruction of artists in seventeenth-century Holland.[1] The attribution to Sweerts was upheld by Kronig in his 1914 catalogue of Doughty House, in Maurice Brockwell's 1932 catalogue of the Cook Collection, in the Royal Academy's extensive Dutch exhibition of 1952–3, in Kultzen's 1954 monograph on Sweerts, as well as in Rotterdam's 1958 exhibition of the art of Sweerts and his circle (see literature and exhibitions). Indeed, while in Lord Samuel's collection and until now, the painting has carried an attribution to Sweerts. However Kultzen was the first to point to analogies with the art of Sweerts' Franco-Dutch contemporary, Wallerant Vaillant, and in his review of the Sweerts exhibition in *Paragone*, Malcolm Waddingham first proposed an unequivocal re-attribution to Vaillant. The assignment was later supported by Vitale Bloch in 1965, and reiterated by Waddingham in 1976–7.[2]

The subject of a young apprentice beginning his artistic instruction by copying sculpture, casts or paintings, was treated by several Dutch and Flemish artists.[3] Sweerts

however showed a special interest in images of art education, depicting not only a *Boy Copying the Head of a Roman Emperor* (Vitellius?) (fig. 1)[4] but also entire artists' studios where young men draw studiously from sculpted *ecorché* figures (Rijksmuseum, Amsterdam, no. A1957), examine plaster casts and sculpture (Institute of Arts, Detroit, no. 30.297) or draw as a group from a live model (Frans Halsmuseum, Haarlem, no. 270). Sweerts also depicted a young artist drawing out-of-doors from a sculpted fountain by Bernini in the Villa Montalto in Rome (Museum Boymans-van Beuningen, Rotterdam, inv. 2358).[5] The relationship between Sweerts and Vaillant has not been fully clarified, but Vaillant was sufficiently attracted to the former's painting of a *Boy Copying the Head of a Roman Emperor*, now in Minneapolis, (fig. 1) to copy it in mezzotint.[6] Moreover, Waddingham has observed the striking similarities between this painting and Vaillant's study (fig. 2), of a young boy examining drawings before a cast of the Michelangelo in the Cathedral of Nôtre Dame in Bruges, beside which appears another almost identical bust of Vitellius in the background shadows.[7] Vaillant's style resembles Sweerts' manner, but his treatment of form is usually fuller and less insistent, his modelling softer, indeed at times reminiscent of the velvety quality of the mezzotints in which he excelled. In these regards the Samuel painting is more likely to be by Vaillant than Sweerts.

The work is undated, but another painting signed by Vaillant of a boy seated drawing a bust was said by Maclaren to be dated 1658,[8] and Vaillant's *Young Boy Copying a Bust on a Table* at Brodie Castle is reported to be dated 1656.[9] Sweerts' Minneapolis painting (fig. 1) is also undated, but although it must be allowed that its simple naturalism seems more Dutch than Flemish it need not be the product of his Amsterdam years (possibly by 1659 and certainly by 1661) as Waddingham implied.[10] Given Sweerts' more consistent and innovative interest in the theme of the studio, it seems logical that he was the first of the two artists to explore the subject. Nonetheless, as Waddingham observed, in the Samuel painting 'the artist was certainly as perceptive and skilled as Sweerts and it is without doubt his chef-d'œuvre'.[11] A painting by Vaillant in Lille also takes up the theme of the young draughtsman copying from casts and paintings (fig. 3), but scarcely so successfully.[12]

The painting within Vaillant's painting was first attributed by Martin to the battle painter, J. J. van der Stoffe (1611–82) or Hendrick de Meyer (c. 1641–c. 1683).[13] The actual painting is now also in Lord Samuel's collection

(see Cat. 53) where it has been called until now a work by the Delft genre and portrait painter, Anthonie Palamedesz, although Kronig (who had been the Director of the Frans Halsmuseum in Haarlem) and Waddingham both correctly deduced from Vaillant's painting that the author of the work was Anthonie's brother, Palamedes Palamedesz.[14] The large wooden manikin or lay figure seen to the right of the boy had been a common studio accessory since the fifteenth century.[15] Then as now, manikins were used for figure and drapery studies. They appear in other Dutch seventeenth-century painters' depictions of artists' studios, e.g. by Adriaen van Ostade (q.v.) and J. van Spreeuwen and Gerard ter Borch (q.v.) who was unrivalled in the painting of silks and satins and is known to have owned a fairly large lay figure.[16] Several engravings by C. van de Passe illustrate such devices (fig. 4).

The Cook Collection included excellent Old Master paintings and was exceptionally strong in Dutch genre paintings, including, for example, both the ter Borch and the Metsu later in the van der Vorm collection and now in the Museum Boymans-van Beuningen, Rotterdam.[17]

1 W. Martin, *The Burlington Magazine*, vol. 7 (1905), p. 424. On Sweerts, see W. Martin, 'Michiel Sweerts als schilder: Proeve van een biografie en een catalogus van zijn schilderijen', *Oud-Holland*, vol. 25 (1907), pp. 133–56; Rolf Kultzen, *Michael Sweerts*, dissertation, Hamburg, 1954; exh. Rotterdam 1958; Didier Bodart, *Les Peintres des pays-bas meridionaux* (Brussels and Rome, 1970), vol. 1, pp. 419–23; Malcolm Waddingham, 'Additions to the Œuvre of Michael Sweerts'. *J. P. Getty Museum Journal*, vol. 8 (1980), pp. 63–8; Malcolm Waddingham, 'Recently Discovered Paintings by Sweerts', *Apollo*, vol. 118 (October 1983), pp. 281–3; C. Brown, in P. Sutton *et. al.*, *Masters of Seventeenth-Century Dutch Genre Painting* exh. cat. Philadelphia/Berlin/London 1984, pp. 326–7 (with bibliography); Rolf Kultzen, 'Michael Sweerts als Bildnismaler', *Wiener Jahrbuch für Kunstgeschichte*, vol. 40 (1987), pp. 209–7; and note 5 below.
2 See M. Waddingham, *Paragone*, vol. 107 (November, 1958), p. 72; V. Bloch, *Jahrbuch der Statlichen Kunstsammlungen in Baden-Württemberg*, vol. 2 (1965), p. 172; and M. Waddingham, *Minneapolis Institute of Arts Bulletin*, vol. 63 (1976–7), p. 62.
3 See the many reproductions illustrated by W. Martin in Part II of his article (see note 1) 'The Life of a Dutch Artist in the Seventeenth Century – Instruction in Painting', pp. 416ff. See also exh. cat. *Children of Mercury. The Education of Artists in the Sixteenth and Seventeenth Centuries*, Brown University, Providence, 1984.
4 See Malcolm R. Waddingham, 'Michael Sweerts, *Boy Copying the Head of a Roman Emperor*', *Minneapolis Institute of Arts Bulletin*, vol. 63 (1976–7), pp. 57–65.
5 On Sweerts' paintings of artists' studios, see Rolf Kultzen, 'Michael Sweerts als Lernender und Lehrer', *Münchener Jahrbuch der bildenden Kunst*, vol. 33 (1982), pp. 109–30. On Detroit's studio painting, see Julius Held, *Flemish and German*

Paintings of the 17th century. The Collections of the Detroit Institute of Arts (Detroit, 1982), pp. 113–14.

6 See Clifford S. Ackley, *Printmaking in the Age of Rembrandt*, exh. Boston and St. Louis, 1980–1, cat. 190, ill.

7 Waddingham 1976–7, p. 62.

8 See Neil Maclaren, *The Dutch School, National Gallery Catalogues* (London, 1960), pp. 412–13, note 17.

9 See Duncan Thomson, *A Virtuous and Noble Education*, National Gallery of Scotland (Edinburgh, 1971), p. 39, no. 45, ill. (panel 37.5 × 46.3 cm.).

10 Waddingham 1976–7, p. 59.

11 Waddingham 1976–7, p. 62.

12 See Hervé Oursel, *Le Musée des Beaux-Arts de Lille* (Paris, 1984) p. 223, no. 68.

13 See note 1.

14 Kronig, Cook collection cat. 1914, no. 361; Waddingham 1976–7, p. 62.

15 On manikins, see P. T. A. Swillens, 'Beelden en ledepoppen in de Schilderkunst', *Maanblad voor beeldende kunsten*, vol. 23 (1947), pp. 247–58, 277–90; Arpad Weixlgartner, 'Von der Gliederpuppe', *Göteborgs Kunstmuseum Artstyck*, 1953, pp. 37–71; and E. F. van der Grinten, 'Le Cachalot et le mannequin. Deux facettes de la réalité dans l'art hollandais du seizième et du dix-septième siècles', *Nederlands Kunsthistorisch Jaarboek*, vol. 13 (1962), pp. 149–79.

16 See S.J. Gudlaugsson, *Gerard ter Borch*, vol. 2 (The Hague, 1960), pp. 15–16.

17 Respectively D. Hannema, *Beschrijvende Catalogus van de schilderijen uit de kunstverzameling Stichting Willem van der Vorm*, 2nd edn (Rotterdam, 1962), nos. 4 and 49.

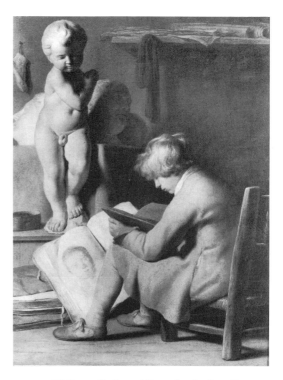

FIG. 2 *Wallerant Vaillant, A Young Boy Studying Drawings ('Le Petit Dessinateur')* signed, oil on canvas 129 × 100 cm., Louvre, Paris, no. R.F. 2502.

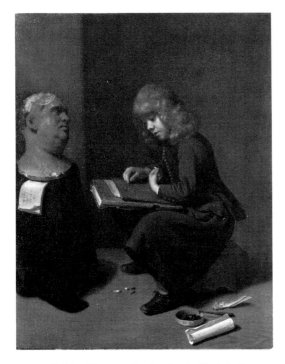

FIG. 1 Michael Sweerts, *Boy Copying the Head of a Roman Emperor*, monogrammed?, oil on canvas, Minneapolis Institute of Arts, The Walker H. and Valborg P. Ude Memorial Fund, 72.65.

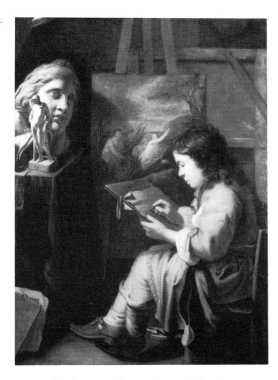

FIG. 3 Wallerant Vaillant, *A Young Boy Copying from Casts and Paintings*, oil on canvas, Musée des Beaux-Arts, Lille, cat. 1984, no. 68.

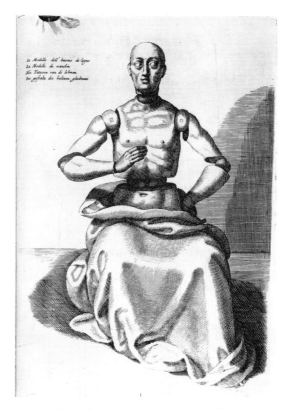

FIG. 4 C. van der Passe, *Manikin*, engraved illustration from *Luce del dipingere et disegnare* (Amsterdam, 1643).

ADRIAEN VAN DE VELDE

(AMSTERDAM 1636–1672 AMSTERDAM)

Baptized on 30 November 1636 in Amsterdam's Oudekerk, Adriaen van de Velde was the son of Willem van de Velde I (1611–93) and the younger brother of Willem van de Velde the Younger (q.v.), both accomplished marine painters. According to Houbraken, he was taught successively by his father and by Jan Wijnants (1631/2–84) in Haarlem. There is no documentation for a hypothetical trip to Rome in about 1653–6. His earliest dated works are etchings of 1653, his earliest dated paintings are landscapes with animals of 1654; these works clearly document the influence of Philips Wouwermans and Paulus Potter on the artist's career. On 5 April 1657, van der Velde married Maria Ouderkerk in Amsterdam, where he evidently remained for the rest of his life, dating paintings as late as 1671. He was buried in the Nieuwe Kerk, Amsterdam, on 21 January 1672. His brother and father emigrated permanently to England the following year.

A versatile painter, Adriaen van de Velde not only executed pastoral landscapes, but also forest, beach and winter scenes, portraits, allegories, genre scenes and religious paintings. A Catholic, van de Velde reportedly painted a Passion series for the Spinhuiskerk, one of a number of 'hidden churches' in Amsterdam. The ambitiously conceived *Allegory of Life* dated 1663 (Pushkin Museum, Moscow) suggests he also received official commissions. Other landscapists, including Jan Wijnants, Jacob van Ruisdael, Meindert Hobbema, Jan Hackert, Jan van der Heyden and Frederick de Moucheron employed him to paint staffage in their paintings. Houbraken informs us that Adriaen was devoted to making drawings of farm animals from life and landscape studies out-of-doors: 'he carried his equipment each day out to the countryside – a practice maintained until the end of his life once per week'. Among approximately two hundred drawings by the artist that have survived are preparatory studies which show that he proceeded methodically from preliminary compositional sketches, to chalk studies of animals and figures, to more finished drawings before executing his paintings. His œuvre also includes twenty-six etchings.

LITERATURE: Sandrart 1675, p. 314; Houbraken, vol. 1 (1718), pp. 275, 355; vol. 2 (1719), pp. 128, 132, 328; vol. 3 (1721), pp. 48, 53, 90–1, 181, 286, 288, 358; Descamps 1753–64, vol. 3, pp. 72–7; Smith, vol. 5 (1834), pp. 167–226; A.D. de Vries, 'Biografische aanteekeningen', *Oud-Holland*, vol. 4 (1886), pp. 143–4; Emile Michel, 'Adriaen van de velde', *L'Art*, vol. 53 (1892), pp. 54–8; Emile Michel, *Les van de Veldes* (Paris, 1892); Wilhelm Bode, 'Adriaen van de Velde', *Die graphische Künste*, vol. 29 (1906), pp. 14–24; Wurzbach, vol. 2 (1910), pp. 748–50; Hofstede de Groot, vol. 4 (1912), pp. 452–581; Kurt Zoege von Manteuffel, *Die Künstlerfamilie van de Velde* (Bielefeld and Leipzig, 1927) pp. 55–83; K. Zoege van Manteuffel, in Thieme and Becker, vol. 34 (1940), pp. 198–9; Stechow 1966, pp. 31–2, 60–1, 80, 98–9, 107–9, 160–2; Salerno 1977–80, vol. 2, pp. 750–3; William W. Robinson, 'Preparatory Drawings by Adriaen van de Velde', *Master Drawings*, vol. 17 (1979), pp. 3–23; Amsterdam/Boston/Philadelphia 1987–8, pp. 492–6.

CAT. 73

Winter Landscape with Skaters

Initialled lower left: A.V.V.
Oil on (original) panel 8½ × 8¼ in. (21.7 × 21.1 cm.)

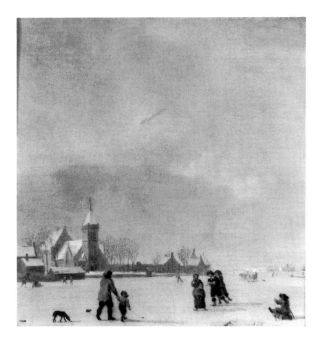

PROVENANCE: With dealer Goudstikker, Amsterdam, 1932;
Etienne Nicolas, Paris.

EXHIBITIONS: Amsterdam, dealer J. Goudstikker, *Tentoonstelling van hollandsche winterlandschappen uit de 17de eeuw*, 6–29 February 1932, no. 86, ill. (with facsimile of the initials); London 1988, no. 69.

LITERATURE: *Die Weltkunst*, 21 February 1932, p. 2, ill.; *Beeldende Kunst*, vol. 19, no. 72, ill.; P. C. Sutton, in Amsterdam/Boston/Philadelphia 1987–8, p. 496; Russell 1988, p. 789.

CONDITION NOTES: The original panel support has been enlarged by 7 mm. strips on all sides, resulting in overall measurements of 9⅛ × 8⅞ in. (23.1 × 22.5 cm.). The edges may have been shaved slightly to accommodate these strips, but the panel has not been cut down or sawn in the back. There are numerous tiny retouches in the paint film in the sky (especially in the upper left) and in the ice to disguise the vertical grain of the wood. There is also some minor strengthening of the forms of the figures, i.e. the man at the back of the pair skating in tandem. The stickers of Nicolas' French packers, Ch. Pottier and H. Gerfaud, are on the back, as well as the number s.1686 in chalk.

In an upright winter scene with a vast expanse of sky, tiny figures walk, skate and slide over the ice. In the lower left a man walks holding the hand of a boy who carries a 'colf' stick (on 'colf', see Cat. 3). They are followed by a dog who has stopped to sniff at an object on the ice. On the right a woman approaches on skates, followed by two men skating in tandem, while in the lower right corner a boy in a broad-brimmed hat and seated in a sledge poles himself forward. Farther back on the ice are the faint silhouettes of other skaters, a man pushing a sledge on the left, and a horse-drawn sleigh on the right. Snow-covered houses, trees and a church with a square tower line the diagonally receding bank on the left. Fully three quarters of the composition is devoted to the towering sky.

Adriaen van de Velde painted very few winter scenes and most seem to date from a two year period, 1668–9.[1] As Wolfgang Stechow observed, these paintings can be divided into two groups: those in which the genre figures are large and the landscape plays a more subsidiary role, like the *Colfers on the Ice near Haarlem* dated 1668 (fig. 1) and the *Skaters near a Town Wall* of 1669 (Staatliche Kunstsammlungen, Dresden, no. 1659)[2] and those in which the landscape itself is of greatest interest. Examples of the latter kind are the winter scenes in the John G. Johnson Collection at the Philadelphia Museum of Art (no. 603)[3] and the Louvre, Paris, dated 166[8?] (fig. 2).[4] With its very tiny figures and tall sky, the latter painting is closest to the delicate and intimate style of the Samuel painting. However, the Samuel painting is even sparer in conception, and unusual for its nearly square format. Although the vertical composition and tall sky of this work might recall Jacob van Ruisdael's recent innovations to the panorama (see Cat. 59), Adriaen van de Velde rarely emphasized the melancholy or threatening aspect of winter that so obsessed Ruisdael. And he was far less interested than Aert van der Neer, Jan van de Cappelle or Jan van Goyen (see Cats. 42, 43, 12 and 21) in painterly atmospheric effects, though the last mentioned precedes him in painting winter series on an upright format (see fig. 3). His light has a greater consistency and clarity, his sky a velvety smoothness, while his control of aerial perspective is virtually unrivalled. As in his summer beach scenes, his winter landscapes celebrate nature's happier and most beneficent moments.

1 See Hofstede de Groot, vol. 4 (1912), nos. 368–83c.
2 See also *Winter Landscape with Snowballers*, of which two versions exist: Hofstede de Groot, vol. 4 (1912), no. 374, sale Viscount Chandos *et al.* (G.W. Maculpine), London (Sotheby's), 19 March 1975, no. 10, ill. (ex-Cook Collection); and Berlin Museum, cat. 1931, no. 1999.
3 Panel 30.5 × 36.8 cm., Hofstede de Groot, vol. 4 (1912), no. 373; see Amsterdam/Boston/Philadelphia 1987–8, cat. no. 104, ill.
4 Hofstede de Groot, vol. 4 (1912), no. 371.

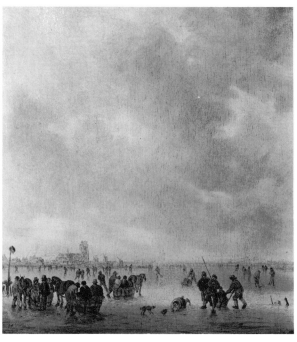

FIG. 3 Jan van Goyen, *Winter Landscape with Skaters near Dordrecht*, signed and dated 1643, oil on panel 37.5 × 34.3 cm., St Louis Art Museum, St Louis, Mo., inv. no. 223;1916.

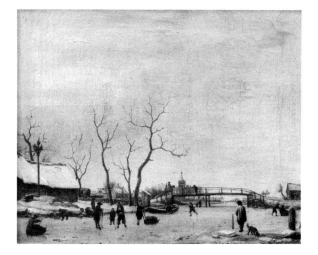

FIG. 1 Adriaen van de Velde, *Colfers on the Ice near Haarlem*, signed and dated 1668, panel 30.3 × 36.4 cm., National Gallery, London, no. 869.

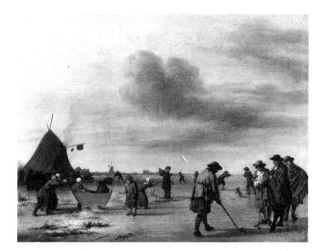

FIG. 2 Adriaen van de Velde, *Winter Landscape*, signed and dated 166[8?], oil on canvas 23 × 30 cm., Musée du Louvre, Paris, inv. 1920.

ESAIAS VAN DE VELDE

(AMSTERDAM 1587–1630 THE HAGUE)

Esaias van de Velde (he most commonly used 'van den Velde') was baptized in Amsterdam's Oudekerk on 17 May 1587. His father, Hans van de Velde (1552–1609), was a Protestant artist and art dealer who fled religious oppression in Antwerp and settled in Amsterdam in 1585. Esaias was a second cousin of the landscape etcher and draughtsman Jan van de Velde (c. 1593–1641). This van de Velde family was unrelated to that of the painters Adriaen (q.v.) and Willem van de Velde, which originated in Leiden. Presumably Esaias first studied with his father, and may also have been a pupil of Gillis van Coninxloo, whose death in 1607 provides a *terminus ante quem* for this earliest period of training; in an entry of 1621 from his *Res Pictoriae*, Arnout van Buchell cites a landscape by Coninxloo with figures by Esaias van de Velde. In addition, Hans van de Velde bought some of Coninxloo's drawings at the sale following the latter's death. Esaias may also have studied with David Vinckboons, whose work his art acknowledges. The influence of Jan van de Velde and Claes Jansz Visscher is also evident in Esaias' landscapes.

Esaias was in Haarlem in 1609 and had settled there by 1610. On 10 April 1611, he married Catelijn Maertens of Ghent; the couple had three children, including the artists Esaias the Younger (b. 1615) and Anthonie the Younger (1617–72). Esaias was admitted to the Haarlem Guild of St Luke in 1612, the same year as Willem Buytewech (1591/2–1624) and Hercules Segers. His earliest dated works are of 1614. He was a member of the Haarlem rhetoricians' chamber 'De Wijngaertranken' in 1617 and 1618. In 1618, he moved to The Hague and joined the guild there; he became a citizen of the town in 1620. On 3 January 1626, the treasurer of the Prince of Orange accused Esaias of maligning him in public in a matter concerning a payment of 200 guilders for one of the artist's paintings; two days later Esaias testified that he had been paid in full, adding that he had never intended any offence. Esaias died in The Hague and was buried in the Grote Kerk there on 18 November 1630.

Esaias van de Velde was a draughtsman, painter and etcher of landscapes, cavalry battles, and genre scenes. He played a pioneering role in the development of a more naturalistic and indigenous Dutch landscape style and Constantijn Huygens singled out Esaias' landscapes for special praise in his private memoirs. He often contributed staffage to the architectural paintings of Bartolomeus van Bassen (c. 1590–1652) and the landscapes of other painters. His pupils included Jan van Goyen (q.v.) and Pieter de Neyn (1597–1639).

LITERATURE: J. J. Orlers, *Beschrijvinge der stadt Leyden*, 3 vols. (Leiden, 1641; 1st edn Leiden, 1614), pp. 373–4; Dirck van Bleyswijck, *Beschrijvinge der stadt Delft*, 2 vols. (Delft, 1667; supplement 1674), vol. 2, p. 897; Sandrart 1675, p. 310; Houbraken, vol. 1 (1718), pp. 171, 173, 275, 303; Descamps, vol. 1 (1753), p. 396; van der Willigen 1870, p. 305; Obreen 1877–90, vol. 3, pp. 260, 298, vol. 5, pp. 117, 126, 178, 306, vol. 6, p. 172; Emile Michel, 'Les van de Veldes', *Gazette des Beaux-Arts*, vol. 37 (1888); Emile Michel, *Les van de Veldes* (Paris, 1892); Wurzbach, vol. 2 (1910) pp. 751–2; K. Zoege van Manteuffel, in Thieme and Becker, vol. 34 (1940), pp. 199–200; Georg Poensgen, 'Der Landschaftstil des Esaias van de Velde', dissertation Freiberg, 1924; Rolph Grosse, *Die holländische Landschaftskunst, 1600–1650* (Berlin and Leipzig, 1925), pp. 44–5; Kurt Zoege von Manteuffel, *Die Künstlerfamilie van de Velde* (Bielefeld and Leipzig, 1927); J. G. van Gelder, *Jan van de Velde* (The Hague, 1933); M. Siwajew, 'Esajas van de Velde als Schlachtenmaler', *Travaux du département de l'art européen. Musée de l'Ermitage*, vol. 1 (1940), pp. 31–54; Wolfgang Stechow, 'Esajas van de Velde and the Beginnings of Dutch Landscape Painting', *Nederlands Kunsthistorisch Jaarboek*, vol. 1 (1947), pp. 83–94; Ake Bengtsson, *Studies on the Rise of Realistic Landscape Painting in Holland, 1610–1625* (Figura, vol. 3) (Stockholm, 1952); Horst Gerson, 'Enkele vroege werken van Esajas van de Velde', *Oud-Holland*, vol. 70 (1955) pp. 131–5; Rotterdam, Museum Boymans-van Beuningen, *Esaias van de Velde, Jan van de Velde: Grafiek*, 1959; Stechow 1966, pp. 19–23, 25–7, 34–6, 51–6, 84, 88; Teréz Gerszi, 'Zur Zeichenkunst Esaias van de Velde', *Actae Historiae Artium*, vol. 24 (1978), pp. 272–7; Amsterdam, Gallery Gebr. Douwes, *Esaias van de Velde, schilder, 1590/91–1630; Jan van Goyen, tekenaar, 1596–1656* (cat. by Evert J. M. Douwes), 1981; Haak 1984, pp. 186–7; George Keyes, *Esaias van de Velde 1587–1630* (with a biographical chapter by J. G. C. A. Briels; Doornspijk, 1984); Philadelphia/Berlin/London 1984, pp. 186–7; Amsterdam/Boston/Philadelphia 1987–8, pp. 497–502.

CAT. 74

Winter Landscape with Skaters

Signed with initials lower left: E V W
Oil on circular panel 6¾ in. (17.2 cm.) diameter

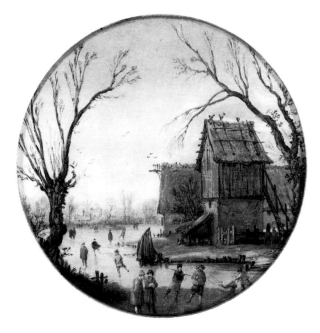

PROVENANCE: Sale London (Christie's), 3 August 1917, no. 495; Canford Manor (?) (see sticker on the back); Mrs Dorothy Hart; acquired from Edward Speelman in 1970.

EXHIBITION: London 1988, no. 70.

LITERATURE: George S. Keyes, *Esaias van de Velde 1587–1630* (Doornspijk, 1984), p. 139, pl. 202; Russell 1988, p. 789.

CONDITION NOTES: The circular panel is generally in good condition but has a small sliver of a loss at the bottom edge. The paint film has some old losses and fills in the lower left and some minor abrasion. The varnish is relatively clear. The date of the 1917 Christie's sale appears on the back as well as the numbers in black stencil 455CO and 987SJ. The name Canford Manor appears on the back and in pencil the name Gilbey Brian (?).

In a circular scene of a frozen river bordered and framed by tall sinuous trees, figures skate on the ice (some carrying poles), stop to chat, or push a sledge. In the right middle distance are two large farm buildings, one tall and narrow, the other long and low. On the far shore in the centre, a boat upturned in the frozen river serves as an outhouse. In the distance are skaters, trees and farm buildings.

Esaias van de Velde had begun painting winter scenes of an unprecedented naturalism by 1614, the date on his painting in the Fitzwilliam Museum, Cambridge, no. M79.[1] Van de Velde's winter scenes rarely emphasize the merriment of the skaters or the picturesque quality of winter, which was a central feature of Hendrick Avercamp's frozen vistas, but they better capture the chilled atmosphere and bleakness of the landscape. The round or tondo format had been used earlier by Hans Bol in his prints of winter (fig. 1), by the Flemish sixteenth-century landscape painter Abel Grimmer, as well as by Hendrick Avercamp (fig. 2). Esaias probably began painting circular winter scenes about the same time as his oblong winter landscapes, but the earliest certainly dated tondo is of 1616.[2] He continued to paint these roundels at least through the mid-1620s;[3] however, on the basis of the men's costumes ('with their low, wide-brimmed hats') Keyes would date the Samuel painting to about 1620.[4] He further suggests that a summer landscape (fig. 3) with a path in the dunes and a Gothic church spire and gallows, signed and dated 1620, may have been the pendant to the present work.[5] Although the two works are comparable in style and dimension and employ a similarly broad technique, their companionship is unproven. In the 1620s, Esaias van de Velde's pupil, the young Jan van Goyen, painted many roundel pendants in imitation of his teacher.[6]

1 See Keyes 1984, no. 71; see also no. 73, pl. 4 (Private Collection, Cologne), and no. 89, pl. 9 (North Carolina Museum of Art, Raleigh, no. 52.9.16) which are also dated 1614.
2 Keyes 1984, cat. no. 101, fig. 419, present location unknown. See also Keyes 1984, cat. no. 70, fig. 420, dated 1617, Private Collection, Berlin.
3 See Keyes 1984, cat. no. 96, pl. 421 (dated 1624), cat. no. 100, pl. 208 (dated 1625), both present location unknown.
4 Keyes 1984, p. 139, cat. no. 74.
5 Keyes 1984, cat. 117, fig. 394, as Private Collection, Great Britain.
6 See, for example, van Goyen's pendants dated 1625 in the Rijksmuseum, Amsterdam, nos. A3945 and A3946 (Hans Ulrich Beck, *Jan van Goyen, 1596–1656*, 2 vols. (Amsterdam, 1972–3), vol. 2, nos. 108 and 109; Amsterdam/Berlin/Philadelphia 1987–8, cats. 31 and 32).

FIG. I Hans Bol, *Winter Landscape*, engraving.

FIG. 3 Esaias van de Velde, *Path in the Dunes*, signed and dated 1620, panel 16.5 cm. diameter, sale London (Christie's), 6 July 1984, no. 70, ill.

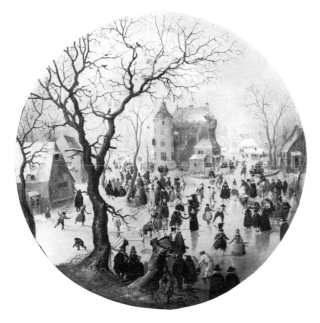

FIG. 2 Hendrick Avercamp, *Winter Landscape with Castle*, c. 1605, monogrammed, panel 40.7 cm. diameter, National Gallery, London, no. 1346.

JAN JANSZ VAN DE VELDE III

(HAARLEM 1619/20–1663 OR LATER, AMSTERDAM)

Born to an exceptionally distinguished family of Dutch artists, Jan Jansz van de Velde III was the grandson of the great calligrapher of the same name (c. 1568–1623) who designed *Deliciae variarum insigniumque scripturarum* (1604) and *Spiegel der schrift-Konste* (1605) and son of the pioneer of landscape drawings and engravings, Jan II (c. 1593–1641). He was also a cousin of the landscapist, Esaias van de Velde II, and of the marine painters Willem I and II van de Velde (q.v.). Jan III's date of birth is established by the record of his marriage; when, on 24 April 1643, he married Diewertje Willems Middeldorp in Amsterdam, he was reported to be twenty-three years old. In 1644 he was a witness at the baptism of Esaias van de Velde's son of the same name. In 1656 he was married for a second time to Christina van Hees. His paintings range in date from 1639 to 1663, but the date of his death is unknown.

Jan III was a still-life painter who specialized in images of smoking requisites often accompanied by roemers of wine or beer, nuts and sometimes fruit. The greatest influence on his art were the still lifes of Pieter Claesz but among Amsterdam painters of intimate still lifes from his era (including Jan Jansz Treck, Jan Fris, Simon Luttichuys and Cornelis Kick) he was one of the most accomplished. He is at his most memorable in intimate images of the most commonplace objects, a few oyster shells, pears, or simple clay pipes and a brazier. Many of his approximately fifty works are dated and the signed pictures exhibit flourishes in the signatures which may attest to the elegant precedents of the painter's grandfather.

LITERATURE: A. P. A. Vorenkamp, *Bijdrage tot de geschiedenis van het Hollandsch stilleven in de zeventiende eeuw*, dissertation, Leiden, 1933, pp. 44ff.; Zoege von Manteuffel, in Thieme and Becker, vol. 34 (1940), p. 202; N. R. A. Vroom, *De Schilders van het monochrome banketje* (Amsterdam, 1945); Ingvar Bergström, *Dutch Still-Life Painting in the Seventeenth Century* (New York, 1956), p. 144; Laurens Bol, *Holländische Maler des 17. Jahrhunderts nahe den grossen Meistern: Landschaften und Stilleben* (Braunschweig, 1969), pp. 76–80; N. R. A. Vroom, *A Modest Message as Intimated by the Painters of the 'Monochrome Banketje'* (Schiedam, 1980), vol. 1, pp. 222–30, vol. 2, pp. 131–7, cat. nos. 676–710; George S. Keyes, *Esaias van de Velde 1587–1630* (Doornspijk, 1984), pp. 18–19.

CAT. 75

Still Life with Glass of Beer, Brazier and Clay Pipes 1649

Signed and dated on the table edge: J v Velde Anno 1649
Oil on panel 15⅞ × 12¼ in. (40.1 × 31 cm.)

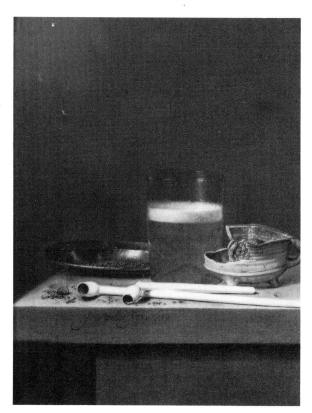

PROVENANCE: Count Cavens, Brussels; with Goudstikker, Amsterdam, 1933, inv. no. 965; H. E. ten Cate, Oldenzaal, by 1950, cat. 1955, no. 15, fig. 15; acquired from the son of ten Cate by Edward Speelman who in turn sold it to Harold Samuel.

EXHIBITIONS: Amsterdam, Goudstikker Gallery, *Het Stilleven*, 1933, no. 329; Rotterdam, Museum Boymans, Christmas Exhibition, 1934, no. 20, ill.; Almelo, *Oude Kunst uit Twents*

Particulier Bezit (cat. by D. Hannema), 1953, cat. no. 56, fig. 38; Dordrecht, Dordrechts Museum, *Nederlandse Stillevens uit vier eeuwen*, 1954, cat. no. 95 (lent by H. E. ten Cate); Rotterdam, Museum Boymans, *Kunstschatten uit Nederlandse Verzamelingen* (cat. by E. Haverkamp Begemann and Bernadine R. M. de Neeve), 1955, cat. no. 129, fig. 49; London 1988, no. 71.

LITERATURE: N. R. A. Vroom, *De Schilders van het Monochrome Banketje* (Amsterdam, 1945), p. 166, fig. 146; *Catalogue of the Collection of Dutch and Flemish Still-Life Pictures Bequeathed by Daisy Linda Ward*, Ashmolean Museum (Oxford, 1950), p. 181, under cat. no. 83, p. 182, under cat. no. 84; D. Hannema, *Catalogue of the H. E. ten Cate Collection*, 2 vols. (Rotterdam, 1955), vol. 1, p. VIII, nos. 15, 19, vol. 2, pl. 5; Laurens J. Bol, *Holländische Maler des 17. Jahrhunderts nahe den grossen Meistern: Landschaften und Stilleben* (Braunschweig, 1969), p. 78, fig. 65; N. R. A. Vroom, *A Modest Message as Intimated by the Painters of the 'Monochrome Banketje'*, 2 vols. (Schiedam, 1980), vol. 1, p. 222, fig. 301, vol. 2, p. 132, no. 681; Speelman 1988, p. 15.

CONDITION NOTES: The panel support is in good condition, uncradled and uncut. An interesting feature of the support is an incised line along the upper edge that may be the original panel-maker's guideline. Some small old dents, in the paint film as well as the support, appear just below the rim of the beerglass and near its right edge. Some minor retouches, now somewhat discoloured, are scattered in the background and in the glass. The varnish is moderately discoloured. Several exhibition and dealers' stickers appear on the reverse, including those of: Goudstikker (no. 965), the exhibition of Almelo in 1953, and in Dordrecht of 1954. A cloth label bears the number L.2170.49.29.

In an upright composition, a short glass half filled with a dark, almost crimson-hued beer, a broken pinkish-orange clay brazier with glowing coals, a metal plate filled with granular ashes, and two long white clay pipes decorated with a triple diamond design are grouped on the edge of a table. Smoking embers spill from the bowls of the pipes. The table betrays old burns on its surface. On the table's edge is the flourish of van de Velde's elegant signature.

Van de Velde was preceded and no doubt influenced in his paintings of smoking requisites by the works of Pieter Claesz (q.v.). His paintings are dated from 1639 to 1663, but he had begun to concentrate on smoking motifs by 1647, the date of the painting now in Prague (fig. 1).[1] That work has a similarly spare and understated design and includes virtually all the same objects as the Samuel picture (with the exception of the brazier), again viewed at the edge of a table but arranged in reverse. In place of the brazier is a pack of cards, while a glowing wick used to light the pipes has been added at the left. Authors of the Ward catalogue were first to observe the similarities between the Samuel painting and a similar, though horizontally composed, tobacco still life with broken brazier dated 1651 in the Ward Collection at the Ashmolean Museum, Oxford (fig. 2).[2] Still another upright tobacco still life dated 1653 from

the Ward Collection shares with the Samuel painting the near view of the table edge, the white clay pipe laid horizontally, the dish of tobacco, as well as the vertical accent of the beerglass; now, however, it has been transformed into a tall graduated cylinder and supplemented with a wineglass.[3] Van de Velde had painted more monumental and elaborately conceived designs as early as 1644,[4] and seems to have increasingly favoured more complicated arrangements of richer tabletop objects.[5] However, to the modern taste, the artist is most appealing when at his most restrained in subject matter and muted in palette – the amber overall tonality, the sheen of pewter and the tortoiseshell hues of the beer glass.

In the seventeenth century the Dutch had an ambivalent attitude towards tobacco and the relatively new practice of smoking.[6] Some enthusiasts assigned medicinal properties to the weed and composed songs and poems in praise of its powers, but most condemned it as a harmful intoxicant to be equated with excessive drinking. *Predikants* and public watchdogs not only censored taverns for serving alcohol, but also the dank *tabagies* that catered to the new mania for smoking. Petrus Scriverius' *Saturnalia* published in Haarlem in 1630 was a satire on the uses and abuses of tobacco which associated it with drunkenness and death. The title page was decorated with a still life including a skull, winged hour-glass, candle, pipes and smoking requisites, thus underscoring smoking's traditional vanitas associations.[7] Dissipating smoke could serve as a reminder of the fleeting nature of life or, alternatively, allude to the sense of smell in a Five Senses series. Yet while Jacob Cats might create an emblem in 1618 of a winged cupid bringing a smoker a handful of pipes as a symbol of contentment with little (a table, a chair and a gratifying smoke are sufficient to the abstemious life of thought),[8] the many low-life images of stupefied smokers and rowdy drinkers by Brouwer and his followers usually satirized smoking as the immoderate pursuit of sensual gratification.[9]

1 Vroom 1980, vol. 1, fig. 303, vol. 2, cat. 679.
2 Vroom 1980, vol. 2, cat. 685, ill. p. 132; *Catalogue of the Collection of Dutch and Flemish Still Life Pictures bequeathed by Daisy Linda Ward*, Ashmolean Museum (Oxford, 1950), p. 181, cat. 83, ill. Compare also the broken brazier in the painting dated 1658 by van de Velde in the Museum Boymans-van Beuningen, Rotterdam, no. 1893; and the still life with brazier, pipe, walnuts and cards, dated 1660, wrongly attributed to A. van Ostade in the Musée de Nancy, Nancy, cat. 1909, no. 365.
3 Vroom 1980, vol. 1, fig. 304, vol. 2, cat. no. 688; Oxford cat. 1950, p. 182, cat. no. 84.
4 See the *Breakfast Still Life with Cards and Pipe*, signed and dated 1644, oil on panel 93 × 74 cm., Heinz Collection: Vroom

1980, vol. 1, fig. 308, vol. 2, cat. 676; *Still Lifes of the Golden Age. Northern European Paintings from the Heinz Family Collection* (cat. by Ingvar Bergström and Arthur Wheelock, Jr) National Gallery of Art, Washington, 14 May–4 September 1989; Museum of Fine Arts, Boston, 18 October–31 December 1989, no. 43, ill.

5 See for example, *Breakfast Piece*, dated 1658, panel 36 × 32 cm., Rijksmuseum, Amsterdam, no. A1766 (Vroom 1980, vol. 1, fig. 306, vol. 2, cat. 703), and the *Breakfast Still Life with Oysters*, dated 1661, canvas 65 × 58 cm., present location unknown (Vroom 1980, vol. 1, fig. 307, vol. 2, cat. 704).

6 On smoking, see Cat. 56, and Eddy de Jongh *et al.*, in *Tot Lering en Vermaak*, Rijksmuseum, Amsterdam, 16 September–5 December 1976, cat. no. 7.

7 *Saturnalia ofte Poëtisch Vasten-avond-spel vervatende het gebruyk ende misbruyk van de Taback* (Haarlem, 1630); see ill. of title page in Amsterdam 1976 (note 6), cat. no. 7.

8 Jacob Cats, *Emblemata ofte minnelycke, zedelijke ende stichtelijke sinnebeelden* (Middleburg, 1618), p. 12; ill. in exh. cat. Philadelphia/Berlin/London 1984, p. 175, fig. 2.

9 See note 6, and William Robinson's comments in Philadelphia/Berlin/London 1984, cat. no. 21.

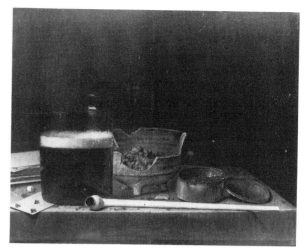

FIG. 2 Jan Jansz van de Velde III, *Still Life with Smoking Requisites*, signed and dated 1651, oil on panel 29 × 37 cm., Ashmolean Museum, Oxford, Ward Bequest, cat. 1950, no. 83.

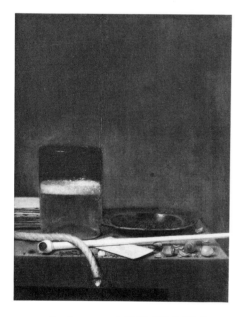

FIG. 1 Jan Jansz. van de Velde III, *Still Life with Smoking Requisites*, signed and dated 1647, oil on panel 39.8 × 31.4 cm., National Museum, Prague, inv. no. 1392.

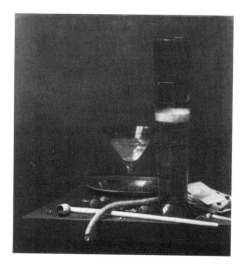

FIG. 3 Jan Jansz van de Velde III, Still Life with Smoking Requisites, signed and dated 1653, oil on canvas 43 × 40 cm., Ashmolean Museum, Oxford, Ward Bequest, cat. 1950, no. 84.

WILLEM VAN DE VELDE THE YOUNGER

(LEIDEN 1633–1707 LONDON)

The second child of the marine artist of the same name, Willem van de Velde the Younger was baptized in Leiden on 18 December 1633. His younger brother Adriaen was a noted landscapist (q.v.). The family settled in Amsterdam in 1636. Willem II probably first studied with his father, although according to Houbraken he was a pupil of Simon de Vlieger, probably at Weesp, where de Vlieger had settled by March 1650 and perhaps as early as 1648. On 13 March 1652, at age eighteen, he married Petronella de Maire of Weesp in Amsterdam. The marriage lasted only eighteen months before van de Velde brought proceedings against his wife, with de Vlieger testifying on his behalf. In 1666 Willem was married for a second time to Magdalena Walravens; the couple had six children, and three of the sons (Willem, Cornelis and Peter) became painters. Van de Velde's earliest dated paintings are of 1651 and 1653. He lived and worked in Amsterdam until the French invasion in 1672, when the art market collapsed. According to a letter from Peter Blaeu to Cardinal Leopoldo de'Medici, Willem the Elder decided to emigrate to England or, if that failed, Italy. Willem the Younger was certainly in London by the end of 1672. He painted overdoors for Ham House in 1673, and by 1674 both father and son were in the service of Charles II who paid them each an annual retainer fee of £100. They resided in England for the remainder of their lives, making only brief return visits to Holland. They shared a studio in the Queen's House at Greenwich, where they lived until moving to Westminster in 1691 where Willem the Elder died in 1693. The son outlived his father by fourteen years; he was buried in St James in Piccadilly in April 1707.

Van de Velde's early paintings acknowledge the influence of Simon de Vlieger. During the mid-1650s and 1660s he produced the best works of his Dutch period, often depicting ships in a calm. Van de Velde represented naval battles fought during the Second Anglo-Dutch War of 1666 during his later years in England increasingly favouring historical maritime themes. After 1673 Willem the Younger painted many royal British ceremonial subjects. However, even after moving across the Channel he was still com-missioned to paint maritime subjects by the Amsterdam Harbour Commission and by Admiral Tromp (*Battle of the Texel*, 1687, now in the National Maritime Museum) for his country house, Trompenburg in 's Gravesande. In England, Willem and his father managed a large studio with many assistants and students who produced versions, replicas and copies of their most successful compositions. The shop included not only the sons of Willem the Younger, Willem and Cornelis, but also Isaac Sailmaker, Jacob Knyff, Peter Monamy and others.

LITERATURE: Houbraken, vol. 2 (1719), p. 325; Smith, vol. 6 (1835); P. Haverkorn van Rijsewijk, 'Willem van de Velde de Jonge', *Oud-Holland*, vol. 19 (1901), pp. 61–3; F. C. Willis, *Die Niederländischen Marinemaler* (Leipzig, 1911), pp. 79–89; Hofstede de Groot, vol. 7 (1918); K. Zoege von Manteuffel, *Die Künstler-familie van de Velde* (Bieleveld/Leipzig, 1927); L. R. Preston, *Sea and River Painters of the Netherlands in the Seventeenth Century* (London, 1937), pp. 40–2, 55–9; H. P. Baard, *Willem van de Velde de Oude; Willem van de Velde de Jonge*, Palet Serie (Amsterdam, 1942); M. S. Robinson, *Van de Velde Drawings: A Catalogue of Drawings in the National Maritime Museum*, 2 vols. (Cambridge 1958–74); Laurens J. Bol, *Die Holländische Marinemalerei des 17. Jahrhunderts* (Braunschweig, 1973), pp. 231–43; L.R. Preston, *The Seventeenth Century Marine Painters of the Netherlands* (Leigh-on-Sea, 1974), pp. 52–7; Greenwich, National Maritime Museum, *The Art of the Van de Veldes* (cat. by D. Cordingly), 1982; M. S. Robinson, *The Paintings of Willem van de Velde. A Catalogue of the Paintings of the Elder and the Younger Willem van de Velde*, 2 vols. (Greenwich, 1990); Minneapolis, Minneapolis Institute of Arts, *Mirror of Empire. Dutch Marine Art of the Seventeenth Century* (catalogue by George Keyes *et al.*), also shown at the Toledo Museum of Art, 27 January–21 April 1991, and Los Angeles County Museum of Art, 23 May–11 August 1991, pp. 160–76, 420–2.

CAT. 76

A Weyschuit Coming Ashore near Den Helder, c. 1655

Initialled lower left: W.V.V.
Oil on panel 6⅟₁₆ × 9⅜ in. (15.4 × 23.7 cm.)

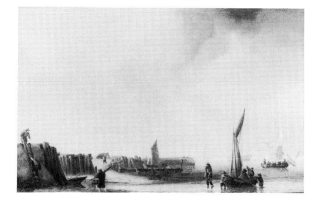

PROVENANCE: Baron A. W. C. Nagell van Ampsen, The Hague, by 1835; sale Baron van Nagell van Ampsen, The Hague, 5 September 1851, no. 68 (1010 frs., to Lamme); sale D. Vis Blokhuysen of Rotterdam, Paris, 1 April 1870, no. 75 (4260 or 4200 frs.); acquired from Edward Speelman in 1970.

EXHIBITION: London 1988, no. 72 [as Willem van de Velde the Elder].

LITERATURE: Smith, vol. 6 (1835), no. 214; *Supplement* (1842), no. 53; Hofstede de Groot, vol. 7 (1923), no. 281; M. S. Robinson, *A Catalogue of the Paintings of the Elder and the Younger Willem van de Velde*, 2 vols. (National Maritime Museum, Greenwich, 1990), vol. I, pp. 432–3, no. 607, ill.

CONDITION NOTES: The wood panel support is cradled and has ¼ in. (5 cm.) wood strip additions running with the horizontal grain on all sides. The overall dimensions with the additions is 6½ × 9¾ in. (16.5 × 24.8 cm.). Generally the paint film is in very good condition with minor retouches in the sky and in the lower right. The varnish is clear.

Under a heavy overcast sky, weak sun and light air, small boats come ashore by a sea wall. On the right two men draw a *weyschuit* or similar vessel carrying two men up onto the shore. Her brown spritsail is brayed up and her foresail is furled around the forestay. Often used in estuaries, the *weyschuit* was a small open Dutch vessel with straight raking stem and was usually rigged with a sprit. In the shallow water to the left of the boat a man wades ashore with a second man on his back. On the left a man carrying spars walks towards the sea wall. One man climbs a ladder set

against the wall while a second stands at the top ready to assist. Farther back in a break in the sea wall a sandy path leads up to a small cottage. Near the wall in the middle distance is a *kaag* with her spritsail set. In the right middle distance a ship's boat rows towards shore. In the background on the right are two large ships at anchor as well as smaller vessels under sail.

Robinson gave a thorough description of the scene and its vessels.[1] He assumed that the site of the sea wall was near Den Helder, and noted that the same site recurred in other paintings (see fig. 1) and drawings by van de Velde II.[2] Robinson felt that the initials of the signature could have been strengthened, that 'the ships and vessels and the figures are less accurately drawn than in the oil sketches by the Younger, c. 1700', while noting 'some defects in the ships that could be due to faulty restoration'. However, he also observed that the ships in the distance with the high sterns are dateable to about 1650, so he concluded that 'it seems likely therefore that this is an early work, c. 1655, by [Willem] the Younger painted for the van de Velde studio, comparable to the small freely painted picture in Greenwich thought to be signed and dated 1654' (fig. 2).[3]

When the painting was recorded by Smith and, according to Hofstede de Groot, when later sold with the Baron van Nagell collection on 5 September 1851, it was said to have a pendant.[4] However, as Robinson observantly pointed out, the measurements for the putative pendants in the van Nagell sale (nos. 67 and 68) in fact differ (respectively 13 × 19 cm. and 16 × 24 cm.), thus it is unlikely that they were conceived by van de Velde as a pair. Although he questioned the signature on the Samuel painting, claiming that it 'looks unconvincing', he allowed that it is not a modern addition;[5] the monogram was noted in the Blokhuysen sale, Paris, April 1, 1870, no. 75.

1 Robinson 1990, vol. I, p. 432.
2 Robinson 1990, cat. no. 374; compare also Robinson 1990, cat. nos. 310 and 375.
3 Robinson 1990, pp. 374–5, cat. no. 398.
4 See Smith, vol. 6 (1835), no. 215, *Supplement* (1842), no. 52; Hofstede de Groot, vol. 7 (1923), no. 346: '*Fishing Boats near the Shore in a Calm*. In the left foreground are two small fishing boats, with a man in each. A fisherman with a basket on his back walks in the shallow water. Beyond him are two small sailing boats. To the right are a rowing boat with two men in her, several piles, and figures unloading a small boat on the shore. Panel 6 × 9½ in'.
5 Robinson 1990, vol. I, p. 433.

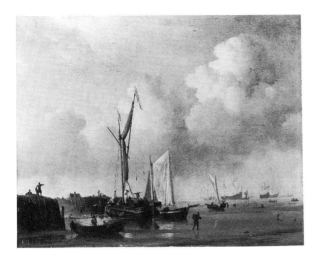

FIG. I Willem van de Velde the Younger, *Vessels near a Sea Wall*, signed, oil on panel 40.6 × 53 cm., Gemäldegalerie, Schloss Wilhelmshohe, Kassel, inv. no. 421.

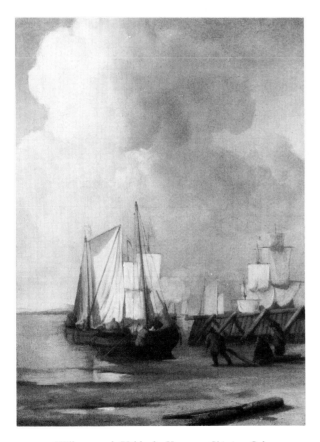

FIG. 2 Willem van de Velde the Younger, *Ship in a Calm*, formerly signed and dated 1654, oil on canvas 29 × 21.8 cm., National Maritime Museum, Greenwich, England, inv. no. 42-85.

CAT. 77

A Kaag and Smalschip near the Shore, with a Ship Firing a Gun, c. 1660

Initialled lower right on a plank: W.V.V.
Oil on panel 14 × 17⅞ in. (35.4 × 44.7 cm.)

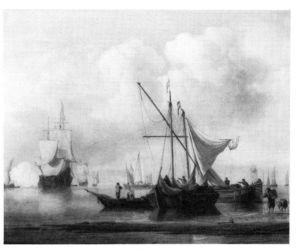

PROVENANCE: Earl Granville, London, by 1835 (see exh.); sale Earl Granville, London, 21 June 1845, no. 19 (to the dealer Nieuwenhuys, £346.10s); sale Eugène Schneider, Paris, 6 April 1876, no. 41, with an etched ill. by Toussaint [as on canvas (sic) 36 × 45 cm.] (to 'Kurmus [Kums] de Anvers', 10,100 frs.); sale Edouard Kums, Antwerp, 17 May 1898, no. 134 (19,000 frs.); sale Paris, 10 March 1932, no. 117 (from sticker on reverse); Dr. O. Wertheimer, Basle, who sold it in 1956 to Edward Speelman, from whom it was acquired by Lord Samuel.

EXHIBITIONS: London, British Institution, 1835, no. 104 [lent by Earl Granville, London]; London 1988, no. 76, ill.

LITERATURE: Smith, *Supplement* (1842), no. 14; Hofstede de Groot, vol. 7 (1923), no. 302; Russell 1988, p. 789; M. S. Robinson, *A Catalogue of the Paintings of the Elder and the Younger Willem van de Velde, 2 vols. (National Maritime Museum, Greenwich, 1990)* vol. 1, pp. 398–9, no. 668.

CONDITION NOTES: The panel support is uncradled and in good condition. Some minor retouching appears along the upper edge, and some drying crackle is evident in the sail of the ship at the left and in the darker passages of the shallows on the right. The varnish layer is thick and discoloured along the edges, indicating that the panel was once cleaned in its frame. A typewritten transcription (in French) of Hofstede de Groot's entry, no. 302, appears on the back with the added provenance: sale Paris, 10 March 1932, no. 117.

Under a sunny sky with cumulus clouds and light air, a *kaag* viewed from the port bow appears in the right foreground. A *kaag* is a round-hulled Dutch vessel with deep rail, straight raking stem, and clinker built (the planking overlaps). Close in to shore, it has its grapnel secured to a spit of sand that extends horizontally across much of the painting's foreground. Her brown spritsail is lowered onto the deck with her sprit at a steep angle in the slings; her foresail is also lowered. Close alongside the *kaag* to starboard there is a small *weyschuit* with two men onboard. (On the *weyschuit*, see Cat. 76.) At the stern of the *kaag* is another *kaag* or *smalschip* (on the *smalschip*, see cat. 80) viewed broadside from the port; her white spritsail is half lowered and the sprit horizontal. The foremost *kaag* has a vane at the masthead striped blue and white and at the peak a flag with narrow stripes of blue. On the right at the water's edge is a man with a basket on his back and a second person bending over. In the left background is a large ship firing a gun to starboard. Across the horizon are other becalmed sailing vessels.

Smith regarded the painting as 'an excellent production',[1] Hofstede de Groot advanced the provenance, and Robinson gave a detailed technical description of the vessels in the scene.[2] The signature in the lower right, however, has been hitherto overlooked. Hofstede de Groot and Robinson both accepted the claim in the Schneider sale catalogue of 1876 that the painting was the companion to the picture of virtually the same dimensions of the Dutch warship *The 'Eendracht' in a Strong Breeze*, now in a private collection (fig. 1).[3] However, in 1835 that painting was in the collection of Thomas Kibble, Green Trees, while the Samuel painting was in the Earl Granville Collection, and there is no evidence that van de Velde designed these two very different compositions as companions. Robinson even dated the putative pair differently, suggesting that the Samuel painting was, 'painted substantially by the Younger for the van de Velde studio, c. 1660', while he would date the *'Eendracht'* '1665–6'.[4]

FIG. 1 Willem van de Velde the Younger, *The 'Eendracht' in a Strong Breeze*, c. 1665–6, signed with a monogram, oil on panel 35.2 × 44.2 cm., Private Collection, Wassenaar.

1 Smith, *Supplement* (1842), no. 14.
2 Hofstede de Groot, vol. 7 (1923), no. 302; Robinson 1990, vol. 1, pp. 398–9, no. 668.
3 Ibid., see Hofstede de Groot, vol. 7 (1923), no. 405; The Hague, Mauritshuis, *Terugzien in Bewondering*, 19 February 1982– 9 March 1982, no. 87 [incorrectly as canvas 38 × 49 cm.]; Robinson 1990, vol. 2, pp. 738–740, no. 262, ill. I am grateful to Sam Nystad for remeasuring fig. 1.
4 See Robinson 1990, cats. nos. 668 and 262.

CAT. 78 Willem van de Velde the Younger (attributed to)

A Kaag Anchored by a Sandbank with Two Other Vessels, 1650s?

Initialled on a plank in the water to the right: W.V.V.
Oil on canvas 13 × 15⅛ in. (33 × 39.2 cm.)

PROVENANCE: Leonino, Paris; Nicolas, Paris; acquired from Edward Speelman in c. December 1970.

EXHIBITION: London 1988, no. 74.

LITERATURE: M. S. Robinson, *A Catalogue of the Paintings of the Elder and Younger van de Velde* (National Maritime Museum, Greenwich, 1990), vol. 1, pp. 393–4, no. 608, ill.

CONDITION NOTES: The canvas support has been relined. Minor retouches appear along the left edges and throughout the sky, mostly to moderate prominent areas in the craquelure. The varnish is relatively clear. On the back imprinted in red sealing wax is the defaced image of a putto with a staff (?).

Under a bright sun with cumulus clouds and light air, a *kaag* (on the *kaag*, see Cat. 77) is seen from the port broadside with a second *kaag* or *boeier* (a *boeier* has a round hull and deep rail like a *kaag* but with a curved spoon bow) viewed perpendicularly from the port quarter. The large *kaag* has her white mainsail set and square topsail hoisted; her foresail is lowered onto the foredeck. The smaller *kaag* is sprit-rigged. Alongside the larger *kaag* is a *smalschip* (on the *smalschip*, see Cat. 80) or similar vessel with a brown spritsail half lowered with the sprit horizontal in the sling and a skiff alongside. On the left on the other side of the sandbank is a *weyschuit* with a man in the bow and a second man standing in the water. In the centre distance is another *weyschuit* under sail and on the left is a small ship with sails loosed. In the left distance is another larger ship seen from the port broadside. Other smaller sailing vessels appear on the horizon.

Robinson gave a full technical description of the vessels in the scene and suggested that the painting belonged stylistically to the 1650s. However he noted technical aspects of the ships (the principal vessel has late features for a *kaag*: 'a standing-gaff rig and steering bowsprit'; and the 'long and low' profile of the ship in the left distance is inconsistent with a ship of c. 1660) that 'would be more appropriate to the last quarter of the seventeenth century'. Robinson even speculated that there might have been someone in Willem the Younger's studio who continued the artist's earlier style into the English period.[1]

1 Robinson 1990, vol. 1, p. 393, no. 608.

CAT. 79 Willem van de Velde the Younger and Studio

A Hoeker Alongside a Kaag at Anchor, c. 1660

Initialled on the buoy in the right foreground: W.V.V.
Oil on panel 8¼ × 11⅛ in. (20.9 × 28.3 cm.)

PROVENANCE: Prince Beauharnais, Munich, 1826; Duke of
Leuchtenberg, Munich, by 1841 (see Literature), Leuchtenberg
Gallery, St Petersburg, cat. 1866, no. 138; with dealer A.S. Drey,
Munich, 1912 [as 17.3 × 27.4 cm.]; Villeroy collection, April 1922
(see sticker); Vicomte de Noailles, Paris; acquired from Edward
Speelman in 1966.

EXHIBITION: London 1988, no. 73 [as Willem van de Velde the
Elder].

LITERATURE: J. N. Muxel, *Gemälde Sammlung in Munchen . . . des
Herzogs von Leuchtenberg* (1841), no. 154, with ill. in etching,
edition 1852, no. 157; Leuchtenberg Gallery, catalogue 1886, no.
138; G. F. Waagen, *Die Gemäldegalerie S.K.H. des Herzogs von
Leuchtenberg. Die Gemäldesammlung in der Kaiserlich Ermitage*
(1864), p. 388, no. 157 ['6⅔ Z.[oll] × 10⅓ Z.']; Hofstede de Groot,
vol. 7 (1918), no. 215 [17.3 × 27.4 cm.]; M. S. Robinson,
*A Catalogue of the Paintings of the Elder and Younger Willem van de
Velde*, 2 vols. (National Maritime Museum, Greenwich, 1990),
vol. 1, p. 542–3, no. 600, ill.

CONDITION: The paint film has been abraded and extensively
retouched. Conspicuous areas of retouching appear between the
two pairs of boats, in the stern of the *hoeker*, in the sky, along the
left edge and in the upper and lower left corners. The rigging of
both boats has been abraded and inaccurately restored. The varnish
layer is relatively clear. Three stickers appear on the back, includ-
ing those of the Duke of Leuchtenberg ('Herzog Leuchtenberg/
Majorats Fideicommiss./Matrikel II.2/inventar No. 234'), the
Villeroy Collection ('W. van de Velde [Le Jeune]. 57. Mer Temps
calme./Signé W.V.V. sur une bouée/Sequestre Villeroy, Avril
1922') and an unidentified collection (316/Willem van de
Velde/P/9056).

On a sunny day with very light wind, a *hoeker* is viewed
from the port bow. A *hoeker* is a Dutch fishing vessel with a
square foresail and mainsail. Her white mainsail is at half
mast while her foresail is lowered on deck. Close to star-
board is a *kaag* (on the *kaag*, see Cat. 77) with her brown
spritsail set and white foresail lowered onto the foredeck;
she has an anchored buoy out to the left. There is also a
large buoy in the right foreground. In the right middle
distance there is a two-decker seen from the stern and a
quartering view to starboard. She has her fore course half
clewed up and the yard lowered a little. A flag hangs at the
main and there is a full-length figure on the tafferel. She
fires a gun to port as a rowing-boat pulls away. In the
centre background there is another tall ship viewed from
the port side.

A thorough technical description of the scene is provided
by M. S. Robinson, who also pointed to the inaccurate
restoration at an early date of the ships' rigging: 'The fore
topmast yard is lying on the top and not on the cap of the
lowermast; there is a main topgallant yard on the topmast;
the mizzen lowermast is too high and there is no crossjack.
These mistakes appear also in N. Muxel's etching, first
known in the 1841 edition of the catalogue of the
Leuchtenberg Collection'.[1] While Robinson cautiously
withheld judgement as to whether the Samuel painting was
identical with the Leuchtenberg Collection picture
catalogued by Muxel, an inscribed sticker on the reverse of
the painting confirms the provenance (see Condition
Notes).

Muxel and Hofstede de Groot accepted the painting as
by Willem van de Velde the Younger, but it was confusedly
exhibited in 1988 in London as the work of Willem the
Elder. Robinson rightly downgraded the attribution, stating
that the picture was 'Painted perhaps only partly by the
Younger for the van de Velde studio, c. 1660'.[2]

1 Robinson 1990, vol. 1, pp. 542–3, no. 600.
2 Ibid.

CAT. 80 Studio of Willem van de Velde the Younger

Two Smalschips off the End of a Pier, early eighteenth century

Unsigned
Oil on panel 6½ × 7¾ in. (16.4 × 19.6 cm.)

PROVENANCE: Lesser; Prideaux; acquired from Edward Speelman.

EXHIBITION: London 1988, no. 75.

LITERATURE: M. S. Robinson, *A Catalogue of the Paintings of the Elder and Younger Willem van de Velde*, 2 vols. (Greenwich, 1990), vol. 1, p. 510, no. 828, ill.

CONDITION NOTES: The panel support has ⅟₃₂ in. (2 mm.) wooden strips added at the bottom and top edges. The paint film has been abraded and there is extensive inpainting in the sky. Some of the forms have also been strengthened: the spritsail and hull of the foremost *smalschip*, the jetty at the right, the man standing furthest to the left on the jetty, and the pole rising from the water in the centre foreground.

Beneath a bright sky with cumulus clouds and very light air two *smalschips* lie close together off a pier, offering a starboard view. *Smalschips* were small Dutch transport vessels, sprit rigged (a rig which has a fore-and-aft sail extended by a sprit) and tiller through rail. The nearer of the two has her brown spritsail half lowered with the sprit horizontal; her white foresail is lowered onto the foredeck. The vessel behind has her white spritsail and brown square-sail set, while her foresail is lowered nearly to the deck. Four people stand on the jetty in the right foreground. A small vessel with its mast lowered and a man seated in it lies off the end of the pier, while water fills the foreground.

The painting was acquired as the work of Willem van de Velde the Younger and exhibited as such in 1988 but Robinson correctly raised doubts about the painting in 1990, stating that 'It might be a late copy by one of the Van de Velde studio, possibly done soon after the master's death'.[1]

1 Robinson 1990, p. 510, no. 828 [incorrectly as 6½ × 9 in.].

CORNELIS VROOM

CAT. 81 Cornelis Vroom (c. 1591–1661) (follower of)

Cottage on a Canal with a 'Trekschuit'

Oil on panel 11⅛ × 15¼ in. (28.3 × 38.8 cm.)

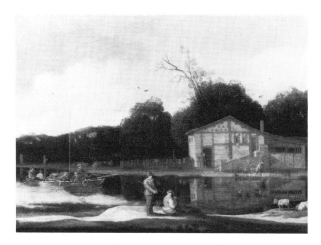

PROVENANCE: G. Murray Bakker, Amsterdam; Mrs B. van Rossem, The Hague; F. van Wijk of Oosterbeek, The Hague; sale P. van Wijk, Amsterdam (van Stokkum), 19 July 1943, no. 49, ill. (sold to P. de Boer for 900 fl.); with P. de Boer, Amsterdam; with Horace Buttery, London; sale Amsterdam (Mak van Waay) 17–18 December 1968, no. 212, ill. (sold to H. Schlichte Bergen, for 21,090 fl.); with Leonard Koetser, London; acquired from E. Speelman in 1969.

EXHIBITION: London 1988, no. 77.

LITERATURE: Jakob Rosenberg, 'Cornelis Hendricksz. Vroom', *Jahrbuch der Preussischer Kunstsammlungen*, vol. 49 (1928), p. 168, no. 1, fig. 2; Stechow 1966, p. 58, fig. 109; Georges S. Keyes, *Cornelis Vroom: Marine and Landscape Artist* (Utrecht, 1975), vol. 2, no. PP3, fig. 75.

CONDITION NOTES: The panel support is cradled and has ¼ in (5 mm.) wood additions on all sides running parallel with the grain of the panel. There is a horizontal crack in the panel 9.5 cm. from the bottom. The paint film is only in fair condition with extensive abrasion and repaint, especially in the sky to disguise the grain of the wood that has become visible. Tiny horizontal strokes of inpaint cover the upper third of the painting. Additional repaint is scattered throughout the scene. A large repentir runs the full

height of the panel roughly in the position of the mast of the *trekschuit* and corresponds to the position of the large tree in the preparatory drawing in Berlin (see fig. 1). The varnish is discoloured.

A strip of land appears in the immediate foreground before a canal or stream that retreats diagonally from right to left. In the centre on the near bank are two goatherds, with two of their flock on the far right. From a half-timbered cottage on the right, the tree-lined far shore retreats in a wedge shape to the left. In the cottage's doorway are two figures. Laundry hangs over a clapboard fence, while to the far left are other figures and sheep, and on the far right a dog. At the right on the far shore, two men tug vigorously at a line that stretches to a heavily laden vessel on the far left of the composition.

 The painting's attribution to Cornelis Vroom was accepted by both Jakob Rosenberg and Wolfgang Stechow, who characterized the work as an early example of the artist's style, dating from soon after 1620.[1] Rosenberg was first to note the relationship to a drawing in Berlin of a *Cottage by a Stream* (fig. 1). The drawing shows the cottage and the woods on the far shore but omits the barge, its two human engines and the shepherds in the foreground, substituting a large tree on the near shore. Careful examination of the painting's surface now confirms that this drawing was preparatory to the painting, because a ghost of the tree in the drawing has emerged as a pentiment, thus proving that the latter's composition first worked out in the drawing must have been altered only in the final stage of the painting's execution. In his monograph on Vroom, Keyes correctly doubted the attribution of both the painting and its preparatory drawing to Cornelis, speculating less persuasively that the author of the painting might either be the seascapist, Hendrick Vroom, who may have adapted one of Cornelis' designs to his own commission; or still less plausibly, that the drawing and painting (or perhaps only portions thereof) might be 'early works by the little-known Frederick Vroom'.[2] In either case the explanation seems elaborately contrived and hypothetical. A more fruitful line

of inquiry follows from Keyes' observation that the drawing closely resembles print designs by Jan van de Velde II. Among the comparisons he proposes, especially revealing for the painting is J. van de Velde's *Ver* (Spring) (fig. 2), from a series of the *Four Seasons*, which depicts a river running almost parallel to the picture plane, a narrow bank of the near shore in the immediate foreground and a *trekschuit* in the middleground.[3] The author of the painting reworked his initial design (which itself was inspired by Jan van de Velde's river scenes) at the painting stage perhaps after consulting still other prints by van de Velde. However, the whole execution of the painting lacks the control and skilful draughtsmanship of Vroom even in his early years (compare the painting in Cracow), and indeed is considerably weaker than contemporary paintings by Esaias van de Velde (to whom Stechow compared the figures) or the young van Goyen. Rather it seems closer in style – though not attributable to – the followers and imitators of the last mentioned: artists like Adriaen van der Cabel (1613–1705) and J. van der Croos, who also painted river scenes with *trekschuits*.[4] Perhaps with the appearance of Beck's forthcoming volume on the followers of van Goyen we will be able to advance a more accurate attribution.

On the importance of *trekschuits* and other tow barges and passenger vessels for the Dutch economy, see J. de Vries' study.[5]

1 Rosenberg, 1928, p. 168; Stechow 1966, p. 58.
2 Keyes 1975, p. 196.
3 Ibid., where he cites D. Franken and J. P. van der Kellen, *L'Œuvre de Jan van de Velde* (Amsterdam, 1883; reprint Amsterdam, 1968), nos. 304, 311, 360 and especially no. 146; repr. in Irene de Groot, *Landscape Etchings by the Dutch Masters of the Seventeenth Century* (Maarsen, 1979), fig. 71.
4 See for example, sale New York (Sotheby's), 19 January 1984, no. 21, ill., said to be dated 1636 but probably 1630.
5 *Barges and Capitalism: Passenger Transportation in the Dutch Economy, 1632–1839* (Utrecht, 1981).

FIG. 1 Follower of Cornelis Vroom, *Cottage by a Stream*, pen, brown ink, grey, red and blue washes and traces of black chalk, 186 × 297 mm., Staatliche Museen Preussischer Kulturbesitz, Berlin-Dahlem, inv. no. 5483.

FIG. 2 Jan van der Velde II, *Ver* (Spring), etching.

EMANUEL DE WITTE

(ALKMAAR 1616/18–1692 AMSTERDAM)

Emanuel de Witte was the son of a schoolmaster, Pieter de Wit, and Jacomijntje Marijnus. Houbraken claimed that he was born in 1607 but documents indicate he was born between 1616 and 1618; his birthplace is given as Alkmaar in a betrothal document of 1655. De Witte entered the Guild of St Luke in Alkmaar in 1636. Houbraken reported that he was a pupil of the Delft still-life painter, Evert van Aelst (1602–57). In July 1639 and June 1640 he was recorded in Rotterdam but was in Delft in 1641 when his daughter was born. On 23 June of the following year he joined the Delft guild. On 4 October 1642 he married his daughter's mother, Geertgen Arents, and was living on the Choerstraat in Delft. A second daughter was born to the couple in 1644. De Witte is regularly recorded in Delft between 1644 and 1650, and probably relocated to Amsterdam before 24 January 1652. In April 1654, together with Caesar and Allart van Everdingen (1617/21–78 and 1621–75, respectively), he served as a paintings appraiser in Haarlem. A widower, de Witte was married to 28-year old Lysbeth Lodewyck van der Plass on 3 September 1655. He is mentioned regularly in Amsterdam documents until his death in 1692. Despite a lucrative commission from the King of Denmark in 1658, de Witte was indentured to a series of patrons who functioned both as his landlord and dealer. Houbraken called de Witte a 'Diogenes Cynicus' and reported that he was a difficult man who ended his life by suicide. His frozen body was discovered in a canal with a cord around his neck when the ice thawed.

De Witte began his career painting portraits and history paintings, but after 1650 specialized in depictions of church interiors and other architectural subjects. Together with Gerard Houckgeest (c. 1600–61) and Hendrick Cornelisz. van Vliet (1611/12–75), he is regarded as the chief exponent of the Delft architectural style and was at his most subtle in the treatment of strong sunlight in church interiors. The Nieuwe Kerk and Oude Kerk in Delft furnished de Witte with the greatest number of his subjects and individual motifs, but these were not always accurately depicted and were often freely combined with imaginary elements. In addition, he painted fanciful Gothic and Romanesque churches with both Protestant and Roman Catholic appointments. Finally, he also painted a handful of genre scenes in orderly interiors and fanciful harbour views and, after 1660, a series of open-air markets. De Witte's only known pupil was Hendrick van Streeck (1659–c. 1719), an Amsterdam painter of still lifes and church interiors.

LITERATURE: Houbraken, vol. 1 (1718), pp. 282–7; vol. 2 (1721), p. 292; Hans Jantzen, *Das Niederländische Architekturbild* (Leipzig, 1910, reprint Braunschweig, 1979), pp. 113–26; Wurzbach, vol. 2 (1910), p. 894; Abraham Bredius, *Künstler-Inventare*, 8 vols. (The Hague, 1915–21), vol. 5, pp. 1829–47, and vol. 7, pp. 294–5; Abraham Bredius, 'Emanuel de Witte', *Zeitschrift für bildende Kunst*, vol. 27 (1916), pp. 157–62; Clotilde Brière-Misme, 'Un petit maître hollandais: Emanuel de Witte', *Gazette des Beaux-Arts*, 5th ser., vol. 7 (1923), pp. 137–56; D. Hannema, 'Over beelden, historien en portretten van Emanuel de Witte', *Oudheidkundig Jaarboek*, 4th ser., vol. 1 (1932), pp. 116–20; Rotterdam, Museum Boymans, *Vermeer, oorsprong en invloed, Fabritius, de Hooch, de Witte*, 9 July–9 October 1935 (cat. by D. Hannema); M. F. Hennus, 'Emanuel de Witte, 1617–1692', *Maandblad voor beeldende kunsten*, vol. 13 (1936), pp. 3–12; E. P. Richardson, 'De Witte and the Imaginative Nature of Dutch Art', *The Art Quarterly*, vol. 1, no. 1 (Winter 1938), pp. 5–17; E. Trautscholdt, in Thieme and Becker, vol. 36 (1947), pp. 121–7; J. Belonje, 'Nogmaals Emanuel de Witte', *Oud-Holland*, vol. 67 (1949), pp. 109–10; Ilse Manke, *Emanuel de Witte, 1617–1692* (Amsterdam, 1963); Ilsa Manke, 'Nachträgen zum Werkkatalog von Emanuel de Witte', *Pantheon*, vol. 30 (1972), pp. 389–91; Arthur K. Wheelock, Jr, 'Gerard Houckgeest and Emanuel de Witte: Architectural Painting in Delft around 1650', *Simiolus*, vol. 8, no. 3 (1975–6), pp. 167–85; Walter Liedtke, *Architectural Painting in Delft: Gerard Houckgeest, Hendrick van Vliet, Emanuel de Witte* (Doornspijk, 1982), pp. 76–96, 115–117.

CAT. 82

Interior of an Imaginary Protestant Gothic Church

Oil on canvas 14⅜ × 12 in. (36.5 × 30.5 cm.)

PROVENANCE: Probably from the collection of the Viscomte Bus de Gisignies, Brussels (according to the Hofstede de Groot 'fiches'; see Manke); Baron Albert Oppenheim Collection, Cologne, by 1876 (see Exhibitions), cat. 1904, no. 46; sale Oppenheim, Cologne, 27 October 1914, no. 44, ill. [bought in?]; sale Baron Albert Oppenheim, Berlin (Lepke; catalogue by Wilhelm von Bode),19 March 1918, no. 44, ill. (18,000 mrk. to Klausner); with dealers Volmer and Schönemann, Vienna, 1922; Sittenfeld; Etienne Nicolas, Paris, who sold it to Edward Speelman in late 1959, who in turn sold it to Harold Samuel.

EXHIBITIONS: Cologne, *Kunsthistorische Ausstellung zu Cöln. II Abtheilung. Original-Gemälde der Kölner und Niederländischen Malerschule bis zum Schluss des 17. Jahrhunderts*, 1876, no. 65 [lent by Albert von Oppenheim]; Cologne, Wallraf-Richartz-Museum, Exhibition of the Oppenheim Collection, July–August 1914 (no catalogue); London 1988, no. 78.

LITERATURE: Emile Molinier, *Collection du Baron Albert Oppenheim. Tableaux et objects d'art* (Paris, 1904), no. 46, ill.; Eduard Trautscholdt, in Thieme and Becker, vol. 36 (1947), p. 125; Ilse Manke, *Emanuel de Witte, 1617–1692* (Amsterdam, 1963), p. 109, cat. no. 130 [c. 1660]; Russell 1988, p. 788.

CONDITION NOTES: The canvas support has been relined and the tacking margins cut. The dimensions of the original canvas are 14 × 11½ in. (36 × 29.5 cm.). The paint film is in very good condition, especially for one of de Witte's darker paintings in which many of the deeper tones are notoriously fugitive when cleaned. Minor areas of inpainting appear at the top of the organ and above the archway at the left. The edges have also been retouched. The varnish is mildly discoloured.

On the left a view down the nave of a Gothic church with a vaulted wooden ceiling extends to a choir loft before the windows of the rear wall. At the foot of a pier on the right sits a nursing mother with a young boy, a dog, covered basket and walking stick. Beside them is a gravedigger's wheelbarrow, a mound of dirt and a skull; above is the funeral hatchment of one of the deceased in the form of a blazon with a coat of arms in gold, red and black. Further back in the nave, two gentlemen in black converse and in the distance an elegantly dressed couple with a dog look up at a sculpted memorial with an epitaph on a column. Above it hangs a sword and helm. On the far right, is an organ suspended on the wall. The stained glass window in the distance depicts a sailing vessel with a flag and beneath it an historical scene with blue, red and yellow figures, perhaps an Adoration of the Magi. Strong alternating bands of light and shade striate the floor of the nave.

When de Witte first began painting church interiors around 1650 he often depicted identifiable structures, most often the Oude Kerk and Nieuwe Kerk in Delft, but also their counterparts in Amsterdam. Noach showed, for example, that de Witte repeatedly employed aspects of the architecture and ecclesiastical appointments or furnishings of the Oude Kerk in Amsterdam.[1] Houbraken reported that people admired de Witte's truthful representations of churches and their inhabitants, further observing that the artist had made many drawings 'variously from life' (*op verschieden wyze naar 't leven afgeteekent*) of most of the churches in Amsterdam 'to know them' and, to familiarize himself not only with the pulpits, organs, tombs and so forth, but also the people, 'each in their customary attire' (*elk in zyn gewoone drachten*).[2]

After c. 1660, however, de Witte increasingly incorporated fanciful inventions in his church interiors, and in fact imaginary interiors dominate his paintings of the 1670s and 80s. The columns on the left of the present work vaguely recall the architecture of Amsterdam's Oude Kerk but the overall scene is imaginary. Church interior compositions with a view down the nave on the left and a large pier and secondary view on the right had already been employed by Pieter Saenredam in the 1630s.[3] However de

Witte and his fellow pioneers of the Delft architectural style never exaggerated the linear perspective as Saenredam had, and employed less dramatically foreshortened designs with greater contrasts of light and shade and enhanced aerial perspective. Houbraken commended de Witte's 'witty play of light' (*geestige verkiezinge van lichten*).[4]

All the essential features of the Samuel painting's design had already appeared in an earlier painting by de Witte that was in the Wetzlar Collection in Amsterdam in 1961 (fig. 1). That work includes the monumental epitaph for C. J. de Haan from the Oude Kerk in Amsterdam as well as other features from the church such as the choir stall on the right, but once again the scene is essentially an imaginary confection.[5] Manke dated the Wetzlar painting c. 1653/5, but she would date the Samuel painting 'about 1660'.[6] A larger and less well-preserved painting formerly said to be dated 1661 but now catalogued in the Thyssen-Bornemisza Collection, Lugano, as dated 166[9?] (fig. 2), seems to represent a later development of the composition.[7] All three of these paintings depict imaginary Gothic structures. Eddy de Jongh has shown that in the seventeenth century the Gothic style was often disdained as a 'barbaric way of building' ('Barbarische wyse van Bouwen' – Salomon de Bray), described as an 'excessively ornamented Gothic folly' (''t Gotsche krulligh mall' – Constantijn Huygens), or as 'a most wretched, artless, and barbaric style' ('zeer jammerlijke, kunsteloze, en barbarische manieren' – Willem Goeree).[8] However, the appeal of these church interior paintings probably had less to do with any particular architectural style than with the images' associations with religious and historical ideas.

Gravediggers were, of course, logical inhabitants of churches, but the regularity with which they or their barrows, tools and equipment appear in de Witte's art underscores the function of the church as a burial ground. The addition of the skull in the foreground of the Samuel painting and several other pictures, moreover, undoubtedly could have encouraged thoughts on the transience of life.[9] De Witte often depicted figures looking at tombs or memorials in his churches; for example, in a painting dated 1656, in the Museum in Lille (fig. 3), a gentleman in a red cape with an elegant lady companion gestures toward the famous Tomb of William the Silent (1533–84) by Hendrick de Keyser in the Nieuwe Kerk in Delft.[10] The figure closely recalls his counterpart at the back of the nave in the Samuel painting, who again draws attention to a memorial on a column which, though unidentified, to judge from the helmet and sword was probably dedicated to an important person, presumably a man of action. Of course the vanitas

associations of tombs were strong; indeed, it has been observed that in 1667 the chronicler of the city of Delft, Dirck van Bleyswyck, recommended that people visit tombs every day to contemplate death and the vanities of life.[11] Petra ten Doesschate Chu has even suggested that the long shadows in de Witte's church interiors might have prompted additional thoughts of transience, citing in support of her theory biblical passages (Job 8, 9; Psalms 144; Solomon 8, 13), an engraving by Jacob Matham after Karel van Mander of the *Vanities of Human Life*, and verses by the popular 'Vader' Jacob Cats.[12] While nursing mothers with children also often appear in de Witte's church interiors, it can scarcely be accidental that the artist here has brought the image of new life into such close conjunction with images of death.[13] Indeed one may well ask to what extent the staffage in the Samuel painting, including the elderly gentlemen in conversation and the young couple in the distance, are intended consciously or unconsciously to illustrate the cycle of life and ages of man.[14]

Elaborately decorated organs, like the one seen through the arch on the right, often also appear on the walls of de Witte's imaginary church interiors. Gaskell reminded us of the controversy that had raged earlier in the seventeenth century when strict Calvinists sought to banish organs, prompting Frederik Hendrik's secretary Constantijn Huygens to rise to their defence; but by the time most of de Witte's paintings were executed this furore had passed and the instruments had become objects of civic pride.[15]

The Samuel painting was formerly part of the collection of Baron Albert Oppenheim, which also included outstanding Dutch paintings by ter Borch, Hobbema, and P. de Hooch. Part of this collection has descended through the van Pannwitz Collection to Lord Chichester in Salisbury.

FIG. 1 Emanuel de Witte, *Interior of a Protestant Gothic Church*, signed, oil on panel 43 × 33 cm., Dr H. Wetzlar, Amsterdam, 1961 (not in the Wetzlar sale, Amsterdam, 9 June 1977).

FIG. 2 Emanuel de Witte, *Interior of a Gothic Church*, signed and dated 166[9], oil on canvas 52.2 × 36.5 cm., Thyssen-Bornemisza Collection, Lugano, Switzerland, no. 1972.10.

FIG. 3 Emanuel de Witte, *Nieuwe Kerk, Delft, with the Tomb of Willem the Silent*, signed and dated 1656, oil on canvas 97 × 85 cm., Musée des Beaux-Arts, Lille, cat. (1932), no. 902.

1 A. Noach, *De Oude Kerk te Amsterdam. Biografie van een gebouw* (Amsterdam, 1939), pp. 117–27.
2 Houbraken, vol. 1 (1718), p. 283.
3 See, for example, his *Interior of St Maria Kerk, Utrecht*, dated 1638, Kunsthalle, Hamburg, no. 412.
4 Houbraken, vol. 1 (1718), p. 283.
5 See Ilse Manke, *Emanuel de Witte* (Amsterdam, 1963), p. 106, no. 118, fig. 27.
6 Manke 1963, p. 109, no. 130.
7 See Ivan Gaskell, *Seventeenth Century Dutch and Flemish Painting. The Thyssen Bornemisza Collection* (London, 1990), cat. no. 60.
8 See E. de Jongh, '"'t Gotsche krulligh mall." De houding tegenover de gotiek in het zeventiende-eeuwse Holland', in *Nederlands Kunsthistorisch Jaarboek*, vol. 24 (1973), pp. 85–145.
9 A gravedigger's wheelbarrow and skull appear in several paintings by de Witte, including the *Protestant Gothic Church* of c. 1665, Boymans-van Beuningen Museum, Rotterdam, inv. 2536 (Manke 1963, cat. no. 131, fig. 61), and the *Nieuwe Kerk Amsterdam*, dated 1677, Museum of Fine Arts, Boston, no. 49.7 (Manke 1963, cat. no. 87, fig. 78), where the gravedigger, as in so many works by Hendrik Cornelisz van Vliet, is standing in the grave as he works.
10 Manke 1963, cat. 27, fig. 35.
11 Dirck van Bleyswyck, *Beschryvinge der Stadt Delft* (Delft, 1667), vol. 1, p. 270; cited by Arthur K. Wheelock, Jr, 'Gerard Houckgeest and Emanuel de Witte: Architectural Painting in Delft around 1650', *Simiolus*, vol. 8 (1975–6), p. 181.
12 See Basle, Kunstmuseum, *Im Lichte Hollands. Holländische Malerei des 17. Jahrhunderts aus den Sammlungen des Fürsten van Liechtenstein und aus Schweizer Besitz*, 14 June–27 September 1987, p. 282, discussing the painting in the Thyssen-Bornemisza Collection, our fig. 2.

13 See in addition to the painting in Rotterdam (note 9), Manke 1963, no. 65, fig. 46 (with Brod Gallery, 1981), no. 72, fig. 43 (Nieuwe Kerk, Amsterdam), no. 74, fig. 44 (dated 1659, Museum Groningen, on loan from Rijksdienst Beeldende Kunst, inv. no. NK 2503), no. 75 (sale London (Sotheby's), 14 May 1958, no. 126) and Timken Art Gallery, San Diego, (*Nieuwe Kerk, Amsterdam*, dated 1657).

14 On the possible symbolism of the staffage figures in de Witte's church interiors generally, see Beverly Heisner, 'Mortality and Faith: The Figural Motifs within Emanuel de Witte's Dutch Church Interiors', *Studies in Iconography*, vol. 6 (1980), pp. 107–114, especially p. 111–12. She relates the nursing mother to Mary, her humility and the Calvinist church; thus the juxta-position of the grave and the nursing mother suggests to Heisner the promise of redemption from death vouchsafed by the church.

15 Gaskell 1990, p. 278, citing H. A. Bruinsma, 'The Organ controversy in the Netherlands Reformation to 1640', *Journal of the American Musicological Society*, vol. 7 (1954), pp. 205–12.

PHILIPS WOUWERMANS

(HAARLEM 1619–1668 HAARLEM)

The eldest son of Pauwels Joostens Wouwermans, a painter from Alkmaar, and Adriaenke Jans, Philips Wouwermans was baptized in Haarlem on 24 May 1619. The Wouwermans family was originally from the southern Netherlands. Philips' brothers Pieter (1632–82) and Jan (1629–66) also became painters. He probably took his first instruction in painting from his father but according to Cornelis de Bie, he was a student of Frans Hals (q.v.). In 1638 Wouwermans travelled to Hamburg to marry a Catholic girl named Annetje Pietersz van Broeckhof. While in Hamburg, he worked for several weeks in the atelier of the German history painter Evert Decker (died 1647). By 1640 he had returned to Haarlem where he joined the guild; he was elected *vinder* in 1646. He seems to have remained in Haarlem for the rest of his life. He was living on the Begijnhof in 1643, bought a house called 'de Croon' in the Grote Houtstraat in 1645, and sold it the following year to buy a house on the Bakenessergracht. In 1658 he was living on the Jansstraat when he and his wife made a will. Wouwermans died on 19 May 1668 and was buried in the Nieuwe Kerk in Haarlem. The inheritance he left to his three sons and four daughters was substantial, proving that he was a wealthy man; however, Houbraken's claims that Philips' daughter Ledewina (Ludovica) brought a dowry of 20,000 fl. to her marriage to the still-life painter Hendrick de Fromantiou (1633/4–after 1694) is unsubstantiated.

Wouwermans was an exceptionally productive artist to whom more than 1000 paintings have been assigned. He specialized in Italianate landscapes with horses and small figures, battles, hunting scenes and riding schools. An important early influence on his work was the Italianate bamboccianti painter Pieter van Laer, whose sketches he is reported to have owned. He occasionally painted staffage in the landscapes by Jacob van Ruisdael, Jan Wijnants and Cornelis Decker. In addition to his brothers, he had as students Nicolaes Ficke (c. 1620–71), the little-known Jacob Warnais, Coort Witholt from Sweden (both in 1642), Eduard Dubois (in 1653), and in 1656 Anthony de Hern (1640–before 1675) and Hendrick Berkmans (1629–79). He also had an influence on many other painters, including Adriaen van de Velde (q.v.).

LITERATURE: De Bie 1661, p. 281; Houbraken, vol. 2 (1719), pp. 70, 102, 128, 131, 132; Jeon Moyreau, *Œuvres de Ph.pe Wouwermens hollandais* (Paris, 1737); Descamps, vol. 2 (1757), pp. 286–95; Smith, vol. 1 (1829), vol. 9 (1842); van der Willigen 1870; Cornelis Hofstede de Groot 'Die Malerfamilie Wouwerman', *Kunstchronik*, vol. 2 (1891), pp. 1–5; Wurzbach, vol. 2 (1910), pp. 902–3; Hofstede de Groot, vol. 2 (1909); S. Kalff, 'De Gebroeders Wouwerman', *Elsevier*, vol. 30 (1920) pp. 96–103; Thieme and Becker, vol. 36 (1947), pp. 265–68; Stechow 1966, pp. 29–31; Amsterdam/Boston/Philadelphia 1987–8, pp. 528–34; Frits Duparc is currently preparing a study of the painter.

CAT. 83

Landscape with Kermis ('The Rustic Wedding'), mid to later 1650s

Monogrammed in the lower right: PHILS (in ligature) W
Oil on canvas (original unrelined dimensions) 23⅜ × 33½ in. (59.2 × 85 cm.)

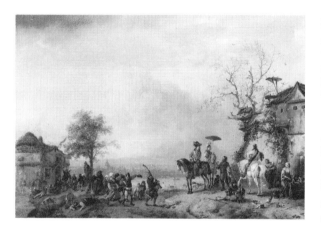

PROVENANCE: Gerard Braamcamp, Amsterdam, inventory of 1766 (hung in 'Première Chambre à droit'); but not in Hoet's 1752 catalogue of the collection; sale Gerard Braamcamp, Amsterdam, 31 July 1771, no. 279 (3510 fl. to John Hope); John Hope, manuscript inventory cat. II, no. 298 (see Niemeyer 1981); Henry Philip Hope, no. 1 Harley Street, London, cat. B (1795) (valued at £350) (see Buist 1974); Thomas Hope, London, 1829 (valued by Smith at £840); Henry Thomas Hope, London, 1849; Lord Francis Pelham-Clinton-Hope, Deepdene (on loan to South Kensington Museum, London, 1891–7); the Hope collection was purchased en bloc in 1898 by P. and D. Colnaghi and A. Wertheimer; Alfred Beit, 26 Park Lane, London, cat. 1904, p. 58; Otto Beit, 49 Belgrave Sq., London, 1906–19, cat. 1913, no. 71, plate xx; Sir Alfred Beit Bt., Russborough, Blessington, Co. Wicklow; acquired via Edward Speelman in 1959.

EXHIBITIONS: London, British Institution, 1815; London, Royal Academy, Winter 1881, no. 109; London, South Kensington Museum, *A Catalogue of Pictures of the Dutch and Flemish Schools, lent to the South Kensington Museum, by Lord Francis Pelham-Clinton-Hope* (London, 1891), [1891–7] no. 56; Cape Town, National Gallery of South Africa, *Old Master Paintings from the Beit Collection. Supplement*, 1950, no. 65; London 1988, no. 79, ill. p. 27 and on cover.

LITERATURE: Sir Joshua Reynolds, 'A Journey to Flanders and Holland in the Year 1781', in *Collected Works* (London, 1883), vol. 2, p. 200; Henry Tresham, R.A., and William Young Ottley, *The British Gallery of Pictures Selected from the Most Admiral Productions of the Old Masters in Great Britain; Accompanied with Descriptions, Historical and Critical* (London, 1818), n.p., ill.; Smith, vol. 1 (1829), no. 87; Gustav Waagen, *Treasures of Art in Great Britain* (London, 1854), vol. 2, p. 121; Hofstede de Groot, vol. 2 (1909), no. 1019;

Wilhelm Bode, *The Art Collection of Mr Alfred Beit at his Residence, 26 Park Lane, London* (Berlin, 1904), pp. 20–1, 58; Wilhelm Bode, *Pictures and Bronzes in the Possession of Mr Otto Beit* (London, 1913), pp. 24–5, cat. no. 71, pl. xx; Clara Bille, *De Tempel der Kunst of het kabinet van den heer Braamcamp* (Amsterdam, 1961), vol. 1, ill. cat. no. 279, vol. 2, pp. 67–67a; Martin G. Buist, *At Spes non fracta. Hope & Co. 1770–1815*, Bank Mees and Hope (1974), p. 495; J. W. Niemeyer, 'De Kunstverzameling van John Hope (1737–1784)', *Nederlands Kunsthistorisch Jaarboek*, vol. 32 (1981), pp. 147, 203, no. 298; Woodhouse 1988, p. 126; Speelman 1988, p. 14; Russell 1988, p. 789.

CONDITION NOTES: The tacking margins of the original support were cut off when the painting was relined long ago. The overall dimensions with the relining is 23⅞ × 34 in. (60.5 × 86 cm.). The paint film is in very good state with little abrasion and only scattered inpaint. The varnish is relatively clear.

A broad landscape with a river in the middle distance is bracketed on either side by rustic taverns. On the right the innkeeper offers a drink to an elegant hunting party which includes two gentlemen on horseback and a lady in purple riding side-saddle with a parasol. On the ground before them a boy leashes two of the dogs, while at the far right a woman draws water from a well. In the tree overhead is a dovecot and additional perches are attached to the roof of the inn. On the road leading from the inn on the left are a procession of drunken peasants led by a hurdy-gurdy player. Three of the company perform a clumsy dance, while one man lies vomiting beside the road. Two children with a whirly-gig attend the group. Further back a man embraces a smiling woman. In front of the tavern, about two dozen other peasants make merry, dancing to the music of a hurdy-gurdy player standing on a barrel. In the river figures bathe and on the far shore rises a town with church steeple. In the blue distance are mountains.

Riders stopping before an inn was one of Wouwermans' favourite subjects, but few of his compositions are as richly detailed and full of incident as the Samuel painting. Wouwermans had depicted a village festival in a broad landscape as early as 1653 in the painting from the Sweatt Collection now at the Minneapolis Art Institute (fig. 1).[1] However the Samuel painting has the greater delicacy of touch, lighter atmosphere and colouring, as well as the richness of anecdote and elegant figures that are most often encountered in the artist's works from the 1660s. In 1829 Smith recognized the painting as a later work, calling it 'An excellent picture, painted in the artist's second manner; full of variety and interesting detail'.[2] While in the Henry Thomas Hope Collection, the work was described by Waagen as 'Far more attractive than most of Wouvermans' pictures for richness of composition, happy dramatic action,

and most delicate finish, in the warm golden tone of his second manner'.[3] Bode also praised it liberally in 1904 ('It is vivid and realistic to an extraordinary degree, so much so that the observer lives again the emotions depicted') and in 1913, stating that 'The Dresden Gallery with sixty examples by this painter, and the Hermitage with about forty, can scarcely boast of possessing anything better'.[4] He allowed that its 'highly descriptive' style would not be appreciated by 'advocates of the most modern tendencies in art' but 'those who still consider that vivid imagination, consummate drawing, and the highest proficiency in grouping and scenic arrangement count for something in art will find this picture wholly admirable and will delight in its many striking artistic qualities and the spirited, refined, and humorous portrayal of the life of the time'.[5]

We now recognize that this portrait is formed as much by artistic tradition and imagination as by observation of the 'life of the time'. The neat juxtaposition of the recreations of high and low life in the Samuel painting reflect Wouwermans' artistry. The theme of the rest at the inn was a time-honoured subject in Dutch landscape painting, though it must be said that Wouwermans lent it an unprecedented elegance in his images of hunting, hawking and coursing parties at their ease. His conception of the peasant carnival has still deeper roots and can be traced to the comical bruegelian *kermis* of the sixteenth century, which includes many stock characters – not only the hurdy gurdy and 'doodlesack' players and ludicrously bumptious dancers, but also the drunkard vomiting amid swine, and possibly the 'pregnant' or 'dirty bride'. The last-mentioned may be represented by the embracing peasant couple with the man placing his hand on the woman's distended stomach. These surely are the bride and groom implied in the work's traditional though latter day title, 'The Rustic Wedding'. Wouwermans' fellow Haarlemmer, Jan Steen (q.v.), had treated the 'pregnant bride' subject very recently (fig. 2), albeit with grander nuptials.[6]

Wouwermans' wittily elegant and picturesque view of the world was much admired in the eighteenth century. Indeed, he was one of the most influential forerunners of the rococo. In an age that valued Wouwermans more highly than in our own time, this painting's exceptional quality won it a place of honour in the first room on the right in Gerard Braamcamp's mansion on the Herengracht in Amsterdam. One of the greatest private collections formed in eighteenth-century Holland, it was visited by many connoisseurs, including Sir Joshua Reynolds on his visit to the Netherlands in 1781. In his published observations on his journey, Reynolds judged this painting 'The best work I ever saw [by the artist]'. The height of eighteenth-century taste, the Braamcamp Collection included many Leiden *fijnschilder* paintings, Dutch Italianate landscapes (Asselijn, Berchem, Both, P. van Laer, K. Dujardin, A. van de Velde and later artists), animal paintings by Potter, still lifes by Huysum and Jan Weenix, and genre scenes by Steen, Isaac Koedijk, A. van Ostade and de Hooch. When the collection was dispersed in 1771, the sale even attracted buyers for Catherine the Great (whose purchases were tragically lost at sea *en route* to Russia). Of Braamcamp's seventeen (!) works by Wouwermans, this painting brought the highest price and was singled out for praise in the catalogue as 'one of the freshest known by this master, not only as regards handling but also in colouring and the richness of design' ('Dit stuk is een der fraaiste die van deezen Meester bekend zyn, zoo ten aanzien der behandeling, het koloriet, als de rykheid van ordonnantie'). Indeed the only paintings among the 313 sold from the Braamcamp Collection which brought higher prices were by the Leiden *fijnschilders* G. Dou, Frans van Mieris, Isack Koedijk and G. Metsu; two paintings by Potter, and works by Rembrandt and Rubens. The Wouwermans was easily the most expensive landscape in the sale.[7]

The painting was purchased at the sale by Jan (John) Hope (1737–84), a very active collector who was heir to the famous Bisschop Collection of Rotterdam and left a detailed description of his own expanded collecton.[8] The Hopes were bankers who left the Netherlands for England shortly before the French Revolution. While in the collection of Henry Philip Hope in London, it was selected by the engraver and publisher, Peltro William Tomkins, to be included in his lavish folio-sized series of engraved reproductions, *The British Gallery of Pictures* (1818), which illustrated what were then regarded as the finest Old Master paintings in England and included descriptions and comments by Henry Tresham, R.A., and the collector, William Young Ottley. During the nineteenth century the Hope collection in London rivalled even the Royal Collections, and from 1891 to 1897 eighty-three of their paintings hung in the South Kensington Museum (now the Victoria and Albert Museum). In 1898 a judge had to intervene to grant Lord Henry Francis Hope Pelham-Clinton-Hope permission to sell the collection.[9] The sale was handled privately by the dealers Colnaghi and Asher Wertheimer, who sold the Wouwermans to the German-born South African diamond king, Alfred Beit (1853–1906). Beit was advised by Wilhelm von Bode, the Director of the Berlin Museum, who wrote two catalogues (1904 and 1913) of the Beit Collection. He housed the collection at 26 Park

Lane, which he built in 1895. When Alfred died, the collection passed to his younger brother Otto (1865–1930), who was a financier and philanthropist. The majority of the collection, including the Vermeer and the exquisite pair of Metsus that were recently stolen, descended to the present Sir Alfred Beit, of Russborough, County Wicklow, and were presented to the National Gallery of Ireland, Dublin. However in late 1959 Alfred Beit sold a group of paintings to Samuel via Speelman.[10]

Admiration for the painting is further reflected in the several whole or partial copies which exist after its design.[11] A watercolour copy by William Marshall Craig (c. 1765–c. 1834) in the Boston Atheneum (30.8 × 44.4 cm.; acc. no. V.R.7.23.1858) served as the model for John Scott's coloured engraving of the painting that appeared in the *British Gallery of Pictures*.[12]

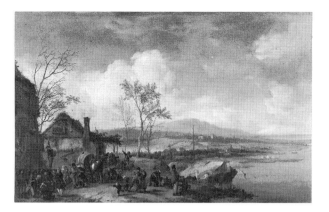

1 Smith, *Supplement* (1842), no. 28; Hofstede de Groot, vol. 2 (1909), no. 1020.
2 Smith, vol. 1 (1829), no. 87.
3 Waagen, vol. 2 (1854), p. 121.
4 Bode 1904, p. 20, and Bode 1913, p. 24.
5 Bode 1913, p. 25. In his unpublished notebooks, Ellis Waterhouse commented on the picture following a visit on 8 August 1931, to Sir Otto Beit's Collection at 49 Belgrave Square: '... from the Hope Collection, an extremely good picture; one of the rare tiptop Wouwermans'.
6 See Jan Steen, *Wedding Procession with the Pregnant Bride*, signed and dated 1653, canvas 64 × 81 cm., Museum Boymans-van Beuningen, Rotterdam, no. 2314.
7 On the Braamcamp Collection, see Clara Bille, *De Tempel der Kunst of het kabinet van den heer Braamcamp*, 2 vols. (Amsterdam, 1961).
8 See J. W. Niemeyer, 'De Kunstverzameling van John Hope (1737–1784)', *Nederlands Kunsthistorisch Jaarboek*, vol. 32 (1981), pp. 127–232. For the unpublished catalogue of Henry Hope's Collection at No. 1, the corner of Harley Street, 1795 ('Catalogue B'), see Buist 1974.
9 On the Hope family collections, see also Ben Broos, in exh. cat., The Hague, Mauritshuis, *Great Dutch Paintings from America* (shown at the Fine Arts Museums of San Francisco), 1990–1, pp. 366, 420.
10 On the Beit collection, see also *The Burlington Magazine*, vol. 9 (April–September 1906); *Antique Collector* (April 1938), pp. 69–74; Prebble Raynor, 'The Sir Arthur Beit Collection on View at the National Gallery of South Africa', *Studio*, vol. 140 (August 1950), pp. 33–7; *Antique Collector* (September 1982), pp. 60ff.
11 Two copies of the right-hand side of the composition on an upright format are known: monogrammed, oil on canvas 31 × 25 cm., sale Brunswick (Hünerberg), 1 December 1960, no. 99, ill.; and about 60 × 40 cm., Collection Dr Schmidt, Frankfurt, 1956. A weak copy (panel 33 × 41 cm.) of the right-hand side with a freely invented left side was in the collection of C. Crawford, 'Coolroe', Bray (Co. Wicklow), Ireland, 1982.
12 See Jonathan P. Harding and Harry Likatz, *The Boston Atheneum Collection. Pre-Twentieth Century American and European Painting and Sculpture* (Boston, 1984), pp. 103–4.

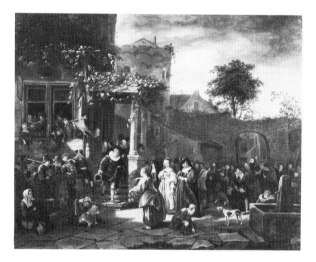

FIG. 1 Philips Wouwermans, *Landscape with Village Festival*, signed and dated 1653, oil on canvas 69.9 × 118.8 cm., Minneapolis Institute of Art, Minneapolis, Gift of Margaret L. Sweatt, no. 81.107.

FIG. 2 Jan Steen, *The Dirty (Pregnant) Bride*, signed and dated 1653, canvas 64 × 81 cm., Museum Boymans-van Beuningen, Rotterdam, no. 2314.

CAT. 84

Landscape with a Grey Horse and Figures by the Wayside, c. 1644–6

Formerly said to be signed with a monogram
Oil on panel 11¾ × 15¾ in. (30 × 39.8 cm.)

PROVENANCE: B. Nathusius, Amsterdam; Baron van der Feltz, Bremen; acquired from Edward Speelman in 1968.

EXHIBITION: London 1988, no. 80.

CONDITION NOTES: The oak panel is cradled. Its lower edge is damaged with losses to both panel and paint. A notch appears in the centre lower edge and at the top right corner. The paint film is moderately abraded but generally in good condition.

On a sandy road in a hilly landscape a man and a woman with a grey horse have stopped by a pool. Beyond them the hindquarters of another horse are just visible rounding the far side of the hill. To the left, silhouetted on the crest of the hill, are two cows. The sky is bright but overcast.

Wouwermans' earliest dated painting is a rather clumsily painted little oval format scene of a *Soldier's Encampment* dated 1639, which seems to attest to the influence of military scenes by followers of Esaias van de Velde, such as Jan Maertsen de Jonge (1609–after 1647).[1] Four years later he had already established his own style when he painted three pictures, including the *Landscape with Rider at Rest* in the Museum in Leipzig (fig. 1).[2] The Samuel painting shares with this work the low point of view, silhouetted hillside, and reclining figure with horse viewed from the rear. It too is probably an early painting and employs the subdued palette and rather angular figure types of his earliest pictures. The treatment of the white horse on the

right also recalls the art of Pieter van Laer (1599–in or after 1642) who was the single greatest influence on Wouwermans' early career.[3] Houbraken claimed that Wouwermans acquired the sketches of Pieter van Laer upon the latter's death in or after 1642. Several other undated early works by Wouwermans may also be compared with the Samuel painting.[4]

Another slightly larger version of this composition which was probably a copy was de-accessioned by the museum in Hamburg.[5]

1 Panel 39 × 53.3 cm., sale London (Christie's), 20 October 1972, no. 13, ill. (not in Hofstede de Groot).
2 Hofstede de Groot, vol. 2 (1908), no. 219. See also the two other paintings dated 1646, the *Scene before an Inn*, City Art Gallery, Manchester (Assheton Bennett Collection), inv. no. 1979.516; and the large *Cavalry Battle*, National Gallery, London, inv. no. 6263 (Hofstede de Groot vol. 2 (1908), nos. 778 and 770b?)
3 See, Albert Blankert, 'Over Pieter van Laer als dier- en landschapschilder', *Oud-Holland*, vol. 83 (1968), pp. 117–34; and especially Frits Duparc's forthcoming publication on Wouwermans.
4 Compare the landscapes: canvas 29 × 32 cm., sale Cologne (Lempertz) 14 June 1941, no. 102, ill.; and panel 27 × 29 cm., formerly in the A. Schloss Collection, Paris (Hofstede de Groot, vol. 2 (1908), no. 173).
5 Panel 34 × 39.5 cm., *Katalog der Alten Meister*, Kunsthalle, Hamburg, 1921, no. 137; sale Berlin (Lepke), 10 December 1925, no. 86; sale Vienna (Dorotheum), 11 September 1952, no. 157, ill.; sale Vienna (Dorotheum) 18 March 1954, no. 128, ill.; sale London (Sotheby's), 10 December 1980, no. 129, ill. [as 'J. Wouwermans'].

FIG. 1 Philips Wouwermans, *Landscape with Rider at Rest*, monogrammed and dated 1646, oil on panel 32.3 × 36.2 cm., Museum der bildenden Künste, Leipzig, inv. no. 825.

Bibliography

Amsterdam/Boston/Philadelphia 1987–8
Amsterdam, Rijksmuseum. *Masters of Seventeenth-Century Dutch Landscape Painting*. Catalogue by Peter Sutton *et al.* 2 October 1987–3 January 1988. Also shown at Museum of Fine Arts, Boston, and Philadelphia Museum of Art.

Bernt 1979–80
Walther Bernt. *Die Niederländischen Maler und Zeichner des 17 Jahrhunderts*. 5 vols. (Munich, 1979–80).

de Bie 1661
Cornelis de Bie. *Het Gulden Cabinet van de edele vry Schilder-const*. (Antwerp, 1661. Reprint, Soest, 1971).

Bol 1969
Laurens J. Bol. *Holländische Maler des 17. Jahrhunderts nahe den Grossen Meistern: Landschaften und Stilleben*. (Braunschweig, 1969).

Descamps 1753–64
Jean Baptiste Descamps. *La Vie des peintres flamands, allemands et hollandais*. 4 vols. (Paris, 1753–64).

van Eynden, van der Willigen 1816–40
R. van Eynden and A. van Willigen. *Geschiedenis van der vaderlandsche schilderkunst sedert de helft der XVIII eeuw*. 4 vols. (Haarlem, 1816–40).

Haak 1984
Bob Haak. *The Golden Age: Dutch Painters of the Seventeenth Century*. (New York, 1984).

Hoet 1752
Gerard Hoet. *Catalogus of Naamlyst van schilderyen met derzelver pryzen* . . . 3 vols. in 2. (The Hague, 1752 (suppl. in Terwesten 1770). Reprint, Soest, 1976).

Hofstede de Groot 1908–27
Cornelis Hofstede de Groot. *A Catalogue Raisonné of the Works of the Most Eminent Dutch Painters of the Seventeenth Century*. Translated by Edward G. Hawke. 8 vols. (London, 1908–27. Reprint, Cambridge, 1976). Originally published as: *Beschreibendes und kritisches Verzeichnis der Werke der hervorragendsten holländischen Maler des XVII Jahrhunderts*. 10 vols. (Esslingen and Paris, 1907–28).

Hollstein 1949–
F. W. H. Hollstein. *Dutch and Flemish Etchings, Engravings, and Woodcuts*. Vols. 1– . (Amsterdam, 1949–).

Hoogstraeten 1969
Samuel van Hoogstraeten. *Inleyding tot de hooge schoole der schilderkonst, anders de zichtbaere werelt*. (Rotterdam, 1678. Reprint, Utrecht, 1969).

Houbraken 1718–21
Arnold Houbraken. *De Groote Schouburgh der Nederlantsche Konstschilders en Schilderessen*. 3 vols. (Amsterdam, 1718–21. Reprint, Maastricht, 1943–53; Amsterdam, 1976).

Immerzeel 1842–3
J. Immerzeel. *De levens en werken der Hollandsche en Vlaamsche kunstschilders, beeldhouwers, graveurs en bouwmeesters van het begin der 15e eeuw tot heden*. 3 vols. (Amsterdam, 1842–3).

Kramm 1857–64
Christiaan Kramm. *De Levens en Werken der Hollandsche en Vlaamsche Kunstschilders, Beeldhouwers, Graveurs en Bouwmeesters, van den vroegsten tot op onzen tijd*. 7 vols. (Amsterdam, 1857–64).

London 1988
London, Barbican Art Gallery. *The Harold Samuel Collection*. (With an introduction by Vivien Knight) 4 August–2 October 1988.

van Mander 1603–4
Karel van Mander. *Het Schilder-boeck*. (Haarlem, 1603–4. Reprint, Utrecht, 1969).

Martin 1935–6
Willem Martin. *De Hollandsche schilderkunst in de zeventiende eeuw*. 2 vols. (Amsterdam, 1935–6. 2nd edn 1942).

Müllenmeister 1973–81
Kurt J. Müllenmeister. *Meer und Land im Licht des 17. Jahrhunderts*. 3 vols. (Bremen, 1973–81).

Obreen 1877–90
F. D. O. Obreen. *Archief voor Nederlandsche Kunstgeschiedenis*. 7 vols. (Rotterdam, 1877–90. Reprint, Soest, 1976).

Philadelphia/Berlin/London 1984
Philadelphia, Philadelphia Museum of Art. *Masters of Seventeenth Century Dutch Genre Painting*. Catalogue by Peter Sutton *et al.* 1984. Also shown at Berlin, Staatliche Museen Preussischer Kulturbesitz, and London, Royal Academy of Arts.

Rosenberg, Slive, ter Kuile 1966
Jakob Rosenberg, Seymour Slive, and E. H. ter Kuile. *Dutch Art and Architecture, 1600–1800*. (Harmondsworth and Baltimore, 1966. Revised edns 1972, 1977).

Russell 1988
Margarita Russell. (Review of London 1988), in *The Burlington Magazine*. vol. 130, no. 1027 (October 1988), pp. 787–9.

Salerno 1977–80
Luigi Salaerno. *Pittori di Paesaggio del Seicento a Roma (Landscape Painters of the Seventeenth Century in Rome)*. 3 vols. (Rome, 1977–80).

Sandrart 1675
Joachim von Sandrart. *L'Academia todesca della architectura, scultura, e pittura: oder, Teutsche Academie der edlen Bau-, Bild- und Mahlerey–Künste*. 2 vols. in 1 (Nuremberg, 1675).

Smith 1829–42
John A. Smith. *A Catalogue Raisonné of the Works of the Most Eminent Dutch, Flemish, and French Painters*. 9 vols. (London, 1829–42).

Speelman 1988
Anthony Speelman, 'The Harold Samuel Collection', *Galleries*, vol. 6, no. 3 (August 1988), p. 14.

Stechow 1966
Wolfgang Stechow. *Dutch Landscape Painting of the Seventeenth Century*. (Kress Foundation Studies in the History of European Art) (London and New York, 1966).

Terwesten 1770
Pieter Terwesten. *Catalogus of Naamlyst van Schilderyen, met derzelver prysen zedert den 22. Augusti 1752 tot den 21. November 1768*. (The Hague, 1770 (Suppl. to Hoet 1752). Reprint, The Hague, 1976).

Thieme and Becker
Ulrich Thieme and Felix Becker, eds. *Allgemeines Lexikon der bildenden Kunstler von der Antike bis zur Gegenwart*. 37 vols. (Leipzig, 1907–50)

Waagen 1854
G. F. Waagen. *Treasures of Art in Great Britain*, 3 vols. (London, 1854; *Supplemental Volume to the Treasures of Art in Great Britain* (London, 1857)).

Weyerman 1729–69
Jacob Campo Weyerman. *De levens-beschryvingen der Nederlandsche konst-schilders en konst-schilderessen*. 4 vols. (The Hague, 1729–69).

van der Willigen 1870
Adriaan van der Willigen. *Les Artistes de Haarlem: Notices historiques avec un précis sur la Gilde de St Luc*. (Haarlem, 1870. Reprint, Nieuwkoop, 1970).

Woodhouse 1988
Adrian Woodhouse. 'A New Home for Old Masters'. *Country Life*, 10 March 1988, pp. 124–7.

Wurzbach 1906–11
Adolph von Wurzbach. *Nederländisches Kunstler-Lexicon*. 3 vols. (Vienna and Leipzig, 1906–11).

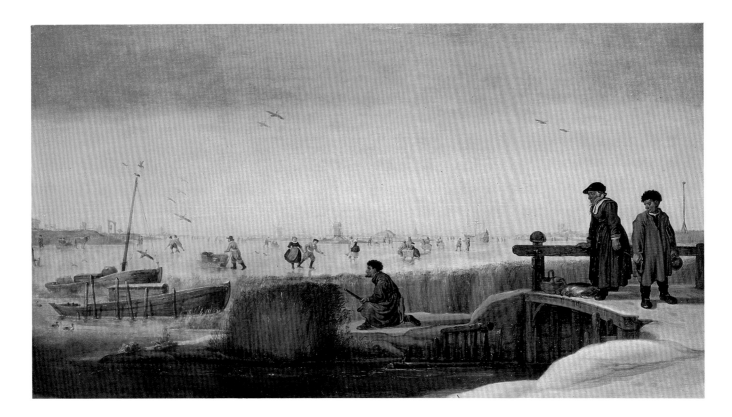

CAT. I Arent Arentsz, called 'Cabel': *Winter Landscape with Figures on a Bridge, a Hunter and Skaters*

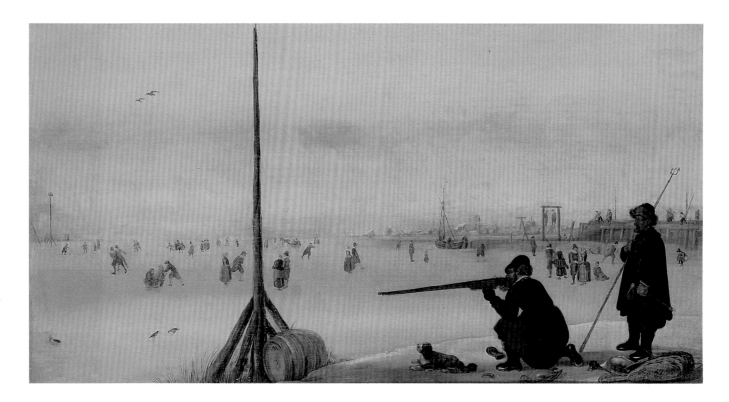

CAT. 2 Arent Arentsz, called 'Cabel': *Winter Landscape with Duck Hunter*

CAT. 3 Hendrick Avercamp: *Winter Landscape on the River Ijsel near Kampen*

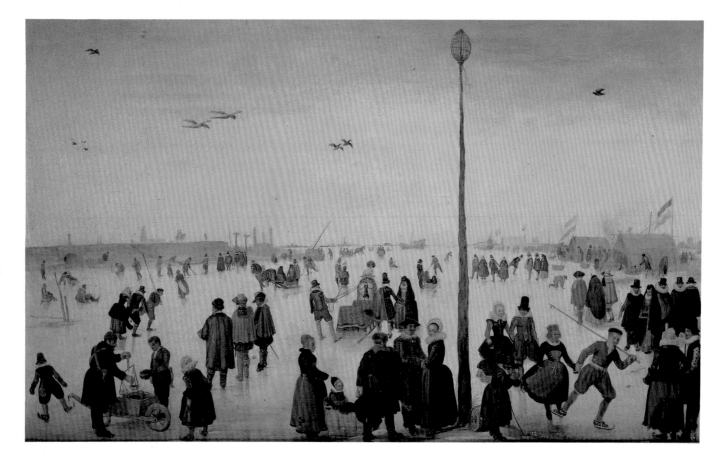

CAT. 4 Hendrick Avercamp: *Winter Landscape with a Frozen River and Figures*

CAT. 5 Gerrit Berckheyde: *The Castle of Heemstede*

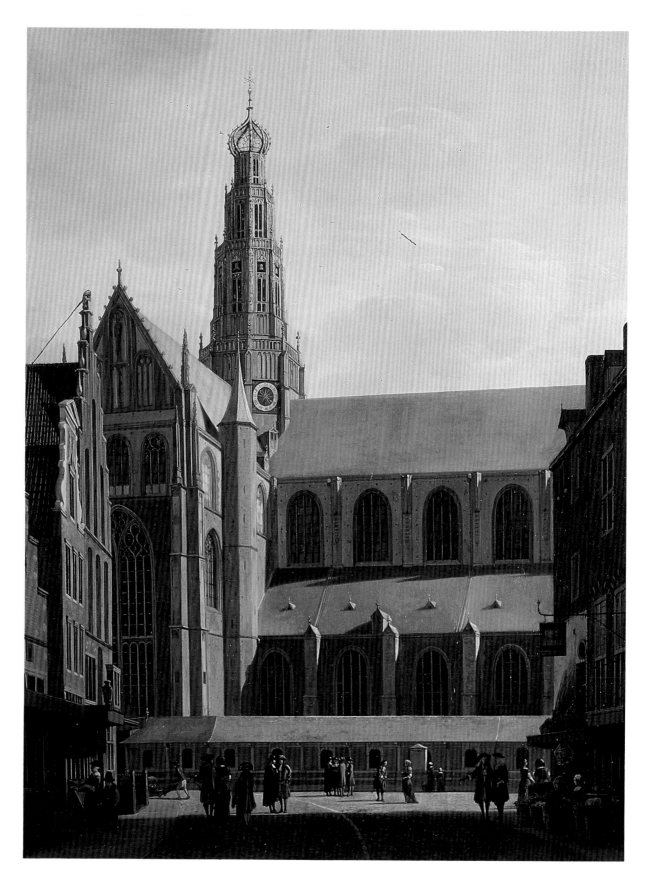

CAT. 6 Gerrit Berckheyde: *The Smedestraat with a View of the Grote Markt and St Bavo's Church, Haarlem*

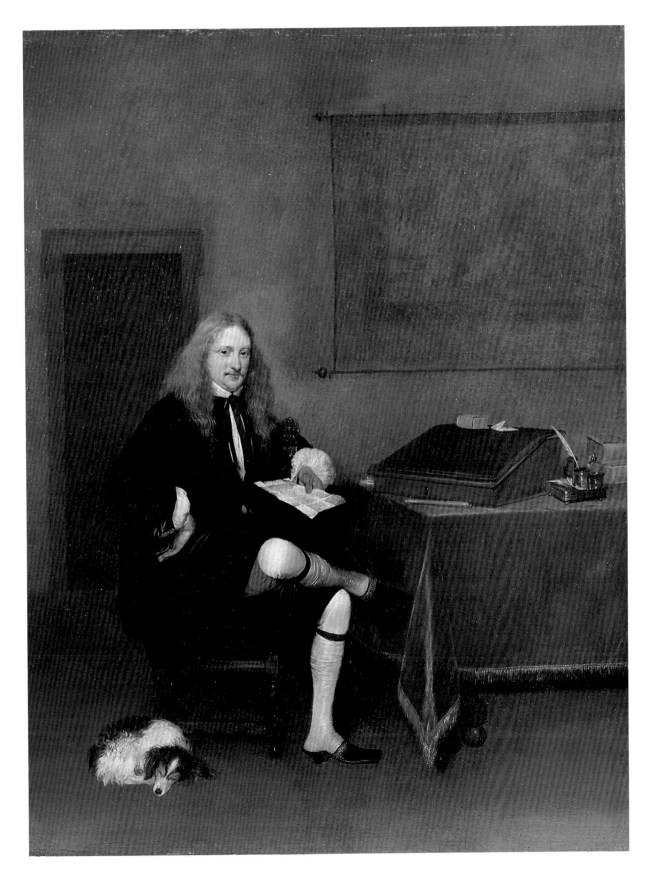

CAT. 7 Gerard ter Borch: *Portrait of a Man in his Study*

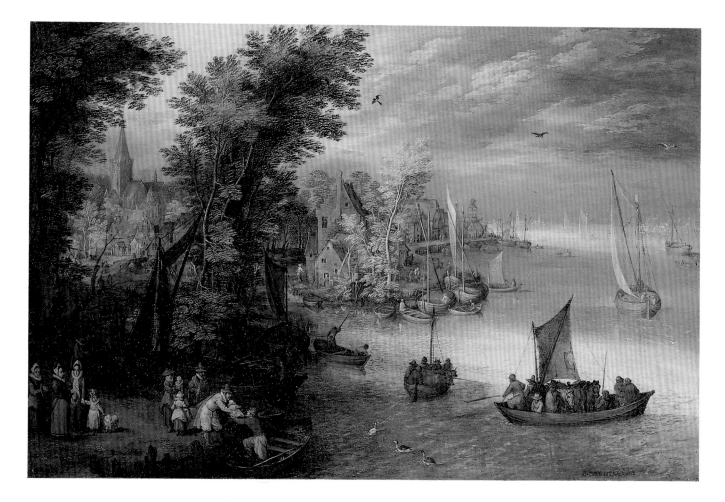

CAT. 8 Jan Brueghel the Elder: *River Landscape with a Village and a Landing*

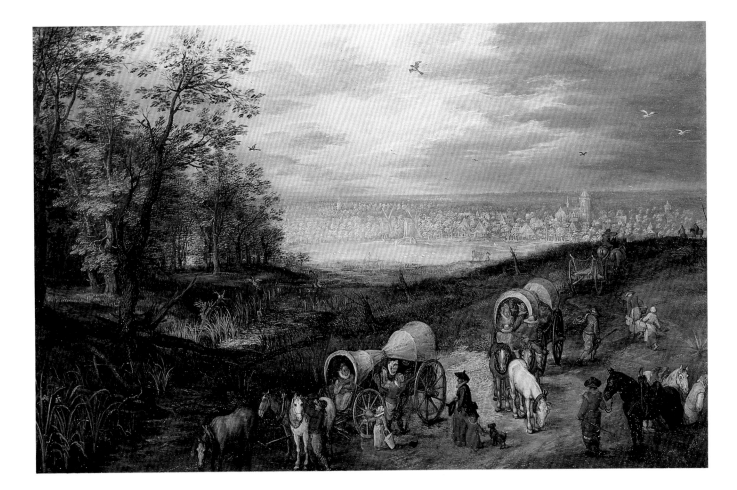

CAT. 9 Jan Brueghel the Elder: *Rest on the Way*

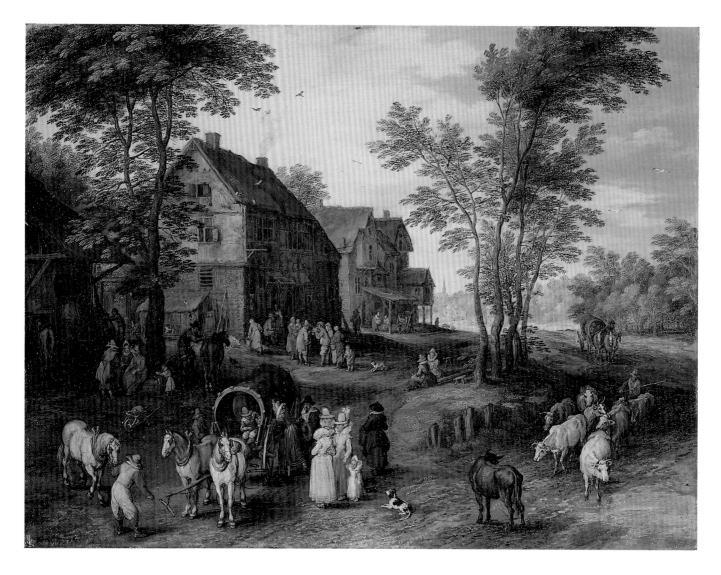

CAT. 10 Jan Brueghel the Elder: *Village Landscape with Figures Preparing to Depart*

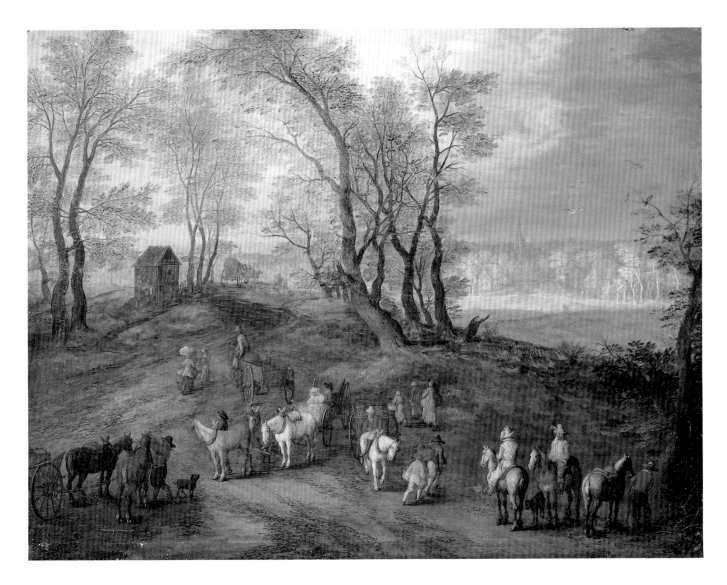

CAT. II Jan Brueghel the Elder (follower of): *The Road to the Market*

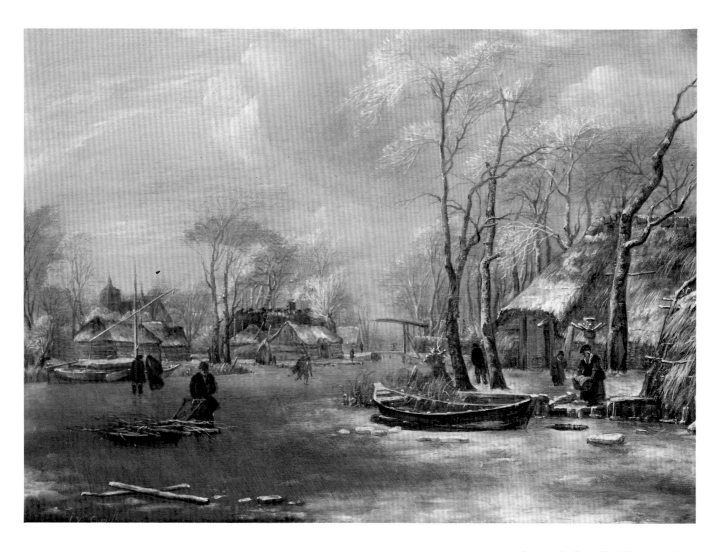

CAT. 12 Jan van de Cappelle: *Winter Landscape*

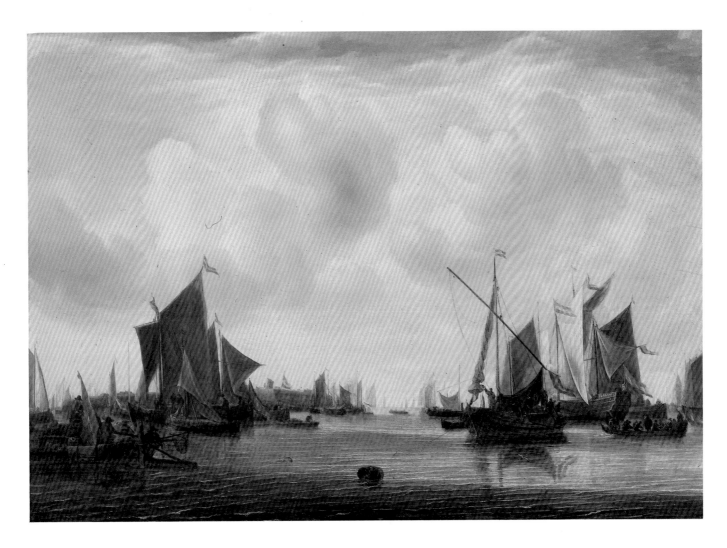

CAT. 13 Jan van de Cappelle (follower of): *Ships at Anchor in a Calm*

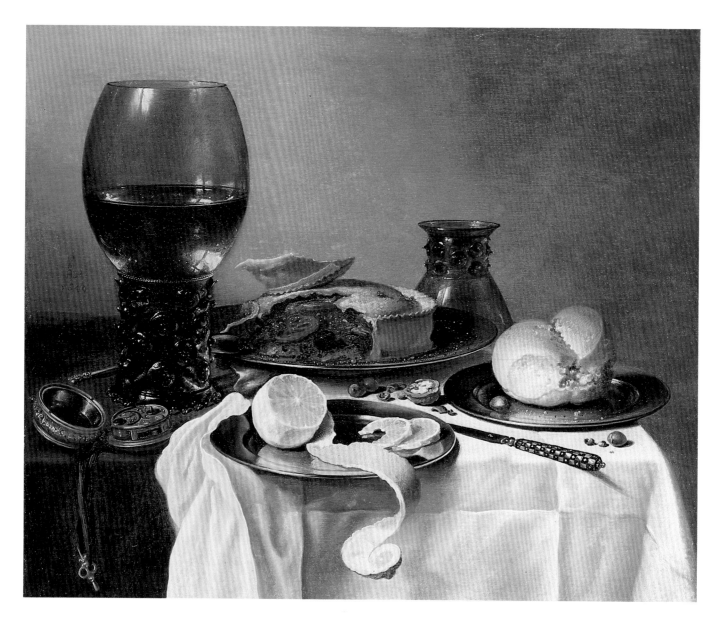

CAT. 14 Pieter Claesz: *Breakfast Still Life with Roemer, Meat Pie, Lemon and Bread*

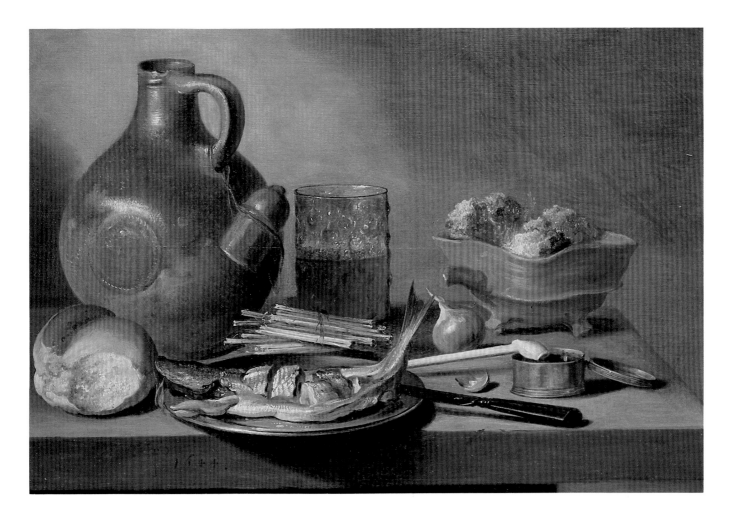

CAT. 15 Pieter Claesz: *Still Life with Jug, Herring and Smoking Requisites*

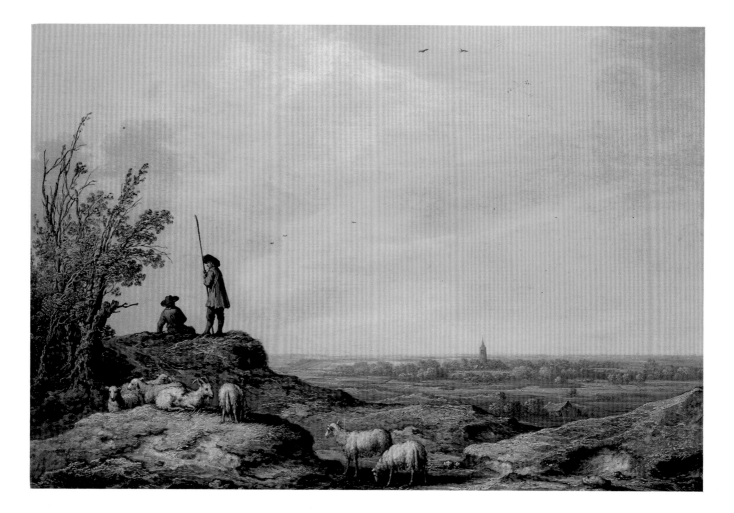

CAT. 16 Aelbert Cuyp: *Panoramic Landscape with Shepherds, Sheep and a Town (Beverwijk?) in the Distance*

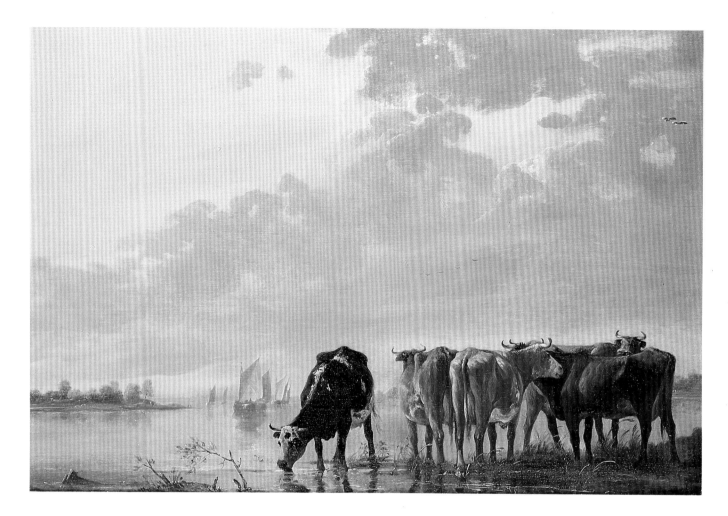

CAT. 17 Aelbert Cuyp (attributed to): *Cattle by a River*

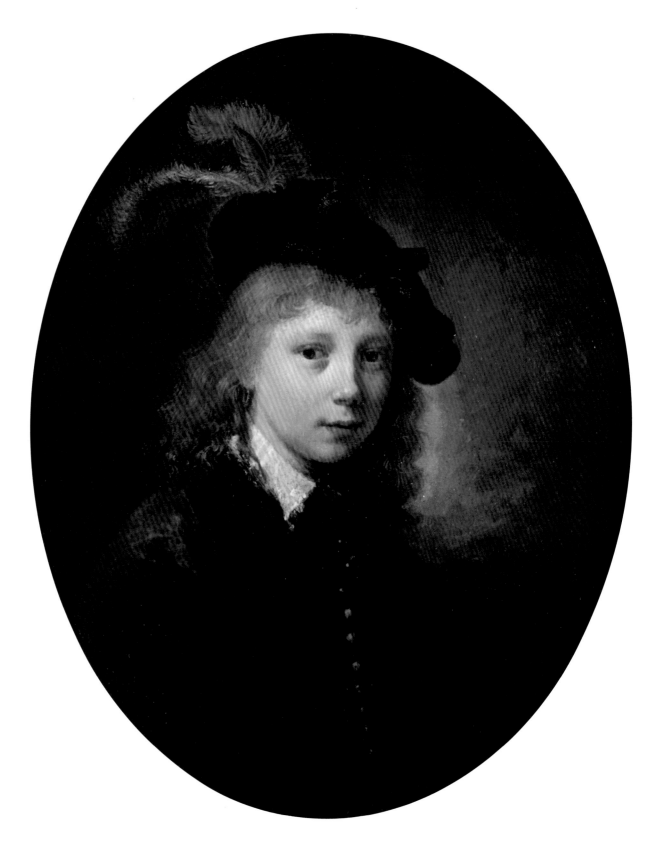

CAT. 18 Gerard Dou: *Portrait of a Young Man*

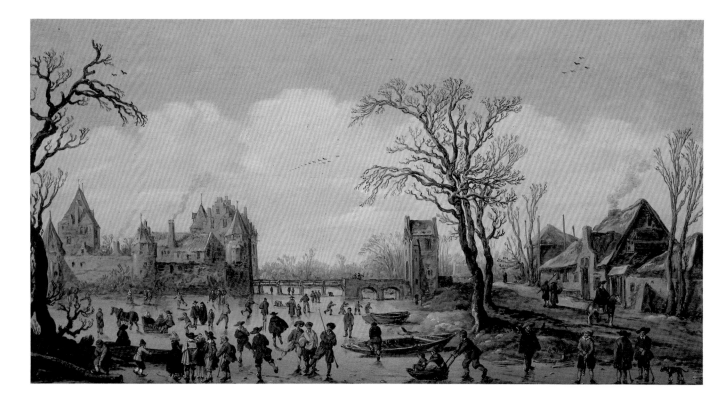

CAT. 19 Jan van Goyen: *Winter Landscape with a Walled Castle*

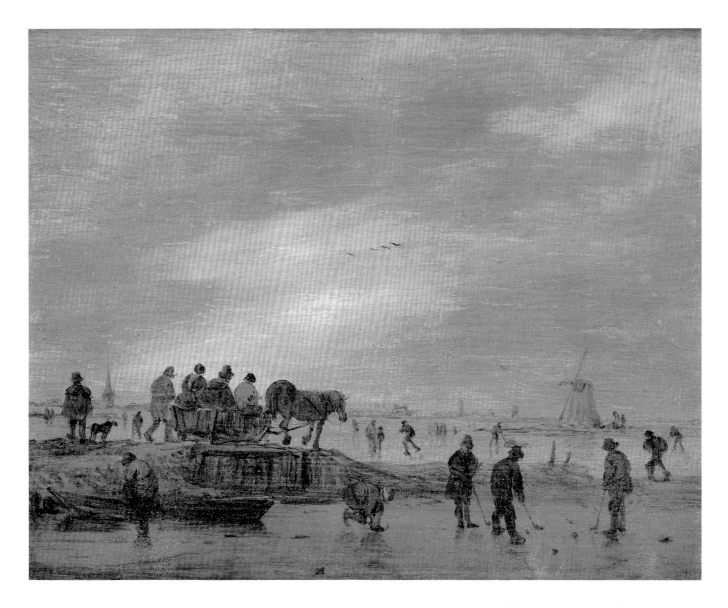

CAT. 20 Jan van Goyen: *Winter Landscape with a Horse-Drawn Sleigh*

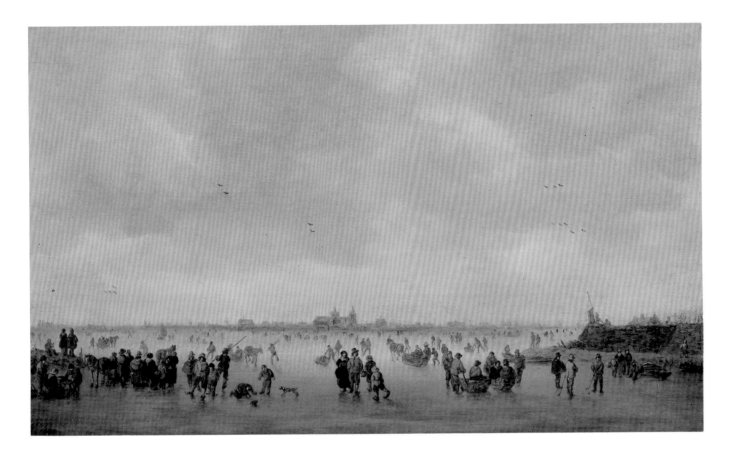

CAT. 21 Jan van Goyen: *Winter Landscape with Skaters before 's-Hertogenbosch*

CAT. 22 Jan van Goyen: *Hofstede Arnestein, with Middleburg in the Distance*

CAT. 23 Jan van Goyen: *An Estuary with Boats*

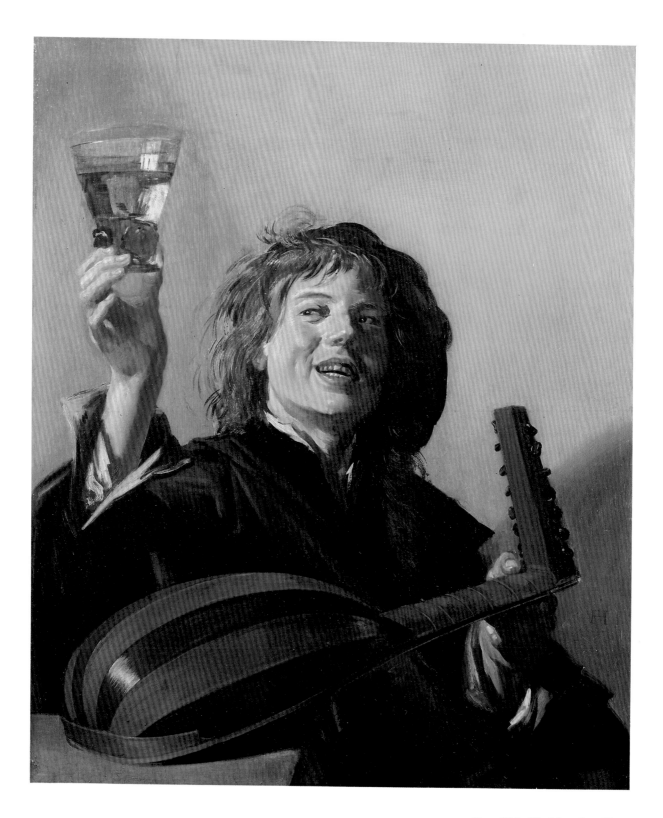

CAT. 24 Frans Hals: *The Merry Lute Player*

CAT. 25 Frans Hals (follower of): *The Lute Player*

CAT. 26 Jan van der Heyden: *View of the Boterbrug with the Tower of the Stadhuis, Delft*

CAT. 27 Jan van der Heyden: *An Imaginary Town Gate with Triumphal Arch*

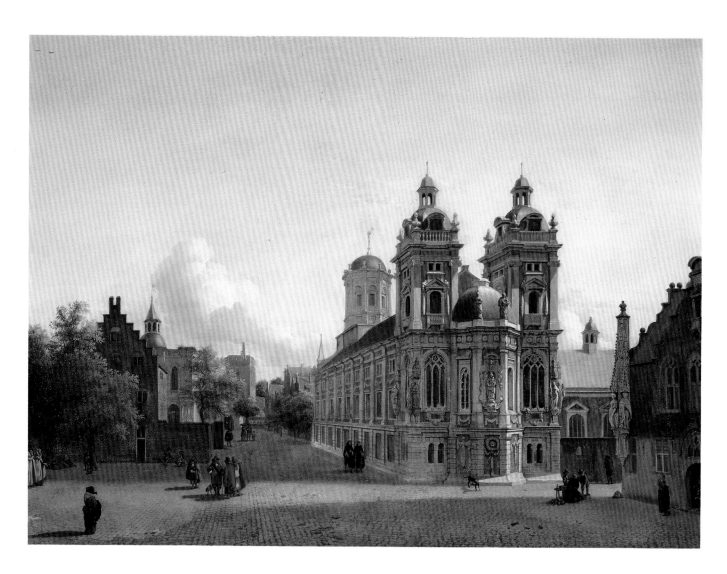

CAT. 28 Jan van der Heyden: *Cityscape with a Church and a Square*

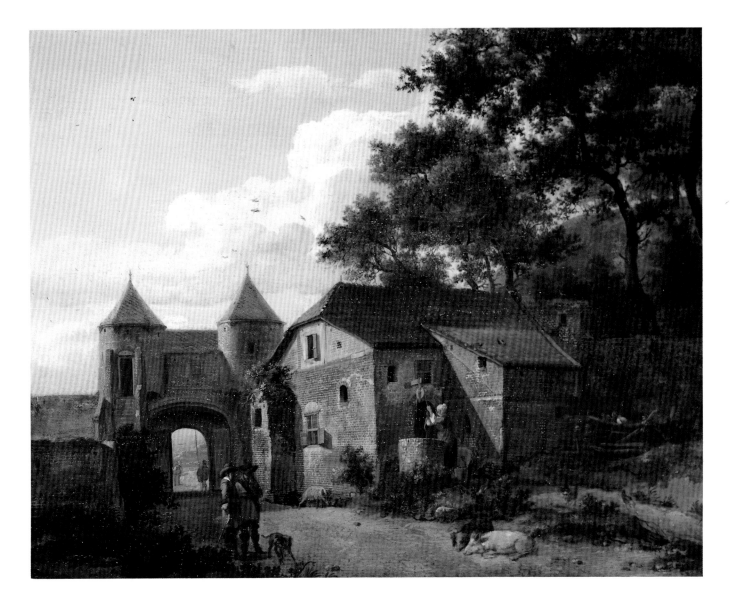

CAT. 29 Jan van der Heyden: *Wassertor, Kleves*

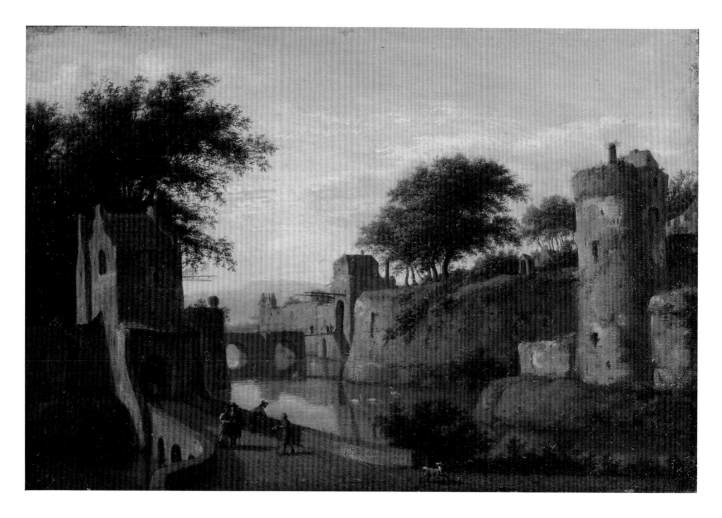

CAT. 30 Jan van der Heyden: *A Fortified Moat or Canal*

CAT. 31 Jan van der Heyden: *A Wooded Landscape with Figures*

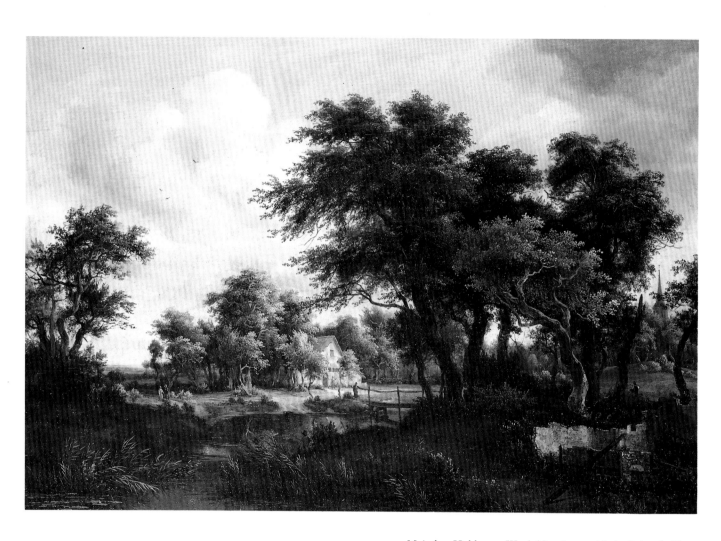

CAT. 32 Meindert Hobbema: *Wooded Landscape with the Ruins of a House*

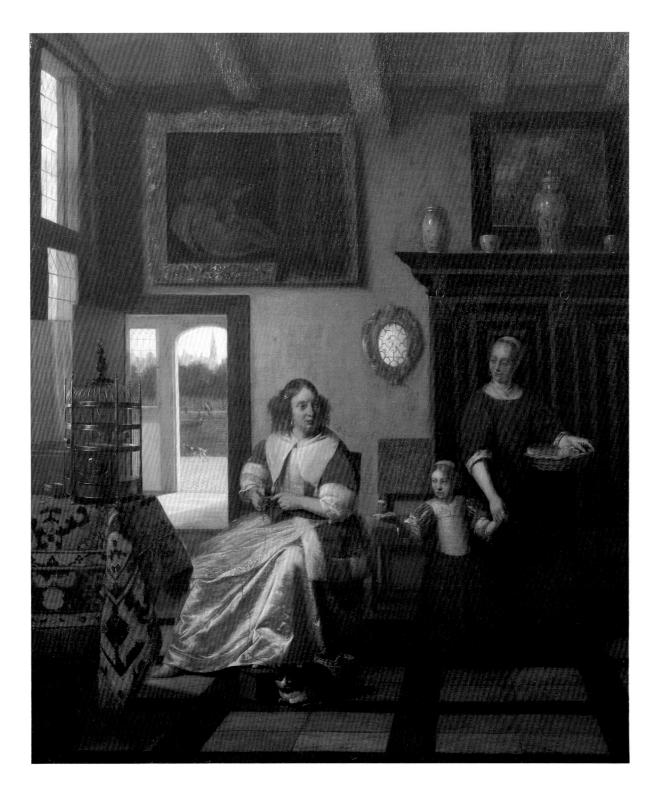

CAT. 33 Pieter de Hooch: *Interior with a Woman Knitting, a Serving Woman and a Child*

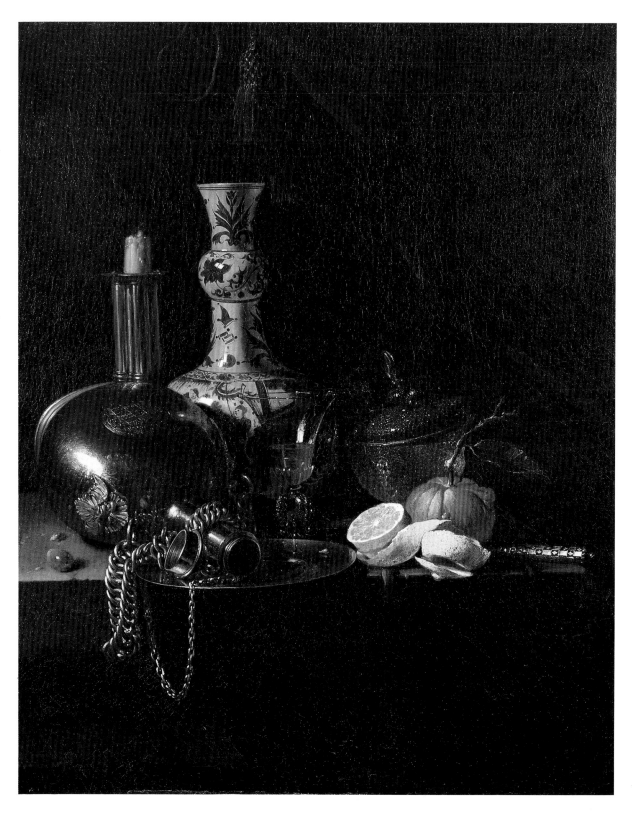

CAT. 34 Willem Kalf: *Still Life with a Pilgrim Flask, Candlestick, Porcelain Vase, Glasses and Fruit*

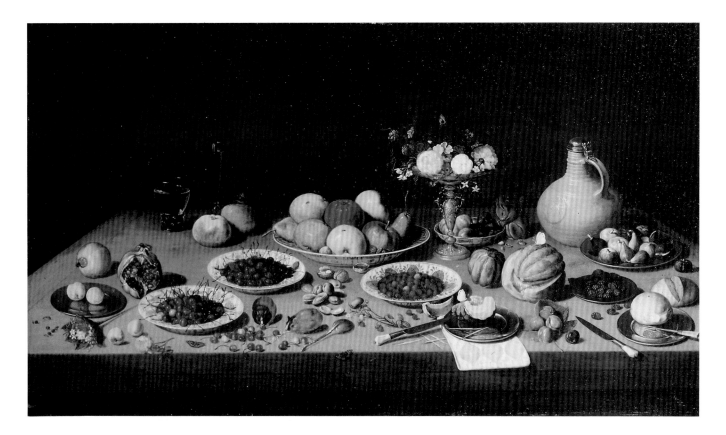

CAT. 35 Jan van Kessel (follower of): *A Still Life with Fruit and Flowers on a Table*

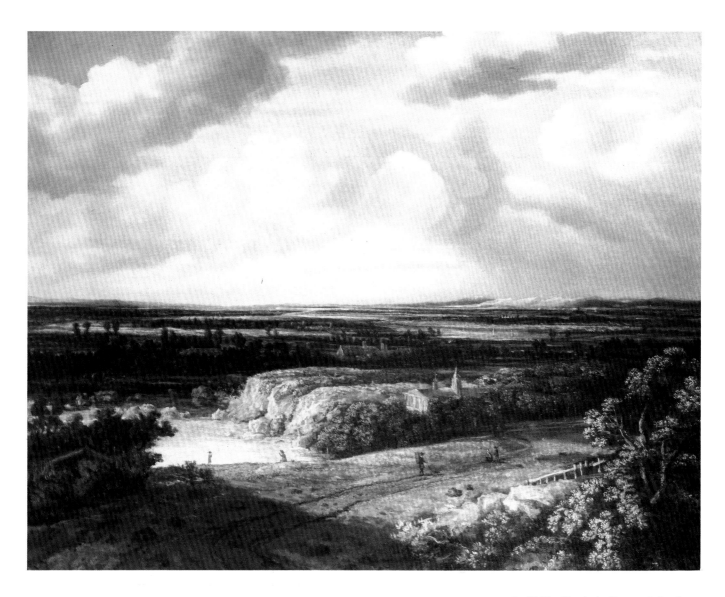

CAT. 36 Philips Koninck: *Panoramic Landscape*

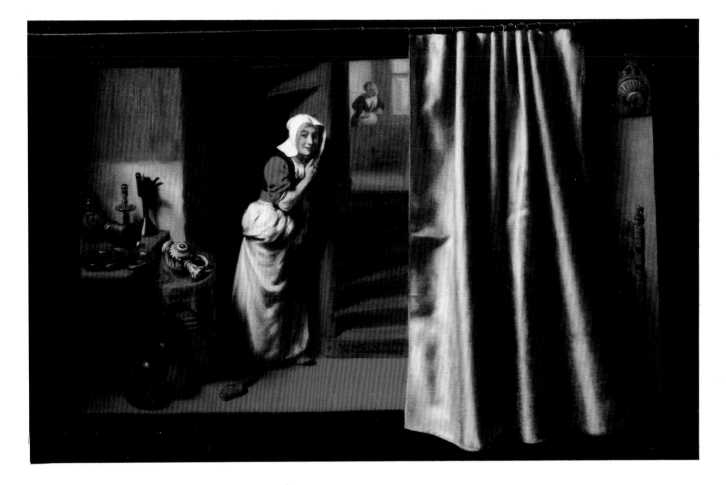

CAT. 37 Nicolaes Maes: *An Eavesdropper with a Woman Scolding*

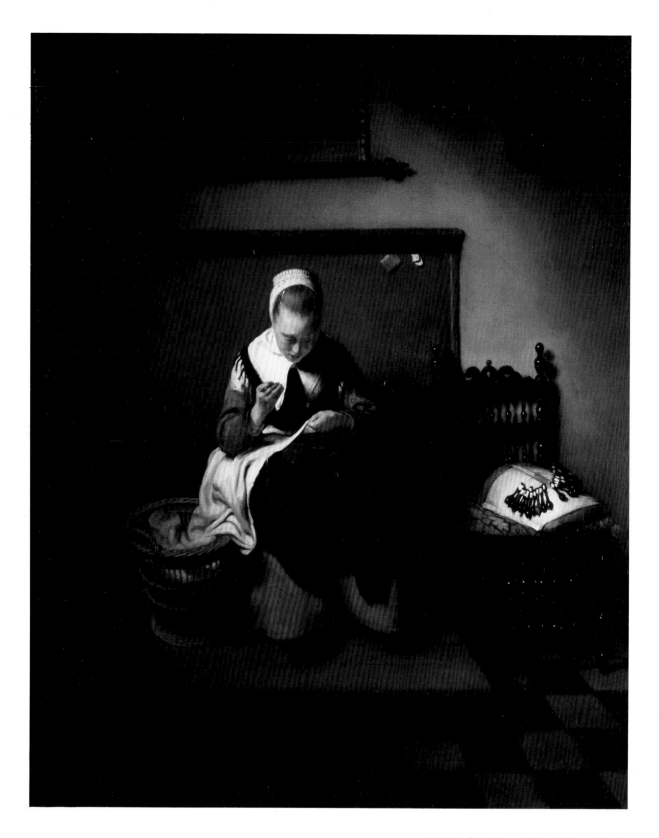

CAT. 38 Nicolaes Maes: *A Young Woman Sewing*

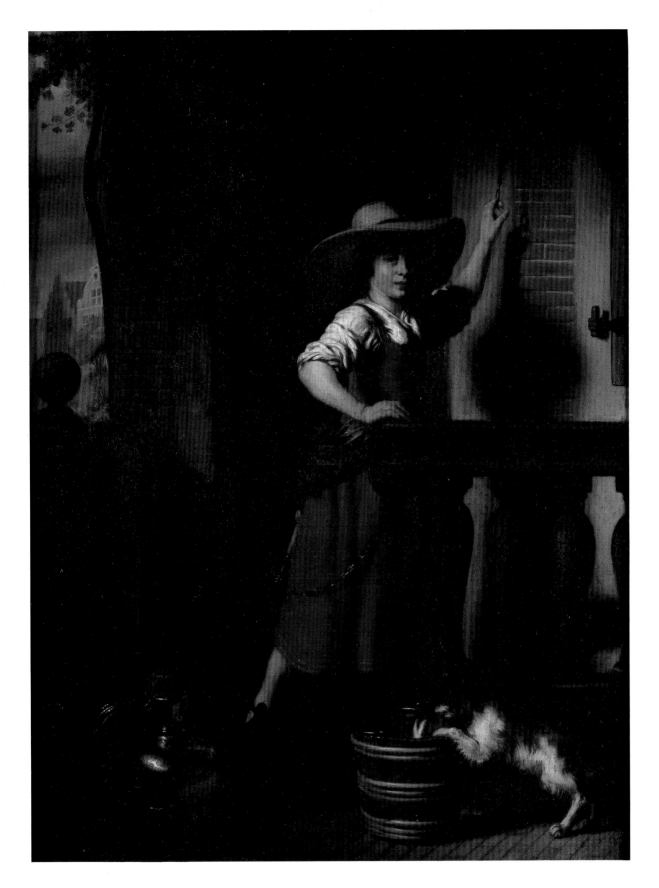

CAT. 39 Nicolaes Maes: *A Woman Selling Milk*

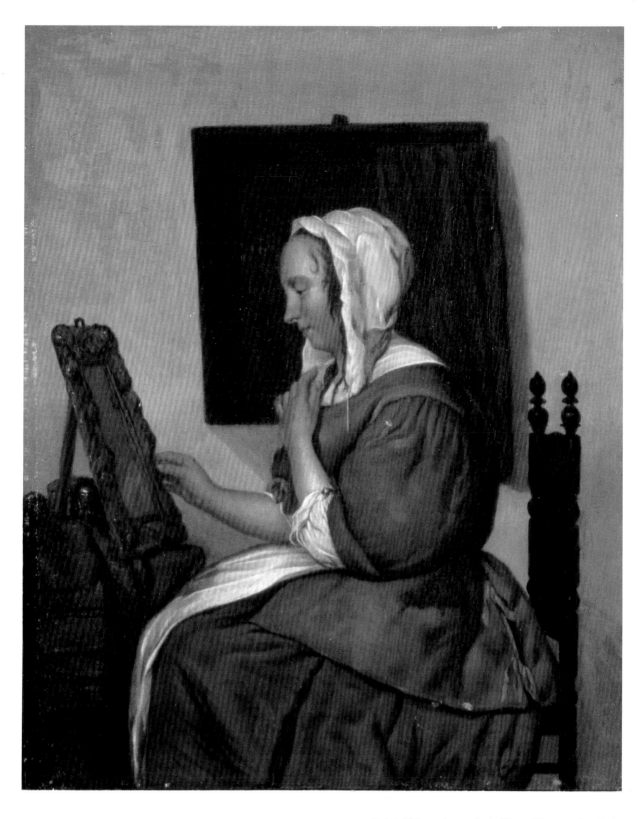

CAT. 40 Gabriel Metsu (copy after): *Young Woman at her Toilet*

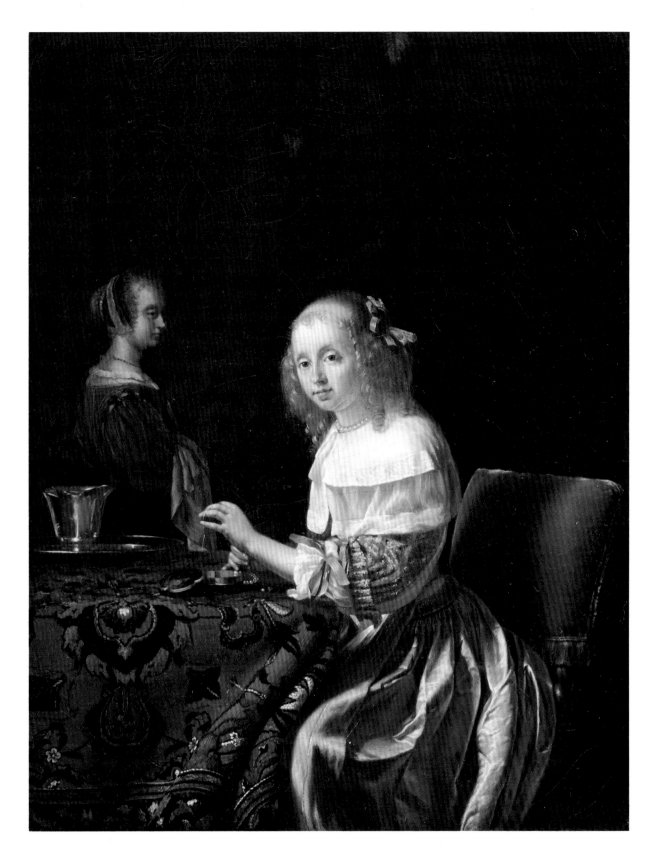

CAT. 41 Frans van Mieris (copy after): *A Young Woman Stringing Pearls*

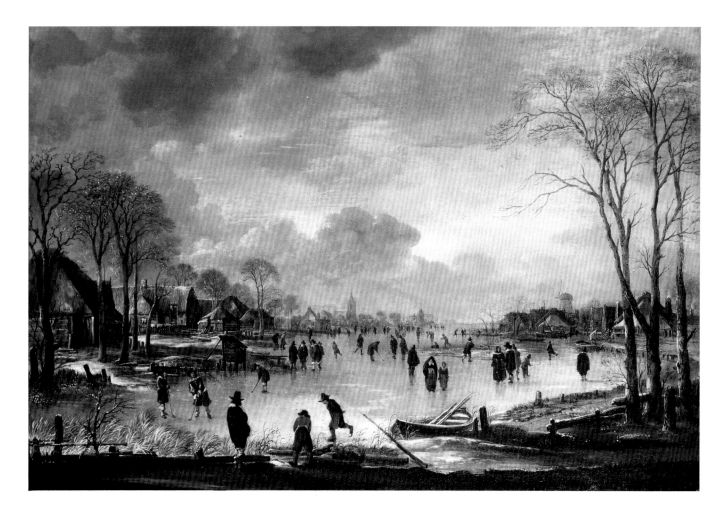

CAT. 42 Aert van der Neer: *Winter Landscape with Figures on a Frozen Canal*

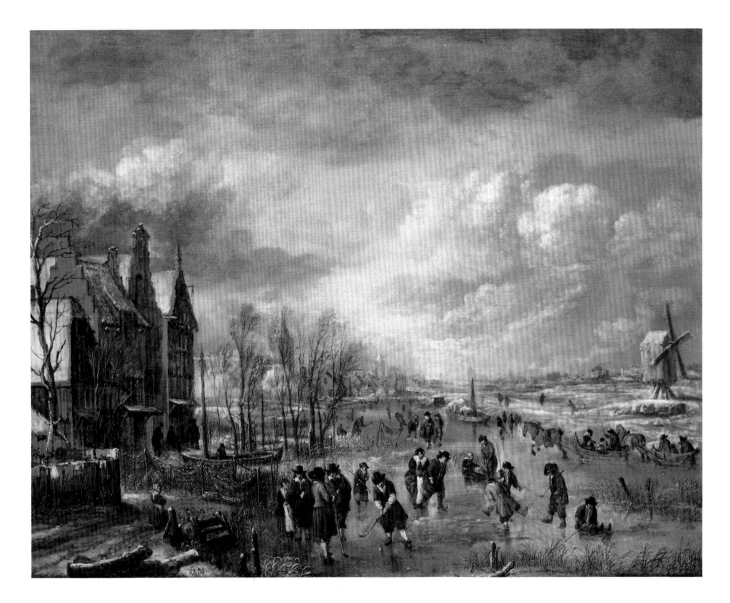

CAT. 43 Aert van der Neer: *Winter Landscape with Skaters*

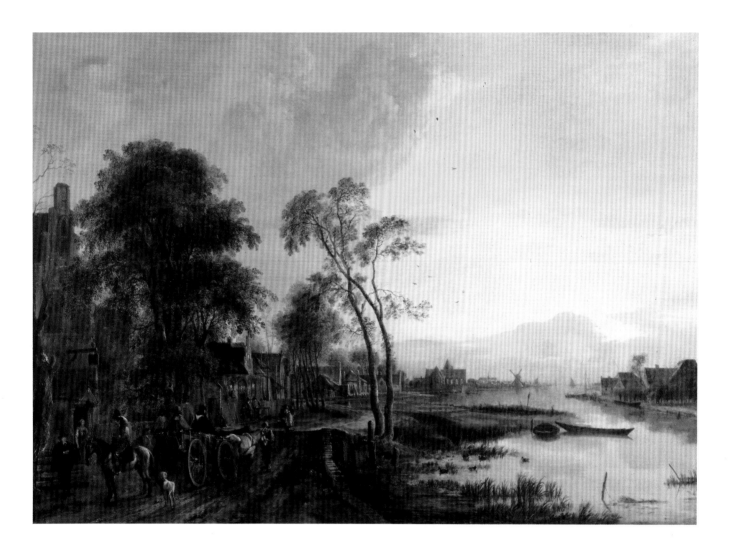

CAT. 44 Aert van der Neer: *Evening Landscape*

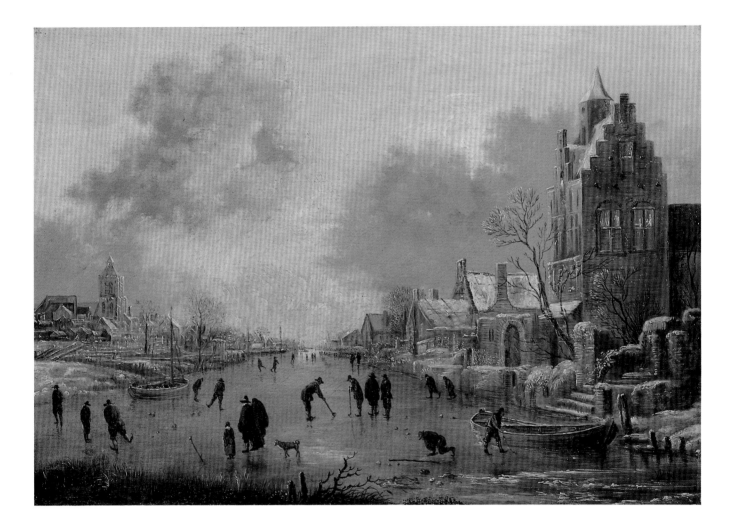

CAT. 45　Aert van der Neer (imitator of): *A Canal in Winter*

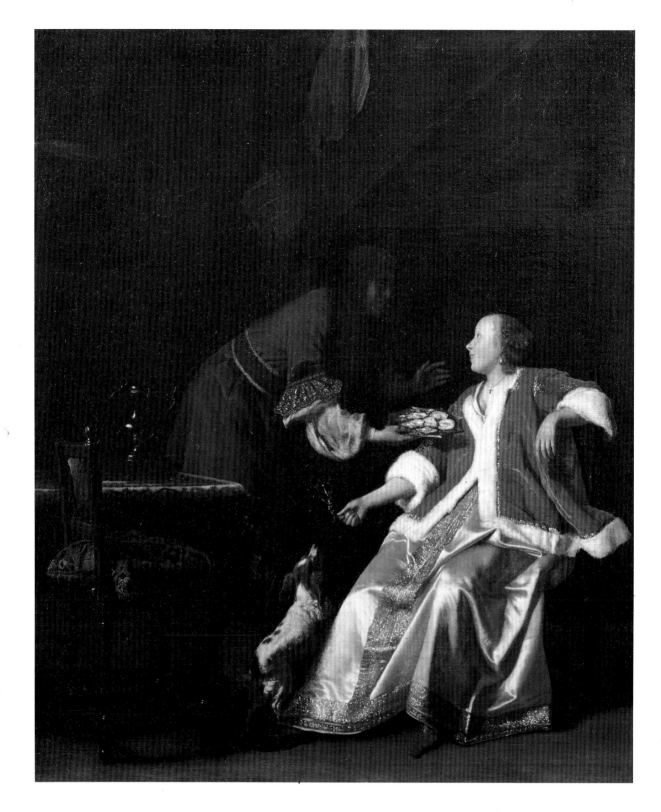

CAT. 46 Jacob Ochtervelt: *The Oyster Meal*

CAT. 47 Jacob Ochtervelt: *A Lady and Maid Choosing Fish*

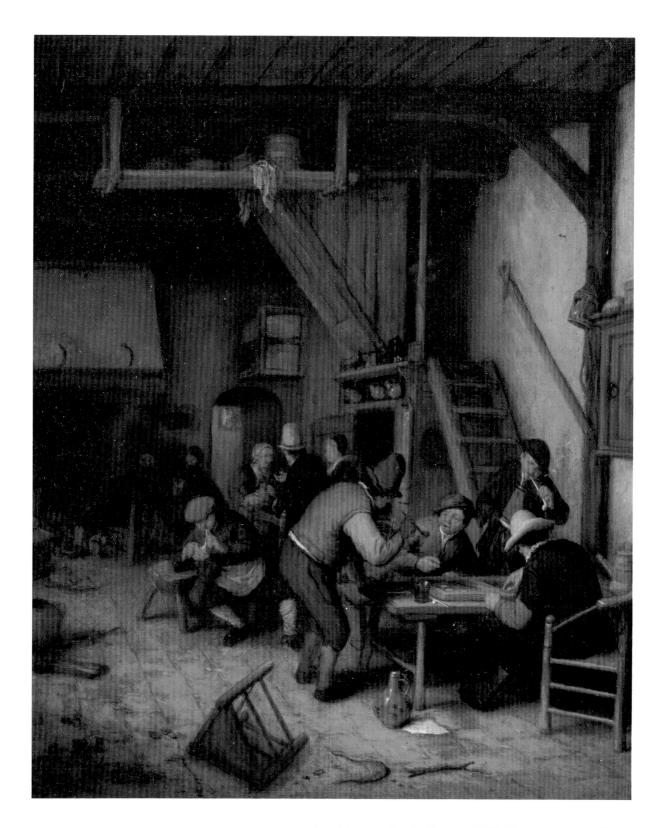

CAT. 48 Adriaen van Ostade: *Tavern with Tric-Trac or Backgammon Players*

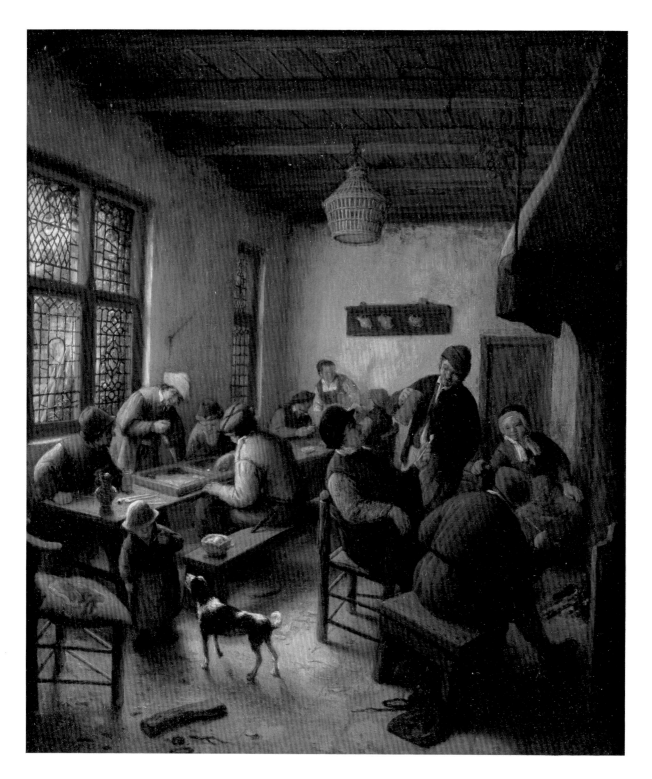

CAT. 49 Adriaen van Ostade: *Village Inn with Backgammon (Tric-Trac) and Card Players*

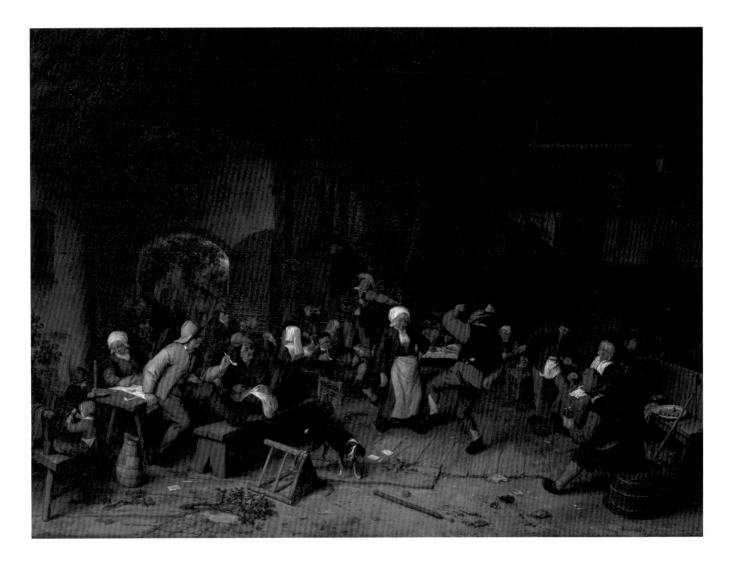

CAT. 50 Adriaen van Ostade: *Peasants Dancing in a Tavern*

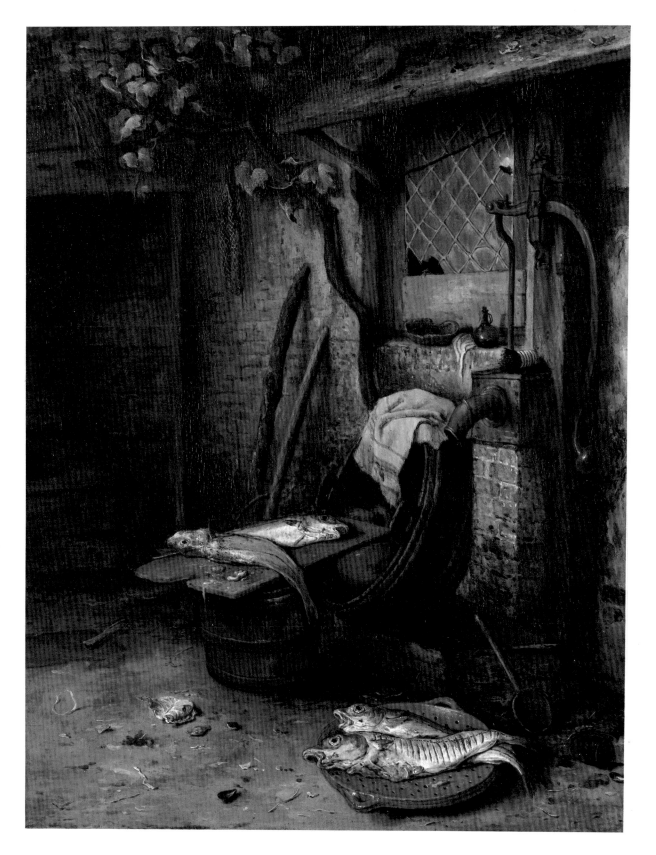

CAT. 51 Adriaen van Ostade: *The Water Pump*

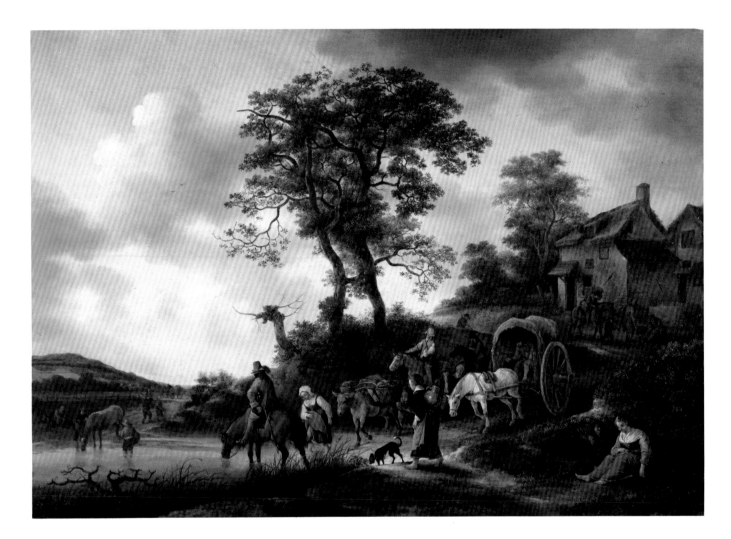

CAT. 52 Isack van Ostade: *A Ford*

CAT. 53 Palamedes Palamedesz: *Cavalry Battle on a Bridge*

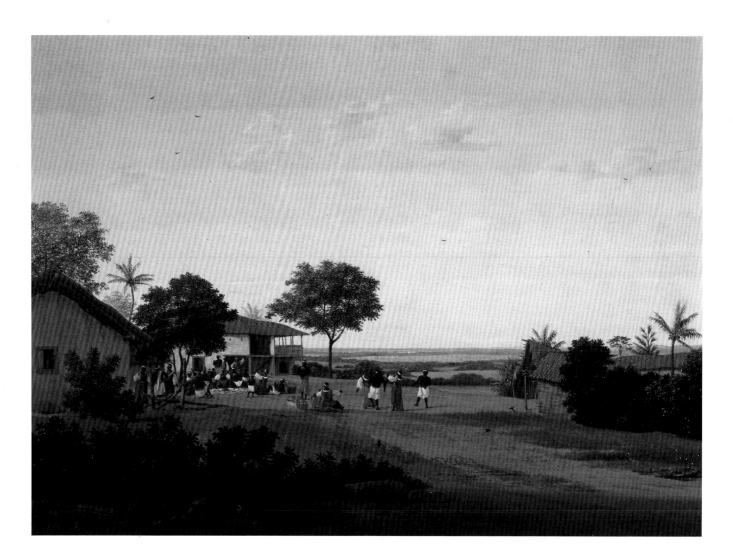

CAT. 54 Frans Post: *Brazilian Village with Buildings and Native Figures*

CAT. 55 Frans Post: *Brazilian Landscape with Native Figures*

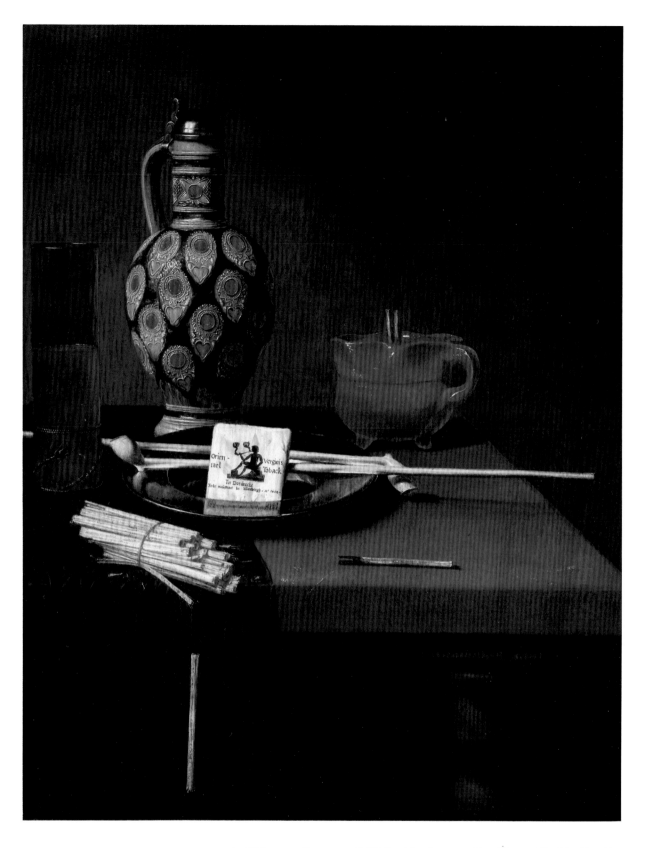

CAT. 56 Hubert van Ravesteyn: *Still Life with a Stoneware Jug, Glass and Smoking Requisites*

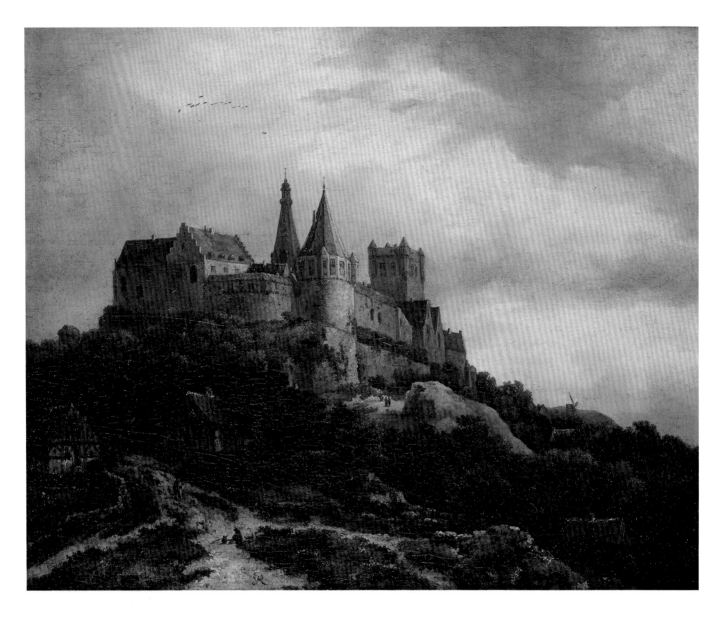

CAT. 57 Jacob van Ruisdael: *The Castle of Bentheim*

CAT. 58 Jacob van Ruisdael: *Landscape with Cornfield*

CAT. 59 Jacob van Ruisdael: *Panoramic View of Haarlem*

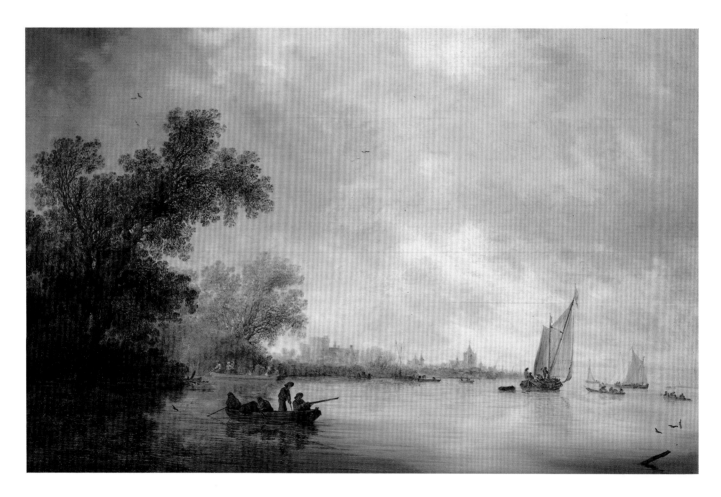

CAT. 60 Salomon van Ruysdael: *View of the River Lek with Boats and Liesvelt Castle*

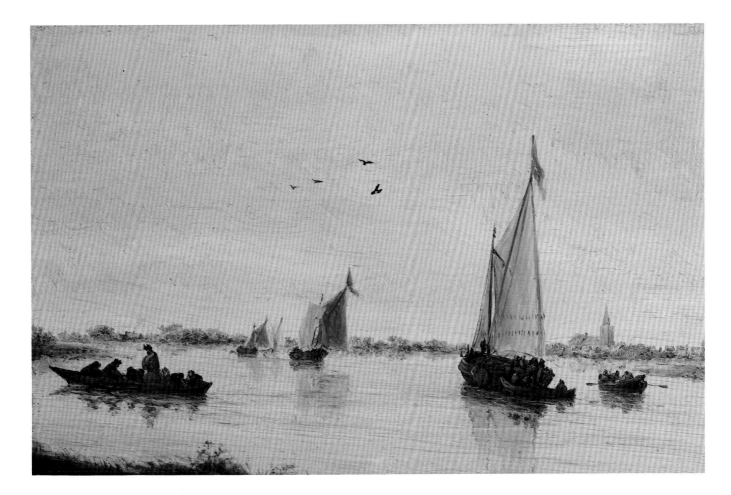

CAT. 61 Salomon van Ruysdael: *Sailing-Boats on a River*

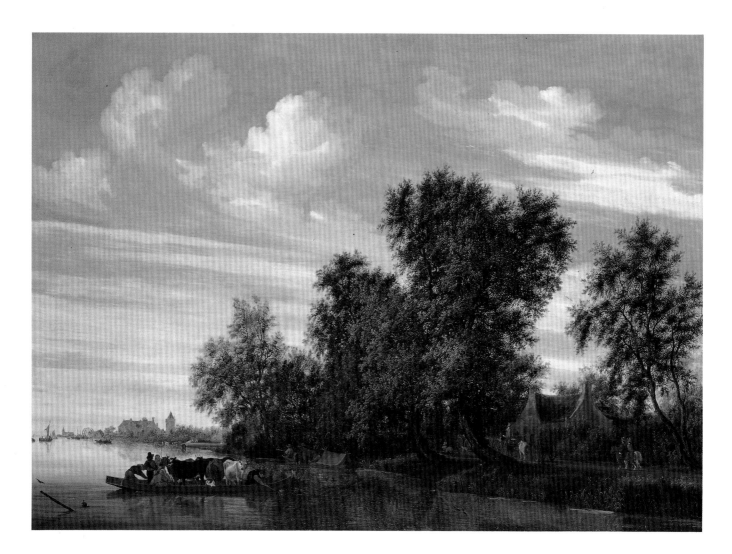

CAT. 62 Salomon van Ruysdael: *River Landscape with Ferry Boat*

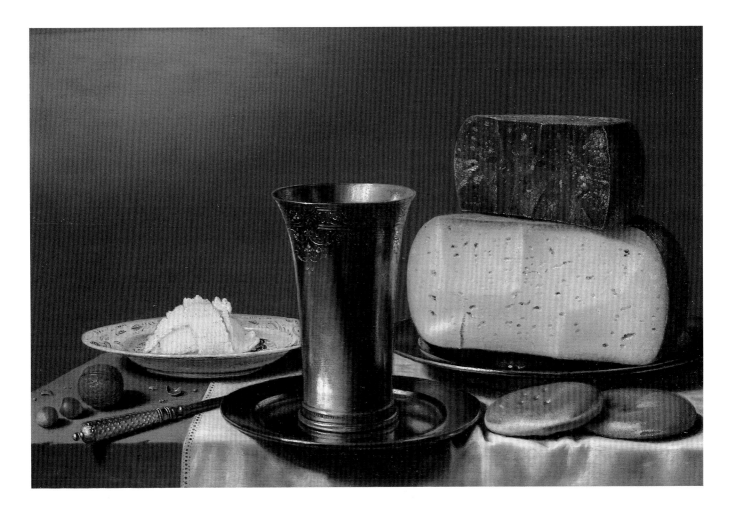

CAT. 63 Floris van Schooten: *Still Life with Beaker, Cheese, Butter and Biscuits*

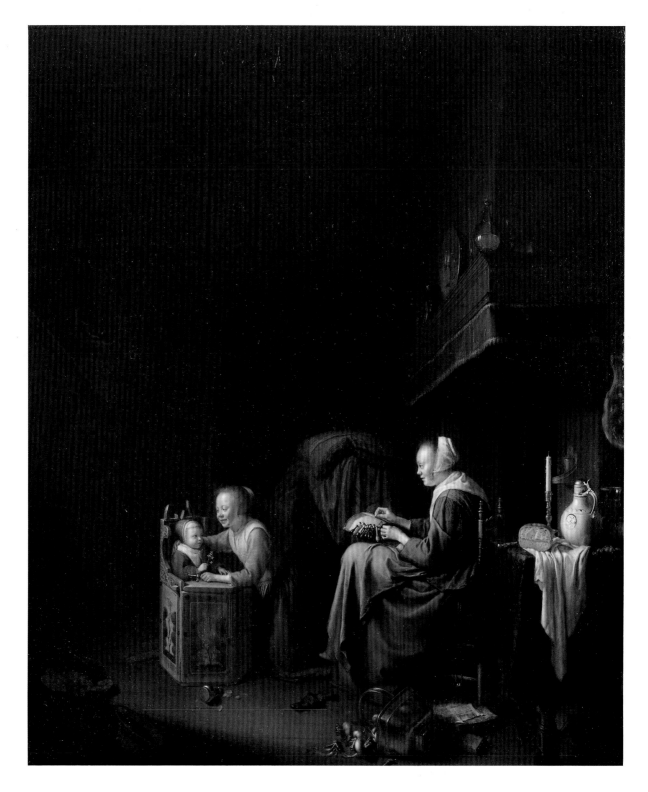

CAT. 64 Pieter Cornelis van Slingelandt: *Woman Making Lace With Two Children*

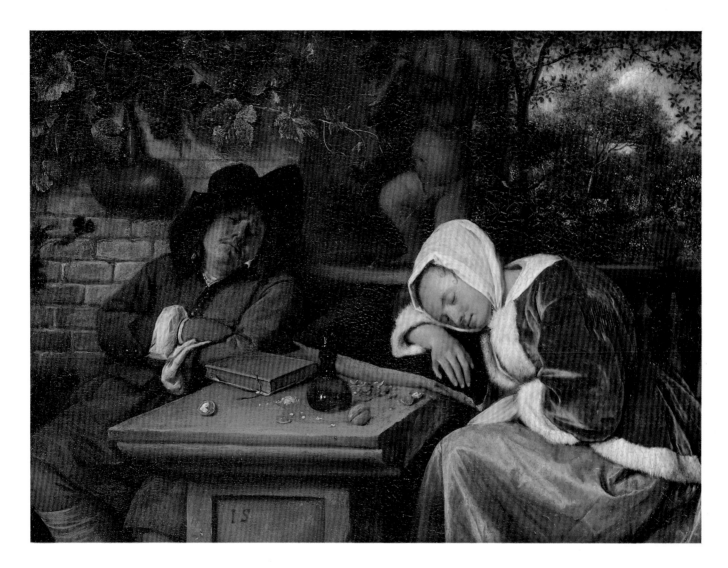

CAT. 65 Jan Steen: *The Sleeping Couple*

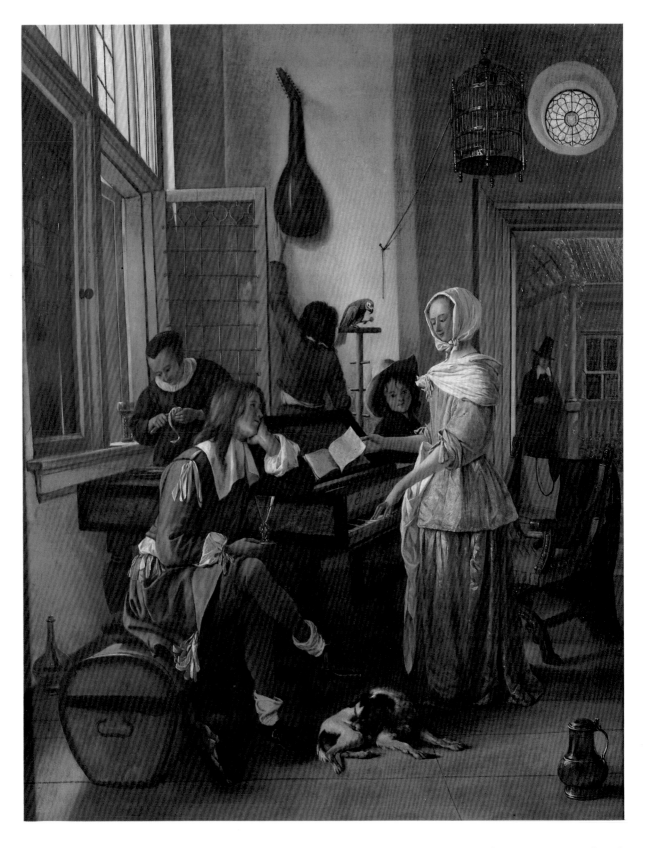

CAT. 66 Jan Steen: *Musical Company* (known as *'The Young Suitor'*)

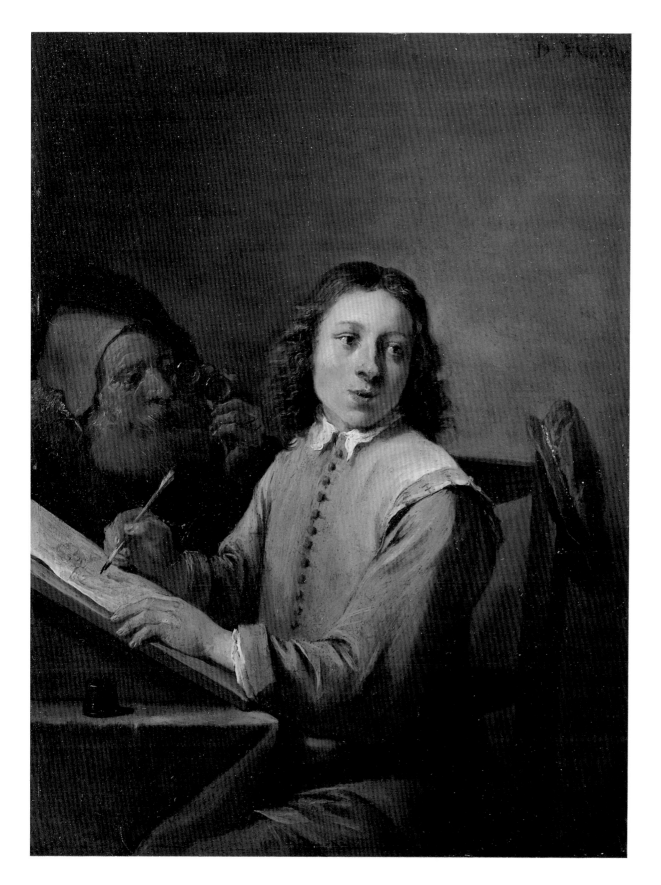

CAT. 67 David Teniers the Younger: *Sight*

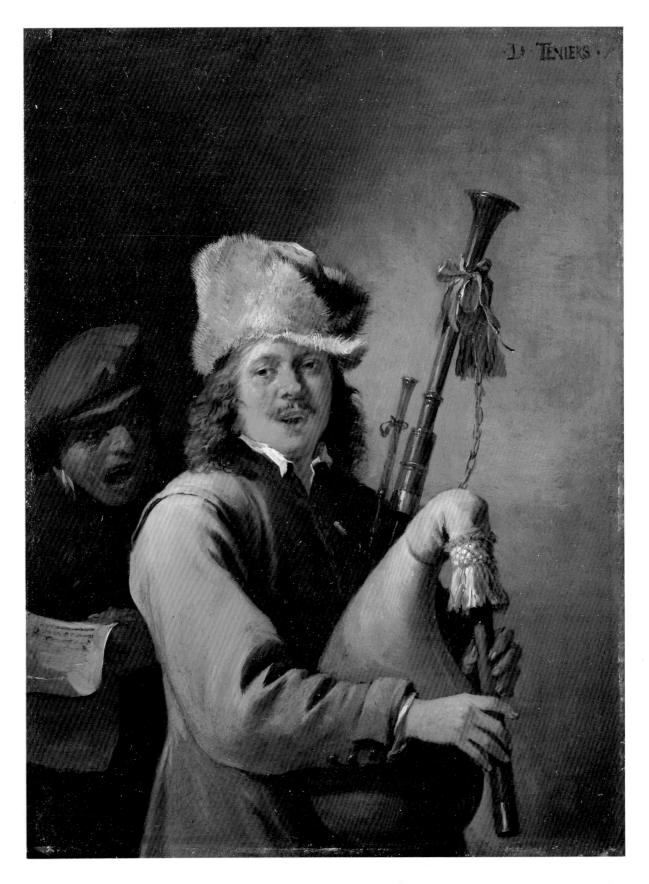

CAT. 68 David Teniers the Younger: *Hearing*

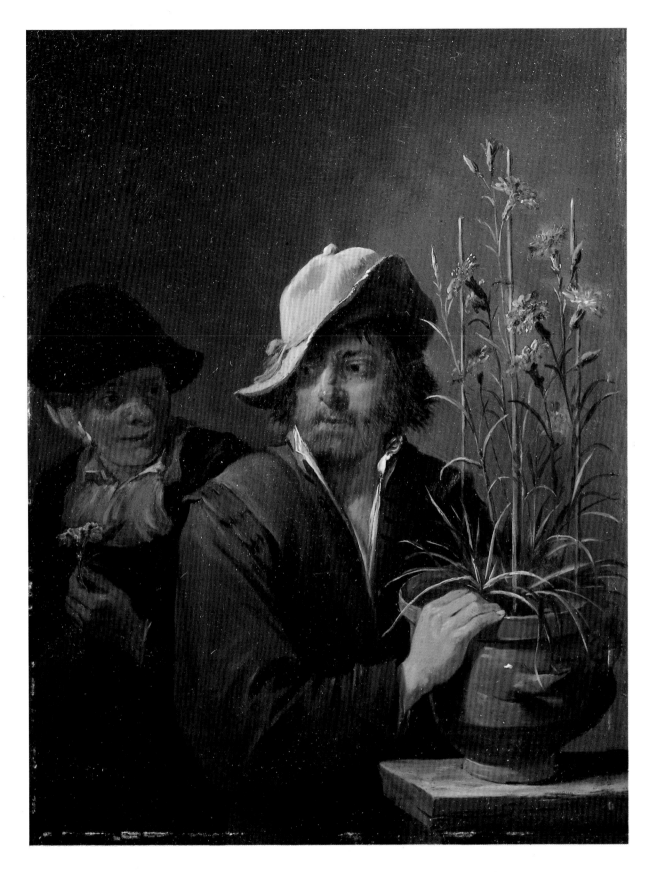

CAT. 69 David Teniers the Younger: *Smell*

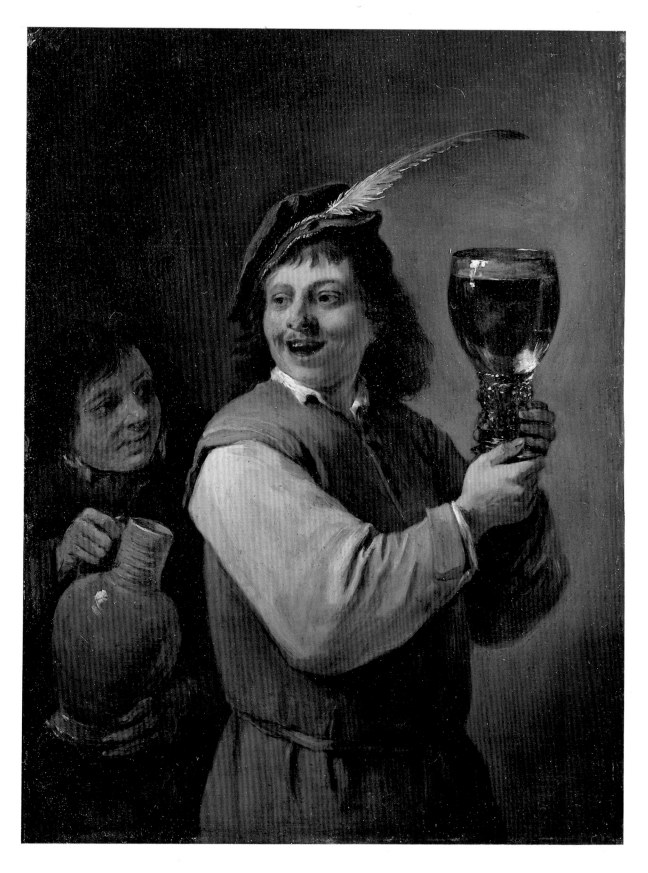

CAT. 70 David Teniers the Younger: *Taste*

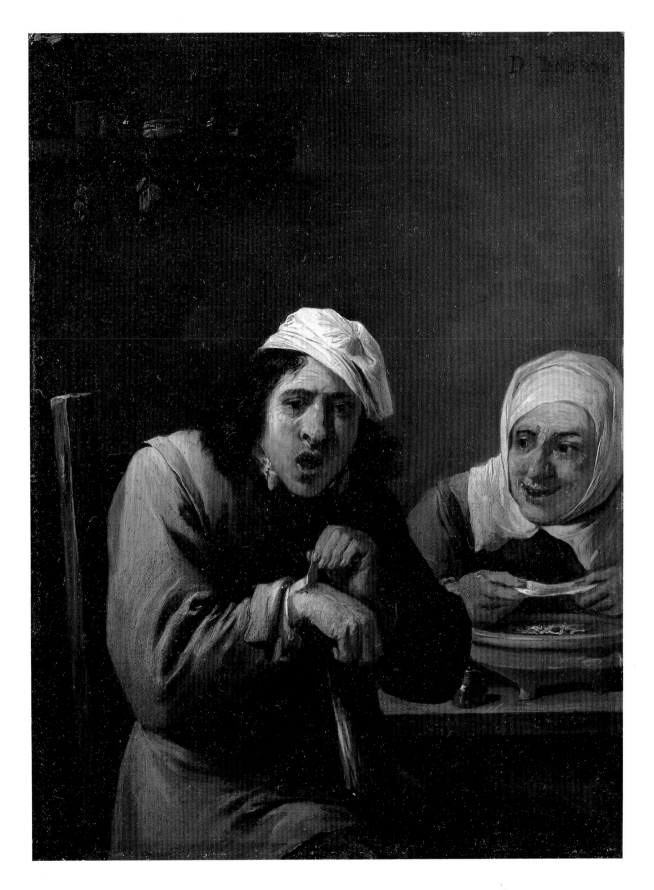

CAT. 71 David Teniers the Younger: *Feeling*

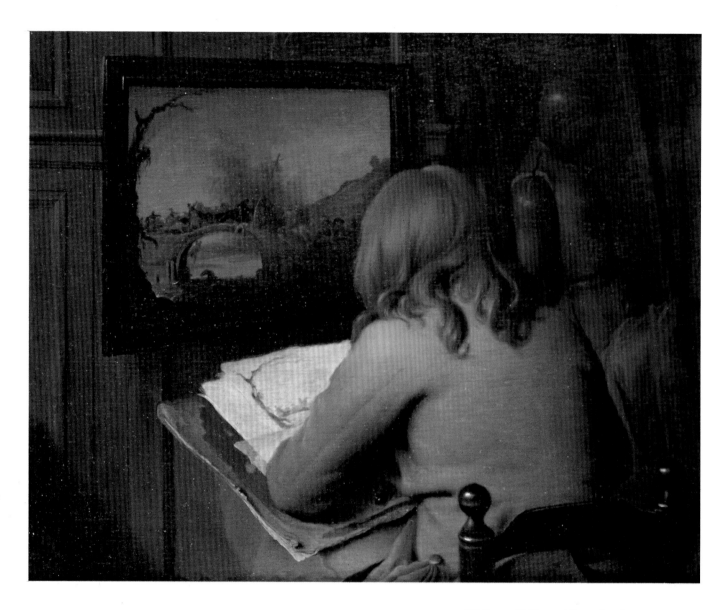

CAT. 72 Wallerant Vaillant: *A Young Boy Copying a Painting*

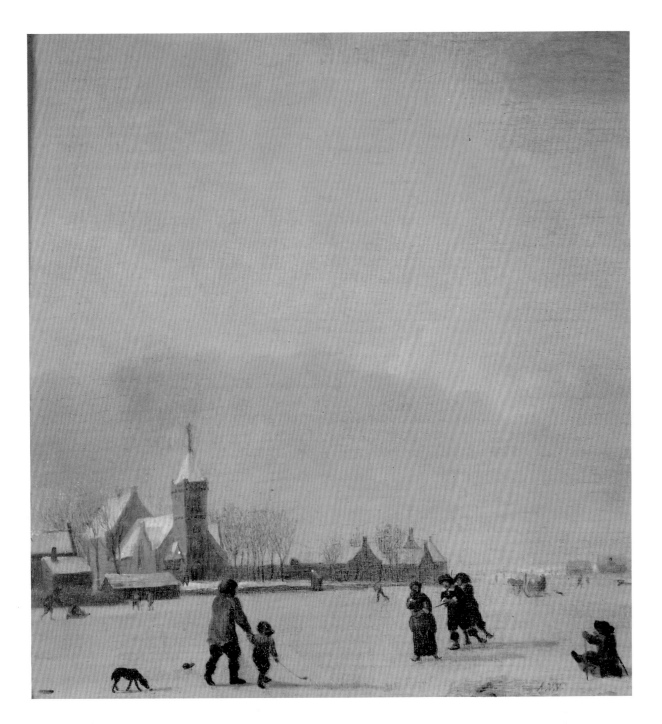

CAT. 73 Adriaen van de Velde: *Winter Landscape with Skaters*

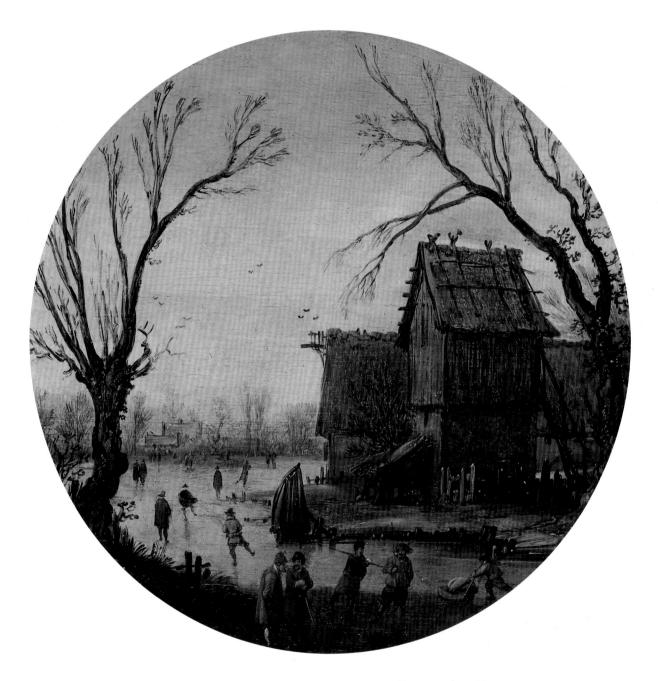

CAT. 74 Esaias van de Velde: *Winter Landscape with Skaters*

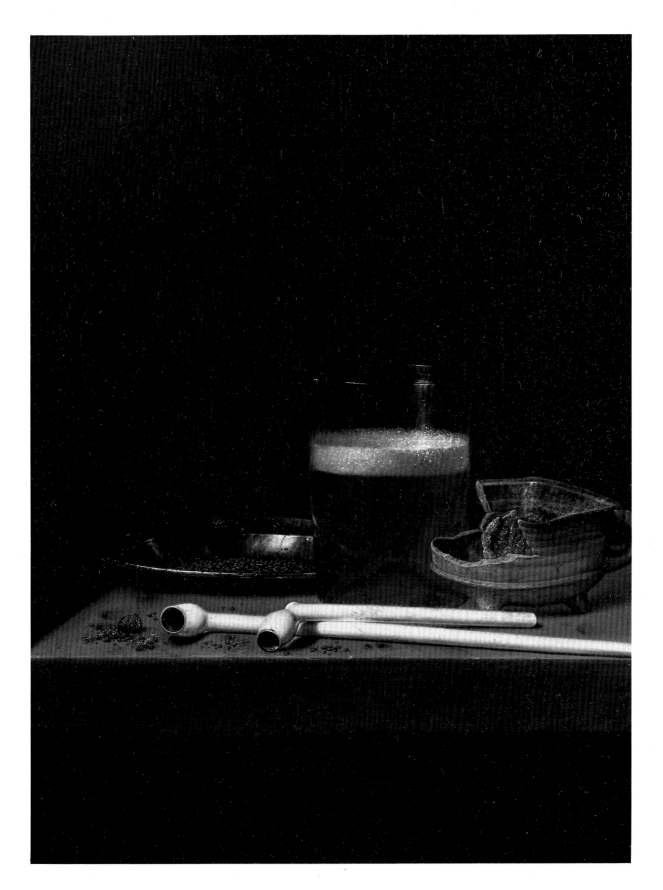

CAT. 75 Jan Jansz van de Velde III: *Still Life with Glass of Beer, Brazier and Clay Pipes*

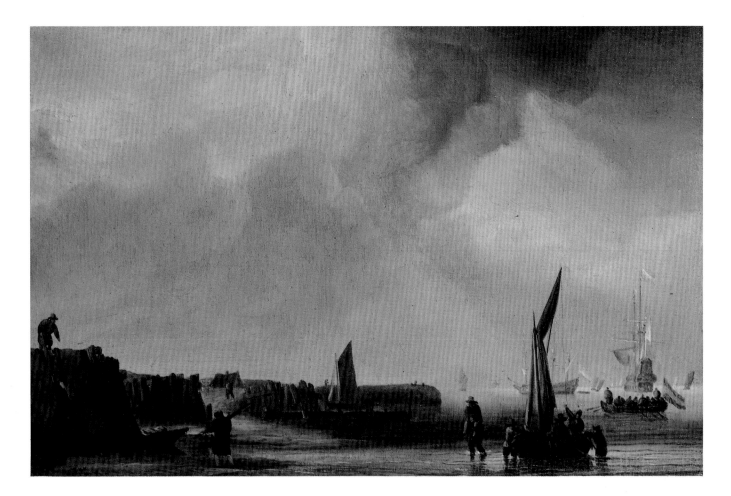

CAT. 76 Willem van de Velde the Younger: *A Weyschuit Coming Ashore near Den Helder*

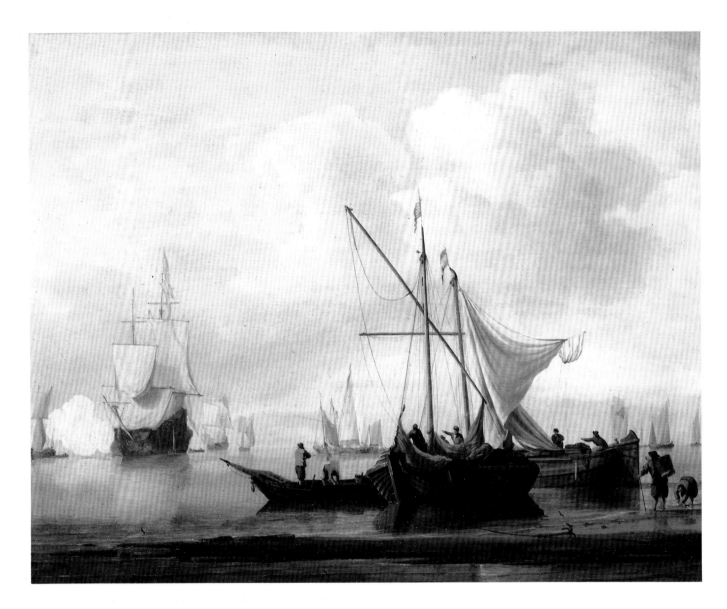

CAT. 77 Willem van de Velde the Younger: *A Kaag and Smalschip near the Shore, with a Ship Firing a Gun*

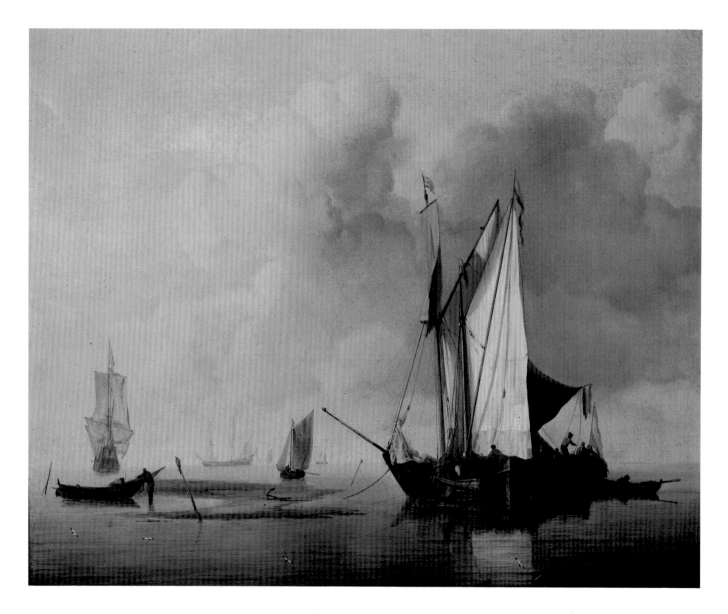

CAT. 78 Willem van de Velde the Younger (attributed to): *A Kaag Anchored by a Sandbank with Two Other Vessels*

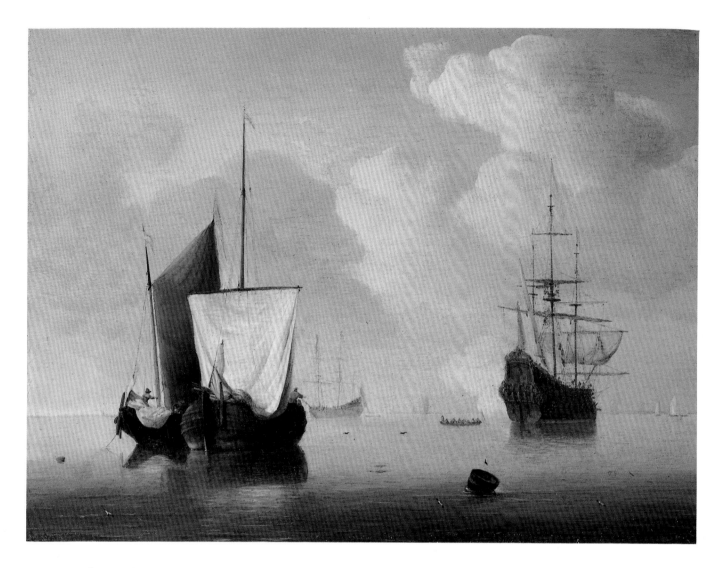

CAT. 79 Willem van de Velde the Younger and Studio: *A Hoeker Alongside a Kaag at Anchor*

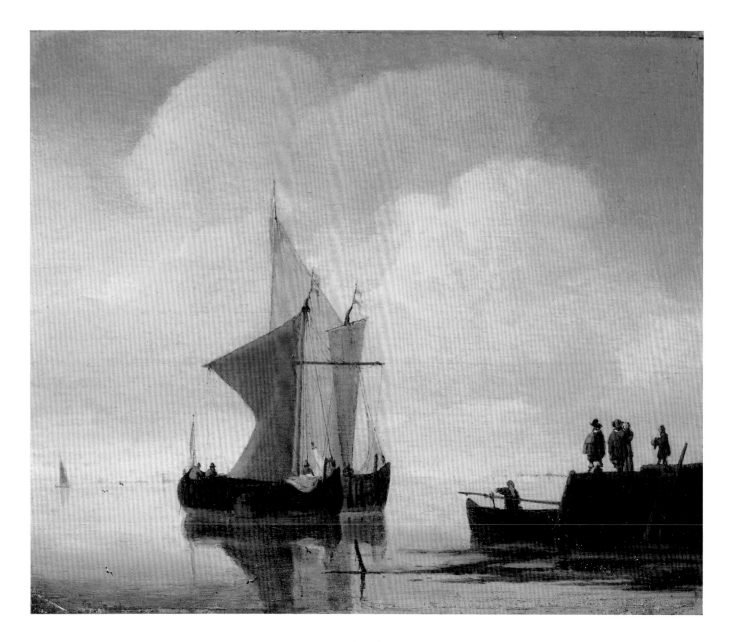

CAT. 80 Studio of Willem van de Velde the Younger: *Two Smalschips off the End of a Pier*

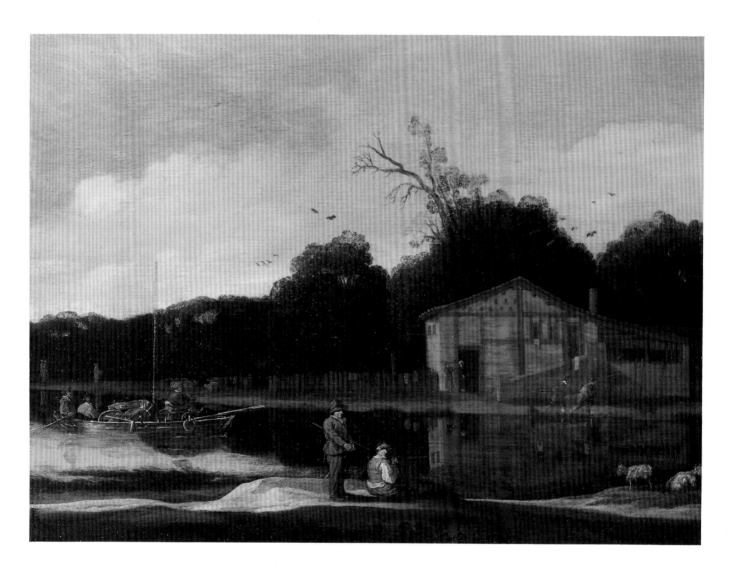

CAT. 81 Cornelis Vroom (follower of): *Cottage on a Canal with a 'Trekschuit'*

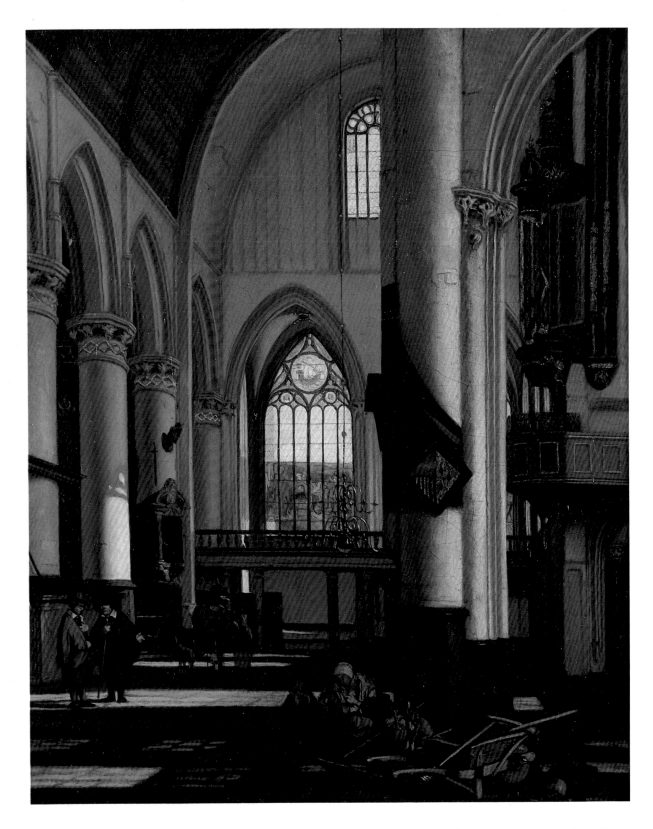

CAT. 82 Emanuel de Witte: *Interior of an Imaginary Protestant Gothic Church*

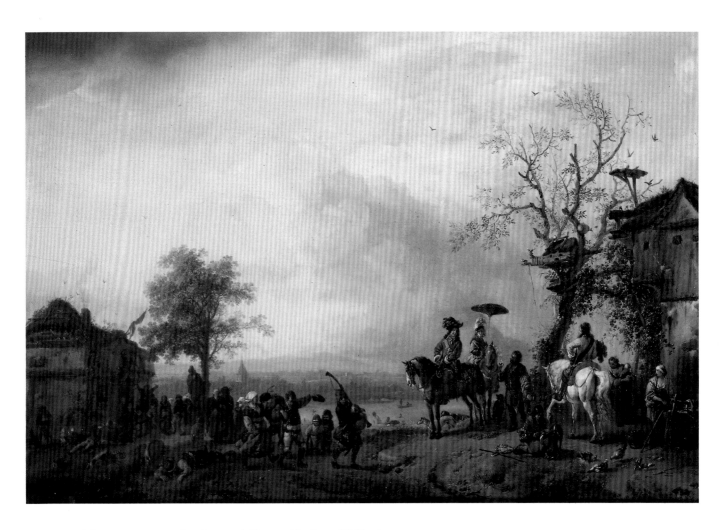

CAT. 83 Philips Wouwermans: *Landscape with Kermis ('The Rustic Wedding')*

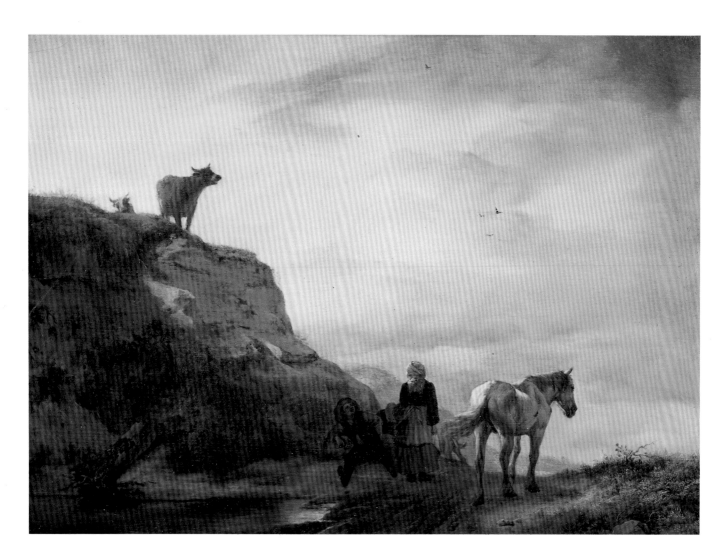

CAT. 84 Philips Wouwermans: *Landscape with a Grey Horse and Figures by the Wayside*